Digital Photography
for the Older and Wiser

The Third Age Trust

The Third Age Trust is the body which represents all U3As in the UK. The U3A movement is made up of over 700 self-governing groups of older men and women who organise for themselves activities which may be educational, recreational or social in kind. Calling on their own experience and knowledge they demand no qualifications nor do they offer any. The movement has grown at a remarkable pace and offers opportunities to thousands of people to demonstrate their own worth to one another and to the community. Their interests are astonishingly varied but the members all value the opportunity to share experiences and learning with like-minded people. The Third Age Trust's endorsement of the Older and Wiser series hints at some of that width of interest.

THE THIRD AGE TRUST

THE UNIVERSITY OF THE THIRD AGE

Digital Photography for the Older and Wiser

Get Up and Running with your Digital Camera

Kim Gilmour

A John Wiley and Sons, Ltd., Publication

Library of Congress Cataloging-in-Publication Data

Gilmour, Kim.
 Digital photography for the older and wiser : get up and running with your digital camera/Kim Gilmour.
 p. cm.
 Includes index.
 ISBN 978-0-470-68702-4 (pbk.: alk. paper) 1. Photography—Digital techniques. I. Title.
 TR267.G554 2010
 775—dc22
 2009045992

ISBN 978-0-470-68702-4

A catalogue record for this book is available from the British Library.

Set in 11/13 Zapf Humanist 601 BT by Laserwords Private Limited, Chennai, India
Printed in Trento, Italy, by Printer Trento

Dedication

To my daughter Audrey, with love

Contents

Contents

Contents

Contents

Part III – Liberating your digital photos 197

Chapter 14 – Sharing your images online and off 199

Chapter 15 – Printing photos at home 217

Contents

Acknowledgements

Thanks to everyone who helped make this book a joy to write – including those who've contributed photos for this book, and anyone who appears in photos! Particular mention goes to: my parents Brian and Liem Gilmour, Isabel Atherton, Steve Hill, Nina Ippolito, Sarah Kidner, Mark Massey, Sean McManus, Terry and Kristian Barlow, the Snelling family and the Robertson-Neil family.

I'm also hugely grateful to the team at John Wiley for their encouragement and support.

About the Author

Kim Gilmour is a journalist and author who has been demystifying the world of technology since 1998. She is a regular contributor to UK computing titles including *Which? Computing* and *Web User*, and is co-author of eBay.co.uk Business All-in-One for Dummies.

Originally from Sydney, Australia, Kim has lived in London since 2000. She enjoys digital photography as a hobby, and wishes she had more time to update her website at www.londonphotos.org.

Publisher's Acknowledgements

Some of the people who helped bring this book to market include the following:

Editorial and Production
VP Consumer and Technology Publishing Director: Michelle Leete
Associate Director – Book Content Management: Martin Tribe
Associate Publisher: Chris Webb
Assistant Editor: Colleen Goldring
Publishing Assistant: Ellie Scott
Content Editor: Claire Spinks
Project Editor: Juliet Booker
Development Editor: Kenyon Brown
Technical Editor: Brian Peart
Copy Editor: Shena Deuchars

Marketing
Senior Marketing Manager: Louise Breinholt
Marketing Executive: Chloe Tunnicliffe

Composition Services
Compositor: Laserwords Private Limited
Proof Reader: Sarah Lewis
Indexer: Geraldine Begley

With thanks to U3A member, Mrs Gillian Brown, for naming our Older and Wiser owl "Steady Stanley". This was the winning entry from the U3A News competition held in October 2009.

Icons used in this Book

Throughout the book you will notice symbolic images. These have been introduced to help focus your attention on certain information and are summarised as follows:

 Equipment needed — Lets you know in advance the equipment you will need to hand as you progress through the chapter.

 Skills needed — Placed at the beginning to help identify the skills you'll need for the chapter ahead.

 Tip — Tips and suggestions to help make life easier.

 Note — Take note little extras to avoid confusion.

 Warning — Read carefully, a few things could go wrong at this point.

 Try It — Go on, enjoy yourself you won't break it.

 Trivia — A little bit of fun to bring a smile to your face.

 Summary — Recap at the end of each chapter with the short summary.

 Brain Training — Brain training, test out your memory.

PRACTICE MAKES
PERFECT

To build upon the lessons learnt in this book, visit www.pcwisdom.co.uk

- **More training tutorials**

- **Links to resources**

- **Advice through frequently asked questions**

- **Author videos and podcasts**

- **Author blogs**

Introduction

Equipment needed: none (although you may already have a digital camera and want to have it to hand when reading this chapter).

Skills needed: some confidence and enthusiasm.

Digital photography is one of the most popular hobbies around today. It's amazing to see how much it has grown in the past five years. This book is designed for anyone who wants to get involved and learn all about this exciting field, but has felt bewildered by the sheer choice of cameras out there and the overwhelming amount of paraphernalia that seems to be on sale in every high street store. What on earth do you need to get started? And how do you actually begin?

It is never too late to explore digital photography. Learning how to use a digital camera is a very rewarding experience. Feeling a little lost at first is completely understandable but it needn't be that way. The main thing to remember is that what makes a 'good' photo relies little on the type of camera you have – it's a matter of opinion!

An ideal composition, being in the right place at the right time and some decent lighting are important, but these are precisely the same rules that apply to traditional film photography!

Nor is there any need to 'upgrade' your camera every other year if it is perfectly capable of producing quality photographs, even if the advertisements and the pushy salespeople have you thinking otherwise. You will know when the time is right to get a new camera.

However, owning a camera that is easy to use and causes little worry is important, so I spend a lot of time on how you can choose the right one to suit your needs, particularly if you are new to such technology. There are also a few digital photography concepts that will help you make a good photo brilliant. A small tweak of the settings here and there when you are composing your image can really bring out the best of a situation.

How this book is structured

This book is divided into three parts. I think it's best if you read them in order but some people do like to dip in and out of chapters. If that sounds like you, please note that I assume you have some knowledge of concepts outlined in previous chapters.

Part I: Understanding your digital camera

The first part of the book starts by assuming no prior knowledge and explains the reasons why you might be interested in digital photography. I outline how digital photography is similar to (and different from) film, as well as some of the major terms you'll encounter when you're using your camera. There's a chapter on what to look out for when buying a camera and how to see through the salesperson's hype (ease of use is the most important thing).

The rest of Part I includes essential, illustrated chapters on taking your first photographs and the main features you'll find on your digital camera. In Chapter 8, there's a special emphasis on taking photos of children and animals. But really, the best way to get great shots is to practice and experiment. We all know that digital photography can produce some excellent results, so this book is more functional than artistic (although my contributors have provided some beautiful photographs!).

If you are hungry for more tips and photographs, there are many other resources at your disposal and I list some of them at the back of the book.

Part II: Entering the digital darkroom

The second part of the book is about the 'digital darkroom': step-by-step instructions show you how you can get your photographs on to your computer and what you can do with them from there.

If you are interested in using your computer to help you make the most of your digital photographs, I do assume a little prior knowledge of computing before you get started, including how to use a mouse, open a program, access files and folders within Windows and how to copy or move a file from one folder to another. Please refer to *Computing with Windows 7 for the Older and Wiser* should you need help with these tasks.

I go on to explain how you can store your photographs and keep them organised on your computer using free tools from Microsoft and Google (you may need to ask someone to help if you have no prior knowledge of installing a program on your computer). The remaining chapters in Part II introduce the concept of photo-editing software – this is the modern equivalent of the darkroom of old, without the smell of chemicals that I remember always ended up on your hands, no matter how hard you tried to avoid it!

I also include some easy fixes you can make to your photographs to instantly brighten them up or correct common problems, such as red eye (when flash photography turns your subject's eyes red) or incorrect colour balance (when unexpected colours turn up in your photos). If you are hungry for more, then I point you in the right direction, too.

Part III: Liberating your digital photos

The last part of the book explains how you can share your photographs with your friends, family and even the rest of the world (perhaps on email or by using an online photo album). People end up taking thousands of photographs but who gets to see them? I outline the types of home printer available, how you can print photographs at home and ways to share them with friends and family over the Internet. A little basic computing knowledge and prior experience of browsing the Web is assumed for some chapters, but even those who don't want to get involved with the computer side of things will find ways to circumvent them in this section!

Appendices

You'll find an extensive glossary here if you want a refresher on a particular definition. Both digital photography and computing terms you may come across are covered.

I also list a heap of useful websites and other resources for you to continue exploring and learning. Why not join an online community to discuss your new hobby?

Common worries

Here are some of the reasons I think people have delayed their foray into digital photography. Maybe one or more of these 'worries' have crossed your mind? They aren't all exclusive to the 'older' generation, either.

- **The camera is hard to use:** Take things at your own pace and don't let anyone else (however well-meaning they may be) rush you into things – everyone learns things differently. Do not worry if your camera proves frustrating to use and does not behave itself, for whatever reason. You may just need to go back a step or two and try again – perseverance is key. Being frustrated can stifle your creativity and make you less keen on continuing with such a rewarding hobby, but don't give up yet. I have had the experience myself: for a while after acquiring my first digital camera I used to think none of my photographs matched the ones I took with film, but that was because I was more familiar with my old camera's functions. Gradually, however, I managed to become more aware of my new camera's features and how they could benefit my photos.

 If you keep trying and are still uncomfortable with using your digital camera, perhaps it isn't right for you: the buttons or the screen at the back could be too small, for example. I thoroughly outline what to look out for when you are buying a digital camera so you can avoid this situation and choose the best one for your needs. You may need to try an alternative model if you received the camera as a gift.

- **I'm not a good photographer:** Everyone has occasions when their photos may not turn out quite right depending on the lighting or the circumstances, but the thing about digital is that you can take as many photos as you like without worrying about the cost of film, as the 'bad' photos can be easily erased and minor problems with lighting and composition can be miraculously fixed on your computer. A few common photography tips are provided in this book and there are plenty of online resources, too. Why not ask people for honest and constructive feedback?

- **I will press the wrong button and lose all my photos:** Another worry is that you will lose all your digital photographs in an instant should you press

the wrong button on the camera. This is not necessarily the case, as you will usually have to confirm that you are sure you want to erase the photo, or photos, before you proceed. This book also shows you how to copy your photos on to your computer for safekeeping and backing up. It's easier than you think, and you can still go to a photo lab to get them to copy the images on to a disk if you are really not keen on using your computer. I can't guarantee that the worst won't happen, it's just that it is very unlikely so long as you take precautions. There *are* ways to try and retrieve photos you may have accidentally erased, which I explain in the book – although these solutions are not always guaranteed, they are worth a try.

- **There is too much technical stuff to learn:** While digital photography has spawned a whole new set of buzzwords, such as megapixel, JPG, red eye, resolution, pixels, memory cards and so on (sorry!), this book guides you through the most common terms and what they mean. There are many manual controls but in practice you won't need to worry about too many of them because modern digital cameras have automatic modes that require minimal input from you. However, those who do want a bit more creative control are catered for in this book, too.

- **It makes me feel stupid:** *You* are in control of your digital camera. Relax, have fun and try again – that way you can learn from any mistakes.

- **I don't know anything about computers:** You don't actually need to use a computer if you want to get started with digital photography. You can always get a photo lab to print and back up your photographs and, in fact, the first part of the book barely even mentions computers. That said, knowing at least some basic computer concepts will put you at an advantage as you will be able to organise, enhance and share your images. A large part of the book focuses on just that, but there are many consumer-friendly tools out there to make things easy for you.

Your digital camera

Don't worry if you don't have a digital camera yet, as this book explains what to look out for when you are in the shops. Most of the book is targeted towards people who plan to use compact 'point and shoot' cameras rather than digital single-lens reflex (SLR) models with interchangeable lenses, but there is some information about digital SLRs for those who want an 'upgrade'.

The only thing you need to know is how much you are prepared to spend (I provide some money-saving tips, too).

If you already have a digital camera, you'll find plenty of advice on technique and how to make the most of the equipment you've got.

Your computer

Assuming you have a computer and want to use it for digital photography, these are the ideal specifications you'll need (if you don't know what these terms mean, don't worry, I explain them in more detail in Part II):

- A broadband connection.
- Ample hard disk space to store all your photographs (as much as possible).
- At least 1GB of RAM (you *can* get away with 512MB but the more the better for digital photography).
- A DVD drive with the capability to write (burn) data.
- A flat-screen monitor, preferably with a 17-inch screen to help you see your images clearly and crisply.
- Windows Vista or Windows 7 (you can use the older Windows XP operating system but some instructions may be slightly different from the book).
- A printer if you want to print photos at home (please see Chapter 15 for more on choosing a printer, which may include one with scanning functions).

If you are a Mac user, you will still find this book useful as all the principles I discuss are basically the same – you just need to disregard some of the step-by-step instructions that relate to Windows.

This book is your companion: it will help you demystify the jargon and the glossy marketing surrounding digital photographs, so you have the knowledge and, most of all, the confidence to go ahead and experiment with taking photographs and even editing and printing them. Happy snapping!

Summary

- Take things slowly and at your own pace
- Let this book help you choose the right digital camera for your needs and budget
- Practice makes perfect

Brain Training

There may be more than one answer to each of these questions.

1. In digital photography, what is 'red eye'?

a) Changing the colour of your photograph

b) When your subject's eyes look red as a result of flash photography

c) The strain your eyes get when you stare at a computer screen for too long

d) Another name for your camera lens

2. Why would you want to use a computer for digital photography?

a) To correct red eye

b) To fix incorrect colours

c) To store your photographs

d) To print your photographs

3. What is the most important thing to consider when buying a digital camera?

a) How many megapixels it has

b) How much it costs

c) How easy it is to use

d) How small the buttons are

4. What makes a good photograph?

a) How advanced your digital camera is

b) How skilful your photography is

c) It's a matter of personal opinion

d) How many accessories you use

5. Why shouldn't you worry about erasing or losing all your photos?

a) There are ways to back them up

b) You will usually be warned before you erase them

c) They are unable to be erased

d) You can always undo the action and retrieve them later

Answers

Q1 – b **Q2** – All are correct **Q3** – c **Q4** – c

Q5 – a and b

PART I
Understanding your Digital Camera

It's so technically advanced that it goes off and takes its own pictures!

Getting started with digital photography

Equipment needed: none (although you may already have a digital camera and want to have it to hand when reading this chapter).

Skills needed: some confidence and enthusiasm.

Congratulations! You've decided to take the plunge and find out what all the fuss is about digital photography. It almost seems like the whole digital revolution has come out of nowhere. Just ten years ago, most of us were still using film in our cameras. I still reminisce about the satisfying whirr mine made as the next frame on the roll progressed or, with older manual cameras, the clunky sounds associated with winding on the 35mm film. These cameras are still great investments: well-built, made to last and producing rich, memorable results.

But it is easy to get caught up in nostalgia. We are living in the digital age after all. Advances in technology mean that digital cameras are cheap; photographs nowadays are crisper than ever; film is fragile and deteriorates over time whereas a digital photo, when stored correctly, should last indefinitely; and you don't need to keep spending money on film each time you want to take photos.

Before you start

You may already have a digital camera – maybe someone has given one to you new or second hand. But many of you may be thinking about buying one. Whatever the scenario, this chapter explains how digital photography differs from

traditional, 35mm film-based photography. Later, in Chapter 4, we get on to choosing and buying a digital camera.

Remember, the digital camera is your tool – it can't choose what it thinks will make a good photo (although who knows what will happen in the future!). Definitive observations of street life taken by masters such as Henri Cartier-Bresson or Brassaï will always hold their place in history. And a portrait of a smiling grandchild taken with a throwaway camera provides a lasting memory.

You don't actually need a computer to enjoy digital photography! Yes, if you want to make the most of organising, enhancing, editing and sharing your memories, then you certainly need a computer – and a large part of this book is dedicated to just that. For those chapters, we assume that you do have a little basic computing knowledge, perhaps sourced from our sister title in this series, *Computing with Windows 7 for the Older and Wiser*. However, there are several ways to store and print your photos that bypass computers altogether. Granted, it's not nearly as efficient to use a digital camera without a computer, but if you aren't quite ready to learn about the computing side of things just yet, then that's fine.

What computers can do is enhance a photograph to make it far more appealing – often referred to as the 'digital darkroom'. People say photographs can be easily manipulated in the digital era using computer wizardry. But photographs have always been edited in some manner. Photography is an art and if you've ever used a darkroom, you'll know how easy it's always been to cheat a little, such as using gadgets to 'burn' in certain features or 'dodge' out certain unwanted elements. And filters placed on lenses or darkroom enlargers have always been used to add atmosphere and drama to a photograph.

Digital photography comes with a lot of associated buzzwords, but don't worry: I'll explain what you need to know as we go along. You won't need to remember all of it, either – almost all digital cameras have an 'auto' mode that does all the work for you, but there are times when you might need a little more manual control. That's why it's a good idea to have some knowledge of the basic concepts, if only to help you if you run into a little trouble.

What's similar to film?

Some of the following points will be obvious – but I've listed them here just to illustrate how similar digital is to film.

● Both film and digital cameras require a lens to capture images. And they do so in the same way as your eyes capture the images around you – with light passing through a curved optical element. It's just that the technologies used to capture the images are different. Figure 2.1 shows a Fujifilm digital camera and Figure 2.2 shows a film camera. From the outside, they don't look that different, do they?

Source: www.fujifilm.co.uk

Figure 2.1 **Figure 2.2**

● Both use a shutter release. You need to press a button (see Figure 2.3) in order to take a photograph.

Source: Canon

Shutter button

Figure 2.3

- Both are sensitive to light conditions. If you take a film camera into a concert and flash photography is not allowed, you need to use high-speed film (see Figure 2.4) to capture fast-moving images. With a digital camera, you enter the appropriate settings into the device rather than load a roll of film into it.

Source: www.fujifilm.co.uk

Figure 2.4

- With automatic film cameras, depressing the shutter halfway usually focuses on your main subject. Digital cameras do the same thing.

There are different types of digital camera to suit amateurs, professionals and those on a budget, just as there are different types of film camera. More about these later, but here are three from the manufacturer Canon.

Figure 2.5

Figure 2.6

Source: Canon UK

Figure 2.7

What's different from film?

- A digital camera captures images and turns them into digital signals using an image sensor, a chip that is housed in the camera. There are two main types of sensor around: CCD is used for smaller cameras and CMOS, in Figure 2.8, is used for more advanced ones. You won't need to know about how they work.

Source: Canon UK

Figure 2.8

- Digital cameras store images on a memory card – a small, removable card that you can use again and again. There are many different types of memory card and you need to buy the type that goes with your camera. You'll find them in different capacities (just as if you were to buy a roll of film with 24 or 36 exposures – but on memory cards, you can store up to thousands of images!).

Source: SanDisk

Figure 2.9

- With a film camera, you have to wait until your negatives or slides are developed before you can see how your photos turned out. But on a digital camera, you can review the photos you've taken as soon as you've captured them, using the colour monitor (the screen) at the back of the device. You can use your camera's

functions to zoom into the displayed image and look at details such as the settings used and the time and date it was taken.

- You can use a digital camera to review and erase photos that you don't like.

- Most compact digital cameras also have a built-in video recorder, so you can capture moving images and sound as well as still images. Quality isn't as great as a dedicated camcorder, but it's still decent enough to put on to a video-sharing website, such as YouTube.

- The quality and detail of your photos can vary depending on the camera's specifications. Most modern digital cameras can capture enough detail for you to print out a brilliant-looking 8x10-inch photograph, or even one at poster size. However, the best film cameras – with the best lenses and ability to capture scenes on large-format negatives – are still just as good as, if not better than, the highest-quality digital cameras – and they are far cheaper (excluding the film costs). That's why many professionals still work with film for large-scale photographic works.

There are, of course, many other features (and drawbacks) to digital cameras. We don't want to overwhelm you at this stage, though!

Taking photos with your digital camera

Taking photos with your digital camera is relatively simple, especially if it's set to automatic mode – this means that the camera detects your surroundings (whether you're inside or outside, for example) and adjusts its settings accordingly. There are times you'll need to exercise some manual control but most people do just fine with the basic settings, at least to start with.

On/off switch

Let's get this bugbear out of the way: one thing I find annoying about digital cameras is that they have to be switched on for you to use them. And sometimes they take a second or two to start up, by which time the moment has passed. There's nothing more frustrating than this! But, thanks to advances in technology, cameras do start up far quicker than they used to.

Monitor/screen

I'm sure you've seen many friends and family members happily snapping away with their digital cameras. The photographer holds the camera a few inches in front of their face and views the scene in front of them on the colour monitor at the back of the camera – it's just like a mini television screen (see Figure 2.10). This screen serves many functions – it's used to frame and review images and it's also used to view and control various camera settings, such as changing the date or time or erasing an unwanted photo.

Source: www.fujifilm.co.uk

Figure 2.10

The size of the camera's screen differs from model to model depending on its age and style. A screen is typically a liquid crystal display (LCD). Due to economies of scale, it has become cheaper to produce these monitors, so the size of them has increased. Some seem to take up the entire back of the camera. The advantage of having a larger screen, of course, is that it's easier to see the image you are composing – which is good for anyone whose sight isn't the greatest. Just wait until you see these images on a computer screen or in printed form. Amazing!

 LCD screens are a drain on the camera's battery so it's best to keep a fully-charged spare (or two) to hand when you are going somewhere special.

Viewfinder

Your old film camera has a viewfinder, the little hole you gaze through when framing an image. Most compact 'point-and-shoot' digital cameras these days don't have a viewfinder and you'll need to rely solely on the monitor, so it may take a little getting used to. Cameras that are targeted towards enthusiastic amateurs often do include a viewfinder. I find it disappointing that many of the small cameras don't have a viewfinder, because monitors can suffer from glare if you are in a particularly sunny place and you may not see the screen properly. Having a viewfinder to look through is a good backup option. And if you're low on battery power, turning the monitor off can save precious energy.

I have to admit that I rarely need to use the viewfinder as most modern LCD monitors are pretty good at coping with sunny conditions. But there's another advantage to having a viewfinder. If you don't have a tripod, I find that holding the camera against your nose and peering through the viewfinder steadies the camera far better than if you hold it in front of you. When we discuss buying a camera in Chapter 4, those who don't have the steadiest of hands might consider trying to find a camera with a viewfinder as well as a monitor (see Figure 2.11).

Source: Canon UK

Figure 2.11

Shutter button

Once you are happy with the scene in front of you, you depress the shutter button on top of the camera to take the photograph. Most cameras these days are very sophisticated. Depressing the button halfway tells the camera to focus on your main subjects. Many cameras can recognise if there are faces in the scene and automatically adjust the camera settings to make sure the resulting photograph is the best it can be. The automatic mode will generally suit you fine, but there will be plenty of occasions when the camera acts a bit stupidly (it is a machine, after all) and doesn't understand what's going on, so your picture turns out too bright (overexposed), too dark (underexposed), or out of focus. That's when you'll need a little more manual control – sometimes switching to a different setting is all that's required.

Reviewing the photo

As soon as you take the photo, it should appear for a few seconds on your monitor just to assure you it's definitely been taken – and you can also check to see if it looks relatively decent. Then, you're free to take the next photo (or turn the camera off).

Don't worry if you don't get a chance to see the photo you just took – you and your friends can go back and review your photo at greater length later; you can erase it if it doesn't look as you expected.

Storing the photo

So, without film to record your photos, where do they go? As I've mentioned, your camera records your images on a removable memory card. Each photo is an individual file, just like a document on your computer – and each is assigned a different file name, such as IMG_1459.JPG or IMG_3421.JPG. IMG is short for 'image' and the numbers increase like an odometer as you take more photographs. JPG is short for 'JPEG' (pronounced 'jay peg'), which is an abbreviation of Joint Photographic Experts Group. This is a type of image file, by far the most common file format.

You can open your camera to retrieve this tiny, miraculous sliver of silicon. You won't lose any of your photos if you do this (unlike a film camera, where opening the back and exposing undeveloped film to light will spoil it in an instant).

Your memory card is designed to be used again and again, but it fills up as you take more images, so you'll need to wipe (erase) your photographs from the card in order to free up space on it. This is where your computer comes in handy – you can copy the files from your camera on to your home computer and store them on your computer's hard drive (more about this in Chapter 10). It's the best place to store your images safely.

After copying images to your PC, it's a good idea to employ a regular backup routine, in case your hard drive does ever become corrupted. I explain more about backup techniques in Chapter 11.

Your photos do not degrade in quality when you directly copy them in their original form to your computer. Once the files are safely copied over, you can then erase the data from your card. The idea of erasing anything can be daunting, but don't worry. You can't just press one wrong button and instantly delete the whole card. You usually have to go through a series of steps, where the camera will ask you if this is what you really want to do (see Figure 2.12). And because you have successfully copied your files over to your computer, you can erase with confidence!

Source: Kim Gilmour

Figure 2.12

You don't necessarily have to erase the *entire* card after you copy the images over to your computer. Your camera settings should allow you to erase a range of older images. Each time you delete a photo, you free up space on the card to take new images.

Those of you who aren't comfortable around gadgets of any kind need not feel left out. You can take your memory card to a photo lab – your local pharmacy or Snappy Snaps will be happy to accept it – and they will copy the data safely on to a CD or a larger-capacity DVD disk. Be sure to ask the assistant to check that it has copied over correctly and do label the disk indicating its contents – it's not a negative, so you can't hold it up to the light to see what it contains. You may also want to order a few prints while you are there.

If you ever want reprints, just take the disk to any lab. There are some easy-to-operate, self-operated kiosks available in places like Boots where you can insert your disk or memory card and select which images you would like to print, but anyone who gives all computers – including ATMs – a wide berth may prefer some personal assistance.

Sharing your photos

Because it's so easy to take photos with a digital camera, you will find yourself taking many more than you would with a film camera – there's no need to worry about costly film running out. But this means that there are many digital photos waiting to be set free – they sit, alone and unloved, on your computer.

There are a number of ways to share your photographs. How to do each of these tasks is explained in due course but to give you an idea, you could:

- Display a selection as a digital slideshow on your computer.

- Print them out on a home printer using special photo paper.

- Make a CD or DVD of your photos and take them to a photo lab for printing.

- Sign up to a photo-printing website, such as Snapfish or Photobox, and upload your photographs to it (uploading is the process of sending data – in this case,

your photographs – to a faraway location on the Internet). You can then order some very reasonably priced prints.

- Join a social networking website, such as Facebook, and upload your photos to it for friends and family to view.

I visited some family friends, Irene and Joe, who wanted to show us their latest batch of digital photographs, which were still stored on their camera's memory card. Their computer was very old – it took about ten minutes to start up – so it was unsuitable for displaying photographs without the whole thing grinding to a complete halt. By using a cable that came with their camera, I was able to hook it up to their large television and display the images stored on the memory card using the camera's built-in slideshow settings.

Most DVD players also detect the presence of images on a disk – so if you have stored your pictures on a DVD, then you should be able to view the images on the DVD player as a slideshow.

Summary

- Film and digital cameras are more similar than you may think

- Owning a computer is not necessary for digital photography, but it will help you make the most of your photos

- A digital camera stores images, instead of on film, on a removable memory card, which you can use again and again

- You use the colour LCD monitor at the back of a digital camera to compose, capture and review your images

Brain Training

There may be more than one correct answer to these questions.

1. What do the vast majority of digital cameras use to store your images instead of film?

a) A CD

b) A memory card

c) A floppy disk

d) A hard drive

2. What is the monitor at the back of the camera used for?

a) Framing and composing images

b) Reviewing images

c) Accessing camera settings

d) Erasing unwanted photos

3. What is a JPG?

a) A virus

b) A type of image file

c) A type of memory card

d) A camera manufacturer

4. Why would you erase images on your memory card?

a) To free up space on your card

b) To get rid of unwanted photos

c) To print photos

d) To watch DVDs

5. What happens when you press the shutter button halfway?

a) Nothing

b) The camera focuses on a subject

c) A photo is taken

d) You can review the last photo you took

Answers

Q1 – b **Q2** – All are correct **Q3** – b **Q4** – a and b

Q5 – b

Digital photography terms

Equipment needed: none.

Skills needed: an open mind and some confidence.

Chapter 2 explained the basic concepts of taking digital photographs and what you can do with them. In this chapter, I get some of the tricky stuff out of the way. Many of us are bombarded with techno-babble whenever we enter an electronics store or read over a camera's specifications in the latest Argos catalogue. What some shop assistants may think is very important (the word *megapixel* springs to mind) is often not the most crucial thing on our minds when we are choosing a new camera. For example, I want to know how sturdy it is to hold in the hand and, let's face it, how idiot-proof it is.

Important terminology

There is also jargon involved when you are taking photographs and reviewing them, but that will come later in the book. Some of those terms, like *shutter speed*, may already be familiar to you, especially if you have some photographic experience with traditional film cameras.

I don't explain every single term you will ever encounter here – just the main concepts.

JPG

In Chapter 2, we explained that JPG is the most common type of image file. JPG files are very efficient as they don't take up as much space on your memory card or computer as other formats do. That's why JPG is used for mass-market digital photography. When you are surfing the Web, the photos that load up on your screen are, in the vast majority of cases, zippy little JPGs (but they have been resized so that they are far smaller than the ones your digital camera captures).

Memory cards

We already know that these removable devices are where digital cameras store your images – camera-enabled mobile phones use them too. But there are several formats out there. They are made by many manufacturers and come in various shapes and capacities. Some have fast *write speeds*, meaning that they can record information on to the card very quickly. Don't worry if your camera uses a different card to everyone else because the JPG image file format is universal. The 'contents' are the same.

Some of the most common memory card types are:

- SD (Secure Digital) and SDHC (higher-capacity SD): Probably the most prevalent card today.
- CompactFlash (CF): A very popular storage format used in larger cameras and older compacts.
- MemoryStick Pro: Often found in Sony cameras and Sony Ericsson mobile phones.
- xD: Often found in Olympus and Fujifilm cameras.
- miniSD: Often found in mobile phone cameras.

Source: SanDisk

Figure 3.1

 Many digital cameras come with a small amount of 'internal memory' built into the camera that lets you take a dozen or so photos without a memory card – good for emergencies when you've forgotten to bring a card along!

Pixels

The cute little word *pixel* is a contraction of 'picture element'. Pixels are the small dots that make up every image. If you zoomed right in to an image, as illustrated in Figure 3.3, you would eventually be able to see every pixel. The more pixels an image has, the more detail it has.

Source: Kim Gilmour

Figure 3.2 **Figure 3.3**

Resolution

We just talked about how more pixels results in more detail in an image. The measure of this detail is called *resolution*; the higher the resolution, the better. It's a very important term for both viewing and printing images. We will refer to it again in later chapters.

Megapixel (shortened to M or Mp)

This is the word that you've probably heard bandied about whenever people try and sell you a new camera: "So-and-so has ten megapixels, whereas such-and-such only has seven megapixels." One million pixels makes up one megapixel. You probably think that the more megapixels a camera has, the better the resolution. Technically that is true but in reality the quality of the resulting image is what counts, and that's usually down to the quality of the lens and the type of image sensor. Most people go for the camera with the most megapixels thinking it's going to be better, but unless you want to print very large images (I'm talking poster size), then any decent camera with around 8 megapixels will suit you fine – this is good enough to print 8x10-inch photographs at the very least. Don't worry if someone you know has a 10- or 12-megapixel camera and you don't! There are loads of other features, such as usability, that will probably be more important to you than megapixels when choosing a digital camera – we discuss this in Chapter 4.

Megabyte (MB)

This is a measurement of data storage. One megabyte is made up of around 1,000,000 bytes.

Gigabyte (GB)

Approximately 1000 megabytes make up a gigabyte. When buying memory cards, those with more gigabytes have greater capacity and are therefore able to store more images.

Menu

The menu is the place where you access your camera's settings. You view these settings on your LCD screen and make selections using the buttons available to you. Depending on the make of your camera, there should be a couple of menu types: a day-to-day menu accessible while you are framing a photograph that lets you turn the flash on or off or go from automatic to manual mode; and another menu 'behind' this that lets you do things such as set the date or time, erase the contents of the memory card, or turn the red-eye reduction function on or off (see below for more on red eye). You usually use various buttons to navigate through the menus and they can be fiddly on very small cameras. As on mobile phones, some of the buttons serve different functions depending on the mode or menu you are in.

Typical buttons

Figure 3.4 identifies the typical function buttons that your camera is most likely to include (although the buttons will vary depending on the make of your camera).

Compression

You can use your digital camera to reduce, or compress, the file size of your images if space on your memory card is precious, but doing so will reduce the quality of your images because detail is lost in the process. The number of pixels in the image remains the same but the compression process reduces the overall file size. Sometimes this loss of quality is minimal and barely visible to the naked eye, but it does depend on how much you have compressed your images and how large you want to display or print them.

Source: Sony

Figure 3.4

1. **Shutter button** (on the top of the camera): Press this fully to take the image.

2. **W** and **T**: Used to zoom out (W) and in (T) when framing an image.

3. **Grid** and **Magnify** mode (nine boxes): When in playback mode and reviewing your images, use W and T to zoom in and out of the photos you have just taken. Keep zooming out to view up to nine images on the screen.

4. **P**: Although not available on all cameras, Program mode is a fully automatic mode that allows you to override some settings if you wish.

5. **Camera**: Select this mode when composing an image.

6. **Film reel**: For taking videos.

7. **SCN**: Used to choose the scene mode (see below).

8. **ISO**: Used to choose the light sensitivity.

9. **Easy**: A simple, automatic mode that gives you on-screen instructions.

10. **Menu**: Used to access camera settings.

11. **Up, Down, Left, and Right**: This keypad serves two purposes: It lets you navigate up, down, left, and right when you are reviewing images or navigating through menu options. It also lets you quickly access functions when taking images.

12. **Tulip**: Mode for taking close-up (macro) images.

13. **Flash**: For automatic flash mode, or for forcing the flash to turn on and off.

14. **Timer**: A self-timer mode to let you be in a group photograph.

15. **Disp**: Shows certain settings on the LCD screen.

16. **Middle button**: Use this button in the same way you would use the 'enter' or 'select' key of your computer keyboard or mobile phone – when you want to make or confirm a selection, press this button.

17. **Playback**: Press this button to go into the playback mode and review the images you have just taken.

18. **Trash can**: Press this button when you don't like the image you are reviewing. You will be asked if you want to delete it. Press the middle button (16) to confirm.

Image-editing or photo-editing

If you are using a computer to store your digital photographs, you will find that there are a number of tools to view, enhance and optimise your images. Many of them are absolutely free, and some of the more basic ones are built into Windows. Nothing beats taking a nicely-framed and focused photograph in the first place, but sometimes tiny tweaks to a flat photograph – even just changes to the colour and brightness – can work wonders. There are also a number of cheesy effects you can apply to your images, such as swirling or distorting people's faces, turning them into Pop Art masterpieces, making a new photo look antique or covering an image with words, flowers or even virtual confetti. Fun as these are, I would use them sparingly – they can look extremely cheap and tacky.

Exposure

Just as with film cameras, this is a measurement of how much light falls on to the photograph. A photo that is *underexposed* (see Figure 3.5) has not been exposed to a sufficient amount of light and tones are quite dark. Conversely, an

Source: Kim Gilmour

Figure 3.5

overexposed photograph (Figure 3.6) has been exposed to too much light and features look burnt out or overblown. I'll explain how to avoid both situations later in the book. An underexposed photograph is usually easier to work with than an overexposed one: you can use photo-editing software to brighten up dark tones or ask a lab to touch it up for you. Figure 3.5 is an underexposed photo that turned out that way because the camera thought there was sufficient light due to the sunny view outside. As a result, it didn't think more light was required. Using a flash or adjusting the exposure settings could have solved the problem.

Source: Kim Gilmour

Figure 3.6

Shutter lag

Digital cameras often suffer from a slight time delay between pressing the shutter button and the photograph being taken. Shutter lag can be very frustrating. It can cause you to miss the crucial moment of a photograph, for example, if a rare animal in the wild turns its head at the wrong time or a child blinks. The lag occurs because the camera needs a little time to autofocus. Depressing the shutter halfway to allow the camera to focus on your subject

can minimise this lag. Try out different cameras from different manufacturers and find a model that is fast enough for you.

White balance

On a digital camera, the white balance feature ensures that colours are recorded as your eye sees them. Most cameras have an automatic white balance setting but sometimes colours don't turn out quite right, such as on cloudy days or in fluorescent lighting conditions. Often, the light from a bulb causes a yellowish, unnatural cast (see Figure 3.7). A snowy mountain might have a blue tinge to it. A good digital camera will let you select the correct white balance setting depending on your location. (You can also correct colours on your computer later.)

Source: Kim Gilmour

Figure 3.7

Red eye

This phenomenon, which is not exclusive to digital cameras, causes your subject's eyes to glow a devilish red when a flash photograph is taken (see Figure 3.8). It can happen with pets as well as people! This annoying occurrence can be remedied

33

on your computer later using the wonders of red-eye removal technology or may be minimised using a red-eye reduction mode if your camera has one.

Source: Kim Gilmour

Figure 3.8

Optical zoom

Being able to home in on a faraway subject is a brilliant bonus. Most digital cameras have a zoom lens that magnifies the scene you are viewing, usually by pressing a zoom button (you may already be familiar with this concept from your regular film camera). The range of a zoom lens is represented by a term called 'focal length'. My compact Canon has a focal length of 35–105mm, or 3x optical zoom. The lower the first number, the wider the viewing angle, which is handy if you are taking a photo in a crowded room and want to get in as much of the scene as possible. Figure 3.9 shows a street scene and Figure 3.10 shows the scene with the camera zoomed in to a specific area.

Source: Kim Gilmour

Figure 3.9

Source: Kim Gilmour

Figure 3.10

Digital zoom

On a digital camera, this electronically enlarges the image you are viewing (as opposed to using a lens to do so). As a result, some loss of quality is involved because the camera is basically guessing (interpolating) the extra detail. Take a look at what happens in Figure 3.11 when I zoom in using the highest digital zoom setting on my camera. It's not bad, but it could be a lot sharper.

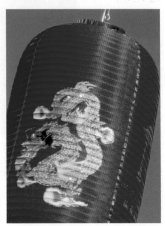

Source: Kim Gilmour

Figure 3.11

Scene modes

On your camera you will find various 'camera scene mode' settings which you can select depending on the scenario you are in. Each mode is represented by an icon or symbol – how these look will vary depending on the make of your camera. Some of the icons can be hard to see. On one camera I saw, the 'portrait' mode (which focuses on the subject's face, leaving the background in softer focus) was represented by a woman in a hat – but I could have sworn it was a skier! 'Night' mode makes it easier for you to take an evening photo that is not blurred due to lack of light. Some cameras have a dial that lets you easily switch between modes, while others let you choose the mode you are after by using the menu settings displayed on your camera's monitor – Figure 3.12 is an example of 'foliage mode' selected; the icon of a snowman to the right is 'snow' mode, followed by 'beach' mode, then 'fireworks' mode. There are many other scene modes available depending on your make of camera. Essentially, choosing the right scene mode can help improve the quality of your photograph because the camera can automatically optimise your settings depending on your surroundings.

Source: Kim Gilmour

Figure 3.12

Movie mode

Digital cameras aren't just for taking photos – you can shoot videos with them too but be aware that videos take up far more space on your memory card so use them only for short clips of around 30 seconds or so. They record sound, too, but don't expect surround-sound quality!

Playback mode

You can review and browse the photos and videos on your card at your leisure by switching your camera to this mode – usually it's just a matter of turning a dial, pressing a button or flicking a switch. If you ever find yourself wondering why you can't take a photo, the first thing to check (apart from whether the camera is on) is whether you are still in playback mode as opposed to camera mode.

Macro and landscape modes

Often represented by a tulip icon, the macro mode lets you take extreme close-up images. Landscape mode (often represented by a mountain) is for wider shots.

Image stabilisation (IS) or anti-blur

This is a feature on some cameras that compensates for shaky hands. Even the slightest tremble can be accentuated in an image, causing blurry images. This is especially the case if you have zoomed in on an image and do not have a tripod to stabilise the camera. If your camera doesn't have a viewfinder (which can sometimes be used to help steady a shot) then the image stabilisation feature could be the answer.

There are many more functions and concepts to discover as we progress through the book, but this is just a gentle introduction. In Chapter 4, we discuss the main types of digital camera and how to choose one for your particular needs.

Summary

- Pixels are the small picture elements that make up an image; the more pixels, the more detailed the image

- Resolution is the measure of detail in an image

- Scene modes are settings that represent your surroundings – they can help improve the quality of your photographs

- Shutter lag is the time delay between pressing the shutter button and the camera taking the photograph

Brain Training

There may be more than one correct answer to these questions.

1. On a digital camera, the menu:

a) Is where you access your camera's settings

b) Lets you choose your favourite meal

c) Lets you set the date and time

d) Lets you zoom in and out

2. How many pixels make up a megapixel?

a) Around 1000

b) 10

c) None

d) 1,000,000

3. How can you prevent, reduce or fix red eye?

a) Avoid using the flash

b) Use red-eye reduction mode

c) Fix it up later on your computer

d) Avoid taking photos of people

4. Your camera has a number of scene modes. Of the following, what would be the best scene mode for taking photos on Bonfire Night?

a) Night mode

b) Fireworks mode

c) Beach mode

d) Auto mode

5. Incorrect white balance settings can

a) Cause subjects to look out of focus

b) Make a room look yellow

c) Cause the photo to be too dark

d) Turn a photo black and white

Answers

Q1 – a and c **Q2** – d **Q3** – a, b and c (not d; pets can get red eye too!) **Q4** – b

Q5 – b

Buying a digital camera

4

Equipment needed: a knowledgeable friend to take into the camera shop with you.

Skills needed: some confidence.

None of us want to get ripped off when we are buying any kind of item. When out shopping, don't feel pressured by anyone into going with the latest and greatest model if:

- it doesn't feel comfortable in your hands;

- you can't see the LCD screen or the menu system clearly;

- the assistant is unable to demonstrate how it works;

- it's way above your budget.

You could take a trusted friend or relative with you, who has some experience with digital photography, to help you make your decision and offer a second opinion.

Types of digital camera

Broadly speaking, there are three main types of digital camera:

- Small, **point-and-shoot compact** cameras that can fit in your pocket and are capable of taking great shots. These mass-market digital cameras are what we focus on most in this book. They are well-built, light, slip easily into a pocket or handbag and capture images in great detail. You may be happy using your camera in fully automatic mode but, underneath its simple exterior, you often find some sophisticated functions.

- **Digital single-lens reflex** (DSLR) models have interchangeable lenses and use an angled mirror to reflect the scene into the viewfinder. It flips out of the way when the shutter button is pressed, allowing light to hit the image sensor. Sensors used on DSLR cameras tend to capture more details than a compact camera, as they are larger. They are also faster, have minimal shutter lag and allow greater creative control, including manual focusing. However, due to their steep learning curve, they are targeted towards enthusiasts who are a little more experienced in photography. Prices have declined quite rapidly and DSLRs are the fastest-growing type of digital camera – I think this is because people have gained confidence using a point-and-shoot and are ready for more.

- **Bridge** models fall between these two categories. They sport a large lens built into the camera and a few more manual controls than portable models (sometimes they are known as 'prosumer' models – a mixture of consumer and professional). Critics of this type of camera think they try to be too many things at once, but it's a matter of personal taste.

Even within each of these broad categories, you'll find a world of variation in features and styles. That's why choosing the right camera can seem like a nightmare, but don't worry – you probably won't need to use all of the settings or features. This chapter explains what features you might want to consider when buying a camera.

To help you figure out what camera is best for you, I've put together a list of pros and cons in the following table:

Type of camera	Pros	Cons
Digital compact	Portable and convenient Inexpensive Easy to handle and frame images Discreet Handy automatic features that detect faces, scenes and surroundings High-quality images Less susceptible to dust entering camera than DSLRs Image stabilisation/anti-blur features Large and easy-to-see LCD screen	Not always having a viewfinder Fewer manual controls (such as focus) available Harder to handle for less agile fingers Slower to react (shutter lag), so not always great for capturing running cheetahs or active kids! Hard-to-see or hard-to-access buttons
Digital SLR (DSLR)	Fast; reduced shutter lag Far greater creative control Interchangeable lenses, some with very wide or narrow focal lengths More image detail, due to larger image sensor than compact cameras Accurate viewfinder Compatible with accessories, such as extra-powerful flashes Manual control of lenses – easier to focus selectively on a subject Automatic modes available	More expensive Bulky to carry around Greater learning curve, especially if you haven't used an electronic film SLR Heavier than compact cameras More susceptible to dust entering the camera Many features – maybe more than you need Expensive specialist lenses
Bridge	Powerful zoom features More features and manual control than compact cameras Less susceptible to dust entering camera than DSLRs Accessible buttons and functions Capable of shooting high-definition (HD) movies	Bulkier than compact cameras More expensive than compact cameras May not strike the right balance of features, depending on your needs Greater learning curve than compact cameras

Camera manufacturers

The main camera manufacturers and their websites, where you can obtain the latest product information, are:

- Canon – **www.canon.co.uk**
- Casio – **www.casio.co.uk**
- Fujifilm – **www.fujifilm.co.uk**
- Kodak – **www.kodak.co.uk**
- Nikon – **www.nikon.co.uk**
- Olympus – **www.olympus.co.uk**
- Panasonic – **www.panasonic.co.uk**
- Samsung – **www.samsung.co.uk**
- Sony – **www.sony.co.uk**

Other manufacturers you may come across include Pentax, Leica, Hitachi, Ricoh, Vivitar and more – this isn't an exhaustive list and there are others around but it's good to go with a brand you have heard of if you need technical support.

Ease-of-use considerations

Designers these days want to make everything tiny – but I think sometimes this is at the expense of usability.

Not all of us have 20/20 vision and are able to decipher exactly what all the tiny buttons and settings mean at the back of a digital camera. And not everyone has the dexterity of a 12-year-old's fingers – less nimble hands may not be able to deal with small, close-together buttons at the back of a digital camera.

Then there is the complexity issue – you don't want to have to remember a whole sequence of tasks in order to take a straightforward, run-of-the-mill photo. Is there an easy-to-access 'automatic' or 'simple' mode you can go back to if you accidentally press the 'wrong' button? Can you do this without your reading glasses? When my mother thought her camera was broken as she couldn't see

anything on her screen, she eventually discovered this was because she had accidentally turned the display screen off.

Some cameras that are too small to handle might get dropped or damaged easily or they may not be sturdy enough for shaky hands. Conversely, a larger camera may be far too bulky and heavy, especially if you are taking it out and about regularly.

All these are important things to bear in mind, and in my opinion are far more important than knowing whether a camera is capable of doing everything apart from iron your clothes and wash your dishes.

Before going into the shop, here are some questions to think about, surrounding ease of use:

- How easy is it to see the LCD screen to review and compose images?
- Are the images on the LCD screen clear? What about viewing the screen in bright light?
- How sturdy is the camera in your hands?
- How easy is it to access or view the major settings? The main buttons and functions my mother told me she needs to remember and access on her camera are:
 - turning the camera on and off;
 - the button to take a photograph (shutter button);
 - erasing a photo (represented by a picture of a rubbish bin);
 - seeing the photos taken (reviewing the photos).
- Can you make the camera 'beep' when you choose certain menu settings to help alert you when you have (perhaps inadvertently) pressed a button?
- Are any buttons, including the on/off and shutter buttons, big enough? Are they easy to press and access – are they too small or close together?
- If you don't have much experience with gadgets, is there a simple and easy way to access an automatic mode?
- How quickly does the camera start up – does it seem sluggish to react?

Most manufacturers don't radically reinvent the wheel when they issue a new camera model – they might add a few features or increase the megapixel count or the monitor size. So if you have relatives who have a brand or model they enjoy, you could ask them what's good about it or even try it out. Chances are it is quite similar to the newer model available.

The Internet is a great place to do your research when coming up with a shortlist of suitable cameras – check out *Internet for the Older and Wiser* for more about browsing the Web. Online retailers, such as **www.amazon.co.uk** and **www.argos.co.uk**, let customers review and rate products they have tried. This is a good way of finding out what features people like (and don't like). If you are a subscriber to *Which?* magazine, you can access its website at **www.which.co.uk** to read reviews of the latest cameras; if not, you can access back copies in your local library. There are many other magazines on the newsstand that can help you make a purchasing decision but some of them are a little heavy on the jargon.

Budget considerations

Digital cameras are a lot like mobile phones. There appears always to be some incessant need by advertisers to try and convince us to 'upgrade' to a better model – it rarely seems a justified move. Yet our beloved film cameras stay with us for decades and still end up producing perfectly acceptable images. There's no reason why a well-built and well-cared-for digital camera can't last you many years too – holding on to one isn't necessarily down to stubbornness or resistance to change – I liken it more to an 'If it ain't broke, don't fix it' mentality.

Many friends of mine have given their digital cameras to their parents or other older relatives when they have chosen to go for an upgrade. If so, you are in luck. Not only have you inherited what is likely to be a perfectly good digital camera, but you will also be able to draw upon this generous person's advice when trying to get to grips with the camera's quirks. This book, of course, will help you avoid having to ask them about every single thing, but because there are countless varieties of digital cameras out there, each with their own settings, knowing someone who's familiar with your camera's workings is extremely valuable!

You don't need to go for the latest and greatest model in the first place; during the end-of-season sales, you might find some great end-of-line bargains.

The Canon website at **www.canon.co.uk**, among others, lets you compare features of certain cameras at a glance. For example, just choosing a selection of three cameras from the Ixus compact line alone shows a huge difference in recommended retail prices, ranging from £219 to £379.

The main differences in features between the £219 and the £379 models I chose to compare from the range are:

- **Megapixels:** The cheaper model is 10 megapixels (M or Mp), another is 12.1 megapixels. Personally, I don't think there's a discernible difference between the two specifications if you are printing anything up to 8x10 inches.

- **Focal length:** The optical zoom on the more expensive model is a couple of times more powerful, but unless you are really zooming in on something far away, it may not be a concern.

- **Face detection:** Both can detect faces in a photo but the more expensive model can track a moving subject.

- **Macro mode:** The cheaper model requires you to be at least 3cm from a subject; the more expensive model lets you be 2cm away.

- **LCD screen:** The costlier model has a slightly larger LCD monitor.

- **Scene modes:** There are more scene modes and special effects modes in the costlier model, but how many would you actually use?

- **Viewfinder:** Only the cheaper model has a viewfinder.

- **Video:** The costlier model produces better-quality video.

- **Weight:** The cheaper model is 120g as opposed to 160g.

Out of these differences, what is important to you? I would find the cheaper model perfectly suitable for my needs. Bear in mind, though, that this is just a feature comparison – ease of use is far more important and that is a very personal choice.

When you are travelling abroad, you may be able to save money on a digital camera depending on the exchange rate. But you may need to declare the camera and pay duty upon your return to the EU (for more information, see **http://www.hmrc.gov.uk/customs/arriving/arrivingnoneu.htm**), so you'll need to work out if you are still saving money this way. Remember also to buy an adaptor for your battery charger (more on accessories in Chapter 5) and make sure there are printed English instructions. And is there an international guarantee?

Where to buy a digital camera

There's no shortage of places where you will find digital cameras – even your local supermarket probably has a few on sale. You can have a play with a camera at your usual high street shops – Currys.digital (formerly Dixons, which now operates online), Jessops, John Lewis, and PC World. There are also a few specialist camera shops, such as Calumet, which target more professional users. Don't forget your friendly local trader, too!

Often you can get a few freebies thrown in when buying a digital camera – such as a 1GB or 2GB memory card (the one that comes with your digital camera, if there is one, is only likely to be large enough to take a handful of pictures) or a small camera bag. Ask about this when you are trying to negotiate. For more on accessories, see Chapter 5.

Is there a money-back guarantee if you don't like the camera after trying it out for a little while? Although stores are only legally obliged to refund or replace your item if it's faulty, many larger ones do offer a satisfaction guarantee – you just have to make sure you keep all the packaging (and the camera) in a saleable condition.

Many shop assistants will try to sell you an extended warranty with your camera beyond the usual warranty. It's rarely worth buying one. Your statutory rights in the UK under the Sale of Goods Act state that your item needs to last a reasonable amount of time and be fit for purpose – so if your camera develops a fault even once the standard warranty has expired, you still have the right to return it to the retailer and get your camera fixed or replaced within a 'reasonable' time period – I would argue that a digital camera should last you at least three years. You may need to provide an independent report indicating the fault.

Getting more control

DSLR and bridge cameras allow for a bit more creative, manual control and you may want to take this into consideration when looking for features in a digital camera. Many digital compacts have a whole range of creative features, too – you won't always need to access them but they are handy to have in the background, to be used for a rainy day! So what are some of these manual features and what are they good for?

I talked about how the Internet is a great place to do your research. It is also a brilliant place to grab a digital camera bargain. Buying from a reputable site, and using your credit card for extra protection, will help make your online purchasing experience trouble-free. You will find many price-comparison websites, such as **www.pricerunner.co.uk** or **www.kelkoo.co.uk**, if you want to search multiple websites simultaneously when looking for a good deal on a particular model. If you find something cheaper online but want to support your local business, why not try to bargain with them by telling them where you have found it cheaper? For more information about shopping online and your consumer rights, read *Internet for the Older and Wiser*.

Shutter speed

Like a film camera, this measures the amount of time the shutter – the panel in front of the camera – remains open in order to capture light passing into it. I'm sure some of you have used shutter speed settings for more creative control on

a film camera. The dial on my old Pentax K1000, which dates from the mid-1970s, nicely illustrates the concept of shutter speed (Figure 4.1). Each number represents the fraction of a second the camera's shutter will remain open. So having the dial on 60 means the shutter stays open for 1/60th of a second, while 1000 is 1/1000th of a second.

Source: Kim Gilmour

Figure 4.1

So what is the point of shutter speed? The photo of fast-moving marathon runners (Figure 4.2) taken at 1/10th of a second using a digital camera means the runners come out as a blur. If you were to take the same photograph at 1/500th of a second, the movement is likely to be frozen.

Reproduced by permission of Mark Massey

Figure 4.2

Slow shutter speeds are also good when you are taking photos in dark conditions without a flash (a flash photo taken in the dark can often seem either very harsh or not powerful enough) – but this means you will need to use a tripod to avoid camera shake. This photo of the Rialto bridge in the wee hours (Figure 4.3) had an exposure of 5 seconds.

Source: Kim Gilmour

Figure 4.3

You won't need to worry about shutter speeds if you just want to take snaps in automatic mode, but many compact digital cameras also give you the option for a little more creative control.

Aperture

This is the hole through which light passes from the lens to the image sensor (or film). Like the retina of your eye, the hole can increase or decrease in size, letting more or less light in. The aperture is measured in values known as 'f-stops'. Each f-stop represents how large or small the hole is. A small aperture records more 'depth of field' (more about this in Chapter 9), which means more of the image appears in sharp focus. This means that you'll have to leave the shutter open for longer to let more light in (most cameras can automatically detect the appropriate shutter settings). Figure 4.4 has a great depth of field (as well as being a photo of a field)!

Figure 4.4

When you want to take a portrait of someone, choose a larger aperture – this gives less depth of field, meaning the person's face can be in sharp focus whilst the background is out of focus or softly focused, giving a nice separation of the subject from the background (Figure 4.5). The larger the number (f16, say), the smaller the aperture – this is because f-stop numbers are actually fractions (1/16 is smaller than 1/2).

Figure 4.5

RAW

JPG is the most common type of image file but, because it's very efficient and relatively small in file size, some detail does get lost – even if it's not visible to the naked eye. Step in RAW mode, which is what photography enthusiasts use to make sure that their camera has recorded all the possible detail in a scene. As the name suggests, RAW mode means that an image may be rough around the edges and will need tidying up on a computer later – so it's really for people who like tinkering under the bonnet with the way their photos look. That's why mass-market digital cameras usually don't have this feature (another reason is that the file size of RAW is far larger). RAW is a format typically found on DSLRs. If you compose a photo well enough in the first place and it looks fine when you review it on your LCD screen, then you needn't worry about whether your camera has RAW.

Most cameras, even digital compacts, have what is known as a histogram function. Most of you won't feel a need to use it but it's a handy graph that helps you determine if a photograph you have taken has the right balance of light and dark tones. Look for a graph that shows a nice distribution from left to right – if the graph shows a heavy bias to the left then the image is dark; if there is bias to the right then the image is brighter. If there are absolutely no values registering on the far left or right of the histogram then you know that the image is either too bright or too dark. You can fix the problem by adjusting the exposure setting or changing the scene mode on your camera, then trying to take the photo again. Histograms are also good reference tools as they can help you optimise photos on your computer at home with a few mouse clicks.

Continuous shooting mode

Most digital cameras let you take a series of photographs in quick succession, known as continuous shooting (or 'burst' mode). Keep the shutter button fully depressed and the camera will keep taking photos until the memory card is full or until you release the button. Today's compact cameras usually have this feature but tend to take 'only' around one photo per second – more advanced cameras take photos in far quicker succession because they are more powerful.

Continuous mode is good for capturing shots where you don't want to miss a piece of the action, but can't predict exactly when it might happen – such as an imminent goal at your nephew's football match.

ISO settings

The camera's sensitivity to light is known as the ISO speed. Your camera automatically chooses what it thinks are the best ISO settings but sometimes, particularly in dark surroundings, the results don't turn out quite right. Manually change the speed to a higher value (such as 800 or 1600) when you are taking photographs in darker conditions and aren't using a flash – this helps reduce the exposure time in order to avoid blurry images or the side-effects of shaky hands. If a scene is particularly dark, you can also use a long exposure to capture images without having to use a flash but you'll need a tripod to steady the camera during this time. The downside with choosing a high ISO is that something called *noise* may develop on an image – in the days of film this was known as *grain*; it looks like tiny dots on your photograph (see Figure 4.6).

In some cases, noise can add a bit of atmosphere to an image.

When you are taking photos on a sunny tropical island beach, you can choose a low ISO, such as 100.

Source: Kim Gilmour

Figure 4.6

In the days of film, you would have to buy a whole roll of, say, 100 or 800 speed film; on a digital camera, you can take one photo at 100 ISO and the next photo at 1600 ISO – you don't need to worry about using up the whole roll first!

I realise there is a lot of information to take in here, some of which you may not need to know further down the track – but knowledge is power.

Good luck in your search for the ideal camera. Once you have your camera in your hands, you are ready to read the next chapter and beyond!

Summary

- Think about ease of use when buying a digital camera; ignore the salesperson's hype over megapixels or zoom specifications

- Always try the camera you want to buy (or at least a similar model that a friend or relative owns) to make sure it feels right in your hands

- A digital point-and-shoot compact camera is great if you want something versatile, light, efficient and powerful

- A digital SLR is suitable for photography enthusiasts who want more control over their images, but they are far bulkier and have a steeper learning curve

Brain Training

There may be more than one correct answer to these questions.

1. What is the appeal of a point-and-shoot compact camera?

a) Powerful zoom lenses

b) Portability

c) Convenience

d) Price

2. Why might you consider a DSLR?

a) Fits in your pocket

b) More creative control

c) Fixed lens

d) Better image quality

3. What is arguably the most important consideration when buying a digital camera?

a) Price

b) Colour

c) Brand

d) Usability

4. What is continuous shooting?

a) Taking a photo without you being behind the camera

b) Shooting a video

c) Taking a number of images in quick succession

d) Taking a photo without a flash

5. Which is the best of the following shutter speeds for freezing the action of a moving subject?

a) 1/60 sec

b) 5 sec

c) 1/500 sec

d) 1/8 sec

Answers

Q1 – b, c, d **Q2** – b and d **Q3** – d **Q4** – c

Q5 – c

Camera accessories: batteries, bags and more

5

Equipment needed: your digital camera.

Skills needed: familiarity with main digital camera concepts and functions.

There are a number of useful accessories to buy for your digital camera. This chapter doesn't include all the computing-related software and equipment you can buy – just the things that you will find handy 'in the field'.

Nice to have or need to have?

I explain what all the following accessories are in more detail. At the very least, everyone will need:

● at least one spare set of fully charged batteries;

● a decent camera bag or protective pouch;

● a couple of memory cards, perhaps with a capacity of at least 2GB each.

Then there are optional extras, which are very handy and inexpensive, including:

● a basic tripod;

● travel adaptors for your battery charger;

● a soft microfibre cloth for safely wiping smudges and dust off the lens and camera.

The real enthusiast may want:

- extra lenses, flashes and filters, if you have a DSLR
- more versatile camera bags, with different compartments for lenses and other kit – again, only if you have a larger camera
- full-length tripods
- reflectors.

Batteries

Digital camera batteries come in all shapes and sizes, and there doesn't seem to be a universal standard either. Many cameras these days come with one rechargeable lithium-ion battery pack (see Figure 5.1) and a battery charger. Your battery will last you several hours of use when fully charged (your digital camera LCD screen should indicate how much battery power is left). But when you are out and about, you'll need a fully charged spare in case you take too many photos and the battery drains due to the LCD screen being on for too long. It's a lot like making sure your car has a spare tyre in case of emergencies.

Cold conditions can make a battery's power drain far quicker than it would in temperate conditions. Your battery needs to wrap up warm as much as you!

Many a time I have been caught out without a spare battery at a wedding or other important event – when you are busy preparing for everything else, it's easy to forget these things. Also, in group scenarios, people – especially children – will want to have a look at the photos you have just taken. Reviewing them will use up the battery power far more quickly.

The make of your battery is listed on the battery itself and in your camera's instruction manual. You can buy a spare battery from the manufacturer for £20 or so.

Source: Kim Gilmour

Figure 5.1

You will find that third-party companies also produce perfectly compatible, and cheaper, battery packs. After some safety concerns, in June 2009, Panasonic ceased supporting third-party batteries in its digital cameras. Do check if any third-party batteries are compatible with your camera and whether using them might invalidate your warranty should something go wrong.

Many digital cameras still run on conventional AA batteries. We all have a few spare AA batteries to hand but you should always use rechargeable AA batteries except in an emergency – it is not cost-effective to buy brand new alkaline batteries each time you need a fresh set. You can buy AA battery chargers (Figure 5.2) from hardware and electronics stores.

Source: Uniross

Figure 5.2

Under the EU-wide Waste Electrical and Electronic Equipment (WEEE) Directive, retailers must either take your old digital camera or battery back from you for recycling – or tell you the closest place to recycle it – when you buy a similar product from them. This applies to all electronic equipment, such as computers. If you are just getting rid of an item, call your local council to ask them how you can recycle your old digital kit.

Whenever you buy an electrical item and see an icon of a wheelie bin with a cross through it, this means that it's not advisable to dispose of it in your regular household waste. Apart from the landfill generated, lots of electrical equipment, such as computers, uses mercury, cadmium, lead or other dangerous substances that can get into our waterways, damaging wildlife and posing a health hazard.

Camera bags

A massive market has sprung up in camera bags and bags for other digital essentials, such as laptops. In fact, it might take you almost as long to choose a bag for your camera as it takes to choose the camera itself! Look at prices carefully and check you aren't just paying more for the style or brand of the bag (unless you want to) rather than how well it will protect your camera. If you're using a small, compact point-and-shoot camera, you could fit it into a pocket or handbag and, in that case, all you might need is a small, soft protective pouch, of which there are many around. Often they are made of a synthetic, hardy, rubbery substance called *neoprene*.

For those wanting to invest in a bag, the main factors are:

- ease of use
- durability
- cost
- size.

The bag should house the camera snugly, so make sure you take the camera into the shop or note all the dimensions if you are ordering one over the Internet. Try to find one that lets you easily take the camera out without having to faff around.

You might want something that has inside or outside pockets for memory cards, batteries and other odds and ends, such as credit cards, keys and spare change (make sure items in this compartment don't scratch against your camera). You may want a slightly larger bag to accommodate a small tripod.

● The *shoulder strap* (if any) should be adjustable and strong and the *padding* inside should be able to protect the camera from moderate bumps or even being dropped from waist height (I wouldn't want to test drive this, though!).

● How well will the bag withstand the unpredictable British climate? What about anything from raindrops to torrential downpours? Is there a waterproof lining and could water seep through any zips or clasps?

● Design-wise, you might want to buy something subtle that doesn't scream, "I've got a camera in my bag – please mug me!" or, "Hello, I am a tourist." This is a matter of personal taste.

You will find most major luggage manufacturers, such as Samsonite, do a line in camera bags of all sizes and camera manufacturers have own-brand bags available to purchase. There are also many specialist camera bag manufacturers with attractive designs available – look out for companies such as Crumpler, Lowepro, Hama and Case Logic.

Source: Kim Gilmour

Figure 5.3

For those who have a bridge or digital SLR, it's especially important to protect your valuable equipment. Many bags have special compartments to house extra bits, such as lenses, or to keep the camera body safe and secure.

Memory cards

We have talked about the different memory cards on the market. You'll have to buy a couple that are compatible with your camera and there are loads of manufacturers around. Your memory card will house your precious photographs so this is one area where you should always ensure that you use a reputable, branded manufacturer. Your local high street store will sell decent, reliable brands. It can cost around £7 for a branded 2GB memory card.

> Although the risk of accidentally erasing images is low, some cards have a feature called a 'write-protect' tab – once the memory card is full, you can slide this tab to prevent any more data from being recorded to, or erased from, the card. (Remember the old compact audio cassettes, where pushing in the tabs at the top would prevent you from accidentally recording over the tape?) Simply slide the tab back into its original position once you are ready to use the card for recording again.

Memory cards have plummeted in price and their capacities have increased (Figure 5.4). The advantage of buying a higher-capacity memory card (4GB, 8GB, or even more) is that you can fit more photos onto the card. You need to check that your camera can accept memory cards over 1GB or 2GB in size, particularly if it's more than a couple of years old.

Source: Kim Gilmour

Figure 5.4

A digital camera usually comes with a memory card, but its capacity is very tiny – something like 32MB. This is only enough to take around ten decent-sized photos, if that. So you'll definitely need to buy extras.

Some people don't like buying higher-capacity memory cards and use a selection of lower-capacity memory cards to 'spread the risk', in case the higher-capacity card gets damaged, corrupted or dropped in a river before all the photos have been backed up or printed. I wouldn't worry too much about this – the risk of it happening is minuscule and you may be just as likely to misplace a series of smaller cards.

The time taken for your camera to copy photographs on to your memory card is called the *write speed*. If you are taking many photographs in quick succession or long videos, then a fast memory card is a must to make sure the camera doesn't run sluggishly. Check your camera's manual to see what speed it recommends and look for this specification when buying your card.

Other useful equipment

There is other equipment that you'll also find useful to have with you, especially when you're travelling.

Tripods

Tripods typically come in two sizes: mini and full-length.

Mini-tripods

A light mini-tripod is a great addition to any photographer's kit. You can pick a decent one up for less than £10. I have even seen ones for £1, but the legs are 'plasticky' and they are probably only best for very light and cheap cameras (or the bin), so do check that your tripod is made of sturdy material (Figure 5.5).

Source: Kim Gilmour

Figure 5.5

If you find that your photos turn out shaky and blurred, using a tripod on a flat surface will help stabilise your photographs. They are also good for taking longer exposure photos, when you need to keep your camera still for a longer time.

A tripod is very easy to use and if you already have one for a similar-sized film camera, it is likely to be compatible with your digital camera, too. Simply screw the tripod's mount into the base of the camera (Figure 5.6). You can adjust the ball head if the camera is not completely horizontal by using the clamp. You can also unscrew the clamp and turn the ball head 90 degrees if you are taking a portrait-style photo.

Source: Kim Gilmour

Figure 5.6

There is a range of innovative 'tripods' that can be placed in any location. The Joby Gorillapod is a wonderful invention – the legs wrap around anything from tree branches to rails and even bicycles (Figure 5.7).

I've also seen small beanbag 'pods' that let you lay the camera on wonky surfaces, like a rocky wall. These are also handy if you are on safari taking photos through

the window of a moving vehicle. The pods cushion the camera to prevent damage at the same time as helping to stabilise it.

Source: Joby

Figure 5.7

Full-length tripods

A decent, full-length tripod is great if you have a DSLR – you won't need to worry about finding a table or bench on which to lay your mini-tripod. They collapse and can be quite compact. After lengthy lugging around, however, they can get a little heavy (unless you buy a top-of-the-range, ultra-light model).

Travel adaptors

When you are going on holiday there is every chance that you will need to recharge your camera's battery. Travel adaptors, of course, are handy for other electrical items, such as mobile phones. Battery chargers should use 100V–240V voltage so you can use them safely in the United States without having to convert the voltage, but do double-check the specifications.

Microfibre cloth

It's easy to get dust and fingerprints on lenses and the LCD screen, so regularly use a soft cloth – not tissue paper – to gently wipe off the smudges (Figure 5.8). You can buy a microfibre cloth from a camera shop or use the one you wipe your spectacles with. Never use random cleaning solvents – a cloth should be all you need.

Sometimes you might see a round white or grey circle in the same position on all your photos. The likely culprit is a speck of dust. If it happened as a one-off, it might just have been dust floating close to the lens that was accentuated when the flash went off.

Source: Kim Gilmour

Figure 5.8

Dislodge specks of dirt by using a lens blower brush – a small gadget that lets you pump air on to the lens and brush dust away. Those with a DSLR will find a blower brush very valuable as dust can settle on to the inside of the camera under the lens.

Lenses and flashes

The main lenses that come with a DSLR starter kit are perfectly adequate for most needs, but a DSLR lets you change lenses and be more experimental with your photographs (Figure 5.9). They don't come cheap: they often cost the same as, and in many cases more than, the body of the camera itself. Plus they aren't universal so you normally have to stick with buying a lens from the same manufacturer (although some companies, such as Sigma, make compatible lenses; just make sure that the lens fits your camera). A specialist lens will let you take a variety of

creative images, such as close-up, macro shots; a wide-angle lens for landscape shots; or a telephoto zoom lens to take on safari.

You can buy an add-on flash for a DSLR to help enhance indoor photos, because many of the built-in flashes that come with digital cameras are quite harsh or not powerful enough to fill a room.

Source: Canon UK

Filters

Those of you who opt for a DSLR may want to buy filters for your lenses. A filter makes a scene that you're capturing look more true to how it seems to the naked eye (if that is the effect you're after).

Figure 5.9

A polarising filter, for example, works by reducing the amount of light that is bouncing off various elements of your photo. If you take an image of a sandy beach on a bright, cloudless day without a polarising filter, you may find that the image looks washed out or overblown and the sky loses its colour.

You can still use filters if you have a compact digital camera, as there are workarounds available. A company called Cokin (**www.cokin.co.uk**) produces special adaptors that attach to a tripod mount and sit in front of your compact camera. The filters slot into the adaptor.

Reflectors

When I talk about photographic techniques in Chapter 8, I touch on reflectors. They are an inexpensive way to make a portrait better when there is inadequate light – they gently reflect available light on to a subject (often you will need your subject to hold the reflector in front of them).

Summary

- Essential items include spare batteries, memory cards and a pouch or bag to protect your camera

- Mini-tripods are good for preventing shaky images

- When choosing a camera bag, look for something comfortable and durable that will protect your camera

- Always use a soft microfibre cloth for cleaning your lens

Brain Training

There may be more than one correct answer to these questions.

1. What can cause a battery to drain?

a) Cold conditions

b) Using the LCD screen

c) Using the memory card

d) Using a tripod

2. What would you use to remove fingerprints from your lens?

a) Warm water

b) A soft cloth

c) A blower brush

d) A soft tissue

3. What does WEEE stand for?

a) Wasting Everyone's Everyday Energy

b) Waste Electrical and Electronic Equipment

c) Waste Electronic Energy and Equipment

d) Waste Energy Electrics Emanate

4. Why or when would you use a tripod?

a) When it's cold

b) When you aren't using the LCD screen

c) To avoid blurry images

d) For long exposures

5. If you already have a handbag you carry around, what might you use to protect a compact digital camera?

a) A plastic bag

b) A pouch

c) Nothing

d) A soft cloth

Answers

Q1 – a and b **Q2** – b **Q3** – b **Q4** – c and d
Q5 – b

Before you begin

Equipment needed: your digital camera and all the accessories it comes with.

Skills needed: basic knowledge of how a digital camera works (from the previous chapters).

It's time to take some photographs! So your digital camera has arrived – whether it's in a nice, fresh box or has arrived second-hand, you'll find plenty of goodies, including an array of cables, disks and manuals.

Accessories

In this chapter, I assume you have a digital point-and-shoot camera with a built-in lens but many of the main concepts will apply for those with more advanced models. Typically, expect the following accessories with your camera:

● battery;

● battery charger;

● memory card;

● cable for attaching the camera to your computer (if you need to buy one, check to make sure it is compatible with your brand);

● cable for attaching the camera to your TV (if you need to buy one, check to make sure it is compatible with your brand);

- installation disc, including software and drivers (more on this in Part II)
- warranty, guarantee and registration information
- wrist strap
- instruction manuals for your camera, and for using a printer and computer.

Figure 6.1 illustrates the typical kit that comes with a Canon camera.

Source: Canon UK

Figure 6.1

If you haven't bought a spare memory card, the one shipped with your camera (if there is one) will usually only allow you take a few shots before it fills up, so it's a good idea to have at least one extra to hand (2GB should do it) before you get started.

Don't worry if you don't seem to have everything in this list. All digital cameras vary slightly, so the checklist won't necessarily apply to your camera. Your camera may even come with more items! For example, Kodak EasyShare cameras come with a *docking station* that connects to your computer; when you want to copy images on to your computer, you put your camera on the docking station to initiate the connection.

Charging the battery

Mobile phones, electric razors and the like all require you to fully charge their batteries before first use, and digital cameras are no different.

Your camera manual will tell you how to charge your battery. Essentially, the battery should click into your charger easily without any need to be forceful. If it doesn't seem to want to slot into the charger, it's probably facing the wrong way. You will know that the battery is in correctly when you plug it in and the charge indicator lights up. There's usually a small arrow to tell you which way to insert the battery.

It should take a few hours for the battery to charge – usually the indicator light will turn green when it is finished. Once it does, it's good practice to remove the charger from the wall socket to prolong its life – don't leave it plugged in for days on end.

Source: Kim Gilmour

Figure 6.2

Reading the instructions

It's absolutely essential to take a look at the instruction manual and refer to it regularly. I am always tempted to delve in and start playing with a new machine without reading the manual but ultimately I find that even a cursory glance at the basic functions makes life a lot easier in the long run.

Your camera may come with 'quick start' instructions that summarise how to get going. These are no substitute for the full instructions but can be a handy reference guide.

With so many digital cameras out there, this book is unable to give 'one size fits all' advice when it comes to your camera's specific controls. Your manual may seem a bit like gobbledygook at first but generally they are designed to be relatively simple to read. The most important thing at this stage is knowing where to access the basics (and you can ignore anything else for now). A good manual will introduce you to the main functions first – these include:

- on/off button
- shutter button
- zoom controls
- playback/review mode
- auto mode (important when we want things to go on auto-pilot!)
- erase button
- where to insert the battery and memory card.

Usually there is an annotated illustration or photograph pointing to the camera's main functions (see Figure 6.3).

Source: Kim Gilmour/Canon UK

Figure 6.3

If you received a second-hand camera and the instruction manual is missing, it's likely that you will be able to download it from the manufacturer's website for free (see Figure 6.4). Those of you familiar with downloading a program from the Internet should have no problem. Usually it is available under the 'customer support' section of the website. You can ask a friend who has some experience with using the Web to help.

(For some manufacturers, such as Nikon, you will have to register your details via the website before you can access the link to download the manual.)

Manuals are usually in a common format, called Portable Document Format (PDF). You need a program called Adobe Reader to open it – this is likely to be on your computer already; if not, install it from **www.adobe.com** or ask a friend to do so.

As manuals can be quite lengthy it's probably not cost-effective to print it all out, but you could print the essential pages for easy reference.

Source: Sony

Figure 6.4

Some websites will try to sell you PDF files of these manuals. Always go direct to the manufacturer's official website to find and download the manual for free. If you can't find your manual on the official site, email them.

Inserting the battery and memory card

Now that you've charged the battery, let's have a look at how to insert it and the camera's memory card.

Open the compartment

At the base or side of the camera, you need to slide open or unlatch the lid of the compartment that houses the battery and memory card, and gently flip it open. Your design may vary slightly but generally the principles for all digital cameras are the same.

Insert the battery and memory card

There is only one correct way to insert the battery and the memory card into the camera. The 'correct' way varies depending on the model, but there are usually

indicators to tell you which way to insert it. You should feel a nice 'click' once you know the battery has been correctly inserted.

Source: Kim Gilmour

Figure 6.5

Similarly, the memory card can only be inserted in the one correct way. Firmly click the card into place. Some cameras have a spring mechanism that locks the card into place.

Source: Kim Gilmour

Figure 6.6

Close the compartment

Once both are inserted (Figure 6.7), slide the lid closed again and you are almost ready to go! If you can't close the lid, maybe you put the battery or memory card in the wrong way – double-check.

Source: Kim Gilmour

Figure 6.7

Wrist strap

This is something I sometimes forget: to wear the wrist strap. Your camera should come with a strap that you'll need to attach to the camera by looping it through a small hole and securing it. It's a good idea to make a habit of putting the strap around your wrist when you are taking handheld photographs in busy surroundings, in case the camera slips out of your hands.

Summary

- Always charge the battery fully before first use

- Read the instruction manual to discover how to access the camera's main functions

- There is only one correct way to insert the battery and memory card

- Remember to insert your battery and memory card before heading out

Brain Training

There may be more than one answer to these questions.

1. What's the best way to obtain an instruction manual if you don't have one?

a) Buy one over the Internet

b) Download one from the manufacturer's website

c) Order a printed copy from the manufacturer

d) You can't obtain extra instruction manuals

2. How long does it usually take to recharge a fully discharged battery?

a) A few minutes

b) A day

c) A few hours

d) Who knows?

3. What does a good manual tell you?

a) How to insert the battery and memory card

b) Where to get a refund

c) Where to find the shutter button

d) How to access automatic mode

4. How do I know if both my battery and memory card have been inserted correctly?

a) The camera turns on

b) The compartment closes

c) Both battery and card lock nicely into place

d) An indicator lights up

5. What's the best use of a wrist strap?

a) Hanging the camera on a hook

b) Steadying your shot

c) Preventing the camera from being dropped

d) Preventing the camera from hitting someone

Answers

Q1 – b **Q2** – c **Q3** – a, c, d **Q4** – c

Q5 – c

Taking your first shots

Equipment needed: a digital camera with a fully charged battery; someone or something to photograph.

Skills needed: enthusiasm and confidence; familiarity with your digital camera's main functions based on reading the camera's instruction manual.

Getting ready

Now that your battery and memory card have been inserted and you're familiar with the camera's main functions, including how to ensure you are in 'automatic' mode, it's time to take a few test photos. Here, my friend Steve pops out into my (overgrown) garden to give the camera a test run.

Powering up

As Steve demonstrates (Figure 7.1), your camera should have a power button or switch to turn the camera on and off. The large shutter button should be somewhere nearby.

Viewing the scene

Once the camera is on, the lens should pop out. When looking at the back of the camera, you should be able to see the view in front of you through the LCD screen.

Source: Kim Gilmour

Figure 7.1

If you don't see anything and the lens hasn't extended – but the camera is clearly on – this is probably because you aren't in camera mode. There should be a button, dial or, in this case, a switch that is set to camera mode (Figure 7.2). This is often indicated by an icon of, you guessed it, a camera – but not always. Simply move the dial, or press the appropriate button, to switch to camera mode.

Source: Kim Gilmour

Figure 7.2

The LCD screen should be on now (Figure 7.3).

Source: Kim Gilmour

Figure 7.3

We can easily move the camera around to frame the scene in front of us.

Aren't sure if you are in automatic mode? The LCD screen should momentarily tell you this when you are framing a photo, as shown in Figure 7.4.

Source: Kim Gilmour

Figure 7.4

Getting focused

To *focus* on your subject, press the shutter button down halfway. Don't depress it fully just yet. Depending on the model of your camera, you should hear a beep that indicates that it has automatically focused on your subject, and the LCD screen may display the exposure settings it is about to use to take the photo.

Taking the photo

Press the shutter down firmly the rest of the way to take the photograph. You should see the photo you've just taken show up momentarily on your LCD screen (to review it at length, you'll need to be in playback mode, which I discuss later).

Congratulations, you have just taken your first digital photo!

Don't get frustrated if you do run into trouble and things are taking a little longer than you anticipated. Go at your own pace and take things one tiny step at a time. You can always ask someone for specific advice relating to your camera.

Test drive

Even in the days of film, I wonder how many test photographs were taken in the camera shop? Photos of tables, ceilings, shop fixtures, wonky photos of the shop assistant's arm . . .

Maybe your first digital photo was good enough to save for posterity – but maybe it is as uninspiring as the view of the camera showroom. (I just had a look at the cameras in my local Jessops, and the photos stored on the cameras were, of course, of the till, the shops outside and so on.)

Some cameras have gimmicky features to try to make you look slimmer – a few years ago, the HP Photosmart R727 caused a bit of a stir when it claimed to have a setting that 'squeezed' your subject to make him or her look like they hadn't eaten all the pies!

Getting used to holding the camera in front of your face rather than against your eye does take a bit of getting used to.

And it can be just as weird for someone not used to film! When my parents were on holiday with their old film camera, they asked someone to take a photo of them and the bemused person was holding it in front of them, trying to figure out what was going on without the LCD screen.

Practice taking a few shots to get a feel for the camera.

The right stance

You can observe how other people stand when they are composing a digital photograph, but the right 'technique' is really up to you.

Steve (Figure 7.5) is keeping his arms bent and his elbows relatively close to his body to help reduce camera shake, while still ensuring that he can see what is on

Source: Kim Gilmour

Figure 7.5

the LCD screen. After taking the photo, keep your arms in that stance for a split second until the photograph has definitely been taken. Try and hold the camera as still as possible during the exposure.

In Figure 7.6, Steve makes good use of the available railing to help stabilise the camera. (Rails are particularly handy if you are taking photos on cruise ships!) I am sure you will find other stabilising 'props' in your travels.

Source: Kim Gilmour

Figure 7.6

Reviewing the photographs

One of the beautiful things about taking digital photos is that you can review them later and delete the ones that didn't work out. All digital cameras have a playback mode to let you check out the images you have just taken. It's often indicated by a play symbol, familiar from a VCR or audio-cassette player.

To browse through these photos, you usually need to navigate left and right to move back and forth through the virtual 'roll' of film you have taken. To do this, you need to press the left and right buttons – all cameras have left, right, up and down functions on a keypad, known sometimes as a 'directional pad', or 'd-pad'. The directional effect is usually achieved by pressing the edges of the pad. Figure 7.7 shows an example from a Fujifilm model.

Source: www.fujifilm.co.uk

Figure 7.7

In Figure 7.8, you can see it in context on my Canon camera complete with photograph.

Source: Kim Gilmour

Figure 7.8

On many cameras, you will find the middle of the d-pad has a trigger button. I've seen it on various cameras as the 'OK', 'set' or 'menu' button – and sometimes it doesn't seem to have a name at all. The button is used for making selections. If your camera doesn't seem to have this, there will be an equivalent button – check your manual.

Because the LCD screen is relatively small, your photo might look good at a glance, but you can't always be sure if you focused on the right subject, whether you shook the camera, or whether your subject blinked as soon as you pressed the shutter button.

In that case, you can usually zoom in and out of the image using the same zoom functions that you would use when taking a photograph (Figure 7.9).

Source: Kim Gilmour

Figure 7.9

If you keep zooming out, you will usually see multiple photos on your screen (Figure 7.10) – these small versions of your images are called *thumbnails*. Use the left, right, up and down buttons on your keypad to browse through the thumbnails until your selected one is highlighted, then press the appropriate button to choose it.

Source: Kim Gilmour

Figure 7.10

Erasing an image

Don't like an image? You can trash it, if you like. When reviewing an image, there should be an option to erase (delete) it. Most cameras have a button featuring an icon of a bin (see Figure 7.7).

Setting the date and time

At some point, you may want to program your camera so that it is set to the correct date and time. The word 'program' does conjure up images of geeks in basements writing endless reams of computer code but it should be far easier than programming a DVD recorder.

Please consult your instruction manual to find out how to do this – it's a good exercise to try yourself because it will help you understand how the menus and controls for your specific camera work.

Many automatic film cameras from the 1980s and beyond allow you to display the date in the bottom right corner (many digital cameras also let you do this, if you choose). On a digital camera, this information is always registered on the image file, regardless of whether or not you display it on the actual photograph.

The time and date is just one of the valuable bits of information stored on a digital image file. The information, known as Exchangeable Image File (EXIF) data, is accessible in a number of ways and we'll explain this later in the book. It's very handy if you are looking back at old photographs and trying to categorise them. Some of the details that an image file records are:

- time and date
- make and model of camera
- shutter speed and aperture
- focal length
- dimensions
- whether the flash was used

. . . and a lot more.

When you are on holiday abroad, don't forget to change the time!

When in automatic mode, your camera will detect when flash is required. This is especially useful in group shots, when people's faces need to be seen clearly. You may need to turn off the flash in some circumstances, but your photo may turn out blurry if you don't keep it still or supported on a tripod or stable surface – if you can't do this then you may need to manually increase the ISO settings to avoid this troublesome occurrence.

Timer mode

Solo traveller? Or do you want everyone, including yourself, to be included in a group shot? Step in 'timer mode'. Once this is set, place the camera on a stable surface, frame the shot and press the shutter button (Figure 7.11). Depending on

Source: Kim Gilmour

Figure 7.11

the timer settings you chose, you usually have a timeframe of at least ten seconds in which to run to the appropriate spot and pose for the shot. (Some cameras are so advanced that they can use face recognition to wait for a new person – you – to enter the frame before taking the photo!)

Feel free to experiment with your camera by pressing the various buttons and exploring the menus while consulting the manual. You can't break the camera by doing this. If you do somehow change some settings, it may be upsetting if you don't seem to be able to get things back to how they were. However, all is not lost. You can always restore the camera back to its *default* settings – the factory settings. The instruction manual will tell you how to do this. If you are playing with the camera settings, insert a blank memory card to avoid the unlikely scenario of accidentally erasing any images already on it – or, if it uses an SD card, you can slide the tab to write-protect it.

Summary

- When framing a photo, depress the shutter button halfway to focus on your subject, then press it the rest of the way to take the photo
- You can review photos you've taken in playback mode
- Keep the camera as still as possible while taking the photo
- Practise a lot, and go at your own pace

Brain Training

There may be more than one answer to these questions.

1. What mode would you use to review images?

a) Camera mode

b) Snow mode

c) Playback mode

d) Zoom mode

2. What's a way to avoid the effects of camera shake?

a) Use a tripod

b) Lean against something stable

c) Use the image stabilisation function

d) Increase the ISO

3. How do you focus on a subject in automatic mode?

a) Press the shutter button fully

b) Press the zoom button

c) Press the shutter button halfway

d) Turn on the flash

4. How would you take a photo of yourself?

a) Use scene mode

b) Use the timer function

c) You can't

d) Ask someone to take a photo of you

5. What's a thumbnail?

a) A small version of a photo

b) The LCD screen

c) The enter button

d) A zoomed-in version of a photo

Answers

Q1 – c **Q2** – All are correct **Q3** – c **Q4** – b – and d of course!

Q5 – a

Taking brilliant shots

Equipment needed: your digital camera, complete with charged battery and memory card; a destination (or destinations) and possible models.

Skills needed: knowledge of basic camera functions, and some practice taking photos with your camera.

In this chapter, I outline some tips to help you create some great shots while the next chapter discusses how you can gain a little more creative control over your images using your camera settings.

Remember, feel free to break any of these 'rules'!

Rule of thirds

The rule of thirds has been around before photography and applies to classic visual arts, such as landscape paintings.

The rule of thirds states that to make a scene more interesting, dynamic and dramatic, you need to mentally divide it into a grid of nine equally-shaped boxes. Any 'points of interest' – in other words, where the action is – should fall a little off centre, on one of the four imaginary points where two lines intersect. If you put the subject slap-bang in the middle of the composition, it doesn't create any tension, and spoils the surprise. Many of us follow the rule of thirds without even thinking about it.

Some digital cameras let you display grid lines on the LCD screen to help you frame your image (Figure 8.1) – but I think it's easy enough to do in your head and you should always leave room for some flexibility. Having the lines there all the time could be disconcerting.

Source: Kim Gilmour

Figure 8.1

Frames

You might find a 'frame' for your image, such as a hole in a fence, some flowers, or an arch, creating an original take on an otherwise clichéd shot.

Source: Kim Gilmour

Figure 8.2

Diagonals

Give movement to an otherwise dull image by adding diagonals – whether it's via a vanishing perspective, or a series of triangular shapes within the photo. Your eye will be naturally drawn along these lines.

Source: Kim Gilmour

Figure 8.3

The rule of thirds is related to the golden ratio, or *phi*, approximately equivalent to 1:1.61803399. This aesthetically pleasing ratio is physically represented by a 'golden rectangle' divided into a square and smaller rectangle. You'll find the ratio in ancient Greek architecture. In practice, it means composing interesting things about a third of the way across the photo.

Get down low (or high)

If you are keen, why not try taking photos from a very low perspective? You could use a timer and place the camera on a mini tripod near the ground. There's no need to lie on the floor and look through the LCD screen to frame

the shot – simply review the photo once it's been taken to see how well it turned out and, if something doesn't look quite right, adjust the camera position accordingly. That's the good thing about being able to review your photograph as soon as you take it!

Also, try holding the camera above your head, to look over a crowd, for example.

Source: Kim Gilmour

Figure 8.4

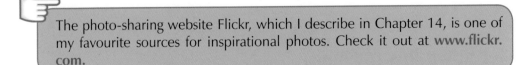

The photo-sharing website Flickr, which I describe in Chapter 14, is one of my favourite sources for inspirational photos. Check it out at **www.flickr. com.**

Pole position

An otherwise brilliant photograph can be ruined by an errant pole, tree, plant or other fixture seemingly protruding from your subject's head (Figure 8.5). We have all done it, only for someone else to notice (normally after the photograph has been printed). The wonders of image-editing mean we can remove these things later in the virtual darkroom, but avoiding the occurrence in the first place is your best bet. Sometimes just moving a few inches to the left or right is all that is needed.

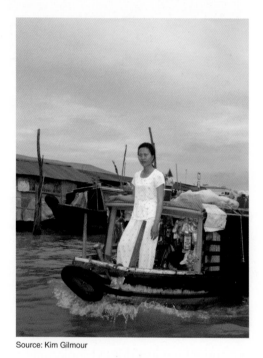

Source: Kim Gilmour

Figure 8.5

Using colour

You can use colour in various ways, such as drawing the viewer's eyes around your photo (perhaps someone wearing a yellow scarf might be standing in front

of a yellow New York taxi). Or you may see colours repeating and contrasting, as in Figure 8.6.

Source: Kim Gilmour

Figure 8.6

Portrait or landscape?

Framing a photo but something just doesn't look quite right? Maybe there's too much happening on the fringes of the scene? You don't always need to stick to the horizontal 'landscape' position – maybe it will look better taken as a vertical 'portrait' instead.

Textures and layers

Zooming in on this old rusty building in Zanzibar (Figure 8.7) allows us to capture the different layers and add depth to the image.

Source: Kim Gilmour

Figure 8.7

Repetition

Look for patterns in objects when you are out and about, as with the fridge magnets in Figure 8.8.

Source: Kim Gilmour

Figure 8.8

Lighting considerations

When shooting outdoors, try to have the sun behind you so that natural light can shine on your subject. This will minimise contrasts and shadows. However, when photographing people, try to avoid harsh sun shining directly into their eyes as they may squint and look upset.

If that is the case, you may need to have the sun behind them after all and use a small *reflector* to help redirect light gently to the person's face and reduce shadows. This handy prop will need to be held out of shot, in front of their face – they could even hold it for you. You can buy collapsible reflectors from photographic shops for around £12 or try improvising by using a large white card. Reflectors, such as this range from Lastolite (Figure 8.9), come in all shapes and sizes – you will only need a small one!

Source: Photo courtesy of Lastolite

Figure 8.9

Up or down?

Taking a portrait of someone standing higher than you (on a chair, say) could give a sense of power and strength. On the other hand, if you are the one standing on the chair then perhaps the person you are depicting may look more vulnerable.

Taking photos of animals and children

The show-business cliché credited to WC Fields, "Never work with children or animals", can be appreciated by anyone who has tried to photograph them. But the results can be rewarding with a little perseverance and, dare I say, luck.

My top ten tips for getting great kid and animal photographs include:

1. Get down to the child's eye level to capture their expressions and engage their interest. If this is impractical, you could both be sitting at a table or sofa where you will be at the same approximate height.

Source: Kim Gilmour

Figure 8.10

2. Always have your camera around. When you see a golden moment that deserves to be captured, capture it!

Source: Sarah Kidner

Figure 8.11

3. If your camera supports it, use the continuous or burst mode when shooting fast-moving children or animals. Then you have a better chance of getting a good shot.

4. Read tip number one – then break it. You can take some really fun photos from different angles, as Figures 8.12 and 8.13 show.

Source: Miriam Chan

Figure 8.12

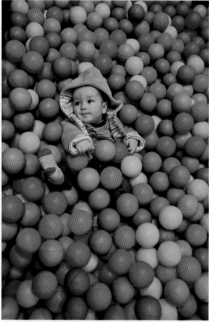

Source: Miriam Chan

Figure 8.13

5. Use natural light rather than your camera's built-in flash wherever possible, to avoid animals and children being startled. It'll also avoid a harsh-looking photo and the red-eye effect.

Source: Kim Gilmour

Figure 8.14

6. Dangle a toy to get a pet's attention.

7. Move in close and fill the frame to capture timeless facial expressions, but do it quickly! Don't get too close though, as your subject may look distorted depending on the focal length of the camera lens. You may want to zoom in just a little.

8. Some children aren't used to posing and have short attention spans, so aim to capture them looking candid. (And some kids love hamming it up for the camera as soon as they see it and pull faces, so you have to find the right moment to get them looking natural!)

9. Younger children may be camera-shy so don't draw attention to your gadget! You could try to sit further away then zoom in to be less intrusive, but the quality of your image may not be as good as if you were physically closer.

10. Experiment!

Reproduced by permission of Mark Massey

Figure 8.15

In the next chapter, I explain how you can get greater control over your photographs by using some of the creative or manual settings. This will involve coming out of 'automatic' mode, but it's well worth it after you have gained confidence and experience using your digital camera.

Summary

- Keeping your subject a little off-centre often creates drama and interest

- Try to get to the same eye-level as your subject

- Patterns, textures and colours can make great photos

- Aim to capture children looking candid and natural

- Know the rules then feel free to break them!

Brain Training

There may be more than one answer to these questions.

1. **With the rule of thirds, at how many points do lines in the grid intersect?**

a) Three

b) Nine

c) One

d) Four

2. **What's the 'best' position from which to take a photo of a child?**

a) From above

b) From below

c) From eye-level

d) From far away and zoomed in

3. **Taking a photo of someone standing above you could make them look:**

a) Weak

b) Powerful

c) Scared

d) Strong

4. **What's a good position for the sun when taking a photo in natural light?**

a) At its highest point in the sky

b) In front of you

c) Behind you

d) Behind a tree

5. **What's the best way to get great photos?**

a) Do a photography course

b) Keep practising

c) Always use automatic mode

d) Get a professional camera

Answers

Q1 – d **Q2** – c **Q3** – b and d **Q4** – c

Q5 – b

Getting more control of your photos

Equipment needed: digital camera, perhaps a knowledgeable friend or partner, a destination or destinations for taking photos.

Skills needed: experience with taking photos using your digital camera; reasonably good familiarity with the instruction manual, even if you have only taken photographs in automatic mode.

I hope the last few chapters have helped to introduce you to the joys of digital photography. Perhaps by now you have had plenty of experience with taking photographs of the things and people around you using the automatic settings on your camera. I think you probably realise that most of the time the results – at least as you see them on your LCD screen – are very good.

Using special settings and modes on your camera

However, there are plenty of other creative effects you can achieve using the special settings and modes on your camera. I explained many of the concepts in earlier chapters, but here we put them in a more practical context.

Most of the settings mentioned in this chapter should be available on typical point-and-shoot cameras but, particularly if your camera is very old or it's a budget, entry-level model, they may not all be. Please don't get disheartened if not all of these effects are available on your camera – the subject matter, lighting and composition are what really count, and some of the colour and exposure correction tips can be achieved using your computer later, as I explain in Chapters 12 and 13.

Your instruction manual is the best place for you to discover how to access various menus and functions. Every camera works slightly differently so I can't give specific step-by-step instructions for your model. If you can't find mention of a particular feature in your instructions then it's likely your camera doesn't have it.

Due to the complexities of digital cameras and the other gadgets I have to contend with, I find that if I go away from my camera for a while, it isn't always second nature accessing particular modes or settings. I then have to read the manual again to familiarise myself with it all. Sadly, it's not at all like riding a bicycle! But after a couple of hours I do tend to get the hang of it again. Practice does make perfect.

Macro mode

Often represented by an image of a tulip, *macro mode* lets you take close-up images of objects – it doesn't stop at flora. Depressing the shutter halfway focuses on the subject. With point-and-shoot cameras, you'll probably still need to be at least a couple of centimetres (around one inch) away from the subject. In Figures 9.1 and 9.2, taken in Central Park, you can see the photo without macro mode and the effect of using macro mode to focus on the pine cone rather than the cherry blossoms.

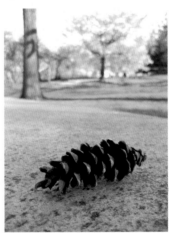

Source: Kim Gilmour

Figure 9.1 **Figure 9.2**

Portrait mode

In this mode, portraits of your subject – whether or not it's a zombie – come out with a softer background due to the larger (wider) aperture used.

Source: Kim Gilmour

Figure 9.3

Effects with slow shutter speeds

In Chapter 4, I explained how a slow shutter speed causes blur, which you can use to great effect in your photos. An effect you have probably seen in sports photography, called *panning*, causes the subject to be in focus while the background is blurred, as shown in Figure 9.4. This gives a sense of movement and action. Can you guess how this is achieved?

Source: Kim Gilmour

Figure 9.4

Well, it's very simple and the effect above was achieved with a point-and-shoot compact camera, nothing fancy at all. First, I used the manual mode of my camera to select a slow shutter speed (in this case, around 1/15 of a second). I also made sure the flash was off and the ISO was low. (You may have to experiment with these settings depending on your scenario and the time of day.)

I then half-pressed the shutter button, focusing on an area directly in front of me that the cyclist would pass. Keeping the shutter half-pressed, I then pointed the camera close to where the cyclist was approaching to my right. A split second before he passed me, I aimed the camera at him and pressed the shutter down all the way, at the same time making sure the camera was following him the whole time as he cycled from right to left (this is what's known as panning).

Essentially, you follow (track) your subject with the camera as they go past you, keeping the shutter depressed as you do so. It might take a few goes and you may have to experiment with different shutter speeds. I also found it better for me to look through the viewfinder when doing this as it stabilised the camera as I panned, but not all of you will have a viewfinder so you should keep your elbows firmly pressed against your body.

You can also use a slow shutter speed for waterfalls and fountains, as you can see in Figure 9.5, to show the effect of the water moving. It's best to use a tripod or ledge for this kind of shot and use timer mode to avoid potential camera shake when the shutter button is pressed.

Source: Kim Gilmour

Figure 9.5

If your camera is too basic and does not allow you to choose a slower shutter speed, you could try seeing if it lets you turn off the flash and select a low ISO.

Face detection

Many cameras automatically detect faces in the frame and even track a subject as they move around. This is a good tool for both beginner and enthusiast – the camera automatically chooses the most appropriate settings.

Source: Kim Gilmour

Figure 9.6

Exposure compensation

Most digital cameras let you adjust the exposure to let in more or less light. This can be handy if automatic mode doesn't seem to produce the best results, but normally it should be fine. The extent to which you can adjust the exposure depends on the model of your camera. Figures 9.7, 9.8 and 9.9 show a normally-exposed photograph whose exposure has been increased and decreased.

Source: Kim Gilmour

Source: Kim Gilmour

Source: Kim Gilmour

Figure 9.7 **Figure 9.8** **Figure 9.9**

Metering modes

These three modes, available on most cameras, can help you adjust the level of exposure on your photograph. Consult your camera instructions to find out how to access the modes.

Evaluative metering

Ninety-nine percent of the time, I'm happy using the automatic *evaluative metering* mode on my camera – sometimes it's known as *multi-zone*, *multi-patterning* or *matrix* metering depending on your camera model. This mode is the main, default, factory setting; it automatically analyses various points in your scene to help determine the best overall exposure. Your camera is probably already in this mode, unless you change it.

Spot metering

In some circumstances you may want to measure the exposure of a small area of your photograph. This may be the case if your photo has a lot of contrast between dark and light tones (such as a backlit subject) and the evaluative metering mode can't handle this scenario. Spot metering lets you concentrate on an extremely small crosshair area at the centre of the frame and adjusts the exposure for that area only, disregarding the rest of the image.

Centre-weighted average

This mode places more emphasis on the exposure settings for the subject at the centre of the frame; unlike spot metering, it does take into account the rest of the scene too.

Dynamic range

This is a relatively new feature found on some digital cameras, such as the Ricoh CX1. This setting takes two separate shots simultaneously – one exposed for the dark shadowy areas; the other for the light ones – then merges them to form one perfectly exposed shot. Many amateur photographers do this kind of thing later, on a computer; a process known as high dynamic range imaging (HDR). The effect, as you can see from members of the Flickr group at **http://www.flickr.com/groups/hdr**, can look a little 'hyper real'.

Red-eye reduction

To reduce the effect of flash causing red eyes, you can turn on the red-eye reduction function. My old film camera had this function and it works the same way on digital cameras. Basically, the flash strobes a few times before the photo is taken, so that the subjects' pupils reduce in size – this minimises the red-eye effect. Be sure to tell your subjects that this mode is on because, in my experience, people often think that the initial flash is the photo being taken and they may move too soon.

Some cameras have built-in settings to let you remove the red-eye effect after you have taken the photograph, but bear in mind you will be doing the retouching work on a relatively small LCD screen. I prefer to work on removing red eye on my computer later, after I have copied my photos on to it. The reason is simply because it's easier for me to see what I am doing.

A rare cancer called retinoblastoma has been diagnosed thanks to red-eye photos, saving lives! When one retina comes out white rather than red in a flash photo, it can indicate a tumour behind the eye. It mostly affects young children and is quite treatable when caught early.

White balance

In Chapter 3, I explained how most cameras try to record colours as your eye sees them by using automatic white balance settings. But, in certain kinds of light, the automatic approach isn't the best. Many digital cameras let you adjust the white

balance settings. Take a look at the selection of images of a ceiling light in Figure 9.10. Each one was taken using a different white balance setting. Which one do you think looks best? There's not necessarily a right or wrong answer – it's all about the particular effect you want to achieve with your image – but in many cases where there is a clear 'colour cast' over the image, such as a blue tinge over a snow photograph, photos can clearly look better after the right white balance settings are achieved.

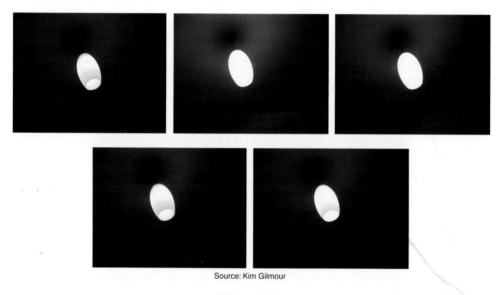

Source: Kim Gilmour

Figure 9.10

During my research for this book I found a great resource for understanding how white balance can change the look of an image, as well as more examples, at Ken Rockwell's personal website at **http://www.kenrockwell.com/tech/whitebalance.htm**.

If your camera doesn't let you adjust the white balance settings, you can fix them up on your computer later by adjusting the colours. See Chapters 12 and 13 for more information.

Panoramic photos

A panoramic photo is a wide, unbroken view of your surroundings. The effect is achieved by putting together several individual photos to form one long photo. Each separate photo slightly overlaps with the next and there is computer software available that magically stitches them together.

My Canon camera has a special 'stitch assist' mode to help me determine where to take the next photograph in the sequence, by showing me where the last image was taken. But you can do this in your head by simply remembering where to take the next shot. In Chapter 13, I explain how to use Windows Live Photo Gallery to create a panoramic photo from these separate images.

Aperture adjustments

In Chapter 4, I touched on how being able to adjust the aperture, or the hole in your camera's lens, can alter how much depth of field there is in a photo. A small or narrow aperture of, say, f/16 means that pretty much everything in the scene is in focus, as we can see in Figure 9.11.

Source: Kim Gilmour

Figure 9.11

The same scene using a wider aperture of f/5 (Figure 9.12) isolates the subject from the background, which becomes blurred.

Source: Kim Gilmour

Figure 9.12

Being able to adjust the aperture is a standard feature in digital SLRs. By prioritising the aperture, the camera can automatically determine the best shutter speed settings. You may need to use a tripod to steady the shot, depending on the circumstances.

If your camera is not an SLR and does not seem to let you adjust the aperture, try using different scene modes, as some of them will have the same effect – the portrait mode's wide aperture setting, for example, doesn't have to be used on faces.

 The amount of sharpness evident in an image is known as its depth of field. A shallow depth of field in a portrait could mean that a subject is in focus and the background isn't – meaning a wide aperture has been used.

Focus adjustments

When you've got a compact digital camera, sometimes it can be frustrating if you want to focus on a particular subject but the camera keeps insisting upon focusing on something else. Your camera should have settings to help you 'lock' a subject into focus. One simple way is to put your subject at the centre of your frame and press the shutter button halfway. Keep your finger there, then recompose the shot so that the subject appears where you want it (such as to the edge of the shot). Then press the shutter button down all the way.

Flash intensity

When using the built-in flash, sometimes indoor photos can come out terribly harsh. Some cameras let you determine the strength or intensity of the flash.

Image file size

The larger the image, the more space it takes up on your memory card. There are ways to fit more photos on to your card but with some loss of quality:

Reducing pixels

My digital camera, when set to its maximum quality setting, produces images with a resolution of 3648×2738 pixels (almost 10 million pixels, or 10 megapixels). This equates to a file size of around 4.5MB (it varies) and is good enough to print photographs at A3 size and above (11.7×16.5 inches).

However, if I were to capture images at a resolution of 2272×1704 (around 4 megapixels), my images would only be 2MB in size. This is still good enough to print 8×10 images and allows me to cram in more than twice as many photos onto a memory card. Your camera settings will tell you how to adjust the resolution.

But be aware: if there is even the slightest chance that you will print your photos very large or perhaps crop into an area of the image and enlarge it, it's best to take images at their highest settings in the first place. Memory cards are cheap. Don't worry that you're using too much space!

Compression

In Chapter 3, I discussed how it's possible to control the amount of JPG compression within an image. This can reduce file size. However, images with a very high level of compression can look 'blocky' – known as having *artifacts*. You can't get this detail back later so I always think it's best to take photos with the least amount of compression (normally set to 'fine' or 'high' on your camera) to start with. This is particularly important if you are capturing images at a lower resolution. Compression is handy when looking at photos over the Internet and on email, though – and I'll discuss this later in the book.

Resizing

Many cameras let you resize your images (thus reducing the pixel count) after you have taken them. This, I think, is a better option if you are short on memory card space and can't back them up onto a computer or disk.

When my friend Anne visited me in London, she took so many photos at Madame Tussaud's wax museum that she didn't have any space on her card for the rest of the holiday – and she hadn't brought a spare! Using the settings on her camera,

she resized the museum images to make them a little smaller so she could cram more photos on to the card. In the end, the photo of her next to King Henry VIII still came out fine on a 4x6 print.

Summary

- You can use a slow shutter speed to experiment with various movement effects

- You can often control the way colour appears on a photograph by using your digital camera's white balance settings

- Macro mode will let you get close-up shots

- For best quality, it's always best to take photos at their maximum resolution with the least compression – if space on your memory card is an issue you can adjust these settings or resize your photographs later

Brain Training

There may be more than one right answer to these questions.

1. In photography, what is panning?

a) A critic's bad review of a photograph

b) Following a moving subject so that it remains in focus with the background blurred

c) The 'moving water' effect

d) Choosing the right size for your photos

2. What effect would using a wide aperture probably have on a portrait photograph?

a) A shallower depth of field

b) The face would be in sharp focus and the background in softer focus

c) All detail including the background would be visible

d) An overexposed photograph

3. What happens if you apply a high amount of compression to a photograph?

a) Better detail and clarity

b) The file size increases

c) The file size decreases

d) The photo can look fuzzy and blocky

4. What causes a colour 'cast' over an image?

a) Slow shutter speed

b) The image is too dark

c) Incorrect white balance settings

d) The resolution is too low

5. What's a good camera setting for extreme close-up shots?

a) Macro mode

b) Foliage mode

c) Portrait mode

d) Sports mode

Answers

Q1 – b **Q2** – a and b **Q3** – c and d **Q4** – c

Q5 – a

PART II
Entering the digital darkroom

You look like quite a catch, now that
I've edited out the wrinkles, shadows and
red-eye...

Getting photos onto your computer

Equipment needed: a computer running Windows and with free disk space; some photos on a memory card, which are ready to transfer to your computer; your digital camera and the required cable to connect the camera to your computer or a memory card reader.

Skills needed: knowledge of the computer keyboard and mouse; knowledge of the concept of using files and folders in Windows; experience with opening files and programs in Windows; a working knowledge of copying files, using methods such as drag and drop; some confidence and enthusiasm.

Why put your digital photos on your computer?

The first part of this book was all about how to choose a digital camera, get to know its functions and start taking some good shots.

You may be happy for now taking photos in this manner. When your memory card gets full, you can go to the photo lab to print your photos just like in the old days of film. Or friends and family may be happy to handle the process for you.

But there is so much more you can do if you can copy your photographs on to your very own computer, including the following things, which I cover in the next few chapters.

Storing

A computer gives you ample space to store and access your photographs, so you can wipe photos from your memory card and use it again and again.

Organising

There are a number of free tools within Windows (and available to download) that let you easily categorise and file the thousands of images you are likely to accumulate. Often you'll be able to do this at the same time you copy over your photos, saving valuable time in the process.

Sharing

Use the Internet to put your photos into web albums, email smaller versions to friends and family, or put them on to social networking sites (such as Facebook) for your contacts to see. Short videos that you take on your camera can be uploaded to sites such as YouTube.

Printing

Using your home printer, you can produce professional-quality prints whenever you like (in fact, many printers don't even require the use of a computer). Or you could send your images to an online photo-printing service where they are stored remotely. You can then order cheap prints over the Internet whenever you like.

Editing

Free tools – either built into Windows or available to download online – let you tweak your photographs to correct any imperfections. Sometimes all it takes is one click to give your photo a new lease of life. If you want to experiment further you have the flexibility to upgrade to a more advanced program.

If you have had a little experience with computers, then it really is quite easy to work with digital photographs.

Even being able to get the photos onto your computer, without organising, manipulating or printing them, is a massive benefit and really quite simple to do. That's what this chapter is all about.

Using a Mac? Any step-by-step instructions here refer to Windows computers, but all the concepts and benefits discussed are the same.

Your computer specifications

There are a number of ways you can copy your digital photographs on to your computer. This process is known as *importing*. When you import, you copy your photos from a memory card to your computer. You can erase (delete) the originals as soon as this process has completed, leaving space free on the memory card for you to take more photos. Importing photos is sometimes just called copying, particularly if the originals are left on the card.

But before I describe importing, I think it's worth quickly checking if your computer is good enough to handle the job on an ongoing basis. I explain how to check these details a little further on, but first, here is what to consider.

Storage space

Like memory cards, computers need to have enough space on their hard drive to be able to store all your photographs – the more photos you take, the more space they will take up on your hard disk drive. How much space will you need? The reply "how long is a piece of string?" comes to mind, but aim for at least 50GB of free hard disk space to start with and more if you can afford it.

If hard disk space on your current computer is limited, you could get a professional to install extra space or buy an external hard drive and copy photos onto that drive. Simply plug the external hard drive into your computer and turn it on to create the extra drive. However this means you always have to have the drive on and attached to your computer in order to access your photos – not convenient if you have a laptop. I think external hard drives are generally best for storing backup copies of your photos.

Memory (RAM)

Not to be confused with memory cards, your computer's memory (technically known as 'random access memory', or RAM) is a bit like a 'buffer': when you are running a lot of resource-hungry programs and large files on your computer, your computer needs ample memory to be able to run them at the same time and at reasonable speed. As a general rule, the more RAM you can afford for your computer, the better. Guidelines vary but I think 2GB is great – ideally, you'll want 512MB at the very least. Photographs are getting larger and larger in size, so having several open on your computer at once will eat up a lot of memory – this means any editing will take longer to achieve and the computer may start acting very slowly.

Other considerations

In computer ads, a big deal is made about the processor – its 'brain' or 'nerve centre'. If your computer is no more than three years old, then I don't think this is a massive issue for what you will probably be using your computer for. It's only important if you are doing really graphics-intensive stuff, such as video games or video editing. Any investment into upgrading your computer should, in my opinion, go into memory and hard disk space, not the processor.

Checking the specifications

To check how much hard disk space and memory your computer has, in Windows Vista and Windows 7, click the Start button (the Windows icon at the bottom left of the screen), then click Computer. In the box that appears, click System Properties to view your computer's specifications.

If your computer doesn't seem up to scratch, don't worry. You should still be able to copy over your photographs, but if things run a little slowly or if you run out of disk space quite quickly, then you'll know why.

Ways to import and view your photos

How do you get your photographs from your memory card on to your computer? The two common ways are to:

- connect your digital camera to your computer;
- use a memory card reader (my preferred method).

Either method requires the use of a cable connection called *universal serial bus* (USB). It is the main way many external hardware devices connect to your computer. Your mouse, keyboard, printer and scanner are likely to use USB connections (if they don't, then your computer is really, really old!).

Your computer should have several free USB *ports* – just look for a slim rectangular socket.

The way you view and import photos is similar for both camera and memory card reader methods so first of all I discuss how to physically connect each type of device.

Connecting a digital camera to a computer

Your digital camera should come with a USB cable. The end of the USB cable that plugs into your computer will consist of a large, flat rectangular plug (the shape of the other end varies – some are even exclusive to certain manufacturers).

The majority of devices plugged in via USB are usually able to be recognised by the computer almost right away – what Windows does is automatically install special software called a *driver* that sits between the device and computer, allowing the device to run. If this doesn't work, you may need to install the driver from the disk that came with your camera. Please check the manual for specific instructions. If you don't have a disk, then you should find the driver available to download from the manufacturer's website.

Carefully open the small, usually hinged compartment on the side of your camera and plug the correct end of the USB cable into it (it will be obvious which end this is), as in Figure 10.1.

Source: Kim Gilmour

Figure 10.1

Now plug the large, flat end of the cable into one of your spare USB ports. It can only go in one way – there should be a symbol on the cable and this side goes face up (see Figure 10.2).

Many computers have USB ports situated on the front rather than the back and you might want to consider using these if you will be frequently plugging and unplugging your camera. Otherwise you might need to get a longer cable, or an extension.

Source: Kim Gilmour

Figure 10.2

Turn the camera on (make sure the battery and memory card are inserted) to install the driver for the first time and initiate the connection.

Before I discuss the viewing and importing options, I'll quickly discuss my preferred connection method, a memory card reader.

Connecting a memory card reader

An alternative way to view and import images is to use a *memory card reader* rather than your camera. Just plug it into a USB port and insert your memory card into the reader's appropriate slot. There is only one correct way to insert the card because of the way the card is shaped. Usually an indicator will light up green to show you that the reader is working. Memory card readers often have

multiple slots to accept different types of cards, like the one in Figure 10.3. (Many computers even have a memory card reader built in!)

Source: Lexar

Figure 10.3

I always use the memory card reader method, rather than connecting my digital camera directly. Why? Consider the following reasons:

- The main reason, by far, is that when you use a camera for transferring images, it uses up valuable battery power. Memory card readers draw their power from your computer.

- When on holiday, it's very easy to carry a memory card and reader into an Internet café if you want to view your images or share them with your friends over the Internet – leave your camera in the hotel safe. There's far less chance of camera driver problems, too.

- Someone else can be out and about using the camera while I'm transferring images at home.

You can buy memory card readers for under a tenner. If you use the newer, higher-capacity SDHC cards, make sure that the memory card reader is compatible. Your card reader may come with driver software but in practice it's unlikely that you'll need any extra driver software to use a card reader.

When using a memory card reader, often it shows up on your computer as being a 'removable storage' device – an extra *drive* on your computer, normally E:. More drives may appear if there are more slots on your reader.

Now let's look at your viewing and import options.

Viewing your photographs

Whichever method you use – camera or card reader – Windows should recognise that your device has been connected. Eventually a box titled Autoplay should pop up, as shown in Figure 10.4.

Figure 10.4

Browsing photos with Autoplay

Autoplay is a tool within Windows that recognises a camera or card reader (or other media, such as a CD) has been connected, and gives you several options on what to do next, including whether to import pictures onto your computer or simply view the pictures. The exact wording you see may vary slightly depending on whether you are using Windows 7, Windows Vista or Windows XP, but any choices that show up in this box are self-explanatory. Some people don't like Autoplay and turn it off, preferring to use their own methods of copying over images and other files. For the purposes of this chapter, I'll be using Autoplay.

If Autoplay doesn't show up (maybe someone in the household turned it off), you can manually bring it up:

- In **Windows Vista** – click Start, then Computer. Right-click your device and click Open Autoplay.

- In **Windows 7** – you can do the same, but there is an Autoplay button displayed in the Computer window so there's no need to right-click the device.

If another program and set of import and view options launches altogether when you connect the camera or card reader, don't worry. It's probably because your computer settings are set to use that program as the *default* (or main) method in which to view and import images, and not Autoplay. This might have happened if you or someone else installed additional software from your camera or installed another image-editing program. Using another program suits a lot of folks just fine. In fact, in the next chapter I discuss how you can use Windows Live Photo Gallery and Picasa as the default way for viewing and importing images. You can still manually turn Autoplay on, as described previously.

Let's choose to browse the files on the memory card without copying them over just yet. Double-click the option to let you view the files in Windows Explorer and you will see *thumbnails*, small versions of the images, appear. It may take a little while for them all to show up on your computer screen because the files are not stored on your local computer – they still reside on your camera or, technically speaking, your camera's memory card, so the speed depends on your memory card and the size of your image files.

The thumbnails in Windows Explorer are very small indeed, especially if one's eyesight isn't the greatest. Luckily, there are options to make these images larger. In Windows 7, for example, click the third-last icon on the top right of Windows Explorer and you can choose to view as 'extra large icons'. You'll find similar options in Vista and XP. Now see what happens (Figure 10.5): nice, larger images that are far easier to browse!
(Choosing this option means *all* icons, not just photos, will look larger.)

Figure 10.5

Viewing a photo

If you would like to open one of these files, just double-click the thumbnail and a larger version of the photograph will open on your screen, most likely using Windows Photo Viewer – if using Windows Vista or Windows 7, it should look something like Figure 10.6.

Figure 10.6

Remember, we have not copied this photo to the computer just yet – it's still stored on the camera's memory card.

To close this photograph, click the X at the top right of the window. *Don't* click the red X displayed under the photograph – confusingly, this is for *deleting* the photo and you don't want to do that. Thankfully, you'll receive a warning message if you do accidentally click this button.

Congratulations, you have successfully mastered the art of viewing a photograph.

Browsing photos without Autoplay

I assume you have some familiarity with navigating files and folders within Windows. If you look under Computer, accessible in Windows Vista and Windows 7 by clicking the Start button and then Computer (called My Computer in XP), then you should see your device listed there alongside your regular hard drive. The memory card is its own removable 'drive' and if you are familiar with opening folders and files, you can access your photographs in the same way as your local drive. In Figure 10.7, the drive is called EOS Digital (G:). Double-clicking the drive and browsing to the folder where your images are stored will allow you to access and view them.

Figure 10.7

Removing the device safely

Don't just unplug your camera or memory card reader from the computer at this point. Although it's unlikely that anything will go wrong if you accidentally do, there is still a risk of some damage to your files – particularly if the computer is in the middle of communicating with the camera or card reader. What you need to do is *safely remove the hardware*. You should see a tiny icon of the USB cable at the bottom right of your screen. Select this icon and you'll see a list of connected devices; choose the camera or removable storage device and Windows tells you when it's safe to unplug or eject it. If you are having trouble with this, the Help files within Windows should explain the process more thoroughly – exact instructions depend on the version you are using.

Importing your photographs

I showed you how to view the photographs from your card and safely remove the device, but we haven't imported them to your computer yet.

Those of you familiar with the concept of copying files from one folder to another by dragging and dropping (for more on this please see *Computing for the Older and Wiser* or *Computing with Windows 7 for the Older and Wiser*) will find that you can manually copy files from your memory card to your chosen folder simply by dragging and dropping, as shown in Figure 10.8.

Figure 10.8

It's actually much easier, as you build up a huge library of images, to transfer your photos from your card to your computer *en masse* using the helpful tools available to you.

When importing, you can choose to:

- import all photos from the card to your computer and leave the originals on the card;

- import a selection of photos from the card to your computer and leave the originals on the card;

- import all photos from the card to your computer and delete the originals from the card;

- import a selection of photos from the card to your computer and delete the originals from the card.

For peace of mind, until you are confident with transferring your images, I would choose to temporarily leave the originals on the card. You will have to erase them eventually so that you can reuse the memory card, but it's good to have two copies, at least until you next back up your computer. Once you have more practice, then you can erase with complete confidence.

We now know that there are a number of options available to you when importing your photographs. In the next chapter, I discuss some more useful methods when I talk about how Windows Live Photo Gallery and Picasa can help you organise your photographs.

Importing photos with Autoplay

To go back to basics, the simplest way is to merely copy *everything* over from your card to your computer. You could do this manually by selecting all files and dragging them to a chosen folder but if you don't have experience with this (or even if you do), Windows provides another way to help using Autoplay.

If you unplugged your camera or card reader during the hardware removal exercise, then plugging it in again should bring up the Autoplay screen once more. If Autoplay was turned off, manually bring it up as described earlier.

By the way, to check if Autoplay is set to always open when you connect a device in future, click Start, then Control Panel, and go to Hardware and Sound. Make sure the box that asks you to use Autoplay for all devices is ticked.

Now, on the screen that appears, select the option Import Pictures and Videos using Windows as in Figure 10.9.

Figure 10.9

Tagging photos on import

Windows automatically detects the presence of the photos on your card, and a screen like Figure 10.10 should appear.

Figure 10.10

You will notice that there is an optional opportunity to *tag* your photos. A tag is a descriptive keyword and I talk more about tags in Chapter 11. In this example, I've chosen the tag 'snow' as the photos on the card are all snow-related. Then I click import and the process begins, as shown in Figure 10.11.

Figure 10.11

What happens next? Well, a new folder containing all the photos is copied to the Pictures library. The name of the folder is, by default, the date of import. Open the folder to view your photos.

Figure 10.12

As you can see in Figure 10.12, we've given the images a 'snow' tag and the photos have been sequentially titled 'snow 01.jpg', 'snow 02.jpg', 'snow 03.jpg' and so on, rather than by the meaningless original names such as IMG_4512. JPG.

Now you can safely remove your device from your computer, and guess what – the photos have been copied over!

Summary

- Make sure your computer has ample hard disk space to store all the photos you'll take and at least 512MB of RAM

- To get photos onto your computer, you either connect your camera to your computer using the supplied USB cable or use a memory card reader

- Windows should automatically install the required driver to get any connected device to work. If not, you can manually install it using the CD that came with your camera, or download it from the manufacturer's website

- The Autoplay tool in Windows is a basic and easy way of importing photos but there are other methods, which are described in Chapter 11

- When you connect your memory card to your computer it acts just like a hard drive, only it's removable

Brain Training

There may be more than one right answer to these questions.

1. What is the name of software that helps a device, such as a printer or camera, to run in Windows?

a) Autoplay

b) Driver

c) Windows Explorer

d) USB port

2. What is the handy tool within Windows that can help you easily view or import photographs?

a) Autoplay

b) Driver

c) Windows Explorer

d) USB port

3. What two things are most important when seeing if your computer is up to the job of handling digital photographs?

a) Memory (RAM)

b) Processor

c) Brand

d) Hard disk space

4. What advantages does using a memory card reader have over connecting a camera directly to your computer?

a) There is less chance of driver issues

b) It doesn't use battery power

c) It's more reliable

d) There are no advantages

5. What is the process of transferring images from your device to your computer called?

a) Importing

b) Copying

c) Deleting

d) Exporting

Answers

Q1 – b **Q2** – a **Q3** – a and d **Q4** – a and b

Q5 – a and b

Organising, backing up and viewing your photos

11

Equipment needed: a computer running Windows, with sufficient free disk space; some photos on a memory card ready to transfer to your computer or some photos already stored on your computer.

Skills needed: knowledge of the computer keyboard and mouse; knowledge of the concept of files and folders within Windows; a working knowledge of copying and moving files and folders using methods such as drag and drop; practice with transferring digital photos to your computer (see Chapter 10); experience with installing a program is also helpful.

Organising your images

In Chapter 10, we established how to transfer photos onto your computer and view them using the basic tools within Windows. But simply transferring them to a digital dumping ground without a suitable 'filing system' could cause frustrations for you later (and for future generations). Over the years, you will accumulate many photographs and you'll want to find them easily without having to trawl through all your thumbnails.

Do you organise your negatives in any way? Think about how they are categorised. If you don't organise them at all and prefer to stuff them into shoeboxes, then imagine how difficult it can be to look for photographs relating to events that happened long ago.

At the very least, a simple way of categorising digital photos could be to go to your My Pictures folder (under Pictures) and create a series of meaningful folders.

instance, you could set up a series of folders by year, and within these you could create sub folders named after certain events and dates, as in Figure 11.1.

folder called
Snow Feb 2009

Figure 11.1

Within these folders, you place your photographs. If you like, you can rename the photos' original filenames to something more meaningful to you, too.

is is a very basic system. While it suited me quite well in the beginning, as the ˈs went by I found it more difficult to find pictures I liked – and if you are ˈming files, it takes a while, if you took thousands on your holiday.

e if you could just type 'Brazil' and '2008' into a box and all images from appear on-screen? Well, that's what makes photo organisation tools so they let you do this and much more.

ˈrams help you import and place your photos into a meaningful filing / also find photos that are already on your computer, so it's never too ˈanised!

w every digital photo includes some data relating to the time and ˈn. The organising tools out there *automatically* sort your photos and many are free. In this book, I focus on Picasa 3.5 (owned

by Google) and Windows Live Photo Gallery (from Microsoft; there is no Mac version).

Both Picasa and Windows Live Photo Gallery do more than just organise photos – they also serve as basic image-editing software and help you share your images online and off, too. In subsequent chapters, I'll be using these programs for some of these tasks.

I am assuming you have had some experience with downloading and installing a program from the Internet. Otherwise, you may want to ask someone to help you. Please make sure you download these programs from the source and not through any third-party websites.

You can obtain Windows Live Photo Gallery from **http://download.live.com/photogallery**. Picasa can be obtained from **http://picasa.google.com**.

A security message or two will show up on your screen whenever you download a program. In this case, make sure Microsoft, Picasa or Google are mentioned – this verifies the program's authenticity.

When installing Windows Live Photo Gallery or Picasa, you will be asked whether you want to make certain changes to your computer, such as changing your favourite search provider to Microsoft's Bing or Google's own search. Feel free to untick or decline any options that you don't want. You can always change your choice later.

Windows Live Photo Gallery

Microsoft's Windows Live Photo Gallery is a great, free program that helps you keep your photos in a logical filing system. It even helps you import your photographs. You can edit and share your photos using Windows Live Photo Gallery too. In terms of organising, it lets you:

● label (tag) the people in your photographs;

● assign descriptive keywords to your photographs to help you find them again;

- rate photos out of five, so you can weed out any rubbish ones;

- file and view photographs according to year and date, based on the information stored within the digital photo itself (that's why it's so important to make sure your camera's date and time are set correctly!).

Installing Windows Live Photo Gallery

First, you need to download Windows Live Photo Gallery from **http://download. live.com/photogallery**.

The download and installation process is relatively straightforward, but when you first launch the installation file, you are encouraged to install other programs from the Windows Live family. I didn't want them, so I unticked all other options and only left the Photo Gallery option ticked.

Those of you using Windows Vista already have Windows Photo Gallery installed. Windows *Live* Photo Gallery is the newer version and is slightly different; the 'Live' part means you can do all sorts of Internet-related things, such as share some of your photos with the greater public. When you use Windows Live Photo Gallery, you may be encouraged to log in using your Windows Live ID. If you have a Hotmail email address, your email address and password is your Live ID, otherwise they are quick to set up. I explain a little more about setting up and using a Windows Live ID in Chapter 14.

It's good practice to leave all your imported photographs in the Pictures/My Pictures library to make retrieving them easier.

At some point when Windows Live Photo Gallery installs, you are asked if you would like Windows Live Photo Gallery to be the main (default) program for opening image files. This is your choice; you can always change your decision later.

Getting to know Windows Live Photo Gallery

Once Windows Live Photo Gallery is installed, you can access it from the Start Menu. (In Windows Vista and Windows 7, type 'Windows Live Photo Gallery' into the search box to find it, if you can't see it right away.)

Upon opening the program, what you will see depends on whether you have previously imported any photographs. Any folders under My Pictures will be listed on the left-hand side. Click on any folder; photos within it show up as thumbnails.

Figure 11.2

You can see several categories listed:

- **All photos and videos** – Here you can see what folders containing pictures are available on your computer.

- **Date taken** – Using the information stored within your digital photographs, Windows Live Photo Gallery automatically sorts your images by date.

- **People tags** –If there are people in your photographs, you can 'tag' them, as I explain a little later. Click a tag to see all photos with that person in them.

- **Descriptive tags** – Each photograph can be assigned tags to help you find it later, such as keywords relating to a city, monument or event. I explain how

to do this further on. This column lists the descriptive tags you have created. Click a tag to see all photos assigned that tag.

Let's use Windows Live Photo Gallery to *import* and *organise* photographs from your camera.

Importing your photos

There are two ways to import your photos:

● **When connecting a camera or memory card reader** – Plug your camera or card reader into a USB port. Select the option in Autoplay that appears, asking you if you'd like to import your photos and videos using Windows Live Photo Gallery.

● **When a camera or card reader is already connected (or if Autoplay does not appear)** – Open Windows Live Photo Gallery, click File and Import From A Camera Or Scanner (if you are using a memory card reader, it is the same as importing from a camera). You should see your device appear. Make sure it is selected and then click Import.

Now, Windows Live Photo Gallery looks for images (and videos) and gives you two options: to review, organise and group the items you wish to import; or to import everything now.

Let's choose the first option to review, organise and group. Then click Next. Windows automatically displays the photos from your camera on the screen, as shown in Figure 11.3.

Choosing what to import and how

As you can see in Figure 11.3, photographs are automatically grouped by date and time. When you import these groups, each group is saved as a separate folder.

You may not be happy with how Windows Live Photo Gallery automatically grouped your photos – for example, if you took some photos on 29 August, Windows Live Photo Gallery might allocate them into one group. But perhaps photos in the morning were taken at Brighton beach and, a few hours later, more snaps were taken at John's wedding. It would make sense to put them into two different groups (and thus two different folders), not one.

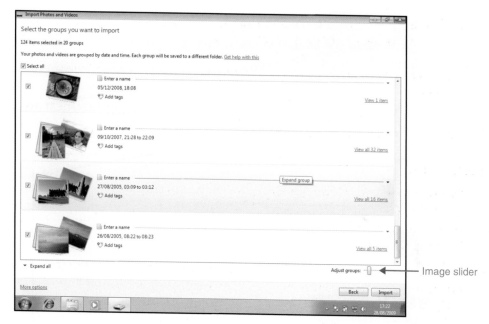

Figure 11.3

You can adjust the time between groups by using the slider at the bottom right of the screen – click and drag it to the left to reduce the timescale between groups (to as little as half an hour between groups) or drag it to the right to increase the time between groups (from 30 minutes between groups to one big group for all photos). In the case of your weekend snaps, you could choose to leave a couple of hours between groups, so Windows Live Photo Gallery will divide the images into two separate ones.

Once you are happy with how the photos have been grouped, have a think about whether you wish to import all of them or not (I strongly advise doing so). To select all the photos on the camera, make sure the Select All box at the top is ticked.

You may decide not to import every photo within a group if there are some clangers – photos of the backs of people's heads or multiple photos of the same thing. Simply click on one of the groups and it will expand to display all the photos contained within that group. You'll see ticks next to them. To exclude a particular photograph from being imported, click to untick it.

Click Expand All to see all the photos within your groups and Collapse All to just display the groups.

To exclude a whole group from being imported, untick the box next to it. (Whenever you untick a photo or group, Select All is unticked.)

Figure 11.4

If you don't choose to import all groups from your card, keep a note of what you haven't copied over. You don't want to accidentally erase the whole card later when you are out and about with your camera. It is probably best to import everything you can't afford to lose at this point.

Just before you import your groups, you can name each one by clicking where it says Enter A Name (Figure 11.3). Type a description (such as, 'Mongolia and China 2007') and press Enter. If you don't name your groups before importing,

you can rename the folder later. The default name is related to the current date (such as 2009-08-20 001).

Additionally, you can assign tags (descriptive keywords that will help you search for your images) to all photos in the group by clicking Add Tags. Don't worry if you don't do this, as you can also add tags after you've imported your images.

Once you have selected everything you want, click Import and wait until all photos are successfully transferred to your computer.

Tagging and describing your photos

All imported groups appear under My Pictures. Click on a folder to display a group's thumbnails.

Try clicking on an individual photo, then click Info to bring up an extra column on the right that contains the following details:

- **People tags** – Windows Live Photo Gallery automatically detects the presence of people in your photos to make it easier to tag them (it's not always accurate – it thought a snowman in one of my snaps was a person!). You'll see, for example, 'People found' or '1 person found' and a link to *identify* them. If you are creating a new tag, type the name into the box and press Enter. If you tagged them previously, just click their name from the people tags listed. To identify a person that Windows Live Photo Gallery has not detected (perhaps their face was obscured), click 'Tag someone', then click their face.

- **Descriptive tags** – Here you can assign descriptive tags to your photograph. Think of words and phrases to describe the image that will help you find it later. The more tags you use, the easier it will be to find the photo again.

- **Caption** – Type an appropriate caption here and press Enter.

- **Information** – This is the EXIF data stored within the digital image. You can edit any details by clicking the fields. You will also see a section called 'rating'. Here, you can click the number of 'stars' you wish to give your photo out of five. This will help you filter the good from the bad later.

Figure 11.5

Toggling the Info button turns the right-hand column display on and off.

Ticking multiple photos in a group (click the top left box on each photo) allows you to add details, such as descriptive tags, to more than one image at a time – so if you have four pictures related to the Summer Palace in Beijing, select all the relevant photographs, then click Info to make the appropriate changes.

Adding photos from other folders

Although I encourage everyone to keep all their photos in the My Pictures folder, there may be photos lurking in other areas. You can add these photos to the Windows Live Photo Gallery by clicking File, then Include A Folder In The Gallery. Browse to the appropriate folder then click OK.

Be aware that if you choose to display, for example, images on your entire C: drive, they may take some time to show up as the program needs to scan your whole computer.

Finding photos later

Now that you have mastered the basics of importing photos into appropriate folders and adding tags to them, how can you find them again?

The easiest way is to type search terms into the Find A Photo box in Windows Live Photo Gallery and press Enter. Relevant images will show up, provided of course that you have added tags to them. Alternatively, click on one of the descriptive tags you've created on the left of the Windows Live Photo Gallery, as shown in Figure 11.6.

Figure 11.6

Picasa 3.5

Picasa, from Google, is another wonderful tool to help you organise your images. It works in a similar way to Windows Live Photo Gallery – it imports and indexes your images and allows you to tag them. It may seem a little trickier to use than Windows Live Photo Gallery as it looks different to Windows programs, but it is easy to get the hang of.

Some of the organising features include:

- scanning your whole computer for available photos and videos;
- letting you assign descriptive keywords to images so you can search for them later;
- using filters to show only photos with faces or photos you particularly like;
- creating 'albums' in order to display chosen photographs, perhaps as a slideshow, or to burn onto a disk;
- a 'photo tray' as a holding area if you wish to make changes to several photos at once, even if they reside in different folders;
- name tags that enable you to identify your friends easily (the latest version has a face recognition feature, too).

Rather than explaining in great detail how everything works (as that would take a few chapters), I'll outline Picasa's main organising features and how to import images from a camera or memory card. It's worth having a quick play with the program yourself to discover all its features – which are not limited to merely organising photos – to see if you are comfortable with using it. You will find comprehensive help documents online at **http://picasa.google.com/support**.

In a similar way to Windows Live Photo Gallery and a Windows Live ID, Picasa lets you share your images with the greater public using your Google account details. If you have a Google Mail address (known as Gmail outside the UK), then you can use those credentials to log into your Google account. Picasa offers a number of options to let you 'post' your pictures publicly. I touch on these in Chapter 14.

Installing Picasa

Download Picasa from **http://picasa.google.com**. As with Windows Live Photo Gallery, the download and installation process is straightforward, but you are encouraged to set Google as your default search provider and to create an easy-access 'shortcut' on your desktop to open Picasa – feel free to untick these options if you are happy with the status quo, but a link to Picasa makes it quicker to access in future.

You are also asked if you want to use Picasa as the main program for opening image files. You can decline the 'offer' for now until you decide whether you would prefer to use Picasa or Windows Live Photo Gallery.

When you open the program, you are asked if you want Picasa to scan the whole computer for image files or just the ones in My Documents, My Pictures and the Desktop. If you know you have images scattered around different folders, then choose the former option.

Importing images

In Picasa, importing images is relatively straightforward:

- **When connecting a camera or memory card reader** – Plug your camera or card reader into your USB port. One of the options on the Autoplay window asks you if you'd like to Copy Your Photos To Your Computer And View Them. This option does not actually mention Picasa but it does display the colourful, circular Picasa logo, shaped like the aperture of a lens. The word 'copy' is arguably a little misleading as it does not automatically copy the photos to your computer, it merely displays them within Picasa for you to import later, as we will see.

- **When a camera or card reader is already connected (or if Autoplay does not appear)** – In Picasa, click Import. On the next screen, your pictures should start displaying on the Import screen, as shown in Figure 11.7. If they don't, you need to select where you would like to import from: click the down arrow on the Select Device button to reveal your options, then select your device.

Reproduced from Google™

Figure 11.7

Under Import to:, you can choose where to import your images – the Pictures folder is already chosen for you and this is where I recommend you keep all your images, so you just need to leave it as is. If you have a burning desire to import them to a different folder, click the down arrow then select Choose to browse to a chosen location. You can give your folder a customised title – otherwise, today's date is used.

To import everything that's on the card, click Import All. Keeping the Exclude Duplicates button ticked means anything you've previously imported into Picasa from the card is ignored.

You will notice clocks next to some of the images – these are groups of images that have been automatically divided by time and date. You can select certain groups to import just by clicking on the clocks.

If you only want to select a few photos to import, keep the Ctrl key pressed while you click the desired photos. You can also drag your mouse over a desired section of photographs if they all appear next to each other (a highlighted square or rectangle appears as they are selected). Then click Import Selected.

Just before you import, you can choose one of several options: to import photos and leave the contents of the card alone, to delete the photos that were imported, or to wipe the entire card after importing the chosen images. By default, the option to leave the card alone is selected, which is what I would recommend for peace of mind when you first start using Picasa. You can manually erase the contents of the card later, once you are sure that the photos have been successfully imported.

Getting to know Picasa

Picasa scans your computer for images and displays folders containing images on the left. The number in parentheses next to the folder indicates how many images it contains.

There are a number of icons and choices on the screen. (If you want an explanation of what each one involves, hover your mouse pointer over the options for a second.)

The main icons that relate to organising your images are described in the following table:

Icon & Name		Description
Import button		Import lets you import your images from another device, as described above.
Photo tray		The *photo tray* at the bottom left of the screen is a 'holding area' for photos that you wish to change.
	Pin Clear Album	Click the *hold* icon, shaped like a pin, to select certain photos or entire albums and add them to the photo tray. You can make changes to anything in the tray, such as adding tags to multiple images. The *clear* icon lets you clear items from the photo tray. The *album* button lets you create albums in which to organise your images – for example, if they reside in different folders, you could put a selection relating to a certain theme into one new album. Picasa albums only exist within the program itself; they don't correspond to what's stored on your actual drive. If you create or delete an album in Picasa, the original photos still remain in their original folders and Windows Live Photo Gallery, for example, won't recognise the albums. Drag photos to an existing album or add a few to your photo tray and create a new album.
	Star	Notable photos can be given a 'star' so you can find them again.
	Tag	Descriptive keywords added to your photos make searching easier later.
Magnify		Click the slider and drag it left and right to zoom in and out of the thumbnails.
Filters		These buttons cause Picasa to display only starred photos, photos with faces, or videos.
Search box		The search box lets you search for photos based on tags, folder or album names, or even the type of camera used to take the photograph.

Reproduced from Google™

Figure 11.8

There is nothing to stop you from having both Windows Live Photo Gallery and Picasa installed at once – any major changes to your images (such as captions and tags) created in one program normally show up in the other. But each one has its quirks, so you may eventually favour one over the other.

Backing up your photographs

One of the scary things about digital photography is that, unless you print the photos out, there isn't actually anything tangible about them. With a negative, at least there's something real in your hand you can hold. You know that, unless it catches fire or it gets stolen, then it won't vanish into thin air.

With digital photography, you sometimes hear all sorts of horror stories about people's honeymoon photos getting corrupted or lost. The reality is that digital photos never deteriorate in quality and, as long as you implement a backup regime that works for you, then there's no reason why your photos won't last.

The process of backing up involves making a copy of your photos, so if the original source material gets corrupted, stolen or accidentally deleted, it can be recovered easily. Back up as often as you can – every week is ideal – and make it a regular routine.

Along with backing up, future generations also need to keep an eye on the technology you used to store the images, so that they can be retrieved easily. Just 25 years ago, there were so many types of computers and file types around that it has now become hard to resurrect some of the more obscure ones without the appropriate software or equipment. Computer hardware has also evolved: if you have had any experience with your kids using old game consoles and computers from the 1980s, you probably realise that these antiquated contraptions won't be able to run today's copies of Windows or display websites as they were intended.

However, people have learnt their lessons about this and so long as you are using the mainstream file formats and backup methods that millions of us use every day, you won't have a problem about photos being unable to be read – there will be a way for them to be accessed!

Don't just back up your photos. Backing up should be part of a routine that involves making a copy of *all* your essential files, including documents, digital music and the like.

Backup options

The main backup options at your disposal are as follows:

- **External hard drive** – The easiest and most popular backup method. A hard drive (Figure 11.9) plugs into your main computer via the USB port, and you can copy all your files on to it. Make sure you buy one with adequate capacity that corresponds to the amount of hard disk space on your computer. To make backing up to an external drive easier, you will need appropriate backup software. The first time you back up will take a while, but subsequent backups shouldn't, because the software detects what files have been added or changed since your last backup. You can buy dedicated backup software from companies such as Acronis and Symantec or use the built-in backup tools in Windows Vista, Windows 7 and Mac OS X. Prices vary and the market is quite competitive, but expect to pay around £60 for a decent-sized hard drive. It's a reasonable investment for peace of mind.

Source: Iomega

Figure 11.9

- **An online backup service** – These services, many of which cost a small subscription fee, let you back up your files to a remote location. Just upload the desired folders you want to back up using your Internet connection. The process is usually encrypted so that others can't eavesdrop on your files

159

while they are in transit. Backing up in this manner may take a while because upload speeds over broadband are usually slower than download speeds. You will have to check the service's terms and conditions to see how well your files are protected and how much storage space is offered. The advantage of having the files stored remotely is that, should your external hard drive get stolen as well as your computer, you will have a copy stored elsewhere. Make sure you know exactly how the company protects your files once they are remotely stored.

- **Burning (copying) files to DVD** – This seems like a cheap, failsafe method and sometimes I still put my favourite photos on to disks. Bear in mind that disks can and do deteriorate and they won't necessarily last forever. They also have limited storage space – a standard DVD has 4.7GB storage capacity; many memory cards have more storage space than this. Now we have Blu-Ray and all sorts of other new formats, too, so making sure these disks can be read well into the future is something to consider. It can also be frustrating to sort through a lot of disks, so they'll need to be labelled and organised. Both Picasa and Windows Live Photo Gallery provide options for you to burn your photos on a disk. Remember you will also need a DVD burner on your computer to copy the files on to it – your computer's DVD drive may only allow you to read, not burn, data.

- **Remote storage on a photo-sharing or storage website** – There are many websites around that will host your photographs on their servers in exchange for offering you photo-printing services. However, these services are not designed to be 'backup' replacements. Although the sites take great care in looking after your photographs, they might not store the highest-resolution version of your images. And should the company go bust, will they get in touch with you about what happens to your photos? If you don't log into the site for a while, will they delete your account? You don't want to risk losing them. I think of these sites as 'backups for my backups' – handy but not to be completely relied upon.

Retrieving deleted or lost photographs

If the worst happens and you do accidentally erase the contents of your memory card, there is still hope for you to retrieve what has been erased. Just be sure not to take any more photographs using the card, because this may overwrite any precious data that may still be present on the card.

There is plenty of commercial software on the market that will help you recover these files. Card Recovery, for example, costs around £26. You can download a free trial from **www.cardrecovery.com** to see if it can view any of the deleted files on your card, and only pay up in order to retrieve the full versions.

If you deleted photos from your computer rather than the memory card, then they have gone into the Recycle Bin and you will be able to recover them. Double-click the Recycle Bin icon, right-click the file you want to restore, then click Restore.

Viewing your photographs

There are a number of ways for you to display your photographs. The Internet also makes it possible for friends and family around the world to see albums or online slideshows of your pictures and I discuss these options in Chapter 14.

Viewing your photos on a computer

Double-clicking a thumbnail in Windows Explorer launches a program that opens it – in Windows Vista and 7, photos open by default in the Windows Live Photo Gallery or Windows Photo Viewer (the *default* is the primary or main program). You'll typically see a screen like the one in Figure 11.10.

Figure 11.10

Hover your mouse pointer over the options at the bottom of the image. As you will see, there are options to rotate the image or view images in that folder as a slideshow, and arrows to move back and forth between images in the folder.

Using the built-in tools within Windows may be all you need. But if you have tried Picasa or Windows Live Photo Gallery to import and organise your photographs, for continuity reasons you can set either of these programs as the default way to open your images. They also provide you with slideshow options and you can easily access their organising and editing tools.

To change your default program to either Windows Live Photo Gallery or Picasa, follow these steps:

1. Click the Start button, then go to Control Panel.

2. Click Programs, then Default Programs.

3. Click Set Your Default Programs, and click on Picasa or Windows Live Photo Gallery. Then click OK, as shown in Figure 11.11.

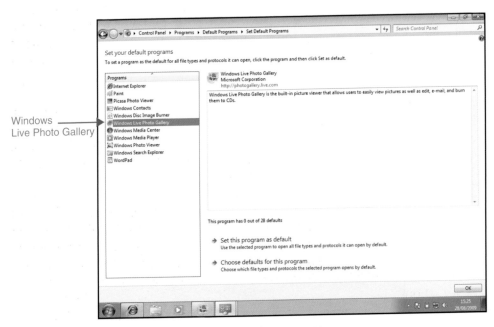

Figure 11.11

So what can you do once you have set up a chosen photo viewer? Apart from using it to view an image, I briefly mentioned slideshows – this option is handy for displaying full-screen, clear versions of your photographs on your computer monitor, for others to view. Normally, there is a set time between photos of a few seconds. In some cases, you can edit this in the program's settings.

To manually speed up the time between photos, or perhaps go back to a photo so people can take another look, use the left and right arrow keys on your computer keyboard. To exit the slideshow and go back to Windows, you usually need to press the Esc (Escape) key at the top left of your keyboard.

Viewing your photos on a television

Many modern, flat-screen television sets have video and audio inputs on the side or back that will display photographs and video clips directly from your camera. Your camera may have come with the appropriate cables to plug into your television. Simply hook the camera up and turn it on. You then need to put your television set on to the appropriate AV (audio-visual) setting and everything that would typically be seen on the camera's LCD screen shows up on your television. Your camera may come with automatic slideshow settings – please check the manual for instructions. If not, just put the camera in playback mode and view the images as you would if you were viewing them on the camera's screen.

After you have displayed your photographs, you probably need to exit the television's AV mode in order to go back to your usual programs – there are so many buttons on remote controls these days, particularly with the DVD player, cable box and, in my case, the old VCR too, that sometimes it can be hard to figure out how to go back to your old settings.

Some flat-screen television sets even have a memory card reader (normally for SD cards). Entering this mode also displays photographs on your television but your television may seem a little slower than expected at reading large images from the card. The advantage is you won't need any special cables and it doesn't drain the camera's battery; just slot the card into place. Please read your television manual for instructions.

Viewing your photos on a DVD player

You can use Windows DVD Maker (part of Windows Vista and Windows 7) to put your photos on to a disk or create a DVD slideshow from them. You need to make sure you have a DVD burner on your computer and that your computer meets the minimum specifications in order for the program to run smoothly.

If you are still using XP and have a DVD or CD burner, some basic DVD creation software may have come with the burner, which you can use to create slideshows. XP also lets you create basic photo CDs that you can also play on your DVD player. The capacity of a CD is far less than that of a DVD but it may still be enough to suit your needs.

Once your disk is created you should be able to send copies to friends so they can play them on their DVD players. For maximum compatibility, I would use DVD-R or DVD+R types that cannot be overwritten. Rewriteable DVDs (ending in RW) may not be recognised by all DVD players.

Picasa also includes the ability to make video files from your images.

Summary

- As you grow your digital photo collection, it's a good idea to use photo-organising tools to help you import, organise and manage them

- Assigning 'tags' or keywords to your images will make it easy for you to find them again

- Photo organisation programs let you filter photos in several ways so you can view them by tag, date taken and rating

- Backing up your photos should be part of a routine

- You can view slideshows of your photographs on your computer screen or connect your camera to your TV if it has the appropriate inputs

- You can also create CD or DVD slideshows of your favourite snaps

Brain Training

There may be more than one correct answer to each question.

1. What is a tag?

a) The price of a photo

b) A keyword that describes a photo

c) A photo's file name

d) A rating out of five applied to your photo

2. In Windows, where is the best place to import your photos, particularly if you are using a photo-organisation program?

a) Into the recycle bin

b) Under My Pictures

c) Wherever you like, as the program automatically indexes the photos on your computer

d) On the desktop

3. How do photo-organisation programs know when your images were taken?

a) They know when you imported them

b) Your camera records the date and time in the image file

c) You indicate it within the program using tags

d) They can't detect it

4. What does it mean if a program is the 'default' for opening images?

a) That program opens when you double-click an image

b) That program does not open when you double-click an image

c) That program opens when you double-click any file

d) You need to reboot your computer

5. What is a disadvantage of using an external hard drive for backing up?

a) You have to pay a subscription

b) You can't see what's on it

c) You can't back up your entire computer

d) It could get stolen

Answers

Q1 – b Q2 – b Q3 – b Q4 – a

Q5 – d

Editing your photos the easy way

Equipment needed: a computer running Windows with sufficient free disk space and memory; some photos on your computer; a photo-editing program, such as Picasa, Adobe Photoshop Elements or Windows Live Photo Gallery.

Skills needed: knowledge of the computer keyboard and mouse (including click and drag); experience with saving documents and files; knowledge of the concept of files and folders within Windows.

What's photo-editing software?

I mentioned how a few minor tweaks to your photos can make a real difference to their overall quality. Although the trick is to take a well-composed and exposed photograph in the first place, sometimes conditions aren't ideal and, on occasion, cameras can't reproduce colours and shadows as well as they could.

You may well ask why we need to go to the trouble of doing this when we didn't need to do it with film. But sometimes nostalgia can get in the way: have a look back at your old photos and you'll be sure to find ones that could use a little oomph. And black and white photos don't show up colour imperfections.

Professional photographers have always had the darkroom at their disposal; dodging out bad bits and adding filters and other effects to their photographs to bring out the best in them.

By using photo-editing software (also known as *image-editing* software), you can easily give your photos a real lift just like the pros. One minute, your photo may seem flat or full of shadow but a few simple tweaks later and you'll have a rich, pleasant photograph to be proud of.

Improving images

Have a look at this photograph (Figure 12.1) that I took on the paradise island of Bali. The colours of the volcano and countryside look rather flat. The trees don't look lush and green, as you would expect for a fertile, volcanic island. Although there is a lot of mist in the distance, which gives the volcano a slightly hazy tinge, the intensity of the colours still doesn't look quite right.

Source: Kim Gilmour

Figure 12.1

Step forward photo-editing software. Quite often, the 'auto-fix' or 'auto-adjust' tools within such software can lift an image in literally seconds without you having to get under the bonnet and think about what you're doing. In some cases, you may need to make a few basic adjustments. Whatever the case, in less than two minutes, you can transform the photo into something like Figure 12.2.

Source: Kim Gilmour

Figure 12.2

Immediately, there is an improvement. Everything seems to be less 'blue', the trees are saturated with green and the roofs of the houses in the foreground have been brought to life. Even the clouds are more visible than they were. It may not be perfect and perhaps the colours are a little too rich, but it's definitely better than the flat atmosphere of the last photograph.

Picasa allows you to make a few easy fixes like this and there are plenty of more advanced programs on the market for even greater control: you might have bought something like Adobe Photoshop Elements or Corel Paint Shop Pro Photo. You may even have some editing software that came with your printer or scanner. In this chapter, I explain what the most common photo-editing tools do (not all are available in every program) and give some examples of how they can improve your photographs.

To access the editing tools, your software may display a series of buttons representing different tasks – which you can click on – or you can select your options from a traditional menu. Your mouse pointer then changes from its usual arrow shape to something that will help you manipulate the photograph – such as a circular 'paintbrush' whose size you can control. You then click on the area you would like to change, or click and drag over a particular section. Please consult the help files relating to your particular program for precise instructions on how to use these tools.

You may find that using a mouse for what can sometimes seem like delicate surgery is very tricky. Remember to *zoom in* to the photo – when it's enlarged, it will be easier to see what you are doing. The zoom, or magnify, tool is often represented by a magnifying glass.

Common photo-editing tools

Let's review some photo-editing tools that you may find useful.

Red-eye removal

This unfortunate occurrence (Figure 12.3) happens all too often. But with photo-editing software, you can easily fix red eye and see an instant improvement. To fix red eye, you usually place a circle over the offending pupil (zoom right in so you can see what you are doing), which then turns it dark grey. You'll be able to adjust the size of the circle so that it fits neatly over your subject's eye (Figure 12.4).

Source: Kim Gilmour

Figure 12.3 **Figure 12.4**

Crop

The crop tool allows you to draw a rectangular shape using the 'click and drag' method around the desired part of the image and remove any unwanted matter surrounding it. Cropping can achieve a tighter, more dynamic result. You can usually adjust the dimensions of the crop (the aspect ratio), if you wish to print it on to a particular size of paper, and you can click and drag the cropped area around the photo for fine-tuning.

We can see the crop tool in action (Figure 12.5), within Picasa. The shaded area will be cut off once the effect is applied.

Figure 12.5

Straighten

Wonky photos can easily be remedied with this tool. You may purposely take a photograph at an angle, but images of horizons usually look best when they are straight! Some photo-editing software can try to straighten things for you automatically but, in my experience, manual adjustment is usually required. Figure 12.6 is an example of a photograph in desperate need of a horizon fix.

Figure 12.6

To straighten the horizon, the photo-editing software places some grid lines over the image and you drag a slider left or right in order to align the horizon against one of these horizontal lines. You can use vertical lines to help straighten wonky lampposts and the like. Keep in mind that the image needs to be cropped because it will now be at an angle; the software usually does this for you. Figure 12.7 shows what the same image looks like once we've straightened it.

Reproduced from Google™

Figure 12.7

Retouch and clone

Retouching tools are among the greatest inventions ever. It literally is like erasing something you don't like from a photograph – whether it be a pole seemingly sticking out of someone's head, chickenpox spots, an ex-spouse . . . the list goes on!

Basic photo-editing software such as Picasa or Windows Live Photo Gallery won't always give you as much control as more advanced software, but can usually remove blemishes and, to some degree, allow simple removal of unwanted elements.

How does it work? When you click on an unwanted part of a photo, the software tries to understand what it is you are trying to remove. For instance, if a fashion model had a big spot on her nose, you would click on it and the software would replace the pimple with the colour of the surrounding skin.

In Figures 12.8 and 12.9, you can see how I removed an entire person from the photograph using the blemish removal tools.

Source: Kim Gilmour

Figure 12.8 **Figure 12.9**

Retouching is also great for repairing scanned-in photographs that have corners missing or particularly bad scratches on them.

When the problem isn't so simple – say you want to remove someone or something that is in front of a complicated background such as patterned wallpaper – you use what is often called a *clone* stamp or tool. However, this feature is usually only available in more advanced packages.

The tool lets you copy (clone) from a 'source' area in another part of the picture and paint with it over the 'target' area you want to replace. The cloning technique varies from program to program – for example, copying a source area could involve holding down the Alt key whilst clicking the mouse, then clicking and dragging your mouse to paste over the target area with this selection. Don't forget, for greater control you can zoom right in.

Colour balance

Earlier, I described how sometimes digital photos can't really interpret colours properly in certain circumstances. You can play around with the white balance settings on your camera but this isn't always practical when you are out and about. Photos, such as this snow image in Figure 12.10, can come out with a colour cast.

Figure 12.10

Don't worry if your pictures don't look as vibrant as you saw in person, however, as you can easily correct the colour balance in your photographs using basic photo-editing tools. In many cases, the software can even do it automatically for you. In Figure 12.11, see how Picasa fixed the dull hue in the photograph when I simply clicked the I'm Feeling Lucky tool? It only took a second and involved no manual intervention from me.

Figure 12.11

There are also cases, such as in the image of the Balinese mountain (Figure 12.2), where you might like to experiment with different colour temperatures and hues.

Brightness and contrast

As with colour balance, many basic photo-editing packages can automatically fix exposure issues (such as whether there are too many shadows in your image) but sometimes you need a little extra control.

In Chapter 4, I discussed your digital camera's histogram function, a graph that shows you how evenly distributed the light and dark levels are in the photograph you just took. Photo-editing software can also let you see your photo's histogram. You can use this to help improve the brightness and contrast in your photographs. In Picasa 3.5, the image's histogram information is displayed to the left of the image when you come to edit it (if you are using an older version of Picasa, click the small icon of the propeller cap at the bottom right of the screen to bring up the histogram).

As you can see in Figure 12.12, although there is a pretty even distribution of light and shade, the far right of the histogram shows that there are some bright parts but there's not much happening on the far left in terms of shadows. Even without consulting the histogram you can see that the image could benefit from a little more contrast.

Histogram &
Camera Information

Kim Gilmour/Reproduced from Google™

Figure 12.12

In Picasa, the 'tuning' feature lets you adjust the highlights and shadows – that is, the light and dark – in the image by dragging the appropriate sliders. After a little experimentation you can come up with an ideal combination. Can you see the difference in Figure 12.13 in both the image and the way the histogram looks?

Kim Gilmour/Reproduced from Google™

Figure 12.13

In this case, the improvement is minor but it still looks far better than the washed-out tones of the previous version.

In Windows Live Photo Gallery, and a lot of other editing software, a quick way to improve a photo is to click and drag the sliders at either side of the histogram and bring them closer together to avoid either end not registering any values (see Figure 12.14).

Histogram

Figure 12.14

Sharpening

The sharpening tool, as the name suggests, sharpens up any fuzzy edges. This can enhance your photograph in a lot of cases and you can adjust the amount of sharpening you wish to apply. I would try not to sharpen too much: the more you sharpen, the more noise and contrast occurs in your photograph – and you also risk 'losing' some of the data, which can affect the way it looks on screen and on a print. If we look at our elephant friends again (Figure 12.15), we can see what happens before the sharpening tool is applied to a slightly fuzzy shot in Picasa.

Kim Gilmour/Reproduced from Google™

Figure 12.15

177

Sharpen

Kim Gilmour/Reproduced from Google™

Figure 12.16

Then see what happens (Figure 12.16) when you put the sharpen tool on its highest setting. As you can see, the contrast is a little high. It is all about experimenting and striking the right balance.

Black and white

Ironically, losing the colour in a photograph can often give it a more dramatic edge. Stripping the photo back to basics and removing colourful distractions can allow the viewer's eye to appreciate the subject more – particularly if those colours don't add much to your image. Try turning one of your images black and white (sometimes known as *greyscale*), increasing the contrast a little and adjusting the histogram levels to even out the tones. How does it look?

Figure 12.17 is an example of a drab, overcast scene. And Figure 12.18 is how it looks after turning it black and white. I don't think the colour in the original added much, do you?

Source: Kim Gilmour

Figure 12.17 **Figure 12.18**

Special effects

Many basic photo-editing programs let you apply special effects to your images. Don't be tempted to go overboard with them. Depending on your photo-editing package, some of the effects you may come across include:

● **Sepia:** Gives an antique tone to your photographs.

● **Vignetting:** Gives a fuzzy dark edge around a photograph.

● **Graduated tint:** Overcast day? This cheat – which many photographers use in the field by attaching a filter to their camera lens – will make your skies seem blue. Taken a photograph of a polluted sky? No matter – just apply a blue filter to the image; the top half of the filter changes the colour. The filter gradually fades out from the horizon.

You will find other weird and wonderful gimmicks depending on the photo-editing package you are using. These may include the ability to pinch, twist and swirl someone's face, saturate colour, add text or tacky patterns, such as leaves or confetti, to an image, give it a bit of a smudge, and lots more. Use them at your own risk!

Undoing changes

Don't worry about making a mistake when you are editing your images. You can always *undo* any changes you have applied – both Picasa and Windows Live Photo Gallery have undo buttons or, as with most programs, you can use the Ctrl+Z keyboard shortcut (hold down the Ctrl key while pressing Z) to go back to the last change.

Picasa and Windows Live Photo Gallery don't actually overwrite your original image when you make changes – they merely keep a record of the effects you apply to it. These changes are kept in the program's memory even after you close the program and come back to it. You can always *revert* to the original version, even when you turn the computer off and come back to the image later.

Saving your changed images

In Windows Live Photo Gallery and Picasa, if you would like to have your edited image available as a separate image file, you will need to save a *copy* of the image. Perhaps you have made a black-and-white version of your image but still want the option to make changes to the colour original. What you do is to save the black-and-white version as a new file, allowing you to go back to the original and make whatever changes you wish.

If you are familiar with word-processing software, making a copy works in a similar way to the Save As function when you make changes to a document and want to save it under another name.

To do this in Windows Live Photo Gallery go to File, Make a Copy and browse to a desired location for your photograph (unless you want to save it in the same folder). Give it a new name, perhaps with some indication that it is an edited version, then click Save.

In Picasa, there are similar options under the File menu, including the ability to *export* your image to a different folder.

You won't *always* need to save a copy in this manner, however, as both programs provide you with tools to share your edited images at different sizes, print them and put them online. I outline what's available in Chapter 14.

Not all photo-editing software automatically saves the changes you make to your photos in the same way as Picasa and Windows Live Photo Gallery do! You may need to save your edited image as a *new file* before you exit the program. If you save the changes without saving as a new file, you will overwrite the original. This is not unusual: most packages are targeted to more experienced users (or confident types who think they don't need an emergency 'undo everything' button!). Please consult your software's help documents for specifics.

Summary

- Basic editing tools such as crop, red-eye removal, straighten, colour correction and contrast adjustments are usually available in free software packages

- More advanced software lets you, for example, clone part of an image, such as a background, and use it to paste over an unwanted element

- Check if the software keeps a copy of your original image after your changes have been applied. Otherwise, save an edited image as a new file if you don't want to overwrite the original

- Special effects allow you to have fun with your images but use them sparingly

- Have fun experimenting – you can always undo your change if you don't like it

Brain Training

There may be more than one answer to these questions.

1. What does the crop tool achieve?

a) Erasing a feature you don't like from your photograph

b) Reducing the size of your photograph

c) Making the photograph look sharper

d) Removing extraneous matter surrounding the central focus of your image

2. What can consulting a photograph's histogram help you improve?

a) Light and dark levels

b) Red eye

c) Sharpness

d) Colour and contrast

3. Of the following, what could the retouching tool help you fix?

a) An unwanted spot on someone's chin

b) A speck of dust on a scanned-in photograph

c) A few leaves that have fallen on otherwise untouched snow

d) Avoid taking photos of people

4. When using the mouse pointer to make changes to your photographs, what can you do to help you see what you are doing?

a) Zoom in to the image

b) Get out your magnifying glass

c) Use a bigger screen

d) Wear stronger glasses

5. What does the sepia tone achieve?

a) Turns a photo black and white

b) Corrects the colour balance

c) Gives an antique look to a photo

d) Removes red eye

Answers

Q1 – d **Q2** – a and d **Q3** – a, b and c

Q4 – a and possibly d as well! c helps increase the 'canvas' size but you still need to zoom in **Q5** – c

Photo-editing software uncovered

13

Equipment needed: a computer running Windows with sufficient free disk space and memory; some photos on your computer; a photo-editing program, such as Picasa, Adobe Photoshop Elements or Windows Live Photo Gallery.

Skills needed: knowledge of the computer keyboard and mouse (including click and drag); experience with saving documents and files; knowledge of the concept of files and folders within Windows.

In Chapter 12, I introduced some of the common elements found in photo-editing software. Rather than bewilder you with step-by-step instructions for both Picasa and Windows Live Photo Gallery, I focus mainly on Picasa here when explaining how to achieve quick and easy fixes, as it has slightly more editing features available. I'm using the latest version, Picasa 3.5, which was released at the time of this book going to press. Just go to **http://picasa.google.com** to find it.

One thing that Picasa doesn't have, which Windows Live Photo Gallery does, is the ability to create *panoramic* images from several photos by automatically stitching them together. It's a bit of fun!

Lastly, I discuss more advanced options for those of you who have outgrown the basic editing packages and want to try something different. There is no shortage of powerful packages available and they are able to do many creative, valuable things.

Quick fixes with Picasa

To use Picasa to make automatic adjustments to a dull-looking image, follow these steps:

1. Start Picasa.

2. Find the thumbnail image you want to edit, double-click it to view the larger version and enter edit mode. Several tabs are displayed: Basic Fixes, Tuning and Effects, as shown in Figure 13.1.

Reproduced from Google™

Figure 13.1

3. On the Basic Fixes tab, click I'm Feeling Lucky and Picasa makes automatic changes to your image, as shown in Figure 13.2.

Figure 13.2

4. Happy with the changes? Click the Back to Library button if so, otherwise click Undo I'm Feeling Lucky and click the Tuning tab to try more fine-grained changes. Use the sliders to adjust the colours, brightness, contrast and so on using the click and drag method.

That is basically all there is to it.

When using the sliders to make fine-tuned adjustments, remember that they are very sensitive and you may only need to move them very slightly to the left or right. This may need a little extra concentration if you have not had a lot of practice with using your mouse. You can experiment by sliding all the way to the left or right and just see how much difference it makes!

185

Retouching with Picasa

If you want to remove something from a photo, you can try Picasa for minor or obvious changes but it won't give you as good control as more advanced packages. For my next trick, I remove the cow from Figure 13.3. The retouch process doesn't always happen in an instant – you may need to repeat it several times to get the effect you want (rather like using a household cleaner on a stubborn stain a couple of times before it disappears completely).

Reproduced from Google™

Figure 13.3

To retouch with Picasa, follow these steps:

1. Open Picasa and double-click the photo you wish to edit. You can zoom in on the photo by dragging the magnifying slider to the right with the mouse pointer – it's located at the bottom of the image. You will notice that once zoomed in, if you put your mouse pointer over the image, it turns into a hand

that looks like it's 'clutching' the photo. You can click on the photo and drag it around until the part you want to fix is clearly on screen (those of you lucky enough to have extremely large monitors may not need to do this, as the 'canvas' you are working on is larger).

2. Click the Retouch button. Your mouse pointer turns into a large circle (the 'brush'), as shown in Figure 13.4. Click and drag the Brush Size slider to adjust the size of the circle so that it covers the area you want to remove.

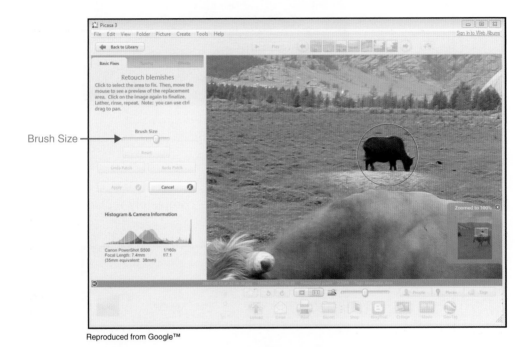

Figure 13.4

3. Next, click the 'blemish' (in this case, a cow). Then move the brush to a nearby area in order to select an area you want to replace the blemish with (in this case, the green patch of grass). You'll notice a live 'preview' around your original selection; click when you are happy. Note that the retouch process is gradual; you need to repeat your selection several times depending on the complexity of the image – after the first retouch a shadow of the cow still remains, as you can see (Figure 13.5).

Figure 13.5

4. But four or five retouches later and the cow is completely replaced by the nearby grass (Figure 13.6).

Figure 13.6

Saving images with Picasa

Picasa is special in that it keeps a record of your original image so you can go back to it at any time if you don't like what you have done. With the image selected, click Picture from the menu, then click Undo All Edits. If you *do* like what you've done with your image and don't want to undo anything, Picasa automatically remembers the changes you apply to your photo. Even if you close the program and come back to it later, the edited version is displayed on screen.

Remember, if you undo all your edits, you lose any changes you have made – this may be fine, if you aren't happy with them, but perhaps you want to save a copy of the edited image first. To do that, you click File, Save As... and give it a name to identify that it is the edited version.

Speaking of renaming files, you should probably make a habit of renaming your images from their original numerical filenames as soon as you import them, particularly if you don't tend to remember to 'tag' them with keywords. This makes things a lot easier if you want to find them again.

To rename multiple image files that are of a similar subject, select the images you want to rename then click File, Rename... and choose a descriptive keyword such as 'barbecue 2009'. Because you can't give more than one file the same name, Picasa numbers them sequentially.

Picasa has other saving and sharing options available, some of which allow you to *export* lower-resolution versions of your files to a different folder, perhaps one reserved for photos that can be sent by email. Picasa has some pretty comprehensive help files online, so take a look – just click Help, then Help Contents and Index to access the Picasa files.

Making a panorama with Windows Live Photo Gallery

In Chapter 9, we discussed how you could make a panorama by overlapping a series of images together.

Say you are on a hill and take several images as you slowly swivel around, with the idea of recreating a 360-degree view of your surroundings. This is what I did

a few years ago at the Rock of Cashel in Ireland. Follow these steps to make a panoramic photo:

1. Open Windows Live Photo Gallery and browse to the folder of images from which you would like to create a panorama.

2. Now, with your mouse, click on every photograph that is part of your panorama to select everything you wish to include (to speed up the process, click and drag over the desired images).

3. Click on Make, then Create Panoramic Photo. Windows Live Photo Gallery then uses its wizardry to stitch the image together – it may take a little while but you can see a progress report on screen (Figure 13.7).

Figure 13.7

4. You will then be asked where to save your image – you may be happy to keep it in the same folder. Give it a new name. Then click Save.

5. You will notice in Figure 13.8 that, due to my not using a tripod during the photography process, there is a lot of black space above and below the image. In this instance, cropping out all the black parts means you would lose a bit from the top of the church – all my fault. (That's when the clone tool could come in handy, as you could literally just paste in more of the crisp blue sky!)

Figure 13.8

Advanced photo-editing software

Those of you who are really serious about photography may eventually 'outgrow' the basic tools and want to experiment with more sophisticated effects. Or perhaps your photos don't have the spark you expected using the tools you have tried out with the basic software.

If you are tempted to gain more skills and fine-grained control of your photographs (particularly if you have been dedicated enough about using a digital SLR and the RAW image file format), then there is no shortage of options on the market.

Remember, for greater efficiency, the more *memory* (RAM) your computer has, the better. If you don't have enough then your computer may run slowly.

Adobe Photoshop Elements

Adobe Photoshop Elements is the most popular and well-established choice for serious enthusiasts. The latest version (currently v8) will set you back around £75, but this is still far less than the professional version of its full-blown photo-editing software, Adobe Photoshop CS4, which costs around £600!

As well as being able to import and organise photographs, there are advanced editing tools you won't find with the basic offerings.

Source: Adobe Systems Incorporated

Figure 13.9

Some of the handy tools include 'touch up' brushes to achieve instant effects such as making a sky bluer. In Figure 13.10, the gentleman's teeth-whitening procedure needn't cost the earth: all that is required are a few mouse clicks!

Source: Adobe Systems Incorporated

Figure 13.10

Adobe Photoshop Elements also has a 'photomerge' tool that can create a composite image of separate photographs – if, for example, you took two family shots but your son had his eyes closed in one shot and your granddaughter was yawning in the other, then you can merge the two and create a photo where everyone is looking at the camera at the same time (Figure 13.11).

Source: Adobe Systems Incorporated

Figure 13.11

Adobe Photoshop Elements (and other advanced software) also allows you to create 'layers' to your photographs – this is a way to make changes to your photograph without 'destroying' the original. You could overlay a transparent layer on to a photograph (a lot like tracing paper), then use it to add some text (which you could then move around) or even a cut-out from another photograph, which, again, you could shift into the desired position. The photograph underneath remains unaffected. You can add and remove layers at any time.

The most useful thing layers can do is help you adjust tones, colours and so on in certain areas of your image without affecting perfectly exposed areas of the image.

There are plenty of other amazing tools and effects, such as a healing tool that magically removes scratches from negatives and old photos, but this book isn't the place to get into how they all work. If you are interested in learning more, there are many, many resources you can search for on the Internet, such as video tutorials, as well as other books, such as *Photoshop Elements 8 for Dummies*, to help you get started. Most of the digital photography magazines on the newsstand feature Photoshop Elements tutorials, too. Have a look!

You can download a free trial (features are limited) to see if Photoshop Elements is something you might be interested in, before paying for the full version. Go to **www.adobe.com/uk/products/photoshopelwin** to find out more.

Gimp

Gimp is a *free* advanced photo-editing program (it stands for GNU Image Manipulation Program) that lets you retouch your images. That's right, it's free to download. This software is safe to use – many altruistic types keen to have their technical efforts recognised have been involved in its development. You'll find tools that let you clone, airbrush, clone out unwanted elements, add layers and more. The only disadvantage is that it may require a steeper learning curve as you come to grips with its features, some of which tend to be on the geeky side. However, you don't have to use all those features and there are help files, a user manual, tutorials and a world of support online should you need it.

It is definitely worth a try if you want to see what the more advanced editing software can do for you. You can download Gimp from the official website at **www.gimp.org**.

Paint Shop Pro Photo

Corel Paint Shop Pro Photo X2 (around £70) is the closest competitor to Adobe Photoshop Elements and perfectly respectable too – they have similar features such as the 'touch up' brushes and one-click-fix tools. As you become more confident you can then move on to more creative edits, including photo merging and more advanced histogram adjustments. There is an 'ultimate' version that, among other things, includes the ability to retrieve images you may have accidentally deleted. You can download a free trial from **www.corel.com**.

As with most software these days, updates are regularly issued by the manufacturers. The program may prompt you from time to time to download official 'patches' or 'fixes'. When you install a disk from a boxed copy, often the program automatically connects to the Internet to check if there have been any subsequent patches.

Updates usually iron out bugs or stabilisation issues (or you may be encouraged to upgrade when a new version is released – for example, in the course of writing this book, Picasa 3 became Picasa 3.5). If in doubt about the source of any upgrade prompt that appears, you can always go to the manufacturer's official website for advice and downloads.

Paint.NET

Another free photo-editing program is Paint.NET – not to be confused with the Paint program that you find in Windows, which is completely different (and far more basic). You'll find Paint.NET available for download at **www.getpaint.net**. Along with layers and special effects, Paint.NET keeps a history of all the changes you make to an image, so if you ever make a mistake you can always go back to a certain point in time.

Although Paint.NET won't cost a penny, its US creators do recommend you donate $12 via the online payment service PayPal if you like the product. It's entirely up to you.

Summary

- Basic photo-editing tools, such as Picasa, can help you remove minor blemishes and imperfections and apply quick fixes, but when you are confident enough and want more advanced control, you could upgrade to something like Adobe Photoshop Elements

- When using photo-editing software, your mouse pointer often changes shape when you hover over the image, signifying that a particular tool has been selected

- You can zoom into your image to see more detail and better control what you are doing on screen

- Windows Live Photo Gallery allows you to create panoramic images by stitching together separate photos

Brain Training

There may be more than one correct answer to each question.

1. When you have an image open in your photo-editing software, how do you zoom in to see more detail?

a) Double-click it

b) Choose the crop tool

c) Use a bigger screen

d) Use the magnifying tool

2. What's the advantage of renaming your image files?

a) Allows you to edit them

b) Makes it easier to find them later

c) Avoids them becoming corrupted

d) No advantage

3. Why would you want to use 'layers' in advanced editing software?

a) To overlay some text on to an image

b) To make tonal adjustments to a specific part of an image

c) To add other pictorial elements to the image

d) To keep the original image unchanged as you make edits to it

4. How would you keep a permanent copy of changes to an image edited within Picasa?

a) Save it as a new file with a new name

b) Revert to the original file

c) Press Ctrl+Z

d) Save it using the same filename

5. How do you know if advanced photo-editing software is right for you?

a) You have outgrown the quick fixes offered by the basic tools

b) You want to experiment with layers and more special effects

c) You have more complicated tasks you want to achieve, such as airbrushing out unwanted elements in front of busy backgrounds

d) You have shot in RAW format using a digital SLR and want to bring out the best in these images

Answers

Q1 – d **Q2** – b **Q3** – All are correct **Q4** – a

Q5 – All are correct

PART III
Liberating your digital photos

Sharing your images online and off

Equipment needed: computer with a broadband Internet connection; an active email account; photos on your computer; a photo-editing program; a web browser such as Internet Explorer or Firefox.

Skills needed: experience browsing the Web; knowledge of the concept of files and folders within Windows; some experience with viewing photographs on your computer; preferably some experience with signing up to a website and attaching a file to an email.

Over time, you will accumulate many photographs on your computer – you might think that some of these deserve a place in the Recycle Bin, but plenty will be worthy of display in a living room, a digital photo frame or online via the Web.

Alternatives to printing

The most obvious way to share photos with friends and family is to print them, and I cover printing in more detail in Chapter 15. This chapter outlines alternative sharing options that are more immediate, including web-based ways of showing off your snaps. There are a number of services that will 'host' your photographs online for you, so you, your friends and your family can access them from any Internet connection. You can upload your photographs and display them in web-based albums, on photo-sharing websites, social networking sites and online-printing websites.

Services dedicated solely to displaying your images in web-based albums don't always hold the original-sized images. They automatically resize your images when you upload them by decreasing their resolution and file size, so that they are quick to view on screen. Holding the lower-resolution versions takes up far less room on their computers, saving on their storage costs.

Even websites specialising in printing your photos may resize your original images slightly, while still retaining enough image quality for you to order up to 8×10-inch prints. A good online printing service will have an option for you to upload the original-sized versions of your photos if, say, you want to print them at poster size.

I assume you have a high-speed broadband connection to make the most of sharing photographs online. If you are still dialing into the Internet (and I don't expect you are, unless you are living in an extremely remote area, as broadband is quite cheap nowadays) then you will find tasks achingly slow and costs may mount if you are paying by the minute.

A typical UK broadband connection has faster download speeds than upload speeds. Information you access from the Internet travels to your computer significantly faster than the information you send to the Internet. So it'll take longer to send photographs than to receive them.

The rest of this chapter considers some of the ways you can share your images and a few step-by-step instructions for the more common websites and tools.

Please note that, because websites tend to evolve their look and feel quite regularly, some of these instructions may end up being slightly different from what you encounter in reality, but the principles are still the same. If something doesn't look quite right and you get stuck, please look at the website's help files to find more up-to-date instructions.

Emailing your photos

You can attach low-resolution versions of your photographs to emails. Have you ever received a series of photographs from a friend as email *attachments*

that simply take an age to download? Then when you open them in your email program (such as Windows Live Mail or Outlook Express), they are so huge you can barely see the photo in context and have to scroll left, right, up and down to see the entire scene – or else zoom right out of it. While having a large image is good if you want to save a friend's photo to edit and print out at home, it doesn't do you any favours if you have a download limit on your broadband connection, a limit on your Inbox or email attachment size, or you aren't particularly keen on having ten photographs of a friend dancing at a wedding of someone you've never met, whose face takes up the entire screen. What's more, some service providers frown on huge email attachments and may even block them at source so you never actually get to see them! And your email program may consider lots of large attachments a security risk.

When it comes to email etiquette, always ask your recipient first if they want to receive the higher-resolution photograph via email. Otherwise, the most courteous (and quickest) thing to do is to resize your photograph so that it is at an ideal size for viewing on screen. (If they want a better-quality version for printing, they will ask you for it!)

For on-screen viewing, whether viewed on email or a website, a photograph doesn't need massive resolution or detail. Instead of a photo taking minutes to download because of its huge file size, you could have a smaller version viewable in seconds. The good news is that resizing your images to attach them to emails is not complicated. All you need to do is either:

● Use your photo-editing program to resize the image so that its dimensions are smaller and reduce its image quality slightly so that it's at a suitable file size. You'll be surprised at how dramatically you can reduce the photograph's file size without seeing a massive loss of quality. Most programs provide you with easy tools to do this. Check your particular program's resizing instructions – search for 'resize' in the help files.

 Remember to save your photo as a new file (give it a new name), perhaps in a brand new folder reserved for low-resolution, email-sized images.

● Use the image-sharing options in your photo-editing or organisation program to export a smaller version of your photo to your email program (such as Windows Mail). Adobe Photoshop Elements, Windows Live Photo Gallery (Figure 14.1) and Picasa all provide you with easy options to attach small, medium or large versions of your images to your email program.

Figure 14.1

Use the manual resize and save option if you don't use an email program and prefer to access your emails using webmail (if you log into, for example, Windows Live Hotmail, Google Mail or Yahoo! Mail from a web browser, such as Internet Explorer). Once you have logged into the webmail account you can click on Attach, then browse to the folder where you have saved your resized file or files.

Choosing the dimensions

The appearance of any image is affected mostly by its size. When resizing your images for email, you'll usually be asked at what dimensions (small, medium, large) you want to send it.

As a guide, your email size options in Windows Live Photo Gallery are:

● Smaller: 640 × 480 pixels

● Small: 800 × 600 pixels

● Medium: 1024 × 768 pixels

● Large: 1280 × 1024 pixels

● Original size

But what size is best? Note that one on-screen pixel on a computer monitor equates to one pixel of a photograph, so long as it is viewed at full size (100%).

Flat-screen, LCD computer monitors have a 'native' resolution, which is the best resolution designed for their size (although this can be changed in your display settings, depending on your viewing preferences). A 19-inch LCD monitor, for example, may have a native resolution of 1280 × 1024 pixels. So, if you sent someone with these settings a large image at 1280 × 1024 pixels, viewing the image at full size would take up the entire monitor's screen – but in reality, the recipient would not be able to see the whole image at once, as the email program itself would take up some of the screen. If you sent a smaller version of the image at 800 × 600 pixels then, when viewed at full size, it would take up far less of the screen's real estate and thus appear smaller but would still be large enough to view comfortably and crisply on screen.

Because you can't predict what everyone's computer monitor display settings are, I recommend 800 × 600 as an ideal size for sharing snapshots on email – and even that is pretty large. Such a size will show up nicely on screens with low resolution, while still remaining crisp and clear on more detailed displays.

File size

You will also need to strike the right balance between the dimensions of your image and its file size. Some programs allow you to apply compression to the image to reduce its file size even further. Most images suitable for on-screen viewing need only be around 60,000–100,000 bytes in size – approximately one million bytes equals one megabyte (MB), so if the original was around 4MB that's up to 60 times smaller, yet still large enough to view clearly on a computer monitor! (Remember we are only talking about resizing images for viewing on screen here, not printing.)

Online galleries and photo-sharing websites

If you have many photographs – say, a gallery consisting of a couple of dozen images of a recent holiday – it's not practical to send all of them to your friends on email, even if they do have a small combined file size.

That is where online galleries and photo-sharing websites come in. You can publish your images on the Internet so everyone (or only selected mates) can see them. Some websites have online slideshow options.

Windows Live

Windows Live is a collection of services from Microsoft that includes email, messaging, photo and video editing and more.

If you are using Windows Live Photo Gallery to organise your images, you can publish photos of your choice on Windows Live by creating a photo album on the Windows Live network. The service automatically resizes your images for web viewing.

Here's how to publish images to Windows Live:

1. **Choose the images:** In Windows Live Photo Gallery, select the images you wish to include and click Publish, Online album.

2. **Log into Windows Live:** You are then prompted to log into the Windows Live network. To do this, you need a Windows Live ID. If you have a Hotmail or Messenger account then you already have a Windows Live ID – simply use the same credentials to log in. If not, click the link for you to sign up and create one. This will launch a page in your web browser, so be ready to follow the instructions.

3. **Create an online album:** Once you have signed in to the Windows Live ID network, then you can create an online album by giving it a name and choosing who you would like to see it. You may select the option to make it public (available to everyone) – but be aware that strangers would be able to see your images. For now, I recommend you choose 'just me' – that way no one else can see your images. Once you are happy with what you can see, then you can invite specific people to view your album.

4. **View album online:** Once the photographs have uploaded, you will be presented with a button to view the album. Clicking this will launch the album's website in your web browser. Don't worry if you missed clicking this button; you can always log directly into Windows Live by going to **http:// windows.live.com** and using your Windows Live ID credentials. Then click the Photos link to view your album.

5. **Invite friends to see your album:** Happy with the album? Now you can invite specific people to view it. From within your album, you should see an option called More (see Figure 14.2). Click it and select Edit Permissions. You can then enter the email addresses of specific people who are allowed to see your album, and click Save. You also have the option to send them an email

notification about your album. They will need to create a Windows Live ID in order to log in and view the album, if they don't already have one. If your album is public then all you need to do is *copy* the album's website address and send it in an email to your friends.

Figure 14.2

A quick way to copy the address is to click the address in your browser's address bar, then press Ctrl+C. In the body of the email, press Ctrl+V to paste the address.

Picasa Web Albums

Picasa has similar tools to let you share your images with your friends and family and it automatically resizes your images for online viewing. Once you have selected the images you wish to share from within Picasa, click the large Upload button at the bottom of the screen. You'll be prompted to log into your Google account in order to use Picasa Web Albums – as with the Windows Live ID, it's free to sign up. And if you already have a Google Mail account you can use these credentials to log in.

The Picasa Web Albums are located at **http://picasaweb.google.co.uk**. Log in to view and share yours.

You don't need to use Windows Live Photo Gallery or Picasa software to use their online album or gallery services.

When you log in to these websites using your Windows Live ID or Google account, there are manual upload options available, which means you can browse to the folder where your image is located (as if you were sending an email attachment) and select it that way. This is handy if you are using a computer that does not have photo-editing software installed.

For example, if you are in an Internet café in a remote part of Cambodia and want to share some images with your friends, then you can just browse to the images that are located on your memory card (provided you have attached it to the computer with a card reader) and the sites will copy small versions over to your web albums.

Flickr

Flickr, owned by Yahoo!, is a great photo-sharing website that I find useful for inspiration (see Figure 14.3). There are millions of images on there and countless groups dedicated to certain themes, which you can join and contribute to – you can even create your own. Many of the popular images on the site tend to be on the more artistic side, rather than your standard family and friends snapshots (but there are plenty of those there, too).

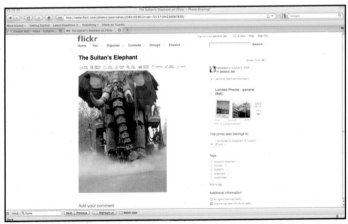

Figure 14.3

You attribute titles, tags (key words and phrases) and descriptions to your uploaded photos to help people find them, and you can add your favourite photographers to a contact list so you can see what they have added recently. When you upload your digital photos, Flickr detects the EXIF information stored within them so all the technical details and the dates they were taken are displayed for the geeks and anyone else who's interested. So if there is a particular photograph someone has taken which you find attractive, you'll be able to see what settings the photographer used, when it was taken, and the make of their camera. There are powerful online organisational tools, too.

Although the photos displayed on the site are quite small you can view better versions as an online slideshow. Flickr has a real sense of community because the site encourages you to make your images public (you can, of course, just share them with chosen contacts or make them private to you). There are discussion forums as well as the ability to leave comments on others' images and receive comments on your own. All this can help you build up confidence as you progress with your digital photography skills.

Check it out at **www.flickr.com**. To sign up, you will need to create a Yahoo! account if you don't already have one. It's free, but upgrading to a Pro account (US$24.95 a year) gives you unlimited uploads.

Social networking websites

It's likely that you have heard of websites such as Facebook, which millions of people around the world use to keep in touch with their friends and family. For much more about the social networking phenomenon, please refer to *Social Networking for the Older and Wiser*, written by my friend and colleague Sean McManus. Here, though, I focus on how people are sharing images using Facebook (**www.facebook.com**) – by far the most popular of these websites.

It may surprise you to know that, according to Facebook's own statistics, the fastest-growing demographic is the over-35 age group. More than 1 billion photographs are uploaded to the site every month – that's right, 1 billion!

There are several different places within Facebook where you can add photos and each technique ends up achieving the same thing. Assuming you already have a Facebook account and want to get started with sharing the photographs you've taken with your new camera, here is one easy way:

1. Sign in to Facebook. Click Profile to access your Facebook profile. Under the Wall tab, next to Attach, click the Photo icon (if you're not sure which one this is, hover your mouse pointer over each icon in turn until the word 'Photos' shows up).

2. Next, click the option to Create an album. Enter a name, describe its location and, importantly, select your privacy parameters – under Who can see this?, click the down arrow to view a drop down menu of who you would like to share your images with. I recommend sharing it with your Facebook friends or friends of friends only. Click Share.

3. Facebook asks your permission to install a small application to your web browser, which will make uploading images easier. You can safely agree to any installation requests. Wait a few seconds, and you will notice a mini-version of Windows Explorer (the window which displays your computer's folder and file directory) appear from within Facebook. Simply browse to the folder where your photos are located (for example under Libraries/Pictures/ Rome 2009) and thumbnails of the photographs should appear on the right-hand side (see Figure 14.4).

Reproduced with permission of Facebook © 2009

Figure 14.4

4. Select the images you would like to include in your album by clicking the tick boxes in the top left corner of the photographs (click Select All to tick every photo in the folder). If a photo is lying sideways, hover your mouse over the photo and click either the clockwise or counter-clockwise arrow to rotate the image right or left.

5. Click Upload. Facebook uploads web-ready, low-resolution versions of your images to your album.

After you upload your photographs, you can 'tag' friends who appear in your images by clicking on their faces.

When browsing the Web, you may want to save a copy of a photo you come across. To do this, *right-click* on the photo and choose the option to save the image as a new file (you'll probably need to give it a new filename too as it may consist of a string of unidentifiable letters and numbers).

If I upload a photo to Facebook and want to show it to a mate who hasn't signed up to the site, I go to the album, save the low-resolution file to my computer, then attach this file to an email. Because Facebook automatically resized my image for on-screen viewing, this saves me from having to resize the original using a photo-editing program.

Online digital photo printing

Another handy way to share images is to sign up to an online photo-printing service. These sites store higher-resolution versions of your images so you can order prints but they can also display lower-resolution versions of the photographs in web albums and as slideshows.

By emailing links to these albums to your friends, they can enjoy your photographs at their leisure and, if they choose, order prints themselves. There are dozens of digital photo-printing services around – major companies include:

● Snapfish – **www.snapfish.co.uk**

● Photobox – **www.photobox.co.uk**

● Kodak Gallery – **www.kodakgallery.co.uk**

● Bonusprint – **www.bonusprint.co.uk**

If you want to share photographs with friends and family living abroad and give them the option to buy prints, try using an international online-printing service that operates in their country. Snapfish, owned by HP, operates in more than 20 countries. Local members can order prints at local prices.

When discussing your backup options (see Chapter 11), I mentioned that these sites aren't to be relied upon to store your images indefinitely. Companies have the right to delete them at any time, particularly if your account remains inactive or if you don't make a print purchase. In my experience, websites generally give you notice before they delete your snaps, but it's up to you to keep your contact details current. Please view the individual website's terms and conditions for precise details. Turn to Chapter 16 to read more about printing digital photos using these sites.

Some printing and photo-sharing websites allow you to edit your photos from within your web browser – which means you can tweak your photos from any Internet-enabled computer without the need to install separate photo-editing software!

For example, sites such as Photobox and Flickr include an application called Picnik that allows you to make comprehensive edits to the tones, colours and contrast of the photographs you have uploaded to them. (In the case of Photobox, you can order prints based on the changes you apply.) Although Picnik isn't as fully-featured as the advanced, standalone editing tools that you install on your own computer, it is still quite impressive and handy if you are on holiday and don't have access to your usual software. You can have a play with Picnik for free at **www.picnik.com** and even upload a photograph to experiment with. You can't break it, so why not give it a go?

Sharing videos

Your digital camera should have the capability to record reasonably good-quality video and sound – and, like your digital photographs, it's a shame to leave these memories languishing on your computer. Why not stick them on the Internet and perhaps achieve global stardom?

Perhaps you have heard of YouTube, the video-sharing site that has taken the world by storm. You can view people's YouTube videos without having a YouTube account, but signing up allows you to rate and comment on videos you come across and upload your own to the site. All you need to do is browse to the folder where your video is located, provide a title and description, then upload. Depending on the make of your camera and whether you have used any video-editing software, your clips are usually stored in a file format with the extension .MPEG, .AVI, .MOV or .MP4. YouTube accepts all these types.

YouTube is owned by Google so you can use your Google account, if you have one, to log into the site.

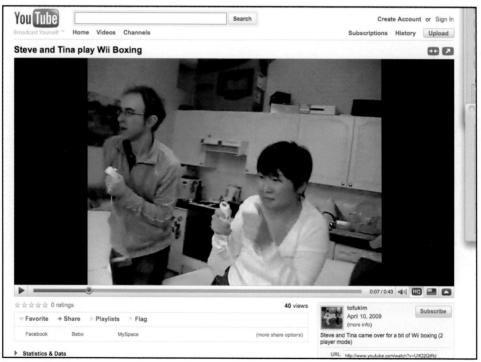

Reproduced from Google™

Figure 14.5

Don't worry if the file sizes of videos you have captured using your digital camera are huge – although this means they will take longer to upload, you can leave your computer on and go and have a cup of tea (or two) while it happens. However, videos are limited to 2GB in size and ten minutes in length. YouTube automatically compresses your video to make it easy for the viewer to watch. When people see videos on YouTube they do not download a local copy on to their computer; they watch what is called a *streaming* version from within their web browser.

Remember that if you make your videos public (and you are encouraged to do this), potentially anyone could watch them.

Facebook also allows you to upload videos, in a similar way to its photo upload process.

Digital photo frames

Although I don't yet own a digital photo frame, I have been researching what is on the market as I think it would be nice to have an inexpensive one for the house. I have seen a few on display in people's homes and perhaps you have, too.

As the name suggests, a digital photo frame displays your digital photos so that you can have a slideshow of various images on rotation. Some support video and have built-in speakers to allow you to play background music (if you have digital music files) while your photographs are on display. If you want to linger on a particular photograph, you can usually pause the photo using a button on the frame (or a remote control if one is supplied).

To use a digital photo frame, you insert a compatible memory card containing your chosen images. Versatile models let you copy your photographs to the frame's built-in memory (so you don't need to use up a memory card). If you have a wireless home network set up, costlier models even have wireless capabilities so you can transfer photos to the frame without the use of cables – some even allow you to email photos to the frame when you are on holidays, so you can gloat at those who are missing out on the fun!

There are so many varieties around, in different sizes and with interchangeable frames to match your decor. They have truly moved on in recent years. When someone first demonstrated a digital photo frame to me about six years ago,

it cost hundreds of pounds. Now, they are quite cheap – Jessops has one for around £49, but a sophisticated model from a brand such as Sony will probably set you back more than £100.

Kodak produces quite a few models, such as the one in Figure 14.6. Can you even tell it's a digital photo frame?

When buying a digital photo frame, have a think about whether you need the extra bells and whistles that add to the frame's price. It's a personal decision. The main considerations are:

Source: Kodak

Figure 14.6

- **Image quality:** The higher the *resolution*, the clearer the image should be, but this will tend to be more important for larger frames that measure more than seven inches or so. Look at how bright the screen is and how well it displays both dark and light images – it's a good idea to have a look at it in action in a shop or seek out customer reviews on the Internet. Also, consider how wide the frame's 'viewing angle' is. If you are sat quite a bit to the left or right of the frame, can you still see the photos clearly? Or do you have to sit straight on to see the photos?

- **Ease of use:** Are any buttons on the frame easy to access? Is it a simple process to insert your memory card? Depending on where you place your frame in the house, it can be awkward having to reach over to change settings so you may even want to consider buying one with a remote control.

- **Compatibility:** Most digital photo frames are compatible with common memory card types (and some also accept the USB memory sticks that are used to store data), but before you buy, double-check to see if it accepts your camera's memory card.

Remember also that although power consumption is minimal, it's a good habit to switch your frame off when you aren't using it as costs can add up.

Summary

- A broadband connection is essential for making the most of sharing your images online

- It's good practice to resize your photographs when emailing them to friends by using your photo-editing program to ensure that they are at the right size for on-screen viewing

- Sites that host your images for on-screen viewing automatically resize your originals

- You can use online photo-printing services to create albums that you can then share with friends; if they like them, your friends may order their own prints

- Digital photo frames are an innovative and increasingly inexpensive way of displaying your favourite photographs on rotation as a slideshow

Brain Training

There may be more than one correct answer to these questions.

1. If you email a photograph to a friend for on-screen viewing, which of the following image sizes would look best when viewed at full size on a monitor set at 1024 × 768 resolution?

a) 64 × 48 pixels

b) 3648 × 2736 pixels

c) 15 × 40 pixels

d) 800 × 600 pixels

2. Why is it a good idea to have a high-speed broadband connection when uploading digital photographs to the Web?

a) It's faster than using dial-up

b) It won't crash your computer

c) It's more secure

d) The sites won't work if you use a dial-up connection

3. Why do Facebook and other services resize your images when you upload them to a web album?

a) The images take up less storage space on their computers

b) It makes it simpler and easier for people to view your images on the Web

c) It saves you the hassle of doing it yourself

d) It increases the speed of the upload

4. What does a digital photo frame need to display your images?

a) A USB cable

b) A printer

c) A memory card

d) Some digital photographs

5. What would you use YouTube for?

a) Viewing videos

b) Sharing videos

c) Editing photographs online

d) Printing images

Answers

Q1 – d

Q2 – a

Q3 – All answers are correct

Q4 – c (and d, of course!)

Q5 – a and b

Printing photos at home

Equipment needed: digital photographs on your computer and memory card; a printer capable of printing colour photographs (if you don't already have a colour printer, this chapter helps you choose the best one for your needs).

Skills needed: some experience with viewing photographs on your computer and digital camera; knowledge of the major digital photography concepts outlined in earlier chapters.

It's a great feeling having a beautiful photograph displayed on the wall, held in your hand or placed in a family photo album – particularly if you are the one who took that photograph!

But the immediacy of digital photography can mean we forget to print our best images on to good old paper.

This chapter is all about printing your images at home, and the types of printer available. I also outline how to print your photographs, although the exact method will vary depending on the software that came with your printer.

You may already have a printer at home and have had experience using it to print web pages and documents – it's still worth reading this chapter for a refresher and for tips on how to get the best out of your prints.

Why print your own photos?

Most of us have been used to taking a roll of film to the chemist or local photo lab, letting them do the hard work then coming back to see the results. However, here are some reasons why you would want to print photos at home.

- **Speed:** Rather than pay a premium for a one-hour turnaround service or wait a few days to receive prints in the post, you can print quality photos at home at your leisure within minutes.

- **Convenience:** Say someone comes to visit and you want to give a photograph to them – well, you don't have to go to the shop and order a reprint. Just print a copy out on your printer and give it to them almost instantly.

- **Consistency and control:** As you gain confidence over your digital photo-graphs and perhaps learn some more editing skills, you may prefer to retain control over how your prints look (and the type of paper they are printed on) rather than have someone else do a shoddy job printing them.

- **Versatility:** Depending on your printer, there are different paper types and sizes at your disposal, and you can use the supplied software to be more creative with your photographs (for example, you could create party invitations, greetings cards or postcards on your home printer). Many printers also have multi-functional capabilities including a scanner and copier.

Some printers don't even require you to own a computer in order to print photographs, a bonus for the computer-phobic among us or for those who don't want to go through the rigmarole of logging in all the time. All you do is insert a memory card into the printer and select the photograph you want to print, or connect your digital camera directly to the printer (if both the camera and the printer support a technology called PictBridge – look for the logo).

I have not listed price as a reason why you would want to print your photographs at home. This is because the cost of ink and paper can mount up and, in the long run, if you print a lot of photographs it can rapidly use up ink. Then there is the cost of the paper. Although you can buy cheap third-party ink and paper alternatives, this isn't usually a good idea if you want to retain consistency and control of your photos. Manufacturers like to design their printers to work specifically with their paper and ink (and this does cost money). When buying a printer, always take into account its running costs, not the sale price of the actual machine. I recommend researching independent reviews of printers (either online or in magazines) that take running costs over a period of time into account.

Types of printer

Assuming you are a typical home user (and are not establishing a printing press in your garage), these are the most common consumer printer types and who they are most suitable for:

Inkjet printers

By far the most common type of printer, inkjet printers are best for printing photographs at home. They work by placing drops of ink on to paper. The ink is stored in cartridges, which you need to replace when stock runs low (you are alerted when your ink needs to be replaced and stock levels show up when you print). If ink is low, you can usually squeeze a photo or two out of the remaining ink supply, but don't wait until the cartridge runs completely dry as this may damage the delicate print heads.

A standard inkjet printer usually accepts different paper sizes up to around A4 size but you can pay more for a bigger model if you need larger format prints. For a domestic printer, expect to pay anything from £40 to £90 for a no-frills model to £200 for one with all the trimmings, such as wireless capability, memory card slots, a scanner and photocopier (more about these in 'all-in-ones' below).

Figure 15.1 is an example of an Epson inkjet printer designed for printing photographs at home.

Source: Epson (UK) Ltd

Figure 15.1

When printers mix colours, they don't use the primary colours of red, green and blue (RGB) we learned about in school. Instead, they use cyan, magenta and yellow – plus black. This is known as CMYK (the K stands for the black 'key' colour). Some inkjet printers use two ink cartridges: one for black and a separate colour cartridge for the CMY component. However, some models have a separate cartridge for each of the three colour separations plus black. This is good if, say, you run out of cyan ink before you run out of yellow – then you only need to buy a cartridge for the colour you are running low on, rather than a whole new combined colour cartridge. In the long run, it will probably save you money and the ink will be of higher quality. (For the enthusiast: some printers accept more than four ink cartridges to produce a greater range of colours.)

Your digital camera and your computer monitor mix colours digitally using the primary RGB colours not CMYK. But don't worry about this difference as your home printer is designed to convert your RGB photographs to CMYK format. You may not see the exact result you are after, however, as monitor colours are richer and more vibrant than colours in printed form – but the results come close. If you do want more control due to unexpected results, experiment with different photo paper or printer driver settings. There are also ways for you to convert RGB to CMYK before printing if you are using specialist photo-editing software, but that's not in the scope of this book.

All-in-one printers

All-in-one printers (sometimes known as multi-function machines or multi-function devices) are very popular because they combine an inkjet printer (and many of its associated features) with other handy elements including a scanner and copier (some models designed for home offices include a fax machine). They are useful space-savers and are still capable of producing quality photographs, depending on the specification. If you do not have a scanner and are interested in digitising old photographs then you might consider buying an all-in-one (if you want the ability to scan slides and negatives, check whether the all-in-one you want supports this).

This all-in-one Epson PX71W (Figure 15.2) has wireless capability and measures 15cm high. Paper trays are hidden to make your desk look neater.

Source: Epson (UK) Ltd

Figure 15.2

This all-in-one HP Photosmart (Figure 15.3) has a handy touch screen to help you make your printing selections.

Source: HP

Figure 15.3

Laser printers

Laser printers are best for those who have a home office and are frequently printing out documents. They are far faster at printing than inkjets and come in colour and black and white (mono) forms. A basic branded colour laser printer is likely to cost from £130 but in the long run they are usually cheaper to use because when it comes to print cost per page, toner is cheaper than inkjet cartridges. Costs are continuing to decrease.

You can print perfectly fine images using a colour laser printer, but not all print on photographic paper. You'll find that, for a typical home laser printer, the quality won't be as good as what you'd find with an inkjet. You'll pay more for the fancier types that can do this.

They are also very heavy and bulky, so they may take up a lot of room. In short, for printing photographs, they are not that consumer-friendly. I have a cheap black and white laser printer that I use for printing documents, which is very quick and handy, but it's definitely not designed for printing photographs.

You would think that printers would come with all the appropriate cables required, but this isn't always the case. In fact you usually need to provide your own USB cable if you wish to connect the printer to your computer. These are widely available, but remember to buy one when you purchase your printer to avoid any delay in your setup. Prices vary depending on the length of the cable and the quality of the connectors, but don't expect to pay more than £12 on the high street. You can find very cheap USB cables on Amazon and eBay (search for 'USB printer cable'), or perhaps you or a member of your family has a spare lurking around, perhaps from an old printer.

Compact photo printers

These delightful portable printers are great for occasional use. They are usually only suitable for printing postcard-sized photographs and do not require a computer. They do not use the conventional ink cartridges found in inkjet printers, but instead use a single cartridge that slots into the device.

To print photos, simply insert a compatible memory card into the slot, or connect your digital camera to the printer if it supports the PictBridge connection. There

are basic automatic adjustments you can choose from including red-eye correction, but you can also connect the printer to your computer in the more conventional manner if you want to print edited versions of the photos that you have on your computer.

This Selphy model from Canon (Figure 15.4) is an example of a compact photo printer. My friend Karen's parents have a similar model they take on holiday with them. They buy compatible paper with a postcard-print backing, take photographs of themselves on the beach then send them to friends! It beats your garden variety 'Wish you were here' postcard any day. Remember to take a power adaptor!

Source: Canon UK

Figure 15.4

Choosing a printer

Once you have decided which kind of printer to purchase, here are some common things to look out for when buying a printer:

- **Image quality:** The most obvious feature of a printer is how well it prints your photographs and other documents. Inkjets are typically best for photos. The quality of the inks used, the paper you are using, and the printer specifications all play a part in how well photographs will reproduce. That is why it's a good idea to shop around and look at reviews. If it's an all-in-one, is it a good one? Perhaps the print quality is discernibly less than dedicated photo printers.

- **Speed:** If you are only printing a few photographs then speed is probably not a huge issue. It may take a minute for quality photos to come out of your printer, but it's worth the wait!

- **Size:** Compact, portable photo printers are designed for postcard-size prints. Look for a larger format printer if you want to print up to A3 size. Most are designed to print up to A4 size, a standard sheet of paper. You will also want to make sure it fits on your desk.

- **Ease of use:** Some of the most frustrating things about printers are things like paper jams, problems cleaning the cartridges, unidentifiable error messages,

how well it alerts you to low ink levels, and how easy it is to directly print the photographs if you aren't using a computer. Luckily, these days printers are a lot more consumer-friendly and do a better job of guiding you through the printing process.

- **Running costs:** I mentioned that it's important to bear running costs in mind when you are buying a printer. The initial price you pay may seem like a bargain – I've seen decent-looking inkjets for around £30 – but how much is the ink and paper? Does it use different ink cartridges for cyan, magenta and yellow, which is more cost-effective in the long run? How many pages does it claim you can print per cartridge? And how much do the branded cartridges cost?

- **Extra features:** Some printers boast special tools to help you enhance your photographs, but these are all optional extras. You may find value in additional image-editing software and, if you have a wireless home network, some even have Wi-Fi capabilities so the printer needn't be tethered to the computer (if you use a laptop, for example, you can send your print job to the printer from anywhere in the house). Some also support the short-range wireless technology called 'Bluetooth' – this is usually built into mobile phones and some laptops. It means you can wirelessly 'send' your image from your phone directly to the printer. You may also want a model that allows you to print directly on to compatible CDs and DVDs for labelling.

Preparing to print the perfect photo

Before you print your photos, let's make sure you've set up your printer correctly.

Installing your printer

When you set up your printer you'll need to install a *driver* to allow it and your computer to work together (I discussed the concept of drivers in Chapter 10). The driver is contained on the installation disk that ships with your printer. It includes the settings unique to your particular printer model, such as the types of paper it accepts and the sizes it can print at.

Your installation disk also includes any other additional programs that ship with the printer, such as basic photo-editing software. Your printer instructions will outline the specifics of the printer installation process and what is included on the disk.

If you don't have the printer's installation disk, you can visit the manufacturer's website to download the driver for it – look under the help or support section.

Your ink cartridges

Your printer will probably ship with ink cartridges for you to get going straight away – but these usually won't be full-capacity ones and will run out of ink quite quickly, so you should have a spare set to hand. The printer is engineered to work best with the manufacturer's own brand of ink cartridges, which often have computer chips embedded in them to deter third-party manufacturers from producing cheaper competitive inks.

That hasn't stopped the cheap ink market, with many companies producing cheaper refillable solutions and other ways to work around the chip issue. Quality of the resulting images may be hit and miss, however, so use them at your own risk – it may invalidate your warranty should something go wrong, but as branded ink typically costs more per millilitre than vintage champagne, it may be something to consider if you want to print a lot of photographs at home – or you could just use an online printing service (more about alternative print options in Chapter 16).

Inserting ink cartridges involves clicking or slotting them into place – the exact process depends on the model, so check your instructions. You may need to remove a protective film from the cartridge before first use.

Photo paper

Like ink cartridges, printer manufacturers produce their own varieties of photo paper which are designed to work best with their own inks. The paper available may come in different grades, from 'standard' quality paper to print everyday snaps, to 'premium' photo paper for special occasions. Some have 'star ratings' to help you choose. Premium papers may last longer and inks are less prone to fading. You may also find glossy and matte varieties, different pack sizes and, of course, varying paper sizes (unless you are using a compact photo printer that only accepts postcard-size paper).

When printing, you will need to select the type of paper being used from your print job settings to optimise the print process. After you install your printer driver, you'll be able to do this by browsing the list of available photo types. You may want to buy small packs of various paper types and experiment until you find one that works best for you and your 'flavour' of digital photos, or if a friend uses the same brand as you then you may want to borrow a sheet or two.

Resolution

I introduced the concept of *resolution* in relation to digital photography back in Chapter 3. The more pixels make up an image, the higher its resolution – and the larger you will be able to print the image without seeing a loss in quality.

But how large? An easy way to find out the dimensions of an ideal print in inches is to divide the digital image's horizontal and vertical pixel count by 300. This is because, to get the best quality print, you'll typically need at *least* 200 (preferably 300) pixels per inch (ppi). So if I have a photograph that was taken at 3072 × 2048 pixels, I can print a nice 10 × 8 image at 300ppi (but can stretch it further if I print 200ppi).

Pixels per inch (ppi) is often confused with dots per inch (dpi) and used interchangeably, but the two concepts are different. A printer's resolution is actually measured in dpi, which refers to the small droplets of ink that it places on the paper – for instance a printer might have a stated resolution of 4800 × 1200, which means it prints up to 4800 dots across a one-inch line and 1200 dots down a one-inch line.

A printer with less resolution places fewer dots on the paper, but the difference won't always necessarily mean a massive loss in quality. A printer with a high resolution is always good to have but isn't the be-all and end-all of your purchase. Modern printers have such a high resolution that it is not possible to see the dots, even if you hold the page under a magnifying glass. Other factors, such as the quality of the mechanics, ink and ease of use, play a very important factor in the quality of the prints.

Printing photos from your computer

If you are familiar with printing documents then you'll be aware of going to File, Print in a Windows application and then printing the page or pages. You may also have gone to the 'print preferences' screen to choose the paper size and print quality.

The same method applies with digital photos. Your printer driver ends up installing plenty of extra preferences for you to choose from to help make your prints the best they can be. If you click File, Print, you can access the printer preferences by clicking a button on the print job window that says 'setup', 'preferences', 'properties' or similar – the exact wording depends on your printer. You should then be able to choose from a range of settings – again, these will vary depending on the manufacturer and printer model, but you should be able to choose from the following:

- **Type of paper/media:** There's a massive range of photo paper types to choose from, so in your print preferences you need to choose the right one that corresponds to the paper you are using before you print. This is important otherwise you may not get the best result. If you opt for third-party photo paper, then your paper type won't be listed here. You'll need to experiment with other choices to find one that best matches the paper type.

- **Paper/print quality:** Again, you'll have a number of different choices here. Some of you may have had experience printing documents and web pages in 'draft' mode to save on ink. But you probably won't want to do this when you are printing photographs you'd like to keep, so choose the 'best quality' setting for top, long-lasting results. This tends to use up more ink, so if you aren't so hung up on having the photo as a keepsake, there may be a setting to print your photo in 'normal' mode.

- **Cropping:** Your digital camera's typical aspect ratio (the proportion of its length to width) may not match the aspect ratio of the paper it is printed on. As a result, there will be some cropping on the sides of the image so that it can fit on the paper. Your printer crops the image to fit automatically for you so if you don't want to lose the edges of the image, you should choose the 'shrink to fit' option but this will mean some white space at the sides of your image. A better option is to crop the image to the desired ratio within your photo-editing program *before* printing to ensure that you have control over what parts get cropped. For example, printing on 6 × 4 paper means the paper has a ratio of 3:2 so you would have to make sure your image retains these proportions – the program's resizing options should help you with this.

- **Border:** If you choose to include a border, then the printer will add a white border around your image.

- **Orientation:** Choose from a portrait (vertical) or landscape (horizontal) view here.

The software that comes with your printer can usually optimise your photograph so that it prints at its best possible quality and you won't have to worry too much about dpi or ppi settings. But your photo-editing software also lets you specify how many pixels per inch you would like to print the image at. For example, in Picasa, you can go to File, Print then click the Printer Setup button. You can then access your printer settings. (Remember, some programs will refer to dpi when strictly speaking they mean ppi.) Figure 15.5 is an example of a typical print preferences screen within Windows.

Figure 15.5

Printing at home without a computer

Yes, it's possible to print at home without any computer intervention! Many models, as I mentioned, accept memory cards, which you can just slot into the printer without the computer needing to be on. You will then look through a small LCD screen on the printer, browse through the selection of images on the card, and choose the photo you would like to print. The printer is capable of doing some basic colour and red-eye adjustments for you, but this is usually an automatic process. Remember though that you will still need to back up the photos on the memory card in some manner.

You can also print directly from your digital camera, using a standard technology (called 'PictBridge', regardless of brand) – if both camera and printer support it. Just plug the camera into the printer, select the image and print. When you plug your camera into the printer, its LCD screen displays any relevant print options, such as whether you want to print multiple images (so long as the printer has that feature). Please consult your digital camera's manual for precise instructions relating to your model.

Your digital camera may have a feature called 'digital print order format' (DPOF). Remember the order sheet you used to take to the chemist that specified which negative frames you wanted them to reprint? Well this is the modern version of that. If your digital camera supports it, DPOF lets you specify or 'tag' which images on the memory card you would like to print. Some photo-printing services support DPOF.

Keeping the engine running

I've worked for more than ten years as a technology journalist for various magazines, and printer troubleshooting is one of the top problems that readers write in about.

Your inkjet printer actually has some utilities that allow you to conduct small maintenance jobs. These can usually be accessed in the print preferences, but check the manual for instructions on how exactly to access them.

- **Print head alignments:** If your prints seem misaligned or colours aren't laying down quite right, then this may require you to align the print heads (the parts

of the printer that place the ink on to the page). The printer will print a test page on plain paper for you to check; you will then tell it how it looks. The test will repeat until the problem is fixed.

- **Nozzle check and cleaning:** If your prints are missing certain colours and you see frequent 'bands' or lines appearing across the image or nothing is coming out, then ink is not coming out of the nozzles properly – perhaps they have dried due to lack of use. The printer will print a nozzle check pattern for you and if there is a problem then the printer will need to clean them out. To do so, the printer actually squeezes out some fresh ink to get any dried gunk out. As this uses up your ink, it should only be performed if your prints are not showing as well as they normally do. Just keep your printer well-oiled by simply using it from time to time, so as not to let any ink in the nozzles dry up.

Summary

- Inkjet printers work by laying small droplets of ink on to the page – they are the most popular type of home printer

- Check long-term running costs of your printer by taking the cost of ink cartridges and paper into account

- When printing from your computer, use the print preferences box to choose the type of photo paper you are using and the level of print quality you are after – that way you will get the best results

- Many consumer printers are designed to work without a computer – you can connect your digital camera to the printer directly or use a memory card

- Printer resolution (dots per inch) is different to image resolution (pixels per inch) but the two terms are often used interchangeably

- Occasional maintenance is necessary to keep your printer running smoothly

Brain Training

There may be more than one answer to each of these questions.

1. What is PictBridge?

a) The ability for the printer to accept memory cards

b) A type of cable that connects a computer to a printer

c) A technology that lets you print directly from a digital camera to a printer

d) A printer with wireless capabilities

2. What is the minimum resolution your printer needs to produce a decent-quality photo print?

a) 200

b) 300

c) 600

d) 2400

3. What is the benefit of an all-in-one printer?

a) Saves space

b) Saves on running costs

c) Easier to use than other printers

d) Prints faster than laser printers

4. Why might your photo's edges get cropped off when you print it?

a) You zoom into the image before printing it

b) The resolution is too high

c) You use the wrong program to print it

d) The photo's aspect ratio doesn't match that of the paper

5. What is the benefit of choosing a printer with separate ink cartridges for cyan, magenta and yellow as well as black?

a) It saves running costs as you need only replace the cartridge that runs out of ink

b) The print nozzles become less clogged

c) There is no benefit

d) It takes less time for photos to print

Answers

Q1 – c Q2 – a Q3 – a Q4 – d

Q5 – a

Other printing options

16

Equipment needed: computer; broadband connection; some photographs on your computer; a memory card or disk containing photographs you would like to print.

Skills needed: confidence and enthusiasm; some experience browsing the Web and transferring photos to your computer.

Prolific photographers may find costs mounting up if they use their home printer frequently. It is up to you to determine how much you are spending on paper and ink, but it may be more cost-effective in the long run to let someone else do the job for you if you plan to regularly print a lot of photographs. Then you can save the inkjet printer for special photographs you want more control over.

In this chapter, I briefly outline the alternative print options available to you.

Online photo-printing services

The market for online photo printing has expanded dramatically – thanks to broadband and the rise of digital photography – and there's plenty of competition when it comes to price. Usually if you buy pre-paid print credits through these sites, you can dramatically decrease the cost per print. New customers often find incentives to sign up, such as free delivery or free print credits for your first order, so you may want to sample *all* of these sites, printing different photos with each one, until you find the service you are most comfortable with using that delivers

the best results! Word of mouth is also wonderful. Perhaps you know someone who is a regular user of one of these services?

You typically need to upload your photographs to the sites but broadband speeds up the upload process. Don't worry; the process is very simple. If you have already managed to transfer your digital photographs to your computer (Chapter 10) or shared images on the Web (Chapter 14), the process will be familiar.

Apart from prints, the sites also let you plaster your masterpieces on things, such as T-shirts, mugs, cards, mouse mats, canvas prints, pillowcases, key rings and photo books – more about these in Chapter 17.

The print-ordering process varies from site to site but, broadly speaking, it involves the following steps:

1. **Create an account at the website.** This is free. You'll need to provide your email address and choose a password. You may also need to provide other contact details such as your address, but you won't need to enter any credit card information prior to your first order.

2. **Upload your chosen photographs to the site.** Before uploading photos, you create a new album for them (or add them to one you've already created). The website may install a small application in your web browser which lets you browse to the location of your photographs on your computer. Next, select the images you wish to upload. The process may take a while depending on your broadband speed and the file size of the images you choose (some services such as Snapfish have a 'fast upload' mode and will resize images before upload unless you specify that you want to upload the original high-resolution image sizes for printing very large images). So sit back and have a cup of tea... or open a new tab or window in your web browser and go visit another website. You should see a progress report on screen that shows you how many of your photos have been uploaded so far.

Don't rely on these sites to back up your photographs because your images could be deleted at any time particularly if your account remains inactive for a period. In addition, the original high-resolution versions may not be stored or you might not be able to access the full versions. Check the site's terms and conditions.

3. **Make any corrections to your images.** Once the photos have uploaded, you can make corrections online (see Figure 16.1), such as cropping them to fit the paper's aspect ratio (turn back to Chapter 15 for more on this), rotating them if they display the wrong way, or allowing the site to apply an 'instant fix' to the photograph's colours and brightness. Most services have these basic tools but some also provide extra fine-tuned enhancements, such as red-eye removal and greyscale (black and white) – if not, you can do all this in a photo-editing program before you upload.

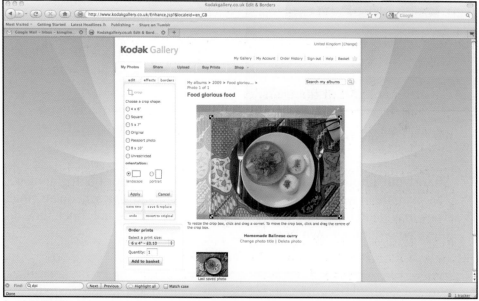

Source: Kodak UK

Figure 16.1

 If you have already edited your photos at home to your satisfaction, check to see if the website applies automatic corrections to your image. You should be able to turn this option off if you wish.

4. **Add prints to your shopping basket.** Select the photographs of which you'd like prints. You can select the number of copies you'd like and choose from a variety of print sizes. Some sites let you print on matte paper as well as

Source: Snapfish UK

Figure 16.2

the regular glossy, if that's the texture you prefer. Remember from Chapter 15 that if you didn't crop the photographs so that their aspect ratio matches that of your chosen print size, the ends tend to get cropped automatically for you. Figure 16.2 shows you how Snapfish automatically crops a photo in order to fit a 6×4 print.

5. **Order prints.** Review your order and the total cost, enter your payment and address details, then sit back and wait by the letterbox!

6. **Share your photos.** As soon as you have uploaded your photographs you can share them with your friends – usually via a private link sent on an email. They may need to sign up to the site to view the images but, once they do, they can order their own prints.

Many of the online photo-printing services provide their own optional desktop software to help speed up the uploading process – it means you don't have to upload the photographs via the website, which can be a little less efficient. Some even allow you to order prints direct from your photo-editing software. Check individual websites for more information.

Some of the more popular online photo-printing services include:

Snapfish

Owned by HP, Snapfish (**www.snapfish.co.uk**) is a massive global operation. From my experience, prints are of excellent quality, but I would expect that, as HP makes printers too!

Prices of prints go down if you buy pre-paid print credits. For example, at the time of writing 500 4×6 print credits cost £25, which amounts to just 5p per print. You don't need to use all these up in one go.

There are several things you can do to your photographs once you have uploaded them, including applying basic edits, fancy borders and red-eye removal. As with several of these services, to avoid 'spoiling' your original, you can choose to save this edited photo as a copy.

Source: Snapfish UK

Figure 16.3

Photobox

Photobox (**www.photobox.co.uk**) is a UK company that has been around since 2000 and now operates throughout Europe. The site is very easy to use and prints often arrive the very next day. Customer service has always been very efficient.

After a major redesign, the site now makes it easier for you to organise and find photographs you have stored on the site. It also uses Picnik, which I discussed in Chapter 14, to let you make fine-tuned enhancements to your photograph's colours, brightness and contrast.

Source: Photobox/Picnik. Photo copyright Kim Gilmour

Figure 16.4

Many of these sites, including Photobox and Bonusprint, offer 6×4.5 prints, as well as the more traditional 6×4 prints, which match the aspect ratio found in many compact digital cameras. This means you don't need to do any cropping. The disadvantage of the unconventional photo print size, however, is that the resulting prints won't fit into typical photo album sleeves. I've used an online store called Arrowfile (**www.arrowfile.com**) that sells sleeves that accommodate these sizes, which you then store in ring binders – but you should probably stick to standard sizes if you are sending them on to friends or putting them into traditional photo frames.

Bonusprint

The long-running, mail-order, photo-developing service has moved to the Web. Along with the ability to upload photographs directly to a web album, you can send your CD or memory card of photographs by post to Bonusprint (**www.bonusprint.co.uk**) if you have a slow Internet connection or aren't yet confident about uploading images from your computer.

Prints are good value at 10p for under 100 4×6 photos, decreasing to 7p for an order of 200 or more. The quality of its prints has received good reviews from numerous publications. If you have used them for developing film and are happy with the results, I am sure you won't find anything to complain about here.

Kodak Gallery

Operated by one of the world's most familiar photography brands, Kodak Gallery (**www.kodakgallery.co.uk**) lets you upload, share and make minor edits to your photographs. The site uses Kodak papers for its prints and claims that these are of the same quality as those used for traditional 35mm prints.

The company claims to have 75 million users worldwide. There is also a pretty comprehensive range of photo-related gifts.

Other services

You will find plenty of other online photo-processing services; my list includes:

- Boots Photo (**www.bootsphoto.com**) uses Photobox's printing engine.
- Jessops Photo (**http://photo.jessops.com**) offers free delivery to your local Jessops store once you order prints.
- Discount supermarket Aldi sells prints for 4p each at **www.aldiphotos.co.uk**.
- Pixum (**www.pixum.co.uk**), headquartered in Germany, is another long-established pan-European provider. You can share albums and upload photos from a variety of sources including email.

Whichever website you choose to use, check its returns policy. You should *always* be able to return images that don't turn out the way you hoped and receive a replacement or refund.

Taking your photos to the lab

Don't forget that your local friendly photo lab will accept your digital media. These shops have had to diversify in recent years – they don't just process film and do your passport photos anymore; you'll be able to print digital photos and put them on all sorts of things! I find these outlets handy if I am on holiday and need to back up my memory card's images on to a CD. They are also good if you just want a bit of face-to-face contact or need your photos in a hurry.

Once you hand over your memory card, disk or other media containing your photos to the lab, they will print them the way they think is best. Be sure to give them any special requests – if you haven't adjusted the aspect ratio of your photograph, then the ends may get chopped off automatically during the printing process (see Chapter 15 and Figure 16.2).

I know I keep mentioning the photo's aspect ratio compared with the proportions of the paper it is printed on, but it can make a difference to how a photo will look. As I was writing this chapter, my mum took some photographs on her memory card to the local photo lab. When the photos came back, one of her friends – who happened to be standing in several group shots while the others were sitting – had most of her head cut off the top of the photos. Needless to say, the friend was a little upset. I told my mum to take a look at the original photo on the memory card. "I guarantee that your friend's entire head will be in the frame", I said. Lo and behold, the friend's head was still in all the photographs. What the photo lab could have done was crop the *bottom* off the photographs. But they hadn't exercised the greatest quality control.

As she is a regular customer to the store, my mum returned and asked them to reprint the photos with all the heads intact. Problem solved!

Using a kiosk

Kiosks are standalone machines (Figure 16.5) in photo labs and larger Boots stores that accept several types of digital media for printing, including memory cards, CDs and USB sticks. They read your card and print your chosen photographs on the spot. You operate the machine yourself.

Kiosks aren't as cost-effective as online photo-printing services if you are printing only a few images – going into Boots recently to print a dozen images at a Kodak kiosk cost me 39p apiece, which is far more than what home or online printing would have cost me. The price per print decreases for orders of more than 50 images.

What I paid for was convenience, speed and ease of use. The whole process only took a couple of minutes and the instructions on the touch screen were very clear. If you are comfortable with using an ATM then you will have no problems using a kiosk. (At any rate, they are far easier to

Source: Kodak UK

Figure 16.5

241

use than the newfangled self-checkout machines in supermarkets that always bark at you when you supposedly put something unusual in the 'bagging area' – about eight times out of ten, I have to ask the shop assistant to unlock the machine because I've done something to irritate it, like use a shopping bag that already has something else in it. But that's another story!)

If you are using a memory card directly from your camera and have not edited your images, there will be some kind of automatic correction mode to choose from but you may have to pay extra to fix red eye and make other fine-tuned adjustments. So if you have edited your photos at home, it's probably easier to upload the edited files directly to an online service rather than copy them back on to a memory card and take them to a kiosk.

Printed photographs don't last forever, even the ones printed from film. Look after them by displaying them in archival (acid-free) quality albums and keeping them away from direct sunlight. Try not to submit them to extreme temperatures or humid conditions, either. If you are storing your mementoes in a loft or basement, you can buy special archival boxes to minimise damage – but you'll still need to keep a regular eye on the varying conditions outside the box. You don't want any mould or water to destroy your treasured photographs.

The grade of paper on which photos are printed and the ink used also make a difference to how long the images will last. Have a look online for independent reviews of the paper you are using. (As an experiment, you could test a range of photo papers yourself but you need to be very patient. For each type of photo paper, print two copies of a photograph, keeping one against a window in direct sunlight for a year and the control photo in a dark, dry place. Then compare how both of them look. Which ones faded the least?)

Summary

- Online photo-printing services are usually more cost-effective than home printing

- Kiosks may cost a little more but are convenient, quick and easy to use

- There are plenty of online services to choose from and many offer incentives for new customers, including free prints, so it's worth sampling a few offerings

- If you are comfortable with transferring digital files to your computer and browsing the Web, using online photo-printing services will be easy

- You need to keep an eye on how your photo is cropped if it's at a different aspect ratio to the paper

Brain Training

There may be more than one answer to each of these questions.

1. Why use a photo kiosk?

a) They are the cheapest option

b) They are convenient

c) They are straightforward to use

d) They don't require a computer

2. Why use an online photo-printing service?

a) They are often cheaper

b) You can make minor edits to your images before ordering

c) They produce better prints than alternative options

d) They are faster than other services

3. What *wouldn't* you use an online photo-printing service for?

a) Sharing photos with friends

b) Touching up photos

c) Backing up photos

d) Ordering T-shirts and mugs with photos of your dog on them

4. Why is it a good idea to check how your digital photo is cropped before ordering a traditional-sized print?

a) Your digital camera may use a different aspect ratio to the paper

b) Cropping always improves the image

c) It saves money

d) You need to do this before placing your order

5. Why would you want a broadband connection to use an online printing service?

a) It's more secure

b) The site won't work if you use a dial-up connection

c) It's faster

d) The uploaded photos are of better quality

Answers

Q1 – b, c and d **Q2** – a and b **Q3** – c **Q4** – a

Q5 – c

Being creative with your photos

Equipment required: a home printer; a scanner if you are planning to digitise old photos, negatives or slides.

Skills required: some confidence and enthusiasm; your creative 'hat'; experience with using a photo-editing program and printing photographs at home or using an online printing service.

You can do a *lot* more with your photographs than print them out as is or display them as a digital slideshow. Why not bring old photographs, negatives and slides to life using a scanner, some photo-editing software and some imagination? Or perhaps you could use your photographs to print greetings cards or invitations either using your home printer or designing and ordering them online? This chapter outlines some of the options available to you.

Scanning

Now that you are hooked on digital, what about all the other photographs and negatives you have lying around the home? Wouldn't it be great if you could organise these in the same convenient way as your digital photographs? That is exactly what a scanner is for.

A flatbed scanner consists of a glass plate with a lid and is designed for transferring two-dimensional items, such as photos, documents and artwork, into digital form.

When you place an item on the glass, light passes through from underneath and reflects the image on to a series of mirrors, where it's converted to a file.

A cheap scanner is usually fine for converting old printed images to digital, and if you have an all-in-one printer then you will have a flatbed scanner as part of the device. However, you may want to invest in a dedicated scanner if you have transparencies – that is, colour slide film (like the classic Kodachrome ones) – or old film negatives. Scanners that have the capability to scan transparencies and negatives pass light from underneath into the scanner's lid so as to capture the 'see-through' media.

There are several reasons for buying a dedicated scanner:

- Not all the all-in-one models can scan transparencies and negatives and a dedicated scanner will usually be more efficient at doing so if you are thinking of scanning hundreds of them.

- Dedicated scanners tend to scan at a higher resolution than all-in-ones. Although cheap scanners are usually fine for scanning in photographs, you may want a bit of leeway if you want the flexibility to print very large reproductions and transparencies. (By the way, when you check the all-in-one's specification, make sure that you are looking at the scanner's maximum resolution, not the printer's.)

- Dedicated scanners are designed to work faster.

- Dedicated scanners come with specialist software to automatically remove scratches and dust and correct colours if you so choose and quality photo-editing software.

- Dedicated scanners have transparency adaptors to accept a range of different film size types.

From my experience, scanning a transparency or negative can take several minutes per frame depending on the resolution required. A scanner capable of at least 3200 dpi is adequate if you want to scan 35mm slides with enough detail for an 8×10-inch print, as well as tiny keepsake photographs that need enlarging and touching up.

This Epson Perfection V600 (Figure 17.1) is an example of a scanner that is designed for photographers – it scans at up to a massive 6400 dpi and ships with useful software such as Adobe Photoshop Elements and a range of transparency

Source: Epson UK

Figure 17.1

adaptors to fit different-sized slides and negatives. With an RRP of £260, you are paying for all these features, but even so, the price of such high-specification scanners has decreased over the years.

The scanning process

After installing the scanner and its drivers, you access it by 'acquiring' it using your photo-editing software. This is achieved usually by going to File, Import (or File, Acquire) then selecting the device. This starts the scanner software. Please consult the software manual for specifics.

You can then specify what the item on the glass plate is (a slide, a print, artwork, a black and white photo, a document, such as your credit card bill, or whatever) and click a *preview* or pre-scan button to have a quick look at the item on screen before initiating a full scan.

This sense-check is important because then you'll be able to apply any other fixes such as dust removal (if available) or adjust the cropping so that the scanner takes only the image held within the crop box. You can also digitally 'flip' a transparency if it was inserted back to front or readjust a photograph that may have been laid down crookedly and start again, although you can always fix this in your image-editing software later.

While scanning negatives, you can often choose the type of negative you are scanning, such as Kodak Gold 200 or Fuji Superia 400. Once the scanner knows the type of negative you have, this can help improve the scanned result.

Before scanning, you need to specify the resolution you would like to scan the item at. The setting you choose depends on how large you eventually want to print the image.

Scanning at the device's top resolution can make the resulting image file size absolutely (and unnecessarily) massive – and I mean massive. Even if it's slide film, they can be huge: some of my slides have been 120MB or more because they were scanned in at the top resolution and saved in the high-quality TIFF format rather than the more conventional JPG. It's a hassle having to reduce the file size after the scan.

Scanners often come with the ability to turn documents, such as bank statements, into PDF files for archiving, as well as software that can read the printed text and turn it into a digital format (known as OCR, or *optical character recognition*).

You can reduce file size *significantly* in a couple of ways. The first approach is to scan the image at the required resolution. I discussed in Chapter 15 that to print an image you need 200 to 300dpi. So if you want to print a 35mm slide (a slide has a physical dimension of 1×1.5 inches) on 4×6-inch paper then multiply its longest side, in inches, by 300 – this means you only need to scan it in at 1800dpi.

The second approach, which is easier than doing the calculations in your head, is to scan the item on the scanner at the standard, print-quality resolution of 300dpi while also specifying your maximum print size, such as 10×8 inches. There is usually an 'output' field where you enter the desired width and height of your final print size. What this does is change the scale (or magnification) of the original slide. The image's file size subsequently

increases to the exact size needed to make your print: no more and no less than what's required.

Depending on the approach you take, if you ever want larger prints further down the line, you'll need to scan the item again and increase the resolution or the specified output size. It's best practice to scan the item in with an idea of your maximum print size, to save you having to repeat the process.

Once these settings are in place, click the scan button and the scanner starts whirring away using the parameters you specified to capture the item.

After the item is scanned, it opens in your photo-editing program. Your negative may look far from perfect – colours may seem quite odd, for example. At this stage, it's important to do a little post-production tweaking to the colours, brightness and contrast and dust removal (see Chapter 12 for more on this).

If you scanned your file as a TIFF, then saving the file as a JPG after editing it reduces its file size, but does result in a loss of quality (if you do this, for best results, choose to save it at maximum JPG quality settings; saving at lower quality may still give you good results at much smaller file sizes). If it's a particularly valuable photograph, you may want to keep it as a TIFF. Some experimentation may be necessary to retain image quality without using up too much hard disk space.

We have talked a lot about JPG files in this book. High-quality TIFF files are often used in publishing because they are 'lossless', meaning they don't lose image quality in the way that JPGs lose data whenever they are saved. However TIFF files are quite big, so hard drive space can become an issue. I think it's fine to save scans as high-quality JPGs.

Dust, scratches and fingerprints

Slides and negatives in particular attract *dust* like there is no tomorrow. Check out this negative that had been hiding in my cupboard for years (Figure 17.2). It's absolutely riddled with dust. You won't find this a problem with digital photography – another reason why digital is so much more appealing, despite the nostalgic feel of film!

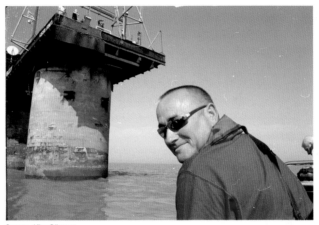

Source: Kim Gilmour

Figure 17.2

I used a photo-editing program to remove the vast majority of the dust (and many scanners have built in dust-detection and removal tools to reduce the problem) but it does take time. To reduce the amount of dust in the first place, try using a *blower brush* to gently dislodge and blow away specks from the negatives – you'll find them at photographic shops, such as Jessops, for under £5. It's a brush that lets you pump air through the bristles (they are also useful for removing dust from camera lenses). Here is how the image looked after a bit of intervention. It's about 95% there.

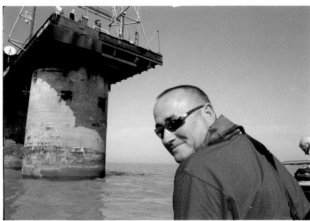

Source: Kim Gilmour

Figure 17.3

A similar problem arises with scratches and creases on old photographs, or missing corners. Using your photo-editing software's clone or blemish-removal tools should help you recreate missing elements of an image or airbrush out those unsightly scratches. Just zoom in on the photo and either drag the brush over the areas that need fixing or copy a nearby area that you want to place over the damaged area (the clone tool).

Depending on the sophistication of the software and the severity of scratches in the photo, this could be a quick process or it may require a little more patience and manual intervention.

Remember to keep a copy of the original scan in case you are not happy with your edits and wish to start again.

Touching up images is a challenge, but an enjoyable one – a little like delicate surgery, perhaps! There is much satisfaction in fixing problems with a few clicks of the mouse and restoring an old image to make it new again. Then you will be able to save and print it again, just as it used to be.

Fingerprints and smudges on fragile negatives can also be a problem and if you are scanning very old film I would think it best to ask for professional advice on how best to wipe these off safely.

Printing fun things

Many of the online photo-printing websites I discussed in Chapter 16 also let you place your prints on things such as mugs, T-shirts, calendars, cushion covers, mouse mats, magnets and stickers. These are great fun. Look out for any special promotional two-for-one offers, as they make good gifts. Here is a canvas print (Figure 17.4) that I ordered online, hanging in my living room, and a magnet on my dishwasher (Figure 17.5) given to me by a friend.

Specialist companies, such as the Moonpig greeting card website (**www.moonpig. com**), VistaPrint stationery company (**www.vistaprint.co.uk**) and Lulu DIY publishing house (**www.lulu.com**) produce these types of things.

Source: Kim Gilmour

Figure 17.4

Source: Kim Gilmour

Figure 17.5

Photobooks

I particularly like the ability to create your own photobook: a bound, printed coffee-table book that you customise with your own photographs and commentary. A photobook is a brilliant keepsake and makes a good wedding gift, too. They don't have the heavy bulk of a traditional album, are easy to flick through, and you can display images in different ways.

Figure 17.6 is an example of a photobook that records a trip to the Greek Islands, which I created using Photobox, along with another all about London snow. It's very easy to design the photobook, so long as you have uploaded all your desired photographs to the website beforehand.

Source: Kim Gilmour

Figure 17.6

Create a photobook project by logging into the site to access its photobook creator, then choose from a mixture of pre-determined layouts – each featuring an empty space for your photographs. You can usually mix and match these – and have say one page featuring a full-page photo of the bride and groom, with the

opposite displaying a triptych of items such as the wedding cake, flowers and church, along with some captions.

You'll be able to access all the photographs you have previously uploaded on to the website then simply drag and drop the desired ones into the appropriate spaces (the process of accessing your photos varies depending on the site, so look at the online instructions for guidance). You can add more pages to the book as necessary and insert captions if the layout allows. Here's Snapfish's photobook creator in action (Figure 17.7).

Source: Snapfish UK

Figure 17.7

Remember that this process can take a little while if your computer does not have much RAM (memory) as the application that installs within your browser can be quite large and eat into your computer resources.

By the way, you don't have to complete your project in one sitting. You can save it and come back to it later when you have thought about how you want to lay it out. By the same token, you can edit and change your layout around before you place your order, or make a slightly different book based on a previous creation.

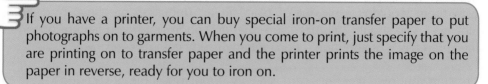

If you have a printer, you can buy special iron-on transfer paper to put photographs on to garments. When you come to print, just specify that you are printing on to transfer paper and the printer prints the image on the paper in reverse, ready for you to iron on.

Greetings cards and other items

Printers often ship with software that lets you create things such as greetings cards and invitations, or photo-themed decorations to place into scrapbooks.

You will be able to work with a series of templates to help you on your way. A template is a pre-determined theme, which you can customise to suit your needs. Some templates may feature fancy fonts and backgrounds dedicated to travel, parties or plainer, more classic themes; and you will often be able to slot your photographs into empty 'frames'. Word-processing software also comes with templates you can often use to showcase your photographs. Figure 17.8 is an example of a calendar template in Microsoft Word, using my own pictures.

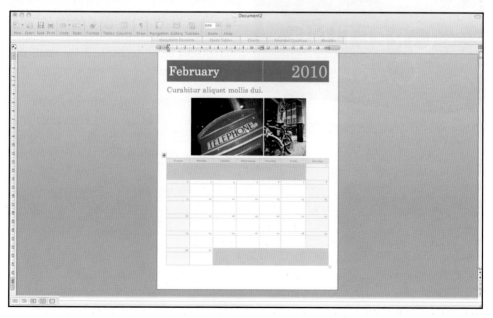

Figure 17.8

Increasingly templates have become more sophisticated and what you create with them wouldn't look out of place in an upmarket greetings card store. However, you should still make sure that any photograph you feature becomes the centrepiece of attention – don't let any gaudy colours overpower it.

Creating your own greetings card is a very popular pastime. If you don't seem to have the software you require, there are many decent packages on the market such as Greeting Card Factory Deluxe from Avanquest.

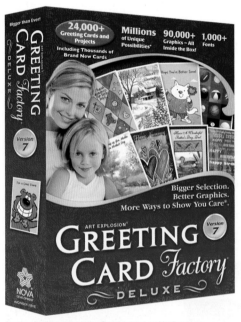

Source: © 2000–2009 Nova Development and its licensors

Figure 17.9

Greeting Card Factory even includes a basic photo editor (you aren't obliged to use it; you can always edit your photo in another program and insert it into your card). The selling point of greeting card creation software, as shown in Figure 17.10, is the ability to customise your cards in countless ways by adding photos, art, text and 'accents' (the little embellishments you can add to your card, such as textured backgrounds, pictures, and the like). And of course, it's cheaper to print your own one-off greetings cards rather than head to a high street store to buy costly, marked-up alternatives.

Such software is readily available to purchase online or you can pop into somewhere like PC World to see what they have on sale.

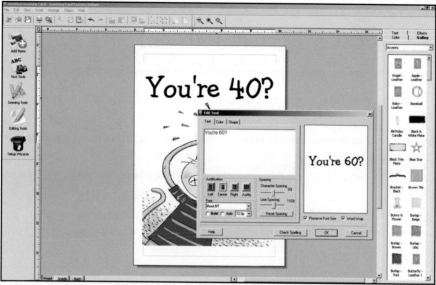

Source: © 2000–2009 Nova Development and its licensors

Figure 17.10

Summary

- Dedicated scanners often have tools to reduce the amount of dust and scratches showing up on your scanned images

- Photo-editing software allows you to remove additional dust, scratches and blemishes from scans

- A scanner's resolution settings are important, particularly if you are scanning tiny slides and negatives

- You can create fun photo-themed gifts using your home printer or an online photo-printing service

Brain Training

There may be more than one answer to each of these questions.

1. How can you minimise the file size of a scanned image?

a) Scan at 300dpi while specifying the output size

b) Scan only at the resolution you require

c) Compress the image slightly

d) Save it as a TIFF file

2. Why would you want a dedicated scanner rather than an all-in-one?

a) They are generally cheaper

b) They scan at lower resolutions

c) They are designed for a greater range of scanning tasks

d) They are easier to use

3. When would a blower brush come in useful?

a) To remove scratches from a photo

b) To remove dust from a negative

c) To remove dust from a camera lens

d) To paint over scratches

4. Why is it important to preview your scans?

a) To adjust how the colours will be scanned

b) To adjust how it will be cropped

c) It is not important

d) To check if it is correctly positioned on the scanner

5. How might you remove scratches from a photograph?

a) Using photo-editing software

b) Using a blower brush

c) Using specialist tools found in your scanner software

d) By scanning at a higher resolution

Answers

Q1 – a, b and c **Q2** – c **Q3** – b and c **Q4** – a, b and d

Q5 – a and c

PART IV
Appendix and Glossary

Thank goodness for image stabilisation.

Appendix: Useful websites

Here is a list of websites that are mentioned in the book as well as some additional photography resources, which I hope you find useful. This list is by no means exhaustive. I am sure that by typing a few terms such as 'photography tips' into Google or a similar search site you will find even more wonderful and inspirational destinations.

Camera, printer and scanner manufacturers

I've listed the most popular manufacturers' websites here. For specific advice related to your product, look for a link called 'support', 'customer services', 'help' or something similar.

www.canon.co.uk	Canon
www.casio.co.uk	Casio
www.epson.co.uk	Epson
www.fujifilm.co.uk	Fujifilm
www.hp.co.uk	HP
www.kodak.co.uk	Kodak
www.leica-camera.co.uk	Leica
www.nikon.co.uk	Nikon
www.olympus.co.uk	Olympus
www.panasonic.co.uk	Panasonic

www.pentax.co.uk Pentax

www.ricoh-cameras.co.uk Ricoh

www.samsung.co.uk Samsung

www.sony.co.uk Sony

Online photo-printing and album services

www.aldiphotos.co.uk ALDI photos

www.bonusprint.co.uk Bonusprint

www.bootsphoto.com Boots Photo

www.colorama.co.uk Colorama

http://uk.foto.com FOTO.com

http://photo.jessops.com Jessops Photo

www.kodakgallery.co.uk Kodak Gallery

www.photobox.co.uk Photobox

www.pixum.co.uk Pixum

www.snapfish.co.uk Snapfish

www.tescophoto.com Tesco Photo

Memory card manufacturers

www.lexar.com Lexar

www.pny-europe.com PNY

www.sandisk.co.uk SanDisk

Camera bags and equipment

www.caselogic.com	Case Logic
www.crumpler.co.uk	Crumpler
www.hama.co.uk	Hama
www.hoya.co.uk	Hoya
www.jessops.com	Jessops
www.joby.com	Joby
www.lastolite.com	Lastolite
www.lowepro.com	Lowepro
www.manfrotto.com	Manfrotto
www.samsonite.co.uk	Samsonite
www.tamrac.co.uk	Tamrac
www.targus.com/UK	Targus
www.thepod.ca	Makers of the beanbag 'tripod'
www.uniross.com	Uniross

Photo-editing software

These programs are designed for use on Windows operating systems unless otherwise stated. For optimum results, please check to ensure that your computer meets the minimum specifications.

www.apple.com	Apple iPhoto (Mac only; part of iLife)
www.arcsoft.com/products/ photoimpression	Arcsoft PhotoImpression

www.adobe.com/products/photoshopelwin	Adobe Photoshop Elements (also available for the Mac)
www.corel.com	Corel Paint Shop Pro Photo
http://download.live.com/photogallery	Windows Live Photo Gallery (free)
www.getpaint.net	Paint.NET (free)
www.gimp.org	GNU Gimp (free; there is a way to run Gimp on a Mac, but I have found it quite tricky to use)
http://picasa.google.com	Google Picasa (free; also available for Mac)
http://www.serif.com/photoplus	Serif PhotoPlus

Photo-sharing and social networking websites

This is a small list of destinations where you can share photos, communicate with friends and discover online chums with like-minded interests.

www.facebook.com	Facebook (the most popular of them all)
www.flickr.com	Flickr (photo sharing; good for inspiration!)
www.friendsreunited.co.uk	Friends Reunited (find old friends)
http://photos.live.com	Windows Live Photos
http://picasaweb.google.com	Picasa Web Albums
www.sagazone.co.uk	Saga Zone (social networking for over 50s)
www.shutterchance.com	Shutterchance
www.shutterfly.com	Shutterfly

External hard drives

There are many manufacturers that make external hard drives. I highly recommend purchasing one to back up your precious photographs.

www.buffalotech.com	Buffalo
www.freecom.com	Freecom
www.iomega.com	Iomega
www.lacie.com/uk/	LaCie
www.maxtor.com/gb	Maxtor
www.seagate.com	Seagate
www.wdc.com	Western Digital

Computer help

Whenever you run into a computing problem, it's likely that someone else on the planet has experienced the same thing. So it's worthwhile searching for your problem online using a search engine such as **www.ask.co.uk**, **www.bing.com**, **www.yahoo.co.uk** or **www.google.co.uk**. If you keep getting a particular error message, for example, you could search for that message.

Use your common sense when you trawl through any websites that proclaim to have all the answers. For example, if you come across a website demanding money in order to fix a computer problem, *ignore it*. Also, be wary of downloading anything to fix a problem unless you are sure it comes from a trusted source, such as from Microsoft's or your camera manufacturer's website.

When searching for the answer to your problem, you are likely to come across questions and solutions that have been posted on online forums. Members of these communities are on hand to give step-by-step solutions. You can visit the forums just to read queries, or join the community yourself by creating an account with them (this is free). The forums usually have their own search tools; I advise using these to check if someone has asked your question before. If you

post a question that gets asked by a new member every other day, it can get a bit tedious for the regulars!

Here's a list of some forums and support pages that you may come across when you conduct a search for your problem. You can also visit them directly. In addition to the following computing-related websites, see the next two sections for photography-related forums and support pages.

http://answers.yahoo.com	Questions and answers posted here aren't just related to computers, but there are always people on hand to respond to your queries
www.bleepingcomputer.com	Bleeping Computer forums and tutorials
www.compukiss.com	Compu-KISS tutorials (KISS is an acronym for 'Keep it simple, stupid' or – my preferred definition – 'Keeping it short and simple')
www.computerhope.com/forum	Computer Hope is one of the biggest help forums on the web
http://support.microsoft.com	Microsoft's official support site is a trusted source

Photography and computing magazines

There is no shortage of magazines that will complement your digital photography adventures. (Note: I am a regular contributor to *Which? Computing* magazine, an independent, subscription-only title that regularly tests digital cameras and related software.)

Many of the websites that accompany the magazines have forums and other resources such as archived reviews. There may be someone online to help if you find yourself in a pickle or just want to show off your latest creative efforts!

www.amateurphotographer.co.uk	*Amateur Photographer* magazine
www.bjp-online.com	*British Journal of Photography*
www.computeractive-magazine.co.uk	*Computeract!ve* magazine and forum
www.digitalslrphoto.com	*Digital SLR Photography* magazine (for users of more advanced digital SLRs)
www.photoanswers.co.uk	*Digital Photo* and *Practical Photography* magazines
www.photographymonthly.com	*Photography Monthly* magazine
www.photoradar.com	*Digital Camera* and *PhotoPlus* magazines
www.webuser.co.uk	*Web User* magazine has an active help forum
www.whatdigitalcamera.com	*What Digital Camera*
www.which.co.uk	*Which? Computing* (part of *Which?*)

Photography forums and communities

Many of the following are US-based but attract international visitors. When following up camera reviews, check to see if that model is available in the UK. It may be marketed under a slightly different name. Members who have signed up to these sites can also help you with specific photography-related queries.

www.dpreview.com	Digital Photography Review
www.ephotozine.com	ePHOTOzine
www.imaging-resource.com	Imaging Resource

www.photo.net	Online forums, peer-to-peer critique and learning resource
www.photocritique.net	Photo Critique
www.photography-forum.org	Photography discussion, help and critique
www.photographyreview.com	Photography Review
www.shutterbug.com	A popular US magazine
www.talkphotography.co.uk	UK-based photography discussion and advice forum

Video tutorials

You can search for photography tips and tutorials on these video-sharing and how-to websites.

www.videojug.com	Good resource of how-to videos on a wide variety of subjects
www.youtube.com	Video demonstrations on all manner of topics

Accessibility help

If you run into any frustrations using your computer due to a disability of any kind, help is at hand. The UK charity AbilityNet is able to give you impartial advice on how to adapt your computer to suit your needs; it can also give you advice about what kind of assistive technology products are available for purchase. Take a look at **www.abilitynet.org.uk**/athome for free factsheets and contact details.

You can also modify your computer settings to increase font sizes or make the computer keyboard and mouse less sensitive to touch, for example. Check out **www.microsoft.com/ENABLE** for more.

Glossary

ALL-IN-ONE A type of printer that combines scanner and copier functions to save on space. Also known as a multi-function device.

APERTURE The adjustable hole in your camera's lens that lets light pass through to its image sensor or film. The aperture size (small or large) affects the image's *exposure* and *depth of field*.

APERTURE PRIORITY A semi-automatic mode found on some cameras where the photographer chooses a desired aperture and the camera sets a shutter speed to ensure the best exposure. Choosing the aperture (whether in aperture priority or completely manual mode) often happens when the photographer wants to adjust the depth of field.

APPLICATION A computer program.

ARTIFACT Unwanted, blocky effect seen on images that have been excessively compressed to reduce their file size.

ASPECT RATIO An image or screen's proportion in relation to length and width, for example 3:2.

AUTO-FOCUS The function on your camera that can automatically detect how an image should be focused.

BROADBAND A high-speed, always-live connection to the Internet; usually accessed over copper phone lines or cable.

BROWSER Software such as Internet Explorer or Firefox that you use to access websites.

BURST MODE (CONTINUOUS MODE) The function on your camera that allows you to take a series of continuous shots in quick succession, so as not to miss any high-speed action.

CAMERA SHAKE Movement of the camera during the moment of exposure. Usually found in pictures taken with a long exposure time, it looks like the picture is slightly blurred. It tends to be exaggerated when you use the zoom function on your lens. To avoid camera shake, use a tripod to steady the camera.

CARD READER See *memory card reader*.

CCD Charge-coupled device. A type of *image sensor* often found in a compact digital camera.

CLONE TOOL A function used in *photo-editing* programs that helps you remove and replace unwanted elements in an image.

CMOS Type of *image sensor* often found in larger cameras such as SLRs. Pronounced 'C-moss', it stands for complementary metal-oxide semiconductor (but you don't really need to know this!).

CMYK Stands for cyan, magenta, yellow and black (the 'key' colours). The colours of the inks used for printing.

COLOUR CORRECTION In photo-editing, this process is used to tweak the colours in an image – for example, if they display an incorrect or undesired colour temperature (*white balance*).

COLOUR TEMPERATURE See *white balance*.

COMPACTFLASH A common type of removable *memory card*.

COMPRESSION A way of reducing the file size of an image. The more compression is applied, the more the file size is reduced – but this irreversibly reduces the image quality.

CONTINUOUS MODE See *burst mode*.

CONTRAST The difference between dark and light elements of an image.

CONTROL PANEL In Windows, this is the area where you can configure the main functions of your computer, such as how the screen looks.

CROP The ability to remove unwanted surroundings of an image, often in order to make it look more interesting and dynamic.

CUT and COPY AND PASTE In computing, this refers to choosing an item such as a block of text or an image then copying it and pasting it into another area or program.

DATA Digital information.

DEPTH OF FIELD How much of an image is in sharp focus. Choosing a small aperture will give you more depth of field (good for landscapes); a large aperture will cause less depth of field to allow a distinct separation of foreground and background (good for portraits).

DESKTOP The main worktop area on your screen that appears when you start up Windows.

DIGITAL ZOOM A way of enlarging an image using digital means rather than a lens, but this results in loss of image quality.

DOWNLOAD The process of obtaining or accessing data from a remote source and on to your computer.

DPI Dots per inch. A measurement of the number of tiny dots that a printer can lay down per linear inch.

DRAG AND DROP The ability to select a file or files with your mouse by pressing the left-mouse button and moving (dragging) it to a different area, such as to a new folder.

DRIVER Computer software that enables a computer and an external device such as a digital camera, printer or scanner to work together.

DSLR/DIGITAL SLR Digital single lens reflex. A camera with an interchangeable lens that lets you have more creative control over your camera settings.

EXIF eXchangeable Image File Format. The information about a photo recorded by a digital camera such as the date, time and camera settings used to take the image and much more.

EXPOSURE Measure of an image's brightness and contrast range; controlled by its shutter speed, ISO and aperture settings.

EXTERNAL HARD DRIVE A device capable of storing data by externally attaching it to your computer. Often used to back up (make a copy of) the contents of the hard drive on your main computer.

F-STOP/F-NUMBER The measurement of the camera's aperture size, which determines how much light goes through, such as f/8 or f/16. The larger the number, the smaller the aperture.

FILE FORMAT The way data is structured in a particular type of file. In digital photography, JPG is the most common file format.

FILE SIZE In digital photography, this refers to how much room a photo takes up on your memory card or hard drive. This depends on several factors including the amount of compression applied, the file format and the photo's resolution.

FOCUS LOCK A feature on automatic cameras that lets you focus on a subject by keeping the shutter button half pressed, and allows them to still be in focus after you recompose the shot.

GIF Graphics Interchange Format. A type of image file you may come across that is more typically used for artwork than photography, as it only supports 256 colours. GIFs can be animated and are commonly seen on websites.

GIGABYTE A measurement of storage, equivalent to 1000 or 1024 megabytes.

GRAPHIC Pictures, such as artwork and photographs.

GREYSCALE The name sometimes given to a black and white image.

HARD DISK/HARD DRIVE The main storage space of your computer, often the C: drive. The higher the capacity of your hard disk, the more it can store.

HARDWARE The physical parts of your computer system such as a keyboard.

HISTOGRAM In digital photography this is a graph that displays the bright and dark elements of an image. Useful for seeing whether a photograph's tones are evenly exposed. You can usually view an image's histogram levels on your digital camera's LCD screen or on your computer using a photo-editing program.

IMAGE EDITING See *photo-editing*.

IMAGE SENSOR The part of a digital camera that captures the image and converts it to digital form.

IMAGE STABILISATION/ANTI-BLUR A common feature of a digital camera that tries to remedy the effect of camera shake.

INKJET PRINTER A printer that lays drops of ink on the paper using nozzles.

ISO International Standards Organisation. A measurement of how sensitive the camera film or image sensor is to light. A high ISO is more sensitive and suitable for when there is less available light.

JPG/JPEG The most common type of image file. Pronounced 'jay peg', it stands for Joint Photographic Experts Group.

KEYWORD In photography, this is a descriptive word or phrase you assign to an image to help you find it again by conducting a keyword search. Many keywords can be assigned to an image.

KILOBYTE (K) A unit of storage. Equivalent to 1000 or 1024 bytes.

LASER PRINTER A type of printer, often used in offices, that can print documents very quickly. Cost-effective and becoming more common in home offices but not usually used for printing quality photographs.

LCD Liquid Crystal Display. The energy-efficient, flat panel used to display electronic images. You'll find an LCD screen at the back of your digital camera. A flat-screen monitor is also an LCD type.

MACRO MODE The feature on your camera that lets you take close-up images.

MANUAL EXPOSURE When composing an image, this allows you to manually control the exposure settings and override any automatic calculations.

MANUAL FOCUS Where available, this lets you control the lens to manually focus on a subject, rather than letting the camera focus automatically.

MEGABYTE A unit of storage equivalent to around 1,000,000 bytes.

MEGAPIXEL Used to measure the amount of detail in an image or the resolution of a digital camera. One million pixels equals one megapixel.

MEMORY See *RAM*.

MEMORY CARD A small, removable device used for storing data; usually found in digital cameras, mobile phones, digital music players and so on. Common memory card types include SD (Secure Digital) and Compact Flash.

MEMORY CARD READER A device that connects to your computer to allow you to read what is stored on the memory card and transfer data to and from it.

MONITOR The screen you use with your computer. Most commonly a flat-screen LCD monitor rather than the older, chunkier CRT (cathode ray tube) type.

NETWORK A series of computers linked together wirelessly or with cables.

NOISE Graininess found in a digital image, which usually happens when ISO settings are high or if exposures are lengthy.

OFFLINE Not connected to the Internet.

ONLINE Connected to the Internet.

OPERATING SYSTEM The underlying software that runs your computer and all its associated programs. Windows is an operating system.

OPTICAL ZOOM A traditional way of zooming in on a subject by using the camera lens, without losing image quality. Optical zoom is a good way of determining the quality of a camera's mechanics. The higher the zoom range, the better.

PDF Stands for Portable Document Format. Owned by Adobe, this file type retains a document's look and feel and does not require you to own the program it was created in. In digital photography, you will find user manuals in PDF form. Get Adobe Reader to view PDF files (**www.adobe.com**).

PHOTO-EDITING The process of manipulating a digital photograph using appropriate software. Also known as image editing.

PHOTO PAPER The special type of paper that allows compatible printers and ink to produce quality photographs.

PHOTO-SHARING The process of transferring photographs across the Internet, often using online albums, so other people can view them.

PICTBRIDGE An industry-standard technology that allows a printer to print photos directly from a digital camera without the use of a computer, so long as both devices support the PictBridge standard.

PIXEL Picture element. One of the small dots that makes up an image. One million pixels equals one megapixel. The more megapixels in an image, the more detail is retained.

PPI Pixels per inch. The more ppi in a digital image, the better the printed image – this is because more definition can be seen.

RAM Random Access Memory. The more memory your computer has, the more programs and large files you can have open at the same time without the computer slowing down.

RAW A type of image file used by professionals and enthusiastic amateurs, usually available in digital SLRs. RAW files retain all detail captured and remain in unprocessed 'raw' form so that they can be edited later on a computer.

RED EYE The effect that happens when flash photography shines into a subject's eyes, causing them to look red.

RESIZE The process of changing the height and width of a digital photograph, for example to make it a more appropriate size to email to a friend.

RESOLUTION The amount of detail recorded in a digital image, usually measured in pixels. A high resolution tends to produce more detailed images due to its increased definition.

RGB Red, green and blue. A combination of these colours makes up the colours displayed on a computer screen.

RULE OF THIRDS The classic rule in visual arts that states how subjects that are slightly off-centre have more appeal.

SCANNER Hardware that transfers two-dimensional items, such as documents, artwork, photos and transparencies, to digital form.

SCENE MODE The feature on a digital camera that allows you to choose the most appropriate scene (such as snow, sport or portrait mode) for your surroundings so that the best exposure, which combines an ideal shutter speed and aperture combination, is automatically achieved.

SD CARD Secure Digital card. A very common type of removable *memory card*.

SDHC CARD Secure Digital High-Capacity card. The new generation of SD card that is able to store far larger amounts of data. However, if you have an older camera or memory card reader, check to see if it supports the SDHC format.

SERVER A computer that has the capability to store a vast amount of data. It allows many other computers to send and receive data from it.

SHARPEN A feature in photo-editing software that makes elements in an image look more prominent and crisp.

SHUTTER The part of a camera that opens and shuts in order to let light in. Activated by pressing the shutter button when taking a photograph.

SHUTTER LAG The inconvenient delay found in some digital cameras between pressing the shutter button and the camera taking the shot.

SHUTTER PRIORITY A semi-automatic mode found on some cameras where the photographer chooses a desired shutter speed, and the camera sets an appropriate aperture to ensure the best exposure. Choosing a shutter speed (whether in shutter priority or completely manual mode) is typically used to 'freeze' or 'blur' movement in a photo.

SHUTTER SPEED The measurement of the length of time the camera shutter is open to allow light to enter, such as 1/60 of a second.

SLR Single lens reflex (see *digital SLR*).

TAG Another name for *keyword*; also used to label people in a digital photo.

TEMPLATE A pre-determined theme or layout that you can customise to suit your needs, such as by substituting your own text or photographs.

THUMBNAIL A small version of a photo that typically links to its full-sized counterpart. Used to let you see your photos at a glance. Double-clicking a thumbnail from Windows Explorer opens the image.

TIFF Tagged Image File Format. A high-quality type of image file that retains, rather than loses, data when it is saved. It is therefore a useful format for archiving, when all detail needs to be retained in the original image. However, files are usually far larger in size than other formats, such as JPG.

TRANSPARENCIES Slide film (also known as positives).

TRIPOD Three-legged device that attaches to your camera and helps stabilise it. Use it in dim or dark conditions or when camera shake may become a problem.

UPDATE A slight upgrade to a program, usually issued to fix minor problems. Most programs need to be updated from time to time by downloading and installing a software update.

UPLOAD Opposite of download – the process of sending information to a remote source.

USB Universal serial bus. A common way of connecting external devices to a main computer.

VIEWFINDER The small hole found in some cameras that you look through when composing an image.

WEB BROWSER See *browser*.

WHITE BALANCE The feature of a digital camera that adjusts an image's colours so that they are better matched to the lighting conditions (fluorescent or cloudy for example). Most cameras have automatic white balance settings (AWB) but there are times you may want to specify your own.

WINDOWS 7 The latest Windows *operating system* from Microsoft, released commercially in late 2009.

WINDOWS VISTA The *operating system* from Microsoft that came before *Windows 7*.

WINDOWS XP An older *operating system* from Microsoft that came before *Windows Vista*.

WIZARD A feature found in many programs that guides you through a particular task such as installing software.

Index

NEW DIRECTION

"... I think that this style of text hits a 'home run.' It meets a serious market need for a text that is short enough to be mostly covered in a semester at an affordable price. Another strength is the integration of services along with manufacturing."

~Don Pope, College of Business Administration, Abilene Christian University

HEAD TO A GREAT ONLINE EXPERIENCE—
4ltrpress.cengage.com/om

- ▸ Data Sets
- ▸ Cases and Problems
- ▸ Interactive Quizzes
- ▸ Printable Flash Cards
- ▸ Interactive Games
- ▸ New Videos
- ▸ PowerPoint® Slides

SOUTH-WESTERN
CENGAGE Learning™

OM, 2010-2011
David A. Collier, James R. Evans

Executive Vice President and Publisher:
Jonathan Hulbert

Vice President of Editorial, Business:
Jack W. Calhoun

Publisher: Joe Sabatino

Director, 4LTR Press: Neil Marquardt

Sr. Acquisitions Editor: Charles McCormick, Jr.

Development Editor: Margaret Kubale

Product Development Manager, 4LTR Press:
Steven Joos

Project Manager, 4LTR Press: Michelle Lockard

Marketing Manager: Bryant Chrzan

Marketing Coordinator: Suellen Ruttkay

Sr. Marketing Communications Manager:
Libby Shipp

Sr. Content Project Manager: Tim Bailey

Media Development Director: Rick Lindgren

Media Editor: Chris Valentine

Manufacturing Frontlist Buyer: Amanda Klapper

Production House: Bill Smith Studio

Sr. Art Director: Stacy Jenkins Shirley

Internal Designer: KeDesign, Mason, OH/
cmiller design

Cover Designer: KeDesign, Mason, OH

Cover Image: © Getty Images/iStock Images

Sr. Image Rights Acquisitions Account Manager:
Deanna Ettinger

Photo Researcher: Jaime Jankowski, Pre-Press
PMG

Sr. Text Rights Acquisitions Account Manager:
Mardell Glinski Schultz

For product information and technology assistance, contact us at
Cengage Learning Customer & Sales Support, 1-800-354-9706

For permission to use material from this text or product,
submit all requests online at **www.cengage.com/permissions**
Further permissions questions can be emailed to
permissionrequest@cengage.com

Exam*View*® is a registered trademark of eInstruction Corp. Windows is a registered trademark of the Microsoft Corporation used herein under license. Macintosh and Power Macintosh are registered trademarks of Apple Computer, Inc. used herein under license.

Cengage Learning WebTutor™ is a trademark of Cengage Learning.

Library of Congress Control Number: 2009930959

Student Edition Package
ISBN-13: 978-0-538-74556-7

ISBN-10: 0-538-74556-8

Student Edition (book only)
ISBN-13: 978-0-538-74555-0

ISBN-10: 0-538-74555-X

South-Western Cengage Learning
5191 Natorp Boulevard
Mason, OH 45040
USA

Cengage Learning products are represented in Canada by Nelson Education, Ltd.

For your course and learning solutions, visit **www.cengage.com**

Purchase any of our products at your local college store or at our preferred online store **www.ichapters.com**

Printed in the United States of America
1 2 3 4 5 6 7 13 12 11 10 09

Brief Contents

Supplementary Chapters (online)

Contents

Supplementary Chapters (On Premium Website)

GOODS, SERVICES, AND OPERATIONS MANAGEMENT

*W*alt Disney clearly put us on the path toward things like quality, great guest service, creativity and innovation," said Mr. Bruce Jones, programming director for the Disney Institute. Disney theme parks and resorts are designed to "create happiness by providing the finest in entertainment for people of all ages, everywhere." How do they accomplish this? By meticulous attention to the management of operations! Disney theme parks and resorts, for example, focus on training employees ("cast members") to provide exceptional guest service; on the use of technology both for entertainment and operational efficiency; on the physical setting (i.e., facility layout, lighting, signage, music, appealing to all five senses), separating "onstage" public areas from "backstage" work operations that include a complex underground system to move materials and people around the properties; on process design issues like efficient waiting lines—and on continuous improvement of everything they do.[1]

© Images-USA/Alamy

What do **you** think?

Describe one experience you had at a theme park that illustrates either good or bad customer service or operational design. What can we learn from your experience regarding how a theme park can create a positive customer experience or improve on a bad one through its design and operations?

learning outcomes

After studying this chapter you should be able to:

LO1 **Explain the concept of operations management.**

LO2 **Describe what operations managers do.**

LO3 **Explain the differences between goods and services.**

LO4 **Describe a customer benefit package.**

LO5 **Explain three general types of processes.**

LO6 **Summarize the historical development of OM.**

LO7 **Describe current challenges facing OM.**

 1 Operations Management

Operations management (OM) *is the science and art of ensuring that goods and services are created and delivered successfully to customers.* Applying the principles of OM entails a solid understanding of people, processes, and technology, and how they are integrated within business systems to create value.

The opening description of Disney illustrates a key theme of this book—*the importance of the design and management of operations for creating goods and services that are valued by customers and society. The way in which goods and services, and the "processes" that create and support them, are designed and managed can make the difference between a delightful or unhappy customer experience.*

Operations management is the only function by which managers can directly affect the value provided to all stakeholders—customers, employees, investors, and society. Effective operations management is essential to providing high-quality goods and services that customers demand, motivating and developing the skills of the people who actually do the work, maintaining efficient operations to ensure an adequate return on investment, and protecting the environment.

Operations management (OM) is the science and art of ensuring that goods and services are created and delivered successfully to customers.

Applying the principles of OM entails a solid understanding of people, processes, and technology, and how they are integrated within business systems to create value.

2 OM in the Workplace

You need not have the title of "operations manager" to "do operations management." Every job entails some aspects of operations management. The ideas and methods of operations management will help you get things done successfully regardless of your functional area of business or industry. As you manage business functions such as accounting, human resource management, legal, financial, operations, supply chain, environment, service, or marketing processes, you create value for your internal customers (within the organization) and for your external customers (outside the organization). Everyone who manages a process or some business activity should possess a set of basic OM skills.

Alaska Airlines' Airport of the Future

At many airports, the passenger check-in area often resembles a mob scene. Passengers queue up in long lines, customers waiting for agents block self-serve kiosks, and finished passengers must push through the crowd again. The process often takes 25–30 minutes. But at Alaska Airlines, employees roam a spacious hall, directing customers toward kiosks. Lines aren't more than three-people deep, and travelers are on their way to security in eight minutes or less.

Moving customers from frustration to relief—in a fraction of the time—has been at the focus of Alaska Airlines' Airport of the Future project. The carrier has spent more than a decade designing a better way to get customers through airport check-in. Alaska's embrace of the future came out of necessity. By the mid-1990s, it was running out of space to handle its Seattle passengers. A new terminal would have cost around $500 million. Alaska tried self-serve kiosks, but technology alone wasn't the answer. Kiosks were pushed against the ticket counter, which only slowed the flow of passengers. The airline assembled a team of employees from across the company and visited theme parks, hospitals, and retailers to see what it could learn. Similar to Disneyland, Alaska placed "lobby coordinators" out front to help educate travelers. The bag-drop stations are further back and arranged so that passengers can see security. Other airlines'

agents lose precious time hauling bags and walking the length of the ticket counter to reach customers. Alaska agents stand at a station with baggage conveyor belts on each side, assisting one passenger while a second traveler places luggage on the free belt. With just a slight turn, the agent can assist the next customer. The project has significantly reduced customer wait times and increased agent productivity.[2]

Operations management is an integrative and interdisciplinary body of knowledge. OM skills are needed in industries as diverse as health care, education, telecommunications, lodging, food service, banking, consulting, and manufacturing.

Below are some other examples of how former students are using OM in their jobs.

Teresa Louis was an accounting major in college and started her career at Chiquita Brands in a division that produces and sells fruit ingredients such as banana puree, frozen sliced bananas, and other types of fruit products. Although her primary job title is accountant and she is involved in monthly accounting closings and

What Do Operations Managers Do?

Some of the key activities that operations managers do include

- Translating market knowledge of customers to design and manage goods, services and processes.
- Helping organizations do more with less.
- Ensuring that resources (labor, equipment, materials, and information) and operations are coordinated.
- Exploiting technology to improve productivity.
- Building quality into goods, services, and processes.
- Determining resource capacity and schedules.
- Creating a high-performance workplace.
- Continually learning and adapting the organization to global and environmental changes.

other accounting tasks, Teresa uses OM skills to support her work. These include:

- **Quality and customer service issues:** If there is a quality issue with a product either at the plant level or the customer level, the accounting group has to account for it in the Inventory Reserve account, which is reconciled during the closing process.

- **Performance measurement and evaluation:** Part of Teresa's responsibility is to look at the monthly profit versus cost analysis by product to calculate a net contribution. She examines the product costs at the plant level to find more efficient and cost-effective methods of production. An example is to increase efficiency by reducing plant down-times, which increases the price per pound of the product. To find more cost-effective methods of producing the product, the biggest area is in constantly looking for better/cheaper fruit sourcing suppliers.

United Performance Metals

United Performance Metals, formerly known as Ferguson Metals, located in Hamilton, Ohio, is a supplier of stainless steel and high-temperature alloys for the specialty metal market. Ferguson's primary production operations include slitting coil stock and cutting sheet steel to customer specifications with rapid turnaround times from order to delivery. Bob Vogel is the Director of Operations and Quality at Ferguson. With only 78 employees, about half of whom are in operations, Bob is involved in a variety of daily activities that draw upon knowledge of not only OM and engineering, but also finance, accounting, organizational behavior, and other subjects. He typically spends about 50 percent of his time working with foremen, supervisors, salespeople, and other staff through email and various meetings, discussing such issues as whether or not the company has the capability to accomplish a specific customer request, as well as routine production, quality, and shipping issues. While he makes recommendations to his direct reports, his interaction is more of a consultant than a manager; his people are fully empowered to make key decisions. The remainder of his time is spent investigating such issues as the technical feasibility and cost implications of new capital equipment or changes to existing processes, trying to reduce costs, seeking and facilitating design improvements on the shop floor, and motivating the work force. For example, one project involves working with the Information Technology group to reduce the amount of paperwork required to process orders. While understanding specialty metals is certainly a vital part of his job, the ability to understand customer needs, apply approaches to continuous improvement, understand and motivate people, work cross-functionally across the business, and integrate processes and technology define Bob's job as an operations manager. In 2008, the company merged with AIM International as United Performance Metals.

V. P. of Operations Bob Vogel

Coiled steel awaiting processing

Slitting coils into finished strips

Some of Ferguson's finished products

- **Managing inventory:** Part of the closing process is to reconcile the Inventory Movement because inventory is what drives the fruit commodity business. It is very important to make sure inventory balances and levels are accurate as this is what the percentage of sales is based on. She is also involved in ensuring inventory accuracy at the company's distribution centers.

Tom James is a senior software developer for a small software development company that creates sales proposal automation software. Tom uses OM skills in dealing with quality and customer service issues related to the software products he is involved in developing. He is also extensively involved in project management activities related to the development process, including identifying tasks, assigning developers to tasks, estimating the time and cost to complete projects, and studying the variance between the estimated and actual time it took to complete the project. He is also involved in continuous improvement projects; for example, he seeks to reduce development time and increase the efficiency of the development team. Tom was an information technology and management major in college.

Brooke Wilson is a process manager for JPMorgan Chase in the credit card division. After several years working as an operations analyst, he was promoted to a production supervisor position overseeing "plastic card production." Among his OM-related activities are

- **Planning and budgeting:** Representing the plastic card production area in all meetings, developing annual budgets and staffing plans, and watching technology that might affect the production of plastic credit cards.

- **Inventory management:** Overseeing the management of inventory for items such as plastic blank cards, inserts such as advertisements, envelopes, postage, and credit card rules and disclosure inserts.

- **Scheduling and capacity:** Daily to annual scheduling of all resources (equipment, people, inventory) necessary to issue new credit cards and reissue cards that are up for renewal, replace old or damaged cards, as well as cards that are stolen.

- **Quality:** Embossing the card with accurate customer information and quickly getting the card in the hands of the customer.

Brooke was an accounting major in college.

3 Understanding Goods and Services

good *is a physical product that you can see, touch, or possibly consume.* Examples of goods include: oranges, flowers, televisions, soap, airplanes, fish, furniture, coal, lumber, personal computers, paper, and industrial machines. *A **durable good** is a product that typically lasts at least three years.* Vehicles, dishwashers, and furniture are some examples of durable goods. A **nondurable good** *is perishable and generally lasts for less than three years.* Examples are toothpaste, software, shoes, and fruit. *A **service** is any primary or complementary activity that does not directly produce a physical product.* Services represent the nongoods part of a transaction between a buyer (customer) and seller (supplier).[3] Common examples of services are hotels, legal and financial firms, airlines, health care organizations, museums, and consulting firms.

Goods and services share many similarities. They are driven by customers and provide value and satisfaction to customers who purchase and use them. They can be standardized for the mass market or customized to individual needs. They are created and provided to customers by some type of process involving people and technology. Services that do not involve significant interaction with customers (for example, credit card processing) can be managed much the same as goods in a factory, using proven principles of OM that have been refined over the years. Nevertheless, some very significant differences exist between goods and services that make the management of service-providing organizations different from goods-producing organizations and create different demands on the operations function.[4]

1. *Goods are tangible while services are intangible.* Goods are consumed, but services are experienced. Goods-producing industries rely on machines and "hard technology" to perform work. Goods can be moved, stored, and repaired, and generally require physical skills and expertise during production. Customers can often try them before buying. Services, on the other hand, make more use of information systems and other "soft technology," require strong behavioral skills, and are often difficult to describe and demonstrate. A senior executive of the Hilton Corporation stated, "We sell time. You can't put a hotel room on the shelf."[5]

> A senior executive of the Hilton Corporation stated, "We sell time. You can't put a hotel room on the shelf."

© Digital Vision/Getty Images

2. *Customers participate in many service processes, activities, and transactions.* Many services require that the customer be present either physically, on a telephone, or online for service to commence. In addition, the customer and service-provider often co-produce a service, meaning that they work together to create and simultaneously consume the service, as would be the case between a bank teller and a customer to complete a financial transaction.

This characteristic has interesting implications for operations. For example, it might be possible to off-load some work to the customer by encouraging self-service (supermarkets, cafeterias, libraries) and self-cleanup (fast-food restaurants, campgrounds, vacation home rentals). The higher the customer participation, the more uncertainty the firm has with respect to service time, capacity, scheduling, quality performance, and operating cost.

Customers judge the value of a service and form perceptions through service encounters.

A **service encounter** *is an interaction between the customer and the service provider.* Service encounters consist of one or more **moments of truth**—*any episodes, transactions, or experiences in which a customer comes into contact with any aspect of the delivery system, however remote, and thereby has an opportunity to form an impression.*[6] Employees who interact directly with customers, such as airline flight attendants, nurses, lawyers, fast-food counter employees,

telephone customer service representatives, dentists, and bank tellers need to understand the importance of service encounters to their customers. Customers judge the value of a service and form perceptions through service encounters.

3. *The demand for services is more difficult to predict than the demand for goods.* Customer arrival rates and demand patterns for such service delivery systems as banks, airlines, supermarkets, telephone service centers, and courts are very difficult to forecast. The demand for services is time-dependent, especially over the short term (by hour or day). This places many pressures on service firm managers to adequately plan staffing levels and capacity.

4. *Services cannot be stored as physical inventory.* In goods-producing firms, inventory can be used to decouple customer demand from the production process or between stages of the production process and ensure constant availability despite fluctuations in demand. Service firms do not have physical inventory to absorb such fluctuations in demand. For service delivery systems, availability depends on the system's capacity. For example, a hospital must have an adequate supply of beds for the purpose of meeting unanticipated patient demand, and a float pool of nurses when things get very busy. Once an airline seat, a hotel room, or an hour of a lawyer's day are gone there is no way to recapture the lost revenue.

5. *Service management skills are paramount to a successful service encounter.* Service-providers require service management skills such as knowledge and technical expertise (operations), cross-selling other products and services (marketing), and good human interaction skills (human resource).

Service management *integrates marketing, human resource, and operations functions to plan, create, and deliver goods and services, and their associated service encounters.* OM principles are useful in designing service encounters and supporting marketing objectives.

A **service encounter** is an interaction between the customer and the service provider.

Moments of truth—any episodes, transactions, or experiences in which a customer comes into contact with any aspect of the delivery system, however remote, and thereby has an opportunity to form an impression.

6. *Service facilities typically need to be in close proximity to the customer.* When customers must physically interact with a service facility, for example, post offices, hotels, and branch banks, they must be located convenient to customers. A manufacturing facility, on the other hand, can be located on the other side of the globe, as long as goods are delivered to customers in a timely fashion. In today's Internet age and with evolving service technologies, "proximity" need not be the same as location; many services are only a few mouse clicks away.

7. *Patents do not protect services.* A patent on a physical good or software code can provide protection from competitors. The intangible nature of a service makes it more difficult to keep a competitor from copying a business concept, facility layout, or service encounter design. For example, restaurant chains are quick to copy new menu items or drive-through concepts.

These differences between goods and services have important implications to all areas of an organization, and especially to operations. These are summarized in Exhibit 1.1. Some are obvious, while others are more subtle. By understanding them, organizations can better select the appropriate mix of goods and services to meet customer needs and create the most effective operating systems to produce and deliver those goods and services.

Service management integrates marketing, human resource, and operations functions to plan, create, and deliver goods and services, and their associated service encounters.

A **customer benefit package (CBP)** is a clearly defined set of tangible (goods-content) and intangible (service-content) features that the customer recognizes, pays for, uses, or experiences.

A **primary good or service** is the "core" offering that attracts customers and responds to their basic needs.

Peripheral goods or services are those that are not essential to the primary good or service, but enhance it.

A **variant** is a CBP feature that departs from the standard CBP and is normally location- or firm-specific.

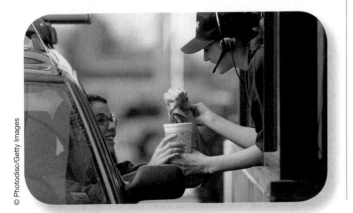

© Photodisc/Getty Images

4 Customer Benefit Packages

a**customer benefit package (CBP)** *is a clearly defined set of tangible (goods-content) and intangible (service-content) features that the customer recognizes, pays for, uses, or experiences.* In simple terms, it is some combination of goods and services configured in a certain way to provide value to customers. A CBP consists of a primary good or service, coupled with peripheral goods and/or services, and sometimes variants. *A primary good or service is the "core" offering that attracts customers and responds to their basic needs.* For example, the primary service of a personal checking account is convenient financial transactions. **Peripheral goods or services** *are those that are not essential to the primary good or service, but enhance it.* A personal checking account might be supported and enhanced by such peripheral goods as a printed monthly account statement, designer checks and checkbooks, a special credit card, and such peripheral services as a customer service hotline and online bill payment. It is interesting to note that today, many business-to-business manufacturers, such as custom machining or metal fabricators, think of their core offering as service—providing customized design assistance and on-time delivery—with the actual good as peripheral. *Finally, a **variant** is a CBP feature that departs from the standard CBP and is normally location- or firm-specific.* A CBP can easily be expressed in a graphical fashion as shown in Exhibit 1.2. The CBP attributes and features (described in the circles) are chosen by management to fulfill certain customer wants and needs. For example, designer checks, a peripheral good, meet the customer's wants and needs of style and image. Online bill payment, a peripheral service, meets the customer's wants and needs of convenience and speed of service. A variant might be a fishing pond where kids can fish while parents shop for vehicles. When drawing the CBP one should not mix CBP features and customer wants and needs on the same diagram. An electronic key on a hotel door is a CBP feature while what the customer wants and needs is safety.

The size of the circles in the CBP framework can signify the relative importance of each good and service. In some cases, goods and services content in a CBP framework are approximately equal. For

Exhibit 1.1 *How Goods and Services Affect Operations Management Activities*

OM Activity	Goods	Services
Forecasting	Forecasts involve longer-term time horizons. Manufacturers can use physical inventory as a buffer to mitigate forecast errors. Forecasts can be aggregated over larger time frames (e.g., months or weeks).	Forecast horizons generally are shorter, and forecasts are more variable and time-dependent. Forecasting must often be done on a daily or hourly basis, or sometimes even more frequently.
Facility Location	Manufacturing facilities can be located close to raw materials, suppliers, labor, or customers/markets.	Service facilities must be located close to customers/markets for convenience and speed of service.
Facility Layout and Design	Factories and warehouses can be designed for efficiency because few, if any, customers are present.	The facility must be designed for customer interaction.
Technology	Manufacturing facilities use various types of automation to produce goods.	Service facilities tend to rely more on information-based hardware and software.
Quality	Manufacturers can define clear, physical, and measurable quality standards and capture measurements using various physical devices.	Quality measurements must account for customer's perception of service quality and often must be gathered through surveys or personal contact.
Inventory/Capacity	Manufacturers use physical inventory as a buffer for fluctuations in demand.	Service capacity is the substitute for inventory.
Process Design	Because customers have no participation or involvement in manufacturing processes, the processes can be more mechanistic.	Customers usually participate extensively in service creation and delivery, requiring more flexibility and adaptation to special circumstances.
Job/Service Encounter Design	Manufacturing employees require strong technical skills.	Service employees need more behavioral and service management skills.
Scheduling	Scheduling revolves around movement and location of materials, parts, and subassemblies and can be accomplished at the discretion and for the benefit of the manufacturer.	Scheduling revolves around capacity, availability, and customer needs, often leaving little discretion for the service provider.

A similar classification of OM activities in terms of high/low customer contact was first proposed in the classic article: Chase, R. B., "Where does the customer fit in a service operation?" *Harvard Business Review*, November–December 1978, p. 139.

Buying More than a Car

Goods and services are usually bundled together as a deliberate marketing and operations strategy. Mercedes automobiles, for example, bundle a premium good, the automobile, with many premium services. Such services include customized leasing, insurance, and warranty programs that focus on the "financial productivity" of owning a Mercedes vehicle. Other customized services bundled with the vehicle include personalized invitations to drive its new cars on a test track, a 24/7 telephone hot line, and invitations to private owner parties. Such bundling is described by the customer benefit package framework.[7]

example, McDonald's (food and fast service) and IBM (computers and customer solutions) might argue that their primary goods and services are of equal importance, so a graphical representation would show two equal-sized and overlapping circles as the center of the CBP.

Finally, we may bundle a group of CBPs together. One example would be a combined land-cruise vacation to Alaska, which might consist of a bundle of CBPs such as the travel agency that books the package and optional land excursions from the ship; the land-tour operator that handles hotels, transportation, and baggage handling; and the cruise line that provides air travel, meals, and entertainment. Bundled CBPs raise some interesting issues about pricing strategies and partnerships among firms. For example, a firm

Exhibit 1.2 *A CBP Example for Purchasing a Vehicle*

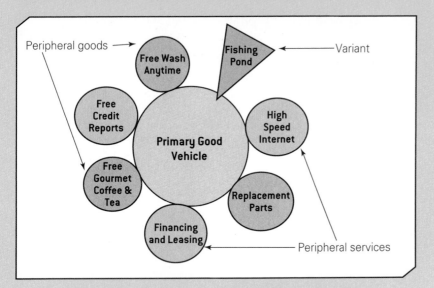

Peripheral goods →

Free Wash Anytime

Fishing Pond ← Variant

Free Credit Reports

Primary Good Vehicle

High Speed Internet

Free Gourmet Coffee & Tea

Replacement Parts

Financing and Leasing

Peripheral services →

might actually be able to charge a premium price for the bundled CBPs than if purchased separately, or alliances between hotels and airlines provide discounted vacation packages that are less expensive than if booked separately.

The CBP framework is a way to conceptualize and visualize goods and services by thinking broadly about how goods and services are bundled and configured together. This is a key input to designing the right process to create and deliver each of the goods or services to customers.

In most cases, however, many "goods" and "services" that we normally think of have a mixture of both goods and service content. Exhibit 1.3 illustrates a continuum of goods and service content with several examples. Toothpaste, for instance, is high in goods content, but when you purchase it, you are also purchasing some services, such as a telephone call center to field customer questions and complaints. Similarly, a bicycle might seem like a pure good, but it often includes such services as safety instruction and maintenance. At the other extreme in Exhibit 1.3 are psychiatric services, which are much higher in service content, but might include goods such as a bill, books, and medical brochures that support the service. Attending a symphony, play, or movie is essentially a pure service, but may include program brochures and ticket stubs that offer discounts at local restaurants as peripheral goods.

Exhibit 1.3 *Examples of Goods and Service Content*

Toothpaste
Bicycle
Medicine Prescription
Automobile brakes and mufflers
Fast Food Restaurant
Computer Diagnosis & Repair
College
Automobile Loan & Leasing
Symphony, Play and Movie
Psychiatric Session

High Goods Content (Tangible) (Pure Goods)

Low Goods Content (Intangible) (Pure Service)

Biztainment – (Huh?)

Why would someone pay, for example, to crush grapes with her feet? Might it be that the process of doing this is as valuable to the customer as the outcome itself? Entertainment is the act of providing hospitality, escapism, fun, excitement, and/or relaxation to people as they go about their daily work and personal activities. The addition of entertainment to an organization's customer benefit package provides unique opportunities for companies to increase customer satisfaction and grow revenue. **Biztainment** is the practice of adding entertainment content to a bundle of goods and services in order to gain competitive advantage. The old business model of just selling and servicing a physical vehicle is gone. For example, a BMW automobile dealership in Fort Myers, Florida, recently opened a new 52,000-square-foot facility that offers a putting green, private work areas, a movie theater, wireless Internet access, massage chairs, a golf simulator, and a café, so that customers have multiple entertainment options during their visits.

Biztainment can be applied in both manufacturing and service settings. Consider the following examples:

- Manufacturing—old and new factory tours, showrooms, customer training and education courses, virtual tours, short films on how things are made, driving schools, history lessons on the design and development of a physical good
- Retail—shopping malls, simulators, product demonstrations, climbing walls, music, games, contests, holiday decorations and walk-around characters, blogs, interactive store designs, aquariums, movie theaters, makeovers
- Restaurants—toys, themes, contests, games, characters, playgrounds, live music
- Agriculture—pick-your-own food, mazes, make-your-own wine, grape-stomping, petting zoos, farm tours
- Lodging—kids' spas, health clubs, casinos, cable television, arcades, massage, wireless Internet, arts and crafts classes, pools, family games, wildlife, miniature golf
- Telecommunications—picture mail, text and video messaging, music and TV downloads, cool ring tones, designer phones, iPhone "apps"

Some organizations that use entertainment as a means of enhancing the firm's image and increasing sales that you might be familiar with are the Hard Rock Café, Chuck E. Cheese, and Benihana of Tokyo restaurants; cable TV shows like *How It's Made*; the Las Vegas Treasure Island casino/hotel pirate battle; and so on. The data show the value of biztainment. For example, Build-A-Bear Workshop boasts an average of $600 per square foot in annual revenue, double the U.S. mall average, and Holiday Inns found that hotels with holidomes have a 20% higher occupancy rate and room rates that are, on average, $28 higher.[8]

5 Processes

 process *is a sequence of activities that is intended to create a certain result,* such as a physical good, a service, or information. A practical definition, according to AT&T, is that a process is how work creates value for customers.[9] Key processes in business typically include:

1. **value creation processes,** focused on primary goods or services, such as assembling dishwashers or providing a home mortgage;
2. **support processes,** such as purchasing materials and supplies, managing inventory, installation, customer support, technology acquisition, and research and development; and
3. **general management processes,** including accounting and information systems, human resource management, and marketing.

Exhibit 1.4 depicts how these different types of process are interrelated. For example, the objective of general management processes is to coordinate key value creation and support processes to achieve organization goals and objectives.

Processes are the building blocks for the creation of goods and services, and are vital to many activities in operations management. For example, consider the CBP for purchasing a vehicle that is shown in Exhibit 1.2. Processes need to be designed to create and deliver each of the peripheral goods and services shown in the exhibit.

> A **process** is a sequence of activities that is intended to create a certain result.

Exhibit 1.4 *How Primary, Support, Supplier, and Management Processes Are Related*

For example, process objectives for a free car wash would be speed of service, a clean car, and no vehicle damage. OM managers would ask questions such as: Should the car wash clean the inside as well as the outside of the car? How long should a customer be expected to wait? What types of chemicals should be used to clean the car? What training should the employees who interact with the customer and service the vehicle have? The process would consist of such steps as checking the car in, performing the wash, inspecting the results, notifying the customer that the car is finished, and quickly delivering the car back to the customer.

All organizations have networks of processes that create value for customers (called *value chains*, which we explore in Chapter 2). For example, Pal's Sudden Service (see the box below) begins with raw materials and suppliers providing items such as meat, lettuce, tomatoes, buns, and packaging; uses intermediate processes for order taking, cooking, and final assembly; and ends with order delivery and hopefully—happy customers.

Pal's Sudden Service

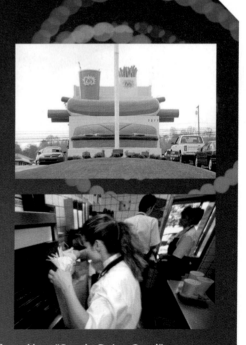

Pal's Sudden Service is a small chain of mostly drive-through quick service restaurants located in northeast Tennessee and southwest Virginia. Pal's competes against major national chains and outperforms all of them by focusing on important customer requirements such as speed, accuracy, friendly service, correct ingredients and amounts, proper food temperature, and safety. Pal's uses extensive market research to fully understand customer requirements: convenience; ease of driving in and out; easy-to-read menus; simple, accurate order-system; fast service; wholesome food; and reasonable price. To create value, Pal's has developed a unique ability to effectively integrate production and service into its operations. Pal's has learned to apply world-class management principles and best-in-class processes in a customer-driven approach to business excellence that causes other companies to emulate their systems. Every process is flowcharted and analyzed for opportunities for error, and then mistake-proofed if at all possible. Entry-level employees—mostly high school students in their first job—receive 120 hours of training on precise work procedures and process standards in unique self-teaching, classroom, and on-the-job settings, and reinforced by a "Caught Doing Good" program that provides recognition for meeting quality standards and high-performance expectations. In such performance measures as complaints, profitability, employee turnover, safety, and productivity, Pal's has a significant advantage over its competition.

Courtesy of Pal's Sudden Service

6 OM: A History of Change and Challenge

n the last century, operations management has undergone more changes than any other functional area of business and is the most important factor in competitiveness. That is one of the reasons why every business student needs a basic understanding of the field. Exhibit 1.5 is a chronology of major themes that have changed the scope and direction of operations management over the last half century. To better understand the challenges facing modern business and the role of OM in meeting them, let us briefly trace the history and evolution of these themes.

6.1 A Focus on Efficiency

Contemporary OM has its roots in the Industrial Revolution that occurred during the late 18th and early 19th centuries in England. Until that time, goods had been produced in small shops by artisans and their apprentices without the aid of mechanical equipment.

During the Industrial Revolution, however, many new inventions came into being that allowed goods to be manufactured with greater ease and speed. The inventions reduced the need for individual artisans and led to the development of modern factories.

© Bettmann/CORBIS

As international trade grew in the 1960s, the emphasis on operations efficiency and cost reduction increased. Many companies moved their factories to low-wage countries. Managers became enamored with computers, robots, and other forms of technology. While advanced technology continues to revolutionize and improve production, in the 1960s and 1970s technology was viewed primarily as a method of reducing costs, and distracted managers from the important goal of improving the quality of goods and services and the processes that create them. American business was soon to face a rude awakening.

Exhibit 1.5 *Five Eras of Operations Management*

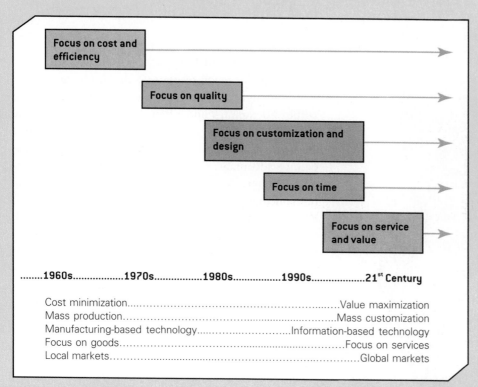

Focus on cost and efficiency

Focus on quality

Focus on customization and design

Focus on time

Focus on service and value

........1960s................1970s...............1980s................1990s..................21ˢᵗ Century

Cost minimization...Value maximization
Mass production..Mass customization
Manufacturing-based technology............................Information-based technology
Focus on goods...Focus on services
Local markets...Global markets

Today, about 90 percent of the jobs in the U.S. economy are in service-providing processes.

6.2 The Quality Revolution

As Japan was rebuilding from the devastation of World War II, two U.S. consultants, W. Edwards Deming and Joseph Juran, were sought extensively by Japanese industry. Deming and Juran told Japanese executives that continual improvement of quality would open world markets, free up capacity, and improve their economy. The Japanese eagerly embraced that message. They embarked on a massive effort to train the workforce, using statistical tools developed at Western Electric and other innovative management tools to identify causes of quality problems and fix them. They made steady progress in reducing defects and paid careful attention to what consumers wanted. Those efforts continued at a relentless pace until, by the mid 1970s, the world discovered that Japanese goods had fewer defects, were more reliable, and better met consumer needs than American goods. As a result, Japanese firms captured major shares of world markets in many different industries such as automobiles and electronics. Therefore, quality became an obsession with top managers of nearly every major company and its impact continues to be seen today. In 1987 the U.S. government established the Malcolm Baldrige National Quality Award to focus national attention on quality.

Courtesy of Motorola Archives

6.3 Customization and Design

As the goals of low cost and high product quality became "givens," companies began to emphasize innovative designs and product features to gain a competitive edge. Quality meant much more than simply defect reduction; quality meant offering consumers new and innovative products that not only met their expectations, but also surprised and delighted them. Inflexible mass-production methods that produced high volumes of standardized goods and services using unskilled or semiskilled workers and expensive single-purpose equipment, though very efficient and cost-effective, were inadequate for the new goals of increased good and service variety and continual product improvement. The operating system had to change.

New types of operating systems emerged that enabled companies to manufacture goods and services better, cheaper, and faster than their competitors, while facilitating innovation and increasing variety. The Internet began to help companies customize their goods and services for global markets.

6.4 Time-Based Competition

Companies that do not respond quickly to changing customer needs will lose out to competitors that do. An example of quick response is the production of the custom-designed Motorola pager, which is completed within 80 minutes and often can be delivered to the customer the same day. As information technology matured, time became an important source of competitive advantage. Quick response is achieved by continually improving and reengineering processes; that is, fundamentally rethinking and redesigning processes to achieve dramatic improvements in cost, quality, speed, and service. That task includes developing products faster than competitors, speeding ordering and delivering processes, rapidly responding to changes in customers' needs, and improving the flow of paperwork.

Exhibit 1.6 *U.S. Employment by Major Industry*

U.S. Industry	Percent of Total Employment
Goods-Producing Sector	
Construction	4.1%
Agriculture	2.2
Mining	0.3
Fishing, Forestry, Hunting, and Misc.	0.1
Manufacturing	11.6
Durable Goods*	7.0
Nondurable Goods**	4.6
Total	18.2%
Service-Providing Sector	
Transportation	3.0%
Communication and Public Utilities	1.7
Wholesale Trade	4.5
Finance, Insurance, and Real Estate	5.2
Agricultural Services	0.7
Hotels and Lodging	1.5
Personal Services	1.0
Business Services	8.0
Auto Repair and Parking	1.1
Motion Pictures	0.5
Amusement and Recreation Services	1.4
Health Services	8.6
Legal Services	0.8
Education Services	2.2
Child Care and Other Services	2.6
Membership Organizations	2.1
Museums and Zoological Gardens	0.1
Engineering, Architectural, and Management Services	3.1
Retail Trade and Services	15.7
Federal Government Services	1.6
State and Local Government Services	11.9
Miscellaneous Services	4.6
Total	81.8%
Grand Total	100.0%

*Durable goods are items such as instruments, vehicles, aircraft, computer and office equipment, machinery, furniture, glass, metals, and appliances.
**Nondurable goods are items such as textiles, apparel, paper, food, coal, oil, leather, plastics, chemicals, and books.
Source: United States Bureau of Labor Statistics

6.5 The Service Revolution

While the goods-producing industries were getting all the attention in the business community, the popular press, and in business school curricula, service industries were quietly growing and creating many new jobs in the U.S. economy. In 1955, about 50 percent of the U.S. workforce was employed in goods-producing industries and 50 percent in service-providing industries. Today, about four of every five U.S. jobs are in services.

Exhibit 1.6 documents the structure of the U.S. economy and where people work. This aggregate mix between goods-producing and service-providing jobs is 81.8 percent service and 18.2 percent goods. There are many interesting industry comparisons in Exhibit 1.6, but let's point out just a few. Manufacturing, for example, accounts for 11.6 percent of total U.S. employment or about 1 in 10 jobs. Today, state and local government jobs are 11.9 percent of total jobs, that is, about the same percent as manufacturing. Many other countries, such as France and the United Kingdom, also have a high percentage of total jobs in the service sector.

In addition, estimates are that at least 50 percent of the jobs in goods-producing industries are service- and information-related such as human resource management, accounting, financial, legal, advertising, purchasing, engineering, and so on. Thus, today, about 90 percent of the jobs in the U.S. economy are in service-providing processes [81.8 + (.5)(18.2%) = 90.9%]. This means that if you are employed in the United States, you will most likely work in a service- or information-related field. Because of these statistics, a principal emphasis in this book is on services—either in service-providing industries such as health care and banking or understanding how services complement the sale of goods in goods-producing industries such as machine tools and computers.

7 Current Challenges in OM

OM is continually changing, and all managers need to stay abreast of the challenges that will define the future workplace. Among these are technology, globalization, changing customer expectations, a changing workforce, the loss of manufacturing jobs in western nations, and building sustainability as part of an organization's corporate responsibility.

- Technology has been one of the most important influences on the growth and development of OM during the second half of the 20th century. Microprocessors have become ubiquitous in most consumer products and industrial processes. Advances in design and fabrication of goods as well as advances in information technology to enhance services have provided the ability to develop products that one could only dream of a few decades ago. They also enable managers to more effectively manage and control extremely complex operations.

- Globalization has changed the way companies do business and must manage their operations. With advances in communications and transportation, we have passed from the era of huge regional factories with large labor forces and tight community ties to an era of the "borderless marketplace." No longer are "American" or "Japanese" products manufactured exclusively in America or Japan. The Mazda Miata, for example, was designed in California, financed in Tokyo and New York, tested in England, assembled in Michigan and Mexico, and built with components designed in New Jersey and produced in Japan.

- Consumers' expectations have risen dramatically. They demand an increasing variety of products with new and improved features that meet their changing needs. They expect products that are defect-free, have high performance, are reliable and durable, and are easy to repair. They also expect rapid and excellent service for the products they buy. For the services they buy, customers expect short waiting and processing times, availability when needed, courteous treatment from employees, consistency, accessibility and convenience, accuracy, and responsiveness to unex-

Sustainability refers to an organization's ability to strategically address current business needs and successfully develop a long-term strategy that embraces opportunities and manages risk for all products, systems, supply chains, and processes to preserve resources for future generations.

pected problems. Companies must now compete on all these dimensions.

- Today's workers are different; they demand increasing levels of empowerment and more meaningful work. Today's work requires constant learning and more abstract thinking and on-the-spot decision-making skills. Service plays a much greater role within organizations. Finally, the environment is different; we live in a global business environment without boundaries.

- Perhaps the biggest challenge that OM faces in modern Western nations is the loss of manufacturing jobs. While manufacturing has contributed immensely to Western nations' standard of living and quality of life, the economic pressures on manufacturing are so great that firms move operations to other nations, merge with other firms, or face bankruptcy. Today, manufacturing is truly a global management challenge where OM plays a vital role. Companies that are persistent innovators of their global operations and supply chains create a huge competitive advantage. In addition, for a whole host of emerging industries, such as recycling, genetic engineering, nanotechnology, green manufacturing, space technology, new methods of energy generation, and robotic medical equipment, new and exciting opportunities emerge for manufacturers. OM issues of design, production, quality, cost, cycle time, safety, and delivery have been critical in past decades, and they will continue to be so in the future. To compete, manufacturers must stay ahead of consumers' needs by increasing product innovation, speeding up time-to-market, and operating highly effective global supply chains. This global perspective makes OM a critical skill, now and in the future.[10]

- A final challenge that nearly every organization faces is sustainability. **Sustainability** *refers to an organization's ability to strategically address current business needs and successfully develop a long-term strategy that embraces opportunities and manages risk for all products, systems, supply chains, and processes to preserve resources for future generations.* The three dimensions of sustainability are environmental, social, and economic. Environmental sustainability focuses on OM activities such as remanufacturing, waste management, green supply chains, and energy conservation. Social sustainability requires organizations to continually evaluate the impacts of their products and operations on society as a part of the organization's overall corporate responsibilities, such as creating a zero carbon footprint product or supply chain. Finally, economic sustainability revolves around making sound financial and operational decisions about workforce capability and capacity, resource acquisitions, technology, knowledge, core competencies, work systems, facilities, and equipment, as well as preparation for real-time or short-term emergencies. All of these activities relate closely to OM, making sustainability an important issue for all operations managers.

Problems, Activities, and Discussions

1. Explain how operations management activities affect the customer experiences described in the anecdote at the beginning of this chapter. What "moments of truth" would a customer at Disney World encounter? Think about the total experience including lodging, food service, shopping, and transportation, as well as theme park attractions and operations.

2. Describe a customer experience you have personally encountered where the good or service or both were unsatisfactory (for example, defective product, errors, mistakes, poor service, service upsets, and so on). How might the organization have handled it better and how could operations management have helped?

3. What implications do the differences between goods and services have for organizations trying to provide both goods and services to customers in a balanced CBP? Do you see any conflicts in a goods-producing versus service-providing way of thinking?

4. Provide some examples similar to those in Exhibit 1.3, and explain the degree of goods and services content for these examples.

5. Explain why a bank teller, nurse, or flight attendant must have service management skills. How do the required skills differ for someone working in a factory? What are the implications for hiring criteria and training?

6. Draw the customer benefit package (CBP) for one of the items in the following list and explain how your CBP provides value to the customer. Make a list of the processes that you think would be necessary to create and deliver each good or service in the CBP you selected and briefly describe issues that must be considered in designing these processes.

 - a trip to Disney World
 - a new personal computer
 - a credit card
 - a fast-food restaurant
 - a wireless mobile telephone
 - a one-night stay in a hotel

7. Review the box for Pal's Sudden Service and find Pal's Web site. Based on this information, describe all the OM activities that occur in a typical day at Pal's.

8. Search the Web for "factory tours or stories of quality failures." Write a paper describing the operations in one of the companies you found.

9. One of our students, who had worked for Taco Bell, related a story of how his particular store developed a "60-second, 10-pack club" as an improvement initiative and training tool. The goal was to make a 10-pack of tacos in a minute or less, each made and wrapped correctly, and the total within one ounce of the correct weight. Employees received recognition and free meals for a day. Employees strove to become a part of this club, and more importantly, service times dropped dramatically. Techniques similar to those used to improve the taco-making process were used to improve other products. Explain how this anecdote relates to process thinking. What would the employees have to do to become a part of the club?

10. Do you think you will be working in manufacturing or services when you graduate? What do you think will be the role of manufacturing in the U.S. economy in the future?

Zappos Case Study

Zappos (www.zappos.com) is a Las Vegas-based online retailer that has been cited in *Fortune's* list of the Best Companies to Work For and *Fast Company's* list of the world's most innovative companies. Zappos was founded in San Francisco in 1999 and moved to Las Vegas for the cheap real estate and abundant call center workers. The company sells a very large variety of shoes from nearly every major manufacturer and has expanded its offerings to handbags, apparel, sunglasses, watches, and electronics. Despite the crippling economic downturn, sales jumped almost 20% in 2008, passing the $1 billion mark two years ahead of schedule.

The company's first core value is "Deliver WOW through service," which is obvious if you've ever ordered from Zappos. It provides free shipping in both directions on all purchases. It often gives customers surprise upgrades for faster shipping. And it has a 365-day return policy. In 2003, Zappos made a decision about customer service: they view any expense that enhances the customer experience as a marketing cost because it generates more repeat customers through word of mouth. CEO Tony Hsieh never outsourced his call center because he considers the function too important to be sent to India. Job one for these front-liners is to delight callers. Unlike most inbound telemarketers, they don't work from a script. They're trained to encourage callers to order more than one size or color, because shipping is free in both directions, and to refer shoppers to competitors when a product is out of stock. Most important, though, they're implored to use their imaginations. Which means that a customer having a tough day might find flowers on his or her doorstep the next

© LWA-Stephen Welstead/CORBIS

morning. One Minnesota customer complained that her boots had begun leaking after almost a year of use. Not only did the Zappos customer service representative send out a new pair—in spite of a policy that only unworn shoes are returnable—but she also told the customer to keep the old ones, and mailed a hand-written thank-you.[11]

Zappos uses a sophisticated computer system known as *Genghis* to manage its operations. This includes an order entry, warehouse management, inventory, and e-commerce system. It tracks inventory so closely that customers can check online how many pairs of size 12 Clarks Desert boots are available in the color sand. For employees, it automatically sends daily email reminders to call a customer back, coordinates the warehouse robot system, and produces reports that can specifically assess the impact on margins of putting a particular item on sale.

Case Questions for Discussion

1. Draw and describe the customer benefit package that Zappos provides. Identify and describe one primary value creation, one support, and one general management process you might encounter at Zappos (see Exhibit 1.4).

2. Explain the role of service encounters and service management skills at Zappos. How does Zappos create superior customer experiences?

3. Describe how each OM activity in Exhibit 1.1 impacts the management of both the goods that Zappos sells and the services that it provides. (You might want to build a table like Exhibit 1.1 to organize your answers.)

SPEAK UP!

OM2 was built on a simple principle: to create a new teaching and learning solution that reflects the way today's faculty and students teach and learn. Through conversations, focus groups, surveys, and interviews, we collected data that drove the creation of the version of OM2 that you are using today.

But it doesn't stop there – in order to make OM2 an even better learning experience, we'd like you to SPEAK UP and tell us how OM2 works for you.

What do you like about it? What would you change? Do you have additional ideas that would help us build a better product for next year's Operations Management students?

Go to 4ltrpress.cengage.com/om to *Speak Up!*

VALUE CHAINS

at a time when more than 98 percent of all shoes sold in the United States are made in other countries, Allen-Edmonds Shoe Corp. is a lonely holdout against offshoring. Moving to China could have saved the company as much as 60 percent. However, John Stollenwerk, chief executive, will not compromise on quality, and believes that Allen-Edmonds can make better shoes and serve customers faster in the United States. An experiment in producing one model in Portugal resulted in lining that wasn't quite right and stitching that wasn't as fine. Stollenwerk noted "We could take out a few stitches and you'd never notice it– and then we could take out a few more. Pretty soon you've cheapened the product, and you don't stand for what you're about."[1] Instead, Allen-Edmonds invested more than $1 million to completely overhaul its manufacturing process into a leaner and more efficient system that could reduce the cost of each pair of shoes by 5 percent. One year after implementing its new production processes, productivity was up 30 percent, damages were down 14 percent, and order fulfillment neared 100 percent, enabling the company to serve customers better than ever.[2]

Allen-Edmonds Shoe Corporation

What do **you** think?

What is your opinion of companies that move operations to other countries with cheaper labor rates? Should governments influence or legislate such decisions?

learning
outcomes

After studying this chapter you should be able to:

LO1 Explain the concept of value and how it can be increased.

LO2 Describe a value chain and the two major perspectives that characterize it.

LO3 Describe a supply chain and how it differs from a value chain.

LO4 Discuss key value chain decisions.

LO5 Explain offshoring and the key issues associated with it.

LO6 Identify important issues associated with value chains in a global business environment.

The creation of value depends on an effective system of linked facilities and processes that involves everyone in the organization such as marketing, finance/accounting, information systems, and human resource personnel—and not simply those in operations. This system characterizes the concept of a value chain, which is a dominant theme of this book. *A value chain is a network of facilities and processes that describes the flow of goods, services, information, and financial transactions from suppliers through the facilities and processes that create goods and services and deliver them to the customer.* It is important for every business student to understand how operations management influences the design and management of value chains.

The advances in transportation and information technology have made the world a much smaller place and have created a significantly more intense competitive business environment, resulting in value chains that span across the globe. Today's managers face difficult decisions in balancing cost, quality, and service objectives to create value for their customers and stakeholders. As a result, many companies have reconfigured their value chains and moved some operations out of the United States to keep costs competitive and remain profitable. Others have moved operations offshore in order to improve customer service. "... the reality is we are in a global company and have customers around the world," said a Lucent Technologies manager. "We have to shift work close to our customers for fast delivery and customization, and remain competitive." For others, like Allen-Edmonds, the configuration of the value chain revolves around quality.

A **value chain** is a network of facilities and processes that describes the flow of goods, services, information, and financial transactions from suppliers through the facilities and processes that create goods and services and deliver them to the customer.

© V1/Alamy

In addition, today's operations managers increasingly deliver goods and services to multiple markets and operate in a shrinking global business environment. As one chief financial officer wrote in a *CFO Magazine* survey, "You cannot compete globally unless you use global resources."[3] Thus, we emphasize the importance of understanding the global business environment and local culture, and their impact on value chain design and operations.

1 The Concept of Value

today's consumers demand innovative products, high quality, quick response, impeccable service, and low prices; in short, they want *value* in every purchase or experience. One of the most important points that we can emphasize in this book is this:

The underlying purpose of every organization is to provide value to its customers and stakeholders.

© Ryan McVay/Digital Vision/Getty Images

If the value ratio is high, the good or service is perceived favorably by customers, and the organization providing it is more likely to be successful.

Value *is the perception of the benefits associated with a good, service, or bundle of goods and services (i.e., the customer benefit package) in relation to what buyers are willing to pay for them.* The decision to purchase a good or service or a customer benefit package is based on an assessment by the customer of the perceived benefits in relation to its price. The customer's cumulative judgment of the perceived benefits leads to either satisfaction or dissatisfaction. One of the simplest functional forms of value is:

> **Value** is the perception of the benefits associated with a good, service, or bundle of goods and services (i.e., the customer benefit package) in relation to what buyers are willing to pay for them.

$$\text{Value} = \frac{\text{Perceived benefits}}{\text{Price (cost) to the customer}}$$

How to Increase Value?

To increase value, an organization must

(a) increase perceived benefits while holding price or cost constant;

(b) increase perceived benefits while reducing price or cost; or

(c) decrease price or cost while holding perceived benefits constant.

In addition, proportional increases or decreases in perceived benefits as well as price results in no net change in value. Management must determine how to maximize value by designing processes and systems that create and deliver the appropriate goods and services customers want to use, pay for, and experience.

Pre- and postproduction services complete the ownership cycle for the good or service.

*A competitively dominant customer experience is often called a **value proposition**.*[4] The focus on value has forced many traditional goods-producing companies to add services to their customer benefit packages. If the quality or features of goods cannot be improved at a reasonable cost and prices cannot be lowered, then enhanced or additional services may provide better total value to customers.

The integration of services in manufacturing was recognized some time ago. "In the same way that service businesses were managed and organized around manufacturing models during the industrial economy, we can expect that manufacturing businesses will be managed and organized around service models in this new economy."[5] A goods-producing company can no longer be viewed as simply a factory that churns out physical goods, because customer perceptions of goods are influenced highly by such facilitating services as financing and leasing, shipping and installation, maintenance and repair, and technical support and consulting. Coordinating the operational capability to design and deliver an integrated customer benefit package of goods and services is the essence of operations management, and leads to the concept of a value chain.

2 Value Chain Perspectives

as shown in Exhibit 2.1, a value chain is a "cradle-to-grave" input/output model of the operations function. The value chain begins with suppliers who provide inputs to a goods-producing or service-providing process or network of processes. Suppliers might be retail stores, distributors, employment agencies, dealers, financing and leasing agents, information and Internet companies, field maintenance and repair services, architectural and engineering design firms, and contractors, as well as manufacturers of materials and components. The inputs they provide might be physical goods such as automobile engines or microprocessors provided to an assembly plant; meat, fish, and vegetables provided to a restaurant; trained employees provided to

> A competitively dominant customer experience is often called a **value proposition**.

Exhibit 2.1 *The Value Chain*

organizations by universities and technical schools; or information such as computer specifications or a medical diagnosis. Inputs are transformed into value-added goods and services through processes or networks of work activities, which are supported by such resources as land, labor, money, and information. The value chain outputs—goods and services—are delivered or provided to customers and targeted market segments.

The success of the entire value chain depends on the design and management of all aspects of the value chain (suppliers, inputs, processes, outputs, or outcomes) including both short- and long-term decisions. Some examples of value chains are shown in Exhibit 2.2. Note that what is being transformed can be almost anything; for instance, people as in the hospital, a physical good as in the oil refinery, information and entertainment as in the e-publishing business, or a mixture of people, physical goods, and information as in many government services.

A second view of the value chain from pre- and postproduction service perspectives is shown in Exhibit 2.3. Pre- and postproduction services complete the ownership cycle for the good or service. Preproduction

services include customized and team-oriented product design, consulting services, contract negotiations, product and service guarantees, customer financing to help purchase the product, training customers to use and maintain the product, purchasing and supplier services, and other types of front-end services. The focus here is on "gaining a customer."

Postproduction services include on-site installation or application services, maintenance and repair in the field, servicing loans and financing, warranty and claim services, warehouse and inventory management for your company and sometimes for your customers, training, telephone service centers, transportation delivery services, postsale visits to the customer's facility by knowledgeable sales and technical-support people, recycling and remanufacturing initiatives, and other back-end services. The focus here is on "keeping the customer."

This view of the value chain emphasizes the notion that service is a critical component of traditional manufacturing processes. For example, Ford Motor Company found that the total value of owning a Ford vehicle averaged across all market segments for service and the

Exhibit 2.2 *Examples of Goods-Producing and Service-Providing Value Chains*

Organization	Suppliers	Inputs	Transformation Process	Outputs	Customers and Market Segments
Auto assembly plant	Engine plant Tires Frame Axles Paint Seats	Labor Energy Auto parts Specifications	Welding Machining Assembly Painting	Automobiles Trucks	Economy Luxury Rental Trucking Ambulance Police
Hospital	Pharmaceutical companies Equipment suppliers Food suppliers Organ donors Medical suppliers	Patients Beds Staff Drugs Diagnostic equipment Knowledge	Admissions Lab testing Doctor diagnosis Food service Surgery Schedules Drug administration Rehabilitation	Healthy people Lab results Accurate bills Community health education	Heart clinics Pediatrics Emergency and trauma services Ambulatory services Medical specialties and hospital wards
State Government	Highway and building contractors Employment agencies Food suppliers Equipment suppliers Other governments	Labor Energy Information Trash Crimes Disputes Sick people Low income people	Health care benefits Food stamps Legal services Prisons Trash removal Park services License services Police services Tax services	Good use of tax-payers' monies Safety net Security Reallocate taxes Clean, safe, and fun parks	Disabled people Low income people Criminals and prisons Corporate taxes Boat licenses Building inspections Weekend vacationers Child custody services Legal court services

Exhibit 2.3 *Pre- and Postservice View of the Value Chain*

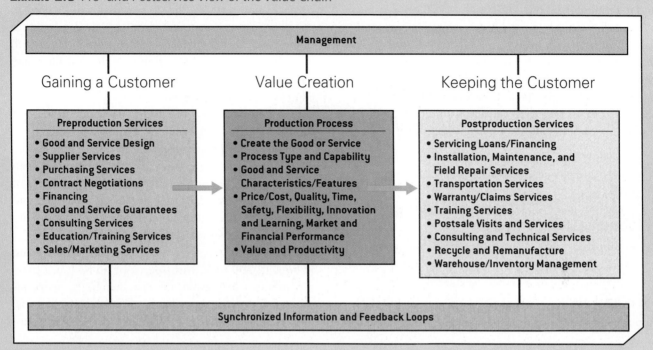

Management		
Gaining a Customer	Value Creation	Keeping the Customer
Preproduction Services	**Production Process**	**Postproduction Services**
• Good and Service Design • Supplier Services • Purchasing Services • Contract Negotiations • Financing • Good and Service Guarantees • Consulting Services • Education/Training Services • Sales/Marketing Services	• Create the Good or Service • Process Type and Capability • Good and Service Characteristics/Features • Price/Cost, Quality, Time, Safety, Flexibility, Innovation and Learning, Market and Financial Performance • Value and Productivity	• Servicing Loans/Financing • Installation, Maintenance, and Field Repair Services • Transportation Services • Warranty/Claims Services • Training Services • Postsale Visits and Services • Consulting and Technical Services • Recycle and Remanufacture • Warehouse/Inventory Management

Synchronized Information and Feedback Loops

vehicle was allocated as follows: the vehicle (i.e., product features and performance) itself accounted for 52 percent of total value, the sales process for 21 percent, and the maintenance and repair service processes for 27 percent. These statistics are based on average customer perceptions for all cars and vary by type of vehicle and market segment.[6] Ford's research indicated that when vehicle features and quality, performance, and price per target market segment were roughly the same as its competitors, presale and postproduction services were the factors that enticed customers for all target market segments. Service has become a key differentiating factor in the eyes of customers for many manufacturing firms. Ford Motor Company is continuing to develop a competitive strategy where "service is the centerpiece of their global strategy." A good example of a value chain that integrates pre- and postproduction services is described next.

Nestle Sells More than Coffee

Pre- and postproduction services also represent huge opportunities to increase revenue and provide new sources of income. For example, Nestle once defined its business from a physical good viewpoint as "selling coffee machines." Using service management thinking, Nestle redefined its business from a service perspective where the coffee machine is more of a peripheral good. Nestle decided to lease coffee machines and provide daily replenishment of the coffee and maintenance of the machines for a contracted service fee. This "primary leasing service" was offered to organizations that sold more than 50 cups of coffee per day. The results were greatly increased coffee sales, new revenue opportunities, and much stronger profits. Of course, Nestle's service vision of its business required a completely new service and logistical value chain capability. Moreover, the difficulty of providing this service to thousands of organizations (sites) in a geographical region is a barrier to entry for competitors and a challenge for Nestle.

2.1 An Example of a Value Chain: Buhrke Industries, Inc.

Buhrke Industries Inc., located in Arlington Heights, Illinois, provides stamped metal parts to many

industries, including automotive, appliance, computer, electronics, hardware, housewares, power tools, medical, and telecommunications.

Buhrke's objective is to be a customer's best total-value producer with on-time delivery, fewer rejects and high-quality stampings. However, the company goes beyond manufacturing goods; it prides itself in providing the best service available as part of its customer value chain. Service is more than delivering a product on time. It's also partnering with customers by providing

- personalized service for fast, accurate response;
- customized engineering designs to meet customer needs;
- preventive maintenance systems to ensure high machine uptime;
- experienced, highly trained, long-term employees; and
- troubleshooting by a knowledgeable sales staff.

Exhibit 2.4 illustrates the components of Buhrke's value chain. The process begins with a customer request

for a quotation. The estimating department processes such job parameters as specifications, metals, finishing or packaging services, the presses that will be used to run the job, and customer deadlines in developing a quote. Next, a sales engineer is assigned to monitor each stamping job from start to finish, so the customer may have the convenience of a single point of contact. Sales engineers work closely with the engineering staff to convey customer needs. Engineers then design the best tooling for the job, using computer-assisted design processes to ensure precise designs and timely completion. After a tool is designed and built, it is maintained in an on-site tool room. Buhrke's toolmakers have decades of experience constructing tools for metal stamping, and they are put on a strict maintenance regimen to assure long life and consistent stampings.

Parts are stamped on a full range of presses, from 15 tons to 200 tons, with speeds of up to 1,500 parts per minute. Inspection of raw materials, work-in-process, and finished products help ensure zero defects. The company provides a full range of secondary and

Exhibit 2.4 *The Value Chain at Buhrke Industries*

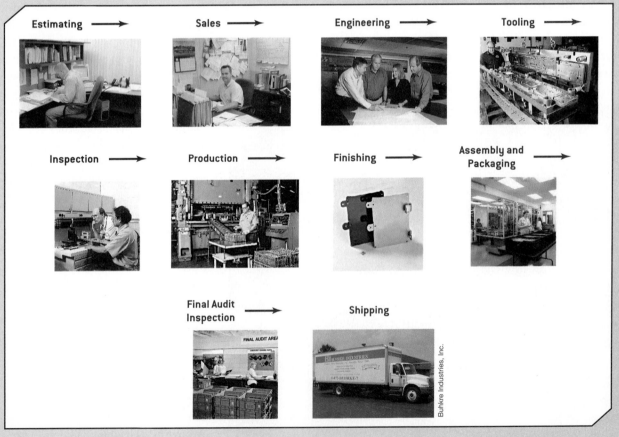

Courtesy of Buhrke-Olson, IMS Companies, LLC

finishing operations from heat-treating to powder coating to tapping to add value to customers. Customers do not need to ship stampings elsewhere or arrange for another service provider to finish the job.

At the customer's request, Buhrke will assemble the stampings with other components to deliver a complete subassembly. They will even procure parts for assembly, such as plastics that the company does not manufacture. Buhrke is also able to package finished stampings or subassemblies. Before stampings are boxed up and shipped (and even after the incoming inspection and in-process audits), Buhrke provides a final audit inspection. Finally, Buhrke offers the convenience of shipping finished product where and when customers want. For further information and video tours of the plant, visit www.buhrke.com.

3 Supply Chains

a **supply chain** *is the portion of the value chain that focuses primarily on the physical movement of goods and materials, and supporting flows of information and financial transactions through*

the supply, production, and distribution processes. Supply chains have become a critical focus for almost every company today. For example, Exhibit 2.5 shows a conceptual model of a supply chain developed by Procter & Gamble, which began working on supply chain design issues and strategies in 1995. P&G's "Ultimate Supply System" seeks to understand the impact of tightly coupling supply chain partners to integrate information, physical material and product flow, and financial activities to increase sales, reduce costs, increase cash flow, and provide the right product at the right time at the right price to customers.[7]

Many organizations use the terms "value chain" and "supply chain" interchangeably; however, we differentiate these two terms in this book. A value chain is broader in scope than a supply chain, and encompasses all pre- and postproduction services to create and deliver the entire customer benefit package. A value chain views an organization from the customer's

> A **supply chain** is the portion of the value chain that focuses primarily on the physical movement of goods and materials, and supporting flows of information and financial transactions through the supply, production, and distribution processes.

Exhibit 2.5 *Procter & Gamble's Conceptual Model of a Supply Chain for Paper Products*

Source: See Endnote 7.

perspective—the integration of goods and services to create value—while a supply chain is more internally focused on the creation of physical goods. In addition, it makes it easier to apply to service-providing organizations as well as to goods-producing firms.

4 Value Chain Decisions

Organizations face numerous decisions in designing and configuring their value chains. Looking back at Exhibits 2.1 and 2.3, we see that these decisions must include the number, type, and location of manufacturing plants, distribution centers, retail stores, repair centers, and customer service or technical support centers; the choice of technology and processes to make goods and deliver services; ways of managing information flow throughout the value chain; the selection of suppliers and partners; and the integration of all the pieces into an effective and efficient system.

The operational structure of a value chain is the configuration of resources such as suppliers, factories, warehouses, distributors, technical support centers, engineering design and sales offices, and communication links. Different management skills are required for different operational structures. For example, Wal-Mart's value chain, though very large, is focused on purchasing and distribution, and is controlled from a centralized location in Bentonville, Arkansas. In contrast, General Electric's value chain, which

encompasses such diverse businesses as medical imaging, jet engines, appliances, and electrical power generation, are all quite different. Each business is a profit center with its own unique market and operating conditions. Consequently the operational structure is decentralized.

Technology enables processes and value chains to lower the cost of goods and services, speed delivery, and provide customization where required. Examples include rental car transponders to speed checkout and check-in, computer-driven machines to produce manufactured parts, geographic and wireless information systems to locate vehicles and inventory, and electronic patient medical records.

4.1 Outsourcing and Vertical Integration

One of the most important decisions a firm can make about its value chain is whether to vertically integrate or outsource key business processes and functions. **Vertical integration** *refers to the process of acquiring and consolidating elements of a value chain to achieve more control.* For example, some firms might consolidate all processes for a specific product or product line in a single facility; for example, Henry Ford's early

The **operational structure** of a value chain is the configuration of resources such as suppliers, factories, warehouses, distributors, technical support centers, engineering design and sales offices, and communication links.

Vertical integration refers to the process of acquiring and consolidating elements of a value chain to achieve more control.

Automobile Suppliers – Vanish or Rebound?

Clips & Clamps Industries located in Plymouth, Michigan, has been selling metal brackets for decades to the Big Three Detroit automobile manufacturers—General Motors, Ford, and Chrysler. But a few years ago, the firm decided it must become a tier-one supplier to Toyota, Honda, and Nissan if it were to survive the global economic downturn. Mr. Aznavirian, president and co-owner, said "You can't sit around waiting for the Big Three to come back." Mr. Aznavirian led efforts to gain work from the Japanese firms by reducing equipment downtime, producing less scrap, and becoming a more efficient part of the global supply chain. "We got some difficult jobs and had to prove ourselves," he said, referring to jobs for Japanese auto firms. The Japanese firms now account for one quarter of the company's business. Mr. Craig Fitzgerald, a consultant, noted that "more than half of North America's 1,200 small auto suppliers will vanish into bankruptcies, mergers, and liquidations…. But some like Clips and Clamps will reinvent themselves and rebound."[8]

factories did everything from steel-making to final assembly. While such a strategy provides more control, it adds more complexity to managing the value chain. In contrast, today's automobile production is characterized by a complex network of suppliers. Decentralizing value chain activities lessens the control that a firm has over cost, quality, and other important business metrics, and often leads to higher levels of risk.

Outsourcing *is the process of having suppliers provide goods and services that were previously provided internally.* Outsourcing is the opposite of vertical integration in the sense that the organization is shedding (not acquiring) a part of its organization. The organization that outsources does not have ownership of the outsourced process or function. Some large U.S. banks and airlines, for example, have outsourced their telephone call service centers to third-party suppliers within or outside the United States.

The U.S. has experienced three waves of outsourcing:

- The first wave involved the exodus of *goods-producing jobs* from the United States in many industries several decades ago. Companies relied on foreign factories for the production of computer components, electronics, and many other goods. Gibson Guitars, for example, produces its Epiphone line in Korea.

- The second wave involved *simple service work* such as standard credit card processing, billing, keying information into computers, and writing simple software programs. Accenture, for example, has information technology and bookkeeping operations in Costa Rica.

- The third, and current wave, involves *skilled knowledge work* such as engineering design, graphic artists, architectural plans, call center customer service representatives, and computer chip design. For example, Fluor Corporation of Aliso Viejo, California, uses engineers and draftsmen in the Philippines, Poland, and India to develop detailed blueprints and specs for industrial construction and improvement projects.[9]

Companies must decide whether to integrate backward (acquiring suppliers) or forward (acquiring distributors), or both. **Backward integration** *refers to acquiring capa-*

bilities at the front-end of the supply chain (for instance, suppliers), while forward integration *refers to acquiring capabilities toward the back-end of the supply chain (for instance, distribution or even customers).* Large companies such as Motorola, Siemens, and Sony have the resources to build facilities in foreign lands and develop a high level of vertical integration. Their objective is to own or control most, if not all, of the supply chain. Many large chemical manufacturers, for example, such as DuPont, British Petroleum, Haimen Jiangbin, and GFS Chemicals are buying raw material suppliers and integrating backward. At the same time, chemical manufacturers in industrial countries are focusing on more profitable specialty chemicals and advanced materials. Developing these specialty chemicals by acquiring smaller specialty manufacturers and distributors is a form of forward integration.

4.2 The Economics of Outsourcing

The decision on whether to outsource is usually based on economics, and break-even analysis can be used to provide insight into the best decision.

If a company decides to make a part, they

> **Outsourcing** is the process of having suppliers provide goods and services that were previously provided internally.
>
> **Backward integration** refers to acquiring capabilities at the front-end of the supply chain (for instance, suppliers), while **forward integration** refers to acquiring capabilities toward the back-end of the supply chain (for instance, distribution or even customers).

Nike's Hole in One

An interesting example of the advantages of vertical integration occurred when the director of apparel for Nike Golf watched Tiger Woods win the Masters golf tournament in 2002. He noticed that the collar on Mr. Woods's Nike golf shirt had crumpled up from the heat and perspiration. The next day he called Esquel Apparel Inc. in Hong Kong and told them he wanted to change its polo-shirt collars to a shorter collar that would not crumple and buckle up. Chemists and Esquel shirt designers in China began to work on a new collar fabric. Within weeks, the Chinese company flew six prototype golf shirts to Florida for testing, and by October, new shirts were rolling off the assembly line in Hong Kong. The reason Esquel Apparel Inc. could do this so quickly is because it owns or controls every supplier in the value chain—from the cotton grown in the field to spinning mills that make the yarn to final assembly at the factory.[10]

typically incur fixed costs associated with purchasing equipment or setting up a production line. Fixed costs do not vary with volume and often include costs of a building, buying or leasing equipment, and administrative costs. However, the variable cost per unit will be less if the work is outsourced to some external supplier. Variable costs are a function of the quantity produced and might include labor, transportation, and materials costs. Define

VC_1 = Variable cost/unit if produced

VC_2 = Variable cost/unit (i.e., purchase price/unit) if outsourced

FC = Fixed costs associated with producing the part

Q = Quantity produced (volume)

Then

$$\text{Total cost of production} = (VC_1)Q + FC$$

$$\text{Total cost of outsourcing} = (VC_2)Q$$

If we set these costs equal to each other we obtain:

$$(VC_2)Q = (VC_1)Q + FC$$

$$(VC_2)Q - (VC_1)Q = FC$$

$$(VC_2 - VC_1)Q = FC$$

The breakeven quantity is found by solving for Q:

$$Q^* = \frac{FC}{VC_2 - VC_1} \qquad [2.1]$$

Whenever the anticipated volume is greater than Q^*, the firm should produce the part in-house; otherwise it is best to outsource.

4.3 Value and Supply Chain Integration

For complex value chains that incorporate numerous suppliers, facilities, and outsourced processes, firms need an approach to coordinate and manage information, physical goods, and services among all the players in the value chain. **Value chain integration** *is the process of managing information, physical goods, and services to ensure their availability at the right place, at the right time, at the right cost, at the*

Value chain integration is the process of managing information, physical goods, and services to ensure their availability at the right place, at the right time, at the right cost, at the right quantity, and with the highest attention to quality.

Doug Kanter/Bloomberg News/Landov

Solved Problem

Suppose that a manufacturer needs to produce a custom aluminum housing for a special customer order. Because it currently does not have the equipment necessary to make the housing, it would have to acquire machines and tooling at a fixed cost (net of salvage value after the project is completed) of $250,000. The variable cost of production is estimated to be $20 per unit. The company can outsource the housing to a metal fabricator at a cost of $35 per unit. The customer order is for 12,000 units. What should they do?

Solution:

VC_1 = Variable cost/unit if produced = $20

VC_2 = Variable cost/unit if outsourced = $35

FC = fixed costs associated with producing the part = $250,000

Q = quantity produced

Using Equation 2.1 we obtain

$$Q^* = \frac{250,000}{35 - 20} = 16,667$$

In this case, because the customer order is only for 12,000 units, which is less than the break-even point (Q^*), the least cost decision is to outsource the component.

right quantity, and with the highest attention to quality. (A focus solely on coordinating the physical flow of materials to ensure that the right parts are available at various stages of the supply chain, such as manufacturing and assembly plants, is commonly called *supply chain integration*.) For goods-producing firms it requires consolidating information systems among suppliers, factories, distributors, and customers, managing the supply chain and scheduling factories, and studying new ways to use technology.

Value chain integration includes improving internal processes for the client as well as external processes that tie together suppliers, manufacturers, distributors, and customers. Other benefits are lower total value chain costs to the client, reduced inventory obsolescence, better global communication among all parties, access to new technologies, and better customer service. Some firms, such as Wal-Mart, manage value chain integration themselves. Others make use of third-party "system integrators" to manage the process. One example of a system integrator is Visteon. Visteon has a global delivery system of 106 factories, 11 Visteon assembly plants for major subassemblies, 41 engineering offices, and 25 customer service centers. Their clients include the 19 largest vehicle manufacturers in the world.

Value chain integration in services—where value is in the form of low prices, convenience, and access to special time-sensitive deals and travel packages—takes many forms. For example, third-party integrators for the leisure and travel industry value chains include Orbitz, Expedia, Priceline, and Travelocity. They manage information to make these value chains more efficient and create value for their customers. Many financial services use information networks provided by third-party information technology integrators such as AT&T, Sprint, IBM, and Verizon to coordinate their value chains. Hospitals also use third-party integrators for both their information and physical goods such as managing patient billing and hospital inventories.

5 Offshoring

As we discussed at the beginning of this chapter, offshoring represents one of the most controversial topics in business today. **Offshoring is the building, acquiring, or moving of process capabilities from a domestic location to another country location while maintaining ownership and control.** According to one framework, foreign factories can be classified into one of six categories:[11]

1. *Offshore factories established to gain access to low wages and other ways to reduce costs such as avoiding trade tariffs.* Such a factory is not expected to be innovative and its people follow the standard process procedures dictated by the corporation. Offshore factories usually include some primary manufacturing and secondary support processes. An offshore factory is the way most multinational firms begin their venture into global markets and value chains.

> **Offshoring** is the building, acquiring, or moving of process capabilities from a domestic location to another country location while maintaining ownership and control.

Exel—A Supply Chain Integrator

Exel (www.exel.com), based in the United Kingdom, is a global leader in supply chain management, providing customer-focused solutions to a wide range of manufacturing, retail, and consumer industries, and employing over 109,000 people in 2,050 locations in more than 120 countries worldwide. Exel's customers include over 70 percent of the world's largest, nonfinancial companies in industries such as health care, chemical, retail, and automotive.

Exel manages supply chain activities across industries and geographic regions to reduce costs, accelerate product movement, and allow manufacturers and retailers to focus on their core business. Exel is able to deliver services and solutions such as consulting, e-commerce, transport, global freight, warehousing, home delivery, labeling, and co-packing, on a local, regional, or global basis. With global resources and a complete spectrum of integrated services and capabilities tailored to the needs of the customer, Exel can assume the role of a global lead logistics provider to open new markets and simplify supply chain management.

Courtesy of Exel

2. *Outpost factories established primarily to gain access to local employee skills and knowledge.* Such skills and knowledge might include software programming, machining, sales, or call center service management. AOL's call center in India is an example of an outpost facility.

3. *Server factories established to supply specific national or regional markets.* Coca-Cola bottling factories receive concentrated Coke syrup and follow specific procedures to make the final products. Because of high transportation costs, these bottling plants service local and regional markets.

4. *Source factories, like offshore factories, established to gain access to low-cost production but also have the expertise to design and produce a component part for the company's global value chain.* Sony, for example, built a factory in Wales in the early 1970s and defined its strategy to produce television sets and replacement component parts for its European markets. It customized its design for the European markets.

5. *Contributor factories established to serve a local market and conduct activities like product design and customization.* NCR's factory in Scotland started in the 1960s and played the role of a server factory producing cash registers and computers. By the 1980s, the factory was best described as a contributor factory, and today a lead factory designing and manufacturing automatic teller machines. Primary manufacturing, accounting, engineering design, and marketing and sales processes often reside at contributor factories.

6. *Lead factories established to innovate and create new processes, products, and technologies.* Hewlett-Packard, for example, established an offshore factory in 1970 in Singapore. A decade later it had evolved into a source factory for calculators and keyboards. By the 1990s, the Singapore factory was a lead factory in keyboard and inkjet printer design and manufacturing. Lead factories must have the skills and knowledge to design and manufacturer "the next generation of products."

From a purely economic standpoint, offshoring can make a lot of sense because it generally lowers unit costs. Countries such as China, India, and Russia have many hard-working and educated people who are eager to work at low wage rates. Many U.S. companies have made the strategic decisions necessary to locate certain functions overseas to remain globally competitive.

Offshoring decisions involve determining what primary, support, and/or management processes should move to other countries. Some global trade experts recommend keeping some primary processes or key parts of a manufacturing process out of foreign lands to protect the firm's core competency.

We can pose four possible scenarios. In the first scenario, all key processes remain in the home country, even though the firm sells its products overseas. An example would be Harley-Davidson. The second scenario represents a low degree of offshoring in which some noncritical support processes are moved overseas. Examples would be Microsoft and American Express. A more common scenario is for a company to offshore many of its primary as well as support processes while keeping its management processes consolidated at the corporate headquarters, such as Coca-Cola and FedEx. Finally, true global multinational firms, such

Chevron Texaco in the Philippines

It's 3 a.m. and 750 men and women are jammed into a Chevron Texaco Corporation call center in Manila, Philippines. They're busy handling credit card queries from Chevron customers, mainly in the United States. They drink cappuccinos and eat junk food to stay up all night. Most of the call center employees are very well-educated, such as one employee who graduated from the University of Philippines in 1998 with degrees in German and Italian. The co-worker next to him is a young woman who has a degree in communications. They each make about $13,000 per year, which is well above the average worker's salary in the Philippine economy.

The employee turnover rate for this type of work is only 10 percent per year in the Philippines in contrast to 70 percent per year in the United States. The Philippine employees speak English perfectly and are committed to training programs and doing the job well. The only problem one call center manager noted was that "The Filipino employees are too polite, leading to longer, costly phone chats. We have to teach them to be more rude."

Because global companies are able to hire the best talent in the Philippines, Procter & Gamble, Eastman Kodak, American Express, Intel, and Microsoft have also set up customer service centers there. They handle increasingly complicated calls such as how to operate and take the best picture using Kodak cameras, how to fix software problems, and how to plan a trip overseas.[12]

as Procter & Gamble and Honda, locate all of their key processes across the globe for more effective coordination and local management. The global alignments, of course, may change over time.

The decision to offshore or outsource involves a variety of economic and noneconomic issues. Exhibit 2.6 summarizes the key issues in these decisions. For example, Dell moved a customer call center to Bangalore, India, to lower costs. Later, however, Dell moved the call center back to the United States because of customer dissatisfaction with technical support.

Moving skilled service work offshore, however, incurs some risk. From an operations perspective, work that can be easily measured and monitored, such as detecting keystroke errors in transaction processing, are good candidates for moving offshore. Activities in the moderate and high-risk categories have "carry-forward" implications when errors and service upsets happen. For example, an error in technical support can result in hours or days of lost time. Mistakes in a cash-flow forecast may drive a business to increase their debt when it is not necessary.

Moving skilled service work offshore incurs some risk.

6 Value Chains in a Global Business Environment

although not every organization operates in the global business environment, modern technology and distribution have made it feasible and attractive for both large and small companies to develop value chains that span international boundaries. *A multinational enterprise is an organization that sources, markets, and produces its goods and services in several countries to minimize costs, and to maximize profit, customer satisfaction, and social welfare.* Examples of multinational enterprises include British Petroleum, General Electric, United Parcel Service, Siemens, Procter & Gamble, Toyota, Lufthansa, and the International Red Cross. Their value chains provide the capability to source, market, create, and deliver their goods and services to customers worldwide.

> A **multinational enterprise** is an organization that sources, markets, and produces its goods and services in several countries to minimize costs, and to maximize profit, customer satisfaction, and social welfare.

Exhibit 2.6 *Example Issues to Consider When Making Offshore Decisions*

Economic reasons

Noneconomic reasons

Low labor costs
Lower import duties and fees
Lower capital costs
Grow global market share
Avoid national currency fluctuations
Preempt competitors from entering global market(s)
Hire worldwide skills and knowledge workers
Build robust value chain networks for global markets
Build relationships with government officials
The negative impact and media attention on remaining employees
Potential loss of intellectual property
Lose control of key processes
Develop secure sources of supply and reduce risks
Build relationships with suppliers
Possible political instability in offshore country
Lack of communication and/or technical skills
Learn foreign markets and cultures

Multinational enterprises operate complex value chains that challenge operations managers. Some issues that operations managers must confront in a global business environment include: (1) how to design a value chain to meet the slower growth of industrialized countries and more rapid growth of emerging economies; (2) where to locate manufacturing and distribution facilities around the globe to capitalize on value chain efficiencies and improve customer value; (3) what performance metrics to use in making critical value chain decisions; and (4) how to decide if partnerships should be developed with competitors to share engineering, manufacturing, or distribution technology and knowledge.

To gain a better understanding of value chains in a global context, we present a case study of Rocky Brands, Inc. next.

6.1 A Global Value Chain: Rocky Brands, Inc.

Rocky Brands, Inc. (www.rockyboots.com) headquartered in Nelsonville, Ohio, manufactures rugged leather work boots and shoes. Timberland, Wolverine, and Rocky are popular brand names for this shoe market segment. Rocky began making boots in 1932 as the William Brooks Shoe Company. In the 1960s, Rocky boots and shoes were 100 percent "Made in America." In 1960, more than 95 percent of all shoes sold in America were made in America.

After 70 years in Nelsonville, the main factory closed in 2002. At that time, local labor costs were about $11 per hour without benefits while in Puerto Rico, the hourly rate was $6, in the Dominican Republic, $1.25, and in China, 40 cents. The unemployed U.S. factory workers had a hard time finding other jobs. Some ended up as greeters at retail stores, collecting scrap metal, doing lawn work, and other odd jobs. The Union of Needle Trades, Industrial, and Textile Employees, Local 146, closed its doors. Company medical insurance ran out in February 2003. Since 1972, the U.S. Department of Labor reports, 235,000 U.S. shoe jobs have been lost. It is very difficult for these displaced employees to retrain themselves in today's job market.

© Bradley C. Bower/Bloomberg News/Landov

Today, Rocky Brands, Inc. headquarters remains in Nelsonville along with a warehouse, but all manufacturing is now done overseas at locations such as Moca, Puerto Rico, and La Vega, Dominican Republic. The company made the move to offshore manufacturing much later than its competitors, Wolverine, Dexter, and Timberland, who moved their factories offshore 20 to 30 years ago. However, Rocky Brands, Inc. has successfully transitioned to a global operation. Rocky's global value chain is shown in Exhibit 2.7. A pair of premium Rocky work, hunting, or western boots may reflect components and labor from as many as five countries before landing on a store shelf. The principal characteristics of this global value chain are described as follows:

1. Leather is produced in Australia and then shipped to the Dominican Republic.
2. Outsoles are purchased in China and shipped to Puerto Rico.
3. Gor-Tex fabric waterproofing materials are made in the United States.
4. Shoe uppers are cut and stitched in the Dominican Republic, and then shipped to Puerto Rico.
5. Final shoe assembly is done at the Puerto Rico factory.
6. The finished boots are packed and shipped to the warehouse in Nelsonville, Ohio.

Customer orders are filled and shipped to individual stores and contract customers from Nelsonville.

The challenges continue for Rocky Brands, Inc., who must compete against larger competitors. Rocky profit margins are only about 2 percent on sales of over $100 million, while Timberland sales top $1 billion with a 9 percent profit margin. Meanwhile, the price of boots continues to decline from roughly $95 a pair to $85 and is heading toward $75. The grandson of the founder of Rocky Brands, Inc. said, "We've got to get there, or we're not going to be able to compete."[13]

6.2 Issues in Global Value Chain Decisions

Complex global value chains are more difficult to manage than small domestic value chains. Some of the many issues include the following:

- Global supply chains face higher levels of risk and uncertainty, requiring more inventory and day-to-day monitoring to prevent product shortages. Workforce disruptions such as labor strikes and government turmoil in foreign countries can create inventory shortages and disrupting surges in orders.
- Transportation is more complex in global value chains. For example, tracing global shipments normally involves more than one mode of transportation and foreign company.
- The transportation infrastructure may vary considerably in foreign countries. The coast of China, for example, enjoys much better transportation, distribution, and retail infrastructures than the vast interior of the country.
- Global purchasing can be a difficult process to manage when sources of

© PhotoLink/Photodisc/Getty Images

supply, regional economies, and even governments change. Daily changes in international currencies necessitate careful planning and in the case of commodities, consideration of futures contracts.
- International purchasing can lead to disputes and legal challenges relating to such things as price fixing and quality defects. International quality, cost, and delivery disputes have few legal options, and therefore, it is imperative that global supplier relationships are well established.

Privatizing companies and property is another form of major changes in global trade and regulatory issues. Eastern European nations, China, Brazil, and Russia are other countries initiating private ownership of assets such as land, equipment, and businesses. This privatization movement also helps

Exhibit 2.7 *Rocky Brands, Inc. Value Chain*

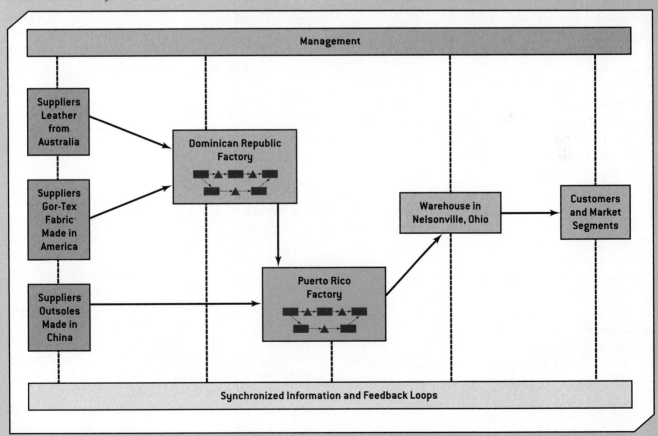

> To build an effective global supply chain, organizations must not only know their own processes, resources, and capabilities, but also those of the countries where the firm's resources are located.

improve the efficiency and effectiveness of global supply chains.

In making global value chain decisions, managers must consider a variety of issues.[14] For example, why go global? Is it to sell products and services to the local market, to export products to other markets, or to source materials, components, labor, or knowledge? Do customers require a presence in these markets? What are different global customer and market segments? Are there key competitors in these regions? Which functions (sales, engineering, manufacturing, purchasing, finance, etc.) need to be present in the region? What is the best way to organize your presence in the region (facilities, joint ventures, alliances, licensing arrangements, etc.)? How will you enter the region? How long will it take to be operational? Who will do the globalization work in your company? How much travel are they willing to do, and for how long? Are core staff willing to relocate? Clearly, a global value chain strategy places numerous demands on operations as well as other functions and their employees, and requires effective planning and execution.

Globalization at Toyota

Workers at Toyota's training center inside its Motomachi assembly complex in Toyota City use golf balls to limber up their fingers before they learn new tasks on the factory floor. Holding two balls in either hand, they try to make them revolve in opposite directions, a maneuver that requires a surprising amount of concentration. The exercises are just a small part of Toyota's plan to continually search for ways to streamline methods to build its cars, breaking down the steps used in thousands of tasks on the assembly line in order to teach them to new employees and managers. Now Toyota plans to build training centers similar to the one in Toyota City and in Georgetown, Kentucky, and in other parts of the world as it gears up for its next major phase of growth. Toyota sees teaching its production system in the new training center in Japan as key to maintaining quality levels and reducing the recalls that have plagued the company in recent years. Such training is essential in places like China, where Toyota found that some of its newest employees had never driven the cars they were hired to build.

With plants in 27 countries, more new factories under construction, and workers speaking languages from Russian to Turkish, Toyota's top executives are attempting a difficult balancing act: replicating the company's success and operating principles in other countries while at the same time ceding more control to these new outposts. "It's extremely important to have the same common Toyota Way infiltrated to employees in all corners of the world," Katsuaki Watanabe, the company's president, said. "But on the other hand, in each corner of the world, in each region, there are inherent characteristics that need to be respected." Toyota has learned, especially through experience in the United States, that it cannot simply impose Japanese practices on workers in other countries.[15]

6.3 Value Chains and Local Culture

Global organizations must balance the risk of designing and managing global value chains against the potential benefits of emerging markets. Each country has certain skills and resources as well as marketplace potential. To build an effective global supply chain, organizations must not only know their own processes, resources, and capabilities, but also those of the countries where the firm's resources are located. To extend the firm's value chain to other nations requires an understanding of national cultures and practices.

Cultural differences have been studied in detail so there is much opportunity to learn about these issues. For example, because Chinese words

are pictures, the Chinese think more in terms of holistic thoughts and process information emphasizing the big picture over details. This cultural difference is called "zhengti guannian" or holistic thinking. Americans think sequentially, focus on details, and individualistically. They break complex situations into a series of smaller issues such as delivery dates, price, and quantity. Chinese tend to talk about all issues at once, skipping among them, and from the American point of view, never seem to settle anything. Obviously, this one cultural difference can have a major impact on designing, implementing, and managing any operations initiative.[16]

The complexity of designing and managing in a global environment requires interacting with people from many different backgrounds and cultures, reevaluating global product mix changes, overcoming global regulatory barriers, and redesigning the operational and logistical structures. The Internet is also driving the restructuring of value chain and operational structures. We will study many topics in future chapters that relate to the structure of operations and value chains, the types of decisions that need to be made, and approaches for making these decisions.

Problems, Activities, and Discussions

1. Provide an example where you have compared a good or service by its value and compared perceived benefits and price. How did your assessment of value lead to a purchase (or nonpurchase) decision?

2. Describe a value chain based upon your work experience, summer job, or as a customer. Sketch a picture of it (as best you can). List suppliers, inputs, resources, outputs, customers, and target markets (similar to Exhibits 2.1 or 2.3).

3. Document the global supply chain for a business of interest to you and sketch out a picture similar to the Procter & Gamble Exhibit 2.5 diagram. Why did the organization use global resources to accomplish its goals? Explain.

4. Research current articles relating to offshoring and outsourcing, focusing on business, operations, and political issues. Summarize your findings in a 1–2 page paper.

5. What implications have the three waves of outsourcing had on the national and global economy?

6. A firm is evaluating the alternative of manufacturing a part that is currently being outsourced from a supplier. The relevant information is provided below:

 For in-house manufacturing

 Annual fixed cost = $45,000

 Variable cost per part = $140

 For purchasing from supplier

 Purchase price per part = $160

 Using this information, determine the break-even quantity for which the firm would be indifferent between manufacturing the part in-house or outsourcing it.

7. Refer to the information provided in question 6 to answer the following:

 a. If demand is forecast to be greater than 2,500 parts, should the firm make the part in-house or purchase it from a supplier?

 b. The marketing department forecasts that the upcoming year's demand will be 2,500 units. A new supplier offers to make the parts for $150 each. Should the company accept the offer?

 c. What is the maximum price per part the manufacturer should be willing to pay to the supplier if the forecast is 1,500 parts, using the information in the original problem (Question #6).

8. One study that focused on the impact of China trade on the U.S. textile industry noted that 19 U.S. textile factories were closed and 26,000 jobs were lost in 2004 and 2005. If these factories had not closed, it would have cost U.S. consumers $6 billion more in higher textile prices. Assuming these facts are true, offer an argument for or against offshoring U.S. jobs.

9. Summarize the key issues that managers face with global value chains in comparison with simple, domestic value chains. What must an organization do to address these issues?

10. Explain why it is important for operations managers to understand the local culture and practices of the countries in which a firm does business. What are some of the potential consequences if they don't?

TuneMan Case Study

The 1998 Digital Millennium Copyright Act requires Internet providers to provide upon subpoena the names of people suspected of operating pirate Web sites. However, the U.S. Supreme Court decided not to become involved in a dispute over illegal downloading of music files. The high court refused to give the recording industry broad power to force Verizon Communications and other Internet service providers to identify subscribers who share copyrighted songs online. The court said it was up to the U.S. Congress, not courts, to expand the 1998 law to cover popular file-sharing networks such as iTunes, Rhapsody, Amazon MP3, eMusic, and Napster.

© i love images/Jupiterimages

Music downloading has become a very controversial subject. The Recording Industry Association of America (RIAA) argues that billions of music files are illegally downloaded each month and this law is needed to identify downloading culprits. For example, on September 8, 2003, RIAA filed lawsuits against 261 people for allegedly downloading thousands of copyrighted songs via popular Internet file-sharing networks. These people copied an average of 1,000 songs into their files for free. Many other lawsuits have followed, such as a current 2009 court case of Napster versus RIAA.

Lester Tune, the founder of TuneMan, one of the more popular downloading sites, debated the issue with a corporate regulator on a recent talk show. He brought the audience to their feet after exclaiming "Well, people listen to music on the radio for free, so what's the big deal?" In response, the corporate regulator was vehement: "We want people to stop engaging in the theft of music so that people can go on making

it. We need to figure out where customer ownership begins. We are about to destroy the long history of professional songwriters and performers in America. Who's going to pay the royalties?"

Many music downloading providers now require customers to pay a fee per song of roughly $1, with albums priced around $10. Wal-Mart has a music site for downloading MP3s at a price of 74 cents per song and is the largest music retailer of CDs. In the past few years, Wal-Mart has reduced store shelf space for CDs by twenty percent. The industry is struggling to define a value chain structure that is fair to all parties—the creators of the song, the record label firms, the distributors, the Web sites, and the customers.

Case Questions for Discussion

1. Draw the "bricks and mortar" process stages by which traditional CDs are created, distributed, and sold in retail stores. How does each player in the value chain make money? (You can use the exhibits in the chapter to help you identify major stages in the value chain.)

2. Draw the process stages for creating and downloading music today. How does each player in this electronic/digital value chain make money?

3. Compare and contrast the approaches in the previous two questions. What's changed? What's new? Are there any advantages/disadvantages to each approach?

4. Compare the role of operations in each of these value chain structures and approaches.

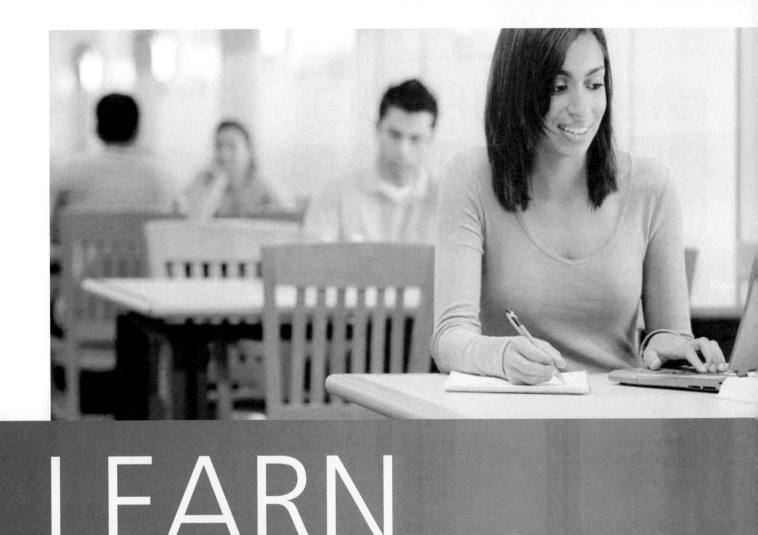

LEARN YOUR WAY!

We know that no two students are alike. You come from different walks of life and with many different preferences. You need to study just about anytime and anywhere. **OM2** was developed to help you learn Operations Management in a way that works for you.

Not only is the format fresh and contemporary, it's also concise and focused. And, **OM2** is loaded with a variety of study tools, like in-text review cards, printable flash cards, and more.

Go to 4ltrpress.cengage.com/om to find plenty of resources to help you study—no matter what learning style you like best!

MEASURING PERFORMANCE IN OPERATIONS

magine entering the cockpit of a modern jet airplane and seeing only a single instrument there.[1] How would you feel about boarding the plane after the following conversation with the pilot?

Passenger: I'm surprised to see you operating the plane with only a single instrument. What does it measure?

Pilot: Airspeed. I'm really working on airspeed this flight.

Passenger: That's good. Airspeed certainly seems important. But what about altitude? Wouldn't an altimeter be helpful?

Pilot: I worked on altitude for the last few flights and I've gotten pretty good on it. Now I have to concentrate on proper airspeed.

Passenger: But I notice you don't even have a fuel gauge. Wouldn't that be useful?

Pilot: You're right; fuel is significant, but I can't concentrate on doing too many things well at the same time. So on this flight I'm focusing on airspeed. Once I get to be excellent at airspeed, as well as altitude, I intend to concentrate on fuel consumption on the next set of flights.

© Anderson Ross/Photodisc/Getty Images

What do **you** think?

What measures do you use to evaluate a company's goods or services? Provide some examples.

learning outcomes

After studying this chapter you should be able to:

LO1 Describe the types of measures used for decision making.

LO2 Explain how to calculate and use productivity measures.

LO3 Explain how internal and external measures are related.

LO4 Explain how to design a good performance measurement system.

LO5 Describe four models of organizational performance.

1 Performance Measurement

measurement *is the act of quantifying the performance criteria (metrics) of organizational units, goods and services, processes, people, and other business activities.* Measurement provides an objective basis for making decisions. The theme of the opening anecdote is about the wisdom of using a single measure to fly the airplane. Concentrating on only one measure at a time is not a good idea. Would you fly in such a plane? World-class organizations normally use between 3 to 10 performance measures per process depending on a host of issues such as the complexity of goods and services, number of market segments, competitive pressures, and opportunities for failure.

Good measures provide a "scorecard" of performance, help identify performance gaps, and make accomplishments visible to the work force, the stock market, and other stakeholders. For example, the ground-operations area of American Airlines is concerned primarily with the service passengers receive at airports.[2] They routinely measure several factors that customers have told them are important, such as ticket-counter waiting time, cabin-door opening time after gate arrival, bag-delivery time, and cabin cleanliness. Knowing that one is doing a good job—or a better job than before—is a powerful motivator for most workers. However, the wrong kind of performance metric can be dangerous. The popular phrase, "How you

Measurement is the act of quantifying the performance criteria (metrics) of organizational units, goods and services, processes, people, and other business activities.

are measured is how you perform," can destroy good intentions.

Performance measures can be classified into several key categories:

- Financial
- Customer and Market
- Safety
- Quality
- Time
- Flexibility
- Innovation and Learning

Within each of these categories are organizational-level measures that are of interest primarily to senior managers, as well as more specific measures that are used by operations managers. Some of them are summarized in Exhibit 3.1.

1.1 Financial Measures

Financial measures often take top priority in for-profit organizations. Cost and price are obvious indicators of performance. For example, the banking industry monitors closely the costs associated with checking account transactions. Internet banking is being promoted because it has a distinct cost advantage: the estimated transaction costs typically are one percent of branch bank transaction costs. Businesses track prices charged by suppliers as part of their process to evaluate suppliers and to predict the effects on the company's financial stability. Traditional financial measures that companies use include revenue, return on investment, operating profit, pre-tax profit margin, asset utilization, growth, revenue from new goods and services, earnings per share, and other liquidity measures. Non-profit organizations, such as the Red Cross, churches, and government agencies, focus more on minimizing costs and maximizing value to their target markets, customers, and society. Monitoring cost and adherence to budgets are important factors in their operational success.

If It Moves, Measure It

A saying around eBay's headquarters is, "If it moves, measure it." Meg Whitman, eBay's CEO, personally monitors a host of measurements and indicators, including such standard ones for Internet companies as how many people visit the Web site, how many register to become users, how long each user remains per visit, how long pages take to load, and so on. She also monitors eBay's "take rate"—the ratio of revenues to the value of goods traded on the site, and what days are the busiest to determine when to offer free listings in order to stimulate the supply of auction items (Mondays in June are slow; Fridays in November rock). She even monitors the "noise" on eBay's discussion boards, online forums where users discuss, among other things, their opinion of eBay's management (Level 1 means "silent," and 10 means "hot" or "the community is ready to kill you." Normal for eBay is about 3).

To Whitman, measurements are a sign of a system that is process-oriented. The more stats, the more early warnings and the more levers to pull to make things work. However, she noted, "You have to be careful because you could measure too much."[3]

1.2 Customer and Market Measures

You have probably completed customer satisfaction surveys at a restaurant or after an Internet purchase, or perhaps you have lodged a complaint. Through customer and market feedback, an organization learns how satisfied its customers and stakeholders are with its goods and services and performance. Other customer-focused performance measures include customer retention, gains and

Exhibit 3.1 *The Scope of Business and Operations Performance Measurement*

Performance Measurement Category	Typical Organizational-Level Performance Measures	Typical Operational-Level Performance Measures
Financial	Revenue and profit Return on assets Earnings per share	Labor and material costs Cost of quality Budget variance
Customer and market	Customer satisfaction Customer retention Market share	Customer claims and complaints Type of warranty failure/upset Sales forecast accuracy
Safety	Number of accidents/injuries Lost workdays	Safety audit score Workplace safety violations
Quality	Goods quality Service quality Environmental quality	Defects/unit Call center courtesy Toxic waste discharge rate
Time	Speed Reliability	Flow (processing or cycle) time Percent of time meeting promise (due) date
Flexibility	Design flexibility Volume flexibility	Number of engineering changes Assembly line changeover time
Innovation and learning	New product development rates Employee satisfaction Employee turnover	Number of patent applications Number of improvement suggestions implemented Percent of workers trained on statistical process control

© Ryan McVay/Photodisc/Getty Images

losses of customers and customer accounts, customer complaints, warranty claims, measures of perceived value, loyalty, positive referral, and customer relationship building.

Measures of customer satisfaction reveal areas that need improvement and show whether changes actually result in improvement. *An effective* **customer-satisfaction measurement system** *provides a company with customer ratings of specific goods and service features and indicates the relationship between those ratings and the customer's likely future buying behavior.* It tracks trends and reveals patterns of customer behavior from which the company can predict future customer needs and wants. It also tracks and analyzes complaints and other measures of dissatisfaction.

At Federal Express, customers are asked to rate everything from billing to the performance of couriers, package condition, tracking and tracing capabilities, complaint handling, and helpfulness of employees. A restaurant might rate food appearance, taste, temperature, and portions, as well as cleanliness, staff friendliness, attentiveness, and perception of value.

Marketplace performance indicators could include market share, measures of business growth, new product and geographic markets entered, and percentage of new product sales as appropriate. In a commodity market (the egg further-processing industry—making liquid egg products from raw eggs) in which Sunny Fresh Foods competes, its performance drivers include the U.S. share of market and total pounds of egg products sold.

In the highly competitive semiconductor industry, STMicroelectronics looks not only at sales growth, but also at differentiated product sales.

1.3 Safety

Safety is such a basic attribute that it is hardly noticed. However, when a safety issue arises, it captures the attention of everyone. Measuring safety is vital to all organizations, as the well-being of its employees and customers should

> A **customer-satisfaction measurement system** provides a company with customer ratings of specific goods and service features and indicates the relationship between those ratings and the customer's likely future buying behavior.

be an organization's principal concern. Moreover, safety enhances employee productivity and morale in all types of organizations such as Federal Express, Nordstrom, General Motors, Ritz-Carlton Hotels, American Airlines, and government services. Federal and state agencies require organizations to track and report safety. Examples of safety-related performance measures include accident rates, the parts per million of arsenic in a public water supply, or the security in a hotel room.

© John Burke/PhotoLibrary

1.4 Quality

Quality *measures the degree to which the output of a process meets customer requirements.* Quality applies to both goods and services. We examine three types of quality—the quality of physical goods, service quality, and environmental quality.

Goods quality *relates to the physical performance and characteristics of a good.* Goods quality is generally measured using instruments, technology, and data collection processes. For example, the dimensions and weight of a good such as a laptop computer, its storage capacity, battery life, and actual speed are easy to measure.

Service quality *is consistently meeting or exceeding customer expectations (external focus) and service delivery system performance (internal focus) for all service encounters.* Many companies, including Amazon.com, Federal Express, and Nordstrom, have worked hard to provide superior service quality to their customers. Measuring service quality is paramount in such organizations.

Service-quality measures are based primarily on human perceptions of service collected from customer surveys, focus groups, and interviews. Research has shown that customers use five key dimensions to assess service quality:[4]

1. *Tangibles*—Physical facilities, uniforms, equipment, vehicles, and appearance of employees (i.e., the physical evidence).
2. *Reliability*—Ability to perform the promised service dependably and accurately.
3. *Responsiveness*—Willingness to help customers and provide prompt recovery to service upsets.
4. *Assurance*—Knowledge and courtesy of the service-providers, and their ability to inspire trust and confidence in customers.
5. *Empathy*—Caring attitude and individualized attention provided to its customers.

These five dimensions help form the basis for quality measurement in service organizations. Note that all but the first pertain to behavioral characteristics at the service encounter level, which are more difficult to measure than physical and technical characteristics.

Every service encounter provides an opportunity for error. *Errors in service creation and delivery are sometimes called* **service upsets** *or* **service failures**. Service measures should be linked closely to customer satisfaction so that they form the basis for improvement efforts. For example, a restaurant manager might keep track of the number and type of incorrect orders or measure the time from customer order to delivery.

Environmental quality *focuses on designing and controlling work processes to improve the environment.* For example, Honda of America requires reusable containers and packaging for most automobile parts and no longer needs to use or recycle cardboard and other packaging materials.

1.5 Time

Time relates to two types of performance measures—the *speed* of doing something (such as the time to process a customer's mortgage application) and the *variability* of the process. Speed can lead to a significant competitive advantage. Progressive Insurance, for example, boasts that it settles auto-insurance claims before competitors know there has been an accident![5] Speed is usually measured in clock time, while reliability is usually measured by quantifying the variance around average performance or targets. A simple metric is **processing time**—*the time it takes to perform some task.* For example, to make a pizza, a worker needs to roll out the dough, spread the sauce, and add the toppings, which might take three minutes. **Queue time** *is a fancy word for* **wait time**—*the time spent waiting.*

An important aspect of measuring time is the variance around the average time, as unanticipated variability is what often leads to an unhappy customer experience. Variability is usually measured by statistics such as the standard deviation or mean absolute deviation. For example, suppose that one company takes 10 days to process a new life insurance application plus or minus one day, while another takes 10 days plus or minus 5 days. Which life insurance process will give the best service to its customers? Which firm would you rather do business with?

Federal Express

Federal Express developed a composite measure of its service performance called the Service Quality Indicator (SQI), which is a weighted sum of 10 factors reflecting customers' expectations of company performance. These are listed below.

Error Type	Description	Weight
1. *Complaints reopened*—customer complaints (on traces, invoices, missed pickups, etc.) reopened after an unsatisfactory resolution		3
2. *Damaged packages*—packages with visible or concealed damage or spoilage due to weather or water damage, missed pickup, or late delivery		10
3. *International*—a composite score of performance measures of international operations		
4. *Invoice adjustments*—customer requests for credit or refunds for real or perceived failures		1
5. *Late pickup stops*—packages that were picked up later than the stated pickup time		3
6. *Lost packages*—claims for missing packages or with contents missing		10
7. *Missed proof of delivery*—invoices that lack written proof of delivery information		1
8. *Right date late*—delivery past promised time on the right day		1
9. *Traces*—package status and proof of delivery requests not in the COSMOS IIB computer system (the FedEx "real time" tracking system)		3
10. *Wrong day late*—delivery on the wrong day		5

Source: Service Quality Indicators at FedEx (internal company document).

The weights reflect the relative importance of each failure. Losing a package, for instance, is more serious than delivering it a few minutes late. The index is reported weekly and summarized on a monthly basis. Continuous improvement goals for the SQI are set each year. SQI is really a measure of process effectiveness. Meeting SQI performance goals also can account for as much as 40 percent of a manager's performance evaluation!

The importance of innovation and learning is well stated when Bill Gates said, "Microsoft is always two years away from failure."

1.6 Flexibility

Flexibility *is the ability to adapt quickly and effectively to changing requirements.* Flexibility can relate either to adapting to changing customer needs or to volume of demand. **Goods and service design flexibility** *is the ability to develop a wide range of customized goods or services to meet different or changing customer needs.* Examples of design flexibility include Dell's ability to provide a wide range of customized computer hardware to accommodate home users, small businesses, and large company's server needs, or a health club's ability to customize an individual client's workout or provide cardio rehabilitation classes for heart patients. Such flexibility requires a highly adaptable operations capability. Design flexibility is often evaluated by such measures as the rate of new product development or the percent of a firm's product mix that have been developed over the past three years.

Volume flexibility *is the ability to respond quickly to changes in the volume and type of demand.* This might mean rapid changeover from one product to another as the demand for certain goods increases or decreases, or the ability to produce a wide range of volumes as demand fluctuates. A hospital may have intensive-care nurses on standby in case of a dramatic increase in patient demand because of an accident or be able to borrow specialized diagnostic equipment from other hospitals when needed. Measures of volume flexibility would include the time required to change machine setups or the time required to "ramp up" to an increased production volume in response to surges in sales.

Electronic Airline Ticketing— Fast and Less Cost

Paper tickets cost airlines $10 to $17, on average, compared with $1 or less for electronic tickets. As a result, some airlines charge hefty fees for paper tickets and are encouraging customers to use electronic tickets instead. A fully electronic ticketing system will save the U.S. airline industry $3 billion a year. Electronic ticketing also lets airlines record revenue more quickly on their balance sheets and track revenue patterns. Airlines used to have to bundle and ship paper tickets to a processing facility that took weeks to process, but it now takes seconds.[6] Also, boarding passes can be printed at home at the customer's expense and speed up the check-in process at airports.

© Jeff Roberson/AP Photo

1.7 Innovation and Learning

Innovation *refers to the ability to create new and unique goods and services that delight customers and create competitive advantage.* Many goods and services are innovative when they first appear—think of the MP3 player and Palm Pilot. However, competitors quickly catch up; thus, innovation needs to be a constant process for many companies and must be measured and assessed. **Learning** *refers to creating, acquiring, and transferring knowledge, and modifying the behavior of employees in response to internal and external change.* For instance, when something goes wrong in one office or division, can the organization ensure that the mistake is not repeated again and does not occur in other offices or divisions? The importance of innovation and learning is well stated when Bill Gates said, "Microsoft is always two years away from failure."

© Rubberball/Jupiterimages

2 Productivity

productivity *is the ratio of output of a process to the input.*

$$\text{Productivity} = \frac{\text{Quantity of Output}}{\text{Quantity of Input}} \qquad [3.1]$$

As output increases for a constant level of input, or as the amount of input decreases for a constant level of output, productivity increases. Thus, a productivity measure describes how well the resources of an organization are being used to produce output. Productivity measures are often used to track trends over time.

> **Productivity** is the ratio of output of a process to the input.

Solved Problem

Consider a division of Miller Chemicals that produces water purification crystals for swimming pools. The major inputs used in the production process are labor, raw materials, and energy. For Year 1, labor costs are $180,000; raw materials cost $30,000; and energy costs amount to $5,000. Labor costs for Year 2 are $350,000; raw materials cost $40,000; and energy costs amount to $6,000. Miller Chemicals produced 100,000 pounds of crystals in Year 1 and 150,000 pounds of crystals in Year 2.

Solution:

Using equation 3.1 we have for Year 1:

$$\text{Productivity} = \frac{\text{Quantity of Output}}{\text{Quantity of Input}}$$

$$= \frac{100,000}{(\$180,000 + \$30,000 + \$5,000)}$$

$$= 0.465 \text{ lb / dollar}$$

For Year 2 we have:

$$\text{Productivity} = \frac{\text{Quantity of Output}}{\text{Quantity of Input}}$$

$$= \frac{150,000}{(\$350,000 + \$40,000 + \$6,000)}$$

$$= 0.379 \text{ lb / dollar}$$

We see that productivity has declined in the past year.

Measures of innovation and learning focus on an organization's people and infrastructure. Key measures might include intellectual asset growth, patent applications, the number of "best practices" implemented within the organization, and the percentage of new products developed over the past few years in the product portfolio. Of particular importance are measures associated with an organization's human resource capabilities. These can relate to employee training and skills development, well-being, satisfaction, and work system performance and effectiveness. Examples include health, absenteeism, turnover, employee satisfaction, training hours per employee, training effectiveness, and measures of improvement in job effectiveness. For instance, The Ritz-Carlton Hotel Company tracks percent turnover very closely, as this measure is a key indicator of employee satisfaction and the effectiveness of their selection and training processes.

3 Linking Internal and External Measures

anagers must understand the cause and effect linkages between key measures of performance. These relationships often explain the impact of (internal) operational performance on external results, such as profitability, market share, or customer satisfaction. For example, how do goods- and service-quality improvements impact revenue growth? How do improvements in complaint handling affect customer retention? How do increases or decreases in employee satisfaction affect customer satisfaction? How do changes in customer satisfaction affect costs and revenues?

The quantitative modeling of cause-and-effect relationships between external and internal performance criteria is called **interlinking**.[7] Interlinking tries to quantify the performance relationships between all parts of the value chain—the processes ("how"), goods and services outputs ("what"), and customer experiences

> The quantitative modeling of cause-and-effect relationships between external and internal performance criteria is called **interlinking**.
>
> The **value of a loyal customer (VLC)** quantifies the total revenue or profit each target market customer generates over the buyer's life cycle.

and outcomes ("why"). With interlinking models, managers can objectively make internal decisions that impact external outcomes, for example, determining the effects of adding resources or changing the operating system to reduce waiting time, and thereby, increase customer satisfaction (see Exhibit 3.2).

3.1 The Value of a Loyal Customer

Another example of an interlinking model is the financial **value of a loyal customer (VLC)**, *which quantifies the total revenue or profit each target market customer generates over the buyer's life cycle.* The VLC also provides an understanding of how customer satisfaction and loyalty affect the bottom line. Many organizations lose customers because of poor goods quality or service performance. This is often the result of operations managers failing to consider the economic impact of lost customers when they cut service staff or downgrade product designs. Likewise, many organizations do not understand the economic value of potential new customers when evaluating proposed goods or service improvements on a strict economic basis. Understanding the effects of operational decisions on revenue and customer retention can help organizations more appropriately use their resources. Goods-producing and service-providing organizations both benefit from understanding the value of a loyal customer performance relationship. When one considers the fact that it costs three to five times more to acquire a new customer than keep an existing customer, it is clear why customer retention is often the focus of top management improvement initiatives and strategies.

We will walk through an example of computing the average value of a loyal customer. Suppose that a computer manufacturer estimates that its annual customer retention rate is 80 percent, which means that 20 percent of customers who purchase a computer will not buy from them again (we call this the *customer defection rate* = 1 − *customer retention rate*). Assume that fixed costs are 35 percent and the manufacturer makes a before-tax profit margin of 10 percent.

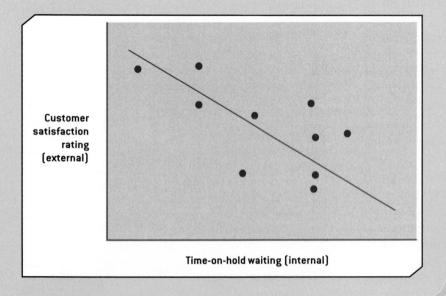

Exhibit 3.2 *Interlinking Internal and External Performance Measures*

Customer satisfaction rating (external)

Time-on-hold waiting (internal)

Therefore, the incremental contribution to profit and overhead is 45 percent. We also assume that customers buy a new computer every two years or 0.5 times per year at an average cost of $1,000.

On an annual basis, the average contribution to profit and overhead of a new customer is ($1,000)(0.45)(0.5) = $225 (the multiplier of 0.5 takes into account that customers purchase a new machine every two years). If 20 percent of customers do not return each year, then, on average, the buying life of a cus-tomer is five years (1/0.2 = 5). Therefore, the average value of a loyal customer over his or her average buying life is ($225 per year)(5 years) = $1,125.

Now suppose that the customer defection rate can be reduced to 10 percent by improving operations and/or employee service management skills. In this case, the average buying life doubles and the average value of a loyal customer increases to ($225 per year)(10 years) = $2,250. If goods and service improve-ments can also lead to a market share increase of 10,000 customers, the total contribution to profit and overhead would be $22,500,000 = ($1,000)(0.45)(0.5)(10)(10,000).

We can summarize the logic of these calculations with the following equation:

$$VLC = (P)(CM)(RF)(BLC) \qquad [3.2]$$

where P = the revenue per unit

CM = contribution margin to profit and over-head expressed as a fraction (i.e., 0.45, 0.5, and so on).

RF = repurchase frequency = number of pur-chases per year

BLC = buyer's life cycle, computed as 1/defec-tion rate, expressed as a fraction (1/0.2 = 5 years, 1/0.1 = 10 years, and so on).

By multiplying the VLC times the absolute number of customers gained or lost, the total market value can be found.

Solved Problem

What is the value of a loyal customer (VLC) in the small contractor target market segment who buys an electric drill on average every 4 years or 0.25 years for $100, when the gross margin on the drill averages 50 percent, and the customer retention rate is 60 percent? What if the customer retention rate increases to 80 per-cent? What is a 1 percent change in market share worth to the manufacturer if it represents 100,000 customers? What do you conclude?

Solution:

If customer retention rate is 60 percent, the average cus-tomer defection rate = (1 − customer retention rate). Thus, the customer defection rate is 40 percent, or 0.4. The average buyer's life cycle is 1/0.4 = 2.5 years. The repurchase frequency is every 4 years or 0.25 (1/4). Therefore,

VLC = (P)(RF)(CM)(BLC) = ($100)(0.25)(0.50)(1/0.4)
= $31.25

The value of a 1 percent change in market share
= (100,000 customers)($31.25/customer/year)
= $ 3,125,000

If customer retention rate is 80 percent, the average cus-tomer defection rate is 0.2, and the average buyer's life cycle is 1/0.2 = 5 years. Then,

VLC = (P)(RF)(CM)(BLC) = ($100)(0.25)(0.50)(1/.2)
= $62.50

Thus, the value of a 1 percent change in market share
= (100,000 customers)($62.50/customer/year)
= $ 6,250,000

The economics are clear. If customer retention can be increased from 60 to 80 percent through better value chain performance, the economic payoff is doubled.

4 Designing Measurement Systems in Operations

hat makes a good per-formance measurement system for operations? Many organizations define specific criteria for selecting and delet-ing performance measures from the organization's information system. IBM Rochester, for example, asks the following questions:

- Does the measurement support our mission?
- Will the measurement be used to manage change?
- Is it important to our customers?

- Is it effective in measuring performance?
- Is it effective in forecasting results?
- Is it easy to understand/simple?
- Is the data easy/cost-efficient to collect?
- Does the measurement have validity, integrity, and timeliness?
- Does the measurement have an owner?

Good performance measures are actionable. **Actionable measures** *provide the basis for decisions at the level at which they are applied*—the value chain, organization, process, department, workstation, job, and service encounter. They should be meaningful to the user, timely, and reflect how the organization generates value to customers. Performance measures should support, not conflict with, customer requirements. For example, customers expect a timely response when calling a customer support number. A common operational measure is the number of rings until the call is picked up. If a company performs well on this measure, but puts the customer on hold or in a never-ending menu, then a conflict clearly exists.

5 Models of Organizational Performance

four models of organizational performance—the Malcolm Baldrige National Quality Award framework, the Balanced Scorecard, the Value Chain model, and the Service-Profit Chain—provide popular frameworks for thinking about designing, monitoring, and evaluating performance. The first two models provide more of a "big picture" of organizational performance, while the last two provide more detailed frameworks for operations managers. Although OM focuses on execution and delivery of goods and services to customers, it is important to understand these "big picture" models of organizational performance because opera-

Actionable measures provide the basis for decisions at the level at which they are applied.

Measuring the Dough

Consider the process of placing, cooking, and delivering a pizza order. Customer expectations for such a process might be a good-tasting pizza prepared with the toppings requested, a quick delivery, and a fair price. Some possible performance measures are

- Number of pizzas, by type per hour.
- Number of pizzas rejected per number prepared and delivered.
- Order entry to customer delivery time.
- Number of errors in payments and collections.
- Raw materials (dough, toppings, and so on) or finished pizzas inventory in average units and dollars per day. A high inventory might result in spoilage and excess operating costs. Low inventory might result in stockouts, lost orders, or excessive customer delivery time.

Notice that these performance measures are related to the customer's expectations of goods (pizza) and service (order taking, delivery) performance. Can you think of any other useful performance measures for a pizza business?

tions managers must communicate with all functional areas. In addition, understanding these models helps you to better appreciate the interdisciplinary nature of an organization's performance system, the role that operations plays, and why operations managers need interdisciplinary skills.

5.1 Malcolm Baldrige National Quality Award Framework

The Malcolm Baldrige National Quality Award (MBNQA)—now known as the Baldrige National Quality Program–has been one of the most powerful catalysts for improving organizational performance in the United States, and indeed, throughout the world, in all sectors of the economy, including manufacturing, service, small business, health care, and education. The award was created to help stimulate American organizations to improve quality, productivity, and overall

competitiveness, and to encourage the development of high-performance management practices through innovation, learning, and sharing of best practices. Considerable evidence exists that it is working. An annual study conducted by the National Institute of Standards and Technology found that publicly traded Baldrige winners have generally outperformed the S&P 500 stock market index.[8]

Organizations can receive Baldrige awards in each of the original categories of manufacturing, small business, and service, and since 1999, in nonprofit education and health care. The program's Web site at http://baldrige.nist.gov provides a wealth of current information about the award, the performance criteria, award winners, and other aspects of the program.

Although the award itself receives the most attention, the primary purpose of the program is to provide a framework for performance excellence through self-assessment to understand an organization's strengths and weaknesses, thereby setting priorities for improvement. This framework is shown in Exhibit 3.3, and defines the *Criteria for Performance Excellence*. The criteria are designed to encourage companies to enhance their competitiveness through

an aligned approach to organizational performance management.

The criteria consist of a hierarchical set of *categories, items,* and *areas to address.* The seven categories are

1. *Leadership:* This category focuses on how senior leaders address values, directions, and performance expectations, as well as on customers and other stakeholders, empowerment, innovation, and learning. Also included is the organization's governance and how it addresses its public and community responsibilities.

2. *Strategic Planning:* This category focuses on how the organization develops strategic objectives and action plans, how the chosen strategic objectives and action plans are implemented, and how progress is measured.

3. *Customer Focus:* In this category, the focus is on how the organization determines requirements, expectations, and preferences of customers and markets, and how the organization builds relationships with customers and determines the key factors that lead to customer acquisition, satisfaction, loyalty and retention, and to business expansion.

4. *Measurement, Analysis, and Knowledge Management:* This category focuses on how an organization

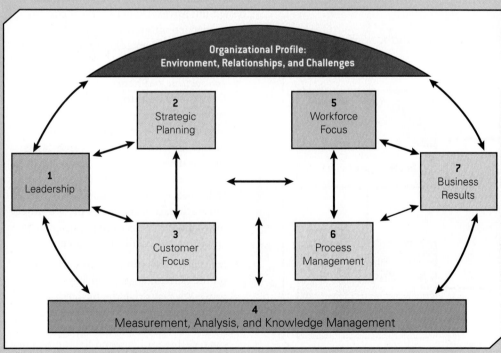

Exhibit 3.3
Malcolm Baldrige National Quality Award Model of Organizational Performance

Source: 2006 Malcolm Baldrige National Quality Award Criteria, U.S. Dept. of Commerce

selects, gathers, analyzes, manages, and improves its data, information, and knowledge assets.

5. *Workforce Focus:* This category addresses how an organization's work systems and employee learning and motivation enable employees to develop and utilize their full potential in alignment with the organization's overall objectives and action plans. Also included are the organization's efforts to build and maintain a work environment and an employee support climate conducive to performance excellence and to personal and organizational growth.

6. *Process Management:* This category examines the key aspects of process management, including product, service, and business processes for creating customer and organizational value, as well as key support processes.

7. *Business Results:* This category looks at the organization's performance and improvement, in key business areas—customer satisfaction, product and service performance, financial and marketplace performance, human resource performance, operational performance, and government and social responsibility.

The criteria are designed to help organizations focus on results and understand the impact that management practices and decisions have on these results. In essence, the criteria framework represents a macro-level interlinking model that relates management practices to business results. For example, if senior managers understand their customers and lead the planning process effectively (Categories 1, 2, and 3), and then translate plans into actions through people and processes (Categories 4 and 5), then positive business results should follow. Category 4—Information and Analysis—provides the foundation for assessment of results and continual improvements.

5.2 The Balanced Scorecard

Robert Kaplan and David Norton of the Harvard Business School, in response to the limitations of traditional accounting measures, popularized the notion of the **balanced scorecard**, which was first developed at Analog Devices. Its purpose is "to translate strategy into measures that uniquely communicate your vision to the organization." Their version of the balanced scorecard, as shown in Exhibit 3.4, consists of four performance perspectives:

- *Financial Perspective:* Measures the ultimate value that the business provides to its shareholders. This includes profitability, revenue growth, stock price, cash flows, return on investment, economic value added (EVA), and shareholder value.

- *Customer Perspective:* Focuses on customer wants and needs and satisfaction as well as market share and growth in market share. This includes safety, service levels, satisfaction ratings, delivery reliability, number of cooperative customer-company design initiatives, value of a loyal customer, customer retention, percent of sale from new goods and services, and frequency of repeat business.

- *Innovation and Learning Perspective:* Directs attention to the basis of a future success—the organization's people and infrastructure. Key measures might include intellectual and research assets, time to develop new goods and services, number of improvement suggestions per employee, employee satisfaction, market innovation, training hours per employee, hiring process effectiveness, revenue per employee, and skills development.

- *Internal Perspective:* Focuses attention on the performance of the key internal processes that drive the business. This includes such measures as goods and service quality levels, productivity, flow time, design and demand flexibility, asset utilization, safety, environmental quality, rework, and cost.

Exhibit 3.4 *The Balanced Scorecard Performance Categories and Linkages*

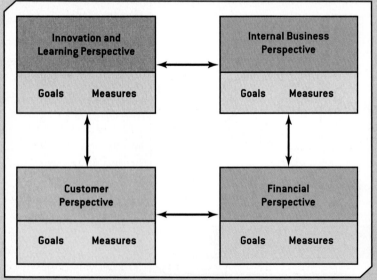

Source: Kaplan, R.S., and Norton, D.P., "The Balanced Scorecard—Measures That Drive Performance," *Harvard Business Review,* January–February 1992, p. 72.

PRO-TEC Coating Company

Established in 1990 as a joint venture between United States Steel Corporation and Kobe Steel Ltd. of Japan, PRO-TEC Coating Company is the industry leader in advanced high-strength steel coating and ultra-high strength steel coating, supplying about 15 percent of all hot-dipped galvanized steel to the automotive market. PRO-TEC's 236 employees, called Associates, work in a state-of-the-art 730,000-square-foot facility that is surrounded by corn and soybean fields. The small rural town of Leipsic, Ohio, was chosen for its access to Midwestern steel markets, its connection to rail and motor transportation, and its proximity to U.S. Steel's production facilities in Indiana and Pennsylvania.

PRO-TEC defines six key success factors (KSFs) for its business: associate quality of life, customer service, technical innovation and product development, system reliability, good citizenship, and long-term viability. A balanced scorecard (BSC) approach was designed to help align the company's KSFs with its mission, vision, and values; its quality, safety, and environmental policies; company policy manuals; and procedure and work instruction manuals for its integrated Quality and Environmental System. The BSC provides senior leaders a method to review key measures on a regular basis. The performance measures are determined through the strategic planning process, communicated to the workforce and stakeholders, and reviewed monthly for compliance.

Each Leadership Team member is responsible for reporting actual performance using a stoplight color-coded designation (green, yellow, red) that reflects the actual performance (good, marginal, or at-risk) against short-term targets. At-risk BSC measures require action, and the action is monitored through a formal management review process at the monthly plant management meeting. The BSC is also used for managing daily operations. For example, the workplace was designed with safety, environmental

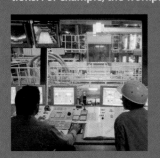

conditions, health, and security in mind. Thus, the balanced scorecard includes metrics for safety and health. The safety indicators report, which includes metrics on completion of housekeeping and quarterly safety audit items, mobile equipment inspections, and the weekly safety binder sign-off, is reviewed each Monday.[9]

The internal perspective is most meaningful to operations managers, as they deal with the day-to-day decisions that revolve around creating and delivering goods and services. As noted in Chapter 1, the internal perspective includes all types of internal processes: value creation processes, support processes, and general management or business processes.

The balanced scorecard is designed to be linked to an organization's strategy. The linkages between corporate and operations strategy and associated performance measures (called *competitive priorities*) are discussed in Chapter 4. Top management's job is to guide the organization, make tradeoffs among these four performance categories, and set future directions.

5.3 The Value Chain Model

A third way of viewing performance measurement is through the value chain concept itself. Of the four models of organizational performance presented in this chapter, the value chain model is probably the dominant model, especially for operations managers. Exhibit 3.5 shows the value chain structure and suggests some typical measures that managers would use to evaluate performance at each point in the value chain.

Suppliers provide goods and services inputs to the value chain that are used in the creation and delivery of value chain outputs. Measuring supplier performance is critical to managing a value chain. Typical supplier performance measures include quality of the inputs provided, price, delivery reliability, and service measures such as rates of problem resolution. Good supplier-based performance data is also the basis for cooperative partnerships between suppliers and their customers.

Operations managers have the primary responsibility to design and manage the processes and associated resources that create value for customers. Process data can reflect defect and error rates of intermediate operations, and also efficiency measures such as cost, flow time, delivery variability, productivity, schedule performance, equipment downtime, preventive

Exhibit 3.5 *Examples of Value Chain Performance Measurements*

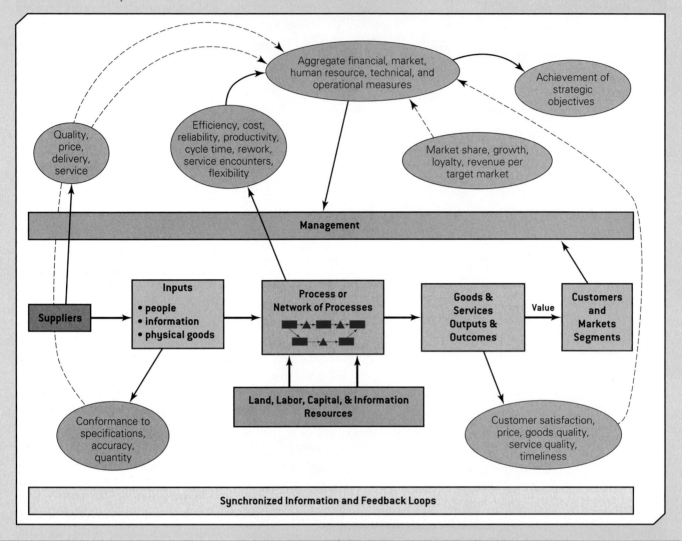

maintenance activity, rates of problem resolution, energy and equipment efficiency, and raw material usage. For example, Motorola measures nearly every process in the company, including engineering design, order entry, manufacturing, human resources, purchasing, accounting, and marketing, for improvements in error rates and flow times. One of its key business objectives is to reduce total organizational flow time—the time from the point a customer expresses a need until the customer pays the company for the good or service.

Measuring goods and service outputs and outcomes tell a company whether its processes are providing the levels of quality and service that customers expect. Organizations measure outputs and outcomes using metrics such as unit cost, defects per million opportunities, and lead time. Through customer and

market information, an organization learns how satisfied its customers and stakeholders are with its goods and services and performance and how best to configure the goods and services (i.e., customer benefit packages). Measures of customer satisfaction and retention reveal areas that need improvement, and show whether changes actually result in improvement.

Synchronized information and feedback loops provide the means of coordinating the value chain's physical and information flows, and for assessing whether the organization is achieving its strategic objectives. This is similar to the role of Category 4 (Measurement, Analysis and Knowledge Management) in the Malcolm Baldrige framework. One objective of timely information-sharing is to reduce or replace assets (employees, inventory, trucks, buildings,

Exhibit 3.6 *The Service-Profit Chain Model*

Adapted from J.L. Heskett, T.O. Jones, G.W. Loveman, W.E. Sasser, Jr., and L.A. Schlesinger, "Putting the Service-Profit Chain to Work," *Harvard Business Review*, March–April 1994, pp. 164–174.

etc.) with smart and timely performance information. For example, General Electric sells light bulbs in Wal-Mart stores; these sales are recorded immediately at General Electric factories and production is scheduled to real-time sales data. Fewer resources are needed to achieve performance goals when "information replaces assets." That is, inventories are reduced, flow times are shorter, quality is better, and costs are lower.

5.4 The Service-Profit Chain

The **Service-Profit Chain** (SPC) was first proposed in a 1994 *Harvard Business Review* article and is most applicable to service environments.[10] Exhibit 3.6 is one representation of the SPC, and many variations of this model have been proposed in academic and practitioner articles. Many companies, such as Citibank, General Electric, Intuit, Southwest Airlines, Taco Bell, Marlow Industries, and Xerox, have used this model of organizational performance. The theory of the Service-Profit Chain is that employees, through the

service delivery system, create customer value and drive profitability. As J.W. Marriott, the founder of Marriott Hotels said long ago, "Happy employees create happy customers."

The model is based on a set of cause-and-effect linkages between internal and external performance, and in this fashion, defines the key performance measurements on which service-based firms should focus. Because much of the value created in service processes is at the service encounter level, the Service-Profit Chain focuses on employees or service-providers. Healthy, motivated, well-trained, and loyal employees demonstrate higher levels of satisfaction that result in higher retention and productivity. This leads to higher levels of external service value to customers. External service value is created by service-providers mainly at the service encounter level. Buyers of services focus on outcomes, results, and experiences. Ultimately, good value creates higher customer satisfaction and loyalty, which in turn leads to higher revenue growth and profitability.

> As J.W. Marriott, the founder of Marriott Hotels said long ago, "Happy employees create happy customers."

IBM Rochester

IBM's AS/400 Division in Rochester, Minnesota, used the Service-Profit-Chain concept to help understand relationships that existed among measurements such as market share, overall customer satisfaction, employee morale, job satisfaction, warranty costs, inventory costs, product scrap, and productivity in order to determine which factors had the greatest impact on business performance and to improve management decisions. Using 10 years of data and statistical correlation analysis, they identified strong relationships among market share, customer satisfaction, productivity, warranty cost, and employee satisfaction. Their results suggested that to improve market share, the company needed to increase productivity and customer satisfaction, and decrease the costs of poor quality. These results indicate the importance of understanding the relationships between internal and external performance measures. Both productivity and customer satisfaction, as well as market share, were found to be strongly correlated to employee satisfaction. The results also suggested that to increase employee satisfaction, a manager must focus on improving job satisfaction, satisfaction with management, and satisfaction with having the right skills for the job.

The analysis helped managers to understand not only how to manage the workforce more effectively, but also how decisions at the operations level can affect long-term business success. Such decisions cannot be made without considering the ripple effects throughout the company. For example, if an action is taken that impacts employee satisfaction, such as a layoff, managers must consider counteractions to prevent a decline in productivity, customer satisfaction, and market share.[11]

© Sportstock/istockphoto.com

1. Interview managers at a local company to identify the key business measures (financial, market, supplier, employee, process, information, innovation, etc.) for that company. What quality indicators does that company measure? What cause and effect (interlinking) performance relationships would be of interest to the organization?

2. A major airline is attempting to evaluate the effect of recent changes it has made in scheduling flights between New York City and Los Angeles. Data available are shown below.

	Number of Flights	Number of Passengers
Month prior to schedule change	21	8,335
Month after schedule change	26	10,608

Using passengers per flight as a productivity indicator, comment on the apparent effect of the schedule change.

3. Revenue or costs per passenger mile are two key performance metrics in the airline industry. Research their use in this industry and prepare a one-page paper summarizing how they are used and why they are so important.

4. A hamburger factory produces 40,000 hamburgers each week. The equipment used costs $5,000 and will remain productive for 3 years. The labor cost per year is $8,000.

 a. What is the productivity measure of "units of output per dollar of input" averaged over the 3-year period?

 b. We have the option of $10,000 equipment, with an operating life of 5 years. It would reduce labor costs to $4,000 per year. Should we consider purchasing this equipment (using productivity arguments alone)?

5. A fast-food restaurant has a drive-through window and during peak lunch times can handle a maximum of 60 cars per hour with one person taking orders, assembling them, and acting as cashier. The average sale per order is $7.00. A proposal has been made to add two workers and divide the tasks among the three. One will take orders, the second will assemble them, and the third will act as cashier. With this system it is estimated that 100 cars per hour can be serviced. Use productivity arguments to recommend whether or not to change the current system.

6. When the value of a loyal customer (VLC) market segment is high, should these customers be given premium goods and services for premium prices? If the VLC is low, should they be given less service? Explain.

7. What is the average value of a loyal customer (VLC) in a target market segment if the average purchase price is $50 per visit, the frequency of repurchase is 12 times per year, the contribution margin is 10 percent, and the average customer defection rate is 25 percent? If a continuous improvement goal is set of a 20 percent defection rate next year and 15 percent two years from now, what are the revised VLCs over their average buying life?

8. What is the average defection rate for grocery store shoppers in a local area of a large city if they spend $50 per visit, shop 52 weeks per year, the grocery store has a 16 percent gross margin, and the value of a loyal customer is estimated at $3,000 per year?

9. Go to the Baldrige Web site, http://baldrige.nist.gov, and find the links to award winners. Review some of their application summaries and summarize the types of performance measures that these companies use.

10. The balanced scorecard was originally developed by Arthur M. Schneiderman at Analog Devices. Visit his Web site, www.schneiderman.com, and read the articles to answer the following questions:

 a. How was the first balanced scorecard developed?

 b. What steps should an organization follow to build a good balanced scorecard?

 c. Why do balanced scorecards fail?

BankUSA: Credit Card Division Case Study

BankUSA operates in 20 states and provides a full range of financial services for individuals and business. The credit card division is a profit center that has experienced a 20 percent annual growth rate over the last five years. The credit card division processes two types of credit (bank) cards. One type is for traditional card issuers such as savings and loan banks, credit unions, small banks without credit card processing capability, selected private label firms such as a retail chain, and BankUSA's own credit cards. This "individual customer" market segment involves about 15,000,000 cardholders. These credit card services include producing and mailing the plastic credit cards to customers, preparing and mailing monthly statements to customers, handling all customer requests such as stop payments and customer complaints, and preparation and distribution of summary reports to all internal and external customers.

The second major category of credit card customers includes major brokers and corporations such as IBM, Dean Witter, State Farm Insurance, and Merrill Lynch. These corporate customers use all the services of traditional card issuers but also usually have electronic access to their account files and desired a cash management type service. Although there are less than 3,000,000 cards issued the dollar volume of transactions processed is about equal to the traditional individual card issuers.

"Our internal operational measures seem to be good," Ms. Juanita Sutherland, the president of BankUSA's credit card division stated, "but the customer perceives our performance as poor based on marketing's recent customer survey. So, what's going on here? Can anyone at this meeting explain to me this mismatch between these two different sources of information? Is it an important problem or not?"

Mr. H.C. Morris, the vice president of operations quickly responded, "Juanita, one reason there's a mismatch is that operations doesn't have a say in the customer survey's design or performance criteria. We don't ask the same questions or use the same criteria!"

"Wait a minute H.C.! We often ask you operations folks for input into our customer survey design but the job usually gets shuttled to your newest MBA who doesn't have enough company knowledge to truly help us out," stated Mr. Bill Barlow, the corporate vice president of marketing, as he leaned forward on the conference room table.

"O.K.," Ms. Sutherland interjected, "I want you two to work on this issue and tell me in one week what to do." I've got another appointment so I must leave now but you two have got to work together and figure this thing out. I'm worried that we are losing customers!"

At a subsequent meeting between Mr. Morris and Mr. Barlow and their respective operations and marketing staffs, the following comments were made:

- "Reports are routed to over 1,200 institutions (i.e., card issuers), some on a daily and weekly basis but most on a monthly and quarterly basis. We don't have total control over providing accurate and timely report distribution because we must depend on other banks for certain detailed information such as debt notices and various transportation modes such as airborne courier service."

- "The trends in the marketing customer survey are helpful to everyone but the performance criteria simply do not match up well between marketing and operations."

- "Who cares about averages? If a client bank or corporate customer gets a quarterly performance report from us and it says we are meeting 99.2 per-cent of our service requirements but they are

© Stockbyte/Getty Images

getting bad service, then they wonder how important a customer they are to us."

- "Plastic card turnaround performance is very good based on the marketing survey data, but the wording of the customer survey questions on plastic card turnaround time is vague."
- "Operations people think they know what constitutes excellent service but how can they be sure?"
- "You'll never get marketing to let us help them design 'their' customer survey," said an angry operations supervisor. "Their marketing questions and what really happens are two different things."
- "We need a consistent numerical basis for knowing how well process performance matches up with external performance. My sample of data (see Exhibit 3.7) is a place to start."
- "Multiple sites and too many services complicate the analysis of what our basic problem is."
- "If your backroom operational performance measures really do the job, who cares about matching marketing and operations performance information. The backroom is a cost center, not a profit center!"

The meeting ended with a lot of arguing but not much progress. Both functional areas were protecting their "turf." How would you address Ms. Sutherland's questions?

Case Questions for Discussion

1. What are the major problems facing the credit card division?
2. What steps are required to develop a good internal and external performance and information system?
3. How should internal and external performance data be related? Are these data related? What do graphs and/or statistical data analysis tell you, if anything? (Use the data in Exhibit 3.7 to help answer these questions.)
4. Is the real service level what is measured internally or externally? Explain your reasoning.
5. What are your final recommendations?

Exhibit 3.7 *Sample Internal and External Credit Card Division Performance Data (This spreadsheet is available on the Premium Website.)*

Month	Customer Satisfaction Percent (%)	New Applicant Processing Time (Days)	Plastic Production Turnaround Time (Days)
1	80.4	1.5	1.4
2	81.8	1.0	1.1
3	81.6	1.4	1.2
4	83.7	1.8	0.9
5	83.3	1.6	1.1
6	81.7	1.5	1.1
7	84.0	1.2	0.8
8	84.5	1.3	1.2
9	84.3	1.7	0.9
10	86.3	1.1	1.1
11	84.2	1.3	1.1
12	85.0	1.1	1.2
13	85.3	0.9	0.8
14	85.8	1.0	1.1
15	84.1	0.9	0.9

OPERATIONS STRATEGY

r ival golf club manufacturers TaylorMade and Callaway are both based in Carlsbad, CA. That's about where the similarity ends. Callaway makes clubs for average golfers, while TaylorMade takes the clubs pro golfers use and adjusts them to suit amateurs. Callaway focuses on management and production efficiency while sticking to core product designs. TaylorMade, however, is constantly reinventing its products lines, and in an industry that expects product cycles to last 18 months or longer, releases new drivers and irons in rapid succession. Even new product launches show the difference between these companies: Callaway typically launches products with lengthy PowerPoint presentations, while TaylorMade turns them into huge pep rallies. TaylorMade's strategy seems to have paid off; late in 2003 it overtook Callaway in market share for metalwoods.[1]

© Golf Research In Play/PRNewsFoto/AP Photo

What do **you** think?

What implications would the different strategies chosen by Callaway and TaylorMade—sticking to core product designs versus continual innovation—have for key operations management decisions such as outsourcing and designing flexibility into their processes?

learning outcomes

After studying this chapter you should be able to:

LO1 Explain how organizations seek to gain competitive advantage.

LO2 Explain approaches for understanding customer requirements.

LO3 Describe how customers evaluate goods and services.

LO4 Explain the five key competitive priorities.

LO5 Explain the role of OM and operations strategy in strategic planning.

LO6 Describe Hill's framework for operations strategy.

1 Gaining Competitive Advantage

Competitive advantage *denotes a firm's ability to achieve market and financial superiority over its competitors.* In the long run, a sustainable competitive advantage provides above-average performance and is essential to survival of the business. Creating a competitive advantage requires a fundamental understanding of two things. First, management must understand customer wants and needs—and how the value chain can best meet these needs through the design and delivery of customer benefit packages that are attractive to customers. Second, management must build and leverage operational capabilities to support desired competitive priorities.

Every organization has a myriad of choices in deciding where to focus its efforts—for example, on low cost, high quality, quick response, or flexibility and customization—and in designing its operations to support its chosen strategy. The differences between Callaway and TaylorMade clearly show the significantly different strategies that competitors in the same industry can choose. These choices should be driven by the most important customer requirements and expectations. In particular, what happens in operations—on the front lines and on the factory floor—must support the strategic direction the firm has chosen.

Any change in a firm's customer benefit package or strategic direction typically has significant consequences for the entire value chain and for operations. While it may be difficult to change the *structure* of the

Competitive advantage denotes a firm's ability to achieve market and financial superiority over its competitors.

Every organization has a myriad of choices in deciding where to focus its efforts—for example, on low cost, high quality, quick response, or flexibility and customization—and in designing their operations to support their chosen strategy.

value chain, operations managers have considerable freedom in determining what components of the value chain to emphasize, selecting technology and processes, making human resource policy choices, and in making other relevant decisions to support the firm's strategic emphasis.

2 Understanding Customer Requirements

because the fundamental purpose of an organization is to provide goods and services of value to customers, it is important to first understand customer needs and requirements, and also to under-

stand how customers evaluate goods and services. However, a company usually cannot satisfy all customers with the same goods and services. Often, customers must be segmented into several natural groups, each with unique wants and needs. These segments might be based on buying behavior, geography, demographics, sales volume, profitability, or expected levels of service. By understanding differences among such segments, a company can design the most appropriate customer benefit packages, competitive strategies, and processes to create the goods and services to meet the unique needs of each segment.

To correctly identify what customers expect requires being "close to the customer." There are many ways to do this, such as having employees visit and talk to customers, having managers talk to customers, and doing formal marketing research. Marriott Corporation, for example, requires top managers to annually work a full day or more in the hotels as bellhops, waiters, bartenders, front desk service-providers, and so on, to gain a true understanding of customer wants and needs, and the types of issues that their hotel service-providers must face in serving the customer. Good marketing research includes such techniques as focus groups, salesperson and employee feedback, complaint analysis, on-the-spot interviews with customers, videotaped service encounters, mystery shoppers, telephone hotlines, Internet monitoring, and customer surveys.

A Japanese professor, Noriaki Kano, suggested three classes of customer requirements:

Follow the Money

Fidelity Investments discovered that when a customer does limited business and calls a service representative too frequently, costs can outweigh profits.[2] So when such customers called, Fidelity's reps began teaching them how to use its automated phone lines and Web site, which were designed to be friendlier and easier to use. These customers could talk to a service representative, but the phone system routed them into longer queues so the most profitable customers could be served more quickly. If these lower account balance customers switched to lower-cost channels such as the Web site, Fidelity became more profitable. If they did not like the experience and left, the company became more profitable without them. However, 96 percent of them stayed and most switched to lower-cost channels, and customer satisfaction actually increased as these customers learned to get faster service. This operations strategy helped the firm to lower costs and focus on its most profitable customers. In essence, Fidelity influences customer behavior within its value chain to create better operational efficiency.

1. **Dissatisfiers:** *Requirements that are expected in a good or service.* In an automobile, a radio and driver-side air bag are accessories that are expected by the customer; they are generally not stated as such by customers but are assumed as given. For a hotel, the customer assumes the hotel room is safe and clean. If these features are not present, the customer is dissatisfied, and sometimes very dissatisfied.

2. **Satisfiers:** *Requirements that customers say they want.* Many car buyers want a sunroof, power windows, or antilock brakes. Likewise, a hotel guest may want an exercise room, hot tub, or a restaurant in the hotel. Providing these goods and service features creates customer satisfaction by fulfilling customer's wants and needs.

3. **Exciters/delighters:** *New or innovative goods or service features that customers do not expect.* The presence of unexpected features leads to surprise, excitement, and enhances the customer's perceptions of value. Collision avoidance systems or an automobile satellite-based locator system, for example, can surprise and delight the customer, and enhance the customer's feeling of safety. Adding exciting music and laser lights can entertain and delight the customer as they shop for clothes in retail stores. Within the framework of the customer benefit package introduced in Chapter 1, these features are usually peripheral goods or services.

Dissatisfiers and satisfiers are relatively easy to determine through routine marketing research. As customers become familiar with new goods and service features that delight them, these same features become part of the standard customer benefit package over time. Eventually, exciters/delighters become satisfiers.

Basic customer expectations—dissatisfiers and satisfiers—are generally considered the minimum performance level required to stay in business and are often called **order qualifiers.** The unexpected features that surprise, entertain, and delight customers by going beyond the expected often make the difference in closing a sale. **Order winners** *are goods and service features and performance characteristics that differentiate one customer benefit package from another, and win the customer's business.* For example, decades ago financing the sale of an automobile was not nearly as important as financing and leasing options today. If three automobiles are roughly equal in terms of goods quality, manufacturer and dealer service quality, and price (i.e., price and quality parity), then an attractive leasing package bundled with the other goods and services may very well be the order winner.

Listen to Your Customers—Creatively!

At IDEO, one of the world's leading design firms (which designed Apple's first mouse, standup toothpaste tubes, and the Palm V), design doesn't begin with a far-out concept or a cool drawing. It begins with a deep understanding of the people who might use whatever product or service eventually emerges from its work, drawing from anthropology, psychology, biomechanics, and other disciplines. When former Disney executive Paul Pressler assumed the CEO position at Gap, he met with each of Gap's top 50 executives, asking them such standard questions as "What about Gap do you want to preserve and why?" "What about Gap do you want to change and why?" and so on. But he also added one of his own: "What is your most important tool for figuring out what the consumer wants?" Some companies use unconventional and innovative approaches to understand customers. Texas Instruments created a simulated classroom to understand how mathematics teachers use calculators; and a manager at Levi Strauss used to talk with teens who were lined up to buy rock concert tickets. The president of Chick-

© David Rogers/Publicity/Getty Images

fil-A spends at least one day each year behind the counter, as do all of the company's employees, and has camped out overnight with customers at store openings. At Whirlpool, when customers rate a competitor's product higher in satisfaction surveys, engineers take it apart to find out why. The company also has hundreds of consumers fiddle with computer-simulated products while engineers record the users' reactions on videotape.[3]

3 Evaluating Goods and Services

research suggests that customers use three types of attributes in evaluating the quality of goods and services: search, experience, and credence.[4] **Search attributes** *are those that a customer can determine prior to purchasing the goods and/or services.* These attributes include things like color, price, freshness, style, fit, feel, hardness, and smell. **Experience attributes** *are those that can be discerned only after purchase or during consumption or use.* Examples of these attributes are friendliness, taste, wearability, safety, fun, and customer satisfaction. **Credence attributes** *are any aspects of a good or service that the customer must believe in, but cannot personally evaluate even after purchase and consumption.* Examples would include the expertise of a surgeon or mechanic, the knowledge of a tax advisor, or the accuracy of tax preparation software.

This classification has several important implications for operations. For example, the most important search and experience attributes should be evaluated during design, measured during manufacturing, and drive key operational controls to ensure that they are built into the good with high quality. Credence attributes stem from the nature of services, the design of the service system, and the training and expertise of the service-providers.

These three evaluation criteria form an evaluation continuum from easy to difficult, as shown in Exhibit 4.1. This model suggests that goods are easier to evaluate than services, and that goods are high in search qualities while services are high in experience and credence attributes. Of course, goods and services are usually combined and configured in unique ways, making for an even more complex customer evaluation process. Customers evaluate services in ways that are often different from goods. A few ways are summarized below along with significant issues that affect operations.

- Customers seek and rely more on information from personal sources than from nonpersonal sources when evaluating services prior to purchase. Operations must ensure that accurate information is available, and that experiences with prior services and service-providers result in positive experiences and customer satisfaction.

- Customers perceive greater risks when buying services than when buying goods. Because services are intangible, customers cannot look at or touch them prior to the purchase decision. They experience the service only when they actually go through the process. This is why many are hesitant to use online banking or bill-paying.

Dissatisfaction with services is often the result of customers' inability to properly perform or co-produce

Search attributes are those that a customer can determine prior to purchasing the goods and/or services.

Experience attributes are those that can be discerned only after purchase or during consumption or use.

Credence attributes are any aspects of a good or service that the customer must believe in, but cannot personally evaluate even after purchase and consumption.

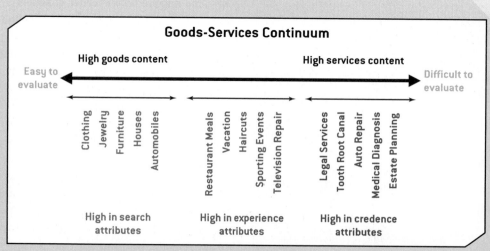

Exhibit 4.1
How Customers Evaluate Goods and Services

Source: Adapted from V.A. Zeithamel, "How Consumer Evaluation Processes Differ Between Goods and Services," in J.H. Donnelly and W.R. George, eds., *Marketing in Services*, published by the American Marketing Association, Chicago, 1981, pp. 186–199. Reprinted with permission from the American Marketing Association.

their part of the service. A wrong order placed on the Internet can be the result of customer error despite all efforts on the part of the company to provide clear instructions. The design of services must be sensitive to the needs to educate customers on their role in the service process.

These insights help to explain why it is more difficult to design services and service processes than goods and manufacturing operations.

4 Competitive Priorities

Competitive priorities *represent the strategic emphasis that a firm places on certain performance measures and operational capabilities within a value chain.* Understanding competitive priorities and their relationships with customer benefit packages provides a basis for designing the processes that create and deliver goods and services. Every organization is concerned with building and sustaining a competitive advantage in its markets. A strong competitive advantage is driven by customer needs and aligns the organization's resources with its business opportunities. A strong competitive advantage is difficult to copy, often because of a firm's culture, habits, or sunk costs.

Competitive advantage can be achieved in different ways, such as outperforming competitors on price or quality, responding quickly to changing customer needs in designing goods and services, or providing rapid design or delivery. In general, organizations can compete on five key competitive priorities:

1. Cost
2. Quality
3. Time
4. Flexibility
5. Innovation

All of these competitive priorities are vital to success. For example, no firm today can sacrifice quality simply to reduce costs, or emphasize flexibility to the extent that it would make their goods and services unaffordable. However, organizations generally make trade-offs among these competitive priorities and focus their efforts along one or two key dimensions. For example, Dell Computer manufactures PCs (1) with high goods quality, (2) configured to customer specifications, and (3) tries to deliver them quickly to customers. However, they are not always the least-expensive machines available, and customers must wait longer to

> **Competitive priorities** represent the strategic emphasis that a firm places on certain performance measures and operational capabilities within a value chain.

Coffee Wars

Starbucks is facing growing competition from competitors like Dunkin' Donuts and McDonald's for a good and inexpensive cup of coffee. McDonald's introduced "premium roast coffee" a few years ago, which was cited by *Consumer Reports* as the "cheapest and best." More recently, it has also added separate coffee bars—"McCafés"—to thousands of its stores and introduced traditional Starbucks-type coffee products such as lattes and mochas. (Interestingly, although McCafé is new to America, it has been available in Australia and Asia for many years.) Now Starbucks is fighting back and playing the McDonald's game: Starbucks is testing a $1 cup of coffee with free refills in the Seattle area. The CEO of Starbucks, Howard Schultz, says this is not a new strategy but that he believes that price is the number one competitive priority and that Starbucks lost its focus on customer service in recent years as it concentrated on growth.[5]

© Tim Boyle/Newsmakers/Getty Images

get a Dell computer as opposed to picking one off the shelf at a retail store. Hence, high goods quality and flexibility are top competitive priorities at Dell while cost and delivery time are of somewhat lesser importance.

4.1 Cost

Many firms, such as Wal-Mart, gain competitive advantage by establishing themselves as the low-cost leader in an industry. These firms handle high volumes of goods and services and achieve their competitive advantage through low prices. Although prices are generally set outside the realm of operations, low prices cannot be achieved without strict attention to cost and the design and management of operations. General Electric, for example, discovered

that 75 percent of its manufacturing costs are determined by design. Costs accumulate through the value chain, and include the costs of raw materials and purchased parts, direct manufacturing cost, distribution, postsale services, and all supporting processes. Through good design and by chipping away at costs, operations managers help to support a firm's strategy to be a low-price leader. They emphasize achieving economies of scale and finding cost advantages from all sources in the value chain.

Low cost can result from high productivity and high capacity utilization. More importantly, improvements in quality lead to improvements in productivity, which in turn lead to lower costs. Thus a strategy of continuous improvement is essential to achieve a low-cost competitive advantage.

Southwest Airlines

The only major U.S. airline that has been continuously profitable over the last several decades is Southwest Airlines. Other airlines have had to collectively reduce costs by $18.6 billion or 29 percent of their total operating expenses to operate at the same level (cost per mile) as Southwest. The high-cost airlines such as United and American face enormous pressure from low-fare carriers such as Southwest Airlines. Mr. Roach, a long-time industry consultant says "The industry really is at a point where survival is in question." In recent years, airlines have reduced capacity, cut routes, and increased fees for peripheral services like baggage and food. We have also seen mergers, such as between Delta and Northwest, to reduce system-wide costs.[6]

© Donna McWilliam/AP Photo

4.2 Quality

The role of quality in achieving competitive advantage was demonstrated by several research studies.[7] Researchers have found that

- Businesses offering premium quality goods usually have large market shares and were early entrants into their markets.

- Quality is positively and significantly related to a higher return on investment for almost all kinds of market situations.

- A strategy of quality improvement usually leads to increased market share, but at a cost in terms of reduced short-run profitability.

- Producers of high quality goods can usually charge premium prices.

Exhibit 4.2 summarizes the impact of quality on profitability. The value of a good or service in the marketplace is influenced by the quality of its design. Improvements in performance, features, and reliability will differentiate the good or service from its competitors, improve a firm's quality

reputation, and improve the perceived value of the customer benefit package. This allows the company to command higher prices and achieve an increased market share. This, in turn, leads to increased revenues that offset the added costs of improved design. Improved conformance in production leads to lower manufacturing and service costs through savings in rework, scrap, and warranty expenses. The net effect of improved quality of design and conformance is increased profits.

Operations managers deal with quality issues on a daily basis; these include ensuring that goods are produced defect-free, or that service is delivered flawlessly.

In many industries, strategies often lead to tradeoffs between quality and cost; some company strategies are willing to sacrifice quality in order to develop a low cost advantage. Such was the case with new automobile startups, especially with Hyundai Motor Co. However, goods quality has evolved over the years and now is generally considered to be an order qualifier. Operations managers deal with quality issues on a daily basis; these include ensuring that goods are produced defect-free, or that service is delivered flawlessly. In the long run, it is the design of

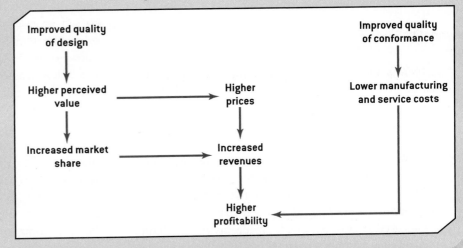

Exhibit 4.2 *Interlinking Quality and Profitability Performance*

Hyundai Motor Company

Hyundai Motor Company automobiles had been viewed as low-cost knockoffs of Japanese cars. When Hyundai's new CEO, Chung Mong Koo, took over in 1999, he walked on the factory floor and demanded a peek under the hood of a Sonata sedan. He didn't like what he saw: loose wires, tangled hoses, bolts painted four different colors. On the spot, he demanded that the bolts be painted black and ordered workers not to release any car unless all was orderly under the hood. The plant chief recalls Chung fuming: "The only way we can survive is to raise our quality to Toyota's level." Within months, he established quality-control units, promoted a pair of U.S. designers, and sold 10 percent of the company to DaimlerChrysler with the aim of building a strategic alliance. He poured money into research and development to build cars that not only compete on price but also on quality. Hyundai bought several new Toyota and Honda SUVs and tore them apart to analyze them and devise features that would set their product apart. Hyundai innovations ranged from a cup holder large enough to hold a liter soft drink bottle to extra power ports for cell phones. Their strategy is to be the low-cost producer (the order winner) and maintain competitive goods quality (the order qualifier).[8]

goods and service processes that ultimately define the quality of outputs and outcomes.

4.3 Time

In today's society, time is perhaps the most important source of competitive advantage. Customers demand quick response, short waiting times, and consistency in performance. Many firms such as Charles Schwab, Clarke American Checks, CNN, Dell, FedEx, and Wal-Mart know how to use time as a competitive weapon to create and deliver superior goods and services.

Reductions in flow time serve two purposes. First, they speed up work processes so that customer response is improved. Deliveries can be made faster, and more often on-time. Second, reductions in flow time can only be accomplished by streamlining and simplifying processes and value chains to eliminate non-value-added steps such as rework and waiting time. This forces improvements in quality by reducing the opportunity for mistakes and

that can exploit flexibility by building several different vehicles on the same assembly line at one time, enabling them to switch output as demand shifts, will be able to sell profitably at lower volumes. This is one key advantage that Japanese manufacturers have over U.S. automakers. Honda's two plants that produce Acura's MDX crossover sport utility vehicle and the less-expensive Honda Pilot can produce any combination of 300,000 MDX, Pilot, and Odyssey minivans. This allows Honda to concentrate on whatever model happens to be in greatest demand.[9] In contrast, competitors like Ford, GM, and DaimlerChrysler have as many as three factories dedicated to a single vehicle.

Flexibility is manifest in mass customization strategies that are becoming increasingly prevalent today. **Mass customization** *is being able to make whatever goods and services the customer wants, at any volume, at any time for anybody, and for a global organization, from any place in the world.*[10] Some examples include Sign-tic company signs that are uniquely designed for each customer from a standard base sign structure; business consult-

Innovations in all forms encapsulate human knowledge.

errors. By reducing non-value-added steps, costs are reduced as well. Thus, flow time reductions often drive simultaneous improvements in quality, cost, and productivity. Developing processes and using technology efficiently to improve speed and time reliability are some of the most important activities for operations managers.

Significant reductions in flow time cannot be achieved simply by focusing on individual subprocesses; cross-functional processes must be examined all across the organization. This forces the company to take a system's view of operations and to engage in cooperative behaviors.

Mass customization is being able to make whatever goods and services the customer wants, at any volume, at any time for anybody, and for a global organization, from any place in the world.

Innovation is the discovery and practical application or commercialization of a device, method, or idea that differs from existing norms.

4.4 Flexibility

Success in globally competitive markets requires a capacity for both design and demand flexibility. In the automobile industry, for example, new models are constantly being developed. Companies

ing; Levi's jeans that are cut to exact measurements; personal Web pages; estate planning; Motorola pagers customized in different colors, sizes, and shapes; personal weight-training programs; and modular furniture that customers can configure to their unique needs and tastes. Customer involvement might occur at the design (as in the case of custom signs), fabrication (Levi's jeans), assembly (Motorola pagers), or postproduction (customer-assembled modular furniture) stages of the value chain. Mass customization requires companies to align their activities around differentiated customer segments and design goods, services, and operations around flexibility.

4.5 Innovation

Innovation *is the discovery and practical application or commercialization of a device, method, or idea that differs from existing norms.* Innovations in all forms encapsulate human knowledge. Over the years, innovations in goods (such as telephones, automobiles, refrigerators, computers, optical fiber, satellites, and cell phones) and services (self-service, all-suite hotels, health

Solved Problem

Define the customer benefit package for a health club or recreation center or gymnasium you frequent. (Check out the Web site of your favorite club, center, or gym for more information.) Use this information to help describe the organization's strategic mission, strategy, competitive priorities, and how it wins customers.

One example is depicted below.

Mission: The mission of our health club is to offer many pathways to a healthy living style and body.

Strategy: We strive to provide our customers with superior:

- customer convenience (location, food, communication, schedules, etc.)
- clean facilities, equipment, uniforms, parking lot, and the like.
- friendly professional staff that care about you.
- ways to improve and maintain your body and mind's health and well being.

Competitive Priorities: #1 Priority: Many pathways to healthy living and a healthy body (design flexibility); #2 Priority: Friendly, professional staff and service encounters (service quality); #3 Priority: Everything is super clean (goods and environmental quality); #4 Priority: Customer convenience in all respects (time); and #5 Priority: Price (cost).

How to win customers? Providing a full-service health club with superior service, staff, and facilities. (Although you would not see this in company literature, this health club provides premium service at premium prices.)

Remember that each primary or peripheral good or service in the CBP requires a process to create and deliver it to customers, and therefore, OM skills are needed.

maintenance organizations, and Internet banking) have improved the overall quality of life. Within business organizations, innovations in manufacturing equipment (computer-aided design, robotic automation, and smart tags) and management practices (customer satisfaction surveys, quantitative decision models, and the Malcolm Baldrige criteria) have allowed organizations to be more efficient and better meet customers' needs.

Many firms focus on research and development for innovation as a core component of their strategy. Such firms are on the leading edge of product technology, and their ability to innovate and introduce new products is a critical success factor. Product performance, not price, is the major selling feature. When competition enters the market and profit margins fall, these companies often drop out of the market while continuing to introduce innovative new products. These companies focus on outstanding product research, design, and development; high product quality; and the ability to modify production facilities to produce new products frequently. As global competition increases, the ability to innovate has become almost essential for remaining competitive.

5 OM and Strategic Planning

t he direction an organization takes and the competitive priorities it chooses are driven by its strategy. The concept of strategy has different meanings to different people. **Strategy** *is a pattern or plan that integrates an organization's major goals, policies, and action sequences into a cohesive whole.*[11] Basically, a strategy is the approach by which an organization seeks to develop the capabilities required for achieving its competitive advantage. Effective strategies develop around a few key competitive priorities, such as low cost or fast service time, which provide a focus for the entire organization and exploit an organization's **core competencies**, *which are the strengths that are unique to that organization.* Such strengths might be a particularly skilled or creative workforce, customer

> **Strategy** is a pattern or plan that integrates an organization's major goals, policies, and action sequences into a cohesive whole.
>
> **Core competencies** are the strengths that are unique to an organization.

relationship management, clever bundling of goods and services, strong supply chain networks, extraordinary service, marketing expertise, or the ability to rapidly develop new products or change production-output rates.

Strategic planning is the process of determining long-term goals, policies, and plans for an organization. The objective of strategic planning is to build a position that is so strong in selected ways that the organization can achieve its goals despite unforeseeable external forces that may arise. Strategy is the result of a series of hierarchical decisions about goals, directions, and resources; thus, most large organizations have three levels of strategy: corporate, business, and functional. At the top level, *corporate strategy* is necessary to define the businesses in which the corporation will participate and develop plans for the acquisition and allocation of resources among those businesses. The businesses in which the firm will participate are often called strategic business units (SBUs), and are usually defined as families of goods or services having similar characteristics or methods of creation. For small organizations, the corporate and business strategies frequently are the same.

The second level of strategy is generally called *business strategy,* and defines the focus for SBUs. The major decisions involve which markets to pursue and how best to compete in those markets; that is, what competitive priorities the firm should pursue.

Finally, the third level of strategy is *functional strategies,* the means by which business strategies are accomplished. A functional strategy is the set of decisions that each functional area (marketing, finance, operations, research and development, engineering, and so on) develops to support its particular business strategy.

Our particular focus will be on operations strategy—how an organization's processes are designed and organized to produce the type of goods and services to support the corporate and business strategies.

© Burke/Triolo/Brand X Pictures/Jupiter Images

An **operations strategy** defines how an organization will execute its chosen business strategies.

5.1 Operations Strategy

An **operations strategy** *defines how an organization will execute its chosen business strategies.* Developing an operations strategy involves translating competitive priorities into operational capabilities by making a variety of choices and trade-offs for design and operating decisions. That is, operating decisions must be aligned with achieving the desired competitive priorities. For example, if corporate objectives are to be the low cost and mass market producer of a good, then adopting an assembly line type of process is how operations can help achieve this corporate objective.

What kind of an operations strategy might a company like Pal's Sudden Service (see Chapter 1) have? Consider the operations management implications of key elements of the company's vision: *To be the preferred quick service restaurant in our market achieving the largest market share by providing:*

1. *The quickest, friendliest, most accurate service available.* To achieve quick and accurate service, Pal's needs highly standardized processes. The staff at each Pal's facility is organized into process teams along the order-taking, processing, packaging, and order-completion line. The process layout is designed so that raw materials enter through a delivery door and are worked forward through the store with one process serving the next. Employees must have clearly defined roles and responsibilities, understanding of all operating and service procedures and quality standards, and job flexibility through cross-training to be able to respond to volume cycles and unplanned reassignments to work activities. To ensure friendly service, Pal's uses specific performance criteria to evaluate and select employees who demonstrate the aptitude, talents, and characteristics to meet performance standards, invests heavily in training, and pays close attention to employee satisfaction.

2. *A focused menu that delights customers.* Employees must understand their customers' likes and dislikes of their products and services as well as their competitors. Operations must address such questions as: What capabilities will we need to support a new menu offering? Do our suppliers have the capacity to

support this new offering? Is the appropriate technology available?

3. *Daily excellence in product, service, and systems execution.* Successful day-to-day operations require employees to effectively apply Pal's On-Line Quality Control process, consisting of four simple steps: standardize the method or process, use the method, study the results, and take control. Each employee is thoroughly trained and coached on precise work procedures and process standards, focusing on developing a visual reference to verify product quality.

4. *Clean, organized, sanitary facilities.* Pal's focuses on prevention—eliminating all possible causes of accidents—first, then finding and eliminating causes of actual incidents. In-house health and safety inspections are conducted monthly using the FDA Food Service Sanitation Ordinance. Results are compiled and distributed to all stores within 24 hours with any identified improvements applied in each store.

5. *Exceptional value.* Through methods of listening and learning from customers and studies of industry standards and best practices, Pal's has designed the following items into its operations: convenient locations with easy ingress and egress, long hours of operation (6:00 a.m. to 10:00 p.m.), easy-to-read 3-D menus, direct fact-to-face access to order taker and cashier/order deliverer, fresh food (cooked hot dogs are discarded after 10 minutes if not purchased), a 20-second delivery target, and a Web site for contacting corporate office and stores. Pal's selects suppliers carefully to ensure not only product quality and on-time delivery, but also the best price for the volume level purchased. Overall supply chain costs are minimized by maintaining only a few, long-term core suppliers.

From this discussion of Pal's Sudden Service, it is clear that how operations are designed and implemented can have a dramatic effect on business performance and achievement of the strategy. Therefore, operations require close coordination with functional strategies in other areas of the firm, such as marketing and finance.

 6 A Framework for Operations Strategy

 useful framework for strategy development that ties corporate and marketing strategy to operations strategy was proposed by Professor Terry Hill at Templeton College, Oxford University, and is shown in Exhibit 4.3.[12] It was originally designed for goods-producing organizations; however, it can also be applied to service-providing firms. This framework

Exhibit 4.3 *Hill's Strategy Development Framework*

Corporate Objectives	Marketing Strategy	How Do Goods and Services Qualify and Win Orders in the Marketplace? (Competitive Priorities)	Operations Strategy	
			Operations Design Choices	**Infrastructure**
• Growth • Survival • Profit • Return on investment • Other market and financial measures • Social welfare	• Goods and services markets and segments • Range • Mix • Volumes • Standardization versus customization • Level of innovation • Leader versus follower alternatives	• Safety • Price (cost) • Range • Flexibility • Demand • Goods and service design • Quality • Service • Goods • Environment • Brand image • Delivery • Speed • Variability • Technical support • Pre- and postservice support	• Type of processes and alternative designs • Supply chain integration and outsourcing • Technology • Capacity and facilities (size, timing, location) • Inventory • Trade-off analysis	• Work force • Operating plans and control system(s) • Quality control • Organizational structure • Compensation system • Learning and innovation systems • Support services

Source: T. Hill, *Manufacturing Strategy: Text and Cases,* 3rd ed., Burr Ridge, IL: McGraw-Hill, 2000, p. 32 and T. Hill, *Operations Management: Strategic Context and Managerial Analysis,* 2nd ed., Prigrame MacMillan, 2005, p. 50. Reprinted with permission from the McGraw-Hill Companies.

defines the essential elements of an effective operations strategy in the last two columns—*operations design choices* and *building the right infrastructure*.

Operations design choices *are the decisions management must make as to what type of process structure is best suited to produce goods or create services.* It typically addresses six key areas—types of processes, value chain integration and outsourcing, technology, capacity and facilities, inventory and service capacity, and tradeoffs among these decisions.

Infrastructure *focuses on the nonprocess features and capabilities of the organization and includes the workforce, operating plans and control systems, quality control, organizational structure, compensation systems, learning and innovation systems, and support services.* The infrastructure must support process choice and provide managers with accurate and timely information to make good decisions. These decisions lie at the core of organizational effectiveness, and suggest that the integrative nature of operations management is one of the most important aspects of success.

A key feature of this framework is the link between operations and corporate and marketing strategies. Clearly, it is counterproductive to design a customer benefit package and an operations system to produce and deliver it, and then discover that these plans will not achieve corporate and marketing objectives. This linkage is described by the four major decision loops illustrated in Exhibit 4.4. Decision loop #1 (shown in red) ties together corporate strategy—which establishes the organization's direction and boundaries—and marketing strategy—which evaluates customer wants and needs and targets market segments.

The output of red loop #1 is the input for green loop #2. Decision loop #2 describes how operations evaluates the implications of competitive priorities in terms of process choice and infrastructure. The key decisions are "Do we have the process capability to achieve the corporate and marketing objectives per target market segment? Are our processes capable of consistently achieving order winner performance in each market segment?"

Decision loop #3 (blue) lies within the operations function of the organization and involves determining if process choice decisions and capabilities are consistent with infrastructure decisions and capabilities. The fourth decision loop (yellow loop #4) represents operations' input into the corporate and marketing strategy. Corporate decision makers ultimately decide how to allocate resources to achieve corporate objectives.

6.1 Operations Strategy at McDonald's

McDonald's Corporation is the world's leading food-service retailer, with sales of over $23 billion in more than 31,000 restaurants in 115 countries, employing 1.6 million people. The company's vision provides the basis for its strategy:

> *McDonald's vision is to be the world's best quick service restaurant experience.* Being the best means providing outstanding quality, service, cleanliness, and

Exhibit 4.4 *Four Key Decision Loops in Terry Hill's Generic Strategy Framework*

value, so that we make every customer in every restaurant smile. To achieve our vision, we focus on three worldwide strategies:

1. **Be the Best Employer**

 Be the best employer for our people in each community around the world.

2. **Deliver Operational Excellence**

 Deliver operational excellence to our customers in each of our restaurants.

3. **Achieve Enduring Profitable Growth**

 Achieve enduring profitable growth by expanding the brand and leveraging the strengths of the McDonald's system through innovation and technology.

© California Milk Processor Board/ PRNewsFoto/AP Photo

What is the customer benefit package (CBP) that McDonald's offers? Exhibit 4.5 shows the CBP, in which goods- and service-content (food and fast service) are equally important and the primary mission, and are supported by peripheral goods and services.

Exhibit 4.6 illustrates how Hill's strategy framework can be applied to McDonald's. One corporate objective is profitable growth. Global research suggests that time pressures are causing people to eat out more than ever. The more people eat out, the more variety they want. That is why McDonald's bought such restaurant chains as Boston Market and Chipotle (Mexican food).

The marketing strategy to support profitable growth consists of adding both company-owned and franchised McDonald's and Partner Brand restaurants. McDonald's is committed to franchising as a key strategy to grow and

leverage value chain capabilities. Approximately 78 percent of McDonald's restaurants worldwide are owned and operated by independent business people—the franchisee.

The core competency to profitable growth is maintaining low cost and fast service. To support this strategy, McDonald's has many operational decisions to make such as: Do they adopt an assembly line approach to process design? Do they standardize store design to make process flow, training, and performance evaluation consistent among stores? Do they standardize equipment and job design work activities? The french fryer equipment and procedure is a good example of standardizing equipment design. There is "only one way to make french fries" in 31,000 stores worldwide and this contributes to consistent goods-quality, fast service, and a standardized training program. Likewise, ordering by the numbers and digital printouts of customer orders in the drive-through improves order accuracy and speed of service. Of course, the entire human resource function is built around the needs of McDonald's value chain and operating systems. McDonald's has been identified as one of the best places to work by *Fortune* and *The American Economic Review*. Examples of supportive infrastructure include good hiring criteria, recognition and reward programs, training, and promotion criteria.

The ultimate objective of operational excellence is satisfied customers. Operational excellence includes value chain, process, equipment, and job efficiencies, as well as superior people-related performance—all focused to support the service encounter level.

A second corporate objective is *operational excellence*. The ultimate objective of operational excellence is satisfied customers. Operational excellence includes value chain, process, equipment, and job efficiencies, as well as superior people-related performance—all focused to support the service encounter level. McDon-

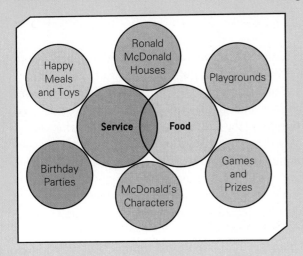

Exhibit 4.5 *McDonald's Customer Benefit Package*

Happy Meals and Toys

Ronald McDonald Houses

Playgrounds

Service — Food

Birthday Parties

McDonald's Characters

Games and Prizes

Exhibit 4.6 *Applying the Hill's Strategy Development Framework to McDonald's*

Corporate Objective Examples	Marketing Strategy Examples	How Do Goods and Services Qualify and Win Orders in the Marketplace? (Competitive Priorities)	Operations Strategy	
			Operating Design Choice Examples	**Infrastructure Examples**
Profitable Growth	Add worldwide 1,000 McDonald's restaurants using company-owned and franchised stores	Competitive priorities tie the corporate and marketing strategies to the operational strategy ⟷	• Flow shop process design • Standardized store design • Equipment design • Job design • Order-taking process • Capacity and facility size, location, and clusters	• Hiring process and criteria • First job training • Recognition and rewards • Training for the unexpected • Keeping it simple • Manager trainee program • Coaching and counseling • Teamwork • e-mail capabilities
Operational Excellence	Ideal store location, best training and employee well-being programs	• #1 Low prices • #2 Quick service (delivery speed) • #3 High service quality	• Global value chain coordination • Suppliers • Resource scheduling • Inventory placement and control • Distribution centers • Standardized operational and job procedures	• Operating plans and control system(s) • Shift management • Supplier relations and negotiation • Equipment maintenance • Online network capability • Distribution centers
Leverage Strengths Through Innovation and Technology	Develop new food items, store and food mix Tie demand analysis to promotions	⟷ • #4 High goods quality	• Store equipment technology • Value chain information systems to tie stores, distribution centers, and suppliers together • New food products	• Quality control • Laboratory testing • Organizational structure • Compensation systems • Online network capability
Diversity	Long-standing commitment to a diverse work force	• #5 Demand flexibility	• Training and franchising • Process performance • Career paths	• Learning and innovation systems • Hamburger University
Social Responsibility	Being a good neighbor and partner with the local community	• #6 Brand image ⟷	• Trade-off analysis • Recycling processes • Package redesign, shipping, warehousing	• Support services • Ronald McDonald House • Mobile health centers • Youth camps

ald's strategy is to deliver exceptional customer experiences through a combination of great-tasting food, outstanding service, being a good place to work, profitable growth, and consistent value. McDonald's service goals also include over 24,000 stores using extended or 24-hour service to make McDonald's the most convenient food-service choice for customers. To put sparkle in McDonald's service, initiatives include training for the unexpected and keeping it simple.

A third corporate objective is leveraging innovation and technology capabilities. In the United States, McDonald's has 40 distribution centers to support more than 12,000 restaurants and about 350 suppliers. More than 2,000 safety and quality checks surround McDonald's food as it moves through their supply chains (from farms to restaurants). Information technology is used to coordinate the activities of McDonald's value chain.

Another corporate objective is developing and maintaining a diverse workforce. Diversity at McDonald's means understanding, recognizing, and valuing the differences that make each person unique. Hamburger University, located in Oak Brook, Illinois, has trained over 275,000 managers in 22 different languages and also manages 10 international training centers in places

like Australia, England, Japan, and Germany.

McDonald's supports its social responsibility objective with over 200 Ronald McDonald House Charities. Social responsibility activities also include funding immunization programs for one million African children, Olympic youth camps, disaster relief, and sponsored mobile health centers in underserved areas. Other corporate objectives not shown in Exhibit 4.6 include a high return on investment, exploring nontraditional

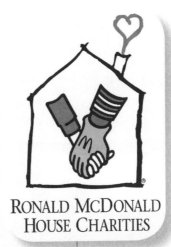

© McDonald's/PRNewsFoto/AP Photo

RONALD MCDONALD
HOUSE CHARITIES

locations for stores, and commitment to the environment.

Competitive priorities are derived from McDonald's vision statement and strategy. The ranking in Exhibit 4.6 reflects their importance. The competitive priorities tie the corporate and marketing strategies to the operations strategy. The competitive priorities provide direction on key operations strategy issues listed in the last two columns of Exhibit 4.6.

Problems, Activities, and Discussions

1. What might the competitive advantage be for each of the following companies:
 a. eBay
 b. Southwest Airlines
 c. Starbucks
 d. Toyota
 e. Apple
 f. Facebook

2. Choose one of the following organizations with which you are familiar:
 - sporting goods store
 - haircut salon
 - college bar or restaurant
 - pizza business
 - a sports team
 - wireless telephone service

 Define the firm's strategic mission, strategy, and competitive priorities. What are the order qualifiers and winners? What would operations have to be good at to make this a successful business or organization?

3. Select businesses you are familiar with and identify and provide examples of customers using search, experience, and credence quality to evaluate the good or service. You might also look up the businesses on the Internet or visit the library.

4. Provide examples of dissatisfiers, satisfiers, and exciters/delighters different from those in the book, and based on your own experience. Why are these classifications important for companies to understand, particularly from a strategic point of view, and how should companies use this knowledge?

5. Explain the interlinking model of quality and profitability (Exhibit 4.2). How does it connect to business and operations strategy? Can you provide any examples of goods and services that support and add credibility to this model?

6. Is it possible for a world-class organization to achieve superiority in all five major competitive priorities—price (cost), quality, time, flexibility, and innovation? Explain your reasoning. Provide examples pro or con.

7. Using the information about Pal's Sudden Service provided in this chapter, apply Hill's generic strategy framework in a similar fashion as the McDonald's example. How do the strategies of Pal's and McDonald's appear to differ? What differences exist in their operations strategies and decisions?

8. Explore the Web sites for several competing companies on the Fortune 500 list. Based on the information you find, on which competitive priorities do these firms appear to focus? What can you say about their operations strategy (either explicit or implied)?

9. Apply Hill's strategy framework to one of the companies in Question 1. This will require research to identify corporate objectives and competitive priorities. See the McDonald's example in the chapter for guidance and make sure that you emphasize OM concepts, capabilities, and execution.

10. Identify two competing organizations similar to TaylorMade and Callaway that were described in the opening scenario of this chapter. Explain the differences in their missions, strategies, and competitive priorities, and how their operations strategies might differ. Use the Internet or business magazines to research the information you need.

"Chris, we make the highest quality grass seed and fertilizer in the world. Our brands are known everywhere!" stated Caroline Ebelhar, the vice president of manufacturing for The Lawn Care Company. "Yeah! But the customer doesn't have a Ph.D. in organic chemistry to understand the difference between our grass seed and fertilizer compared to those of our competitors! We need to also be in the lawn care application service business, and not just the manufacturer of super perfect products," responded Chris Kilbourne, the vice president of marketing, as he walked out of Caroline's office. This ongoing debate among Lawn Care's senior management team had not been resolved but the chief executive officer, Mr. Steven Marion, had been listening very closely. A major strategic decision would soon have to be made.

© Charles Rex Arbogast/AP Photo

The Lawn Care Company, a fertilizer and grass seed manufacturer with sales of almost $1 billion, sold some of its products directly to parks and golf courses. Customer service in this goods-producing company was historically very narrowly defined as providing "the right product to the right customer at the right time." Once these goods were delivered to the customer's premises and the customer signed the shipping documents, Lawn Care's job was done. For many park and golf course customers, a local subcontractor or the customers themselves applied the fertilizer and seed. These application personnel often did the job incorrectly using inappropriate equipment and methods. The relationship among these non-Lawn Care application service personnel, The Lawn Care Company, and the customer also was not always ideal. When the customer made claims because of damaged lawns, the question then became who was at fault? Did the quality of the physical product or the way it was applied cause the damage? Either way, the customer's lawns were in poor shape, and in some cases, the golf courses lost substantial revenue if a green or hole was severely damaged or not playable.

One of Lawn Care's competitors began an application service for parks and golf courses that routinely applied the fertilizer and grass seed for its primary customers. This competitor bundled the application service to the primary goods, fertilizer and grass seed, and charged a higher price for this service. The competitor learned the application business in the parks and golf course target market segment and was beginning to explore expanding into the residential lawn care application service target market. The Lawn Care Company sold the "highest quality physical products" in the industry but it was not currently in either the professional park and golf course or the residential lawn care market segments. Its competitor sold the customer "a beautiful lawn with a promise of no hassles." To the competitor this included an application service bundled to grass seed and fertilizer.

Case Questions for Discussion

1. Define Lawn Care's current strategic mission, strategy, competitive priorities, value chain, and how it wins customers. What are the order qualifiers and winners?

2. Draw the major stages of the value chain with and without an application service and comment on the role of operations in each.

3. What problems, if any, do you see with Lawn Care's current strategy, vision, customer benefit package and value chain design, and pre- and postservices?

4. What pre- and postservices could Lawn Care offer its customers to complement the sale of its physical goods, such as grass seed and fertilizer?

5. Redo questions (1) to (4) and provide a new or revised strategy and associated customer benefit package and value chain where services play a larger role.

6. What are your final recommendations?

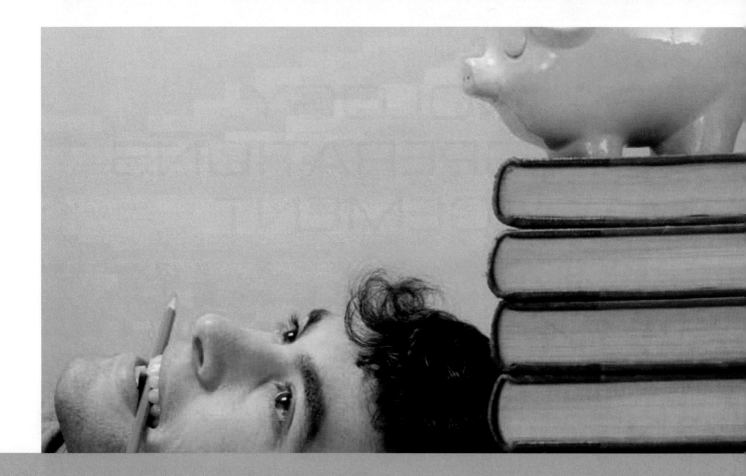

MORE BANG FOR YOUR BUCK!

OM2 has it all, and so can you! Between the text and online resources, **OM2** offers everything you need to study:
- In-Text Review Cards
- Online Tutorial Quizzes
- Printable Flash Cards
- Interactive Games
- In-Text and Online Cases
- And More!

TECHNOLOGY AND OPERATIONS MANAGEMENT

Imagine a team of employees that works 16 hours a day, seven days a week. They never call in sick or show up late. They demand no benefits, require no health insurance, no coffee breaks, and receive no paychecks. They never complain. Sounds like a bunch of robots, huh? They are, in fact, robots—and they're dramatically changing the way Staples, the largest distributor of office products in the United States, delivers thousands of orders to its customers.

Having people run around a warehouse looking for those items is expensive, especially when the company promises next-day delivery. When customer orders come in, the computer tells the 2-foot-high, 3-foot-long machines where to find racks with the appropriate items; the robots, following a network of evenly spaced bar-code stickers spread across the floor, locate the racks, slide beneath them, and lift them in the air. They then carry them to picking stations and wait patiently as humans pull the correct products and place them in boxes. When orders are filled, the robots neatly park the racks back among the rest. When they run low on power, they head to battery-charging terminals, or, as warehouse personnel say, "They get themselves a drink of water." Overall, average daily output is up 60%.[1]

© Andersen Ross/Blend Images/Jupiter Images

What do **you** think?

In what ways has technology benefited your life and work as a student?

learning outcomes

After studying this chapter you should be able to:

LO1 Describe different types of technology and their role in manufacturing and service operations.

LO2 Explain how manufacturing and service technology is strengthening the value chain.

LO3 Explain the benefits and challenges of using technology.

LO4 Describe the processes of technology development and adoption.

Technology—both physical and information—has dramatically changed how work is accomplished in every industry—from mining to manufacturing to education to health care. Technology is the enabler that makes today's service and manufacturing systems operate productively and meet customer needs better than ever. Most of you probably cannot imagine living in a world without personal computers, the Internet, or wireless communications. We are sure that people in the early 1900s felt the same way about the steam engine, as did your parents and grandparents about the automobile and radio. The steam engine lasted only about 50 years before a new technology—the gasoline internal combustion engine—replaced the old technology. Although the gasoline-powered engine has prevailed for about 100 years, we are beginning to see electric, hybrid, and other potential replacements.

Technological innovation in goods, services, manufacturing, and service delivery is a competitive necessity. Jack Welch, retired CEO of General Electric, for example, pushed GE to become a leader among traditional old-economy companies in embracing the Internet after noticing his wife Christmas shopping on the Web. "I realized that if I didn't watch it, I would retire as a Neanderthal," he was reported as saying, "So I just started reading everything I could about it." He began by pairing 1,000 Web-savvy mentors with senior people to get his top teams up to Internet speed quickly.[2]

1 Understanding Technology in Operations

We may categorize technology into two basic groups. **Hard technology** *refers to equipment and devices that perform a variety of tasks in the creation and delivery of goods and services.* Some examples of hard technology are computers, computer chips and microprocessors, optical switches and communication lines, satellites, sensors, robots, automated machines, and bar-code scanners.

Radio frequency identification (RFID) tags, for example, are the modern successor to bar codes. RFID tags are tiny computer chips that transmit radio signals and can be mounted on packages or shipping containers to help organizations identify product locations and movement. They have many different applications in both manufacturing and service industries. RFID tags are being embedded in virtually everything, including clothes, supermarket products, livestock, and prescription medicines. Also, RFID has been used to monitor residents in assisted living buildings and track the movements of doctors, nurses, and equipment in hospital emergency rooms. Retail, defense, transportation, and health care have begun requiring their suppliers to implement this technology. One of the reasons that RFID is so efficient is that it is designed so that individual items can have an individual identifier. RFID tags can be extremely small and can reside under bottles caps or in credit and identification cards. All physical goods in a global supply chain eventually move by air, truck, train, or ship. RFID can bring visibility and enhanced security to the handling and transportation of materials, baggage, and other cargo. Another practical application for RFID is brand authentication. Counterfeit brands have become a serious problem for many industries. RFID is a potentially powerful brand-protection solution that's capable of identifying product pedigree and ensuring brand legitimacy down to the individual item level. Because it is a cost-effective solution for automating brand authentication, RFID can also contribute to lowering overall product and operational costs.[3]

Soft technology *refers to the application of the Internet, computer software, and information systems to provide data, information, and analysis and to facilitate the accomplishment of creating and delivering goods and services.* Some examples are database systems, artificial intelligence programs, and voice-recognition software. Both types are essential to modern organizations.

Information technology also provides the ability to integrate all parts of the value chain through better management of data and information. This leads to more effective strategic and operational decisions to design better customer benefit packages that support customers' wants and needs, achieve competitive priorities, and improve the design and operation of all processes in the value chain.

Increasingly, both hard and soft technology are being integrated across the organization, allowing managers to make better decisions and share information across the value chain. Such systems, often called integrated operating systems (IOS), include computer-integrated manufacturing systems (CIMS), enterprise resource planning (ERP) systems, and customer relationship management (CRM) systems, all of which use technology to create better and more customized goods and services and deliver them faster at lower prices. We will discuss these systems in the following sections.

1.1 Manufacturing Technology

Although high-tech, automated, manufacturing processes receive a lot of media attention, much of the technology used in small- and medium-sized manufacturing enterprises around the world is still quite basic. The accompanying examples of making jigsaw puzzles and machined motorcycle gears illustrate how technology is used and integrated into manufacturing operations. Clearly, there are worlds of differences in the technology used for making puzzles and gears. However, from an operations management standpoint, all organizations face common issues regarding technology:

- The right technology must be selected for the goods that are produced.
- Process resources, such as machines and employees, must be set up and configured in a logical fashion to support production efficiency.
- Labor must be trained to operate the equipment.

Hard technology refers to equipment and devices that perform a variety of tasks in the creation and delivery of goods and services.

Soft technology refers to the application of the Internet, computer software, and information systems to provide data, information, and analysis and to facilitate the accomplishment of creating and delivering goods and services.

Making Jigsaw Puzzles

Drescher Paper Box in Buffalo, New York, formed in 1867, manufactures high-quality laminated cardboard jigsaw puzzles and board games and assembles them for retail stores. Drescher also produces cotton-filled jewelry boxes, candy boxes, business card boxes, and custom-made industrial boxes. Manufacturing jigsaw puzzles consists of three major steps: making the puzzle pieces, making the puzzle boxes, and final assembly. A printed picture is cut to size and laminated on a thick puzzleboard backing. Large presses are used to cut the puzzle into pieces, which are then bagged. The box-making process begins with blank cardboard. Boxes are scored and cut, then laminated with printed graphics. In the final assembly process, the puzzles are boxed and shrink-wrapped for shipment.

© Courtesy of Drescher Paper Box, Inc.

- Process performance must be continually improved.
- Work must be scheduled to meet shipping commitments/customer promise dates.
- Quality must be ensured.

1.2 Computer-Integrated Manufacturing Systems (CIMS)

Computer-integrated manufacturing systems (CIMS) *represent the union of hardware, software, database management, and communications to automate and control production activities from planning and design to manufacturing and distribution.* CIMS include many hard and soft technologies with a wide variety of acronyms, vendors, and applications and are essential to productivity and efficiency in modern manufacturing.

The roots of CIMS began with **numerical control (NC)** *machine tools, which enable the machinist's skills to be duplicated by a programmable device (originally punched paper tape) that controls the movements of a tool used to make*

complex shapes. For **computer numerical control (CNC)** *machines, the operations are driven by a computer.*

Industrial robots were the next major advance in manufacturing automation. *A* **robot** *is a programmable machine designed to handle materials or tools in the performance of a variety of tasks.* Robots can be "taught" a large number of sequences of motions and operations and even to make certain logical decisions. Other typical applications are spray painting, machining,

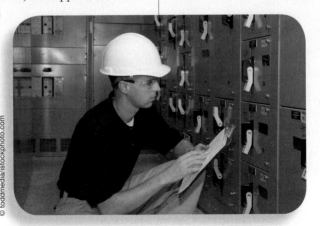

© toddmedia/istockphoto.com

Computer-integrated manufacturing systems (CIMS) represent the union of hardware, software, database management, and communications to automate and control production activities from planning and design to manufacturing and distribution.

Numerical control (NC) machine tools enable the machinist's skills to be duplicated by a programmable device (originally punched paper tape) that controls the movements of a tool used to make complex shapes.

When **computer numerical control (CNC)** machines are used, the operations are driven by a computer.

A **robot** is a programmable machine designed to handle materials or tools in the performance of a variety of tasks.

Honda assembly plants use flexible manufacturing cells where the robots can be reprogrammed to build different models of cars.

CAD/CAE enables engineers to design, analyze, test, simulate, and "manufacture" products before they physically exist, thus ensuring that a product can be manufactured to specifications when it is released to the shop floor.

CAM involves computer control of the manufacturing process, such as determining tool movements and cutting speeds.

Flexible manufacturing systems (FMS) consist of two or more computer-controlled machines or robots linked by automated handling devices such as transfer machines, conveyors, and transport systems. Computers direct the overall sequence of operations and route the work to the appropriate machine, select and load the proper tools, and control the operations performed by the machine.

inspection, and material handling. Robots are especially useful for working with hazardous materials or heavy objects; for instance, in nuclear power plants robots are used to do work in highly radioactive areas. In services, robots help doctors complete intricate brain surgery by drilling very precise holes into the skull.

Integrated manufacturing systems began to emerge with computer-aided design/computer-aided engineering (CAD/CAE) and computer-aided manufacturing (CAM) systems. **CAD/CAE** *enables engineers to design, analyze, test, simulate, and "manufacture" products before they physi-*

cally exist, thus ensuring that a product can be manufactured to specifications when it is released to the shop floor. **CAM** *involves computer control of the manufacturing process, such as determining tool movements and cutting speeds.*

Flexible manufacturing systems (FMS) *consist of two or more computer-controlled machines or robots linked by automated handling devices such as transfer machines, conveyors, and transport systems. Computers direct the overall sequence of operations and route the work to the appropriate machine, select and load the proper tools, and control the operations performed by the machine.* More than one item can be machined or assembled simultaneously, and many different items can be processed in random order. Honda has been a pioneer in using FMS and robotic technology. Its competitive priorities are moving toward design and demand flexibility so it is changing operating systems and technology to support these priorities. Honda assembly plants use flexible manufacturing cells where the robots can be reprogrammed to build different models of cars.[4] Today, many companies have achieved complete integration of CAD/CAE, CAM, and FMS into what we now call computer-integrated manufacturing systems (CIMS).

Manufacturing Motorcycle Gears

Andrews Products is in its 37th year of making aftermarket transmission gears for Harley-Davidson motorcycles. The first step for manufacturing some of its gears and cams is to cut steel slugs on a Mazak Multiplex twin-spindle machining center. These cut steel slugs are loaded using an automatic pallet changer and are machined complete in one setup. Finished parts are then automatically unloaded.

After parts have been machined on lathes, secondary operations such as keyways, drive slots, and lugs are cut with CNC vertical machining centers using such technology as a Matsuura automatic pallet changer. Final operations on these machines include a self-contained computerized inspection of slots and lugs. Additional steps in gear manufacture require cutting teeth on a Mitsubishi GS15 CNC gear shaper. Grinding is one of the last steps in gear or cam manufacture. A Toyoda GC32 CNC angle-head grinder is used to grind a Sportster cam gear thrust face and bearing diameter. CNC angle-head machines can grind multiple diameters in one setup and hold tolerances of 0.0003 inches (0.0076 mm) on a diameter.

© Courtesy of Andrews Products, Inc.

CIMS Facts

According to the National Research Council, companies with computer-integrated manufacturing system experience have been able to

- decrease engineering design costs by up to 30 percent;
- increase productivity by 40 to 70 percent;
- increase equipment utilization by a factor of 2 to 3;
- reduce work-in-process and lead times by 30 to 60 percent; and
- improve quality by a factor of 3 to 4.

© Stockbyte/Getty Images

Under Armour

If you walk into the headquarters of Under Armour, a major manufacturer of sports apparel, you might be surprised to see posters of athletes on the walls, and even a treadmill in the hallway. While it doesn't look like a high-tech operation, Under Armour uses state-of-the art design software, modern manufacturing techniques, and information technology to make nearly all its products. Before it went public, the company used standard, off-the-shelf software to manage its business. When they added running shoes, they faced more challenges because of the large number of unique sizes. Under Armour acquired a new system from SAP to manage its inventory and be able to ship goods directly from the factory to distributors. Special data-management software helps the company to better design shoes that meet schedule deadlines and profit goals. That treadmill isn't for employee workouts; it is used to capture biometric data to help the company understand shoe performance and improve designs. The company also uses three-dimensional design software, which helps to reduce production times.[5]

1.3 Service Technology

You have undoubtedly encountered quite a bit of service technology in your own daily lives. Technology is used in many services, including automated car washes, robotic surgery, mail sorting, delivery of medical records within hospitals, automated one-man garbage trucks, fetal monitors, electronic hotel keys and locks, airline auto-pilot equipment, and entertainment such as the robots used in Disney World's Hall of Presidents and Country Bear Jamboree attractions. You have probably used an automatic teller machine (ATM) or Pay By Touch, a fingerprint-driven payment and check-cashing system used in about 2,200 stores. A recent technology innovation that is being tested in about 20 stores by Stop & Shop, a grocery chain with about 230 outlets serving New England, is the Shopping Buddy. Shoppers scan items—and bag them—as they shop. Using infrared, Wi-Fi, and Bluetooth, the Shopping Buddy can also do such things as transmit an order to the deli department and then tell you when it's ready for pickup.[6]

Other service technologies are used behind the scenes to facilitate your experience as a customer of hotels, airlines, hospitals, and retail stores. To speed order entry for pizza delivery, for instance, many firms use a touch-sensitive computer screen that is linked to a customer database. When a repeat customer calls, the employee need only ask for the customer's phone number to bring up the customer's name, address, and delivery directions (for a new customer, the information need only be entered once). The employee is able to address the customer immediately by name, enhancing the perception of service quality, and then enter the order quickly on the touch-sensitive screen to print for the kitchen, eliminating errors due to misreading of handwritten orders.[7]

Perhaps the most common service technology in use today involves the Internet. **E-service** *refers to using the Internet and technology to provide services that create and deliver time, place, information, entertainment, and exchange value to customers and/or support the sale of goods.* Many individuals use airline, hotel, and rental car Web sites or

> **E-service** refers to using the Internet and technology to provide services that create and deliver time, place, information, entertainment, and exchange value to customers and/or support the sale of goods.

"one-stop" e-services like Microsoft Expedia in planning a vacation. Our chapter discussion of electronic medical record (EMR) systems and the Metropolitan Library System introduce you to more service technology examples.

Using Technology to Improve Library Service

The Metropolitan Library System in Oklahoma City is implementing a new scanning system that uses radio-frequency identification (RFID) tags to keep track of books. The program will cost the library system about $400,000. The system is designed to speed up check-out times. The RFID scanner is installed in the counter, so customers are not even aware of it but are surprised that books check out so fast. Up to five books can be checked in or out at once. One of the most helpful features is a new shelf scanner. Librarians used to check books one at a time, making sure they were on the right shelf and in the right place. This labor-intensive task will be a thing of the past with the new system so that library staff can spend more time helping customers. Library productivity will also increase. But staff members can still handle books borrowed from libraries without RFID—by scanning them the old-fashioned way using bar codes.[8]

IT in Health Care

To ensure quality yet dramatically reduce costs, hospitals and health care clinics are adopting electronic medical record (EMR) systems. EMR systems record all the information generated by the health care facility and its patients in electronic form. Instead of a paper-based medical chart for each patient, the doctor uses a wireless PDA or tablet PC. EMR information also is easily integrated with other health care facility information systems such as billing, patient scheduling, and accounting.

The benefits of an EMR system include:

- *Cost Reduction.* At one medical clinic, transcription costs were reduced by 33 percent and transcription turnaround time went from 7 days to 1 day.
- *Revenue Enhancement.* One health maintenance organization (HMO) used the Internet to contact over 600 patients that were overdue for mammograms, resulting in services that generated $670,000 in additional revenue.
- *Improved Administrative and Support Process Efficiency.* In one medical clinic, one full-time employee filed 600 to 700 patient charts per week. With the installation of EMR, these same medical records could be downloaded in 10 minutes.
- *Improved Clinical Efficiency and Patient Care.* An EMR system helps to standardize chart quality across the clinic or hospital and therefore minimizes the problems that result from poor handwriting and other inconsistencies in paper-based systems.

2 Technology in Value Chains

technology, especially the Internet and e-communications, is changing the operation, speed, and efficiency of the value chain and presents many new challenges to operations managers. In many situations, electronic transaction capability allows all parts of the value chain to immediately know and react to changes in demand and supply. This requires tighter integration of many of the components of the value chain. In some cases, technology provides the capability to eliminate parts of the traditional value chain structure and streamline operations.

Technology, especially the Internet and e-communications, is changing the operation, speed, and efficiency of the value chain and presents many new challenges to operations managers.

With all the new technology that has evolved, a new perspective and capability for the value chain has emerged—the *e-commerce view of the value chain* shown in Exhibit 5.1. Here, buyers and sellers are connected by bricks-and-mortar intermediaries such as logistic and transportation services and/or by electronic means such as the Internet to share information directly. *An **intermediary** is any entity—real or virtual—that coordinates and shares information between buyers and sellers.* Some firms, such

In one medical clinic, one full-time employee filed 600 to 700 patient charts per week. With the installation of electronic medical records (EMR), these same medical records could be downloaded in 10 minutes.

as General Electric, Wal-Mart and Procter & Gamble, use e-commerce to communicate directly with suppliers and retail stores, and thereby skip traditional bricks-and-mortar intermediaries. **Return facilitators** *specialize in handling all aspects of customers returning a manufactured good or delivered service and requesting their money back, repairing the manufactured good and returning it to the customer, and/or invoking the service guarantee.*

Some examples of how information technology has enabled companies to build and sustain competitive advantage for the major e-commerce players: B2B—business to business, B2C—business to customer, C2C—customer to customer, and G2C—government to customer (as well as G2G—government to government and G2B—government to business) follow.

- GE Plastics (www.geplastics.com) used the Internet to completely change how plastics are designed, ordered, researched, and delivered for B2B customers. The entire GE Plastics Web site represents a value-added, information-intensive set of services—e-services—that facilitate the sale of goods—chemi-

cals, plastics, resins, polymers, and the like. GE Polymerland (www.gepolymerland.com) allows other companies to buy, design, interact, research, and participate in a global auction service for many types of chemicals and plastics. The "buy" button reveals many value-added services, such as how to place an order, order status, shipment tracking, pricing, and inventory availability.

- The FedEx B2C value chain is all about saving time. Every day, over five million messages are sent to 40,000 FedEx delivery trucks via public cellular networks or aging FedEx proprietary satellite and repeater systems in major cities. The former communication channel is expensive and breaks down frequently, and the latter requires the driver to call an 800 telephone number or go back to the van to download the information in his or her "SuperTracker" device before uploading it to the operations center in Memphis, Tennessee. The driver frequently returns to the van only to be notified of another pickup in the building, and therefore must go back into the building, making many trips between the van and building. FedEx (www.fedex.com) is testing wireless technologies to enable couriers to send and retrieve real-time package information from handheld devices without having to run back and forth to delivery trucks.

Exhibit 5.1 *E-Commerce View of the Value Chain*

An **intermediary** is any entity—real or virtual—that coordinates and shares information between buyers and sellers.

Return facilitators specialize in handling all aspects of customers returning a manufactured good or delivered service and requesting their money back, repairing the manufactured good and returning it to the customer, and/or invoking the service guarantee.

- eBay (www.ebay.com) started out as a C2C value chain but quickly incorporated B2C and B2B transactions. The eBay business is built on the values of open communication and honesty, and the vast majority of buyers and sellers at eBay are reliable. eBay fights fraud using customer feedback that keeps track of the trustworthiness of its sellers using a point system and posts this information for all site members to see, as well as its own security monitoring processes. In the event a customer pays for an item and never receives it, eBay will reimburse buyers up to a dollar limit, minus processing costs. eBay provides a variety of services, such as on-line seminars and interactive tutorials, to help customers learn how to buy and sell on the Web site, how to search for goods or services on eBay, how to add photos of their goods or services, design store fronts and marketing, and so on.

- Federal, state, and local government value chains (i.e., G2C, G2G, and G2B) use e-commerce to provide better service for citizens, control waste and fraud, and minimize costs. Filing your taxes electronically and the direct deposit of monthly Social Security checks are two examples. Food stamps are now in the form of electronic credit cards and student loan applications must be electronically filed.

Two examples of integrated operating systems that cut across the value chain are Enterprise Resource Planning and Customer Relationship Management systems.

2.1 Enterprise Resource Planning (ERP) Systems

ERP systems integrate all aspects of a business— accounting, customer relationship management, supply chain management, manufacturing, sales, human resources—into a unified information system and provide more timely analysis and reporting of sales, customer, inventory, manufacturing, human resource, and accounting data. ERP systems are vital for linking operations and other components of the value chain together. Two prominent vendors of ERP software are SAP (www.sap.com) and Oracle (www.oracle.com).

Traditionally, each department of a company, such as finance, human resources, and manufacturing, has individual information systems optimized to the needs of that department. If the sales department wants to know the status of a customer's order, for example, someone would typically have to call manufacturing or shipping. ERP combines each department's information into a single, integrated system with a common database so that departments can easily share information and communicate with each other. ERP systems usually consist of different modules that can be implemented individually so that each department still has a level of autonomy, but they are combined into an integrated operating system. For example, when a customer's order is entered by sales, all information necessary to fulfill the order is built into the ERP system. The finance module would have the customer's order history and credit rating; the warehouse module would have current inventory levels; and the supply chain module would have distribution and shipping information. Not only would sales be able to provide accurate information about product availability and shipping dates but orders would get processed faster with fewer errors and delays.

Most of the subsystems of ERP systems, such as customer ordering, inventory management, and production scheduling, are *real-time transaction processing systems*, as opposed to *batched processing systems*, in which a day's entire batch of transactions was typically processed during the night. In real-time processing, information is updated continuously, allowing the impacts to be reflected immediately in all other areas of the ERP system. Some business processes, however, such as the weekly payroll, monthly accounting reports, and billing, do not need real-time processing.

2.2 Customer Relationship Management (CRM) Systems

Satisfying customers and establishing good relationships with them is necessary for sustainable business success. Clearly, this is the ultimate purpose of a value chain. **Customer relationship management (CRM)** *is a business strategy designed to learn more about customers' wants, needs, and behaviors in order to build customer relationships and loyalty and ultimately enhance revenues and profits.*

Technology, especially business intelligence systems that we described earlier in this chapter, is a key enabler of CRM. A typical CRM system includes market segmentation and analysis, customer service

and relationship building, effective complaint resolution, cross-selling goods and services, and pre- and postproduction processes such as preproduction order processing and postproduction field service. Of course, the value chain must be capable of delivering what the customer wants, and that is where sound operational analysis is required.

CRM helps firms gain and maintain competitive advantage by

- segmenting markets based on demographic and behavioral characteristics;
- tracking sales trends and advertising effectiveness by customer and market segment;
- identifying which customers should be the focus of targeted marketing initiatives with predicted high customer response rates;
- forecasting customer retention (and defection) rates and providing feedback as to why customers leave the company;
- identifying which transactions are likely candidates to be fraudulent;
- studying which goods and services are purchased together, and what might be good ways to bundle them (that is, the customer benefit package);
- studying and predicting what Web characteristics are most attractive to customers and how the Web site might be improved; and
- linking the information above to competitive priorities by market segment and process and value chain performance.

3 Benefits and Challenges of Technology

the U.S. Labor Department reported a breathtaking annual rate of productivity growth of 8.1 percent in the third quarter of 2003. In comparison, productivity grew at a rate of just 1.4 percent annually between 1973 and 1995.[9] Former Federal Reserve chairman, Mr. Alan Greenspan, noted that the major causes of these extraordinary increases in U.S. productivity are information technology and high-tech equipment.[10] A summary of the benefits and challenges of technology is given in Exhibit 5.2. Can you think of others?

Technology puts more pressure on front-line employees to excel. The excuses of "I didn't know" or "I didn't have the right information" are no longer valid. For example, one major bank codes its credit card customers with colored squares on the bank's computer screens. A green square on a customer account tells the bank teller or customer service representative or loan officer that this is a very profitable customer and to grant this customer whatever he or she wants—credits for poor service, fee waivers, top priority, callbacks, upgrades, appointment times, and the "white-glove" treatment. On the other hand, a red square

Exhibit 5.2 *Example Benefits and Challenges of Adopting Technology*

Benefits	Challenges
Creates new industries and job opportunities	Higher employee skill levels required, such as information technology and service management skills
Restructures old and less productive industries	Integration of old (legacy) and new technology and systems
Integrates supply and value chain players	Job shift and displacement
Increases marketplace competitiveness and maintains the survival of the firm	Less opportunity for employee creativity and empowerment
Provides the capability to focus on smaller target market segments (customize)	Protecting the employee's and customer's privacy and security
Improves/increases productivity, quality and customer satisfaction, speed, safety, and flexibility/customization—does more with less	Fewer human service providers resulting in customer ownership not being assigned, nonhuman service encounters, and inability of the customer to change decisions and return goods easily
Lowers cost	Information overload
Raises world's standard of living	Global outsourcing and impact on domestic job opportunities

What If Mozart Had Today's Technology?

A full orchestra has performed *The Marriage of Figaro* for over 200 years. Yet, the Opera Company of Brooklyn, New York, plays this Mozart classic with only 12 musicians and one computer technician overseeing the computer program that plays all other instruments. This mix of real and virtual players reduces the cost of performing a symphony by about two-thirds.[11]

indicates an unprofitable customer and signals the service provider to make no special effort to help the customer. In fact, upon seeing the red square on the account, a bank teller once told a customer, "Wow, somebody doesn't like you!"

Managers must make good decisions about introducing and using new technology. They must understand the relative advantages and disadvantages of using technologies and their impact on the work force. Although technology has proven quite useful in eliminating monotony and hazardous work and can develop new skills and talents in people, it can also rob them of empowerment and creativity. The goal of the operations manager is to provide the best synthesis of technology, people, and processes; this interaction is often called the *sociotechnical system*. Topics here include job specialization versus enlargement, employee empowerment, training, decision support systems, teams and work groups, job design, recognition and reward, career advancement, and facility and equipment layout.

A key factor that affects technology decisions is scalability.

Scalability *is a measure of the contribution margin (revenue minus variable costs) required to deliver a good or service as the business grows and volumes increase.* Scalability is a key issue in e-commerce. **High scalability** *is the capability to serve*

Scalability is a measure of the contribution margin (revenue minus variable costs) required to deliver a good or service as the business grows and volumes increase.

High scalability is the capability to serve additional customers at zero or extremely low incremental costs.

Low scalability implies that serving additional customers requires high incremental variable costs.

additional customers at zero or extremely low incremental costs. For example, Monster.com is an on-line job posting and placement service that is largely information-intensive. Customers can post their resumes on the Monster.com Web site and print out job advertisements and opportunities on their office or home computers at their expense. This service is highly scalable because its fixed costs are approximately 80 to 85 percent of total costs. The incremental cost to serve an additional customer is very small, yet the revenue obtained from this customer remains high. If an organization establishes a business where the incremental cost (or variable cost) to serve more customers is zero, then the firm is said to be **infinitely scalable**. On-line newspapers and magazines, e-banking services, and other information-intensive businesses have the potential to be infinitely scalable.

On the other hand, **low scalability** *implies that serving additional customers requires high incremental variable costs.* Many of the dot.com companies that failed around the year 2000 had low scalability and unsustainable demand (volumes) created by extraordinary advertising expenses and artificially low prices.

The WebVan Failure

One dot.com company, WebVan, focused on customers' ordering their groceries on-line and then picking up the orders in a warehouse and delivering them to the customers' homes. The idea was to support the order-pick-pack-deliver process of acquiring groceries through an e-service at the front end of the value chain and with delivery vans at the back end of the value chain. This service made several assumptions about customer wants and needs; for example, that customers have perfect knowledge of what they want when they surf the on-line catalogs; that customers would be home when the delivery arrived; that what the e-catalogue shows is what the customer will get; that the customer doesn't make mistakes when selecting the items; and that time-starved customers are willing to pay a high premium for home delivery. Unfortunately, this was a very high cost process. The $30 to $40 delivery charge for complex and heterogeneous customer orders and the many opportunities for error doomed WebVan. The founders of WebVan did not clearly define their strategy and target market and properly evaluate the operational and logistical issues associated with their value chain design. WebVan designed their system with low scalability and limited growth potential.[12]

Many of the dot.com companies that failed around the year 2000 had low scalability and unsustainable demand (volumes) created by extraordinary advertising expenses and artificially low prices.

4 Technology Development and Adoption

despite its importance, many companies do not really understand technology or how to apply it effectively. The risk of a technology adoption failure is high and the survival of the firm is at stake. For instance, Hershey Foods installed three software packages in the summer of 1999, just as retailers placed orders for Halloween candy. The software was incompatible with other systems, and candy piled up in warehouses because of missed or delayed deliveries. Such experiences are reminiscent of comparable failures of automated manufacturing technology encountered by the automobile and other industries during the 1970s. Reasons include rushing to the wrong technology, buying too much and not implementing it properly, and underestimating the time needed to make it work.

Intel has summarized the technology adoption process eloquently.[13]

Historians tell us that over the last two centuries, major technological revolutions have ridden waves of boom and bust, only to rebound with periods of sustained build-out. This pattern has played out in the steel and rail industries as well as others. If history is any guide, the Internet revolution is on track for decades of growth and has yet to see its most rewarding years.

Technology development and adoption generally has three stages—birth, turbulence, and build-out:

***Stage I. Birth** At the beginning of a major technological era, enabling technologies emerge and are eagerly welcomed as revolutionary. Excitement builds as technological pioneers crowd into the field and innovations flourish. In some cases, early inves-*

tors make extraordinary profits, fueling speculation, chaos and investment mania, even "irrational exuberance."

***Stage II. Turbulence.** Overinvestment and overcapacity burst the bubble of the new technology's progress. Sometimes linked to a slowing economy, stock prices drop and even crash. Some investors lose everything; some companies fold. Investment halts as financiers retrench. Observers may declare the technology dead. But the story is by no means over.*

***Stage III. Build-out.** Confidence returns. Real value emerges. Missing components of the technology are put in place, leading to full implementation. The technology penetrates the economy as other industries organize around it and businesses adjust to take full advantage of it. Sustained investment yields robust returns. The technology becomes the driving engine of the economy.*

Each stage in the development of technologies requires the operations area to excel at different competitive priorities. During the birth stage, design and demand flexibility are critical for gaining a competitive advantage. The best good or service design and the processes that create it are constantly changing; hence the organization must be capable of quickly changing designs and production volumes. At this stage, the cost of the new good or service is important but not as important as flexibility, speed and reliability of delivery, and the quality of the good or service.

During the turbulence stage, the objective is to consolidate resources and marketplace advantages and work on building technical and operational capability. Cash flow, survival, and building process and value chain capabilities are the focus of organizations during these turbulent times. The final stage—build-out—is where operational capability becomes the key to a winning competitive strategy. This capability can be realized with a well-synchronized value chain having coordinated physical and information flows.

The Global Digital Revolution

Today we find ourselves in the midst of an even more powerful technological revolution—the digital or service and information revolution.

Stage I. Global Digital Revolution and Birth. The invention of the integrated circuit was the first of a series of defining innovations that ultimately fueled the Internet revolution. Apple and IBM personal computers entered the marketplace in the early 1980s. Excitement over powerful microprocessors, PCs, software and the emerging Internet economy all contributed to the high-tech boom of the 1990s. Networks are not completely developed to take full advantage of technological capabilities such as optical-fiber transmission lines and switches, quantum leaps in microprocessor power and disk storage capacity, and real or imagined barriers such as how to securely and accurately collect payments over the Internet.

Stage II. Global Digital Revolution and Turbulence. In 2000 and 2001, as hundreds of dot-com companies failed to turn a profit, investor confidence slipped, triggering meltdowns throughout the technology sector. Nasdaq stocks lost more than 70 percent of their value and investors lost money. Facing excess capacity, many companies cut back on their information technology expenditures, and the semiconductor industry entered its worst downturn ever. Surviving companies continue to build their operational capabilities, design and test new goods and services, and get ready for the profitable build-out stage.

Stage III. Global Digital Revolution Build-out. The world's first microprocessor was the Intel 4004 "computer on a chip" built in 1971. It was a 4-bit silicon chip packed with 2,300 transistors and had as much processing power as the old "3,000 cubic foot" ENIAC computer. In 1994, the semiconductor industry produced 176 billion computer chips and even during the economic downturn of 2001 and 2002, chips were still being manufactured at a rate close to one billion per day. The second Internet Revolution and build-out has just begun. Then, the "annual demand" for chips is expected to triple to over one trillion by 2010.[14]

Problems, Activities, and Discussions

1. Research radio frequency identification devices (RFID) and provide examples of how they are or might be used to improve productivity in operations.

2. Describe at least one application of modern technology in each of these service industries:
 a. financial services
 b. public and government services
 c. transportation services
 d. educational services
 e. hotel and motel services

 How does your example application improve things, or does it?

3. Describe a situation where self-service and technology help create and deliver the customer benefit package to the customer. Provide examples of how such a system can cause a defect, mistake, or service upset.

4. Find at least three new applications of modern technology in business that are not discussed in this chapter. What impacts on productivity and quality do you think these applications have had?

5. Discuss each of these statements. What might be wrong with each of them?
 a. "We've thought about computer integration of all our manufacturing functions, but when we looked at it, we realized that the labor savings wouldn't justify the cost."
 b. "We've had these computer-controlled robots on the line for several months now, and they're great! We no longer have to reconfigure the whole line to shift to a different product. I just give the robots new instructions, and they change operations. Just wait until this run is done and I'll show you."
 c. "Each of my manufacturing departments is authorized to invest in whatever technologies are necessary to perform its function more effectively. As a result, we have state-of-the-art equipment throughout our factories—from CAD/CAM to automated materials handling to robots on the

line. When we're ready to migrate to a CIM environment, we can just tie all these pieces together."

d. "I'm glad we finally got that CAD system," the designer said, a computer-generated blueprint in hand. "I was able to draw these plans and make modifications right on the computer screen in a fraction of the time it used to take by hand." "They tell me this new computer-aided manufacturing system will do the same for me," the manufacturing engineer replied. "I'll just punch in your specs and find out."

6. Investigate the current technology available for laptop computers, cell phones, or iPods. Select two or three different models and compare their features and operational characteristics, as well as manufacturer's support and service (you might wish to find some articles in magazines such as *PC World* or *PC Computing*). Explain how you might advise (a) a college student majoring in art, and (b) a salesman for a high-tech machine tool company in selecting the best computer for his or her needs.

7. A manager of Paris Manufacturing that produces computer hard drives is planning to lease a new automated inspection system. The manager believes the new system will be more accurate than the current manual inspection process. The firm has had problems with hard drive defects in the past and the automated system should help catch these defects before the drives are shipped to the final assembly manufacturer. The relevant information follows.

Current Manual Inspection System

 Annual fixed cost = $50,000
 Inspection variable cost per unit = $15 per unit

New Automated Inspection System

 Annual fixed cost = $200,000
 Inspection variable cost per unit = $0.55 per unit

a. Suppose annual demand is 11,000 units. Should the firm lease the new inspection system?

b. Assume the cost factors given have not changed. A marketing representative of *NEW-SPEC*, a firm that specializes in providing manual inspection processes for other firms, approached Paris Manufacturing and offered to inspect parts for $17 each with no fixed cost. They assured Paris Manufacturing the accuracy and quality of their manual inspections would equal the automated inspection system. Demand for the upcoming year is forecast to be 11,000 units. Should the manufacturer accept the offer?

8. Maling Manufacturing needs to purchase a new piece of machining equipment. The two choices are a conventional (labor-intensive) machine and an automated (computer-controlled) machine. Profitability will depend on demand volume. The following table pre-sents an estimate of profits over the next three years.

	Demand Volume	
Decision	Low	High
Conventional machine	$80,000	$110,000
Automated machine	$50,000	$145,000

Given the uncertainty associated with the demand volume, and no other information to work with, how would you make a decision? Explain your reasoning.

9. Characterize an industry you are familiar with using Intel's three technology development stages—birth, turbulence, and build-out. What's your estimate of how long (in years) the technology development and adoption process will be?

10. What challenges do companies face when trying to implement e-commerce business plans and strategies? What can they learn from the WebVan experience?

Bracket International – The RFID Decision Case Study

Jack Bracket, the CEO of Bracket International (BI), has grown his business to sales last year of $78 million with a cost of goods sold of $61 million. Average inventory levels are about $14 million. As a small manufacturer of steel shelving and brackets, the firm operates three small factories in Ohio, Kentucky, and South Carolina. BI's number one competitive priority is "service first," while high product quality and low cost are #2 and #3. Service at BI includes pre-production services such as customized engineering design, production services such as meeting customer promise dates and being flexible to customer driver changes, and post-production services such as shipping, distribution, and field service.

The Ohio and Kentucky factories are automated flow shops, while the South Carolina factory specializes in small custom orders and is more of a batch processing job shop. All three factories use bar coding labels and scanning equipments to monitor and control the flow of materials. BI manually scans about 8,850 items per day at all three factories. An item may be an individual part, a roll of sheet steel, a box of 1,000 rivets, a pallet load of brackets, a box of quart oil cans, a finished shelf or bracket set ready for shipment, and so on. That is, whatever a bar code label can be stuck on is bar coded. A factory year consists of 260 days. One full-time BI employee works 2,000 hours per year with an average salary including benefits of $55,000.

Two recent sales calls have Mr. Bracket considering switching from the old bar coding system to a radio frequency identification device (RFID) system. The RFID vendors kept talking about "on demand" operational planning and control and how their RFID and software systems could speed up the pace of BI's workflows. One RFID vendor provided the following information:

- Bar code scan times for the sheet metal business (similar to BI) average 10 seconds per item and include employee time to find the bar code, pick up the item

© Skip Peterson/AP Photo

and/or position the item or hand-held bar code reader so it can read the bar code, and in some cases physically reposition the item. Item orientation is a problem with manual bar coding.

- The 10-second bar code scan time does not include the employee walking to the bar coding spot or equipment. It is assumed that the employee is in position to scan the item. The 10 seconds does not include the time to replace a scratched or defective bar code label. Replacing a damaged bar code tag including changes to the computer system may take up to 5 minutes.

- All three BI factories can be fitted with RFID technology (readers, item tags, and hardware-related software) for $620,000. In addition, new supply chain operating system software that takes advantage of the faster pace of RFID information is priced for all three factories at $480,000 and includes substantial training and debugging consulting services.

- RFID scan time is estimated to be 2/100ths of a second, or basically instantaneous.

- For the sheet metal business, bar code misreads average 2 percent (i.e., 0.02) over the year of total reads, and this is estimated to reduce to 0.2 percent (i.e., 0.002) for RFID technology. The 0.2 percent is due to damaged RFID tags or occasional radio frequency interference or transmission problems. Misreads are a problem because items are lost and not recorded in BI's computer system. The vendor guessed that a single misread could cost a manufacturer on average $4 but noted this estimate could vary quite a bit.

- According to the RFID vendors, other benefits of RFID systems include readily located inventory, fewer required inventory audits, and reduced misplacements and theft. However, they did not have any information quantifying these benefits.

Bracket International recently had problems adapting quickly to changing customer requirements. BI had to deny a Wolf Furniture job order request because they

could not react quickly enough to a change in job specifications and order size. Eventually, BI lost the Wolf Furniture business that averaged about $2 million per year. Another BI customer, Home Depot, keeps talking about BI needing to be more flexible because Home Depot's on-demand point-of-sale systems requires frequent changes to BI orders. Home Depot is BI's top customer, so every effort needs to be made to keep them happy.

Mr. Bracket doesn't think throwing away the bar-coding system that works is a good idea. The BI employees are familiar with using bar coding technology, while the RFID technology seems hidden from employees. He also doesn't think the ROI on an RFID system is compelling. So why does he feel so guilty when the RFID vendors leave his office? Is he doing the right thing or not? He has an obligation to his trusted employees to do the right thing. Should he adopt RFID based purely on strategic and/or economic benefits? He writes down several questions he needs to investigate.

Case Questions for Discussion

1. By searching the Internet and library, summarize the advantages and disadvantages of RFID systems. How does RFID compare to bar-coding? Did you find any RFID applications for services? (maximum of two pages)
2. What is the payback for this possible RFID adoption?
3. What do you recommend Mr. Bracket do in the short and long terms? Explain your reasoning.

GOODS AND SERVICE DESIGN

b usiness Week *reported that Lockheed Martin beat out Boeing for the largest defense contract in U.S. history— production of the Joint Strike Fighter jet—worth at least $400 billion. Both firms received $750 million contracts to develop concept prototypes. A Pentagon source noted, "Compare the two designs for the Joint Strike Fighter, and you'll see the obvious: Boeing's looks like 'a flying frog with its mouth wide open.' " A senior Air Force general also observed, "The Lockheed design wins hands down." However, a Boeing spokesman retorted, "Boeing officials say looks aren't part of the design. We design our planes to go to war, not to the senior prom." In actuality, during flight testing, the Lockheed Martin X-35B's ability to achieve short take-off and vertical landing (STOVL) was determined to be superior to Boeing's X32 capability, even though both met or exceeded Department of Defense specifications.*

© Stephen Hilger/Bloomberg News/Landov

What do **you** think?

How important are design and style in your purchasing decisions? Provide examples for goods and services.

learning outcomes

After studying this chapter you should be able to:

LO1 Describe the steps involved in designing goods and services.

LO2 Explain the concept of robust design and the Taguchi loss function.

LO3 Explain how to calculate system reliability.

LO4 Explain the concept and application of quality function deployment.

LO5 Describe methods for designing goods.

LO6 Explain the five elements of service delivery system design.

LO7 Describe the four elements of service encounter design.

LO8 Explain how goods and service design concepts are integrated at LensCrafters.

Perhaps the most important strategic decision that any firm makes involves the design and development of new goods and services, and the value chain structure and processes that make and deliver them. In fact, decisions about what goods and services to offer and how to position them in the marketplace often determine the ultimate growth, profitability, and success of the firm. Every design project—a new Motorola cell phone, a new BMW dashboard, a new Manhattan skyscraper—is a series of trade-offs: between technology and functionality, between ambition and affordability, between the desires of the people creating the object and the needs of the people using it.[1]

In today's world, the complexity of customer benefit packages requires a high level of coordination throughout the value chain. The Lockheed-Boeing illustration documents the importance of fully understanding customer needs in design activities. A poor design will not win customers no matter how technologically appealing it might be.

1 Designing Goods and Services

to design and improve goods and services, most companies use some type of structured process. The typical goods and services development processes are shown in Exhibit 6.1. In general, the design of both goods and services follow a similar path. The critical differences lie in the detailed product and process design phases.

© USAF/Reuters/Landov

© Arco Images/Alamy

Steps 1 and 2—Strategic Mission, Analysis, and Competitive Priorities

Strategic directions and competitive priorities should be consistent with and support the firm's mission and vision. These steps require a significant amount of research and innovation involving marketing, engineering, operations, and sales functions, and should involve customers, suppliers, and employees throughout the value chain. The data and information that result from this effort provide the key input for designing the final customer benefit package.

Step 3—Customer Benefit Package Design and Configuration

Clearly, firms have a large variety of possible choices in configuring a customer benefit package (CBP). For example, when buying a new vehicle an automobile dealer might include such options as leasing, free oil changes and/or maintenance, a performance driving school, free auto washes, service pickup and delivery, loaner cars, and so on.

Essentially, CBP design and configuration choices revolve around a solid understanding of customer needs and target markets, and the value that customers place on such attributes as:

- **Time**—Some grocery stores now offer self-service checkout to reduce customer waiting time, and manufacturers such as Dell use the Internet to acquire customer information for more responsive product design.
- **Place**—UPS has "UPS Stores" strategically

located for customer convenience that also provide packaging services; many companies offer day-care centers on-site to provide convenience to their employees.

- **Information**—Bank of America provides an Internet search capability for the best home equity loan; and a business dedicated to providing guitar music books and videos (www.ChordMelody.com) offers a

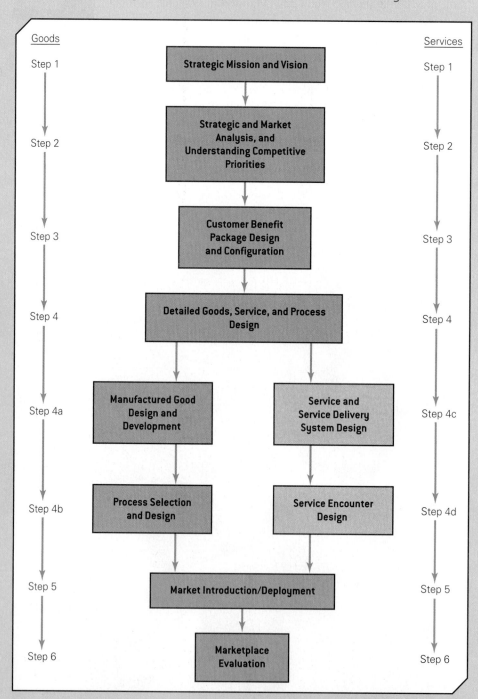

Exhibit 6.1 *An Integrated Framework for Goods and Service Design*

Every design project—a new Motorola cell phone, a new BMW dashboard, a new Manhattan skyscraper—is a series of trade-offs: between technology and functionality, between ambition and affordability, between the desires of the people creating the object and the needs of the people using it.

telephone hot line to speak with a professional guitarist for questions on selecting the proper instructional and performance material.

Using Second Life for Goods and Service Design

Mr. Curet, the owner of Little Wonder Studio in Burbank, California, uses high-powered software such as Rhino 4.0 for industrial modeling and ZBrush for digital sculpting to design toys. But one of his more recent creations uses the virtual world of Second Life to sketch out the toy and its windup mechanisms. Mr. Curet stated, "It took me about half an hour to create the 3D model, where it would have taken me a week to do it before. I sent the virtual models to a factory in Hong Kong and they quickly fabricated a real model and gave me an estimate of how much the toy would cost to manufacture." The result was Noggin Bops, a plastic windup toy that shimmies from side to side while bopping its head. Virtual worlds like Second Life are being used to design, create, and test product concepts before they make their debut in the real world. Starwood Hotels & Resorts tested a new hotel concept called Aloft. After a trial in Second Life, Starwood decided to put more seating in the lobby and install radios in the shower, among other facility design changes.[2]

© Little Wonder Studio

- **Entertainment**—Some Dick's Sporting Goods Stores provide a rock-climbing wall for children while other family members shop; a pianist serenades shoppers at Nordstrom's department stores; and some minivans have built-in DVD players. (See the box on "Biztainment" in Chapter 1.)
- **Exchange**—Retail stores such as Best Buy allow customers to travel to the store and buy the goods, purchase goods on their Web sites and have them delivered, or purchase goods on their Web sites and have them ready to be picked up at the store.
- **Form**—For manufactured goods, form is associated with the physical characteristics of the good, and addresses the important customer need of aesthetics. An interior designer might use different methods such as sketches, photographs, physical samples, or even computer-simulated renderings to show how a kitchen might be transformed.

A job-seeking service such as Monster.com provides pure information value, while buying an automobile or going on a vacation involve all six types.

Step 4—Detailed Goods, Services, and Process Design

If a proposal survives the concept stage—and many do not—each good or service in the CBP, as well as the process that creates it, must be designed in more detail. This is where the design of goods and services differ, as suggested by the alternate paths in Exhibit 6.1. The first three steps in Exhibit 6.1 are more strategic and conceptual in nature while step 4 focuses on detailed design and implementation.

The design of a manufactured good focuses on its physical characteristics—dimensions, materials, color, and so on. Much of this work is done by artists and engineers to translate customer requirements into physical specifications. This is the focus of step 4a in the exhibit. The process by which the good is manufactured (that is, the configuration of machines and labor) can be designed as a separate activity (step 4b), with, of course, proper communication and coordination with the designers of the good.

The process by which the service is created and delivered (that is, "produced") is, in essence, the service itself!

The design of a service in steps 4c and 4d in Exhibit 6.1, however, cannot be done independently from the "process" by which the service is delivered. The process by which the service is created and delivered (that is, "produced") is, in essence, the service itself! For example, the steps that a desk clerk follows to check in a guest at a hotel represents the process by which the guest is served and (hopefully) experiences a sense of satisfaction. Thus, service design must be addressed from two perspectives—the Service Delivery System, and the Service Encounter as noted in steps 4c and 4d in Exhibit 6.1.

Step 5—Market Introduction/Deployment

In this step, the final bundle of goods and services—the customer benefit package—is advertised, marketed, and offered to customers. For manufactured goods, this includes making the item in the factory and shipping it to warehouses or wholesale and retail stores; for services, it might include hiring and training employees or staying open an extra hour in the evening. For many services, it means building sites such as branch banks or hotels or retail stores.

Step 6—Marketplace Evaluation

The marketplace is a graveyard of missed opportunities: poorly designed goods and services and failed execution resulting from ineffective operations. The final step in designing and delivering a customer benefit package is to constantly evaluate how well the goods and services are selling and what customers' reactions to them are.

Goods that are insensitive to external sources of variation are called **robust**.

2 Robust Design and the Taguchi Loss Function

the performance of a good or service is affected by variations that occur during production or service delivery, environmental factors, and the ways in which people use it. *Goods that are insensitive to external sources of variation are called* **robust**. An example of a robust design is the "gear effect" designed into modern golf clubs, which brings the ball back on line even if it is hit off the "sweet spot" of the club. This concept can also be applied to services. For example, an automatic teller machine (ATM) provides only certain ways to process financial transactions. The customer must perform the steps in a certain fashion or sequence, or the transaction is not processed. This is not a particularly robust design.

Genichi Taguchi, a Japanese engineer who made numerous contributions to the field of quality management, explained the economic value of reducing variation in manufacturing. Taguchi maintained that the traditional practice of meeting design specifications is inherently flawed. For most manufactured goods, design blueprints specify a target dimension (called the *nominal*), along with a range of permissible variation (called the *tolerance*), for example, 0.500 ± 0.020 cm. The nominal dimension is 0.500 cm, but may vary anywhere in a range from 0.480 to 0.520 cm. This assumes that the customer, either the consumer or the next department in the production process, would accept any value between 0.480 to 0.520 but not be satisfied with a value outside this range. This is sometimes called the *"goal post model"* of conforming to specifications. Also, this approach assumes that costs do not depend on the actual value of the dimension as long as it falls within the specified tolerance (see Exhibit 6.2).

But what is the real difference between 0.479 and 0.481? The former would be considered as "out of specification" and either reworked or scrapped, whereas the latter would be acceptable. Actually, the impact of either value on the performance characteristic of the product

The marketplace is a graveyard of missed opportunities: poorly designed goods and services and failed execution resulting from ineffective operations.

would be about the same. Neither value is close to the nominal specification 0.500. The nominal specification is the ideal target value for the critical quality characteristic. Taguchi's approach assumes that the smaller the variation about the nominal specification, the better is the quality. In turn, products are more consistent, and total costs are less.

Taguchi measured quality as the variation from the target value of a design specification and then translated that variation into an economic "loss function" that expresses the cost of variation in monetary terms. The economic loss applies to both goods and services.

Taguchi assumed that losses can be approximated by a quadratic function so that larger deviations from target cause increasingly larger losses. The loss function is represented by

$$L(x) = k(x-T)^2 \qquad [6.1]$$

where

L(x) is the monetary value of the loss associated with deviating from the target, T;

x is the actual value of the dimension; and

k is a constant that translates the deviation into dollars.

Exhibit 6.3 illustrates this Taguchi loss function.

The constant, k, is estimated by determining the cost of repair or replacement if a certain deviation from the target occurs, as the following example illustrates.

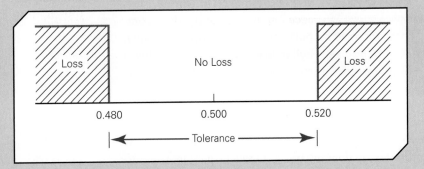

Exhibit 6.2 *Traditional Goal Post View of Conforming to Specifications*

Exhibit 6.3 *Nominal-Is-Best Taguchi Loss Function*

Solved Problem

Suppose that the specification on a part is 0.500 ± 0.020 cm. The target value T is 0.500. A detailed analysis of product returns and repairs has discovered that many failures occur when the actual dimension is near the extreme of the tolerance range—that is, when the dimensions are approximately 0.48 or 0.52—and costs $50 for repair. Thus, in equation 6.1, the deviation from the target, $x - T$ is 0.02 and $L(x) = \$50$. Substituting these values, we have

$$50 = k(0.02)^2$$

or

$$k = 50/0.0004 = 125,000$$

Therefore, the loss function for a single part is $L(x) = 125,000(x - T)^2$. This means, for example, if $x = 0.51$ so that the deviation $(x - T)$ is 0.010, the firm can expect an average loss per unit of

$$L(0.51) = 125,000(0.010)^2 = \$12.50 \text{ per part}$$

3 Reliability

everyone expects the car to start each morning and the computer to work without crashing. **Reliability** *is the probability that a manufactured good, piece of equipment, or system performs its intended function for a stated period of time under specified operating conditions.* Please note that a system could be a service process where each stage (work activity or station) is analogous to a component part in a manufactured good. This definition has four important elements: probability, time, performance, and operating conditions.

First, reliability *is defined as a probability, that is, a value between 0 and 1.* For example, a probability of .97 indicates that, on average, 97 out of 100 times the item will perform its function for a given period of time under specified operating conditions. Often, reliability is expressed as a percentage simply to be more descriptive (97 percent reliable). The second element of the definition is *time.* Clearly, a device having a reliability of .97 for 1,000 hours of operation is inferior to one that has the same reliability for 5,000 hours of operation, if the objective of the device is long life.

The reliability of a system is the probability that the system will perform satisfactorily over a specified period of time. Reliability can be improved by using better components or by adding redundant components. In either case, costs increase; thus, trade-offs must be made.

Many manufactured goods consist of several components that are arranged in series but are assumed to be independent of one another, as illustrated in Exhibit 6.4. If one component or pro-

cess step fails, the entire system fails. If we know the individual reliability, pj, for each component, j, we can compute the total reliability of an n-component series system, R_s. If the individual reliabilities are denoted by p_1, p_2, \ldots, p_n and the system reliability is denoted by R_s, then

$$R_s = (p_1)(p_2)(p_3) \ldots (p_n) \qquad [6.2]$$

Other system designs consist of several parallel components that function independently of each other, as illustrated in Exhibit 6.5. The entire system will fail only if all components fail; this is an example of redundancy. The system reliability of an n-component parallel system is computed as

$$R_p = 1 - (1 - p_1)(1 - p_2)(1 - p_3) \ldots (1 - p_n) \qquad [6.3]$$

Many other systems are combinations of series and parallel components. To compute the reliability of such systems, *first* compute the reliability of the parallel components using equation 6.3 and treat the result as a single series component; *then* use equation 6.2 to compute the reliability of the resulting series system.

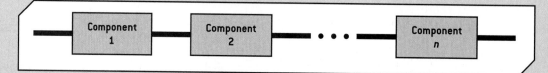

Exhibit 6.4 *Structure of a Serial System*

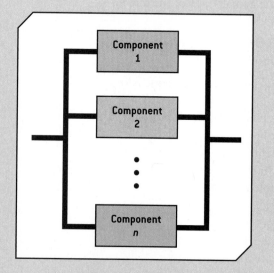

Exhibit 6.5 *Structure of a Parallel System*

Reliability is the probability that a manufactured good, piece of equipment, or system performs its intended function for a stated period of time under specified operating conditions.

Solved Problem

Consider a new laboratory blood analysis machine consisting of three major subassemblies, A, B, and C. The manufacturer is evaluating the preliminary design of this piece of equipment. The reliabilities of each subassembly are shown in Exhibit 6.6.

Exhibit 6.6 *Subassembly Reliabilities*

To find the reliability of the proposed product design, we note that this is a series system and use equation 6.2:

$$R_s = (.98)(.91)(.99) = .883, \text{ or } 88.3 \text{ percent}$$

Now suppose that the original subassembly B (with a reliability of .91) is duplicated, creating a parallel (backup) path as shown in Exhibit 6.7. (Assume equipment software switches to the working subassembly B.) What is the reliability of this configuration? The reliability of the parallel system for subassembly B is $R_p = 1 - (1 - .91)(1 - .91) = 1 - .0081 = .9919$. Now we replace the parallel subsystem with its equivalent

Exhibit 6.7 *Modified Design*

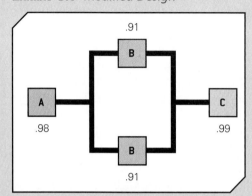

series component. We use equation 6.2 to compute the reliability of the equipment as $R_s = (.98)(.9919)(.99) = .962$, or 96.2 percent. The reliability of the total product increases from 88.3 percent to 96.2 percent for an absolute increase of 7.9 percent.

LaRosa's Pizzeria

LaRosa's Pizzeria, a regional chain of informal Italian restaurants in the greater Cincinnati area, realized that customers know what they want. To gather information to help design a new restaurant configuration, LaRosa's went out to current and potential customers and noncustomers in nonmarket areas to acquire the voice of the customer. Here are some real examples of customers' experiences at other restaurants that LaRosa's clearly wanted to avoid:

- "So there I was, like herded cattle, standing on the hard concrete floor, cold wind blasting my ankles every time the door opened, waiting and waiting for our name to be called."
- "And then I saw a dirty rag being slopped around a dirty table."
- "This is a great place because you can just come in and plop in a booth, just like at Mom's house."
- "I swear! The salad looked like the server ran down to the river bank and picked weeds and grass— I'm never going back!"
- "The server just stood there staring at me, chomping his gum like a cow chewing its cud."
- "When they're that age, going to the bathroom is a full-contact sport—they're reaching and grabbing at everything, and you're trying to keep them from touching anything because the bathroom is so dirty."

In the last example, what the customer really was saying is "The bathroom tells me what the kitchen might be like. Do I really want to eat here?" Clean bathrooms turned out to be the most important customer requirement that the company learned from the voice of the customer process. What do you think the customers were saying in the other examples?

4 Quality Function Deployment

Quality function deployment (QFD) *is both a philosophy and a set of planning and communication tools that focuses on customer requirements in coordinating the design, manufacturing, and marketing of goods or services.* QFD can be applied to a specific manufactured good, service, or the entire CBP.

Customer requirements, as expressed in the customer's own terms, are called the **voice of the customer.** They represent what customers expect a product or service to have or to do. QFD focuses on turning the voice of the customer into specific technical requirements that characterize a design and provide the "blueprint" for manufacturing or service delivery. Technical requirements might include materials, size and shape of parts, strength requirements, service procedures to follow, and even employee behavior during customer interactions. The process is initiated with a matrix, which because of its structure (shown in Exhibit 6.8) is often called the *House of Quality.*

Building a House of Quality begins by identifying the voice of the customer and technical features of the design. The technical features, however, must be expressed in the language of the designer and engineer. The roof of the House of Quality shows the interrelationships between any pair of technical features, and these relationships help in answering questions such as "How does a change in one product characteristic affect others?"

Next, a relationship matrix between the customer requirements and the technical features is developed, which shows whether the final technical features adequately address the customer attributes, an assessment that may be based on expert experience, customer responses, or controlled experiments. The lack of a strong relationship between a customer attribute and any of the technical features would suggest that the final good or service will have difficulty in meet-

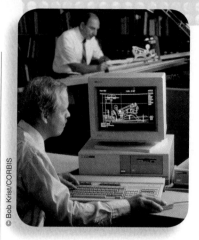

© Bob Krist/CORBIS

ing customer needs. Similarly, if a technical feature does not affect any customer attribute, it may be redundant.

The next step is to add market evaluation and key selling points. It includes rating the importance of each customer attribute and evaluating existing products on each of the attributes to highlight the absolute strengths and weaknesses of competing products. Next, technical features of competitive products are evaluated and targets are developed. These evaluations are compared with the competitive evaluation of customer attributes to spot any inconsistency between customer evaluations and technical evaluations. On the basis of customer-importance ratings and existing product strengths and weaknesses, targets for each technical feature are set.

The final step is to select technical features that have a strong relationship to customer needs, have poor competitive performance, or are strong selling points. Those characteristics will need to be "deployed," or translated into the language of each function in the design and process, so that proper actions and controls are taken to ensure that the voice of the customer is maintained. Characteristics that are not identified as critical do not need such rigorous attention.

Exhibit 6.8 *The House of Quality*

House of Quality

- Interrelationships
- Technical requirements
- Voice of the customer
- Relationship matrix
- Technical requirement priorities
- Customer requirement priorities
- Competitive evaluation

Building a Better Pizza

A restaurant wants to develop a "signature" pizza. The voice of the customer in this case consists of four attributes. The pizza should be tasty, be healthy, be visually appealing, and should provide good value. The "technical features" that can be designed into this particular product are price, size, amount of cheese, type of additional toppings, and amount of additional toppings. The symbols in the matrix in the exhibit at the right show the relationships between each customer requirement and technical feature. For example, taste bears a moderate relationship with amount of cheese and a strong relationship with type of additional toppings. In the roof, the price and size area seem to be strongly related (as size increases, the price must increase). The competitive evaluation shows that competitors are currently weak on nutrition and value, so those attributes can become key selling points in a marketing plan if the restaurant can capitalize on them. Finally, at the bottom of the house are targets for the technical features based on an analysis of customer-importance ratings and competitive ratings. The features with asterisks are the ones to be "deployed," or emphasized, in subsequent design and production activities.

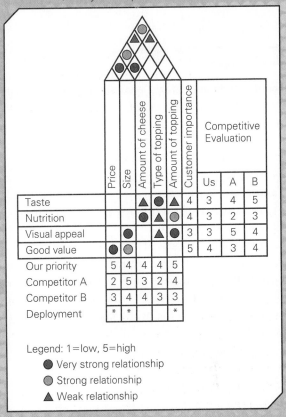

House of Quality Example for a Pizza

	Price	Size	Amount of cheese	Type of topping	Amount of topping	Customer importance	Competitive Evaluation Us	A	B
Taste			▲	●	▲	4	3	4	5
Nutrition			●	▲	●	4	3	2	3
Visual appeal		●		▲	●	3	3	5	4
Good value	●	●				5	4	3	4
Our priority	5	4	4	4	5				
Competitor A	2	5	3	2	4				
Competitor B	3	4	4	3	3				
Deployment	*	*			*				

Legend: 1=low, 5=high
● Very strong relationship
● Strong relationship
▲ Weak relationship

5 Product and Process Design in Manufacturing

In this section we focus on steps 4a and 4b in Exhibit 6.1—the detailed design process for manufactured goods. For a manufactured good, such as an automobile, computer, bank checkbook, or a textbook, the detailed design process begins by determining marketing and technical specifications. This step typically involves engineers who translate a concept into blueprints and select materials or purchased components. In addition, they must coordinate their efforts with operations managers to ensure that existing manufacturing processes can produce the design or that the right process is selected in step 4b of Exhibit 6.1.

For most manufactured goods, this phase usually includes prototype testing. **Prototype testing** *is the process by which a model (real or simulated) is constructed to test the good's physical properties or use under actual operating conditions, as well as consumer reactions to the prototypes.* For example, Boeing's 777 jets were built using digital prototypes and simulating

different operating conditions; no physical prototypes were produced.

5.1 Quality Engineering

Quality engineering *refers to a process of designing quality into a manufactured good based on a prediction of potential quality problems prior to production.* Among the many tools of quality engineering are value engineering, value analysis, and failure-mode-and-effects analysis. **Value engineering** *refers to cost avoidance or cost prevention before the good or service is created.* **Value analysis** *refers to cost reduction of the manufactured good or service process.*

Prototype testing is the process by which a model (real or simulated) is constructed to test the good's physical properties or use under actual operating conditions, as well as consumer reactions to the prototypes.

Quality engineering refers to a process of designing quality into a manufactured good based on a prediction of potential quality problems prior to production.

Value engineering refers to cost avoidance or cost prevention before the good or service is created.

Value analysis refers to cost reduction of the manufactured good or service process.

> Boeing's 777 jets were built using digital prototypes and simulating different operating conditions; no physical prototypes were produced.

Failure-mode-and-effects analysis (FMEA) *is a technique in which each component of a product is listed along with the way it may fail, the cause of failure, the effect or consequence of failure, and how it can be corrected by improving the design.* For instance, one of the components of a table lamp is the socket; a typical FMEA for that component might be

Failure: cracked socket

Causes: excessive heat, forcing the bulb too hard

Effects: may cause shock

Correction: use improved materials

An FMEA can uncover serious design problems prior to manufacturing and improve the quality and reliability of a product considerably. FMEA is finding increased application in the health care industry today.

5.2 Product and Process Simplification

The simpler the design, the less opportunities for error, the faster the flow time, the better the chance of high process efficiency, and the more reliable the manufactured good or service process. So it comes as no surprise that some firms spend considerable resources trying to reduce product or process complexity. **Product and process simplification** *is the process of trying to simplify designs to reduce complexity and costs and thus improve productivity, quality, flexibility, and customer satisfaction.* For example, the redesign of the Cadillac Seville rear-bumper assembly reduced the number of parts by half and cut assembly time by 57 percent, to less than 8 minutes, saving the company over $450,000 annually in labor costs.[3] Since many of the eliminated parts were squeak- and rattle-causing fasteners, nuts, bolts, and screws, the change also improved the quality of the car. Product simplification encourages the use of standard parts and components that are widely available and are less expensive because vendors can produce them on a mass basis. Also, because they do not have to be designed in-house, the development time is decreased.

Simple Design Means Simple Operations

Manufacturing complexity is driven by choices and options. For the Toyota Venza, simplicity is key. In effect, there is one model that is available in four versions: a four-cylinder engine with front-wheel drive or all-wheel drive, or a six-cylinder engine with the same. A simple one-grade, four-model strategy gives consumers a nicely equipped vehicle right from the get-go and allows Toyota the flexibility to offer simple packages and stand-alone options. It also makes things comparatively easier at the Toyota Georgetown assembly plant.[4]

5.3 Design for Environmental Quality

Environmental concerns are placing increased pressure on goods-producing and service-providing organizations. *A focus on improving the environment by better good or service design is often called* **green manufacturing** *or* **green practices**. Green practices are part of a sustainability strategy as discussed in Chapter 1.

Pressures from environmental groups clamoring for "socially responsive" designs, states and municipalities that are running out of space for landfills, and consumers who want the most for their money have caused designers and managers to look carefully at the concept of Design for Environment.[5] **Design for Environment (DfE)** *is the explicit consideration of*

Failure-mode-and-effects analysis (FMEA) is a technique in which each component of a product is listed along with the way it may fail, the cause of failure, the effect or consequence of failure, and how it can be corrected by improving the design.

Product and process simplification is the process of trying to simplify designs to reduce complexity and costs and thus improve productivity, quality, flexibility, and customer satisfaction.

A focus on improving the environment by better good or service design is often called **green manufacturing** or **green practices**.

Design for Environment (DfE) is the explicit consideration of environmental concerns during the design of goods, services, and processes and includes such practices as designing for recycling and disassembly.

environmental concerns during the design of goods, services, and processes and includes such practices as designing for recycling and disassembly. Food packaging for fast-food restaurants, for example, has been redesigned several times over the years and now is more recyclable and biodegradable. One aspect of designing for repairability and disassembly is that products can be taken apart for their components to be repaired and refurbished or otherwise salvaged for reuse.

Many companies now subscribe to ISO 14000, a voluntary set of environmental standards that are administered by the International Organization for Standardization. The aim of the standards is to support environmental protection and prevention of pollution in balance with socioeconomic needs. By obtaining ISO 14001 certification, a company can demonstrate its commitment to the environment and develop a system for better managing environmental risks and reducing costs.

© Tomohiro Ohsumi/Bloomberg News/Landov

6 Service Delivery System Design

Service delivery system design *includes facility location and layout, the servicescape, service process and job design, technology and information support systems, and organizational structure.*

Integrating all of these elements is necessary to design a service that provides value to customers and can create a competitive advantage. A poor choice on any one of these components, such as technology or job design, can degrade service system efficiency and effectiveness.

What is a Service?

A service is not something that is built in a factory, shipped to a store, put on a shelf, and then taken home by a consumer. A service is a dynamic, living process. A service is performed. A service is rendered. The "raw materials" of a service are time and motion; not plastic or steel. A service cannot be stored or shipped; only the means for creating it can. A service cannot be held in one's hand or physically possessed. In short, a service is not a thing.
—G. Lynn Shostack

6.1 Facility Location and Layout

Location affects a customer's travel time and is an important competitive priority in a service business. Health clinics, rental car firms, post offices, health clubs, branch banks, libraries, hotels, emergency service facilities, retail stores, and many other types of service facilities depend on good location decisions. Starbuck's Coffee shops, for example, are ubiquitous in many cities, airports, and shopping malls. The layout of a facility affects process flow, costs, and customer perception and satisfaction.

> **Service delivery system design** includes facility location and layout, the servicescape, service process and job design, technology and information support systems, and organizational structure.

Green Design

BM changed the way it applies acoustic foam to its computer panels by discontinuing the use of chemical-based adhesives. This not only helped IBM reduce the amount of greenhouse gas emissions in the production process through the elimination of the adhesive, but also improved recycling when the product reached the end of its life cycle.

Steelcase's Think office chair was designed with a focus on recycling. It can be disassembled with the use of a few hand tools in 5 minutes, with 99% of its overall content able to head to the recycling heap.

Intel's Haifa, Israel, server facility uses hot water that results from cooling the facility to heat the adjacent buildings in the winter and provide hot water to the showers in the facility's gym. [6]

© Jeff Roberson/AP Photo

6.2 Servicescape

The **servicescape** *is all the physical evidence a customer might use to form an impression.*[7] *The servicescape also provides the behavioral setting where service encounters take place.* People around the world, for example, recognize the servicescape of McDonald's restaurants. The building design ("golden arches"), decorative schemes and colors, playground, menu board, packaging, employee uniforms, drive-through, and so on, all support McDonald's competitive priorities of speed, consistency, cleanliness, and customer service. The standardization and integration of the servicescape and service processes enhance efficiency. McDonald's servicescape also helps establish its brand image.

McDonald's servicescape also helps establish its brand image.

A servicescape has three principal dimensions:[8]

1. *Ambient conditions*—made manifest by sight, sound, smell, touch, and temperature. These are designed into a servicescape to please the five human senses. For example, Starbucks decided to quit serving a warm breakfast in all Starbucks stores because the egg-and-cheese breakfast sandwiches were interfering with the aroma of the coffee in stores.

2. *Spatial layout and functionality*—how furniture, equipment, and office spaces are arranged. This includes building footprints and facades, streets, and parking lots. A law firm would probably design various conference areas for conversations to take place in a quiet and private setting; a children's hospital would probably include safe and enclosed play areas for kids.

3. *Signs, symbols, and artifacts*—the more explicit signals that communicate an image about a firm. Examples include mission statements and diplomas on a wall, a prominently displayed company logo on company vehicles, a trophy case of awards, letterhead, and company uniforms. Luxury automobile dealers offer free food and soft drinks instead of vending machines.

Some servicescapes, termed **lean servicescape environments,** *are very simple.* Ticketron outlets and Federal Express drop-off kiosks would qualify as lean servicescape environments, as both provide service from one simple design. *More complicated designs and service systems are termed* **elaborate servicescape environments**. Examples include hospitals, airports, and universities.[9]

The **servicescape** is all the physical evidence a customer might use to form an impression. The servicescape also provides the behavioral setting where service encounters take place.

Lean servicescape environments provide service using simple designs (for example, Ticketron outlets or FedEx kiosks).

Elaborate servicescape environments provide service using more complicated designs and service systems (for example, hospitals, airports, and universities).

JetBlue's New Servicescape

Fiona Morrison leads a team that has helped develop the passenger-experience elements of T5, JetBlue's new $743 million terminal at JFK, which opened in 2008. "The airport should deliver as much of an experience as the flight itself. There are a million little touches that we've sprinkled throughout T5. We chose Italian furniture that's both sturdy and beautiful; we used indirect lighting and installed colorful, custom-design carpeting. If a space looks like a food court, people will treat it like one. I love talking about the baggage-claim area, because it encapsulates what we've tried to do throughout the building. Our architect, Gensler, came up with the idea of installing backlit blue panels on the walls, and we've covered the luggage carousels with bright orange rugs. People go to baggage claim expecting a dark, dingy basement, and instead find themselves in a gorgeous space. It's so unexpected to be standing in this warm glow of color—it makes people happy."[10]

6.3 Service Process and Job Design

Service process design *is the activity of developing an efficient sequence of activities to satisfy both internal and external customer requirements.* Service process designers must concentrate on developing procedures to ensure that things are done right the first time, that interactions are simple and quick, and that human error is avoided. Fast-food restaurants, for example, have carefully designed their processes for a high degree of accuracy and fast response time.[11] New hands-free intercom systems, better microphones that reduce ambient kitchen noise, and screens that display a customer's order are all focused on these requirements.

6.4 Technology and Information Support Systems

Hard and soft technology is an important factor in designing services to ensure speed, accuracy, customization, and flexibility. Nurses, airline flight attendants, bank tellers, police, insurance claims processors, dentists, auto mechanics and service counter personnel, engineers, hotel room maids, financial portfolio managers, purchasing buyers, and waiters are just a few example job designs that are highly dependent on accurate and timely information.

Where Are My Clothes?

A dry-cleaning service in Naples, Florida, is the first U.S. dry cleaner and the second in the world to have three conveyor belts with radio frequency identification devices (RFID) for tracking customer garments. The company has invested more than $400,000 in computers, software, and other technology, including chips that track garments every step of the way so they're rarely lost. The chips are colored-coded and removed once the garment is cleaned. In this state-of-the-art facility, shirts, dresses, and pants whiz past dry-cleaning workstations where RFID technology helps sort and route garments. Employees no longer have to worry about reading and matching up numbers on safety pin tags and carrying clothing all around the production facility. Customer clothes are much less likely to get mixed in with those of another customer. The owner says, "The equipment is on its way to paying for itself!"[12]

6.5 Organizational Structure

The performance of a service delivery system depends on how work is organized. A pure functional organization generally requires more handoffs between work activities, resulting in increased opportunities for errors and slower processing times. Because no one "owns" the processes, there is usually little incentive to make them efficient and to improve cooperation among business functions.

A process-based organization is vital to a good service design because services are generally interdisciplinary and cross-functional. For example, service upsets and mistakes that occur in the presence of the customer call for immediate responses by the service-provider and often require extensive cooperation among various functions in a service process.

7 Service Encounter Design

Service encounter design *focuses on the interaction, directly or indirectly, between the service-provider(s) and the customer.* It is during these points of contact with the customer that perceptions of the firm and its goods and services are created. Service encounter design and job design are frequently done in iterative improvement cycles.

The principal elements of service encounter design are:

- customer contact behavior and skills;
- service-provider selection, development, and empowerment;
- recognition and reward; and
- service recovery and guarantees.

These elements are necessary to support excellent performance and create customer value and satisfaction.

Service process design is the activity of developing an efficient sequence of activities to satisfy both internal and external customer requirements.

Service encounter design focuses on the interaction, directly or indirectly, between the service-provider(s) and the customer.

7.1 Customer Contact Behavior and Skills

Customer contact *refers to the physical or virtual presence of the customer in the service delivery system during a service experience.* Customer contact is measured by the percentage of time the customer must be in the system relative to the total time it takes to provide the service. *Systems in which the percentage is high are called* **high-contact systems***; those in which it is low are called* **low-contact systems***.*[13,14] Examples of high-contact systems are estate planning and hotel check-in; examples of low-contact systems are construction services and package sorting and distribution.

Many low-contact systems, such as processing an insurance policy in the backroom, can be treated much like an assembly line, while service delivery systems with high customer contact are more difficult to design and control. One of the reasons for this is the variation and uncertainty that people (customers) introduce into high-contact service processes. For example, the time it takes to check a customer into a hotel can be affected by special requests (for example, a king bed or smoking room) and questions that customers might ask the desk clerk. Low customer contact systems are essentially free of this type of customer-induced uncertainty, and therefore, capable of operating at higher levels of operating efficiency. High customer contact areas of the organization are sometimes described as the "front room or front office" and low customer contact areas as "back room or back office."

Customer-contact requirements *are measurable performance levels or expectations that define the quality of customer contact with representatives of an organization.* These might include such technical requirements as response time (answering the telephone within two rings), service management skills such as cross-selling other services and/or behavioral requirements (using a cus-

© Disneyland; Smithsonian's National Museum of American History/ PRNewsFoto/AP Photo

tomer's name whenever possible). Walt Disney Company, highly recognized for extraordinary customer service, clearly defines expected behaviors in its guidelines for guest service, which include making eye contact and smiling, greeting and welcoming every guest, seeking out guests who may need assistance, providing immediate service recovery, displaying approachable body language, focusing on the positive rather than rules and regulations, and thanking each and every guest.[15]

7.2 Service-Provider Selection, Development, and Empowerment

Companies must carefully select customer-contact employees, train them well, and empower them to meet and exceed customer expectations. Many companies begin with the recruiting process, selecting those employees who show the ability and desire to develop good customer relationships. Major companies such as Procter & Gamble seek people with excellent interpersonal and communication skills, strong problem-solving and analytical skills, assertiveness, stress tolerance, patience and empathy, accuracy and attention to detail, and computer literacy.

Empowerment *simply means giving people authority to make decisions based on what they feel is right, to have control over their work, to take risks and learn from mistakes, and to promote change.* At The Ritz-Carlton Hotel Company, no matter what their normal duties are, employees must assist a fellow service-provider who is responding to a guest's complaint or wish if such assistance is requested. Ritz-Carlton employees can spend up to $2,000 to resolve complaints with no questions asked. However, the actions of empowered employees should be guided by a common vision. That is,

Customer contact refers to the physical or virtual presence of the customer in the service delivery system during a service experience.

Systems in which the percentage is high are called **high-contact systems**; those in which it is low are called **low-contact systems**.

Customer-contact requirements are measurable performance levels or expectations that define the quality of customer contact with representatives of an organization.

Empowerment simply means giving people authority to make decisions based on what they feel is right, to have control over their work, to take risks and learn from mistakes, and to promote change.

employees require a consistent understanding of what actions they may or should take.

7.3 Recognition and Reward

After a firm hires, trains, and empowers good service-providers, the next challenge is how to motivate and keep them. Research has identified key motivational factors to be recognition, advancement, achievement, and the nature of the work itself. A good compensation system can help to attract, retain, and motivate employees. Other forms of recognition, such as formal and informal employee and team recognition, preferred parking spots, free trips and extra vacation days, discounts and gift certificates, and a simple "thank you" from supervisors are vital to achieving a high-performance workplace.

7.4 Service Recovery and Guarantees

Despite all efforts to satisfy customers, every business experiences unhappy customers. *A **service upset** is any problem a customer has—real or perceived—with the service delivery system and includes terms such as service failure, error, defect, mistake, or crisis.* Service upsets can adversely affect business if not dealt with effectively.

Service recovery *is the process of correcting a service upset and satisfying the customer.* Service-providers need to listen carefully to determine the customer's feelings and then respond sympathetically, ensuring that the issue is understood. Then they should make every effort to resolve the problem quickly. Often this is accomplished with free meals, discount coupons, or a simple apology. Service recovery normally occurs after a service problem and when the customer is visibly upset. The key to service recovery is an "immediate response"; the longer customers wait, the angrier they might get.

*A **service guarantee** is a promise to reward and compensate a customer if a service upset occurs during the service experience.* Unlike service recovery, which occurs after a service upset, service guarantees are offered prior to the customer experiencing the service. One objective is to encourage the customer to purchase the service. Because the customer cannot truly evaluate the service until he or she experiences it, service guarantees try to minimize the risk to the customer.[16]

8 An Integrative Case Study of LensCrafters

To illustrate how goods and services are designed in an integrated fashion, we will study LensCrafters—a well-known provider of eyeglasses produced "in about an hour." We use the framework for goods and service design shown in Exhibit 6.1.

Steps 1 and 2—Strategic Mission, Market Analysis, and Competitive Priorities

LensCrafters (www.lenscrafters.com) is an optical chain of about 860 special service shops with on-site eyeglass production capabilities in the United States, Canada, and Puerto Rico. All resources necessary to create and deliver "one-stop-shopping" and eyeglasses "in about an hour" are available in each store.

LensCrafters' mission statement is focused on being the best by:

- creating customers for life by delivering legendary customer service,

> A **service upset** is any problem a customer has —real or perceived—with the service delivery system and includes terms such as service failure, error, defect, mistake, or crisis.
>
> **Service recovery** is the process of correcting a service upset and satisfying the customer.
>
> A **service guarantee** is a promise to reward and compensate a customer if a service upset occurs during the service experience.

© Jens Buettner/DPA/Landov

- developing and energizing associates and leaders in the world's best work place,
- crafting perfect-quality eyewear in about an hour, and
- delivering superior overall value to meet each customer's individual needs.[17]

Step 3—Customer Benefit Package Design and Configuration

Our perception of the LensCrafters customer benefit package is the integrated set of goods and services depicted in Exhibit 6.9. The primary good (eyewear) and the primary service (accurate eye exam and one-hour service) are of equal importance. Peripheral goods and services encircle the primary ones to create "a total LensCrafters' experience."

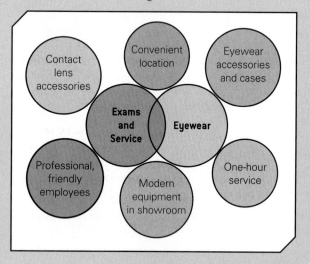

Exhibit 6.9 *One Example View of LensCrafters' Customer Benefit Package*

Steps 4a and b—Manufactured Good Design and Process Selection

The manufacturing process is integrated into the service facility to provide rapid order response, yet not sacrifice quality. In this industry, it is unusual for customers to watch their eyeglasses being made and this "service experience" is viewed as adding value. The equipment used in the labs is the most technologically advanced equipment in the industry. The eyewear is manufactured to specifications in a clean, modern, and professionally run facility.

Other issues that LensCrafters would need to consider in designing its manufacturing processes are:

- How are eyeglass lenses and frames ordered? Are these materials ordered by individual stores or consolidated by region/district? How can the high quality of eyewear be ensured? What new materials are available?
- What items should be stored at the region/district warehouse and stores? What type of purchasing and inventory control systems should be used? How should supplier performance be evaluated?
- What eyewear-making equipment should be used? What is the latest technology? Which equipment is most flexible? Should the equipment be purchased or leased? How should it be maintained and by whom?
- What is the most efficient production procedure to make the goods and meet time schedules? Where should quality be checked in the manufacturing process?

Step 4c—Service Delivery System Design

The service delivery system, as evidenced by the location and layout, servicescape, service processes, job designs, technology, and organizational structure, is combined into an integrated service delivery system. LensCrafters' stores are located in high traffic areas such as shopping centers and malls within five to ten miles of the target market.

A typical store layout is shown in Exhibit 6.10. The servicescape is designed to convey an impression of quality and professionalism. The store is spacious, open, clean, carpeted, with professional merchandise display areas, modern furniture in the retail area, and modern equipment in the laboratory, technicians in white lab coats, shiny machines in the lab, and bright lights throughout. The store display cases, eye examination areas, and fitting stations are in the high-contact area where customers and service-providers interact frequently. Optometry degrees, certifications, and licenses hanging on the wall provide physical evidence of employees' abilities.

A greeter directs each customer as he or she enters the store and to the appropriate service area. The low-contact area of a LensCrafters store—the optical laboratory—is separated from the retail area by large glass panels. The optical laboratory becomes a "showroom" where the customer's perception of the total delivery process is established.

The store is a service factory. The typical service process begins when a customer makes an appointment with an optician and continues until the eyeglasses are received and paid for. Between these two events, the customer travels to the store, parks, receives a greeting from store employees, obtains an eye examination,

selects frames, is measured for proper eyeglasses and frame fit, watches the eyeglasses being made in the laboratory, and receives a final fitting to make sure all is well. Information flow in the forms of prescriptions, bills, and receipts, complements the physical flows of people and eyewear.

Step 4d—Service Encounter Design

Each job at LensCrafters—sales associate, lab technician, and doctor of optometry—requires both technical skills and service management skills. Associates are well-trained, friendly, and knowledgeable about their jobs. The lab technicians are certified in all work tasks and processes. Many associates are cross-trained.

At the service encounter level, key issues that managers need to consider include:

- What human resource management processes and systems will ensure hiring the right people, training them properly, and motivating them to provide excellent service? What recognitions and rewards should be provided?
- How are associates trained to handle service upsets and service recovery?
- What standards should be set for grooming and appearance?
- What behavioral standards, such as tone of voice, physical mannerisms, and the words that associates use in customer interactions, should be set?
- How should employee performance be measured and evaluated?
- What can be done to make the one-hour wait a positive experience for customers?

Steps 5 and 6—Market Introduction/ Deployment and Evaluation

Although the company has been around for some time, it undoubtedly faces challenges in replicating its design concept in new locations. On a continuing basis, as technology and procedures change, LensCrafters will have to develop processes to introduce changes into all existing locations to maintain operational consistency and achieve its strategic objectives. For example, how might it react as competitors such as Wal-Mart enter the optical industry?

As you see, LensCrafters manufacturing and service design depends on a variety of operations management concepts, all of which are integrated and support a rather complex customer benefit package.

Exhibit 6.10 *A Schematic View of a Typical LensCrafters Store Layout*

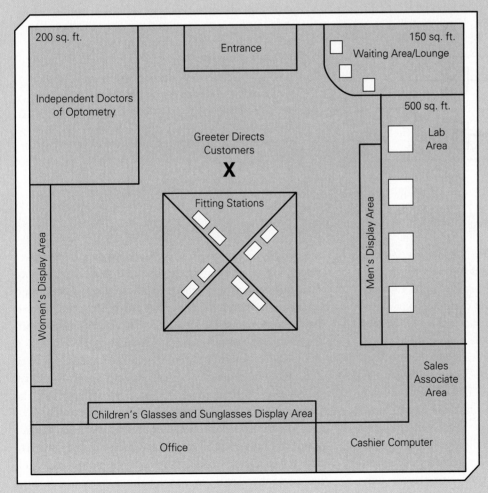

Problems, Activities, and Discussions

1. Suppose that the specifications for a part (in inches) are 6.00 ± 0.15, and that the Taguchi loss function is estimated to be $L(x) = 8{,}500(x - T)^2$. Determine the estimated loss if the quality characteristic under study takes on a value of 6.20 inches and 10 parts are produced.

2. A quality characteristic has a specification (in inches) of 0.200 ± 0.020. If the value of the quality characteristic exceeds 0.200 by the tolerance of 0.020 on either side, the product will require a repair of $150. Develop the appropriate Taguchi loss function by finding the value of k.

3. The service center for a brokerage company provides three functions to callers: account status, order confirmations, and stock quotes. The reliability was measured for each of these services over one month with these results: 90 percent, 80 percent and 86 percent, respectively. What is the overall reliability of the call center?

4. Given the following diagram, determine the total system reliability if the individual component reliabilities are: A = 0.90, B = 0.88, C = 0.92, and D = 0.96. (Hint: Use equations 6.2 and 6.3 and note that the reliabilities of the parallel components are different.)

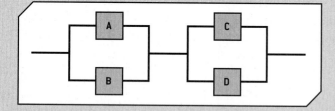

5. Choose a servicescape for a business with which you are familiar and list key physical attributes of the servicescape and their impact on customer service and value. Explain how the servicescape establishes the behavioral setting for your example.

6. Select a service at your school, such as financial aid, bookstore, curriculum advising, and so on. Propose a redesign of this service and its service delivery system. First, baseline the current service and system, and then suggest how to redesign and improve it. Make use of chapter ideas as best you can.

7. What lessons can be learned from the LaRosa's Pizzeria boxed example?

8. Explain how the Goal Post view of conforming to specifications differs from Taguchi's Loss Function. Would you rather buy an automobile where suppliers used the Goal Post or Taguchi models? Why?

9. Considering the same diagram used in Problem 4, what if components A and B were redundant parts providing the same function in parallel with a reliability of 0.85, and components C and D were also redundant parts with a reliability of 0.90. What is the total system reliability?

10. Identify a service-provider job and associated service encounters and design and write a job description for it. (Consider desired customer contact skills and behaviors, education and training requirements, empowerment capabilities, hiring criteria, and so on.)

Bourbon Bank Case Study

"I know what we can do next; everything has been so successful so far," said Kay Ebelhar, marketing services division manager. "How about offering a *courtesy service guarantee*? We will promise to greet customers, give them our undivided attention, and then thank them when they leave. As with our other service guarantees, if we fail to deliver superior service encounters, we'll give the customer $5.00! What do you think?" So the discussion began this Tuesday morning at the monthly meeting of the Marketing Control Task Force (MCTF). Following these words, Sarah Coleman, service guarantee manager for Bourbon Bank, pondered what the next step should be in her company's journey to become the industry leader in customer service.

Four years ago, the bank undertook an extensive study to identify the needs of its target customers and analyze the actions of its competitors. Aided by extensive market research, management quickly realized that certain service features, such as convenient location, interest rates paid on customer accounts, and extended branch bank hours, had become a baseline level of performance (order qualifiers) from which nearly all competitors operated. Bourbon Bank leaders determined that to gain a competitive advantage, they must provide customers with superior service, in addition to the baseline features. To achieve this, the Marketing Control Task Force (MCTF) was created.

The bank's service guarantee program has been in place for 10 months now. Since January, media campaigns have announced the service guarantees to the public and bank employees have received training about them. In this short amount of time, it has been difficult to evaluate the results

of the service guarantee program. Sarah knows that the bank spent $860 for payouts during the 10 months for 300 branch banks and that there seemed to be no trend up or down in the monthly payout amounts. Sarah was the only one asking tough questions during MCTF meetings such as: Are service upsets and errors being reduced? Are employees motivated to provide exceptional service? Are the bank's processes getting better? Or should the next step be to add one or two new service guarantees with the $5 payout? This might be just what is needed to strengthen the program and reinforce Bourbon Bank's commitment to service excellence.

A Gold Service Guarantee Program was developed with the intent of insuring that the bank would emerge as a leader in service quality within its market. It would also be a source of competitive advantage, and a fundamental component of their new corporate culture.

Bruce Ayres/Stone/Getty Images

The initial phase of the Gold Service program consisted of a series of print, radio, and television advertising, as well as promotional campaigns geared toward customers and employees. During this "Awareness Phase," the goal was to create a general market awareness of Bourbon Bank's attention to superior service. Next came the "Action Phase," where the bank set out to show specifically what it meant to have excellent customer service. By implementing external programs for customers, as well as internal programs for employees, it could demonstrate the bank's commitment to following through with the ideals established in the previous phase. Media campaigns played a significant role in this phase, too, and promotional videos were used internally to create service guarantee awareness and action.

Externally, the Gold Service Telephone Line was established to answer and resolve any customer question or problem (although the average speed of answer time at the bank's customer call center was increasing, not decreasing these past 10 months). Single-transaction express teller windows at all branch banks added friendly signs aimed at satisfying customers requiring simple transactions and quick response.

Internally, an extensive two-day training program for all 6,200 employees was developed to teach them how to live up to the attributes of the "customer service pledge." After training and signing the pledge, each employee received a paperweight inscribed with the pledge as a way of making "Gold Service" more meaningful and relevant to both customers and employees.

The bank initially introduced three specific guarantees. First, checking and savings account statements are guaranteed to be accurate. If there is a mistake, regardless of the reason, the customer receives $5.00. Second, customers are promised answers about their application for a home or automobile loan in the time frame specified by the customer. This guarantee is the personal commitment of the employee who takes the application to deliver an answer within the customer's specified time frame. If the employee does not, Bourbon Bank will pay the customer $5.00. Finally, the bank promises that customers who call the Gold Service Telephone Line will not be transferred, asked to tell their story twice, or made to search for answers themselves. If they are, the employee will award the $5.00 payout on the spot. All payouts are credited to the customer's bank accounts.

A $5.00 payout is associated with each guarantee and is given to the customer at the time the guarantee is invoked. In addition, a service upset form is completed describing the incident. Either the employee or the customer can complete the form, but both must sign it to invoke the guarantee. The service upset form is then sent to a central location for tracking. Monthly, managers receive summary reports about the guarantee infractions in their area but the reports do not identify specific individuals who might be at fault. MCTF receives a summary of this report by branch bank.

Sarah Coleman was the only member of the MCTF who had doubts about the success of the service guarantee program but she was not about to tell anyone—her job depended on the success of the program. Everyone else on the task force had jumped on the marketing bandwagon and hyped up the program as a solid success, even the president and CEO, Mr. Del Carr. Privately, Sarah had many questions about this service guarantee initiative.

Case Questions for Discussion

1. What are the objectives of the service guarantee program?
2. Is the service guarantee program successful?
3. Are the bank's services and processes truly redesigned to meet the service guarantee promises?
4. Is a total payout of $860 over 10 months for 300 branches good or bad?
5. What should the MCTF do next?

PROCESS SELECTION, DESIGN, AND ANALYSIS

called to make an airline flight reservation just an hour ago.[1] The telephone rang five times before a recorded voice answered. "Thank you for calling ABC Travel Services," it said. "To ensure the highest level of customer service, this call may be recorded for future analysis." Next, I was asked to select from one of the following three choices: "If the trip is related to company business, press 1. Personal business, press 2. Group travel, press 3." I pressed 1. I was then asked to select from the following four choices: "If this is a trip within the United States, press 1. International, press 2. Scheduled training, press 3. Related to a conference, press 4." Because I was going to Canada, I pressed 2.

Now two minutes into my telephone call, I was instructed to be sure that I had my customer identification card available. A few seconds passed and a very sweet voice came on, saying, "All international operators are busy, but please hold because you are a very important customer." The voice was then replaced by music. After several iterations of this, the sweet voice returned, stating, "To speed up your service, enter your 19-digit customer service number." The voice then said:

© george green, 2009/Used under license from Shutterstock.com

learning outcomes

After studying this chapter you should be able to:

LO1 Describe the four types of processes used to produce goods and services.

LO2 Explain the logic and use of the product-process matrix.

LO3 Explain the logic and use of the service-positioning matrix.

LO4 Describe how to apply process and value stream mapping for process design.

LO5 Explain how to improve process designs and analyze process maps.

LO6 Describe how to compute resource utilization and apply Little's Law.

What do **you** think?

Describe a situation that you have encountered in which a process was either well designed and enhanced your customer experience, or poorly designed and resulted in dissatisfaction.

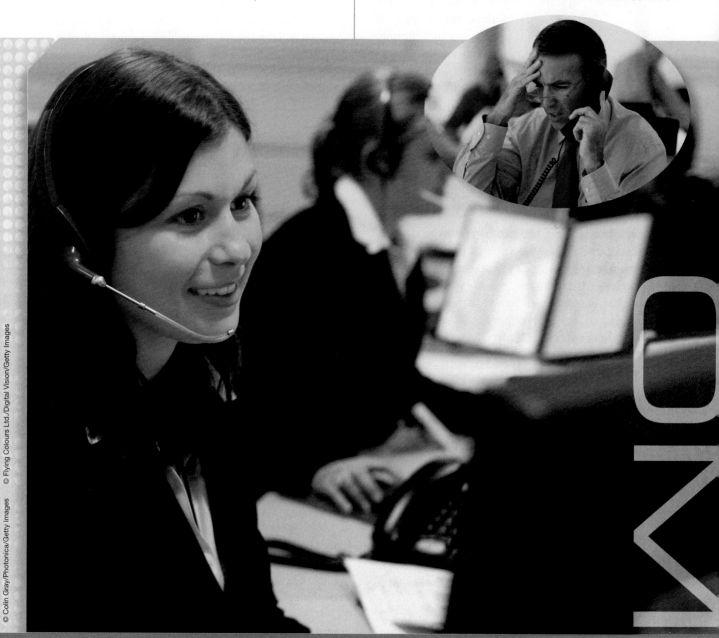

"Thank you. An operator will be with you shortly. If your call is an emergency, you can call 1-800-CAL-HELP. Otherwise, please hold, as you are a very important customer." This time, in place of music, I heard a commercial about the service that the company provides.

Ten minutes passed and then a real person answered the telephone and asked, "Can I help you?" I replied, "Yes, Oh yes. Thank you!" He answered, "Please give me your 19-digit customer service number so I can verify who you are.... Thank you. Where do you want to go and when?" I had previously entered this number but I gave it to him again. I then explained that I wanted to go to Montreal the following Monday morning. He replied: "I only handle domestic reservations. Our international desk has a new telephone number:

1-800-1WE-GOTU. I'll transfer you." A few clicks later a message came on, saying: "All of our international operators are busy. Please hold, as your business is important to us."

Process design is an important operational decision that affects both the cost of operation and customer service.

Choosing appropriate processes and designing them to interface effectively with each other is vital for an effective and efficient value chain and cannot be taken

lightly. The situation humorously described above illustrates a process issue that every reader has most likely encountered. While the automated reservation system may be justified economically, it is clearly not well designed, resulting in customer dissatisfaction. Thus, process design is an important operational decision that affects both the cost of operation and customer service. It often involves making trade-offs among cost, quality, time, and other priorities.

1 Process Choice Decisions

firms generally produce either in response to customer orders and demand or in anticipation of them. This leads to three major types of goods and services: custom, option-oriented, and standard.[2] **Custom, *or* make-to-order, goods and services** *are generally produced and delivered as one-of-a-kind or in small quantities, and are designed to meet specific customers' specifications.* Examples include ships, weddings, certain jewelry, estate plans, buildings, and surgery. Because custom goods and services are produced on demand, the customer must wait for them, often for a long time because the good or service must be designed, created, and delivered.

Option, *or* assemble-to-order, goods and services *are configurations of standard parts, subassemblies, or services that can be selected by customers from a limited set.* Common examples are Dell computers, Subway sandwiches, machine tools, and travel agent services. Although the customer chooses how the good or service is configured, any unique specifications or requirements cannot generally be accommodated.

Standard, *or* make-to-stock, goods and services *are made according to a fixed design, and the customer has no options from which to choose.* Appliances, shoes, sporting goods, credit cards, on-line Web-based courses, and bus service are some examples. Standard goods are made in anticipation of customer demand and stocked in inventory and therefore are usually readily available.

We note that manufacturing systems often use the terms *make-to-order, assemble-to-order,* and *make-to-stock* to describe the types of systems used to manufacture goods. The terminology is not as standardized in service industries although the concepts are similar.

Custom, or **make-to-order, goods and services** are generally produced and delivered as one-of-a-kind or in small quantities, and are designed to meet specific customers' specifications.

Option, or **assemble-to-order, goods and services** are configurations of standard parts, subassemblies, or services that can be selected by customers from a limited set.

Standard, or **make-to-stock, goods and services** are made according to a fixed design, and the customer has no options from which to choose.

So You Want a Bicycle!

Most major bicycle manufacturers—including Taiwan-based Giant, the world's largest bike maker, and Specialized Bicycles—are offering some form of "limited edition" or personalized model, bikes that are produced in limited quantities, have frames signed by famous designers, or come with custom paint jobs or fit your body. The custom-strategy is the latest attempt by bike makers to extract more dollars from a shrinking pool of riders. The number of people riding bicycles fell 8.7 percent to 35.6 million between 2001 and 2006, according to the National Sporting Goods Association. Still, bike makers were able to keep sales and profits up by adopting this limited-edition strategy. These bikes are made in small batches and are priced as high as $10,000 each. What type of process is needed to make these custom bicycles?[3]

© Giant Bicycle Inc./PRNewsFoto/AP Photo

> The most appropriate match between type of product and type of process occurs along the diagonal in the product-process matrix.

Four principal types of processes are used to produce goods and services:

1. projects,
2. job shop processes,
3. flow shop processes, and
4. continuous flow processes.

Projects *are large-scale, customized initiatives that consist of many smaller tasks and activities that must be coordinated and completed to finish on time and within budget.* Some examples of projects are legal defense preparation, construction, and software development. Projects are often used for custom goods and services, and occasionally for standardized products, such as "market homes" that are built from a standard design.

Job shop processes *are organized around particular types of general-purpose equipment that are flexible and capable of customizing work for individual customers.* Job shops produce a wide variety of goods and services, often in small quantities. Thus they are often used for custom or option type products. In job shops, customer orders are generally processed in batches, and different orders may require a different sequence of processing steps and movement to different work areas.

Flow shop processes *are organized around a fixed sequence of activities and process steps, such as an assembly line to produce a limited variety of similar goods or services.* An assembly line is a common example of a flow shop process. Many large-volume option-oriented and standard goods and services are produced in flow shop settings. Some common examples are automobiles, appliances, insurance policies, checking account statements, and hospital laboratory work. Flow shops tend to use highly productive, specialized equipment and computer software.

Continuous flow processes *create highly standardized goods or services, usually around the clock in very high volumes.* Examples of continuous flow processes are automated car washes, paper and steel mills, paint factories, and many electronic information-intensive services such as credit card authorizations and security systems. The sequence of work tasks is very rigid and the processes use highly specialized and automated equipment that is often controlled by computers with minimal human oversight.

Exhibit 7.1 on the next page summarizes these different process types and their characteristics.

2 The Product-Process Matrix

An approach to help understand the relationships between product characteristics for manufactured goods and process choice is the product-process matrix, first proposed by Hayes and Wheelwright and shown in Exhibit 7.2 on page 119.[4] *The **product-process matrix** is a model that describes the alignment of process choice with the characteristics of the manufactured good.*

The most appropriate match between type of product and type of process occurs along the diagonal in the product-process matrix. As one moves down the diagonal, the emphasis on both product and process structure shifts from low volume and high flexibility, to higher volumes and more standardization. This also suggests that as products evolve, particularly from entrepreneurial startups to larger and more mature companies, process changes must occur to keep pace. What often happens in many firms is that product strategies change, but managers do not make the necessary changes in the process to reflect the new product characteristics. If product and process characteristics are not well matched, the firm will be unable to achieve its competitive priorities effectively.

For example, consider a firm that manufactures only a few products with

Projects are large-scale, customized initiatives that consist of many smaller tasks and activities that must be coordinated and completed to finish on time and within budget.

Job shop processes are organized around particular types of general-purpose equipment that are flexible and capable of customizing work for individual customers.

Flow shop processes are organized around a fixed sequence of activities and process steps, such as an assembly line, to produce a limited variety of similar goods or services.

Continuous flow processes create highly standardized goods or services, usually around the clock in very high volumes.

The **product-process matrix** is a model that describes the alignment of process choice with the characteristics of the manufactured good.

Exhibit 7.1 *Characteristics of Different Process Types*

Type of Process	Characteristics	Goods and Services Examples	Type of Product
PROJECT	One-of-a-kind	Space shuttle, cruise ships	
	Large scale, complex	Dams, bridges	
	Resources brought to the site	Skyscrapers, weddings, consulting	
	Wide variation in specifications or tasks	Custom jewelry, surgery	
JOB SHOP	Significant setup and/or changeover time	Automobile engines	Custom or Make-to-Order
	Low to moderate volume	Machine tools	
	Batching (small to large jobs)	Orders from small customers, mortgages	
	Many process routes with some repetitive steps	Shoes, hospital care	
	Customized design to customer's specifications	Commercial printing	
	Many different products	Heavy equipment	
	High work force skills	Legal services	
FLOW SHOP	Little or no setup or changeover time	Insurance polices	Option or Assemble-to-Order
	Dedicated to a small range of goods or services that are highly similar	Cafeterias	
	Similar sequence of process steps	Refrigerators, stock trades	
	Moderate to high volumes	Toys, furniture, lawn mowers	
CONTINUOUS FLOW	Very high volumes in a fixed processing sequence	Gasoline, paint, memory chips, check posting	Standardized or Make-to-Stock
	Not made from discrete parts	Grain, chemicals	
	High investment in equipment and facility	Steel, paper	
	Dedicated to a small range of goods or services	Automated car wash	
	Automated movement of goods or information between process steps	Credit card authorizations	
	24 hour/7 day continuous operation	Steel, electronic funds transfer	

high volumes and low customization using a flow shop process structure. This process choice best matches the product characteristics. However, suppose that as time goes on and customer needs evolve, marketing and engineering functions develop more product options and add new products to the mix. This results in a larger number and variety of products to make, lower volumes, and increased customization. The firm finds itself "off-the-diagonal" and in the lower left-hand corner of the matrix (denoted by Position A in Exhibit 7.2). This results in a mismatch between product characteristics and process choice. If the firm continues to use the flow shop process, it may find itself struggling to meet delivery promises and incur unnecessary costs because of low efficiencies.

On the other hand, by selectively and consciously positioning a business off the diagonal of the product-process matrix, (often called a "positioning strategy"),

a company can differentiate itself from its competitors. However, it must be careful not to get too far off the diagonal or it must have a market where high prices absorb any operational inefficiencies. For example, Rolls-Royce produces a small line of automobiles using a process similar to a job shop rather than the traditional flow shop of other automobile manufacturers. Each car requires about 900 hours of labor. For Rolls-Royce this strategy has worked, but their target market is willing to pay premium prices for premium quality and features.

The theory of the product-process matrix has been challenged by some who suggest that advanced manufacturing technologies may allow firms to be successful even when they position themselves off the diagonal. These new technologies provide manufacturers with the capability to be highly flexible and produce lower volumes of products in greater varieties at lower costs. Therefore,

off-diagonal positioning strategies are becoming more and more viable for many organizations and allow for "mass customization" strategies and capabilities.[5]

3 The Service-Positioning Matrix

t he product-process matrix does not transfer well to service businesses and processes.[6,7] The relationship between volume and process is not found in many service businesses. For example, to meet increased volume, service businesses such as retail outlets, banks, and hotels have historically added capacity in the form of new stores, branch banks, and hotels to meet demand but do not change their processes. These limitations are resolved by introducing the *service-positioning matrix*. To better understand it, we first discuss the concept of a pathway in a service delivery system.

*A **pathway** is a unique route through a service system.* Pathways can be customer- or provider-driven, depending on the level of control that the service firm wants to ensure. **Customer-routed services** *are those that offer customers broad freedom to select the pathways that are best suited for their immediate needs and wants from many possible pathways through the service delivery system.* The customer decides what path to take through the service delivery system with only minimal guidance from management. Searching the Internet to purchase an item is one example.

Provider-routed services *constrain customers to follow a very small number of possible and predefined pathways through the service system.* An automatic teller machine (ATM) is an example. A limited number of pathways exist—for example, getting cash, making a deposit,

A **pathway** is a unique route through a service system.

Customer-routed services are those that offer customers broad freedom to select the pathways that are best suited for their immediate needs and wants from many possible pathways through the service delivery system.

Provider-routed services constrain customers to follow a very small number of possible and predefined pathways through the service system.

Exhibit 7.2 *Product-Process Matrix*

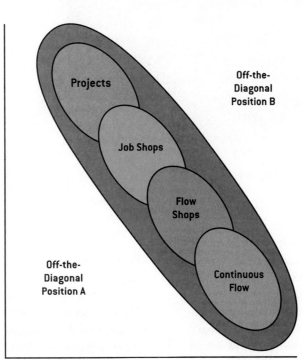

OPERATIONS
Process Choice Decision with Example Process Characteristics

- One-of-a-kind
- Large scale
- Complex
- Wide variation of tasks
- Resources to site

- High setup time
- Batching
- Many process routes
- Customized
- Many different products
- General high level skills

- Low/no setup time
- Highly similar products
- Dominant line flow(s)
- Specialized skills

- High investment in equipment and facility
- Not made from discrete parts
- Automated
- 24/7 continuous operation

Projects

Job Shops

Flow Shops

Continuous Flow

Off-the-Diagonal Position A

Off-the-Diagonal Position B

	Low	Moderate	High
• Demand (Volume)	Low	Moderate	High
• Degree of Customization	High	Moderate	Low
• Number/Range of Products	Low	Many/Multiple	Several
• Type of Good	Custom Make-to-Order	Options Assemble-to-Order	Standardized Make-to-Stock

MARKETING Product Characteristic/Decisions

Becton Dickinson

Becton Dickinson (BD) is the leading producer of needle devices for the medical industry. BD has been an innovator in developing new products to reduce the potential risks of health care workers' accidently sticking themselves with a contaminated needle that might carry HIV or a fatal strain of hepatitis C. As a result, the company needed to convert many of its large and older factories, which had large and inflexible manufacturing systems dedicated to low-cost production to accommodate high-volume production of a larger variety of safe sharp products.

Spring-loaded IV catheters have 12 parts, assembled in an automated process with 48 steps carried out at incredibly fast speeds. Instead of using one long assembly line, BD's Utah plant

uses a production system that makes it relatively easy to modify a product by altering or adding subassembly stations. BD's manufacturing process choice is somewhat off the diagonal of the product-process matrix, producing multiple products in high volumes in more-or-less a continuous flow pattern. This strategy helps the company to continue to hold and grow its market share in a highly competitive industry.

© Paul Burns/Blend Images/Jupiterimages

checking an account balance, and moving money from one account to another.

Some services fall in between these extremes. For example, consider placing a telephone order from a company such as L.L. Bean. The pathway is relatively constrained (that is, provider-routed) as the service representative first acquires the customer's name and address, takes the order and asks questions about colors and sizes, and then processes the credit card payment. However, while placing the order, customers have complete freedom in selecting the sequence in which items are ordered, asking questions, or obtaining additional information.

Designs for customer-routed services require a solid understanding of the features that can excite and delight customers, as well as methods to edu-

> The **service encounter activity sequence** consists of all the process steps and associated service encounters necessary to complete a service transaction and fulfill a customer's wants and needs.

cate customers about the variety of pathways that may exist and how to select and navigate through them.

The service-positioning matrix (SPM), shown in Exhibit 7.3, is roughly analogous to the product-process matrix for manufacturing. The SPM focuses on the service encounter level and helps management design a service system that best meets the technical and behavioral needs of customers. The position along the horizontal axis is described by the sequence of service encounters. The **service encounter activity sequence** *consists of all the process steps and associated service encounters necessary to complete a service transaction and fulfill a customer's wants and needs.* It depends on two things:

1. *The degree of customer discretion, freedom, and decision-making power in selecting the service encounter activity sequence.* Customers may want the opportunity to design their own unique service encounter activity sequence, in any order they choose.

2. *The degree of repeatability of the service encounter activity sequence.* Service encounter repeatability refers to the frequency that a specific service encounter activity sequence is used by customers. Service encounter repeatability provides a measure analogous to product volume for goods-producing firms.

The more unique the service encounter, the less repeatable it is. A high degree of repeatability encourages standardized process and equipment design and dedicated service channels and results in lower costs and improved efficiency. A low degree of repeatability encourages more customization and more flexible equipment and process designs and typically results in higher relative cost per transaction and lower efficiency.

The position along the vertical axis of the SPM reflects the number of pathways built into the service system design by management. That is, the designers or management predefine exactly how many pathways will be possible for the customer to select, ranging from one to an infinite number of pathways.

The SPM is similar to the product-process matrix in that it suggests that the nature of the customer's desired service encounter activity sequence should lead to the most appropriate service system design and that superior performance results by generally staying along the diagonal of the matrix. Like the product-process matrix, organizations that venture too far off the diagonal create a mismatch between service system characteristics and desired activity sequence characteristics. As we move down the diagonal of the SPM, the service encounter activity sequence becomes less unique and more repeatable with fewer pathways. Like the product-process matrix, the midrange portion of the matrix contains a broad range of intermediate design choices.

A **product life cycle** *is a characterization of product growth, maturity, and decline over time.* It is important to understand product life cycles because when goods and services change and mature, so must the processes and value chains that create and deliver them. The traditional product life cycle (PLC) generally consists of four phases—*introduction, growth, maturity, and decline and turnaround.* A product's life cycle has important implications in terms of process design and choice and helps explain the product-process or service-positioning matrix. As

> A **product life cycle** is a characterization of product growth, maturity, and decline over time.

Exhibit 7.3 *The Service Positioning Matrix*

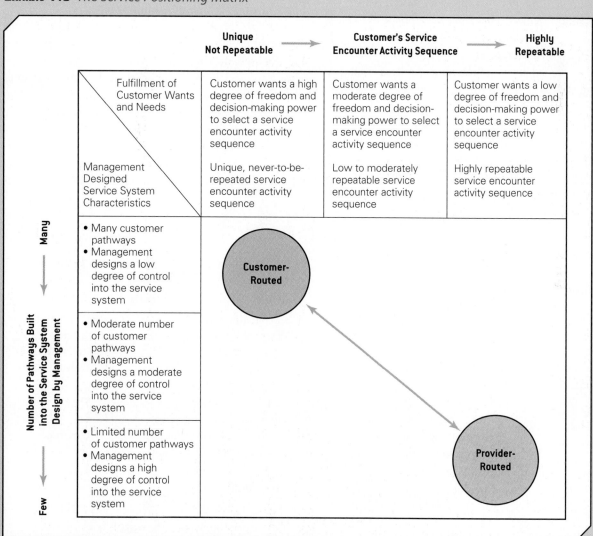

Source: Adapted from D.A. Collier and S.M. Meyer, "A Service Positioning Matrix," *International Journal of Operations and Production Management*, 18, no.12 (1998), pp. 1123–1244. Also see D.A. Collier and S. Meyer, "An Empirical Comparison of Service Matrices," *International Journal of Operations and Production Management*, 20, no. 5–6 (2000), pp. 705–729.

> It is important to understand product life cycles because when goods and services change and mature, so must the processes and value chains that create and deliver them.

goods and services move through different stages of their life cycle, the competitive priorities change, and, of course, the processes need to change. Each phase of the PLC presents operations managers with new challenges and problem structures.

4 Process Design

The goal of process design is to create the right combination of equipment, work methods, and environment to produce and deliver goods and services that satisfy both internal and external customer requirements. Process design can have a significant impact on cost (and hence profitability), flexibility (the ability to produce the right types and amounts of products as customer demand or preferences change), and the quality of the output.

We can think about work at four levels:

1. Task
2. Activity
3. Process
4. Value Chain

A **task** is a specific unit of work required to create an output. Examples are inserting a circuit board into an iPod subassembly or typing the address on an invoice. An **activity** is a group of tasks needed to create and deliver an intermediate or final output. Examples include all the tasks necessary to build an iPod, for example, connecting the battery and assembling the cover pieces; or inputting all the information correctly on an invoice, such as the items ordered, prices, discounts, and so on. A **process** consists of a group of activities, and a **value chain** is a network of processes. Examples of processes would be moving the parts and materials for an iPod to the assembly stations, building the iPod, and packaging the unit and peripherals; or taking a customer order, filling the order, shipping it, and processing the invoice. An example of a value chain might include developing the Web site and video clips for advertising an iPod, purchasing the materials for an iPod, manufacturing and packaging the units, transporting them to warehouses and retail stores, distributing them to customers, and providing customer support, software updates, and so on.

Exhibit 7.4 shows an example for the production of antacid tablets. The value chain shows an aggregate view focused on the *goods-producing processes* (supporting services such as engineering, shipping, accounts payable, advertising, and retailing are not shown). The next level in the hierarchy of work is at the *production process* level where tablets are made. The third level focuses on the *mixing workstation (or work activities)* where the ingredients are unloaded into mixers. The mixer must be set up for each batch and cleaned

Process Design Activities

Designing a goods-producing or service-providing process requires six major activities:

1. Define the purpose and objectives of the process.
2. Create a detailed process or value stream map that describes how the process is currently performed (sometimes called a *current state* or *baseline map*). Of course, if you are designing an entirely new process, this step is skipped.
3. Evaluate alternative process designs. That is, create process or value stream maps (sometimes called *future state maps*) that describe how the process can best achieve customer and organizational objectives.
4. Identify and define appropriate performance measures for the process.
5. Select the appropriate equipment and technology.
6. Develop an implementation plan to introduce the new or revised process design. This includes developing process performance criteria and standards to monitor and control the process.

Exhibit 7.4 *The Hierarchy of Work and Cascading Flowcharts for Antacid Tablets*

for the next batch since many different flavors, such as peppermint, strawberry-banana, cherry, and mandarin orange, are produced using the same mixers. The fourth and final level in the work hierarchy is the *flavoring tasks,* which are defined as three tasks each with specific procedures, standard times per task, and labor requirements. These three tasks could be broken down into even more detail if required.

4.1 Process and Value Stream Mapping

Understanding process design objectives focuses on answering the question: What is the process intended to accomplish? An example process objective might be "to create and deliver the output to the customer in 48 hours." Another key question to consider is: What are the critical customer and organizational requirements that must be achieved?

A **process map (flowchart)** *describes the sequence of all process activities and tasks necessary to create and deliver a desired output or outcome.* It documents how work either is, or should be, accomplished and how the transformation process creates value. We usually first develop a "baseline" map of how the current process operates in order to understand it and identify improvements for redesign.

Process maps delineate the boundaries of a process. *A* **process boundary** *is the beginning*

A **process map (flowchart)** describes the sequence of all process activities and tasks necessary to create and deliver a desired output or outcome.

A **process boundary** is the beginning or end of a process.

or end of a process. The advantages of a clearly defined process boundary are that it makes it easier to obtain senior management support, assign process ownership to individuals or teams, identify key interfaces with internal or external customers, and identify where performance measurements should be taken. Thus, each of the levels in Exhibit 7.4 represents a process map defining different process boundaries.

Typical symbols used for process maps are:

- ■ A rectangle denotes a task or work activity.
- ▲ A triangle indicates waiting.
- ⬭ An oval denotes the "start" or "end" of the process and defines the process boundaries.
- → An arrow denotes movement, transfer, or flow to the next task or activity.
- ⇥ A double-headed arrow denotes an input or arrival into a process.
- ◆ A diamond denotes a decision that might result in taking alternative paths.

One example flowchart is shown in Exhibit 7.5 for an automobile repair process. Process maps clearly delineate the process boundaries.

In service applications, flowcharts generally highlight the points of contact with the customer and are often called *service blueprints* or *service maps*. Such flowcharts often show the separation between the back office and the front office with a "line of customer visibility," such as the one shown in Exhibit 7.5.

Non-value-added activities, such as transferring materials between two nonadjacent workstations, waiting for service, or requiring multiple approvals for a low-cost electronic transaction simply lengthen processing time, increase costs, and, often, increase customer

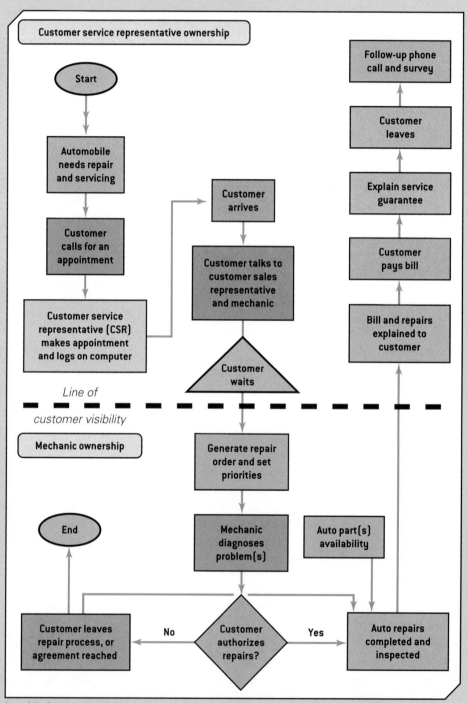

Exhibit 7.5 *Automobile Repair Flowchart*

Source: Collier, David A., *The Service/Quality Solution*, copublished by Irwin Professional Publishing, Burr Ridge, Illinois, and American Society of Quality, ASQ Quality Press, Milwaukee, Wisconsin, 1994, p. 120.

Eliminating non-value-added activities in a process design is one of the most important responsibilities of operations managers.

frustration. Eliminating non-value-added activities in a process design is one of the most important responsibilities of operations managers. This is often accomplished using value stream mapping, a variant of more generic process mapping.

The **value stream** *refers to all value-added activities involved in designing, producing, and delivering goods and*

services to customers. A value stream map (VSM) shows the process flows in a manner similar to an ordinary process map; however, the difference lies in that value stream maps highlight value-added versus non-value-added activities and include costs associated with work activities for both value- and non-value-added activities.

To illustrate this, consider a process map for the order fulfillment process in a restaurant shown in Exhibit 7.6. From the times on the process map, the "service standard" order posting and fulfillment time is an average of 30 minutes per order (5 + 1 + 4 + 12 + 3 + 5). The restaurant's service guarantee requires that if this order posting and fulfillment time is more than 40 minutes, the customer's order is free of charge.

The chef's time is valued at $30 per hour, oven operation at $10 per hour, precooking order waiting time at $5 per hour, and postcooking order waiting time at $60 per hour. The $60 estimate reflects the cost of poor quality for

> The **value stream** refers to all value-added activities involved in designing, producing, and delivering goods and services to customers.

Exhibit 7.6 *Restaurant Order Posting and Fulfillment Process*

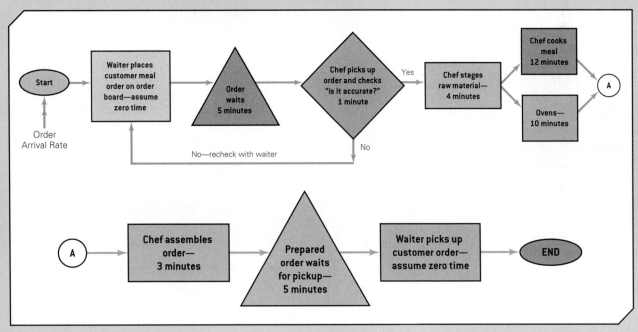

a dinner waiting too long that might be delivered to the customer late (and cold!).

Exhibit 7.7 illustrates a value stream map for the order posting and fulfillment process in Exhibit 7.6. Exhibit 7.7 is one of many formats for value stream mapping. Here, non-value-added time is 33.3 percent (10/30 minutes) of the total order posting and fulfillment time, and non-value-added cost is 31.7 percent ($5.417/$17.087) of total cost. Suppose that a process improvement incorporates wireless technology to transmit food orders to the kitchen and notify the waiter when the order is ready so that the waiting time can be reduced from 10 minutes to 4 minutes on the front and back ends of the process. Hence, the total processing time is reduced from 30 to 24 minutes (a 20 percent improvement). Costs are reduced by $3.25 with a 3-minute wait time reduction on the front and back ends of the process. Therefore, cost per order goes from $17.087 to $13.837 (a 19 percent improvement). Increasing the speed of this part of the restaurant delivery process may also allow for a higher seat turnover during peak demand periods and help to increase total revenue and contribute to profit and overhead.

5 Process Analysis and Improvement

few processes are designed from scratch. Many process design activities involve redesigning an existing process to improve performance. Management strategies to improve process designs usually focus on one or more of the following:

- *increasing revenue* by improving process efficiency in creating goods and services and delivery of the customer benefit package;
- *increasing agility* by improving flexibility and response to changes in demand and customer expectations;

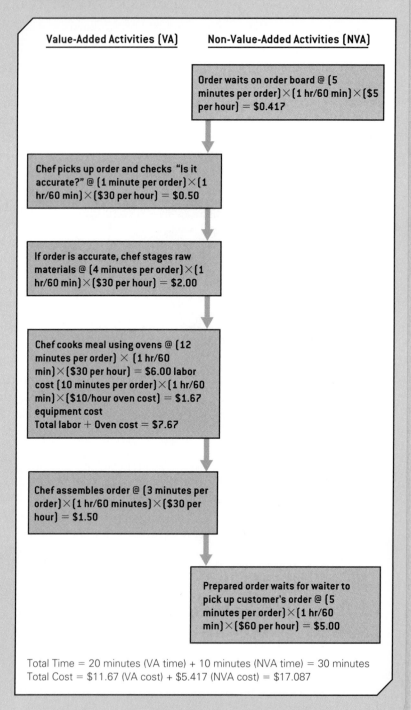

Exhibit 7.7 *Value Stream Map for Restaurant Order Posting and Fulfillment Process*

Value-Added Activities (VA) **Non-Value-Added Activities (NVA)**

Order waits on order board @ (5 minutes per order) × (1 hr/60 min) × ($5 per hour) = $0.417

Chef picks up order and checks "Is it accurate?" @ (1 minute per order) × (1 hr/60 min) × ($30 per hour) = $0.50

If order is accurate, chef stages raw materials @ (4 minutes per order) × (1 hr/60 min) × ($30 per hour) = $2.00

Chef cooks meal using ovens @ (12 minutes per order) × (1 hr/60 min) × ($30 per hour) = $6.00 labor cost (10 minutes per order) × (1 hr/60 min) × ($10/hour oven cost) = $1.67 equipment cost
Total labor + Oven cost = $7.67

Chef assembles order @ (3 minutes per order) × (1 hr/60 minutes) × ($30 per hour) = $1.50

Prepared order waits for waiter to pick up customer's order @ (5 minutes per order) × (1 hr/60 min) × ($60 per hour) = $5.00

Total Time = 20 minutes (VA time) + 10 minutes (NVA time) = 30 minutes
Total Cost = $11.67 (VA cost) + $5.417 (NVA cost) = $17.087

- *increasing product and/or service quality* by reducing defects, mistakes, failures, or service upsets;
- *decreasing costs* through better technology or elimination of non-value-added activities; and

- *decreasing process flow time* by reducing waiting time or speeding up movement through the process and value chain.

Process and value stream maps are the foundation for improvement activities. The baseline process map provides a basis for addressing the following key improvement questions:

- Are the steps in the process arranged in logical sequence?

- Do all steps add value? Can some steps be eliminated and should others be added in order to improve quality or operational performance? Can some be combined? Should some be reordered?

- Are capacities of each step in balance; that is, do bottlenecks exist for which customers will incur excessive waiting time?

- What skills, equipment, and tools are required at each step of the process? Should some steps be automated?

- At which points in the system might errors occur that would result in customer dissatisfaction, and how might these errors be corrected?

- At which point or points should performance be measured?

- Where interaction with the customer occurs, what procedures and guidelines should employees follow that will present a positive image?

Alamo Rent-a-Car and National Car Rental

Alamo Rent-a-Car and National Car Rental are testing a new technology to speed up the return process for rental cars. The device is a small transponder located in the car that records the vehicle's location, mileage, and amount of fuel in the gas tank. Customers can park their vehicle and go—all the necessary information is electronically transmitted to the rental offices. Especially for repeat customers, this technology allows the customer to avoid long lines at rental counters and parking lots. Currently, the vehicle must be within several miles of the return site to transmit car diagnostics, location, and so on. The device cannot track the vehicle away from the rental site. Preliminary tests show the electronic device is more accurate than information recorded by rental car employees, and therefore, reduces human errors. Susan Palazzese, a vice president for system development, said, "This will shave off a significant portion of the return process and enable customers to get in and out a lot faster."[9]

© Oote Boe Photography/Alamy

Process Mapping Improves Pharmacy Service

Metro Health Hospital in Grand Rapids, Michigan, applied process mapping, reducing the lead time for getting the first dose of a medication to a patient in its pharmacy services operations. The lead time was measured from the time an order arrived at the pharmacy to its delivery on the appropriate hospital floor. A process improvement team carefully laid out all the process steps involved and found that it had a 14-stage process with some unnecessary steps, resulting in a total lead time of 166 minutes. During the evaluation process, the pharmacy calculated that technicians were spending 77.4 percent of their time locating products; when a pharmacist needed a technician for clinical activities, the technician was usually off searching for a drug. The team outlined several non-value-added steps in the process, only one of which was out of the pharmacy's control (i.e., the time it took to transport the ordered medication, once filled, to the appropriate floor). Overall, the pharmacy at Metro realized a 33 percent reduction in time to get medications to patients, and reduced the number of process steps from 14 to nine simply by removing non-value-added steps. Patients have experienced a 40 percent reduction in pharmacy-related medication errors, and the severity of those errors has decreased.[8]

Sometimes, processes have gotten so complex that it is easier to start from a "clean sheet" rather than try to improve incrementally. **Reengineering** *has been defined as "the fundamental rethinking and radical redesign of business processes to achieve dramatic improvements in critical, contemporary measures of performance, such as cost, quality, service, and speed."*[10]

Reengineering was spawned by the revolution in information technology and involves

> **Reengineering** has been defined as "the fundamental rethinking and radical redesign of business processes to achieve dramatic improvements in critical, contemporary measures of performance, such as cost, quality, service, and speed."

asking basic questions about business processes: Why do we do it? Why is it done this way? Such questioning often uncovers obsolete, erroneous, or inappropriate assumptions. Radical redesign involves tossing out existing procedures and reinventing the process, not just incrementally improving it. The goal is to achieve quantum leaps in performance. All processes and functional areas participate in reengineering efforts, each requiring knowledge and skills in operations management.

6 Process Design and Resource Utilization

Idle machines, trucks, people, computers, warehouse space, and other resources used in a process simply drain away potential profit. **Utilization** *is the fraction of time a workstation or individual is busy over the long run.* It is difficult to achieve 100 percent utilization. For example, utilization in most job shops ranges from 65 to 90 percent. In flow shops, it might be between 80 to 95 percent, and for most continuous flow processes, above 95 percent. Job shops require frequent machine changeovers and delays, whereas flow shops and continuous flow processes keep equipment more fully utilized. Service facilities have a greater range of resource utilization. Movie theaters, for example, average 5 to 20 percent utilization when seat utilization is computed over the entire week. Similar comments apply to hotels, airlines, and other services.

Two ways of computing resource utilization are

$$\text{Utilization } (U) = \frac{\text{Resources Used}}{\text{Resources Available}} \quad [7.1]$$

$$\text{Utilization } (U) = \frac{\text{Demand Rate}}{[\text{Service Rate} \times \text{Number of Servers}]} \quad [7.2]$$

In equation 7.1, the measurement base (time, units, and so on) must be the same in the numerator and denominator. For a process design to be feasible, the calculated utilization *over the long run* cannot exceed 100 percent. However, over short periods of time, it is quite possible that demand for a resource will exceed its availability. If a manager knows any three of the four variables in equation 7.2, then the fourth can easily be found.

Utilization is the fraction of time a workstation or individual is busy over the long run.

Solved Problem

An inspection station for assembling printers receives 40 printers/hour and has two inspectors, each of whom can inspect 30 printers per hour. What is the utilization of the inspectors? What service rate would be required to have a target utilization of 85 percent?

Solution:

The utilization at this inspection station is calculated to be

Utilization = 40/(2 × 30) = 67 percent.

If the utilization rate is 85 percent, we can calculate the target service rate (SR) by solving equation 7.2:

$$85\% = 40/(2 \times SR)$$
$$1.7 \times SR = 40$$
$$SR = 23.5 \text{ printers/hour}$$

Equations 7.1 and 7.2 can provide useful insight for evaluating alternative process designs. Exhibit 7.8 provides an analysis of the utilization of the restaurant order posting and fulfillment process in Exhibit 7.6. Using equation 7.2, the resource utilization for work activity #3, assuming only one chef and two ovens, is computed as:

(20 orders/hour)/[(5 orders/hour)(1 chef)] = 400 percent

As we noted earlier, whenever the utilization is calculated to be greater than 100 percent, the work will endlessly pile up before the workstation. Therefore, this is clearly a poor process design and we need to add more resources.

A logical question to consider is how many chefs are needed to bring the utilization down below 100 percent at work activity #3? Because the chef is the most skilled and highest paid employee, it would make sense to design the process so that the chef would have the highest labor utilization rate (although 100 percent would probably not be practical). This can be found by solving the equation:

Exhibit 7.8 *Utilization Analysis of Restaurant Order Posting and Fulfillment Process*

	Work Activity #1 (Chef decides if order is accurate)	Work Activity #2 (Chef stages raw materials)	Work Activity #3 (Chef prepares side dishes)	Work Activity #4 (Oven operation)	Work Activity #5 (Chef assembles order)
Order arrival rate (given)	20 orders/hr	20 orders/hr	20 orders/hr	20 orders/hr	20 orders/hr
Time per order	1 minute	4 minutes	12 minutes	10 minutes	3 minutes
Number of resources	1 chef	1 chef	1 chef	2 ovens	1 chef
Output per time period	60 orders/hr	15 orders/hr	5 orders/hr	12 orders/hr	20 orders/hr
Resource utilization with 1 chef and 2 ovens	33%	133%	400%	167%	100%

$(20 \text{ orders/hour})/[(5 \text{ orders/hour}) \times (X \text{ chefs})] = 1.00$

$(5 \text{ orders/hour}) \times 1.00 \times X = 20 \text{ orders/hour},$

or $X = 4.00$ chefs

With four chefs, the resource utilizations are recomputed in Exhibit 7.9. We see that the oven is still a problem, with a calculated 167 percent utilization. To determine how many ovens to have for a 100 percent utilization, we solve the equation:

$(20 \text{ orders/hour})/[(6 \text{ orders/hour}) \times (Y \text{ ovens})] = 1.00$

$(6 \text{ orders/hour}) \times 1.00 \times Y = 20 \text{ orders/hour},$

or $Y = 3.33$ ovens

Rounding this up to 4, actual oven utilization would now be 83 percent (see Exhibit 7.10 for the final results).

Exhibit 7.11 shows a simplified flowchart of the order fulfillment process along with the output rates from Exhibit 7.10 that can be achieved for each

Exhibit 7.9 *Revised Utilization Analysis of Restaurant Order Posting and Fulfillment Process (4 chefs)*

	Work Activity #1 (Chef decides if order is accurate)	Work Activity #2 (Chef stages raw materials)	Work Activity #3 (Chef prepares side dishes)	Work Activity #4 (Oven operation)	Work Activity #5 (Chef assembles order)
Resource utilization with 4 chefs and 2 ovens	8.33%	33%	100%	167%	25%

Exhibit 7.10 *Revised Utilization Analysis of Restaurant Order Posting and Fulfillment Process (4 ovens)*

	Work Activity #1 (Chef decides if order is accurate)	Work Activity #2 (Chef stages raw materials)	Work Activity #3 (Chef prepares side dishes)	Work Activity #4 (Oven operation)	Work Activity #5 (Chef assembles order)
Order arrival rate (given)	20 orders/hr	20 orders/hr	20 orders/hr	20 orders/hr	20 orders/hr
Time per order	1 minute	4 minutes	12 minutes	10 minutes	3 minutes
Number of resources	4 chefs	4 chefs	4 chefs	4 ovens	4 chefs
Output per time period	240 orders/hr	60 orders/hr	20 orders/hr	24 orders/hr	80 orders/hr
Resource utilization with 4 chefs and 4 ovens	8.33%	33%	100%	83%	25%

work activity. *The average number of entities completed per unit time—the output rate—from a process is called* **throughput**. Throughput might be measured as parts per day, transactions per minute, or customers per hour, depending on the context. A logical question to consider is what throughput can be achieved for the entire process. Like the weakest link of a chain, the process in Exhibit 7.11 can never produce more than 20 orders/hour—the output rate of Work Activity #3!

A **bottleneck** *is the work activity that effectively limits throughput of the entire process.* Identifying and breaking process bottlenecks is an important part of process design and will increase the speed of the process, reduce waiting and work-in-process inventory, and use resources more efficiently.

6.1 Little's Law

At any moment of time, people, orders, jobs, documents, money, and other entities that flow through processes are in various stages of completion and may be waiting in queues. **Flow time**, *or* **cycle time**, *is the average time it takes to complete one cycle of a process.* It makes sense that the flow time will depend not only on the actual time to perform the tasks required but also on how many other entities are in the "work-in-process" stage.

Little's Law is a simple formula that explains the relationship among flow time (T), throughput (R), and work-in-process (WIP)[11]

$$\text{Work-in-process} = \text{Throughput} \times \text{Flow time}$$

or

$$WIP = R \times T \qquad [7.3]$$

Little's Law provides a simple way of evaluating average process performance. If we know any two of the three variables, we can compute the third using Little's Law. Little's Law can be applied to many different types of manufacturing and service operations. (See the accompanying solved problems.)

It is important to understand that Little's Law is based on simple averages for all variables. Such an analysis serves as a good baseline for understanding process performance on an aggregate basis, but it does not take into account any randomness in arrivals or service times or different probability distributions.

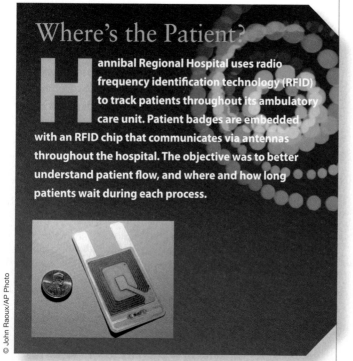

Where's the Patient?

Hannibal Regional Hospital uses radio frequency identification technology (RFID) to track patients throughout its ambulatory care unit. Patient badges are embedded with an RFID chip that communicates via antennas throughout the hospital. The objective was to better understand patient flow, and where and how long patients wait during each process.

© John Raoux/AP Photo

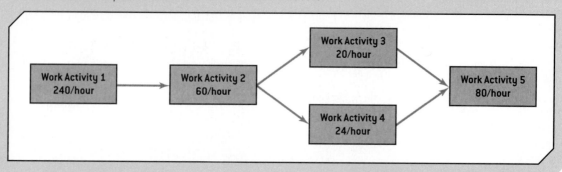

Exhibit 7.11 *Simplified Restaurant Fulfillment Process*

Work Activity 1 240/hour → Work Activity 2 60/hour → Work Activity 3 20/hour → Work Activity 5 80/hour

Work Activity 2 60/hour → Work Activity 4 24/hour → Work Activity 5 80/hour

Solved Problems Using Little's Law

1. Suppose that a voting facility processes an average of 50 people per hour and that, on average, it takes 10 minutes for each person to complete the voting process. Using equation 7.3, we can compute the average number of voters in process:

$$WIP = R \times T$$

$$= 50 \text{ voters/hr} \times (10 \text{ minutes/60 minutes per hour})$$

$$= 8.33 \text{ voters}$$

Therefore, on average, we would expect to find about 8 or 9 voters inside the facility.

2. Suppose that the loan department of a bank takes an average of 6 days (0.2 months) to process an application and that an internal audit found that about 100 applications are in various stages of processing at any one time. Using Little's Law, we see that $T = 0.2$ and $WIP = 100$. Therefore, we can calculate the throughput of the department as:

$$R = WIP/T = 100 \text{ applications}/0.2 \text{ months}$$

$$= 500 \text{ applications per month}$$

3. Suppose that a restaurant makes 400 pizzas per week, each of which uses one-half pound of dough, and that it typically maintains an inventory of 70 pounds of dough. In this case, $R = 200$ pounds per week of dough and $WIP = 70$ pounds. Using Little's Law, we can compute the average flow time as:

$$T = WIP/R = 70/200$$

$$= 0.35 \text{ weeks, or about } 2\frac{1}{2} \text{ days.}$$

This information can be used to verify the freshness of the dough.

Problems, Activities, and Discussions

1. What type of process—project, job shop, flow shop, and continuous flow—would most likely be used to produce the following?

 a. Air conditioners

 b. Weddings

 c. Paper

 d. Many flavors of ice cream

2. Draw a flowchart for a process of interest to you, such as a quick oil-change service, a factory process you might have worked in, ordering a pizza, renting a car or truck, buying products on the Internet, or applying for an automobile loan. Identify the points where something (people, information) waits for service or is held in work-in-process inventory, the estimated time to accomplish each activity in the process, and the total flow time. Evaluate how well the process worked and what might be done to improve it.

3. Design a process for the following activities:

 a. Preparing for an exam

 b. Writing a term paper

 c. Planning a vacation

4. A telephone call center uses two customer service representatives (CSRs) during the 8:30 a.m. to 9:00 a.m. time period. The standard service rate is 3.0 minutes per telephone call per CSR. Assuming a target labor utilization rate of 80 percent, how many calls can these three CSRs handle during this half-hour period?

5. What is the implied service rate at a bank teller window if customer demand is 27 customers per hour, two bank tellers are on duty, and their labor utilization is 90 percent?

6. An accounts receivable manager processes 300 checks per day with an average processing time of 20 working days. What is the average number of accounts receivable checks being processed in her office? What if through information technology she reduces the processing time from 20 days to 5 days? What are the advantages and disadvantages of adopting this technology? Explain.

7. A manufacturer's average work-in-process inventory for Part #2934 is 1,000 parts. The workstation produces parts at the rate of 200 parts per day. What is the average time a part spends in this workstation?

8. The Wilcox Student Health Center has just implemented a new computer system and service process to "improve efficiency." As pharmacy manager, you are concerned about waiting time and its potential

impact on college students who "get no respect." All prescriptions (Rxs) go through the following process:

Assume that students arrive to drop-off Rxs at a steady rate of two Rxs per minute, with an average of one Rx per student. The average number of students in process (assume waiting and being serviced) at each station is:

DROP-OFF—five students

PICK-UP—three students

PAY CASHIER—six students

The fill Rx station typically has 40 Rxs in process and waiting on average. Because of this perceived long wait, 95 percent of the students decide to come back later for pick-up. They come back an average of three hours later. If the students choose to stay, each name is called as soon as the Rx is filled and the student then enters the pick-up line. Assume that the system is operating at a steady state.

a. Draw a process map for the entire process. Be sure to include flow paths for students (solid lines) and prescriptions (dashed lines). You must follow the people and information (Rxs) to answer this question correctly.

b. What is the average time a student spends in the pharmacy if he or she stays to pick up the Rx?

c. How many minutes does the student spend in the pharmacy if he or she picks up the Rx three hours later (i.e., the student goes home after dropping the Rx off)?

d. What is the average time in minutes that all students spend in the pharmacy?

e. What is the average time in minutes that the Rx spends in the process? Count time from entering the drop-off line to completing payment.

9. Paris Health Clinic, located in a large city, sees patients on a walk-in basis only. On average, 10 patients per hour enter the clinic. All patients register at the registration window with a registration clerk (RC), which takes 3 minutes. After registration, but before being seen by a nurse practitioner (NP), the registration records clerk (RRC) pulls the patient's records from the records room, which takes 6 minutes. At his or her turn, each patient then sees a NP, who checks weight, temperature, and blood pressure. This work activity takes 5 minutes. The NP determines if the patient must see a doctor (MD) or can be handled by a Physician's Assistant (PA). There is one MD, one PA, one NP, one RRC, one BC, and one RC in the system at the current time.

The NP sends 40 percent of the patients to the PA and 60 percent to the MD. The PA takes on average 6 minutes per patient whereas the MD takes 15 minutes. After the patient sees the PA and/or MD, the patient pays the bill or processes insurance information with the billing clerk (BC), which takes 5 minutes per patient. Then the patient exits the process.

a. Draw a process flow diagram, label everything, and place the times and percentages given in the problem on the diagram.

b. What is the throughput in patients per hour of each stage in the process?

c. What are the labor utilization rates for the MD, NP, PA, BC, RRC, and RC? Are these values appropriate? If not, how might you redesign the process? Where is the bottleneck?

d. The PA often discovers the patient should see a MD so the patient is sent to the MD after seeing the PA 50 percent of the time. How does this change affect your answers to the preceding questions?

10. A manufacturer of air conditioner compressors is concerned that too much money is tied up in its value chain. Average raw material inventory is $50 million and work-in-process (WIP) production inventory is $20 million. Sales are $20 million per week and finished goods inventory averages $30 million. The average outstanding accounts receivable is $60 million. Assume 50 weeks in one year. The value chain is shown below:

Raw Material Inventory → Production (WIP) Inventory → Finished Goods → Accounts Receivable

(a) What is the flow unit in this system?

(b) What is the total flow time of a throughput dollar?

(c) What is the average dollar inventory in the value chain?

(d) Which of the major stages—raw materials, WIP, finished goods or accounts receivable—is the best candidate for freeing up dollars for the air conditioner manufacturer?

(e) What is the target level of average accounts receivable inventory if management can reduce the time a dollar spends in accounts receivable inventory (processing and collections) by one-half by improving the accounts receivable process?

(f) What else does this flow time analysis problem demonstrate?

Gifford Hospital Pharmacy Case Study

Gifford Hospital is trying to reduce costs yet improve patient and medical services. A hospital pharmacy uses two types of medications—fluids such as intravenous liquids and pharmaceuticals such as pills. The pharmacy buys drugs in bulk containers and bottles and dispenses them in smaller unit-dose amounts based on doctor's orders. The objective of the pharmacy is to "get the right drug in the right amount to the right patient at the right time." The consequences of errors in this process ranged from no visible effects on patient health to allergic reactions, or in the extreme case, to death of the patient. National studies on hospital pharmacies found error rates ranging from .01 percent (0.0001) to 15 percent (0.15).

© Polka Dot Images/Jupiterimages

The hospital pharmacy process at Gifford Hospital includes seven major steps:

Step 1—Receive the doctor's patient medication order via a written prescription, over the telephone, or through the hospital Internet system. This step averages 0.2 minutes per prescription and could be done by the medical technician or a legally registered pharmacist.

Step 2—Verify and validate the order through whatever means necessary. For example, if the handwriting was not legible, the doctor must be contacted to verify the medical prescription. Only a registered pharmacist can do this step, which takes from 1 to 10 minutes depending on the nature of the prescription and checking out potential problems. Since only 10 percent of prescriptions require extensive verification, the weighted average time for this step is 1.9 minutes [.9 × (1 minute) + .1 × (10 minutes)].

Step 3—Determine if duplicate prescriptions exist, and check the patient's allergic reaction history and current medications. This work activity averages 1.4 minutes using the hospital pharmacy's computer system. Only a registered pharmacist can perform this step.

Step 4—Establish that the drug(s) are in stock, have not expired, and are available in the requested form and quantity. Only a registered pharmacist can perform this step and it takes 1 minute.

Step 5—Prepare the prescription, including the label, and attach the proper labels to the proper bottles. Only a registered pharmacist can do this work activity and it averages 4.5 minutes.

Step 6—Store the prescription in the proper place for pick-up and delivery to the patient. Only a registered pharmacist can do this step and it takes 1 minute.

Step 7—Prepare all charges, write notes or comments if needed, and close the patient's pharmacy record in the pharmacy computer system. This step takes 2 minutes and may be done by a registered pharmacist but the law does not require it.

Currently, the pharmacist performs steps 2 to 7 for each patient's prescription. Two medical technicians are on duty at all times to receive the prescriptions, answer the telephone, receive supplies and stock shelves, deliver prescriptions through the service window, and interact with nurses and doctors as they visit the pharmacy service window. You have been called in as a consultant to improve the process and begin by considering the following case questions.

Case Questions for Discussion

1. Draw the process flowchart, including processing times and capacities for each work activity.

2. As a baseline measure, what is the labor utilization if 32 prescriptions arrive between 8 a.m. and 9 a.m. on Monday and five pharmacists are on duty?

3. Clearly identify one alternative process design, and discuss the advantages and disadvantages of it. Also, consider how you will design the jobs for medical technicians and pharmacists.

4. What are your final recommendations?

FACILITY AND WORK DESIGN

professor Frey had just taken his operations management class on a tour of the Honda automobile plant in Marysville, Ohio. During the tour, the students had a chance to see how the facility design helped to improve the efficiency of the assembly processes for the automobiles and motorcycles it manufactures. The students were also very impressed with the level of teamwork among the employees. In the following class debriefing, Steve stated that he didn't realize how important the design of the facility was in promoting teamwork and assuring quality. Arun couldn't believe that they could produce so many different models in any order on the same assembly lines. Kate observed that the entire facility shows an image of safety, efficiency, professionalism, cleanliness, quality, and excitement. "In the factory, everything has its correct place. The workers know where everything is. The facility is spotless, a lot different from my dad's machine shop." Without hesitation she said, "Wow, I think I'll buy a Honda!"

© Muntz/Taxi/Getty Images

What do **you** think?

Think of a facility in which you have conducted business–for instance, a restaurant, bank, or automobile dealership. How did the physical environment and layout enhance or degrade your customer experience?

learning outcomes

After studying this chapter you should be able to:

LO1 Describe four layout patterns and when they should be used.

LO2 Explain how to design product layouts using assembly line balancing.

LO3 Explain the concepts of process layout.

LO4 Describe issues related to workplace design.

LO5 Describe the human issues related to workplace design.

A poorly designed facility can lock management into a noncompetitive situation, and be very costly to correct.

Once processes are selected and designed, organizations must design the infrastructure to implement these processes. This is accomplished through the design of the physical facilities and work tasks that must be performed. The physical design of a factory needs to support operations as efficiently as possible, as we can see in the example about Honda. Facility and work design are important elements of an organization's infrastructure and key strategic decisions that affect cost, productivity, responsiveness, and agility.

In both goods-producing and service-providing organizations, facility layout and work design influence the ability to meet customer wants and needs, and provide value. A poorly designed facility can lock management into a noncompetitive situation, and be very costly to correct. For many service organizations, the physical facility is a vital part of service design. It can also play a significant role in creating a satisfying customer experience, particularly when customer contact is high.

© Kin Cheung/Reuters/Landov

1 Facility Layout

© Joel Page/AP Photo

facility layout *refers to the specific arrangement of physical facilities.* Facility-layout studies are necessary whenever (1) a new facility is constructed; (2) there is a significant change in demand or throughput volume; (3) a new good or service is introduced to the customer benefit package; or (4) different processes, equipment, and/or technology are installed. Layout studies should include a thorough evaluation of material handling capabilities, such as the use of conveyors, cranes, fork lifts, and automated guided vehicles.

A good layout should support the ability of operations to accomplish its mission.

The purposes of layout studies are to minimize delays in materials handling and customer movement, maintain flexibility, use labor and space effectively, promote high employee morale and customer satisfaction, provide for good housekeeping and maintenance, and enhance sales as appropriate in manufacturing and service facilities. Essentially, a good layout should support the ability of operations to accomplish its mission.

Four major layout patterns are commonly used in designing building and processes: product layout, process layout, cellular layout, and fixed-position layout.

1.1 Product Layout

A **product layout** *is an arrangement based on the sequence of operations that is performed during the manufacturing of a good or delivery of a service.* Product layouts

support a smooth and logical flow where all goods or services move in a continuous path from one process stage to the next using the same sequence of work tasks and activities. One industry that uses a product-layout pattern is the winemaking industry (see Exhibit 8.1). Other examples include credit-card processing, Subway sandwich shops, paper manufacturers, insurance policy processing, and automobile assembly lines.

Advantages of product layouts include lower work-in-process inventories, shorter processing times, less material handling, lower labor skills, and simple planning and control systems. However, several disadvantages are associated with product layouts. For instance, a breakdown of one piece of equipment can cause the entire process to shut down. In addition, since the layout is determined by the good or service, a change in product design or the introduction of new products may require major changes in the layout; thus flexibility can be limited. Therefore, product layouts are less flexible and expensive to change. Finally, and perhaps most important, the jobs in a product-layout facility, such as those on a mass-

Facility layout refers to the specific arrangement of physical facilities.

A **product layout** is an arrangement based on the sequence of operations that is performed during the manufacturing of a good or delivery of a service.

Exhibit 8.1 *Product Layout for Wine Manufacturer*

Product 1 · Mixing · Aging · Bottling · Capping · Packaging · Shipping · Product 2

production line, may provide little job satisfaction. This is primarily because of the high level of division of labor often required, which usually results in monotony.

1.2 Process Layout

*A **process layout** consists of a functional grouping of equipment or activities that do similar work.* For example, all drill presses or fax machines may be grouped together in one department and all milling or data entry machines in another. Depending on the processing they require, tasks may be moved in different sequences among departments (see Exhibit 8.2). Job shops are an example of firms that use process layouts to provide flexibility in the products that can be made and the utilization of equipment and labor. Legal offices, shoe manufacturing, jet engine turbine blades, and hospitals use a process layout.

Compared to product layouts, process layouts generally require a lower investment in equipment. In addition, the equipment in a process layout is normally more general purpose, while in a product layout it is more specialized. Also, the diversity of jobs inherent in a process layout can lead to increased worker satisfaction. Some of the limitations of process layouts are:

- high movement and transportation costs;
- more complicated planning and control systems;
- longer total processing time and higher worker-skill requirements.

1.3 Cellular Layout

*In a **cellular layout**, the design is not according to the functional characteristics of equipment, but rather by self-contained groups of equipment (called cells) needed for producing a particular set of goods or services.* The cellular concept was developed at the Toyota Motor Company.

An example of a manufacturing cell is shown in Exhibit 8.3. In this exhibit we see a U-shaped arrangement of machines that is typical of cellular manufacturing. The cell looks similar to a product layout, but operates differently. Within the cell, materials move clockwise or counter-clockwise from one machine to the next. The cell is designed to operate with one, two, or three employees, depending on the needed output during the day (the second figure in Exhibit 8.3 shows how two operators might be assigned to machines). Each of the machines is single-cycle automatic, so the operators unload, check the parts, load another part, and press the start button. They pass the work along to the next worker using decoupler elements placed between the machines.

Cellular layouts facilitate the processing of families of parts with similar processing requirements. The procedure of classifying parts into such families is called *group technology*. Services also group work analogous to manufacturers such as legal (labor law, bankruptcy, divorce, etc.) or medical specialties (maternity, oncology, surgery, etc.).

Because the workflow is standardized and centrally located in a cellular layout, materials-handling requirements are reduced, enabling workers to concentrate on production rather than on moving parts between machines. Quicker response to quality problems within cells can improve the overall level of quality. Since machines are closely linked within a cell, additional floor space becomes available for other productive uses. Because workers have greater responsibility in a cellular manufacturing system, they become more aware of

Exhibit 8.2 *Process Layout for a Machine Shop*

A **process layout** consists of a functional grouping of equipment or activities that do similar work.

In a **cellular layout**, the design is not according to the functional characteristics of equipment, but rather by self-contained groups of equipment (called cells) needed for producing a particular set of goods or services.

Exhibit 8.3 *Cellular Manufacturing Layout*

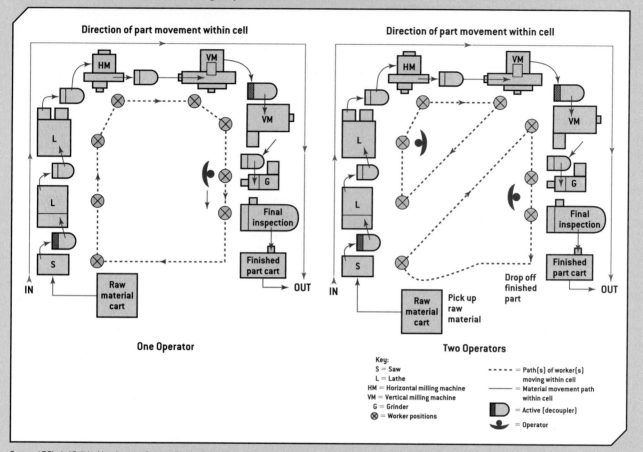

Direction of part movement within cell

One Operator

Direction of part movement within cell

Two Operators

Pick up raw material

Drop off finished part

Key:
S = Saw
L = Lathe
HM = Horizontal milling machine
VM = Vertical milling machine
G = Grinder
⊗ = Worker positions

- - - - = Path(s) of worker(s) moving within cell
——— = Material movement path within cell
= Active (decoupler)
= Operator

Source: J.T.Black, "Cellular Manufacturing Systems Reduce Set Up Time, Make Small-Lot Production Economical," *Industrial Engineering Magazine*, Nov. 1983. Used with permission from the author.

their contribution to the final product; this increases their morale and satisfaction and ultimately, quality and productivity.

1.4 Fixed-Position Layout

A **fixed-position layout** *consolidates the resources necessary to manufacture a good or deliver a service, such as people, materials, and equipment, in one physical location.* Rather than moving work-in process from one work center to another, it remains stationary. The production of large items such as heavy machine tools, airplanes, buildings, locomotives, and ships is usually accomplished in a fixed-position layout. This fixed-position layout is synonymous with the "project"

A **fixed-position layout** consolidates the resources necessary to manufacture a good or deliver a service, such as people, materials, and equipment, in one physical location.

© Ted S. Warren/AP Photo

Service organizations use product, process, cellular, and fixed-position layouts to organize different types of work.

classification of processes. Service-providing firms also use fixed-position layouts; examples include major hardware and software installations, sporting events, and concerts.

Exhibit 8.4 summarizes the relative features of product, process, cellular, and fixed-position layouts. It is clear that the basic trade-off in selecting among these layout types is flexibility versus productivity.

1.5 Facility Layout in Service Organizations

Service organizations use product, process, cellular, and fixed-position layouts to organize different types of work. For example, looking back at Exhibit 6.10, which shows the typical LensCrafters facility layout, we see the customer-contact area is arranged in a process layout. In the lab area, however, where lenses are manufactured, a cellular layout is used.

In service organizations, the basic trade-off between product and process layouts concerns the degree of specialization versus flexibility. Services must consider the volume of demand, range of the types of services offered, degree of personalization of the service, skills

Rockwell International

A cellular layout design at Rockwell reduced throughput time by almost 90 percent. Before the cellular approach was implemented at Rockwell's Dallas plant, it took a typical part 23 moves and 17.2 weeks to flow through the fabrication shop prior to assembly. This long lead time forced planners to forecast part requirements and thus created large amounts of in-process inventory. By reviewing all part designs, tooling, and fabrication methods through a group-technology part-family analysis, a cell was created that allowed parts to be made with only 9 moves in 2.2 weeks. The impact on cost was substantial, but the major impact was on planning. The planner did not have to predict parts requirements; instead, it was possible to make parts in the fabrication shop fast enough so assembly could be supported without inventory buildup.[1]

of employees, and cost. Those that need the ability to provide a wide variety of services to customers with differing requirements usually use a process layout. For example, libraries place reference materials, serials, and microfilms into separate areas; hospitals group services by function also, such as maternity, oncology, surgery, and X-ray; and insurance companies have office layouts in which claims, underwriting, and filing are individual departments.

Exhibit 8.4 *Comparison of Basic Layout Patterns*

Characteristic	Product Layout	Process Layout	Cellular Layout	Fixed-Position Layout
Demand volume	High	Low	Moderate	Very low
Equipment utilization	High	Low	High	Moderate
Automation potential	High	Moderate	High	Moderate
Setup/changover requirements	High	Moderate	Low	High
Flexibility	Low	High	Moderate	Moderate
Type of equipment	Highly specialized	General purpose	Moderate specialization	Moderate specialization

Service organizations that provide highly standardized services tend to use product layouts. For example, Exhibit 8.5 shows the layout of the kitchen at a small pizza restaurant that has both dine-in and delivery.

The design of service facilities requires the clever integration of layout with the servicescape and process design to support service encounters. At Victoria's Secret, the layout of a typical store is defined by different zones, each with a certain type of apparel such as women's sleepwear, intimate apparel, and personal-care products. Display case placement in the store is carefully planned. A companion store, Victoria's Secret Perfume, which specializes in fragrances, color cosmetics, skincare, and personal accessories, is often placed next to and connected to a Victoria's Secret store to increase traffic and sales in both stores.

Exhibit 8.6. Such product layouts, however, can suffer from two sources of delay: flow-blocking delay, and lack-of-work delay. **Flow-blocking delay** *occurs when a work center completes a unit but cannot release it because the in-process storage at the next stage is full. The worker must remain idle until storage space becomes available.* **Lack-of-work delay** *occurs whenever one stage completes work and no units from the previous stage are awaiting processing.*

These sources of delay can be minimized by attempting to "balance" the process by designing the appropriate level of capacity at each workstation. This is often done by adding additional workstations in parallel. Product layouts might have workstations in series, in parallel, or in a combination of both. Thus, many different configurations of workstations and buffers are possible, and it is a challenge to design the right one.

2 Designing Product Layouts

product layouts in flow shops generally consist of a fixed sequence of workstations. Workstations are generally separated by buffers (queues of work-in-process) to store work waiting for processing, and are often linked by gravity conveyors (which cause parts to simply roll to the end and stop) to allow easy transfer of work. An example is shown in

Flow-blocking delay
occurs when a work center completes a unit but cannot release it because the in-process storage at the next stage is full.

Lack-of-work delay
occurs whenever one stage completes work and no units from the previous stage are awaiting processing.

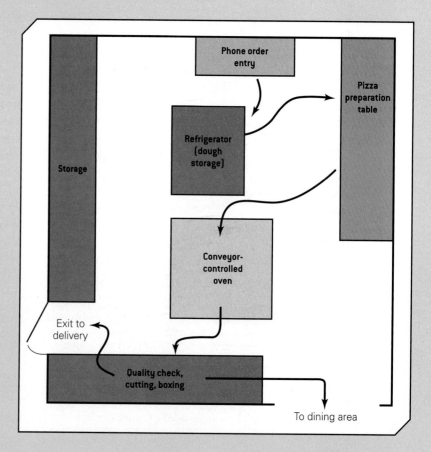

Exhibit 8.5 *Product Layout for a Pizza Kitchen*

Phone order entry

Storage

Refrigerator (dough storage)

Pizza preparation table

Conveyor-controlled oven

Exit to delivery

Quality check, cutting, boxing

To dining area

Exhibit 8.6 *A Typical Manufacturing Workstation Layout*

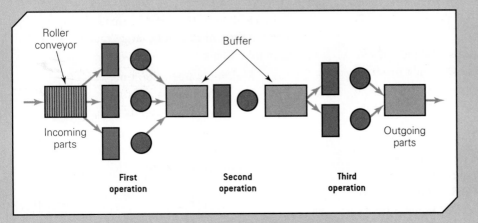

Roller conveyor

Buffer

Incoming parts

Outgoing parts

First operation

Second operation

Third operation

among workstations while trying to achieve a desired output rate. A good balance results in achieving throughput necessary to meet sales commitments and minimize the cost of operations. Typically, one either minimizes the number of workstations for a given production rate or maximizes the production rate for a given number of workstations.

To begin, we need to know three types of information:

1. the set of tasks to be performed and the time required to perform each task,
2. the precedence relations among the tasks—that is, the sequence in which tasks must be performed, and
3. the desired output rate or forecast of demand for the assembly line.

The first two can be obtained from an analysis of the design specifications of a good or service. The third is primarily a management policy issue, because management must decide whether to produce exactly to the forecast, overproduce and hold inventory, subcontract, and so on.

An important type of product layout is an assembly line. *An assembly line is a product layout dedicated to combining the components of a good or service that has been created previously.* Assembly lines were pioneered by Henry Ford and are vital to economic prosperity and are the backbone of many industries such as automobiles and appliances; their efficiencies lower costs and make goods and services affordable to mass markets. Assembly lines are also important in many service operations such as processing laundry, insurance policies, mail, and financial transactions.

2.1 Assembly Line Balancing

The sequence of tasks required to assemble a product is generally dictated by its physical design. Clearly, you cannot put the cap on a ballpoint pen until the ink refill has been inserted. However, for many assemblies that consist of a large number of tasks, there are a large number of ways to group tasks together into individual workstations while still ensuring the proper sequence of work. **Assembly line balancing** *is a technique to group tasks among workstations so that each workstation has—in the ideal case—the same amount of work.* For example, if it took 90 seconds per unit to assemble an alarm clock and the work was divided evenly among three workstations, then each workstation would be assigned 30 seconds of work content per unit. Here, there is no idle time per workstation and the output of the first workstation immediately becomes the input to the next workstation. Technically, there is no bottleneck workstation and the flow of clocks through the assembly line is constant and continuous. In reality, this is seldom possible, so the objective is to minimize the imbalance

To illustrate the issues associated with assembly line balancing, let us consider an activity consisting of three tasks as shown in Exhibit 8.7. Task A is first, takes 0.5 minute, and must be completed before task B can be performed. After task B, which

An **assembly line** is a product layout dedicated to combining the components of a good or service that has been created previously.

Assembly line balancing is a technique to group tasks among workstations so that each workstation has—in the ideal case—the same amount of work.

Exhibit 8.7 *A Three-Task Assembly Line*

Operation time (minutes/part)

.5 .3 .2
A → B → C

takes 0.3 minute, is finished, task C can be performed; it takes 0.2 minute. Since all three tasks must be performed to complete one part, the total time required to complete one part is .5 + .3 + .2 = 1.0 minute.

Suppose that one worker performs all three tasks in sequence. In an eight-hour day, he or she could produce (1 part/1.0 min)(60 minutes per hour)(8 hours per day) = 480 parts/day. Hence, the capacity of the process is 480 parts/day.

Alternatively, suppose that three workers are assigned to the line, each performing one of the three tasks. The first operator can produce 120 parts per hour, since his or her task time is 0.5 minute. Thus, a total of (1 part/0.5 min)(60 minutes per hour)(8 hours per day) = 960 parts/day could be sent to operator 2. Since the time operator 2 needs for his or her operation is only 0.3 minute, he or she could produce (1 part/0.3 min)(60 minutes per hour)(8 hours per day) = 1,600 parts/day. However, operator 2 cannot do so because the first operator has a lower production rate. The second operator will be idle some of the time waiting on components to arrive. Even though the third operator can produce (1 part/0.2 min)(60 minutes per hour) (8 hours per day) = 2,400 parts/day, we see that the maximum output of this three-operator assembly line is 960 parts per day. That is, workstation 1 performing task A is the bottleneck in the process.

A third alternative is to use two workstations. The first operator could perform operation A while the second performs operations B and C. Since each operator needs 0.5 minute to perform the assigned duties, the line is in perfect balance, and 960 parts per day can be produced. We can achieve the same output rate with two operators as we can with three, thus saving labor costs. How you group work tasks and activities into workstations is important in terms of process capacity (throughput), cost, and time to do the work.

An important concept in assembly line balancing is the cycle time. **Cycle time** *is the interval between successive outputs coming off the assembly line.* These could be manufactured goods or service-related outcomes. In the three-operation example shown in Exhibit 8.7, if we use only one workstation, the cycle time is 1 minute/unit; that is, one completed assembly is produced every minute. If two workstations are used, as just described, the cycle time is 0.5 minute/unit. Finally, if three workstations are used, the cycle time is still 0.5 minute/unit,

Cycle time is the interval between successive outputs coming off the assembly line.

because task A is the bottleneck, or slowest operation. The line can produce only one assembly every 0.5 minute.

The cycle time (CT) cannot be smaller than the largest operation time, nor can it be larger than the sum of all operation times. Thus,

$$\text{Maximum operation time} \leq CT$$
$$\leq \text{Sum of operation times} \qquad [8.1]$$

This provides a range of feasible cycle times. In the example, CT must be between 0.5 and 1.0.

Cycle time is related to the output required to be produced in some period of time (R) by the following equation:

$$CT = A/R \qquad [8.2]$$

where A = available time to produce the output. R is normally the demand forecast. Thus, if we specify a required output (demand forecast), we can calculate the maximum cycle time needed to achieve it. Note that if the required cycle time is smaller than the largest task time, then the work content must be redefined by splitting some tasks into smaller elements.

For a given cycle time, we may also compute the theoretical minimum number of workstations required:

Minimum number of workstations required
= Sum of task times/Cycle time = $\Sigma t/CT$ [8.3]

When this number is a fraction, the theoretical minimum number of workstations should be rounded up to the next highest integer number. For example, for a cycle time of 0.5, we would need at least 1.0/0.5 = 2 workstations.

Solved Problem

What must the cycle time in minutes be to produce at least 600 units on an eight-hour shift?

Solution:

Using equation 8.2, A = (8 hours)(60min/hour) = 480 minutes. Therefore, the cycle time must be no greater than A/R = (480 minutes)/(600 units) = 0.8 minutes/unit.

Consequently, either the the two- or three-station design must be used. Alternatively, equation 8.2 states that R = A/CT; that is, for a given cycle time, we can determine the output that can be achieved. If we use the one station configuration, then R = 480/1.0 = 480 units/shift. If we use either the two or three station configurations, then R = 480/0.5 = 960 units/shift.

The following equations provide additional information about the performance of an assembly line:

Total time available
$$= \text{(Number of workstations)(Cycle time)}$$
$$= (N)(CT) \qquad [8.4]$$

Total idle time $= (N)(CT) - \Sigma t$ [8.5]

Assembly-line efficiency $= \Sigma t/(N \times CT)$ [8.6]

Balance delay $= 1 -$ Assembly-line efficiency [8.7]

The total time available computed by equation 8.4 represents the total productive capacity that management pays for. Idle time is the difference between total time available and the sum of the actual times for productive tasks as given by equation 8.5. Assembly line efficiency, computed by equation 8.6, specifies the fraction of available productive capacity that is used. One minus efficiency represents the amount of idle time that results from imbalance among workstations and is called the *balance delay*, as given by equation 8.7.

In the example, suppose that we use three workstations with $CT = 0.5$. The total time available is $3(0.5) = 1.5$ minutes; total idle time is $1.5 - 1.0 = 0.5$ minute; and the line efficiency is $1.0/1.5 = 0.67$. If we use two workstations as described earlier, then the line efficiency increases to 1.0, or 100 percent. One objective of assembly line balancing is to maximize the line efficiency.

2.2 Line Balancing Approaches

Balancing the three-task example in the previous section was quite easy to do by inspection. With a large number of tasks, the number of possible workstation configurations can be very large, making the balancing problem very complex. Decision rules, or heuristics, are used to assign tasks to workstations. Because heuristics cannot guarantee the best solution, one often applies a variety of different rules in an attempt to find a very good solution among several alternatives. For large line balancing problems, such decision rules are incorporated into computerized algorithms and simulation models.

To illustrate a simple, yet effective, approach to balancing an assembly line, sup-

© Rommel/Masterfile

pose that we are producing an in-line skate as shown in Exhibit 8.8. The target output rate is 360 units per week. The effective workday (assuming one shift) is 7.2 hours, considering breaks and lunch periods. We will assume that the facility operates five days per week.

Eight tasks are required to assemble the individual parts. These, along with task times, are:

1. Assemble wheels, bearings, and axle hardware (2.0 min).
2. Assemble brake housing and pad (0.2 min).
3. Complete wheel assembly (1.5 min).
4. Inspect wheel assembly (0.5 min)

Exhibit 8.8 *A Typical In-Line Skate*

5. Assemble boot (3.5 min).

6. Join boot and wheel subassemblies (1.0 min).

7. Add line and final assembly (0.2 min).

8. Perform final inspection (0.5 min).

If we use only one workstation for the entire assembly and assign all tasks to it, the cycle time is 9.4 minutes. Alternatively, if each task is assigned to a unique workstation, the cycle time is 3.5, the largest task time. Thus, feasible cycle times must be between 3.5 and 9.4 minutes. Given the target output rate of 360 units per week and operating one shift per day for five days per week, we can use equation 8.2 to find the appropriate cycle time:

$CT = A/R$

$\quad = [(7.2 \text{ hours/shift})(60 \text{ min/hr})/(72 \text{ units/shift})$

$\quad = 6.0 \text{ minutes/unit}.$

The theoretical minimum number of workstations is found using equation 8.3:

$\Sigma t/CT = 9.4/6.0 = 1.57$ or rounded up, is 2.

The eight tasks need not be performed in this exact order; however, it is important to ensure that certain precedence restrictions are met. For example, you cannot perform the wheel assembly (task 3) until both tasks 1 and 2 have been completed, but it does not matter whether task 1 or task 2 is performed first because they are independent of each other. These types of relationships are usually developed through an engineering analysis of the product. We can represent them by an arrow diagram, shown in Exhibit 8.9. The arrows indicate what tasks must precede others. Thus, the arrow pointing from tasks 1 and 2 to task 3 indicate that tasks 1 and 2 must be completed before task 3 is performed; similarly, task 3 must precede task 4. The numbers next to each task represent the task times.

This precedence network helps to visually determine whether a workstation assignment is *feasible*—that is, meets the precedence restrictions. For example, in Exhibit 8.9 we might assign tasks 1, 2, 3, and 4 to one workstation, and tasks 5, 6, 7, and 8 to a second workstation as illustrated by the shading. This is feasible because all tasks assigned to workstation 1 are completed before those assigned to workstation 2. However, we could not assign tasks 1, 2, 3, 4, and 6 to workstation 1 and tasks 5, 7, and 8 to workstation 2, because operation 5 must precede operation 6.

The problem is to assign the eight work activities to workstations without violating precedence or exceeding the cycle time of 6.0. Different rules may be used to assign tasks to workstations. For example, one line balancing decision rule example is to assign the task with the *longest task time first* to a workstation if the cycle time would not be exceeded. The longest task time first decision rule assigns tasks with long task times first, because shorter task times are easier to fit in the line balance later in the procedure. Another rule might be to assign the shortest task first. These rules attempt to minimize the amount of idle time at workstations, but they are heuristics and do not guarantee optimal solutions.

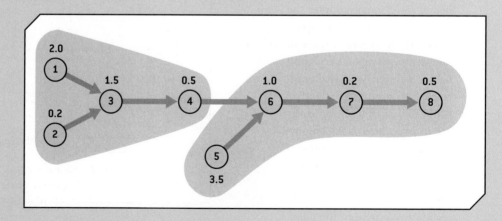

Exhibit 8.9 *Precedence Network for In-Line Skate*

The longest task time rule can be formalized as follows:

1. Choose a set of "assignable tasks"—those for which all immediate predecessors have already been assigned.

2. Assign the assignable task with the *longest* task time first. Break ties by choosing the lowest task number.

3. Construct a new set of assignable candidates. If no further tasks can be assigned, move on to the next workstation. Continue in this way until all tasks have been assigned.

Let us illustrate this with the example. We will call the first workstation "A" and determine which tasks can be assigned. In this case, tasks 1, 2, and 5, are candidates, since they have no immediate predecessors. Using the decision rule—*choose the activity with the longest task time first*—we therefore assign task 5 to workstation A.

Next, we determine a new set of tasks that may be considered for assignment. At this point, we may only choose among tasks 1 and 2 (even though task 5 has been assigned, we cannot consider task 6 as a candidate because task 4 has not yet been assigned to a workstation). Note that we can assign both tasks 1 and 2 to workstation A without violating the cycle time restriction.

At this point, task 3 becomes the only candidate for assignment. Since the total time for tasks 5, 1, and 2 is 5.7 minutes, we cannot assign task 3 to workstation A without violating the cycle time restriction of 6.0 minutes. In this case, we move on to workstation B.

At workstation B, the only candidate we can assign next is task 3. Continuing, we can assign tasks 4, 6, 7, and 8 in that order and still be within the cycle time limit. Because all tasks have been assigned to a workstation we are finished. This assembly line balance is summarized as follows:

Workstation	Tasks	Total Time	Idle Time
A	1, 2, 5	5.7	0.3
B	3, 4, 6, 7, 8	3.7	2.3
	Total	9.4	2.6

Using equations 8.4 to 8.6 we may compute the following:

Total time available

$$= \text{(Number of workstations)(Cycle time)}$$
$$= (N)(CT) = (2)(6) = 12 \text{ minutes}$$

$$\text{Total idle time} = (N)(CT) - \Sigma t$$
$$= (2)(6) - 9.4 = 2.6 \text{ minutes}$$

$$\text{Assembly-line efficiency} = \Sigma t / (N \times CT)$$
$$= 9.4 / (2 \times 6) = 0.783 \text{ or } 78.3\%$$

In this example, efficiency is not very high because the precedence relationships constrained the possible line balancing solutions. The target efficiency for most assembly lines is 80 percent to 90 percent, but this is highly dependent on things like the degree of automation, inspection stations, workforce skills, complexity of the assembly, and so on. One option is to redefine the work content for the assembly task in more detail if this is possible, by breaking down the tasks into smaller elements with smaller task times and rebalancing the line, hoping to achieve a higher efficiency.

In the real world, assembly line balancing is quite complicated, because of the size of practical problems as well as constraints that mechanization or tooling place on work tasks. Also, in today's manufacturing plants, there is virtually no such thing as a single-model assembly line. In the automotive industry, many model combinations and work assignments exist. Such mixed-model assembly-line balancing problems are considerably more difficult to solve. Simulation modeling is frequently used to obtain a "best set" of assembly line balancing solutions and then engineers, operations managers, and suppliers evaluate and critique these solutions to find the best design.

3 Designing Process Layouts

In designing process layouts, we are concerned with the arrangement of departments or work centers relative to each other. Costs associated with moving materials or the inconvenience that customers might experience in moving between physical locations are usually the principal design criteria for process layouts. In general, workcenters with a large number of moves between them should be located close to one another.

Several software packages have been written expressly for designing process layouts; some include simulations of the entire factory layout. These packages have the advantage of being able to search among a much larger number of potential layouts than could possibly be done manually. Despite the capabilities of the computer, no layout program will provide optimal solutions for large, realistic problems. Like many practical solution procedures in management science, they are heuristic; that is, they can help the user to find a very good, but not necessarily the optimal, solution.

One of the most widely used facility-layout programs is CRAFT (Computerized Relative Allocation of Facilities Technique). CRAFT attempts to minimize the total materials-handling cost. The user must generate an initial

layout and provide data on the volume between departments and the materials-handling costs. CRAFT uses the centroid of each department to compute distances and materials-handling costs for a particular layout. In an effort to improve the current solution, CRAFT exchanges the location of two (in later versions, three) departments at a time and determines if the total cost has been reduced. If so, it then uses the new solution as a base for determining new potential improvements. Other programs that have been used in facilities layout are ALDEP (Automated Layout-DEsign Program) and CORELAP (Computerized RElationship LAyout Planning). Rather than using materials-handling costs as the primary solution, the user constructs a preference table

that specifies how important it is for two departments to be close to one another. These "closeness ratings" follow.

A	Absolutely necessary
B	Especially important
C	Important
D	Ordinary closeness okay
E	Unimportant
F	Undesirable

The computer programs attempt to optimize the total closeness rating of the layout. Computer graphics is providing a major advance in layout planning. It allows interactive design of layouts in real time and can eliminate some of the disadvantages, such as irregularly shaped departments, that often result from noninteractive computer packages.

4 Workplace Design

t he techniques we have described address broad layout issues in facilities. However, it is also important to pay serious attention to the design and layout of individual workstations, not only in factories, but in every other facility where work is performed, such as offices, restaurants, and retail stores. Clearly, the workplace should allow for maximum efficiency and effectiveness as the work task or activity is performed, but it may also need to facilitate service management skills in high-contact, front-office environments.

Key questions that must be addressed at the workstation level include:

1. Who will use the workplace? Will the workstation be shared? How much space is required? Workplace designs must take into account different physical characteristics of individuals, such as differences in size, arm length, strength, and dexterity.

2. How will the work be performed? What tasks are required? How much time does each task take? How much time is required to set up for the workday or for a particular job? How might the tasks be grouped into work activities most effectively? This includes knowing what information, equipment, items, and procedures are required for each task, work activity, and job.

Vytec Corporation

V ytec (www.vytec.com) is a leading manufacturer of vinyl siding for homes and businesses. Vytec makes 50 different product lines (called profiles) of siding, soffits, and accessories. Each profile is typically produced in 15 colors creating 750 stock-keeping units. The finished siding is packaged in a carton that holds 20 pieces that are usually 12 feet long. The cartons are stacked in steel racks (called beds). Each bed holds 30 to 60 cartons depending on the bed's location in the warehouse. Vytec's main warehouse is more than 200,000 square feet.

Over time, demand for each siding profile changes, and some are added and discontinued. One problem the warehouse faces periodically is the need to redo the location and capacity of beds in the warehouse. Using basic layout principles, high-demand siding profiles are located closest to the shipping dock to minimize travel and order-picking time. Although management would like to find a permanent solution to this stock placement problem in the warehouse, the continuous changes in demand and product mix necessitate a new design every few years.[3]

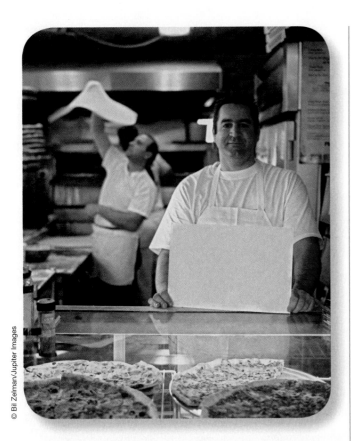

3. What technology is needed? Employees may need to use a computer or have access to customer records and files, special equipment, intercoms, and other forms of technology.

4. What must the employee be able to see? Employees might need special fixtures for blueprints, test procedures, sorting paper, anti-glare computer screens, and so on.

5. What must the employee be able to hear? Employees may need to communicate with others, wear a telephone headset all day, be able to listen for certain sounds during product and laboratory testing, or be able to hear warning sounds of equipment.

6. What environmental and safety issues need to be addressed? What protective clothing or gear should the employee wear?

To illustrate some of these issues, let us consider the design of the pizza-preparation table for a pizza restaurant. The objective of a design is to maximize throughput, that is, the number of pizzas that can be made; minimize errors in fulfilling customer orders; and minimize total flow time and customer waiting and delivery time. In slow demand periods, one or two employees may make the entire pizza. During periods of high demand, such as weekends and holidays, more employees may be needed. The workplace design would need to accommodate this.

An example of a pizza preparation workstation is shown in Exhibit 8.10. Ingredients should be put on the pizzas in the following order: sauce, vegetables (mushrooms, peppers, onions, etc.), cheese, and finally, meat. Since cheese and meat are the highest-cost items and also greatly affect taste and customer satisfaction, the manager requires that those items be weighed to ensure that the proper amounts are included. All items are arranged in the order of assembly within easy reach of the employee and, as the front view illustrates, order tickets are hung at eye level, with the most recent orders on the left to ensure that pizzas are prepared on a first-come-first-served basis.

In office cubicles, e-mails, telephone calls, cell phones, pagers, and the like, interrupt office workers so much that some companies have established "information free zones" within the office. If you work in one of these zones, all of these interruption devices are

Exhibit 8.10 *Pizza Preparation Workplace Design*

turned off or blocked from operating so employees can focus on their work. Companies think information-free zones improve employee attention spans and productivity.

Safety is one of the most important aspects of workplace design, particularly in today's society.

Safety is one of the most important aspects of workplace design, particularly in today's society. To provide safe and healthful working conditions and reduce hazards in the work environment, the Occupational Safety and Health Act (OSHA) was passed in 1970. It requires employers to furnish to each of their employees a place of employment free from recognized hazards that cause or are likely to cause death or serious physical harm. As a result of this legislation, the National Institute of Occupational Safety and Health (NIOSH) was formed to enforce standards provided by OSHA. Business and industry must abide by OSHA guidelines or face potential fines and penalties.

Safety is a function of the job, the person performing the job, and the surrounding environment. The job should be designed so that it will be highly unlikely that a worker can injure himself or herself. At the same time, the worker must be educated in the proper use of equipment and the methods designed for performing the job. Finally, the surrounding environment must be conducive to safety. This might include nonslip surfaces, warning signs, or buzzers.

Ergonomics is concerned with improving productivity and safety by designing workplaces, equipment, instruments, computers, workstations, and so on that take into account the physical capabilities of people.

A **job** is the set of tasks an individual performs.

© Coloblind/The Image Bank/Getty Images

Ergonomics is concerned with improving productivity and safety by designing workplaces, equipment, instruments, computers, workstations, and so on that take into account the physical capabilities of people. The objective of ergonomics is to reduce fatigue, the cost of training, human errors, the cost of doing the job, and energy requirements while increasing accuracy, speed, reliability, and flexibility. Although ergonomics has traditionally focused on manufacturing workers and service providers, it is also important in designing the servicescape to improve customer interaction in high-contact environments.

5 The Human Side of Work

t he physical design of a facility and the workplace can influence significantly how workers perform their jobs as well as their psychological well-being. Thus, operations managers who design jobs for individual workers need to understand how the physical environment can affect people. *A **job** is the set of tasks an*

individual performs. **Job design** *involves determining the specific job tasks and responsibilities, the work environment, and the methods by which the tasks will be carried out to meet the goals of operations.*

Two broad objectives must be satisfied in job design. One is to meet the firm's competitive priorities—cost, efficiency, flexibility, quality, and so on; the other is to make the job safe, satisfying, and motivating for the worker. Resolving conflicts between the need for technical and economic efficiency and the need for employee satisfaction is the challenge that faces operations managers in designing jobs. Clearly, efficiency improvements are needed to keep a firm competitive. However, it is also clear that any organization with a large percentage of dissatisfied employees cannot be competitive.

What is sought is a job design that provides for high levels of performance and at the same time a satisfying job and work environment.

Sunny Fresh Foods

Sunny Fresh Foods (SFF) manufactures and distributes more than 160 different types of egg-based food products to more than 1,200 U.S. foodservice operations such as quick service restaurants, schools, hospitals, convenience stores, and food processors. Although production efficiency requires a product layout design in which each production department is organized into specific work or task areas, SFF has several innovative strategies to design its work systems to also provide a highly satisfying work environment for its employees. Workers are put on a "ramp-in" schedule when hired and only allowed to work for a specified number of hours initially. This not only provides better training and orientation to work tasks but also minimizes the potential for repetitive stress injuries. SFF uses a rotation system whereby workers rotate to another workstation every 20 minutes. This minimizes stress injuries, fights boredom, reinforces the concept of "internal customers," and provides a way of improving and reinforcing learning. SFF has led its industry with this approach since 1990 and OSHA standards were developed that mirror this rotation system.[4]

The relationships between the technology of operations and the social/psychological aspects of work has been understood since the 1950s and is known as the *sociotechnical approach* to job design and provides useful ideas for operations managers. Sociotechnical approaches to work design provide opportunities for continual learning and personal growth for all employees. **Job enlargement** *is the horizontal expansion of the job to give the worker more variety—although not necessarily more responsibility.* Job enlargement might be accomplished, for example, by giving a production-line

Virtual Teams: Why or Why Not?

Here are some advantages and disadvantages of utilizing virtual teams. Do you think that virtual teams are a good idea or not?

Advantages

- Allow the best possible team skills and capabilities to be assembled.
- Allow flexible working hours.
- Firms become more agile and flexible with quicker response time.
- Reduce transportation costs and pollution due to commuting to work.
- Reduce the cost of physical facilities.
- Encourage cross-functional and cross-national coordination and interaction.

Disadvantages

- Team success is highly dependent on each team member doing his or her work on time.
- Lack of human socialization may hurt the productivity of the team.
- Team members must be "self-starters."
- Privacy and security risks.
- Team member calendars must be synchronized.
- Team communication may be less effective or even break down.

Job design involves determining the specific job tasks and responsibilities, the work environment, and the methods by which the tasks will be carried out to meet the goals of operations.

Job enlargement is the horizontal expansion of the job to give the worker more variety—although not necessarily more responsibility.

worker the task of building an entire product rather than a small subassembly, or by job rotation, such as rotating nurses among hospital wards or flight crews on different airline routes.

Job enrichment *is vertical expansion of job duties to give the worker more responsibility.* For instance, an assembly worker may be given the added responsibility of testing a completed assembly, so that he or she acts also as a quality inspector. A highly effective approach to job enrichment is to use teams. Some of the more common ones are:

> **Job enrichment** is vertical expansion of job duties to give the worker more responsibility.

- natural work teams, which perform entire jobs, rather than specialized, assembly-line work;

- virtual teams, in which members communicate by computer, take turns as leaders, and join and leave the team as necessary; and

- self-managed teams (SMTs), which are empowered work teams that also assume many traditional management responsibilities.

Virtual teams, in particular, have taken on increased importance in today's business world. Information technology provides the ability to assemble virtual teams of people located in different geographic locations.[5] For example, product designers and engineers in the United States can work with counterparts in Japan, transferring files at the end of each work shift to provide an almost continuous product development effort.

Problems, Activities, and Discussions

1. Discuss the type of facility layout that would be most appropriate for:
 a. printing books.
 b. performing hospital laboratory tests.
 c. manufacturing home furniture.
 d. a hospital.
 e. a photography studio.
 f. a library.

2. Describe the layout of a typical fast-food franchise such as McDonald's. What type of layout is it? How does it support productivity? Do different franchises (e.g., Burger King or Wendy's) have different types of layouts? Why?

3. Visit a manufacturer or service organization and critique their facility design. What are the advantages and disadvantages? How does the layout affect process flows, customer service, efficiency, and cost? Describe the basic types of materials-handling systems commonly used in manufacturing.

4. Describe the ergonomic features in the automobile that you drive most often. If it is an older model, visit a new-car showroom and contrast those features with those found in some newer models, such as touch screen.

5. Peter's Paper Clips uses a three-stage production process: cutting wire to prescribed lengths, inner bending, and outer bending. The cutting process can produce at a rate of 150 pieces per minute; inner bending, 140 pieces per minute; and outer bending, 110 pieces per minute. Determine the hourly capacity of each process stage and the number of machines needed to meet an output rate of 20,000 units per hour. How does facility layout impact your numerical analysis and process efficiency? Explain.

6. An assembly line with 30 activities is to be balanced. The total amount of time to complete all 30 activities is 42 minutes. The longest activity takes 2.4 minutes and the shortest takes .3 minutes. The line will operate for 480 minutes per day.
 a. What are the maximum and minimum cycle times?
 b. How much daily output will be achieved by each of those cycle times?

7. In Problem 6, suppose the line is balanced using 10 workstations and a finished product can be produced every 4.2 minutes.
 a. What is the production rate in units per day?
 b. What is the assembly line efficiency?

8. A small assembly line for the assembly of power steering pumps needs to be balanced. Exhibit 8.11 is the precedence diagram. The cycle time is determined to be 1.5 minutes.
 a. How would the line be balanced by choosing the assignable task having the *longest* task time first?
 b. How would the line be balanced if the rule were changed to "choose the assignable task having the *shortest* task time first"?

Exhibit 8.11 *Precedence Diagram for Problem 8*

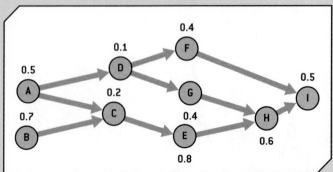

9. For the in-line skate assembly example in this chapter, suppose the times for the individual operations are as follows:

Task	Time (sec.)
1	20
2	10
3	30
4	10
5	30
6	20
7	10
8	20

Assume that inspections cannot be performed by production personnel, but only by persons from quality control. Therefore, assembly operations are separated into three groups for inspection. Design production lines to achieve output rates of 120 per hour and 90 per hour.

10. Balance the assembly line in Exhibit 8.12 for (a) a shift output of 60 pieces and (b) a shift output of 40 pieces. Assume an eight-hour shift, and use the rule: choose the assignable task with the longest processing time. Compute the line efficiency for each case.

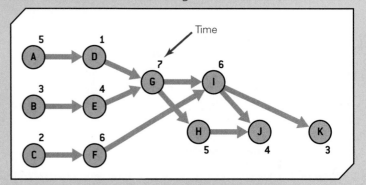

Exhibit 8.12 *Precedence Diagram for Problem 10*

BankUSA: Cash Movement Case Study

"Del, every wire transfer request is processed first-come-first-served. Some of these wires are for millions of dollars while others are under $100," said Betty Kelly, a 28-year-old manager of Cash Movement (CM). She continued by saying, "I'm also concerned that all wires regardless of dollar amount go through the same quality checkpoints and whether we are staffed correctly."

Betty left her boss Del Carr's office with many related issues on her mind. As Betty sat down in her office chair, Steve Breslin, supervisor of outgoing wires, said, "Betty, last week we processed a wire for $80,000 incorrectly to Houston Oaks Bank and now they won't give it back. What should we do?" "Steve, give me the information, and I'll call the bank now," said Betty. The rest of Betty's day was spent recovering this money and discussing several personnel issues.

The Cash Movement (CM) operating unit is responsible for transferring money for BankUSA and any of its customers. Over 80 percent of all transaction requests are for individual customers, while the remaining requests were for commercial (business) customers. For example, a customer will sell stock and request that cash funds be sent to another institution such as a mutual fund, credit union, or another bank. The customer will request

© Brian Hagiwara/Brand X Pictures/Jupiterimages

his or her local customer investment manager (CIM) to transfer money into or out of the account. The CIM will then request by e-mail or fax that Cash Movement process the transaction. All wires must be settled on the same day.

The average demand for outgoing wires is 306 wires per day for a 7.5-hour workday. Therefore, the cycle time for this demand rate using equation 8.2 is computed as follows:

$$CT = A/R = [(7.5 \text{ hours/day})(60 \text{ minutes/hour})]$$
$$\div (306 \text{ wires/day})$$
$$= (450 \text{ minutes/day})/(306 \text{ wires/day})$$
$$= 1.47 \text{ minutes/wire}$$

Cash Movement employs 21 people, with 3 managers, 11 associates in outgoing wires, 2 associates in incoming wires, 3 associates in checks, and 2 associates in other areas. The average annual salary per associate is $30,000 with an additional 30 percent for benefits and overhead costs. Overhead costs include the cost of leasing/renting the building, operation of common areas such as the cafeteria and meeting rooms, utilities, insurance, and photocopy services.

Process workflow is documented in Exhibit 8.13 with 47 detailed steps

Exhibit 8.13 *Outgoing Wire Process Steps and Standard Times*

Process Steps (47 detailed steps aggregated into 16 steps	Workgroup Activity Number	% Work Through This Stage	Processing Times per Client Transfer Request* (minutes)
Client Requests Steps 1 to 3 (client and customer investment manager interaction, accurate collection of process input information, submit to backroom outgoing wire process for transaction execution)		100%	16 minutes (2 to 120 minutes) This front-room step is not part of the outgoing wire backroom process so ignore it.
Logging (Begin Outgoing Wire Process) Steps 4 and 5 (receive request and verify)	1	100%	0.8 minute
Steps 6, 11, and back to 4 and 5 (incorrect or missing information—rework)	2	3%	10 minutes
Step 7 (confirm if >$50,000)	3	100%	0.8 minute
Steps 8 to 10 (separate into different batches and forward)	4	100%	0.1 minute
Verify the Receipt of Fax (Wire Request) (Steps 4 to 7 above)			**First Quality Control Checkpoint**
Direct Wire Input Steps 12 and 13 (receive batches and key into system— batches are variable but a typical batch is about 30 wires, which take about 30 minutes to key into the computer)	5	100%	1 minute
Steps 14 to 16 (run remote report and tape and see if total dollar amounts match—verify)	6	100%	0.1 minute
Steps 17 to 19 (tape and remote report do not match—rework manually by checking each wire against each computer file—done by someone other than keyer)	7	3%	10 minutes
Verify the Accuracy of Wire Request (Steps 12 to 19 above with a focus on keying the wire)			**Second Quality Control Checkpoint**
Steps 20 and 23 (receive and verify the wire's accuracy a second time in the computer—done by someone else)	8	100%	0.5 minute

*These times are based on stopwatch time studies. The weighted average time per outgoing wire is 7.05 minutes. A total of 11 people work in this process.

consolidated into 16 logical workgroups/activities. The assembly line could be balanced using the original 47 steps if the times per step were given (they are not) but Betty thought she would begin by trying to balance the line using a more aggregate grouping of work with 16 workgroup activities. The 16 work activities are performed in a series or sequentially but how they are grouped does make a difference.

The first stage is external to the internal Cash Movement process and involves the front-room interaction between the customer (client) and the CIM. Here, an electronic transfer request can range from a few minutes to hours trying to help the customer decide what to do and may include a visit to the customer's home or office. This external work activity is not part of the internal process assembly line balance. The process begins at work activity 1 and ends at work activity 16.

A wire transfer request can "fail" in several ways with cost consequences to the bank. For example, if the wire is processed incorrectly or is not completed on time, the customer's transaction may fail. The effect of a failed transaction includes the customer being upset, customers leaving the bank forever, customers referring other friends and relatives to other banks, and the possible financial loss of processing the transaction the next business day at a new security price. BankUSA may have to compensate the customer for a failed transaction in terms of customer losses due to lost interest earnings on daily price changes plus processing fees. The average processing fee is $50 per wire. Moreover, any failed transaction must be researched and reprocessed, which constitutes "internal failure costs." Research and reprocessing costs per wire are estimated at $200. CM processes about 1,500 outgoing wires per week with about one error every two weeks. Errors happen due to CM mistakes but also are caused by other BankUSA departments, other financial institutions, and customers themselves. The information flow of this electronic funds transfer system is sometimes

Exhibit 8.13—continued *Outgoing Wire Process Steps and Standard Times*

Process Steps (47 detailed steps aggregated into 16 steps	Workgroup Activity Number	% Work Through This Stage	Processing Times per Client Transfer Request* (minutes)
Verify the Accuracy of the Keyed Wire (Steps 20 and 23 above with a focus on the wire in the computer)			**Third Quality Control Checkpoint**
Steps 24 and 28 (release the wire)	9	100%	1 minute
Steps 25 to 27 (if wire incorrect, cancel wire, and rekey—back to step 12)	10	5%	3 minutes
Step 29 (if CM needs to debit a customer's account, do steps 30 to 32 and batch and run tape)	11	70%	0.1 minute
Step 29 (if CM does not need to debit a customer's account, do step 33—wire is complete and paperwork filed)	12	30%	0.1 minute
Verify the Wire was Sent Correctly (Steps 29 to 33) Steps 34 to 36 (taking money out of the customer's trust account and putting it in a Cash Management internal account)	13	100%	**Fourth Quality Control Checkpoint** 0.75 minute
Verify That Appropriate Funds Were Taken from the Customer's Account (Steps 34 to 36—done by someone else)			**Fifth Quality Control Checkpoint**
Step 37 (if totals on tape match totals on batch, go to steps 38 to 44)	14	97%	0.1 minute
Step 37 (if totals do not match, find the error by examining the batch of wires, then go to steps 39 to 43)	15	3%	10 minutes
Steps 45 to 47 (verify and file wire information)	16	100%	0.75 minute

*These times are based on stopwatch time studies. The weighted average time per outgoing wire is 7.05 minutes. A total of 11 people work in this process.

quite complex, with BankUSA having only partial control of the value chain.

Specific types of errors include the same wire being sent out twice, not sent out at all, sent with inaccurate information on it including dollar amount, or sent to the wrong place. No dollar amount has been assigned to each type of failure. The largest risk to Cash Movement is to send the money twice or to send it to the wrong institution. If CM catches the error the same day the wire is sent, the wire is requested to be returned that day. If a wire is sent in duplication, the receiving institution must receive permission from the customer to return the money to BankUSA. This results in lost interest and the possibility of long delays in returning the money or with BankUSA having to take legal action to get the money back. For international transaction requests that are wired with errors, the cost of getting the money back is high. These costs are potentially so high, up to several hundred thousand dollars, that five quality control steps are built into the cash management process, as shown in Exhibit 8.13. All wires, even low dollar amounts, are currently checked and rechecked to ensure completeness and accuracy.

As Betty, the manager of Cash Movement, drove home, she wondered when she would ever get the time to analyze these issues. She remembered taking a college course in operations management and studying the topic of assembly-line balancing (she majored in finance), but she wondered if this method would work for services. She decided to begin her analysis by answering the following questions.

Case Questions for Discussion

1. What is the best way to group the work represented by the 16 workgroups for an average demand of 306 outgoing wires per day? What is your line balance if peak demand is 450 wires per day? What is assembly-line efficiency for each line balance solution?

2. How many people are needed for the outgoing wire process using assembly-line-balancing methods versus the current staffing level of 11 full-time-equivalent employees?

3. How many staff members do you need for the outgoing wire process if you eliminate all rework?

4. What are your final recommendations?

SUPPLY CHAIN DESIGN

matthews Novelties, Inc., produces a line of popular toys, many on contract from movie studios and other entertainment companies. Matthews Novelties just acquired ToyCo, a smaller company that essentially owns the market for miniature cars and trucks. The vice president of operations stated, "Now that we've inherited ToyCo's product line, we need to decide where to produce them. As you know, our state-of-the art die-casting factory in Malaysia operates at full capacity, and we have no room to expand the factory at the current site and no available land adjacent to it. ToyCo has two factories—one in Thailand and another in Malaysia. Labor costs in Thailand are about half of what we experience in Malaysia but their labor productivity is a lot lower. Our marketing people have also told us that the demand in Asia is increasing rapidly." One senior manager noted, "We shouldn't just make this decision on labor economics. What are building costs? What about housing and dormitory availability and education programs for employees? Do we have accurate demand forecasts? Where are the suppliers located? What regulations and restrictions do we face? How stable is their currency and political situation?"[1]

© Brand X Pictures/Jupiterimages

What do **you** think?

Suppose that you wanted to locate a café on your college campus (other than in the typical student center). What factors might you consider in selecting the location?

learning outcomes

After studying this chapter you should be able to:

LO1 Explain the concept of supply chain management.

LO2 Describe the key issues in designing supply chains.

LO3 Explain important factors and decisions in locating facilities.

LO4 Describe the role of transportation, supplier evaluation, technology, and inventory in supply chain management.

The location of factories, distribution centers, and service facilities establishes the infrastructure for the supply chain and has a major impact on the profitability.

We introduced the concept of a **supply chain** in Chapter 2, noting that a supply chain is a key subsystem of a value chain that focuses primarily on the physical movement of goods and materials along with supporting information through the supply, production, and distribution processes. Supply chains are all about speed and efficiency; poor supply chain performance can undermine the objectives of the firm and can easily result in loss of customers, either individual consumers or major retailers. As a firm's product lines and markets change or expand, the design or redesign of supply chains becomes a critical issue.

As companies merge and consolidate, they face many challenges and must reevaluate their supply chains and locations of facilities. The location of factories, distribution centers, and service facilities

© Yvan Cohen/OnAsia/Jupiterimages

establishes the infrastructure for the supply chain and has a major impact on the profitability. In today's global business environment with emerging markets and sources of supply in Asia and other countries, identifying the best locations is not easy, but good location analysis can lead to major reductions in total supply chain costs and improvements in customer response.

1 Understanding Supply Chains

the basic purpose of a supply chain is to coordinate the flow of materials, services, and information among the elements of the supply chain to maximize customer value. The key functions generally include sales and order processing, transportation and distribution, operations, inventory and materials management, finance, and customer service. Supply chains must focus on exploiting demand information to better match production levels to reduce costs; tightly integrate design, development, production, delivery, and marketing; and provide more customization to meet increasingly demanding customers. As such, a supply chain is an integrated system and requires much coordination and collaboration among the various players in it.

Distribution centers (DCs) are warehouses that act as intermediaries between factories and customers, shipping directly to customers or to retail stores where products are made available to customers.

Inventory refers to raw materials, work-in-process, or finished goods that are maintained to support production or satisfy customer demand.

A goods-producing supply chain generally consists of suppliers, manufacturers, distributors, retailers, and customers, as illustrated in Exhibit 9.1. Raw materials and components are ordered from suppliers and must be transported to manufacturing facilities for production and assembly into finished goods. Finished goods are shipped to distributors who operate distribution centers. **Distribution centers (DCs)** *are warehouses that act as intermediaries between factories and customers, shipping directly to customers or to retail stores where products are made available to customers.* At each factory, distribution center, and retail store, inventory generally is maintained to improve the ability to meet demand quickly. **Inventory** *refers to raw materials, work-in-process, or finished goods that are maintained to support production or satisfy customer demand.* As inventory levels diminish, orders are sent to the previous stage upstream in the process for replenishing stock. Orders are passed up the supply chain, fulfilled at each stage, and shipped to the next stage.

Not all supply chains have each of the stages illustrated in Exhibit 9.1. A simple supply chain might be one that supplies fresh fish at a Boston restaurant. Being

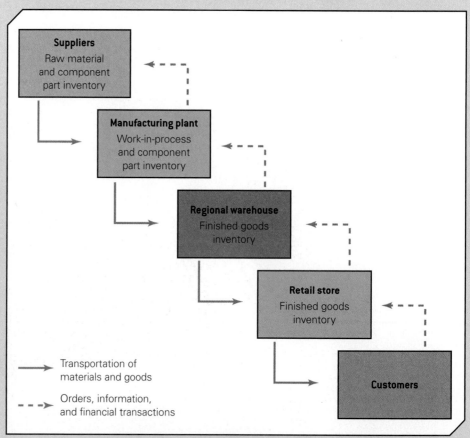

Exhibit 9.1 *Typical Goods-Producing Supply Chain Structure*

The SCOR Model

The **Supply Chain Operations Reference (SCOR) model** is based on five basic functions involved in managing a supply chain and provides an excellent framework for understanding the scope of SCM.[2] These functions include:

1. *Plan*—Developing a strategy that balances resources with requirements and establishes and communicates plans for the entire supply chain. This includes management policies and aligning the supply chain plan with financial plans.
2. *Source*—Procuring goods and services to meet planned or actual demand. This includes identifying and selecting suppliers, scheduling deliveries, authorizing payments, and managing inventory.
3. *Make*—Transforming goods and services to a finished state to meet demand. This includes production scheduling, managing work-in-process, manufacturing, testing, packaging, and product release.
4. *Deliver*—Managing orders, transportation, and distribution to provide the goods and services. This entails all order management activities from processing customer orders to routing shipments, managing goods at distribution centers, and invoicing the customer.
5. *Return*—Processing customer returns; providing maintenance, repair, and overhaul; and dealing with excess goods. This includes return authorization, receiving, verification, disposition, and replacement or credit.

close to the suppliers (fisherman), the restaurant might purchase fish directly from them daily and cut and fillet the fish directly at the restaurant. A slightly more complex supply chain for a restaurant in the midwest might include processing and packaging by a seafood wholesaler and air transportation and delivery to the restaurant. For consumers who want to buy fish from a grocery store, the supply chain is more complex and would include wholesale delivery and storage by the retailer.

Supply chain management (SCM) *is the management of all activities that facilitate the fulfillment of a customer order for a manufactured good to achieve satisfied customers at reasonable cost.* This includes not only the obvious functions of managing materials within the supply chain but also the flows of information and money that are necessary to coordinate the activities. The unique characteristic of SCM is that while material and logistics managers typically focus on activities within the span of their purchasing, manufacturing, and distribution processes, SCM requires a clear understanding of the interactions among all parts of the system.

Supply Chain Problems at Boeing

Boeing has had to push back the production schedule for its first 787 Dreamliner. The twin-engine plane is made of composite material and emphasizes fuel efficiency. With over 800 orders, it's the best-selling new airplane in Boeing's history. Boeing outsourced about 70 percent of the production to suppliers, requiring an unprecedented amount of global supply chain coordination. Boeing's partners in Italy, Japan, and elsewhere in the United States are responsible for manufacturing much of the 787 structure, including the composite wings and composite fuselage. But they stumbled early on, and their spotty performance, coupled with parts shortages from various suppliers, slowed work on the first test plane in final assembly at Boeing's plant in Everett, Washington. That forced Boeing to delay first flight and initial deliveries. Some of this work has been shifted back to the United States.[3]

© PA Photos/Landov

Supply chain operations reference (SCOR) model is a framework for understanding the scope of SCM that is based on five basic functions involved in managing a supply chain: plan, source, make, deliver, and return.

Supply chain management (SCM) is the management of all activities that facilitate the fulfillment of a customer order for a manufactured good to achieve satisfied customers at reasonable cost.

1.1 The Value and Supply Chain at Dell, Inc.

Dell sells highly customized personal computers, servers, computer workstations, and peripherals to global corporate and consumer markets. Dell's primary business model is based on selling direct to customers and bypassing traditional intermediary wholesalers and distributors. Most computers are assembled only in response to individual orders. Customers can place orders via the Internet, toll-free telephone lines, and at retail outlets. About half the orders are placed online; the remaining orders are placed through salespeople. Dell's value chain electronically links customers, suppliers, assembly operations, and shippers. Pre- and postproduction services are vital to Dell's value chain. Exhibit 9.2 depicts Dell's value chain, drawing upon our value chain model in Chapter 2.

Preproduction services, many of which are information-intensive include:

* *Customer benefit package design and configuration*—Dell offers various equipment models and configurations to meet the needs of different markets (for example, home, business, and education) and price points, all of which can be customized to individual specifications. Many peripheral goods are available, including preloaded software, printers, digital cameras, MP3 players, and other products. Peripheral services include technical support and advice for configuring the right system, financing, warranty options such as next-day on-site repair, and even rapid ordering of consumable supplies.

* *Corporate partnerships*—Dell has established partnerships with over 200 major corporate clients. Using secure, customized Intranet sites called Premier Pages, the clients' employees can order preauthorized Dell products on-line, usually at a discount.

* *Customer financing*—Business, education, and government customers represent a substantial portion of Dell's total revenue. Dell Financial Services (DFS) was established to help such organizations finance their purchases.

* *Technical support*—Dell's technical support call centers handle thousands of calls a day. Customer calls involved presale questions as well as postdelivery questions. Therefore, technical support is both a pre- and postproduction service.

* *Purchasing*—Purchasing is a vital part of Dell's supply chain, and Dell creates strong partnerships with some 250 suppliers responsible for delivering over 3,500 parts. Supplier selection is based on cost, quality, speed of service, and flexibility, and performance is tracked using a supplier "report card." About 30 key suppliers provide 75 percent of the parts; most suppliers maintain 8 to 10 days of inventory in multivendor hubs close to Dell assembly plants.

Exhibit 9.2 *A Value Chain Model of Dell, Inc.*

supply chain design to the computer industry. Dell pulls component parts into its factories based on actual customer orders and carries no finished goods inventory, relying on information technology to drive its supply chain. Suppliers' component part delivery schedules must match Dell's factory assembly schedules, which in turn must be integrated with shipping schedules. Each factory worldwide is rescheduled every two hours, and at the same time updates are sent to all third-party suppliers and logistics providers.

The third stage in Dell's value chain is postproduction services, which focus on "keeping the customer." These include

- *Customer order entry*—Orders start the supply chain in motion. Dell's on-line ordering capability gives customers the power to design and configure their customer benefit package any way they want it by selecting the specific hardware and software options, peripherals, service contracts, financing, and so on.

- *Software and hardware licensing*—Dell equipment comes fully loaded with the latest software from suppliers such as Microsoft, Yahoo, and EMC Corporation (storage software). Customers expect frequent software updates with Internet andwireless network capabilities. This is an important peripheral service that is critical to equipment sales.

- *Promotion/Advertising*—Dell offers numerous special deals and promotions on its Web site and the Internet within a short time after realizing it needs to shift or increase demand for its products. For example, if 40 GB hard drives are in short supply, a promotion might offer 60 GB hard drives at the same price; if demand is slow, free shipping or an instant rebate might be offered.

Dell operates one of the most efficient supply chains in the world. The company has been awarded over 550 patents for its business processes, from wireless factory networks to workstations that are 4 times more productive than traditional production methods and assembly lines.

The production system is designed to support Dell's objective of mass customization. To accomplish this objective, Dell introduced the idea of a make-to-order

- *Billing*—Dell's Premier Page customers are billed electronically. Individual customer purchases are charged to credit cards. Once the equipment is paid for, the operating system generates supplier and Dell factory production orders, shipping information, and bills.

- *Shipping*—United Parcel Service (UPS), Federal Express (FedEx), and others ship Dell's products to customers. These outsourcing arrangements provide quality service as well as tracking capability during shipment.

- *Installation, warranty, and field repair services*—Dell offers limited warranty and at-home installation and repair service on a prepaid contract basis. These options are available when the customer purchases the equipment and are executed after shipment.

- *On-line training services*—Dell provides or refers customers to on-line training programs. Dell's on-line instructions are very clear, with examples and frequently asked question links. For major business and government clients, customized training software is also designed to meet specific client needs.

- *Servicing loans/financing*—Dell's Premier Pages helps key clients manage and track equipment purchases, contracts, and leasing agreements on-line. Customers who lease through Dell Financial Services can use these pages to obtain new lease quotes, place lease orders, and track leased assets throughout their life cycles.

- *Returns/Recycling*—With millions of obsolete computers, Dell provides the customer with a way to donate old computers to other organizations or to have them recycled and disposed of in an environmentally safe way. Once the customer receives a new Dell printer, for example, detailed instructions are provided on how to ship the old printer back to Dell's Recycling Center.
- *Technical support*—Dell's postdelivery objective is to fix problems on-line without having to dispatch a technician. Dell embeds diagnostic equipment and software into its equipment before it leaves the factory, making it possible to run many equipment and software checks and make fixes on-line. However, live technical support is also available.

Dell has been recognized as one of the world's top companies on the basis of supply chain best practices and technologies.[4]

2 Designing the Supply Chain

anagers face numerous alternatives in designing a supply chain. For example, most major airlines and trucking firms operate a "hub and spoke" system, whereas others operate on a point-to-point basis. Some manufacturers use complex networks of distribution centers, whereas others like Dell ship directly to customers. Supply chains should support an organization's strategy, mission, and competitive priorities. Thus, both strategic and operational perspectives must be included in supply chain design decisions.

Many supply chains use contract manufacturing. *A contract manufacturer is a firm that specializes in certain types of goods-producing activities, such as customized design, manufacturing, assembly, and packaging, and works under contract for end users.*

Outsourcing to contract manufacturers can offer significant competitive advantages, such as access to advanced manufacturing technologies, faster product time-to-market, customization of goods in regional markets, and lower total costs resulting from economies of scale.

2.1 Efficient and Responsive Supply Chains

Supply chains can be designed from two strategic perspectives—providing high efficiency and low cost or providing agile response. **Efficient supply chains** *are designed for efficiency and low cost by minimizing inventory and maximizing efficiencies in process flow.* A focus on efficiency works best for goods and services with highly predictable demand, stable product lines with long life cycles that do not change frequently, and low contribution margins. In designing an efficient supply chain, for example, an organization would seek to balance capacity and demand, resulting in low levels of inventory; might use only a few large distribution centers (as opposed to small ones) to generate economies of scale; and use optimization models that minimize costs of routing products from factory through distribution centers to retail stores and customers. Examples of companies that run efficient supply chains are Procter & Gamble and Wal-Mart.

On the other hand, **responsive supply chains** *focus on flexibility and responsive service and are able to react quickly to changing market demand and requirements.* A focus on flexibility and response is best when demand is unpredictable; product life cycles are short and change often because of product innovations; fast response is the main competitive priority; customers require customization; and contribution margins are high. Responsive supply chains have the ability to quickly respond to market changes and conditions faster than traditional supply chains; are supported by information technology that provides real-time, accurate information to managers across the supply chain; and use information to identify market changes and redirect resources to address these changes. Companies such as Apple and Nordstrom are examples of having responsive supply chains.

2.2 Push and Pull Systems

Two ways to configure and run a supply chain are as a push or pull system. A supply chain can be viewed from "left to right"—that is, materials, information, and goods are moved or pushed downstream from supplier to customer. *A **push system** produces goods in advance of customer demand using a forecast of sales and moves*

Outsourcing to contract manufacturers can offer significant competitive advantages, such as access to advanced manufacturing technologies, faster product time-to-market, customization of goods in regional markets, and lower total costs resulting from economies of scale.

them through the supply chain to points of sale where they are stored as finished goods inventory. A push system has several advantages, such as immediate availability of goods to customers and the ability to reduce transportation costs by using full-truckload shipments to move goods to distribution centers. Push systems work best when sales patterns are consistent and when there are a small number of distribution centers and products.

In contrast, viewing the supply chain from "right to left" and transferring demand to upstream processes is sometimes referred to as a *demand chain* or *pull system*. A **pull system** *produces only what is needed at upstream*

stages in the supply chain in response to customer demand signals from downstream stages. Pull systems are more effective when there are many production facilities, many points of distribution, and a large number of products.

Many supply chains are combinations of push and pull systems. This can be seen in the simplified version of several supply chains in Exhibit 9.3. *The point in the supply chain that separates the push system from the pull system is called the* **push-pull boundary.** For a company like Dell, the push-pull boundary is very early in the supply chain where suppliers store inventory for frequent deliveries to Dell factories. Dell also ships directly to the customer, skipping the distributors and retailers. General Motors stores finished goods closer to the customer, at dealers. GM pushes finished goods from its factories to the dealer. Dealers might install various options to customize the automobile for the customer. Customers pull the finished goods

Wal-Mart

Wal-Mart operates more than 3,500 discount stores and Sam's Club outlets in the United States, 40 U.S. distribution centers, and over 1,200 stores around the world. The outstanding efficiency of Wal-Mart's supply chain is one of the major reasons it has achieved such market dominance and leadership status in the global retail industry. Wal-Mart's best practices in SCM can be categorized into four elements: strategic concepts, logistics and distribution, information technology, and supplier collaboration. [5]

From a strategic perspective, Wal-Mart has changed the flow of their supply chain to a pull-based production method instead of the traditional push system using "everyday low prices" and expanding to Supercenters. Each distribution center is designed to serve approximately 150 stores, and the distribution network is realigned to maximize efficiencies every time another center is added to the system. The distribution centers combined with Wal-Mart's own private truck fleet allow the company to retain significant control over deliveries and have economies of scale when purchasing but still provide frequent smaller shipments to stores. Information systems and supporting technology are exploited as much as possible. Wal-Mart uses electronic data interchange (EDI), in order to share real-time information with suppliers for better ordering accuracy and transparency throughout the supply chain. Technology such as hand-held scanners and RFID chips allow Wal-Mart to track information throughout the supply chain. Most supplier factories are tied directly into Wal-Mart's store information system so companies such as General Electric know exactly how many light bulbs by type are sold in each store each day. Suppliers are subject to pricing agreements and the costs of their products are expected to decrease on an annual basis.

All of these supply chain management practices combine to create a world-class and highly-efficient supply chain. Some of the benefits of Wal-Mart's supply chain are faster inventory turnover, less warehouse space needed, better working capital and cash flow management, fast response to sales surges and fads, less safety stock, and prices that average 14 percent lower than in competing stores. [6]

A **push system** produces goods in advance of customer demand using a forecast of sales and moves them through the supply chain to points of sale where they are stored as finished goods inventory.

A **pull system** produces only what is needed at upstream stages in the supply chain in response to customer demand signals from downstream stages.

The point in the supply chain that separates the push system from the pull system is called the **push-pull boundary**.

from the dealer. Thus, the push-pull boundary for General Motors is at the dealers.

The third example in Exhibit 9.3 is the supply chain for a college textbook publisher, which begins by ordering raw materials such as paper and ink. The publisher pushes books from design through printing and stores them in warehouses. The pull system begins with instructor order forms for required textbooks and reading lists of optional or supplemental books, consolidation of these demands and estimation of the quantities needed by college bookstores, and placement of orders with publishers. The bookstore purchasing function must effectively interface with the publisher's distribution function. Publishers ship from their warehouses to bookstores or directly to bookstores from the factory.

The location of the push-pull boundary can affect how responsive a supply chain is. Many firms try to push as much

Postponement is the process of delaying product customization until the product is closer to the customer at the end of the supply chain.

of the finished product as possible close to the customer to speed up response and reduce work in process inventory requirements. **Postponement** *is the process of delaying product customization until the product is closer to the customer at the end of the supply chain.* An example is a manufacturer of dishwashers that have different door styles and colors. A postponement strategy would be to manufacture the dishwasher without the door and maintain inventories of doors at the distribution centers. When orders arrive, the doors can be quickly attached and the unit can be shipped. This would reduce inventory requirements.

2.3 Supply Chain Design for Multisite Services

Many service organizations operate large numbers of similar facilities. **Multisite management** *is the process of managing geographically dispersed service-providing*

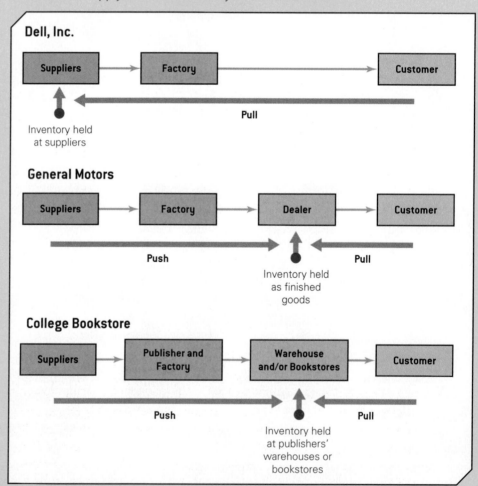

Exhibit 9.3 *Supply Chain Push-Pull Systems and Boundaries*

facilities. For example, McDonald's has over 30,000 restaurants worldwide plus hundreds of food processing factories and distribution centers. Federal Express has over one million pickup and delivery sites worldwide plus hundreds of sorting and distribution facilities. Some major banks have over 5,000 branch banks plus thousands of ATM locations. Supply chains are vital to multisite management, and in each of these cases, it can be difficult to design a good supply chain.

For firms that have a stable customer benefit package and many identical and standardized facilities, the supply chain should focus on standard processes and performance metrics. In the early 1970s, for example, Wendy's grew its business by adding more sites while keeping its customer benefit package and facility designs relatively stable. In these situations, an efficient supply chain design is most appropriate.

If a firm has at most a few sites and provides a broad customer benefit package with many goods and services, the firm cannot generally compete on low cost, but rather competes on variety and service. Thus, a responsive supply chain design is best. Supply chains are normally restricted to the local area and may involve a diverse supplier base.

A third situation is when both the customer benefit package and the number of facilities are changing simultaneously, supply chain design and management is more difficult. With nonstandard facilities and changing goods and service configurations, it is virtually impossible to design an efficient or responsive supply chain. Firms that knowingly or unknowingly pursue this strategy often find themselves at a competitive disadvantage.

Federal Express has over one million pickup and delivery sites worldwide plus hundreds of sorting and distribution facilities.

2.4 Supply Chain Metrics

Supply chain managers use numerous metrics to evaluate performance and identify improvements to the design and operation of their supply chains. These basic metrics typically balance customer requirements as well as internal supply chain efficiencies and fall into several categories, as summarized in Exhibit 9.4.

- *Delivery reliability* is often measured by perfect order fulfillment. A "perfect order" is defined as one that is delivered meeting all customer requirements, such as delivery date, condition of goods, accuracy of items, correct invoice, and so on.

- *Responsiveness* is often measured by order fulfillment lead time or by perfect delivery fulfillment. Customers today expect rapid fulfillment of orders and having promised delivery dates met.

- *Customer-related measures* focus on the ability of the supply chain to meet customer wants and needs. Customer satisfaction is often measured by a variety of attributes on a perception scale that might range from Extremely Dissatisfied to Extremely Satisfied.

- *Supply chain efficiency* measures include average inventory value and inventory turnover. Average inventory value tells managers how much of the firm's assets are tied up in inventory. Inventory turnover is the ratio of the cost of goods sold divided by the average inventory value.

- *Financial measures* show how supply chain performance affects the bottom line. These might include total supply chain costs and costs of processing returns and warranties.

2.5 The Bullwhip Effect

The performance of a supply chain, in terms of both costs and service, often suffers from a phenomenon known as the bullwhip effect, which has been observed across most industries and increases cost and reduces service to the customer. The bullwhip effect results from order amplification in the supply chain. **Order amplification** *is a phenomenon that occurs when each member of a supply chain "orders up" to buffer its own inventory.*[7] This results in larger fluctuations of orders as compared to fluctuations in sales; that is, the number of orders placed over time will cycle up and down (think of the amplitude of a wave in the ocean) more than the up and down pattern of sales.

Order amplification increases as one moves back up the supply chain away from the retail customer. Essentially, the time lags associated with information and material flow cause a mismatch between the actual customer demand and the supply chain's ability to satisfy that demand as each component of the supply chain seeks to manage its operations from its own perspective. This results in large oscillations of inventory in the supply chain network and characterizes the bullwhip effect.

Multisite management is the process of managing geographically dispersed service-providing facilities.

Order amplification is a phenomenon that occurs when each member of a supply chain "orders up" to buffer its own inventory.

Exhibit 9.4 *Common Metrics Used to Measure Supply Chain Performance*

Metric Category	Metric	Definition
Delivery reliability	Perfect order fulfillment	The number of perfect orders divided by the total number of orders
Responsiveness	Order fulfillment lead time	The time to fill a customer's order
	Perfect delivery fulfillment	The proportion of deliveries that were not just complete but also on time
Customer-related	Customer satisfaction	Customer perception of whether customers receive what they need when they need it, as well as such intangibles as convenient time of delivery, product and service quality, helpful manuals, and after-sales support
Supply chain efficiency	Average inventory value	The total average value of all items and materials held in inventory
	Inventory turnover	How quickly goods are moving through the supply chain
	Inventory days' supply	How many days of inventory are in the supply chain or part of the supply chain
Financial	Total supply chain costs	Total costs of order fulfillment, purchasing, maintaining inventory, distribution, technical support, and production
	Warranty/returns processing costs	The cost associated with repairs or restocking goods that have been returned
	Cash-to-cash conversion cycle	The average time to convert a dollar spent to acquire raw materials into a dollar collected for a finished good

Procter & Gamble

Consumers won't pay for a company's inefficiency." When P&G discounted products, consumers stocked up and then substituted competitors' products when P&G's products were not on sale. Within the company, the frequent promotions sent costs spiraling. At one point, the company made 55 daily price changes on some 80 brands, which necessitated rework on every third order. Often, special packaging and handling were required. Ordering peaked during the promotions as distributors stockpiled huge quantities of goods (known as forward buying), which resulted in excessive overtime in the factories followed by periods of underutilization. Factories ran at 55 to 60 percent of rated efficiency with huge swings in output. These fluctuations strained the distribution system, loading up warehouses during slow periods and overworking the transportation systems at peak times. This illustrates the bullwhip effect.

P&G's response was "value pricing," that is, to price its products at a reasonable "everyday low price" rate. With value pricing, demand rates are much smoother. Retailers automatically order products as they sell them. When 100 cases of Cheer detergent leave a retailer's warehouse, a computer orders 100 more. Both P&G and retailers save money. Plant efficiency rates have increased to over 80 percent across the company at the same time North American inventories dropped 10 percent.[8]

> A great servicescape and facility layout can seldom overcome a poor location decision, simply because customers may not have convenient access, which is one of the most important requirements for a service facility.

Many firms are taking steps to counteract this phenomenon by modifying the supply chain infrastructure and operational processes. For example, instead of ordering based on observed fluctuations in demand at the next stage of the supply chain (which are amplified from other stages downstream), all members of the supply chain should use the same demand data from the point of the supply chain closest to the customer. Other strategies include using smaller order sizes, stabilizing price fluctuations, and sharing information on sales, capacity, and inventory data among the members of the supply chain.

3 Location Decisions in Supply Chains

The principal goal of a supply chain is to provide customers with accurate and quick response to their orders at the lowest possible cost. This requires a network of facilities that are located strategically in the supply chain. Facility network and location focuses on determining the best network structure and geographical locations for facilities to maximize service and revenue and to minimize costs. These decisions can become complex, especially for a global supply chain, which must consider shipping costs between all demand and supply points in the network, fixed operating costs of each distribution and/or retail facility, revenue generation per customer location, facility labor and operating costs, and construction costs.

Larger firms have more complex location decisions; they might have to position a large number of factories and distribution centers advantageously with respect to suppliers, retail outlets, *and* each other. Rarely are these decisions made simultaneously. Typically, factories are located with respect to suppliers and a fixed set of distribution centers, or distribution centers are located with respect to a fixed set of factories and markets. A firm might also choose to locate a facility in a new geo-graphic region not only to provide cost or service efficiencies but also to create cultural ties between the firm and the local community.

Location is also critical in service value chains. A great servicescape and facility layout can seldom overcome a poor location decision, simply because customers may not have convenient access, which is one of the most important requirements for a service facility. Service facilities such as post offices, branch banks, dentist offices, and fire stations typically need to be in close proximity to the customer. In many cases, the customer travels to the service facility, whereas in others, such as mobile X-ray and imaging centers or "on-call" computer repair services, the service travels to the customer. Criteria for locating these facilities differ, depending on the nature of the service. For example, service facilities that customers travel to, such as

Toyota

The largest Toyota parts center in the world – 843,000 square feet – was built in northern Kentucky just west of the Greater Cincinnati/Northern Kentucky International Airport as a part of Toyota's globalization strategy.[9] The warehouse receives and stocks 42,000 repair and service parts from more than 375 North American suppliers and its assembly plants, and ships parts to 20 distribution centers in North America, Europe, and Japan for Toyota dealers. Toyota has located production operations in each part of the world where it sells cars and trucks. It also has a similar distribution center in Ontario, California, to handle distribution of parts from Japan to its North American dealers. The facility has allowed Toyota to lower its inventory days of supply on some fast-moving parts down to eight days, from a typical 30–60 days. This reduced space and inventory requirements significantly.

public libraries and urgent-care facilities, seek to minimize the maximum distance or travel time required from among the customer population. For those that travel to customer locations, such as fire stations, the location decision seeks to minimize response time to customers.

3.1 Critical Factors in Location Decisions

Location decisions in supply and value chains are based on both economic and noneconomic factors. Exhibit 9.5 is a list of some important location factors for site selection. Economic factors include facility costs, such as construction, utilities, insurance, taxes, depreciation, and maintenance; operating costs, including fuel, direct labor, and administrative personnel; and transportation costs associated with moving goods and services from their origins to the final destinations or the opportunity cost of customers coming to the facility.

Economic criteria are not always the most important factors in such decisions. Sometimes location decisions are based upon strategic objectives, such as preempting competitors from entering a geographical region. New facilities also require large amounts of capital investment and, once built, cannot easily be moved. Moreover, location decisions also affect the management of operations at lower levels of the organization. For instance, if a manufacturing facility is located far from sources of raw materials, it may take a considerable amount of time to deliver an order, and there will be more uncertainty as to the actual time of delivery.

Noneconomic factors in location decisions include the availability of labor, transportation services, and utilities; climate, community environment, and quality of life; and state and local legal and political factors. These must be balanced with economic factors in arriving at a location decision that meets financial as well as customer and operational needs.

3.2 Location Decision Process

Facility location is typically conducted hierarchically and involves the following four basic decisions where appropriate:

Global location decision Many companies must cope with issues of global operations, such as time zones, foreign languages, international funds transfer, customs, tariffs and other trade restrictions, packaging, international monetary policy, and cultural practices. The global location decision involves evaluating the product portfolio, new market opportunities, changes in regulatory laws and procedures, production and delivery economics, and the cost to locate in different

Exhibit 9.5 *Example Location Factors for Site Selection*

Labor and Demand Factors	Transportation Factors	Utilities Factors	Climate, Community Environment, and Quality of Life Factors	State and Local Legal and Political Factors
Labor supply	Closeness to sources of supply	Water supply	Climate and living conditions	Taxation climate and policies
Labor-management relations	Closeness to markets	Waste disposal	K–12 schools	Local and state tax structure
Ability to retain labor force	Adequacy of transportation modes (air, truck, train, water)	Power supply	Universities and research facilities	Opportunity for highway advertising
Availability of adequate labor skills	Costs of transportation	Fuel availability	Community attitudes	Tax incentives and abatements
Labor rates	Visibility of the facility from the highway	Communications capability	Health care facilities	Zoning laws
Location of competitors	Parking capability	Price/cost	Property costs	Health and safety laws
Volume of traffic around location	Response time for emergency services	Utility regulatory laws and practices	Cost of living	Regulatory agencies and policies

countries. With this information, the company needs to determine whether it should locate domestically or in another country; what countries are most amenable to setting up a facility (and what countries to avoid); and how important it is to establish a local presence in other regions of the world. The decision by Mercedes-Benz to locate in Alabama was based on the fact that German labor costs were about 50 percent higher than in the southern United States; the plant also gives the company better inroads into the American market and functions as a kind of laboratory for future global manufacturing ventures.

Regional location decision The regional location decision involves choosing a general region of a country, such as the northeast or south. Factors that affect the regional decision include size of the target market, the locations of major customers and sources of materials and supply; labor availability and costs; degree of unionization; land, construction, and utility costs; quality of life; and climate.

Community location decision The community location decision involves selecting a specific city or community in which to locate. In addition to the factors cited previously, a company would consider managers' preferences, community services and taxes (as well as tax incentives), available transportation systems, banking services, and environmental impacts. Mercedes-Benz settled on Vance, Alabama, after considering sites in 30 different states. Alabama pledged $250 million in tax

© David Zalubowski/AP Photo

abatements and other incentives, and the local business community came up with $11 million. The community also submitted a plan for how it would help the families of German workers adjust to life in that community.

Local site location decision The site location decision involves the selection of a particular location within the chosen community. Site costs, proximity to transportation systems, utilities, payroll and local taxes, environmental issues, and zoning restrictions are among the factors to be considered.

3.3 The Center of Gravity Method

Supply chain design and location decisions are quite difficult to analyze and make. Many types of quantitative models and approaches, ranging from simple to complex, can be used to facilitate these decisions. We introduce a simple quantitative approach; however, in practice, more sophisticated models are generally used.

The **center-of-gravity method** *determines the* X *and* Y *coordinates (location) for a single facility.* Although it does not explicitly address customer service objectives, it can be used to assist managers in balancing cost and service objectives. The center-of-gravity method takes into account the locations of the facility and markets, demand, and transportation costs in arriving at the best location for a single facility. It would seem reasonable to find some "central" location between the goods-producing or service-providing facility and customers at which to locate the new facility. But distance alone should not be the principal criterion, since the demand (volume, transactions, and so on) from one location to another also affects the costs. To incorporate distance and demand, the center of gravity is defined as the location that minimizes the weighted distance between the facility and its supply and demand points.

The first step in the procedure is to place the locations of existing supply and demand points on a coordinate system. The origin of the coordinate system and scale used are arbitrary, as long as the relative distances are correctly represented. Placing a grid over an ordinary map is one way to do that. The center of gravity is determined by equations 9.1 and 9.2, and can easily be implemented on a spreadsheet.

$$C_x = \Sigma X_i W_i / \Sigma W_i \qquad [9.1]$$

$$C_y = \Sigma Y_i W_i / \Sigma W_i \qquad [9.2]$$

where

C_x = x coordinate of the center of gravity

C_y = y coordinate of the center of gravity

X_i = x coordinate of location i

Y_i = y coordinate of location i

W_i = volume of goods or services moved to or from location i

The **center-of-gravity method** determines the X and Y coordinates (location) for a single facility.

Solved Problem

Taylor Paper Products is a producer of paper stock used in newspapers and magazines. Taylor's demand is relatively constant and thus can be forecast rather accurately. The company's two factories are located in Hamilton, Ohio, and Kingsport, Tennessee. The company distributes paper stock to four major markets: Chicago, Pittsburgh, New York, and Atlanta. The board of directors has authorized the construction of an intermediate warehouse to service those markets. Coordinates for the factories and markets are shown in Exhibit 9.6. For example, we see that location 1, Hamilton, is at the coordinate (58, 96); therefore, $X_1 = 58$ and $Y_1 = 96$. Hamilton and Kingsport produce 400 and 300 tons per month, respectively. Demand at Chicago, Pittsburgh, New York, and Atlanta is 200, 100, 300, and 100 tons per month, respectively. With that information using equations 9.1 and 9.2, the center of gravity coordinates are computed as follows:

$$C_x = \frac{58(400) + 80(300) + 30(200) + 90(100) + 127(300) + 65(100)}{400 + 300 + 200 + 100 + 300 + 100} = 76.3$$

$$C_y = \frac{96(400) + 70(300) + 120(200) + 110(100) + 130(300) + 40(100)}{400 + 300 + 200 + 100 + 300 + 100} = 98.1$$

This location (76.3, 98.1) is shown by the cross on Exhibit 9.6. By overlaying a map on this figure, we see that the location is near the border of southern Ohio and West Virginia. Managers now can search that area for an appropriate site.

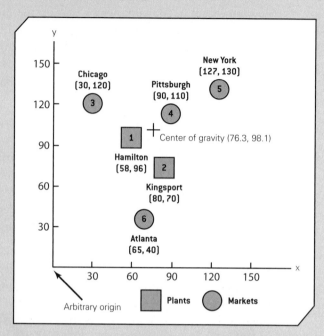

Exhibit 9.6 *Taylor Paper Products Plant and Customer Locations*

The center-of-gravity method is often used to locate service facilities. For example, in locating a waste disposal facility, the location coordinates can be weighted by the average amount of waste generated from residential neighborhoods and industrial sites. Similarly, to locate a library, fire station, hospital, or post office, the population densities will define the appropriate weights in the model.

4 Other Issues in Supply Chain Management

ssues of supply chain structure and facility location represent broad strategic decisions in supply chain design. Managing a supply chain also requires numerous operational decisions, such as selecting transportation services, evaluating suppliers, managing inventory, and other issues.

Managing a supply chain also requires numerous operational decisions, such as selecting transportation services, evaluating suppliers, managing inventory, and other issues.

Selecting transportation services The selection of transportation services is a complex decision, since varied services are available—rail, motor carrier, air, water, and pipeline. Pipelines have limited use and accessibility and are used primarily for such products as oil and natural gas. Similarly, water transportation is generally limited to transporting large quantities of bulky items—historically, raw materials such as coal, but recently, items such as furniture. Most consumer items are shipped via rail, motor carrier, and air. The critical factors in selecting a transportation mode are speed, accessibility, cost, and capability.

Many companies are moving toward third-party logistics providers. UPS Supply Chain Solutions (SCS), a subsidiary of the giant delivery company and its fastest-growing division, is one provider that is focusing on all aspects of the supply chain, including order processing, shipping, repair of defective or damaged goods, and even staffing customer service phone centers.[10]

Supplier evaluation Supplier management is an important support process in managing the entire supply chain. Many companies segment suppliers into categories based on their importance to the business and manage them accordingly.

For example, at Corning, Level 1 suppliers, who provide raw materials, cases, and hardware, are deemed critical to business success and are managed by teams that include representatives from engineering, materials control, purchasing, and the supplier company. Level 2 suppliers provide specialty materials, equipment, and services and are managed by internal customers. Level 3 suppliers provide commodity items and are centrally managed by purchasing.[11] Measurement also plays an important role in supplier management. Texas Instruments measures suppliers' quality performance by parts per million defective, percentage of on-time deliveries, and cost of ownership.[12]

Technology Technology is playing an increasingly important role in supply chain design, and selecting the appropriate technology is critical for both planning and design of supply chains as well as execution. Some important needs in supply chain management include having accurate receipt information identifying goods that have been received, reducing the time spent in staging (between receipt and storage) at distribution centers, updating inventory records, routing customer orders for picking, generating bills of lading, and providing various managerial reports. SCM has benefited greatly from information technology, particularly bar coding and radio frequency identification (RFID) tags, to control and manage these activities. Chapter 5 discussed the use of RFID extensively; RFID has become an important technology in supply chains.

Electronic data interchange and Internet links streamline information flow between customers and suppliers and increase the velocity of supply chains, as we illustrated with Dell. Many other firms, such as MetLife, Marriott Hotels, General Electric, Federal Express, Dow Chemical, Enterprise Rent-A-Car, and Bank of America, have exploited technology effectively in their supply chain designs. E-marketplaces offer many more options for sourcing materials and supplies and facilitate optimization of the supply chain globally.

Trucking companies now track their trucks via GPS technology as they move across the country. In-vehicle navigational systems, vehicle location systems, emergency vehicle deployment, and traffic management are other examples of how GIS and GPS are changing all industries and their value chains.

RFID at Wal-Mart

Wal-Mart Stores, Inc. is accelerating its RFID rollout. The company requires all suppliers shipping products to its Sam's Club distribution center in DeSoto, Texas, to apply the radio tags to their pallets. If they don't, Wal-Mart charges the suppliers $2 per pallet to do it for them. "I think everyone recognizes that it's the future of how products are going to move through the supply chain, and not just at Wal-Mart, but everywhere," said Wal-Mart spokesman John Simley. Dean Frew, president and chief executive of Xterprise Inc., which helps companies implement RFID systems, noted that the benefits are not only for Wal-Mart. "There's clearly a benefit for the suppliers,…you can't ignore the fact that if they're able to keep the shelf stocked more efficiently, in the end suppliers are going to benefit as well."[13]

Difficulties in Managing Supply Chains

Although supply chains can have a profound positive effect on business performance, supply chain initiatives do not always work out as one would hope. *Supply Chain Digest* published "The 11 Greatest Supply Chain Disasters."[14] Interestingly, none of them occurred after 2001, suggesting that organizations may have learned some good lessons from past failures. The list is summarized below.

1. Foxmeyer Drug installed new order management and distribution systems that didn't work. The company filed for bankruptcy and was eventually sold.

2. General Motors invested billions in robot technology to streamline production, and some of the robots painted themselves and dropped windshields on car seats.

3. Webvan's massive investment in automated warehouses drained its capital and wasn't justified by demand. The company went bankrupt in a matter of months.

4. Adidas installed a new warehouse system—and then another—neither of which worked properly.

5. The Denver Airport designed a complex and expensive automated handling system that never worked, causing the new airport to open later than planned. The system was hardly used and eventually dismantled.

6. Toys R Us.com couldn't fulfill thousands of orders for promised delivery by Christmas 1999; it eventually outsourced order fulfillment to Amazon.com.

7. Hershey Foods missed critical Halloween shipments because of order management and warehouse implementation issues, losing at least $150 million.

8. Cisco was stuck with piles of product because of poor demand and inventory forecasting, taking a $2.2 billion write-off.

© Bob Daemmrich/AFP/Getty Images

9. Nike blamed software issues from a new planning and inventory system for a $100 million revenue shortfall for one quarter.

10. Aris Isotoner made a disastrous decision to move production from Manila to lower-cost countries, resulting in higher costs and lower quality.

11. Apple was swamped with demand for new Power Macs in 1995 that it couldn't deliver and lost significant market share.

Inventory management An efficient distribution system can enable a company to operate with lower inventory levels, thus reducing costs, as well as providing high levels of service that create satisfied customers. Careful management of inventory is critical to supply chain time-based performance in order to respond effectively to customers.

Vendor-managed inventory (VMI) is where the vendor (a consumer goods manufacturer, for example) monitors and manages inventory for the customer (a grocery store, for example).

> **Vendor-managed inventory (VMI)** *is where the vendor (a consumer goods manufacturer, for example) monitors and manages inventory for the customer (a grocery store, for example).* VMI essentially outsources the inventory management function in supply chains to suppliers. VMI allows the vendor to view inventory needs from the customer's perspective and use this information to optimize its own production operations, better control inventory and capacity, and reduce total supply chain costs. VMI can also reduce the bullwhip effect discussed earlier in this chapter by allowing vendors to make production decisions using downstream customer demand data. One disadvantage of VMI is that it does not account for substitutable products from competing manufacturers and often results in higher customer inventories than necessary.

Problems, Activities, and Discussions

1. Suppose that a company wanted to write a mission statement for its supply chain. Such a mission statement might include statements about customers, suppliers, quality, delivery, cost, and the environment. What questions might you ask a company to help develop a good mission statement? Propose an example for some industry of your choice such as coffee, movie theater, pizza, credit card, trash/waste removal, or automotive service.

2. Select a firm such as Taco Bell (www.tacobell.com), Bank of America (www.bankofamerica.com), Wal-Mart (www.walmart.com), or another service-providing organization of interest to you and write a short analysis of location and multisite management decisions that the firm faces.

3. Interview a manager for a retail store, factory, or warehouse that was recently built in your location, and ask for an explanation of the economic and noneconomic factors that helped determine this facility's location.

4. Define the principal criteria that might be used for locating each of the following facilities:

- hospital
- chemical factory
- fire station
- elementary school
- regional warehouse

5. The following data are related to the operating costs of three possible locations for Fountains Manufacturing:

	Location 1	Location 2	Location 3
Fixed costs	$165,000	$125,000	$180,000
Direct material cost per unit	8.5	8.4	8.6
Direct labor cost per unit	4.2	3.9	3.7
Overhead per unit	1.2	1.1	1.0
Transportation costs per 1,000 units	800	1,100	950

 a. Which location would minimize the total costs, given an annual production of 50,000 units?

 b. For what levels of manufacture and distribution would each location be best?

6. Given the location information and volume of material movements from a supply point to several retail locations for Bourbon Hardware, find the optimal location for the supply point using the center-of-gravity method.

Retail Outlet	Location Coordinates x	y	Material Movements
1	20	5	2,800
2	18	15	2,500
3	3	16	1,600
4	3	4	1,100
5	10	20	2,000

7. The Davis national drugstore chain prefers to operate one outlet in a town that has four major market segments. The number of potential customers in each segment along with the coordinates are as follows:

Market Segment	Location Coordinates x	y	Number of Customers
1	2	18	2,000
2	15	17	600
3	2	2	1,500
4	14	2	2,400

 a. Which would be the best location by the center-of-gravity method?

 b. If after five years half the customers from segment 4 are expected to move to segment 2, where should the drugstore shift, assuming the same criteria are adopted?

8. MicroFix provides computer repair service on a contract basis to customers in five sections of the city. The five sections, the number of service contracts in each section, and the x, y coordinates of each section are as follows:

Section	No. of Contracts	Coordinates x	y
Parkview	90	8.0	15
Mt. Airy	220	6.7	5.9
Valley	50	12.0	5.2
Norwood	300	15.0	6.3
Southgate	170	11.7	8.3

 Use the center-of-gravity method to determine an ideal location for a service center.

9. A supply chain manager faced with choosing among four possible locations has assessed each location according to the following criteria, where the weights reflect the importance of the criteria. How can he use this information to choose a location? Can you develop a quantitative approach to do this?

Criteria	Weight	Location 1	2	3	4
Raw material availability	0.15	G	P	OK	VG
Infrastructure	0.1	OK	OK	OK	OK
Transportation costs	0.35	VG	OK	P	OK
Labor relations	0.2	G	VG	P	OK
Quality of life	0.2	G	VG	P	OK

 VG = Very good
 G = Good
 OK = Acceptable
 P = Poor

10. How can satellite-based global positioning systems improve the performance of supply chains in the following industries: (a) trucking, (b) farming and food distribution, (c) manufacturing, and (d) ambulance service?

Nike's Supply Chain Case Study

Nike sells retail products in 120 countries, and its innovative product lines include a wide variety of goods: footwear, apparel, socks, bags, dumbbells, watches, eyewear, and golf equipment.[15] Nike markets new products all four seasons of the year, with over 15,000 different styles per season, and it does business with 750 to 800 factories from around the world, many in Asia and some in the United States. Clearly, Nike has very complex supply chains. In 1998, Nike had 27 order management systems around the world, all highly customized, poorly coordinated with one another, and not well-linked to its headquarters in Beaverton, Oregon. Factories making Nike's products experienced huge swings in order size and frequency in those days.

© Stephen Hilger/Bloomberg News/Landov

Today, Nike is in the final stages of a decade-long supply chain management project that may cost up to $500 million. All product design, factory contracting, and supply chain coordination is done from Beaverton, Oregon. The supply chain systems use SAP's Enterprise Resource Planning (ERP) and Customer Relationship Management (CRM) software and a massive common database. Based on past mistakes regarding training, Nike now provides hundreds of hours of training for its employees in the use of the new ERP and CRM systems. Nike's supply chains are built around six-month order cycles that used to be nine months to a year. The goal is to get the order cycle to three months. Efforts are being made to use store point-of-sale information immediately to capture demand and drive factory production.

The company has identified four key challenges.

1. *Changes in the global marketplace.* Nike is a multinational company, and globalization has had a major impact. Not only does it operate in many more countries today than it did 10 to 15 years ago, but the regulations in these countries are always changing. For example, back in 1990, the average tariff in India was about 58% for products coming in, and now it's about 20% or so. Similarly, the average tariff in China used to be 30%, and today it's about 6%. As a result, Nike operates differently today in the global marketplace—even in countries where it has had a presence for years. A second global issue is that infrastructures in many countries are not well-developed. Nike's India distribution center is located in the south near Bangalore, and moving product to the north is a major challenge because of high traffic congestion.

2. *The consumer and changes in consumer behavior.* Consumers expect to have a wide range of choices, and customer wants and needs are different in different markets. So Nike cannot simply take a product that sells well in the U.S. and expect to satisfy a different global consumer with the same product. Worldwide, Nike faces a huge amount of product proliferation, and the challenge is to control product proliferation while simultaneously building more speed, responsiveness, and adaptability into their supply chains.

3. *Demanding retailers.* Big and small retailers are asking for shorter lead times and for faster inventory turns. They are also trying to push inventories away from their stores and toward the Nike factories to reduce inventory and product obsolescence costs. They demand quick response to fashion and holiday sales.

4. *Conflict between cost and flexibility.* While Nike sourcing continues to shift offshore, there are unrecognized costs associated with this trend. Manufacturing lead times remain long because fabrics are technically complex and because products involve complex innovations. Order, production, and shipping delays for global supply chains result in lost sales.

Case Questions for Discussion

1. What are Nike's competitive priorities and how would you rank order them?

2. Should Nike reduce product proliferation in an attempt to reduce their supply chain complexity and costs?

3. What impacts would lower/higher tariffs have on Nike's supply chain, strategy, and sourcing?

4. What concepts in this chapter are illustrated by this case study? Identify each and explain how it is applied at Nike.

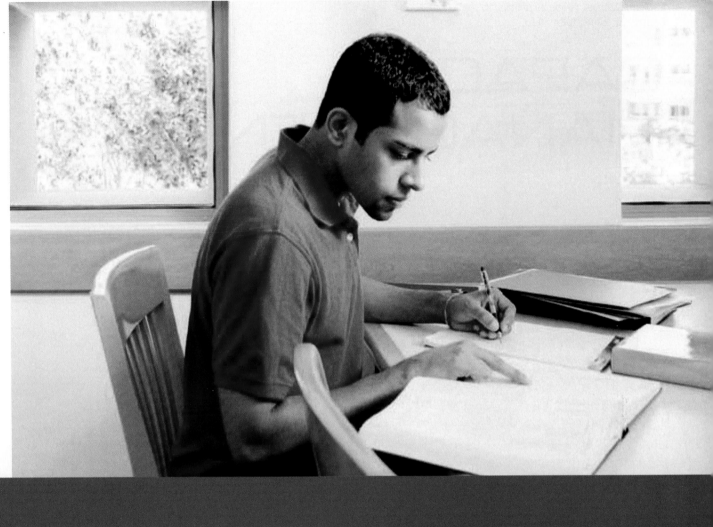

REVIEW!

HE DID

OM2 puts a multitude of study aids at your fingertips. After reading the chapters, check out these resources for further help:

• **Review Cards,** found in the back of your book, include all learning outcomes, key terms and definitions, and visual summaries for each chapter.

• **Online Printable Flash Cards** give you additional ways to check your comprehension of key Operations Management concepts.

• Other great tools to help you review include **interactive games, videos, online tutorial quizzes,** and **case problems.**

Go to 4ltrpress.cengage.com/om to find plenty of resources to help you *Review!*

CAPACITY MANAGEMENT

I f there's a downside to selling a product users can't live without, it's that customers tend to be unforgiving when something goes wrong. That's a lesson BlackBerry maker Research In Motion (RIM) Ltd., based in Waterloo, Ontario, learned in 2008 after the company's popular wireless e-mail service failed for about three hours—the second large-scale service disruption in less than a year—leaving so-called "Crackberry addicts" running for their desktop computers to read messages. Reports suggested the outage was related to RIM's efforts to expand capacity at its central operating center as its subscriber base increased at the rate of one million new users every three months. Critics argue that RIM is more susceptible to major service failures because of its centralized network architecture. RIM designs servers that relay email from a company's own server to a network operating center, where it is then handed off to a wireless carrier and beamed to a subscriber's device. The advantage of such a centralized setup is that it gives RIM more control over the system and its security, even during an interruption. The downside, however, is that a major problem at the operating center such as inadequate server and backup capacity threatens to cascade throughout the entire system, turning a localized issue into a continent-wide mess.[1]

© Comstock/Jupiter Images

What do **you** think?

Have you ever experienced problems with a service because of inadequate labor or equipment capacity?

learning outcomes

After studying this chapter you should be able to:

LO1 Explain the concept of capacity.

LO2 Describe how to compute and use capacity measures.

LO3 Describe long-term capacity expansion strategies.

LO4 Describe short term capacity adjustment strategies.

LO5 Explain the principles and logic of the Theory of Constraints.

In a general sense, *capacity* is a measure of the capability of a manufacturing or service system to perform its intended function. In practice, it is measured by the amount of output that can be produced in a particular time period; for example, the number of hamburgers made during a weekday lunch hour or the number of patients that can be handled during an emergency room shift. Having sufficient capacity to meet customer demand and provide high levels of customer service is vital to a successful business.

Capacity decisions cannot be taken lightly and can have profound impacts on business performance, as the BlackBerry example suggests. Consider, for example, the airline industry. Airbus has decided to produce the A380 with a much greater seating capacity than other aircraft, while Boeing's strategy is to make smaller planes. Clearly, more flights would be needed to achieve the same amount of passenger capacity over a fixed time period. Larger planes might result in better economies of scale, but reduce passenger choice and schedule flexibility. The decision of how much seating capacity to provide in new airplanes depends on forecasts of demand along global air traffic routes, the planes' efficiencies and operating costs, how customers will accept them, and the operational implications of boarding, disembarking, and baggage retrieval.

1 Understanding Capacity

Capacity *is the capability of a manufacturing or service resource such as a facility, process, workstation, or piece of equipment to accomplish its purpose over a specified time period.* Capacity can be viewed in one of two ways:

1. as the maximum rate of output per unit of time; or
2. as units of resource availability.

For example, the capacity of an automobile plant might be measured as the number of automobiles capable of being produced per week. As a resource availability measure, the capacity of a hospital would be measured by the number of beds available.

Operations managers must decide on the appropriate levels of capacity to meet current (short-term) and future (long-term) demand. Exhibit 10.1 provides examples of such capacity decisions. Short-term capacity decisions usually involve adjusting schedules or staffing levels. Longer-term decisions typically involve major capital investments.

1.1 Economies and Diseconomies of Scale

Economies of scale *are achieved when the average unit cost of a good or service decreases as the capacity and/or volume of throughput increases.* Capacity decisions are

No Burgers for You!

McDonald's restaurants in Britain apologized to millions of unhappy customers for running out of Big Macs during a weekend 2-for-1 promotion to celebrate its 25th anniversary in Britain. The demand generated by the promotion far exceeded forecasts. The promotion caused many of the nation's 922 outlets to turn away long lines of customers.

Exhibit 10.1 *Examples of Short- and Long-Term Capacity Decisions*

Short-Term Capacity Decisions	Long-Term Capacity Decisions
• Amount of overtime scheduled for the next week • Number of ER nurses on call during a downtown festival weekend • Number of call center workers to staff during the holiday season	• Construction of a new manufacturing plant • Expanding the size and number of beds in a hospital • Number of branch banks to establish in a new market territory

Operations managers must decide on the appropriate levels of capacity to meet current (short-term) and future (long-term) demand.

Capacity is the capability of a manufacturing or service resource such as a facility, process, workstation, or piece of equipment to accomplish its purpose over a specified time period.

Economies of scale are achieved when the average unit cost of a good or service decreases as the capacity and/or volume of throughput increases.

Legal Bottlenecks

The Clerk of Court office in Lee County, Florida, was inundated with a record number of foreclosures. Of the 32,983 foreclosures filed over three years, more than 22,000 cases were still open in September, 2008. The properties stuck in a clogged court system are left without clear ownership; trigger lawsuits and confusion; deteriorate as time goes on, bringing down the value of the property and the community surrounding the property; and in some cases become havens for criminal activity. Everyone agreed that the courts needed to get these properties back on the market much faster to help the local economy recover and grow. To solve this bottleneck problem the court took several actions—(1) put aside exclusive blocks of time—all day on Mondays—during which the four regular circuit judges hear only foreclosure cases, (2) hired three extra retired judges to deal only with foreclosures on other days of the week, (3) required all paperwork be processed online, and (4) assigned a judge to hear up to 200 cases every fifth week that could not be fit into the Monday hearings.[2]

Solved Problem

An automobile transmission-assembly factory normally operates two shifts per day, five days per week. During each shift, 400 transmissions can be completed. What is the capacity of this factory?

$$\begin{aligned} \text{Capacity} = &\ (2 \text{ shifts/day})(5 \text{ days/week}) \times \\ &\ (400 \text{ transmissions/shift}) \times \\ &\ (4 \text{ weeks/month}) \\ = &\ 16{,}000 \text{ transmissions/month} \end{aligned}$$

often influenced by economies and diseconomies of scale. For example, the design and construction cost per room of building a hotel decreases as the facility gets larger because the fixed cost is allocated over more rooms, resulting in a lower unit room cost. This lends support to building larger facilities with more capacity. **Diseconomies of scale** *occur when the average unit cost of the good or service begins to increase as the capacity and/or volume of throughput increase.* In the hotel example, as the number of rooms in a hotel continues to increase, the average cost per unit begins to increase, because of larger amounts of overhead and operating expenses required by higher levels of such amenities as restaurants, parking, and recreational facilities. This suggests that some optimal amount of capacity exists where costs are at a minimum.

As a single facility adds more and more goods and/or services to its portfolio, the facility can become too large and "unfocused." At some point, diseconomies of scale arise and unit costs increase because dissimilar product lines, processes, people skills, and technology exist in the same facility. In trying to manage a large facility with too many objectives and missions, key competitive priorities such as delivery, quality, customization, and cost performance can begin to deteriorate. This leads to the concept of a focused factory.

A **focused factory** *is a way to achieve economies of scale without extensive investments in facilities and capacity by focusing on a narrow range of goods or services, target market segments, and/or dedicated processes to maximize efficiency and effectiveness.* The focused factory argues to "divide and conquer" by adopting smaller more focused facilities dedicated to (1) a few key products, (2) a specific technology, (3) a certain process design and capability, (4) a specific competitive priority objective such as next day delivery, and (5) particular market segments or customers and associated volumes.

Focus Packaging, Inc.

Focus Packaging, Inc. is a family-owned business in Kansas City, Missouri, that employs 21 people and has annual sales of approximately $6 million. The firm has only one customer—Colgate-Palmolive—and makes 18 different cartons for packaging a variety of items such as Irish Spring soap. The owner, Mr. Davis, stated, "I'll never have a factory with more than three customers. You're always sacrificing one for the other." Davis sees many advantages to his focused factory concept. For example, his crews do not need retraining because of changing customer requirements. They are dedicated to doing it exactly the way Colgate-Palmolive wants. Davis concludes by saying, "I am scouting for another large customer. But, a second customer will mean a second focused factory."[3]

© Mark Lennihan/AP Photo

Capacity decisions are often influenced by economies and diseconomies of scale.

Diseconomies of scale occur when the average unit cost of the good or service begins to increase as the capacity and/or volume of throughput increase.

A focused factory is a way to achieve economies of scale without extensive investments in facilities and capacity by focusing on a narrow range of goods or services, target market segments, and/or dedicated processes to maximize efficiency and effectiveness.

2 Capacity Measurement

Capacity provides the ability to satisfy demand. To satisfy customers in the long run, capacity must be at least as large as the average demand. However, demand for many goods and services typically varies over time. A process may not be capable of meeting peak demand at all times, resulting in either lost sales or customers who must wait until the good or service becomes available. At other periods of time, capacity may exceed demand, resulting in idle processes or facilities or buildups in physical inventories.

2.1 Safety Capacity

The actual utilization rates at most facilities are not planned to be 100 percent of effective capacity. Unanticipated events such as equipment breakdowns, employee absences, or sudden short-term surges in demand will reduce the capability of planned capacity levels to meet demand and satisfy customers. This is evident in Exhibit 10.2. Therefore, some amount of **safety capacity** *(often called the **capacity cushion**), defined as an amount of capacity reserved for unanticipated events such as demand surges, materials shortages, and equipment breakdowns* is normally planned into a process or facility. In general, average safety capacity is defined by equation 10.1.

> Average safety capacity (%)
> = 100% – Average resource utilization (%) [10.1]

Note that equation 10.1 is based on average resource utilizations over some time period. For a factory, average safety capacity might be computed over a year; whereas for an individual workstation, it might be updated monthly.

Safety capacity (often called the **capacity cushion**) is defined as an amount of capacity reserved for unanticipated events such as demand surges, materials shortages, and equipment breakdowns.

2.2 Capacity Measurement in Job Shops

In a job shop, setup time can be a substantial part of total system capacity, and therefore, must be included in evaluating capacity. Equation 10.2 provides a general expression for evaluating the capacity required to meet a given production volume for one work order, i.

$$\text{Capacity required } (C_i) = \text{Setup time } (S_i) + [\text{Processing Time } (P_i) \times \text{Order size } (Q_i)] \quad [10.2]$$

where

C_i = capacity requirements in units of time (for instance, minutes, hours, days).

S_i = setup or changeover time for work order i as a fixed amount that does not vary with volume.

P_i = processing time for each unit of work order i (e.g., hours/part, minutes/transaction, and so on).

Q_i = size of order i in numbers of units.

If we sum the capacity requirements over all work orders, we can compute the total capacity required using equation 10.3.

$$C = \Sigma C_i = \Sigma[S_i + (P_i \times Q_i)] \quad [10.3]$$

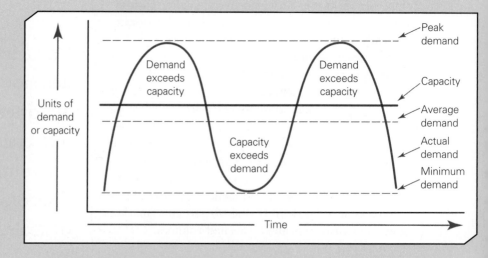

Exhibit 10.2 *The Demand versus Capacity Problem Structure*

2.3 Using Capacity Measures for Operations Planning

Capacity needs must be translated into specific requirements for equipment and labor. To illustrate this, we present a simple example. Fast Burger, Inc., is building a new restaurant near a college football stadium. The restaurant will be open 16 hours per day, 360 days per year. Managers have concluded that the restaurant should have the capacity to handle a peak hourly demand of 100 customers. This peak hour of demand happens two hours before every home football game. The average customer purchase is

1 burger (4-ounce hamburger or cheeseburger)

1 bag of French fries (4 ounces)

1 soft drink (12 ounces)

Consequently, management would like to determine how many grills, deep fryers, and soft drink spouts are needed.

A 36 × 36-inch grill cooks 48 ounces of burgers every 10 minutes, and a single-basket deep fryer cooks 2 pounds of French fries in 6 minutes, or 20 pounds per hour. Finally, one soft drink spout dispenses 20 ounces of soft drink per minute, or 1,200 ounces per hour. These effective capacity estimates are based on the equipment manufacturer's studies of actual use under normal operating conditions.

To determine the equipment needed to meet peak hourly demand, Fast Burger must translate expected demand in terms of customers per hour into needs for grills, deep fryers, and soft drink spouts. First note that the peak hourly demand for burgers, French fries, and soft drinks are as follows.

Product	Peak Hourly Demand (ounces)
Burgers	400
French fries	400
Soft drinks	1,200

Since the capacity of a grill is (48 oz./10-minutes)(60 minutes/hour) = 288 ounces/hour, the number of grills needed to satisfy a peak hourly demand of 400 ounces of burgers is

$$\text{Number of grills} = 400/288$$
$$= 1.39 \text{ grills}$$

To determine the number of single-basket deep fryers needed to meet a peak hourly demand of 400 ounces of french fries, we must first compute the hourly capacity of the deep fryer.

$$\text{Capacity of deep fryer} = (20 \text{ lb/hour})(16 \text{ oz/lb})$$
$$= 320 \text{ oz/hour}$$

Hence, the number of single-basket deep fryers needed is 400/320 = 1.25.

Finally, the number of soft drink spouts needed to satisfy peak demand of 1,200 ounces is

$$\text{Number of soft drink spouts needed}$$
$$= 1,200/1,200 = 1.0$$

After reviewing this analysis, the managers decided to purchase two 36 × 36-inch grills. Grill safety capacity is 2.0 – 1.39 = 0.61 grills or 175.7 oz./hour [(.61) × (48 oz./10 minutes) × (60 minutes/hour) or about 44 hamburgers per hour. Management decided this excess safety capacity was justified to handle demand surges and grill breakdowns. With two grills they reduced their risk of being unable to fill customer demand. If they installed two French fryer machines they would have 0.75 excess machines and that was thought to be wasteful. However, they realized that if the one French fryer machine broke down they would not be able to cook enough fries so they decided to purchase two deep fryers.

Management decided to go with a two-spout soft drink system. Although their analysis showed a need for only one soft drink spout, the managers wanted to provide some safety capacity, primarily because they felt the peak hourly demand for soft drinks might have been underestimated and customers tend to refill their drinks in this self-service situation.

© Gaetan Bally/Keystone/Landov

Solved Problem

A typical dentist's office has a complicated mix of dental procedures and significant setup times; thus, it is similar to a job shop. Suppose a dentist works a nine-hour day with one hour for lunch and breaks. During the first six months the practice is open he does all the work including cleaning and setting up for the next dental procedure. Setup and processing times for three procedures are shown in Exhibit 10.3. Also shown are the number of appointments and demand for each type.

On a particular day, there are two scheduled first appointments for single tooth crowns (see last column of Exhibit 10.3), one second appointment for a single tooth crown, four tooth whitening appointments, three first appointments for a partial denture, and two third appointments for a partial denture. Is there sufficient capacity to perform all the work?

Using equation 10.3, we see in Exhibit 10.4 that a total of 610 minutes of work are scheduled during a 480-minute workday. Therefore, there is a capacity shortage of 130 minutes. The dentist will either have to work two hours longer or reschedule some patients.

From this analysis, we see that 21.3 percent of his total capacity is used to set up and change over from one dental procedure to the next. If a dental assistant or technician is hired to do this work (assuming that this can be done off-line while the dentist continues to work on other patients), revenue would increase by about 20 percent. If setup times could be reduced by 50 percent, the total setup time would be 65 minutes instead of 130 minutes and the capacity shortage would only be 65 minutes, requiring only one hour of overtime.

Exhibit 10.3 Ham's Dental Office Procedures and Times for Today

Dental Procedure	Number of Appointments	Setup or Changeover Time (minutes)	Processing Time (minutes)	Demand (No. of Patients Scheduled)
Single tooth crown	1st	15	90	2
	2nd	10	30	1
Tooth whitening	1st	5	30	4
Partial denture	1st	20	30	3
	2nd	10	20	0
	3rd	5	30	2

Exhibit 10.4 Ham's Dental Office Demand-Capacity Analysis

Dental Procedure	Appointments	Setup Times	Process Time	Number of Patients Scheduled	Total Setup Time	Total Process Time	Total Setup & Process Time
Single tooth crown	1st	15	90	2	30	180	210*
	2nd	10	30	1	10	30	40
Tooth whitening	1st	5	30	4	20	120	140
Partial denture	1st	20	30	3	60	90	150
	2nd	10	20	0	0	0	0
	3rd	5	30	2	10	60	70
					130	480	610
					21.3%	78.7%	100%

*Example computation: $C = \Sigma(S_i + P_i \times Q) = 15 + 15 + (90 \times 2) = 210$ minutes, assuming a setup for each patient.

The average expected equipment utilizations for the two grills, two fryers, and two soft drink spouts are as follows (refer to equation 7.1 in Chapter 7):

Grill utilization (U) = Resources used/Resources available
$$= 1.39/2.0 = 69.5\%$$

Fryer utilization (U) = Resources used/Resources available
$$= 1.25/2.0 = 62.5\%$$

Soft drink spout utilization (U) = Resources used/Resources available
$$= 1.0/2.0 = 50.0\%$$

The managers of Fast Burgers, Inc., must also staff the new restaurant for peak demand of 100 customers/hour. Assume front-counter service personnel can take and assemble orders at the service rate of 15 customers per hour and the target labor utilization rate for this job is 85 percent. The number of front-service counter people that should be assigned to this peak demand period can be found using equation 7.2 in Chapter 7:

Utilization $(U\%)$ = Demand rate/[Service rate \times Number of servers]

or

$$0.85 = \frac{(100 \text{ customers/hour})}{(15 \text{ customers/hour}) \times (\text{Number of servers})}$$

(12.75)(Number of servers) = 100
Number of servers = 7.8

Given these capacity computations, Fast Burger management decides to assign eight people to the front-service counter during this peak demand period. Safety capacity is included in this decision in two ways. First, the target utilization labor rate is 85 percent so there is a 15 percent safety capacity according to equation 10.1. Second, eight people are on duty when 7.8 are needed so there is a safety capacity of 0.2 people. The management at Fast Burger now has an equipment and labor capacity plan for this peak demand period. Notice that equipment capacity which is difficult to increase in the short-term is high while labor is more easily changed. This equipment and labor capacity strategy must also be coupled with good forecasting of demand—the subject of the next chapter.

3 Long-Term Capacity Strategies

In developing a long-range capacity plan, a firm must make a basic economic trade-off between the cost of capacity and the opportunity cost of not having adequate capacity. Capacity costs include both the initial investment in facilities and equipment and the annual cost of operating and maintaining them. The cost of not having sufficient capacity is the opportunity loss incurred from lost sales and reduced market share.

Long-term capacity planning must be closely tied to the strategic direction of the organization—what products and services it offers. For example, many goods and services are seasonal, resulting in unused capacity during the off-season. Many firms offer **complementary goods and services**, *which are goods and services that can be produced or delivered using the same resources available to the firm, but whose seasonal demand patterns are out of phase with each other.* Complementary goods or services balance seasonal demand cycles and therefore use the excess capacity available, as illustrated in Exhibit 10.5. For instance, demand for lawn mowers peaks in the spring and summer; to balance manufacturing capacity, the producer might also produce leaf blowers and vacuums for the autumn season and snowblowers for the winter season.

3.1 Capacity Expansion

Capacity requirements are rarely static; changes in markets and product lines and competition will eventually require a firm to either plan to increase or reduce long-term capacity. Such strategies require determining the *amount*, *timing*, and *form* of capacity changes. To illustrate capacity expansion decisions, let us make two assumptions: (1) capacity is added in "chunks" or discrete increments; and (2) demand is steadily increasing.

Four basic strategies for expanding capacity over some fixed time horizon are shown in Exhibit 10.6 (these concepts can also be applied to capacity reduction):

Complementary goods and services are goods and services that can be produced or delivered using the same resources available to the firm, but whose seasonal demand patterns are out of phase with each other.

1. One large capacity increase (Exhibit 10.6a)

2. Small capacity increases that match average demand (Exhibit 10.6b)

3. Small capacity increases that lead demand (Exhibit 10.6c)

4. Small capacity increases that lag demand (Exhibit 10.6d)

The strategy in Exhibit 10.6a involves one large increase in capacity over a specified period. The advantage of one large capacity increase is that the fixed costs of construction and operating system setup needs to be incurred only once, and thus the firm can allocate these costs over one large project. However, if aggregate demand exhibits steady growth, the facility will be underutilized. The alternative is to view capacity expansion incrementally as in Exhibit 10.6b, c, and d.

Exhibit 10.6b illustrates the strategy of matching capacity additions with demand as closely as possible. This is often called a *capacity straddle strategy*. When capacity is above the demand curve, the firm has excess capacity; when it is below, there is a shortage of capacity to meet demand. In this situation, there will be short

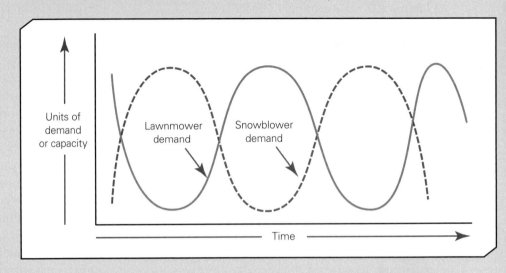

Exhibit 10.5 *Seasonal Demand and Complementary Goods or Services*

periods of over- and under-resource utilization. Exhibit 10.6c shows a capacity-expansion strategy with the goal of maintaining sufficient capacity to minimize the chances of not meeting demand. Here, capacity expansion leads or is ahead of demand, and hence, is called a *capacity lead strategy*. Since there is always excess capacity, safety capacity to meet unexpected demand from large orders or new customers is provided.

Finally, Exhibit 10.6d illustrates a policy of a *capacity lag strategy* that results in constant capacity shortages. Such a strategy waits until demand has

Briggs & Stratton

Briggs & Stratton is the world's largest producer of air-cooled gasoline engines for outdoor power equipment. The company designs, manufacturers, markets, and services these products for original equipment manufacturers worldwide. These engines are primarily aluminum alloy gasoline engines ranging from 3 through 25 horsepower. Briggs & Stratton is a leading designer, manufacturer, and marketer of portable generators, lawn

mowers, snow throwers, pressure washers, and related accessories. It also provides engines for manufacturers of other small engine-driven equipment such as snowmobiles, go-karting, and jet skis.

The complementary and diverse original equipment markets for Briggs & Stratton engines allows factory managers to plan equipment and labor capacities and schedules in a much more stable operating environment. This helps minimize manufacturing costs, stabilize workforce levels, and even out volumes so that assembly lines can be used in a more efficient fashion.[4]

Exhibit 10.6 *Capacity Expansion Options*

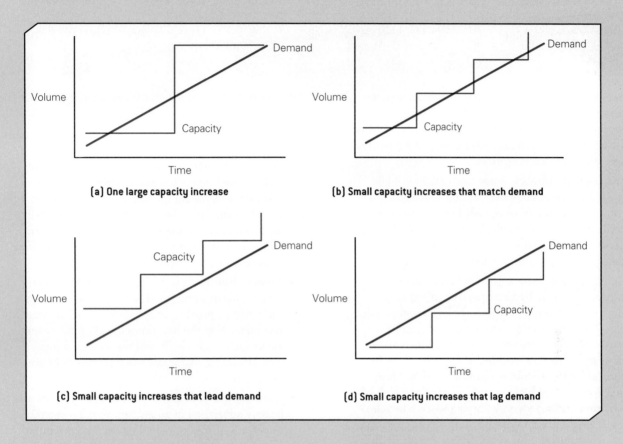

(a) One large capacity increase

(b) Small capacity increases that match demand

(c) Small capacity increases that lead demand

(d) Small capacity increases that lag demand

increased to a point where additional capacity is necessary. It requires less investment and provides for high capacity utilization and thus a higher rate of return on investment. However, it may also reduce long-term profitability through overtime, subcontracting, and productivity losses that occur as the firm scrambles to satisfy demand. In the long run, such a policy can lead to a permanent loss of market position.

4 Short-Term Capacity Management

f short-term demand is stable and sufficient capacity is available, then managing operations to ensure that demand is satisfied is generally easy. However, when demand fluctuates above and below average capacity levels as was illustrated in Exhibit 10.2, firms have two basic choices. First, they can adjust capacity to match the changes in demand by changing internal resources and capabilities. The second approach is to manage capacity by shifting and stimulating demand.

4.1 Managing Capacity by Adjusting Short-Term Capacity Levels

When short-term demand exceeds capacity, a firm must either temporarily increase its capacity or it will be unable to meet all of the demand. Similarly, if demand falls well below capacity, then idle resources reduce profits. Short-term adjustments to capacity can be done in a variety of ways and are summarized below.

- *Add or Share Equipment* Capacity levels that are limited by machine and equipment availability are more difficult to change in the short run because of high capital expense. However, leasing equipment as needed can accomplish this in a cost-effective

Firms can adjust capacity to match changes in demand by changing internal resources and capabilities, or manage capacity by shifting and stimulating demand.

manner. Another way is through innovative partnership arrangements and capacity sharing. For example, a consortium of several hospitals might be set up in which each hospital focuses on a particular specialty and shares services.

- *Sell Unused Capacity* Some firms might sell idle capacity, such as computer storage space and computing capacity, to outside buyers and even to competitors. For example, hotels often develop partnership arrangements to accommodate their competitor's guests when they are overbooked.

- *Change Labor Capacity and Schedules* Labor capacity can usually be managed easily through short-term changes in workforce levels and schedules. Overtime, extra shifts, temporary employees, and outsourcing are common ways of increasing capacity. Adjusting workforce schedules to better coincide with demand patterns is another. Many quick-service restaurants employ large numbers of part-time employees with varying work schedules.

- *Change Labor Skill Mix* Hiring the right people who can learn quickly and adjust to changing job requirements and cross-training them to perform different tasks provides the flexibility to meet fluctuating demand. In supermarkets, for example, it is common for employees to work as cashiers during busy periods and to assist with stocking shelves during slow periods.

- *Shift Work to Slack Periods* Another strategy is to shift work to slack periods. For example, hotel clerks prepare bills and perform other paperwork at night, when check-in and check-out activity is light. This allows more time during the daytime hours to service customers. Manufacturers often build up inventory during slack periods and hold the goods for peak demand periods.

4.2 Managing Capacity by Shifting and Stimulating Demand

A **reservation** is a promise to provide a good or service at some future time and place.

Some general approaches to influence customers to shift demand from periods without adequate capacity to periods with excess

capacity or to fill times with excess capacity, include the following:

- *Vary the Price of Goods or Services* Price is the most powerful way to influence demand. For example, hotels might offer cheaper rates on the weekend; airlines offer better prices for midweek flights; a restaurant might cut its meal prices in half after 9:00 p.m. In a similar fashion, manufacturers typically offer sales and rebates of overstocks to stimulate demand, smooth production schedules and staffing requirements, and reduce inventories.

- *Provide Customers with Information* Many call centers, for example, send notes to customers on their bills or provide an automated voice message recommending the best times to call. Amusement parks such as Disney World use signs and literature informing customers when certain rides are extremely busy.

- *Advertising and Promotion* After-holiday sales are heavily advertised in an attempt to draw customers to periods of traditionally low demand. Manufacturer or service coupons are strategically distributed to increase demand during periods of low sales or excess capacity.

- *Add Peripheral Goods and/or Services* Movie theaters offer rentals of their auditoriums for business meetings and special events at off-peak times. Fast-food chains offer birthday party planning services to fill up slow demand periods between peak meal times. Extended hours also represent a peripheral service; many supermarkets remain open 24/7 and encourage customers to shop during late night hours to reduce demand during peak times.

- *Provide Reservations A* **reservation** *is a promise to provide a good or service at some future time and place.* Typical examples are reservations for hotel rooms, airline seats, and scheduled surgeries and operating rooms. Reservations reduce the uncertainty for both the good- or service-provider and the customer. With advance knowledge of when customer demand will occur, operations managers can better plan their equipment and workforce schedules and rely less on forecasts.

4.3 Revenue Management Systems (RMS)

Many types of organizations manage perishable assets, such as a hotel room, an airline seat, a rental car, a sporting event or concert seat, a room on a cruise line, the capacity of a restaurant catering service or electric power generation, or broadcast advertising space. For such assets, which essentially represent service capacity, high utilization is the key to financial success.

*A **revenue management system (RMS)** consists of dynamic methods to forecast demand, allocate perishable assets across market segments, decide when to overbook and by how much, and determine what price to charge different customer (price) classes.* These four components of RMS—forecasting, allocation, overbooking, and pricing—must work in unison if the objective is to maximize the revenue generated by a perishable asset. The ideas and methods surrounding RMS are often called yield management. Revenue management systems integrate a wide variety of decisions and data into a decision support system used mainly by service-providing businesses.

During the first year of RMS implementation, revenues at National Car Rental increased by $56 million.

The earliest revenue management systems focused solely on overbooking—how many perishable assets to sell in excess of physical capacity to optimally trade off the cost of an unsold asset versus the loss of goodwill of having more arrivals than assets. Modern RMS software simultaneously makes changes in the forecast, allocation, overbooking, and pricing decisions in a real-time operating system. Forecasts are constantly being revised. Allocation involves segmenting the perishable asset into target market categories, such as first, business, and coach classes in an airline flight. Each class is defined by its size (number of seats), price, advance purchase restrictions, and booking policies. Allocation is a real-time, ongoing method that does not end until there is no more opportunity to maximize revenue (the night or concert is over, the airplane takes off). As happens with forecasts, bookings and time move forward; the target market categories are redefined; and prices change in an attempt to maximize revenue.

Many organizations have exploited RMS technology. Marriott improved its revenues by $25–$35 million by using RMS methods. Royal Caribbean Cruise Lines obtained a revenue increase in excess of $20 million for one year.[5] During the first year of RMS implementation, revenues at National Car Rental increased by $56 million.[6]

5 Theory of Constraints

t he **Theory of Constraints (TOC)** *is a set of principles that focus on increasing total process throughput by maximizing the utilization of all bottleneck work activities and workstations.* TOC was introduced in a fictional novel, *The Goal*, by Dr. Eliyahu M. Goldratt.[7] The philosophy and principles of TOC are valuable in understanding demand and capacity management.

The traditional OM definition of throughput is the average number of goods or services completed per time period by a process. TOC views throughput differently:

A **revenue management system (RMS)** consists of dynamic methods to forecast demand, allocate perishable assets across market segments, decide when to overbook and by how much, and determine what price to charge different customer (price) classes.

The **Theory of Constraints (TOC)** is a set of principles that focus on increasing total process throughput by maximizing the utilization of all bottleneck work activities and workstations.

At a bottleneck, the input exceeds the capacity, restricting the total output that is capable of being produced.

throughput *is the amount of money generated per time period through actual sales.* For most business organizations the goal is to maximize throughput, thereby maximizing cash flow. Inherent in this definition is that it makes little sense to make a good or service until it can be sold, and that excess inventory is wasteful.

In TOC, *a* **constraint** *is anything in an organization that limits it from moving toward or achieving its goal.* Constraints determine the throughput of a facility, because they limit production output to their own capacity. There are two basic types of constraints: physical and nonphysical.

A **physical constraint** *is associated with the capacity of a resource such as a machine, employee, or workstation.* Physical constraints result in process bottlenecks. *A* **bottleneck (BN) work activity** *is one that effectively limits the capacity of the entire process.* At a bottleneck, the input exceeds the capacity, restricting the total output that is capable of being produced. *A* **nonbottleneck (NBN) work activity** *is one in which idle capacity exists.*

A **nonphysical constraint** *is environmental or organizational, such as low product demand or an inefficient management policy or procedure.* Inflexible work rules, inadequate labor skills, and poor man- agement are all forms of constraints. Removing nonphysical constraints is not always possible.

Because the number of constraints is typically small, TOC focuses on identifying them; managing BN and NBN work activities carefully; linking them to the market to ensure an appropriate product mix; and sched-

uling the NBN resources to enhance throughput. These principles are summarized in Exhibit 10.7.

In general, the TOC has been successful in many companies. As TOC evolved, it has been applied not only to manufacturing but to other areas such as distribution, marketing, and human resource management. Binney and Smith, maker of Crayola crayons, and Procter & Gamble both use TOC in their distribution efforts. Binney and Smith had high inventory levels yet poor customer service. By using TOC to better position its distribution inventories, it was able to reduce inventories and improve service. Procter & Gamble reported $600 million in savings through inventory reduction and elimination of capital improvement through TOC. A government organization that produces publications of labor statistics for the state of Pennsylvania used TOC to better match work tasks to workers to reduce idle labor and overtime requirements, and to increase throughput, job stability, and profitability.[8]

Throughput is the amount of money generated per time period through actual sales.

A **constraint** is anything in an organization that limits it from moving toward or achieving its goal.

A **physical constraint** is associated with the capacity of a resource such as a machine, employee, or workstation.

A **bottleneck (BN) work activity** is one that effectively limits the capacity of the entire process.

A **nonbottleneck (BN) work activity** is one in which idle capacity exists.

A **nonphysical constraint** is environmental or organizational, such as low product demand or an inefficient management policy or procedure.

Procter & Gamble reported $600 million in savings through inventory reduction and elimination of capital improvement through Theory of Constraints (TOC).

Exhibit 10.7 *Basic Principles of the Theory of Constraints*

Nonbottleneck Management Principles	Bottleneck Management Principles
Move jobs through nonbottleneck workstations as fast as possible until the job reaches the bottleneck workstation.	Only the bottleneck workstations are critical to achieving process and factory objectives and should be scheduled first.
At nonbottleneck workstations, idle time is acceptable if there is no work to do, and therefore, resource utilizations may be low.	An hour lost at a bottleneck resource is an hour lost for the entire process or factory output.
Use smaller order (also called lot or transfer batches) sizes at nonbottleneck workstations to keep work flowing to the bottleneck resources and eventually to the marketplace to generate sales.	Work-in-process buffer inventory should be placed in front of bottlenecks to maximize resource utilization at the bottleneck.
An hour lost at a nonbottleneck resource has no effect on total process or factory output and incurs no real cost.	Use large order sizes at bottleneck workstations to minimize setup time and maximize resource utilization.
	Bottleneck workstations should work at all times to maximize throughput and resource utilization so as to generate cash from sales and achieve the company's goal.

Kreisler Manufacturing Corporation

Kreisler Manufacturing Corporation is a small, family-run company that makes metal components for airplanes. Its clients include Pratt & Whitney, General Electric, Rolls Royce, and Mitsubishi. After learning about TOC, managers identified several areas of the factory, including the Internal Machine Shop and Supplier Deliveries, as bottlenecks, and began to focus on maximizing throughput at these bottlenecks. Setups were videotaped to see exactly what was happening. It was discovered that 60 percent of the time it took to complete a setup involved the worker looking for materials and tools. To remove this constraint, Kreisler assembled all the necessary materials and tools for setup into a prepackage "kit," thus cutting 60 percent off the setup time.

Kreisler also created a "visual factory" by installing red, yellow, and green lights on every machine. If a workstation is being starved or production stops, the operator turns on the red light. If there is a potential crisis or a risk of starving the constraint workstation, the worker turns on the yellow light. If all is running smoothly, the green light is on. Giving the machine operator control over these signals instilled a sense of ownership in the process and caught the attention and interest of everyone in the factory. In the early stages of implementing TOC there were many red lights; today they are green. By applying TOC, on-time deliveries increased to 97 percent from 65 percent, and 15 percent of the factory's "hidden capacity" was revealed and freed up. In addition, WIP inventory was reduced by 20 percent and is expected to be reduced by another 50 percent.[9]

Problems, Activities, and Discussions

1. Define capacity measures for a(n)
 a. brewery.
 b. airline.
 c. movie theater.
 d. restaurant.
 e. pizza store.

2. Hickory Manufacturing Company forecasts the following demand for a product (in thousands of units) over the next five years.

Year	1	2	3	4	5
Forecast demand	60	79	81	84	84

 Currently the manufacturer has eight machines that operate on a two-shift (8 hours each) basis. Twenty days per year are available for scheduled maintenance of equipment. Assume there are 250 workdays in a year. Each manufactured good takes 30 minutes to produce.

 a. What is the capacity of the factory?
 b. At what capacity levels (percentage of normal capacity) would the firm be operating over the next five years based on the forecasted demand? (Hint: Compute the ratio of demand to capacity each year.)
 c. Does the firm need to buy more machines? If so, how many? When? If not, justify.

3. The roller coaster at Treasure Island Amusement Park consists of 15 cars, each of which can carry up to three passengers. According to a time study each run takes 1.5 minutes and the time to unload and load riders is 3.5 minutes. What is the maximum effective capacity of the system in number of passengers per hour?

4. Worthington Hills grocery store has five regular checkout lines and one express line (12 items or less). Based on a sampling study, it takes 11 minutes on the average for a customer to go through the regular line and 4 minutes to go through the express line. The store is open from 9 a.m. to 9 p.m. daily.

 a. What is the store's maximum capacity (customers processed per day)?

 b. What is the store's capacity by day of the week if the five regular checkout lines operate according to the schedule below? (The express line is always open.)

Hours/Day	Mon	Tue	Wed	Thur	Fri	Sat	Sun
9–12 a.m.	1	1	1	1	3	5	2
12–4 p.m.	2	2	2	2	3	5	4
4–6 p.m.	3*	3	3	3	5	3	2
6–9 p.m.	4	4	4	4	5	3	1

 * A 3 means 3 regular checkout lines are open on Monday from 4 to 6 p.m.

5. Given the following data for Albert's fabricating production area:

Fixed costs for one shift	= $60,000
Unit variable cost	= $7
Selling price	= $12
Number of machines	= 5
Number of working days in year	= 340
Processing time per unit	= 50 minutes

 a. What is the annual capacity with a single 8-hour shift?
 b. What is the capacity with two shifts?
 c. What is the break-even volume with a single-shift operation?
 d. What is the maximum revenue with a single shift?
 e. What is the break-even volume with a two-shift operation?

6. How might a college or university with growing enrollment use the capacity expansion strategies in Exhibit 10.6? Discuss the pros and cons of each of these.

7. The process for renewing a driver's license at the Archer County Courthouse is as follows. First, the clerk fills out the application; then the clerk takes the driver's picture; and finally the typist types and processes the new license. It takes an average of five minutes to fill out an application, one minute to take a picture, and seven minutes to type and process the new license.

 a. If there are two clerks and three typists, where will the bottleneck in the system be? How many drivers can be processed in one hour if the clerks and typists work at 80 percent efficiency?

 b. If 40 drivers are to be processed each hour, how many clerks and typists should be hired?

8. How would you apply the Theory of Constraints to a quick-service automobile oil change service? Explain.

9. You have just been promoted to manage the process defined by the five stages A to E below. After three months on the job you realize something is not right with process capacity because your employees experience big pile-ups of work, things take too long to be processed, the opportunity for error is increasing, and the entire process is approaching chaos. Do a capacity analysis of this process. The numbers in parentheses (#) are the time in minutes to complete one unit of work. Demand on the process averages 27 units per hour and each unit must be worked on by all five stages. Administrative clerks complete Stages A and B. The assistant manager completes Stages D and E. The coding specialist takes care of Stage C.

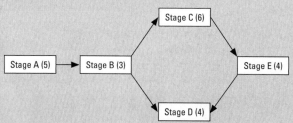

a. How many administrative clerks should be hired assuming a target utilization for them of 90 percent?

b. What is the current labor utilization of the coders if two coding specialists are currently on duty?

c. What is the total process (output) capacity in units per hour for the five-stage process A to E assuming 3 administrative clerks, 2 coding specialists, and 4 assistant managers are on duty?

10. Briefly describe a business you are familiar with and explain how it might use each of the five ways to adjust its short-term capacity levels.

David Christopher, Orthopedic Surgeon, Case Study

David Christopher received his medical degrees from the University of Kentucky and the University of Virginia. He did his residency and early surgeries at Duke University Medical Center. Eight years ago he set up his own orthopedic surgery clinic in Atlanta, Georgia. Today, one other doctor has joined his clinic in addition to 12 support personnel such as X-ray technicians, nurses, accounting, and office support. The medical practice specializes in all orthopedic surgery except it does not perform spinal surgery.

© Goodshoot/Jupiter Images

The clinic has grown to the point where both orthopedic surgeons are working long hours and Dr. Christopher is wondering whether he needs to hire more surgeons.

An orthopedic surgeon is trained in the preservation, investigation, and restoration of the form and function of the extremities, spine, and associated structures by medical, surgical, and physical means. He or she is involved with the care of patients whose musculoskeletal problems include congenital deformities; trauma; infections; tumors; metabolic disturbances of the musculoskeletal system; deformities, injuries; and degenerative diseases of the spine, hands, feet, knee, hip, shoulder, and elbows in children and adults. An orthopedic surgeon is also concerned with primary and secondary muscular problems and the effects of central or peripheral nervous system lesions of the musculoskeletal system. Osteoporosis, for example, results in fractures, especially fractured hips, wrists, and the spine. Treatments have been very successful in getting the fractures to heal.

Dr. Christopher collected the data in Exhibit 10.8 as an example of the clinic's typical workweek. Both surgeons work 11 hours each day with one hour off for lunch or 10 effective hours. All surgeries are performed from 7:00 a.m. to 12:00 noon, four days a week. After lunch from noon to 1:00 p.m., the surgeons see patients

in the hospital and at the clinic from 1:00 p.m. to 6:00 p.m. Over the weekend and on Fridays the surgeons rest, attend conferences and professional meetings, and sometimes do guest lectures at a nearby medical school. The doctors want to leave a safety capacity each week of 10 percent for unexpected problems with scheduled surgeries and emergency patient arrivals.

The setup and changeover times in Exhibit 10.8 reflect time allowed between each surgery for the surgeons to clean themselves up, rest, review the next patient's medical record for any last-minute issues, and prepare for the next surgery. Dr. Christopher feels these changeover times help ensure the quality of their surgery by giving them time between operations. For example, standing on a concrete floor and bending over a patient in a state of concentration places great stress on the surgeon's legs and back. Dr. Christopher likes to sit down for a while between surgeries to relax. Some surgeons go quickly from one patient to the next; however, Dr. Christopher thinks this practice of rushing could lead to medical and surgical errors. Dr. Christopher wants answers to the following questions.

Case Questions for Discussion

1. What is the clinic's current weekly workload?
2. Should the clinic hire more surgeons, and if so, how many?
3. What other options and changes could be made to maximize patient throughput and surgeries, and therefore revenue, yet not comprise on the quality of medical care?
4. What are your final recommendations? Explain your reasoning.

Exhibit 10.8 *Orthopedic Surgeons One-Week Surgery Workload*
(This spreadsheet is available on the Premium Website.)

Orthopedic Surgery Procedure	Surgeon Changeover Time (minutes)	Surgery Time (minutes)	Surgeon Identity	Demand (No. of Patients Scheduled Weekly)
Rotator cuff repair	20	45	B	2
Cartilage knee repair	20	30	B	1
Fracture tibia/fibula	20	60	B	1
Achilles tendon repair	20	30	B	3
ACL ligament repair	20	60	B	4
Fractured hip	30	90	A	0
Fractured wrist	30	75	A	2
Fractured ankle	30	90	A	1
Hip replacement	60	150	A	2
Knee replacement	60	120	A	3
Shoulder replacement	60	180	B	1
Big toe replacement	45	90	B	0

FORECASTING AND DEMAND PLANNING

t he demand for rental cars in Florida and other warm climates peaks during college spring break season. Call centers and rental offices are flooded with customers wanting to rent a vehicle. National Car Rental took a unique approach by developing a customer-identification forecasting model, by which it identifies all customers who are young and rent cars only once or twice a year. These demand analysis models allow National to contact this target market segment in February, when call volumes are lower, to sign them up again. The proactive strategy is designed to both boost repeat rentals and smooth out the peaks and valleys in call center volumes.[1]

© Hill Street Studios/Blend Images/Jupiter Images

learning outcomes

After studying this chapter you should be able to:

LO1 Describe the importance of forecasting to the value chain.

LO2 Explain basic concepts of forecasting and time series.

LO3 Explain how to apply single moving average and exponential smoothing models.

LO4 Describe how to apply regression as a forecasting approach.

LO5 Explain the role of judgment in forecasting.

LO6 Describe how statistical and judgmental forecasting techniques are applied in practice.

What do **you** think?

Think of a pizza delivery franchise located near a college campus. What factors that influence demand do you think should be included in trying to forecast demand for pizzas?

Forecasting *is the process of projecting the values of one or more variables into the future.* Good forecasts are needed in all organizations to drive analyses and decisions related to operations. Forecasting is a key component in many types of integrated operating systems such as supply chain management, customer relationship management, and revenue management systems.

Poor forecasting can result in poor inventory and staffing decisions, resulting in part shortages, inadequate customer service, and many customer complaints. In the telecommunications industry, competition is fierce; and goods and services have very short life cycles. Changing technology, frequent price wars, and incentives for customers to switch services increase the difficulty of providing accurate forecasts.

Many firms integrate forecasting with value chain and capacity management systems to make better operational decisions.

Forecasting is the process of projecting the values of one or more variables into the future.

Many firms integrate forecasting with value chain and capacity management systems to make better operational decisions. National Car Rental, for example, is using data analysis and forecasting methods in its value chain to improve service and reduce costs. Instead of accepting customer demand as it is and trying to plan resources to meet the peaks and valleys, its models help to shift demand to low demand periods and better use its capacity. The proactive approach to spring break peak demand helps plan and coordinate rental office and call center staffing levels and schedules, vehicle availability, advertising campaigns, and vehicle maintenance and repair schedules. Many commercial software packages also tie forecasting modules into supply chain and operational planning systems.

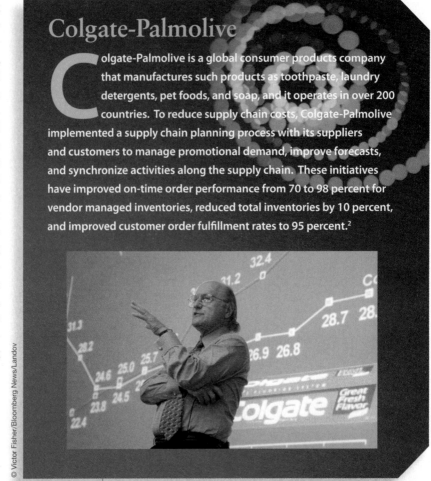

Colgate-Palmolive

Colgate-Palmolive is a global consumer products company that manufactures such products as toothpaste, laundry detergents, pet foods, and soap, and it operates in over 200 countries. To reduce supply chain costs, Colgate-Palmolive implemented a supply chain planning process with its suppliers and customers to manage promotional demand, improve forecasts, and synchronize activities along the supply chain. These initiatives have improved on-time order performance from 70 to 98 percent for vendor managed inventories, reduced total inventories by 10 percent, and improved customer order fulfillment rates to 95 percent.[2]

© Victor Fisher/Bloomberg News/Landov

1 Forecasting and Demand Planning

Organizations make many different types of forecasts. Consider a consumer products company, such as Procter & Gamble, that makes many different goods in various sizes. Top managers need long-range forecasts expressed in total sales dollars for use in financial planning and for sizing and locating new facilities. At lower organizational levels, however, managers of the various product groups need aggregate forecasts of sales volume for their products in units that are more meaningful to them—for example, pounds of a certain type of soap—to establish production plans. Finally, managers of individual manufacturing facilities need forecasts by brand and size—for instance, the number of 64-ounce boxes of Tide detergent—to plan material usage and production schedules. Similarly, airlines need long-range forecasts of demand for air travel to plan their purchases of airplanes and short-term forecasts to develop seasonal routes and schedules; university administrators require enroll-ment forecasts; city planners need forecasts of population trends to plan highways and mass transit systems; and restaurants need forecasts to be able to plan for food purchases.

Accurate forecasts are needed throughout the value chain, as illustrated in Exhibit 11.1, and are used by all functional areas of an organization, such as accounting, finance, marketing, operations, and distribution. Forecasting is typically included in comprehensive value chain and demand-planning software systems. These systems integrate marketing, inventory, sales, operations planning, and financial data. For example, the SAP Demand Planning module enables companies to integrate planning information from different departments or organizations into a single demand plan. Some software vendors are beginning to use the words *demand planning* or *demand chain* instead of *supply chain*. This name change highlights the fact that customer's wants and needs define the customer benefit package and that customer demand pulls goods and services through the supply chain.

Exhibit 11.1 *The Need for Forecasts in a Value Chain*

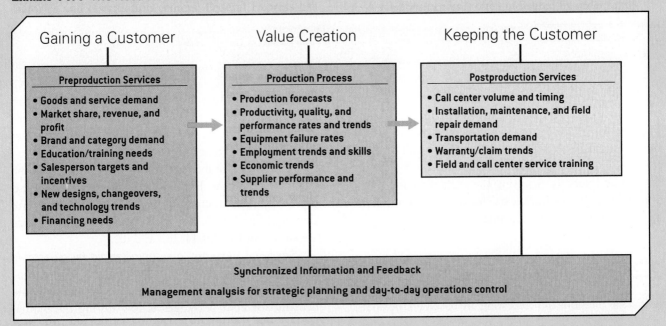

Gaining a Customer | Value Creation | Keeping the Customer

Preproduction Services
- Goods and service demand
- Market share, revenue, and profit
- Brand and category demand
- Education/training needs
- Salesperson targets and incentives
- New designs, changeovers, and technology trends
- Financing needs

Production Process
- Production forecasts
- Productivity, quality, and performance rates and trends
- Equipment failure rates
- Employment trends and skills
- Economic trends
- Supplier performance and trends

Postproduction Services
- Call center volume and timing
- Installation, maintenance, and field repair demand
- Transportation demand
- Warranty/claim trends
- Field and call center service training

Synchronized Information and Feedback

Management analysis for strategic planning and day-to-day operations control

Forecasts of future demand are needed at all levels of organizational decision making.

2 Basic Concepts in Forecasting

before diving into the process of developing forecasting models, it is important to understand some basic concepts that are used in model development. These concepts are independent of the type of model and provide a foundation for users to make better use of the models in operations decisions.

2.1 Forecast Planning Horizon

Forecasts of future demand are needed at all levels of organizational decision making. *The **planning horizon** is the length of time on which a forecast is based.* Long-range forecasts cover a planning horizon of 1 to 10 years and are necessary to plan for the expansion of facilities and to determine future needs for land, labor, and equipment. Intermediate-range forecasts over a 3- to 12-month period are needed to plan workforce levels, allocate budgets among divisions, schedule jobs and resources, and establish purchasing plans. Short-range forecasts focus on the planning horizon of up to 3 months and are used by operations managers to plan production schedules and assign workers to jobs, to determine short-term capacity requirements, and to aid shipping departments in planning transportation needs and establishing delivery schedules.

*The **time bucket** is the unit of measure for the time period used in a forecast.* A time bucket might be a year, quarter, month,

> The **planning horizon** is the length of time on which a forecast is based.
>
> The **time bucket** is the unit of measure for the time period used in a forecast.

week, day, hour, or even a minute. For a long-term planning horizon, a firm might forecast in yearly time buckets; for a short-range planning horizon, the time bucket might be an hour or less. Customer call centers, for example, forecast customer demand in 5-, 6-, or 10-minute intervals. Selecting the right planning horizon length and time bucket size for the right situation is an important part of forecasting.

2.2 Data Patterns in Time Series

Statistical methods of forecasting are based on the analysis of historical data, called a time series. *A time series is a set of observations measured at successive points in time or over successive periods of time.* A time series provides the data for understanding how the variable that we wish to forecast has changed historically. For example, the daily ending Dow Jones stock index is one example of a time series; another is the monthly volume of sales for a product. To explain the pattern of data in a time series, it is often helpful to think in terms of five characteristics: *trend, seasonal, cyclical, random variation, and irregular (one-time) variation.* Different time series may exhibit one or more of these characteristics. Understanding these characteristics is vital to selecting the appropriate forecasting model or approach.

A trend is the underlying pattern of growth or decline in a time series. Although data generally exhibit random fluctuations, a trend shows gradual shifts or movements to relatively higher or lower values over a longer period

A **time series** is a set of observations measured at successive points in time or over successive periods of time.

A **trend** is the underlying pattern of growth or decline in a time series.

Seasonal patterns are characterized by repeatable periods of ups and downs over short periods of time.

Cyclical patterns are regular patterns in a data series that take place over long periods of time.

Random variation (sometimes called **noise**) is the unexplained deviation of a time series from a predictable pattern, such as a trend, seasonal, or cyclical pattern.

Irregular variation is a one-time variation that is explainable.

of time. This gradual shifting over time is usually due to such long-term factors as changes in performance, technology, productivity, population, demographic characteristics, and customer preferences.

Trends can be increasing or decreasing and can be linear or nonlinear. Exhibit 11.2 shows various trend patterns. Linear increasing and decreasing trends are shown in Exhibit 11.2(a) and (b), and nonlinear trends are shown in Exhibit 11.2(c) and (d).

Seasonal patterns *are characterized by repeatable periods of ups and downs over short periods of time.* Seasonal patterns may occur over a year; for example, the demand for cold beverages is low during the winter, begins to rise during the spring, peaks during the summer months, and then begins to decline in the autumn. Manufacturers of coats and jackets, however, expect the opposite yearly pattern. Exhibit 11.3 shows an example of natural gas usage in a single-family home over a two-year period, which clearly exhibits a seasonal pattern.

We generally think of seasonal patterns occurring within one year, but similar repeatable patterns might occur over the weeks during a month, over days during a week, or hours during a day. For instance, pizza delivery peaks on the weekends, and grocery store traffic is higher during the evening hours. Likewise, customer call center volume might peak in the morning and taper off throughout the day. Different days of the week might have different seasonal patterns.

Cyclical patterns *are regular patterns in a data series that take place over long periods of time.* A common example of a cyclical pattern is the movement of stock market values during "bull" and "bear" market cycles.

Random variation *(sometimes called* **noise***) is the unexplained deviation of a time series from a predictable pattern, such as a trend, seasonal, or cyclical pattern.* Random variation is caused by short-term, unanticipated, and nonrecurring factors and is unpredictable. Because of random variation, forecasts are never 100 percent accurate.

Irregular variation *is a one-time variation that is explainable.* For example, a hurricane can cause a surge in demand for building materials, food, and water. After the 9/11 terrorist attacks on the United States, many forecasts that predicted U.S. financial trends and airline

Exhibit 11.2 *Example Linear and Nonlinear Trend Patterns*

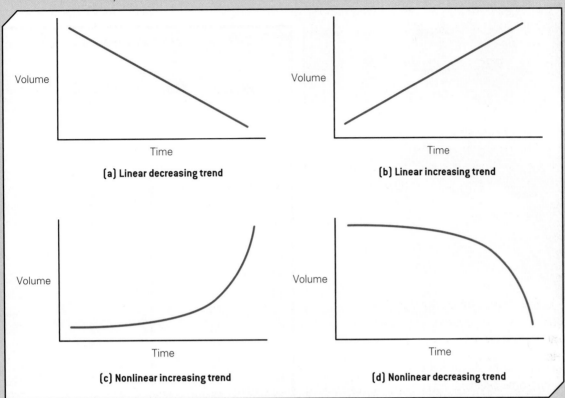

(a) Linear decreasing trend

(b) Linear increasing trend

(c) Nonlinear increasing trend

(d) Nonlinear decreasing trend

Exhibit 11.3 *Seasonal Pattern of Home Natural Gas Usage*

© Superstock/Photolibrary

Exhibit 11.4 *Call Center Volume*

	A	B	C	D
1	Period	Year	Quarter	Call Volume
2	1	1	1	362
3	2	1	2	385
4	3	1	3	432
5	4	1	4	341
6	5	2	1	382
7	6	2	2	409
8	7	2	3	498
9	8	2	4	387
10	9	3	1	473
11	10	3	2	513
12	11	3	3	582
13	12	3	4	474
14	13	4	1	544
15	14	4	2	582
16	15	4	3	681
17	16	4	4	557
18	17	5	1	628
19	18	5	2	707
20	19	5	3	773
21	20	5	4	592
22	21	6	1	627
23	22	6	2	725
24	23	6	3	854
25	24	6	4	661

passenger volumes had to be discarded due to the effects of this one-time event.

An example of a time series is given in the spreadsheet in Exhibit 11.4. These data represent the call volumes over 24 quarters from a call center at a major financial institution. The data are plotted on a chart in Exhibit 11.5. We can see both an increasing trend over the entire six years along with seasonal patterns within each of the years. For example, during the first three quarters of each year, call volumes increase, followed by a rapid decrease in the fourth quarter as customers presumably turn their attention to the holiday season. To develop a reliable forecast for the future, we would need to take into account both the long-term trend and the annual seasonal pattern.

2.3 Forecast Errors and Accuracy

All forecasts are subject to error, and understanding the nature and size of errors is important to making good

decisions. We denote the historical values of a time series by A_1, A_2, \ldots, A_t. In general, A_t represents the value of the time series for period t. We will let F_t represent the forecast value for period t. When we make this forecast, we will not know the actual value of the time series in period t, A_t. However, once A_t becomes known, we can assess how well our forecast was able to predict the actual value of the time series.

All forecasts are subject to error, and understanding the nature and size of errors is important to making good decisions.

Exhibit 11.5 *Chart of Call Volume*

Call Volume

Forecast error *is the difference between the observed value of the time series and the forecast, or $A_t - F_t$.* Suppose that a forecasting method provided the forecasts in column E of Exhibit 11.6 for the call volume time series we discussed earlier. The forecast errors are computed in column F. Because of the inherent inability of any model to forecast accurately, we use quantitative measures of forecast accuracy to evaluate how well the forecasting model performs. Clearly, we want to use models that have small forecast errors. Generally, three types of forecast error metrics are used.

> **Forecast error** is the difference between the observed value of the time series and the forecast, or $A_t - F_t$.

Exhibit 11.6 *Forecast Error of Example Time Series Data (This spreadsheet is available on the Premium Website.)*

	A	B	C	D	E	F	G	H	I	J	K	L
1	Period	Year	Quarter	Call Volume At	Forecast Ft	Error (At - Ft)		Squared Error		Absolute Deviation		Percentage Error
2	1	1	1	362	343.8	18.20		331.24		18.2		5.03%
3	2	1	2	385	361.6	23.40		547.56		23.4		6.08%
4	3	1	3	432	379.4	52.60		2766.76		52.6		12.18%
5	4	1	4	341	397.2	-56.20		3158.44		56.2		16.48%
6	5	2	1	382	415	-33.00		1089.00		33		8.64%
7	6	2	2	409	432.8	-23.80		566.44		23.8		5.82%
8	7	2	3	498	450.6	47.40		2246.76		47.4		9.52%
9	8	2	4	387	468.4	-81.40		6625.96		81.4		21.03%
10	9	3	1	473	486.2	-13.20		174.24		13.2		2.79%
11	10	3	2	513	504	9.00		81.00		9		1.75%
12	11	3	3	582	521.8	60.20		3624.04		60.2		10.34%
13	12	3	4	474	539.6	-65.60		4303.36		65.6		13.84%
14	13	4	1	544	557.4	-13.40		179.56		13.4		2.46%
15	14	4	2	582	575.2	6.80		46.24		6.8		1.17%
16	15	4	3	681	593	88.00		7744.00		88		12.92%
17	16	4	4	557	610.8	-53.80		2894.44		53.8		9.66%
18	17	5	1	628	628.6	-0.60		0.36		0.6		0.10%
19	18	5	2	707	646.4	60.60		3672.36		60.6		8.57%
20	19	5	3	773	664.2	108.80		11837.44		108.8		14.08%
21	20	5	4	592	682	-90.00		8100.00		90		15.20%
22	21	6	1	627	699.8	-72.80		5299.84		72.8		11.61%
23	22	6	2	725	717.6	7.40		54.76		7.4		1.02%
24	23	6	3	854	735.4	118.60		14065.96		118.6		13.89%
25	24	6	4	661	753.2	-92.20		8500.84		92.2		13.95%
26						Sum		87910.60	Sum	1197	Sum	218.13%
27						MSE		3662.94	MAD	49.88	MAPE	9.09%

Mean square error, or MSE, is calculated by squaring the individual forecast errors and then averaging the results over all T periods of data in the time series.

$$MSE = \frac{\Sigma(A_t - F_t)^2}{T} \quad [11.1]$$

For the call center data, this is computed in column H of Exhibit 11.6. The sum of the squared errors is 87910.6, and therefore MSE is 87,910.6/24 = 3,662.94. MSE is probably the most commonly used measure of forecast accuracy. (Sometimes the square root of MSE is computed; this is called the *root mean square error, RMSE*.)

Another common measure of forecast accuracy is the mean absolute deviation (MAD), computed as

$$MAD = \frac{\Sigma|(A_t - F_t)|}{T} \quad [11.2]$$

This measure is simply the average of the sum of the absolute deviations for all the forecast errors. Using the information in column J of Exhibit 11.6, we compute MAD as 1,197/24 = 49.88.

A third measure of forecast error is the mean absolute percentage error (MAPE):

$$MAPE = \frac{\Sigma|(A_t - F_t)/A_t| \times 100}{T} \quad [11.3]$$

This is simply the average of the percentage error for each forecast value in the time series. These calculations are shown in column L of Exhibit 11.6, resulting in MAPE = 218.13%/24 = 9.09 percent. Using MAPE, the forecast differs from actual call volume on average by plus or minus 9.09 percent.

A major difference between MSE and MAD is that MSE is influenced much more by large forecast errors than by small errors (because the errors are squared). The values of MAD and MSE depend on the measurement scale of the time-series data. For example, forecasting profit in the range of millions of dollars would result in very large values, even for accurate forecasting models. On the other hand, a variable like market share, which is measured as a fraction, will always have small values of MAD and MSE. Thus, the measures have no meaning except in comparison with other models used to forecast the same data. MAPE is different in that the measurement scale factor is eliminated by dividing the absolute error by the time-series data value. This makes the measure easier to interpret. The selection of the best measure of forecasting accuracy is not a simple matter; indeed, forecasting experts often disagree on which measure should be used.

3 Statistical Forecasting Models

forecasting methods can be classified as either statistical or judgmental. **Statistical forecasting** *is based on the assumption that the future will be an extrapolation of the past.* Statistical forecasting methods use historical data to predict future values. Many different techniques exist; which technique should be used depends on the variable being forecast and the time horizon. Statistical methods can generally be categorized as *time-series methods*, which extrapolate historical time-series data, and *regression methods*, which extrapolate historical time-series data but can also include other potentially causal factors that influence the behavior of the time series.

A wide variety of statistical forecasting models have been developed, and we cannot discuss all of them. However, we present some of the basic and more popular approaches used in OM applications.

3.1 Single Moving Average

The single moving average concept is based on the idea of averaging random fluctuations in a time series to identify the underlying direction in which the time series is changing. *A moving average (MA) forecast is an average of the most recent "k" observations in a time series.* Thus, the forecast for the next period $(t + 1)$, which we denote as F_{t+1}, for a time series with t observations is

$$F_{t+1} = \Sigma(\text{most recent "}k\text{" observations})/k$$
$$= (A_t + A_{t-1} + A_{t-2} + \ldots + A_{t-k+1})/k \quad [11.4]$$

MA methods work best for short planning horizons when there is no major trend, seasonal, or business cycle patterns, that is, when demand is relatively stable and consistent. As the value of k increases, the forecast reacts slowly to recent changes in the time series because older data are included in the computation. As the value of k decreases, the forecast reacts

Solved Problem

A retail store records customer demand during each sales period. Use the following demand data to develop three-period and four-period moving-average forecasts and single exponential smoothing forecasts with $\alpha = 0.5$. Compute the MAD, MAPE, and MSE for each. Which method provides the better forecast?

Period	Demand	Period	Demand
1	86	7	91
2	93	8	93
3	88	9	96
4	89	10	97
5	92	11	93
6	94	12	95

	A	B	C	D	E
1	Solved Problem				Exponential
2	Period	Demand	3-Month MA	4-Month MA	Smoothing
3	1	86			86
4	2	93			86
5	3	88			89.5
6	4	89	89.00		88.75
7	5	92	90.00	89.00	88.88
8	6	94	89.67	90.50	90.44
9	7	91	91.67	90.75	92.22
10	8	93	92.33	91.50	91.61
11	9	96	92.67	92.50	92.30
12	10	97	93.33	93.50	94.15
13	11	93	95.33	94.25	95.58
14	12	95	95.33	94.75	94.29
15		MAD	1.93	2.09	2.53
16		MSE	5.96	6.21	9.65
17		MAPE	2.04%	1.88%	2.71%

Based on these error metrics, the three-month moving average is the best method among the three. The chart showing these forecasts is shown next.

The spreadsheet (available on the Premium Website) shows the calculations of error metrics using equations 11.1 through 11.3. Be careful to use the correct number of observations when computing the averages; for example, the 3-month moving average has 9 observations while the 4-month moving average has only 8 observations.

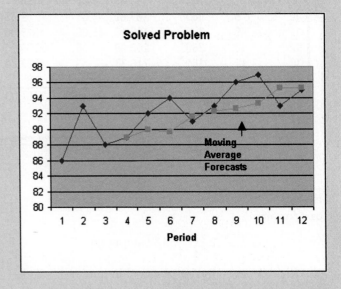

more quickly. If a significant trend exists in the time-series data, moving-average-based forecasts will lag actual demand, resulting in a bias in the forecast.

To illustrate the moving-averages method, consider the data presented in Exhibit 11.7. These data and chart show the number of gallons of milk sold each month at Gas-Mart, a local convenience store. To use moving averages to forecast the milk sales, we must first select the number of data values to be included in the moving average. As an example, let us compute forecasts based on a three-month moving average ($k = 3$). The moving-average calculation for the first three

Exhibit 11.7 *Summary of 3-Month Moving-Average Forecasts (This spreadsheet is available on the Premium Website.)*

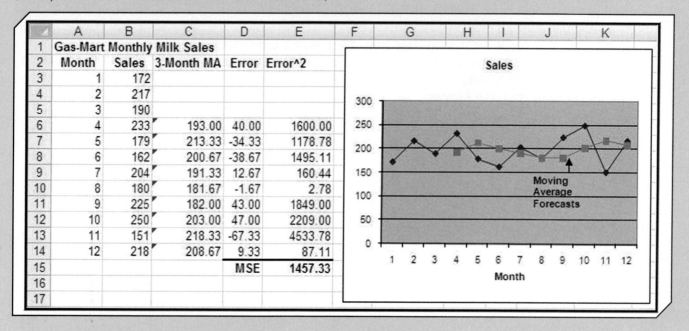

	A	B	C	D	E	F	G	H	I	J	K
1	Gas-Mart Monthly Milk Sales										
2	Month	Sales	3-Month MA	Error	Error^2			Sales			
3	1	172									
4	2	217									
5	3	190									
6	4	233	193.00	40.00	1600.00						
7	5	179	213.33	-34.33	1178.78						
8	6	162	200.67	-38.67	1495.11						
9	7	204	191.33	12.67	160.44						
10	8	180	181.67	-1.67	2.78						
11	9	225	182.00	43.00	1849.00						
12	10	250	203.00	47.00	2209.00						
13	11	151	218.33	-67.33	4533.78						
14	12	218	208.67	9.33	87.11						
15				MSE	1457.33						
16											
17											

months of the milk-sales time series, and thus the forecast for month 4, is

$$F_4 = \frac{172 + 217 + 190}{3} = 193.00$$

Since the actual value observed in month 4 is 233, we see that the forecast error in month 4 is $233 - 193 = 40$. The calculation for the second three-month moving average (F_5) is

$$F_5 = \frac{217 + 190 + 233}{3} = 213.33$$

This provides a forecast for month 5. The error associated with this forecast is $179 - 213.33 = -34.33$. A complete summary of these moving-average calculations is shown in Exhibit 11.8. The mean square error for these forecasts is 1,457.33.

The number of data values to be included in the moving average is often based on managerial insight and judgment. Thus, it should not be surprising that for a particular time series, different values of k lead to different measures of forecast accuracy. One way to find the best number is to use trial and error to identify the value of k that minimizes MSE for the historical data.

Single exponential smoothing (SES) is a forecasting technique that uses a weighted average of past time-series values to forecast the value of the time series in the next period.

3.2 Single Exponential Smoothing

Single exponential smoothing (SES) *is a forecasting technique that uses a weighted average of past time-series values to forecast the value of the time series in the next period.* SES forecasts are based on averages using and weighting the most recent actual demand more than older demand data. SES methods do not try to include trend or seasonal effects. The basic exponential-smoothing model is

$$
\begin{aligned}
F_{t+1} &= \alpha A_t + (1 - \alpha)F_t \\
&= F_t + \alpha(A_t - F_t) \qquad [11.5]
\end{aligned}
$$

where α is called the **smoothing constant** ($0 \leq \alpha \leq 1$). To use this model, set the forecast for period 1, F_1, equal to the actual observation for period 1, A_1. Note that F_2 will also have the same value.

Using the two preceding forms of the forecast equation, we can interpret the simple exponential smoothing model in two ways. In the first model shown in equation 11.5, the forecast for the next period, F_{t+1}, is a weighted average of the forecast made for period t, F_t, and the actual observation in period t, A_t. The second form of the model in equation 11.5, obtained by simply rearranging terms, states

Exhibit 11.8 *Milk-Sales Forecast Error Analysis*
(This spreadsheet is available on the Premium Website.)

	A	B	C	D	E	F	G	H	I	J	K	L
											Squared Errors	
1	Gas-Mart Monthly Milk Sales											
2	Month	Sales	2-Month MA	Error	3-Month MA	Error	4-Month MA	Error		2-Month MA	3-Month MA	4-Month MA
3	1	172										
4	2	217										
5	3	190	194.5	-4.50						20.25		
6	4	233	203.5	29.50	193.00	40.00				870.25	1600.00	
7	5	179	211.5	-32.50	213.33	-34.33	203.00	-24.00		1056.25	1178.78	576.00
8	6	162	206	-44.00	200.67	-38.67	204.75	-42.75		1936.00	1495.11	1827.56
9	7	204	170.5	33.50	191.33	12.67	191.00	13.00		1122.25	160.44	169.00
10	8	180	183	-3.00	181.67	-1.67	194.50	-14.50		9.00	2.78	210.25
11	9	225	192	33.00	182.00	43.00	181.25	43.75		1089.00	1849.00	1914.06
12	10	250	202.5	47.50	203.00	47.00	192.75	57.25		2256.25	2209.00	3277.56
13	11	151	237.5	-86.50	218.33	-67.33	214.75	-63.75		7482.25	4533.78	4064.06
14	12	218	200.5	17.50	208.67	9.33	201.50	16.50		306.25	87.11	272.25
15										16147.75	13116.00	12310.75
16									MSE	1614.78	1457.33	1538.84

that the forecast for the next period, F_{t+1}, equals the forecast for the last period, F_t, plus a fraction, α, of the forecast error made in period t, $A_t - F_t$. Thus, to make a forecast once we have selected the smoothing constant, we need only know the previous forecast and the actual value.

To illustrate the exponential-smoothing approach to forecasting, consider the milk-sales time series presented in Exhibit 11.9 using $\alpha = 0.2$. As we have said, the exponential-smoothing forecast for period 2 is equal to the actual value of the time series in period 1. Thus, with $A_1 = 172$, we will set $F_1 = 172$ to get the computations started. Using equation 11.5 for $t = 1$, we have

$$F_2 = 0.2A_1 + 0.8F_1$$
$$= 0.2(172) + 0.8(172) = 172.00$$

For period 3 we obtain

$$F_3 = 0.2A_2 + 0.8F_2$$
$$= 0.2(217) + 0.8(172) = 81.00$$

By continuing these calculations, we are able to determine the monthly forecast values and the corresponding forecast errors shown in Exhibit 11.9. The mean squared error is MSE = 1285.28. Note that we have not shown an exponential-smoothing forecast or the forecast error for period 1, because F_1 was set equal to A_1 to begin the smoothing computations. You could

use this information to generate a forecast for month 13 as

$$F_{13} = 0.2A_{12} + 0.8F_{12}$$
$$= 0.2(218) + 0.8(194.59) = 199.27$$

Exhibit 11.10 is the plot of the actual and the forecast time-series values. Note in particular how the forecasts "smooth out" the random fluctuations in the time series.

By repeated substitution for F_t in the equation, it is easy to demonstrate that F_{t+1} is a decreasingly weighted average of all past time-series data. Thus, exponential smoothing models "never forget" past data as long as the smoothing constant is strictly between 0 and 1. In contrast, MA methods "completely forget" all the data older than k periods in the past.

Typical values for α are in the range of 0.1 to 0.5. Larger values of α place more emphasis on recent data. If the time series is very volatile and contains substantial random variability, a small value of the smoothing constant is preferred. The reason for this choice is that since much of the forecast error is due to random variability, we do not want to overreact and adjust the forecasts too quickly. For a fairly stable time series with relatively little random variability, larger values of the smoothing constant have the advantage of quickly adjusting the forecasts when forecasting errors occur and therefore allowing

Exhibit 11.9 *Summary of Single Exponential Smoothing Milk-Sales Forecasts with $\alpha = 0.2$ (This spreadsheet is available on the Premium Website.)*

	A	B	C	D	E
1	Gas-Mart Monthly Milk Sales				
2		Alpha	0.2		
3	Month	Sales	Exponential Smoothing Forecast	Error	Error^2
4	1	172	172.00		
5	2	217	172.00	45.00	2025.00
6	3	190	181.00	9.00	81.00
7	4	233	182.80	50.20	2520.04
8	5	179	192.84	-13.84	191.55
9	6	162	190.07	-28.07	788.04
10	7	204	184.46	19.54	381.91
11	8	180	188.37	-8.37	69.99
12	9	225	186.69	38.31	1467.44
13	10	250	194.35	55.65	3096.44
14	11	151	205.48	-54.48	2968.44
15	12	218	194.59	23.41	548.18
16				MSE	1285.28

Exhibit 11.10 *Graph of Single Exponential Smoothing Milk-Sales Forecasts with $\alpha = 0.2$*

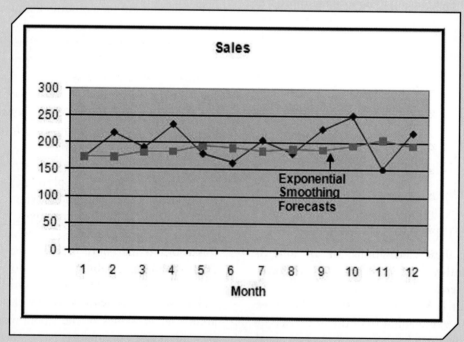

the forecast to react faster to changing conditions. Similar to the MA model, we can experiment to find the best value for the smoothing constant to minimize the mean square error or one of the other measures of forecast accuracy.

The smoothing constant is approximately related to the value of k in the moving-average model by the following relationship:

$$\alpha = 2/(k + 1) \qquad [11.6]$$

Therefore, an exponential smoothing model with $\alpha = 0.5$ is roughly equivalent to a moving-average model with $k = 3$.

One disadvantage of exponential smoothing is that if the time series exhibits a positive trend, the forecast will lag the actual values and, similarly, will overshoot the actual values if a negative trend exists. It is good practice to analyze new data to see whether the smoothing constant should be revised to provide better forecasts. If values of α greater than 0.5 are needed to develop a good forecast, then other types of forecasting methods might be more appropriate.

4 Regression as a Forecasting Approach

regression analysis *is a method for building a statistical model that defines a relationship between a single dependent variable and one or more independent variables, all of which are numerical.* Regression analysis has wide applications in business; however, we will restrict our discussion to simple applications in forecasting. We will first consider only simple regression models in which the value of a time series (the dependent variable) is a function of a single independent variable, time.

Exhibit 11.11 shows total energy costs over the past 15 years at a manufacturing plant. The plant manager needs to forecast costs for the next year to prepare a budget for the VP of finance. The chart suggests that energy costs appear to be increasing in

> **Regression analysis** is a method for building a statistical model that defines a relationship between a single dependent variable and one or more independent variables, all of which are numerical.

Exhibit 11.11 *Factory Energy Costs*

	A	B
1	Factory Energy Costs	
2	Year	Energy Costs
3	1	$ 15,355.38
4	2	$ 15,412.91
5	3	$ 15,926.64
6	4	$ 16,614.18
7	5	$ 16,918.69
8	6	$ 16,837.14
9	7	$ 16,812.51
10	8	$ 17,102.45
11	9	$ 17,461.89
12	10	$ 17,846.76
13	11	$ 18,187.93
14	12	$ 18,782.19
15	13	$ 18,863.18
16	14	$ 18,914.00
17	15	$ 19,319.15

a fairly predictable linear fashion and that energy costs are related to time by a linear function

$$Y_t = a + bt \qquad [11.7]$$

where Y_t represents the estimate of the energy cost in year t. If we can identify the best values for a and b, which represent the intercept and slope of the straight line that best fits the time series, we can forecast cost for the next year by computing $Y_{16} = a + b(16)$.

Simple linear regression finds the best values of a and b using the *method of least squares*. The method of least squares minimizes the sum of the squared deviations between the actual time-series values (A_t) and the estimated values of the dependent variable (Y_t).

4.1 Excel's Add Trendline Option

Excel provides a very simple tool to find the best-fitting regression model for a time series. First, click the chart to which you wish to add a trendline to display the *Chart Tools* menu. The *Trendline* option is selected from the *Analysis* group under the *Layout* tab in the *Chart Tools* menu. Click the *Trendline* button and then *More Trendline Options.* . . . This brings up the *Format Trendline* dialog box shown in Exhibit 11.12. You may choose among a linear and a variety of nonlinear functional forms to fit the data. Selecting an appropriate nonlinear form requires some advanced knowledge of functions and mathematics, so we will restrict our discussion to the linear case. Check the boxes for *Display Equation on chart* and *Display R-squared value on chart.* Excel will display the results on the chart you have selected; you may move the equation and *R*-squared value for better readability by dragging them to a different location. For the linear trendline option

only, you may simply click on the data series in the chart to select the series, and then add a trendline by clicking on the right mouse button (try it!).

Exhibit 11.13 shows the result. The model is

$$\text{Energy cost} = \$15{,}112 + 280.66(\text{Time})$$

Thus, to forecast the cost for the next year, we compute

$$\begin{aligned} \text{Energy cost} &= \$15{,}112 + 280.66(16) \\ &= \$19{,}602.56 \end{aligned}$$

We could forecast further out into the future if we wish, but realize that the uncertainty of the accuracy of the forecast will be higher. The R^2 value is a measure of how much variation in the dependent variable (energy cost) is explained by the independent variable (time). The maximum value for R^2 is 1.0; therefore, the high value of 0.97 suggests that the model will be a good predictor of cost.

Exhibit 11.12 *Format Trendline Dialog Box*

Exhibit 11.13 *Least-Squares Regression Model for Energy Cost Forecasting*

4.2 Causal Forecasting Models with Multiple Regression

In more advanced forecasting applications, other independent variables such as economic indexes or demographic factors that may influence the time series can be incorporated into a regression model. *A linear regression model with more than one independent variable is called a* **multiple linear regression model**.

To illustrate the use of multiple linear regression for forecasting with causal variables, suppose that we wish to forecast gasoline sales. Exhibit 11.14 shows the sales over 10 weeks during June through August along with the average price per gallon. Exhibit 11.15 shows a chart of the gasoline-sales time series with a fitted regression line. During the summer months, it is not unusual to see an increase in sales as more people go on vacations. The chart shows that the sales appear to increase over time with a linear trend, making linear regression an appropriate forecasting technique.

Exhibit 11.14 *Gasoline Sales Data*

	A	B	C
1	Gasoline Sales		
2			
3	Gallons Sold	Week	Price/Gallon
4	10420	1	$ 1.95
5	7388	2	$ 2.20
6	7529	3	$ 2.12
7	11932	4	$ 1.98
8	10125	5	$ 2.01
9	15240	6	$ 1.92
10	12246	7	$ 2.03
11	11852	8	$ 1.98
12	16967	9	$ 1.82
13	19782	10	$ 1.90
14		11	$ 1.80

Multiple regression provides a technique for building forecasting models that not only incorporate time but other potential causal variables.

A linear regression model with more than one independent variable is called a **multiple linear regression model**.

Exhibit 11.15 *Chart of Sales versus Time*

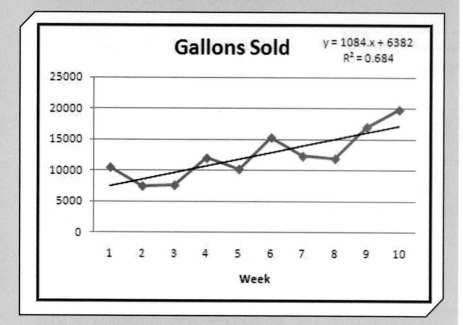

Using the Excel Data Analysis tool for Regression, we obtain the results shown in Exhibit 11.16. The regression model is

Sales = 47,747.81 + (640.71)(Week) − (19,550.6)(Price)

This makes sense because as price increases, sales should decrease. Notice that the R^2 value is higher when both variables are included, explaining almost 86 percent of the variation in the data. The *p*-values for both variables are small, indicating that they are statistically significant variables in predicting sales.

Based on trends in crude oil prices, the company estimates that the average price for the next week will drop to $1.80. Then, using this model we would forecast the sales for week 11 as

Sales = 47,747.81 + (640.71)(11) − (19,550.6)($1.80) = $19,604.54

Notice that this is higher than the pure time-series forecast because the price per gallon is estimated to fall in week 11 and result in a somewhat higher level of sales. The multiple regression model

The fitted regression line is

Sales = 6,382 + (1,084.7)(Week)

The R^2 value of 0.6842 means that that about 68 percent of the variation in the data is explained by time. Using the model, we would predict sales for week 11 as

Sales = 6,382 + (1,084.7)(11) = 18,313.7

However, we also see that the average price per gallon changes each week, and this may influence consumer sales. Therefore, the sales trend might not simply be a factor of steadily increasing demand, but might also be influenced by the average price. Multiple regression provides a technique for building forecasting models that not only incorporate time, in this case, but other potential causal variables. Thus, to forecast gasoline sales (that is, the dependent variable) we propose a model using two independent variables (weeks and price):

Sales = β_0 + (β_1)(Week) + (β_2)(Price)

Exhibit 11.16 *Multiple Regression Results*

▲	A	B	C	D	E	F	G
1	SUMMARY OUTPUT						
2							
3	*Regression Statistics*						
4	Multiple R	0.925735067					
5	R Square	0.856985415					
6	Adjusted R Square	0.816124105					
7	Standard Error	1702.532878					
8	Observations	10					
9							
10	ANOVA						
11		*df*	*SS*	*MS*	*F*	*Significance F*	
12	Regression	2	121585603.5	60792801.75	20.97302837	0.001106194	
13	Residual	7	20290327.4	2898618.2			
14	Total	9	141875930.9				
15							
16		*Coefficients*	*Standard Error*	*t Stat*	*P-value*	*Lower 95%*	*Upper 95%*
17	Intercept	47766.65379	14279.32308	3.345162338	0.012332162	14001.42014	81531.88744
18	Week	640.2462516	241.8696978	2.647070954	0.033082057	68.31529866	1212.177205
19	Price/Gallon	-19557.96493	6725.840727	-2.907884043	0.022728987	-35462.05102	-3653.878837

provides a more realistic and accurate forecast than simply extrapolating the historical time series. The theory of regression analysis is much more complex than presented here, so we caution you to consult more advanced books on the subject for a more complete treatment.

5 Judgmental Forecasting

Judgmental forecasting *relies upon opinions and expertise of people in developing forecasts.* When no historical data are available, only judgmental forecasting is possible. But even when historical data are available and appropriate, they cannot be the sole basis for prediction. The demand for goods and services is affected by a variety of factors, such as global markets and cultures, interest rates, disposable income, inflation, and technology. Competitors' actions and government regulations also have an impact. Thus, some element of judgmental forecasting is always necessary. One interesting example of the role of judgmental forecasting occurred during a national recession. All economic indicators pointed toward a future period of low demand for manufacturers of machine tools. However, the forecasters of one such company recognized that recent government regulations for automobile pollution control would require the auto industry to update its current technology by purchasing new tools. As a result, this machine tool company was prepared for the new business.

One approach that is commonly used in judgmental forecasts is the Delphi method. *The* **Delphi method** *consists of forecasting by expert opinion by gathering judgments and opinions of key personnel based on their experience and knowledge of the situation.* In the Delphi method, a group of people, possibly from both inside and outside the organization, are asked to make a prediction, such as industry sales for the next year. The experts are not consulted as a group so as not to bias their predictions—for example, because of dominant personalities in the group—but make

> **Judgmental forecasting** relies upon opinions and expertise of people in developing forecasts.
>
> The **Delphi method** consists of forecasting by expert opinion by gathering judgments and opinions of key personnel based on their experience and knowledge of the situation.

their predictions and justifications independently. The responses and supporting arguments of each individual are summarized by an outside party and returned to the experts along with further questions. Experts whose opinions fall in the midrange of estimates as well as those whose predictions are extremely high or low (that is, outliers) might be asked to explain their predictions. The process iterates until a consensus is reached by the group, which usually takes only a few rounds. Other common approaches to gathering data for judgmental forecasts are surveys using questionnaires, telephone contact, or personal interviews.

The major reasons given for using judgmental methods rather than quantitative methods are (1) greater accuracy, (2) ability to incorporate unusual or one-time events, and (3) the difficulty of obtaining the data necessary for quantitative techniques. Also, judgmental methods seem to create a feeling of "ownership" and add a common sense dimension.

© SuperStock/Jupiter Images

6 Forecasting in Practice

In practice, managers use a variety of judgmental and quantitative forecasting techniques. Statistical methods alone cannot account for such factors as sales promotions, competitive strategies, unusual economic or environmental disturbances, new product introductions, large one-time orders, labor union strikes, and so on. Many managers begin with a statistical forecast and adjust it to account for such factors. Others may develop independent judgmental and statistical forecasts and then combine them, either objectively by averaging or in a subjective manner. It is impossible to provide universal guidance as to which approaches are best, for they depend on a variety of factors, including the presence or absence of trends and seasonality, the number of data points available, length of the forecast time horizon, and the experience and knowledge of the forecaster. Often, quantitative approaches will miss significant changes in the data, such as reversal of trends, while qualitative forecasts may catch them, particularly when using indicators as discussed earlier in this chapter. The events of 9/11, for example, made it difficult to use trends based on historical data. Quantitative forecasts often are adjusted judgmentally as managers incorporate environmental knowledge that is not captured in quantitative models.

The first step in developing a practical forecast is to understand the purpose of the forecast. For instance, if financial personnel need a sales forecast to determine capital investment strategies, a long (two- to five-year) time horizon is necessary. For such forecasts, using aggregate groups of items is usually more accurate than using individual-item forecasts added together. These forecasts would probably be measured in dollars. In contrast, production personnel may need short-term forecasts for individual items as a basis for procurement of materials and scheduling. In this case, dollar values would not be appropriate; rather, forecasts should be made in terms of units of production. The level of aggregation often dictates the appropriate method. Forecasting the total amount of soap to produce over the next planning period is certainly different from forecasting the amount of each individual product to produce. Aggregate forecasts are generally much easier to develop, whereas detailed forecasts require more time and resources.

The choice of a forecasting method depends on other criteria as well. Among them are the time span for which the forecast is being made, the needed frequency of forecast updating, data requirements, the level of accuracy desired, and the quantitative skills needed. The time span is one of the most critical criteria. Different techniques are applicable for long-range, intermediate-range, and short-range forecasts. Also important is the frequency of updating that

Statistical versus Judgmental Forecasting

A $2-billion consumer packaged-goods company gained significant benefits from implementing a better forecasting system. At the time, the company was selling roughly 1,000 make-to-stock finished goods at 10,000 customer shipment locations which were served through 10 regional distribution centers. The company needed good weekly forecasts for each of the 1,000 finished goods by distribution center.

The forecasting approach depended heavily on numbers generated by sales representatives. However, this approach failed to work. First, the sales representatives had no particular interest in forecasting. They had no training or skill in forecasting and their judgment forecasts on an item and weekly basis were not very good. Second, forecast errors for individual items cancelled each other out when they were aggregated to the assigned distribution center.

Today, standard statistical forecasting approaches are integrated into all company forecasts. Sales representatives have more time to build customer relationships and generate revenue. The company also established a weekly consensus process to review and override the statistical forecasts at the product group level only. Modest changes in the statistical forecasts are made in about half the time. However, of these override decisions, only 40 percent improved the original forecasts—60 percent of the time management overrides made the forecasts worse![3]

will be necessary. For example, the Delphi method takes considerable time to implement and thus would not be appropriate for forecasts that must be updated frequently.

Forecasters should also monitor a forecast to determine when it might be advantageous to change or update the model. *A tracking signal provides a method for doing this by quantifying* **bias**—*the tendency of forecasts to consistently be larger or smaller than the actual values of the time series.* The tracking method used most often is to compute the cumulative forecast error divided by the value of MAD at that point in time; that is,

Tracking signal
$$= \Sigma(A_t - F_t)/\text{MAD} \qquad [11.8]$$

Typically, tracking signals between plus or minus 4 indicate that the forecast is performing adequately. Values outside this range indicate that you should reevaluate the model used.

> A tracking signal provides a method for doing this by quantifying **bias**—the tendency of forecasts to consistently be larger or smaller than the actual values of the time series.

Problems, Activities, and Discussions

1. Discuss some forecasting issues that you encounter in your daily life. How do you make your forecasts?

2. Forecasts and actual sales of portable MP3 players at *Just Say Music* are as follows:

Month	Forecast	Actual Sales
March	150	170
April	220	229
May	205	192
June	256	241
July	250	238
August	260	210
September	270	225
October	280	179

 a. Plot the data and provide insights about the time series.

 b. What is the forecast for December, using a three-period moving average?

 c. What is the forecast for December, using a two-period moving average?

 d. Compute the MAD, MAPE, and MSE for the two- and three-period moving average models and compare your results.

3. For the data in problem 2, find the best single exponential smoothing model by evaluating the MSE for α from 0.1 to 0.9, in increments of 0.1.

4. The monthly sales of a new business software package at a local discount software store were as follows:

Week	1	2	3	4	5	6
Sales	360	415	432	460	488	512

 a. Plot the data and provide insights about the time series.

 b. Find the best number of weeks to use in a moving-average forecast based on MSE.

 c. Find the best single exponential smoothing model to forecast these data.

5. The president of a small manufacturing firm is concerned about the continual growth in manufacturing costs in the past several years. The data series of the cost per unit for the firm's leading product over the past eight years are given as follows:

Year	Cost/Unit ($)	Year	Cost/Unit ($)
1	20.00	5	26.60
2	24.50	6	30.00
3	28.20	7	31.00
4	27.50	8	36.00

a. Construct a chart for this time series. Does a linear trend appear to exist?

b. Develop a simple linear regression model for these data. What average cost increase has the firm been realizing per year?

6. Consider the quarterly sales data for Wothington Kilbourne Health Club shown here:

Year	Quarter 1	2	3	4	Total Sales
1	4	2	1	5	12
2	6	4	4	14	28
3	10	3	5	16	34
4	12	9	7	22	50
5	18	10	13	35	76

a. Develop a four-period moving average model and compute MAD, MAPE, and MSE for your forecasts.

b. Find a good value of α for a single exponential smoothing model and compare your results to part (a).

7. The historical demand for the Panasonic Model 304 Pencil Sharpener in units is: January, 60; February, 80; March, 75; April, 95; and May, 90.

a. Using a four-month moving average, what is the forecast for June? If June experienced a demand of 100, what is the forecast for July?

b. Using single exponential smoothing with $\alpha = 0.2$, if the forecast for January had been 70, compute what the exponential forecast would have been for the remaining months through June.

c. Develop a linear regression model and compute a forecast for June, July, and August.

8. Interview a current or previous employer about how he or she makes forecasts. Document in one page what you discovered, and describe it using the ideas discussed in this chapter.

9. Canton Supplies, Inc., is a service firm that employs approximately 100 people. Because of the necessity of meeting monthly cash obligations, the Chief Financial Officer wants to develop a forecast of monthly cash requirements. Because of a recent change in equipment and operating policy, only the past seven months of data are considered relevant.

Month	Cash Required ($1,000)	Month	Cash Required ($1,000)
1	205	5	230
2	212	6	240
3	218	7	246
4	224		

10. Two experienced managers at Wilson Boat, Inc. are resisting the introduction of a computerized exponential smoothing system, claiming that their judgmental forecasts are much better than any computer could do. Their past record of predictions is as follows:

Week	Actual Demand	Manager's Forecast
1	4,000	4,500
2	4,200	5,000
3	4,200	4,000
4	3,000	3,800
5	3,800	3,600
6	5,000	4,000
7	5,600	5,000
8	4,400	4,800
9	5,000	4,000
10	4,800	5,000

a. How would the manager's forecast compare to a single exponential smoothing forecast using $\alpha = 0.4$?

b. Based on whatever calculations you think appropriate, are the manager's judgmental forecasts performing satisfactory?

c. What other criteria should be used to select a forecasting method for this company?

BankUSA: Forecasting Help Desk Demand by Day Case Study

"Hello, is this the Investment Management Help Desk?" said a tired voice on the other end of the telephone line at 7:42 a.m. "Yes, how can I help you?" said Thomas Bourbon, customer service representative (CSR). "I've got a problem. My best customer, with assets of over $10 million in our bank, received his monthly trust account statement. He says we computed the market value of one of his stocks inaccurately by using the wrong share price, which makes his statement $42,000 too low. I assured him we would research the problem and get back to him by the end of the day. Also, do you realize that I waited

over four minutes before you answered my call?" said the trust administrator, Chris Miami. "Mr. Miami, give me the customer's account number and the stock in question, and I'll get back to you within the hour. Let's solve the customer's problem first. I apologize for the long wait," said Bourbon in a positive and reassuring voice.

The Help Desk supports fiduciary operations activities worldwide by answering questions from company employees, such as portfolio managers, stock traders, backroom company process managers, branch bank managers, accountants, and trust account administrators. These internal customers originate over 98 percent of the volume of Help Desk inquiries. Over 50 different internal processes and organizational units call the Help Desk. Some external customers such as large estate and trust administrators are tied directly to their accounts via the Internet and occasionally call the Help Desk directly.

The Help Desk is the primary customer contact unit within fiduciary operations, employing 14 full-time customer service representatives (CSRs), 3 CSR support employees, and 3 managers, for a total of 20 people. The 3 CSR support employees work full-time on research in support of the CSRs answering the telephone.

The Help Desk handles about 2,000 calls a week, and the pressure to reduce unit cost is ongoing. Forecast accuracy is a key input to better staffing decisions that minimize costs and maximize service. The table at the top of the next column shows the number of calls per day (Call Volume).

The senior manager of the Help Desk, Dot Gifford, established a team to try to evaluate short-term forecasting. The "Help Desk Staffing Team" consists of Gifford, Bourbon, Miami, and a new employee, David Hamlet, who

Day	Call Volume
1	413
2	536
3	495
4	451
5	480
6	400
7	525
8	490
9	492
10	519
11	402
12	616
13	485
14	527
15	461
16	370

has an undergraduate major in operations management at a leading business school. This four-person team is charged with developing a long-term forecasting procedure for the Help Desk. Gifford asked the team to make an informal presentation of their analysis in 10 days. The primary job of analysis has fallen on Hamlet, the newly hired operations analyst. It's his chance to make a good first impression on his boss and colleagues.

© Daniel Karmann/dpa/Landov

Case Questions for Discussion

1. What are the service management characteristics of the CSR job?

2. Define the mission statement and strategy of the Help Desk. Why is the Help Desk important? Who are its customers?

3. How would you handle the customer affected by the inaccurate stock price in the bank's trust account system? Would you take a passive or proactive approach? Justify your answer.

4. Using the data on Call Volume in the table above, how would you forecast short-term demand?

MANAGING INVENTORIES

banana Republic is a unit of San Francisco's Gap, Inc., and accounts for about 13 percent of Gap's $15.9 billion in sales. As Gap shifted its product line to basics such as cropped pants, jeans, and khakis, Banana Republic had to move away from such staples and toward trends, trying to build a name for itself in fashion circles. But fashion items, which have a much shorter product life cycle and are riskier because their demand is more variable and uncertain, bring up a host of operations management issues. In one recent holiday season, the company had bet that blue would be the top-selling color in stretch merino wool sweaters. They were wrong. Marka Hansen, company president noted, "The No. 1 seller was moss green. We didn't have enough."[1]

© Jim Boorman/Pixland/Jupiter Images

learning outcomes

After studying this chapter you should be able to:

LO1 Explain the importance of inventory, types of inventories, and key decisions and costs.

LO2 Describe the major characteristics that impact inventory decisions.

LO3 Describe how to conduct an ABC inventory analysis.

LO4 Explain how a fixed order quantity inventory system operates, and how to use the EOQ and safety stock models.

LO5 Explain how a fixed period inventory system operates.

LO6 Describe how to apply the single period inventory model.

What do **you** think?

Can you cite any experiences in which the lack of appropriate inventory at a retail store has caused you as the customer to be dissatisfied?

Inventory *is any asset held for future use or sale.* Companies such as Banana Republic must order far in advance of the actual selling season with little information on which to base their inventory decisions. The wrong choices can easily lead to a mismatch between customer demand and availability, resulting in either lost opportunities for sales, or overstocks that might have to be sold at a loss or at least a minimal profit.

Simply maintaining large stocks of inventory is costly and wasteful. The old concept of keeping warehouses and stockrooms filled to capacity with inventory has been replaced with the idea of producing finished goods as late as possible prior to shipment to the customer. Better information technology and applications of quantitative tools and techniques for inventory management have allowed dramatic reductions in inventory.

The expenses associated with financing and maintaining inventories are a substantial part of the cost of doing business (i.e., cost of goods sold). Managers are faced with the dual challenges of maintaining sufficient inventories to meet demand while at the same time incurring the lowest possible cost. **Inventory management** *involves planning, coordinating, and controlling the acquisition, storage, handling, movement, distribution, and possible sale of raw materials, component parts and subassemblies, supplies and tools, replacement parts, and other assets that are needed to meet customer wants and needs.*

Inventory is any asset held for future use or sale.

Top management needs to understand the role that inventories have on a company's financial performance, operational efficiency, and customer satisfaction, and strike the proper balance in meeting strategic objectives.

1 Understanding Inventory

nventories may be physical goods used in operations and include raw materials, parts, subassemblies, supplies, tools, equipment or maintenance, and repair items. For example, a small pizza business must maintain inventories of dough, toppings, sauce, and cheese, as well as supplies such as boxes, napkins, and so on. Hospitals maintain inventories of blood and other consumables, and retail stores such as Best Buy maintain inventories of finished goods—televisions, appliances, and DVDs—for sale to customers. In some service organizations, such as airlines and hotels, inventories are not physical goods that customers take with them, but provide capacity available for serving customers.

One of the difficulties of inventory management is that every department in an organization generally views inventory objectives differently. Marketing and operations prefer high inventory levels to provide the best possible customer service and process efficiency, while financial personnel seek to minimize inventory investment and thus would prefer small inventories. Top management needs to understand the role that inventory has on a company's financial performance, operational efficiency, and customer satisfaction and strike the proper balance in meeting strategic objectives.

© StreetStock Images/Brand X Pictures/Jupiter Images

1.1 Key Definitions and Concepts

Many different types of inventories are maintained throughout the value chain—before, during, and after production—to support operations and meet customer demands (see Exhibit 12.1). **Raw materials, component parts, subassemblies, and supplies** *are inputs to manufacturing and service-delivery processes.* **Work-in-process (WIP) inventory** *consists of partially finished products in various stages of completion that are waiting further processing.* For example, a pizza restaurant might prepare a batch of pizzas with only cheese and sauce and add other toppings when orders are placed. WIP inventory also acts as a buffer between workstations in flow shops or departments in job shops to enable the operating process to continue when equipment might fail at one stage or supplier shipments are late. **Finished goods inventory** *is completed products ready for distribution or sale to customers.* Finished goods might be stored in a warehouse or at the point of sale in retail stores. Finished goods inventories are necessary to satisfy customers' demands quickly without having to wait for a product to be made or ordered from the supplier.

High levels of WIP and finished goods inventories can be undesirable. Large WIP can hide such problems as unreliable machines, late supplier shipments,

Exhibit 12.1 *Role of Inventory in the Value Chain*

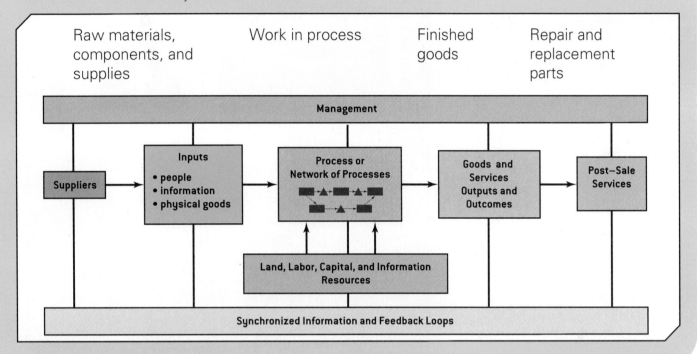

or defective parts; and large amounts of finished goods inventory can quickly become obsolete when technology changes or new products are introduced.

Customer demand is most often highly variable and uncertain. Lack of sufficient inventory can cause production lines to shut down or customers to become dissatisfied and purchase goods and services elsewhere. To reduce the risk associated with not having enough inventory, firms often maintain additional stock beyond their normal estimates. **Safety stock inventory** *is an additional amount that is kept over and above the average amount required to meet demand.*

Where Is Your Inventory?

Today, tiny radio frequency identification (RFID) chips embedded in packaging or products allow scanners to track SKUs as they move throughout the store. RFID chips help companies locate items in stockrooms and identify where they should be placed in the store. Inventory on the shelves can easily be tracked to trigger replenishment orders. Recalled or expired products can be identified and pulled from the store before a customer can buy them, and returned items can be identified by original purchase location and date, and whether or not they were stolen. One interesting application has been developed by CVS, a Rhode Island–based pharmacy chain, which is testing RFID technology to inform when a customer has not picked up his or her prescription medicine.[2]

> **Safety stock inventory** is an additional amount that is kept over and above the average amount required to meet demand.

1.2 Inventory Management Decisions and Costs

Inventory managers deal with two fundamental decisions:

1. When to order items from a supplier or when to initiate production runs if the firm makes its own items, and
2. How much to order or produce each time a supplier or production order is placed.

Inventory management is all about making tradeoffs among the costs associated with these decisions.

Inventory costs can be classified into four major categories:

1. ordering or setup costs,
2. inventory-holding costs,
3. shortage costs, and
4. unit cost of the SKUs.

Ordering costs *or* **setup costs** *are incurred as a result of the work involved in placing orders with suppliers or configuring tools, equipment, and machines within a factory to produce an item.* Order and setup costs do not depend on the number of items purchased or manufactured, but rather on the number of orders that are placed.

Weyerhaeuser

In the pulp and paper industry, pulp mills use large outside storage facilities that store inventories of wood chips. These serve as buffers against differences between mill supply and demand to reduce stockout risk and also act as a hedge against changes in wood prices and allow timely buying when prices are low. However, aging of wood during storage can affect its properties, resulting in color deterioration, decreased pulp yield, lower quality, and higher processing costs. Weyerhaeuser developed a computer model called the Springfield Inventory Target model (SPRINT) to assist inventory managers in dealing with risk in inventory level decisions. The model projects chip inflows, outflows, and inventory levels by time period for any length of time in the future and helps managers to answer such questions as: How reliable are inventory projections? What is the stockout risk in each time period? What are the total inventory costs in each period? Given future projections, what is the optimal inventory level? SPRINT has taken a lot of the guesswork out of making inventory decisions by providing objective assessments of costs and risks. Its principal benefit has been to allow managers to reduce inventories and stay within acceptable risk levels, lowering annual inventory costs by at least $2 million.[3]

© Weyerhaeuser Company/PRNewsFoto/AP Photo

Inventory-holding *or* **inventory-carrying costs** *are the expenses associated with carrying inventory.* Holding costs are typically defined as a percentage of the dollar value of inventory per unit of time (generally one year). They include costs associated with maintaining storage facilities, such as gas and electricity, taxes, insurance, and labor and equipment necessary to handle, move, and retrieve an SKU. However, from an accounting perspective, it is very difficult to precisely allocate such costs to an individual SKU. Essentially, holding costs reflect the opportunity cost associated with using the funds invested in inventory for alternative uses and investments.

Shortage *or* **stockout costs** *are costs associated with a SKU being unavailable when needed to meet demand.* These costs can reflect backorders, lost sales, or service interruptions for external customers, or costs associated with interruptions to manufacturing and assembly lines for internal customers. **Unit cost** *is the price paid for purchased goods or the internal cost of producing them.* In most situations, the units cost is a "sunk cost" because the total purchase cost is not affected by the order quantity. However, the unit cost of SKUs is an important purchasing consideration when quantity discounts are offered; it may be more economical to purchase large quantities at a lower unit cost to reduce the other cost categories and thus minimize total costs.

Ordering costs or **setup costs** are incurred as a result of the work involved in placing orders with suppliers or configuring tools, equipment, and machines within a factory to produce an item.

Inventory-holding or **inventory-carrying costs** are the expenses associated with carrying inventory.

Shortage or **stockout costs** are costs associated with a SKU being unavailable when needed to meet demand.

Unit cost is the price paid for purchased goods or the internal cost of producing them.

2 Inventory Characteristics

a large variety of inventory situations are possible.[4] For instance, a self-serve gasoline station maintains an inventory of only a few grades of gasoline, whereas a large appliance store may carry several hundred different items. Demand for gasoline is relatively constant, while the demand for air conditioners is highly seasonal and variable. If a gasoline station runs out of gas, a customer will go elsewhere. However, if an appliance store does not have a particular item in stock, the customer may be willing to order the item and wait for delivery or go to another appliance store. Since the demand and inventory characteristics of the gasoline station and appliance store differ significantly, the proper control of inventories requires different approaches.

One of the first steps in analyzing an inventory problem should be to describe the essential characteristics of the environment and inventory system that follow.

Number of Items Most firms maintain inventories for a large number of items, often at multiple locations. To manage and control these inventories, each item is often assigned a unique identifier, called a stock-keeping unit, or SKU. *A **stock-keeping unit (SKU)** is a single item or asset stored at a particular location.* For example, each color and size of a man's dress shirt at a department

store and each type of milk (whole, 2 percent, skim) at a grocery store would be a different SKU.

Nature of Demand Demand can be classified as independent or dependent, deterministic or stochastic, and dynamic or static. ***Independent demand** is demand for an SKU that is unrelated to the demand for other SKUs and needs to be forecasted.* This type of demand is directly related to customer (market) demand. Inventories of finished goods such as toothpaste and electric fans have independent demand characteristics.

*SKUs are said to have **dependent demand** if their demand is directly related to the demand of other SKUs and can be calculated without needing to be forecasted.* For example, a chandelier may consist of a frame and six light-bulb sockets. The demand for chandeliers is an independent demand and would be forecasted, while the demand for sockets is dependent on the demand for chandeliers. That is, for a forecast of chandeliers we can calculate the number of sockets required.

*Demand is **deterministic** when uncertainty is not included in its characterization.* In other words, we

> A **stock-keeping unit (SKU)** is a single item or asset stored at a particular location.
>
> **Independent demand** is demand for an SKU that is unrelated to the demand for other SKUs and needs to be forecasted.
>
> SKUs are said to have **dependent demand** if their demand is directly related to the demand of other SKUs and can be calculated without needing to be forecasted.
>
> Demand is **deterministic** when uncertainty is not included in its characterization.

Keeping Track of Farm SKUs

Radio frequency identification devices (RFIDs) are being used to track and monitor farm SKUs such as cans of pistachio nuts, ostriches, cattle, fish, and trees. The technology also helps prevent crime, reduces disease, and provides proximity information on a real-time basis. China, for example, wants to use RFIDs to monitor 1.2 billion pigs in its Sichuan province, which is more than the total number of the pigs in the United States. An outbreak of pig disease in Sichuan in 2005 caused direct losses of $1.5 billion and indirect losses of $1.25 billion. New Zealand wants to pass a legal requirement that its 100 million pet dogs be RFID-tagged. Canada is tagging fish; Germany, trees; and Australia, cattle. Keeping up with the millions of SKUs in global food-supply chains is a monumental task.[5]

© James Baigrie/FoodPix/Jupiter Images

every day of the year. This is an example of static demand because the parameters of the probability distribution do not change over time. However, the demand for airline flights to Orlando, Florida, will probably have different means and variances throughout the year, reaching peaks around Thanksgiving, Christmas, spring break, and in the summer, with lower demands at other times. This is an example of dynamic demand.

assume that demand is known in the future, and not subject to random fluctuations. In many cases, demand is highly stable and this assumption is reasonable; in others, we might simply assume deterministic demand to make our models easier to solve and analyze, perhaps by using historical averages or statistical point estimates of forecasts. **Stochastic demand** *incorporates uncertainty by using probability distributions to characterize the nature of demand.* For example, suppose that the daily demand for milk is determined to be normally distributed with a mean of 100 and a standard deviation of 10. If we develop an inventory model assuming that the daily demand is fixed at 100 and ignore the variability of demand to simplify the analysis, we have a case of deterministic demand. If a model incorporates the actual probability distribution, then it is a stochastic demand model.

Demand, whether deterministic or stochastic, may also fluctuate or remain stable over time. *Stable demand is usually called* **static demand,** *and demand that varies over time is referred to as* **dynamic demand.** For example, the demand for milk might range from 90 to 110 gallons per day,

Number and Duration of Time Periods In some cases, the selling season is relatively short, and any leftover items cannot be physically or economically stored until the next season. For example, Christmas trees that have been cut cannot be stored until the following year; similarly, other items such as seasonal fashions, are sold at a loss simply because there is no storage space or it is uneconomical to keep them for the next year. In other situations, firms are concerned with planning inventory requirements over an extended number of time periods, for example, monthly over a year, in which inventory is held from one time period to the next. The type of approach used to analyze "single-period" inventory problems is different from the approach needed for the "multiple-period" inventory situation.

Lead Time *The* **lead time** *is the time between placement of an order and its receipt.* Lead time is affected by transportation carriers, buyer order frequency and size, and supplier production schedules and may be deterministic or stochastic (in which case it may be described by some probability distribution).

A lost sale has an associated opportunity cost, which may include loss of goodwill and potential future revenue.

Stochastic demand incorporates uncertainty by using probability distributions to characterize the nature of demand.

Stable demand is usually called **static demand,** and demand that varies over time is referred to as **dynamic demand.**

The **lead time** is the time between placement of an order and its receipt.

Stockouts *A stockout is the inability to satisfy the demand for an item.* When stockouts occur, the item is either backordered or a sale is lost. *A* **backorder** *occurs when a customer is willing to wait for the item; a* **lost sale** *occurs when the customer is unwilling to wait and purchases the item elsewhere.* Backorders result in additional costs for transportation, expediting, or perhaps buying from another supplier at a higher price. A lost sale has an associated opportunity cost, which may include loss of goodwill and potential future revenue.

Stockouts Matter

The Grocery Manufacturers of America estimates that almost 40 percent of consumers would postpone a purchase or buy elsewhere when encountering a stockout, resulting in the loss of almost $200,000 in annual sales per average supermarket. More damaging is the fact that more than 3 percent of shoppers are frustrated enough to terminate the entire shopping trip and go to another store.[6]

3 ABC Inventory Analysis

One useful method for defining inventory value is ABC analysis. It is an application of the *Pareto principle*, named after an Italian economist who studied the distribution of wealth in Milan during the 1800s. He found that a "vital few" controlled a high percentage of the wealth. ABC analysis consists of categorizing inventory items or SKUs into three groups according to their total annual dollar usage.

1. "A" items account for a large dollar value but a relatively small percentage of total items.
2. "C" items account for a small dollar value but a large percentage of total items.
3. "B" items are between A and C.

Typically, A items comprise 60 to 80 percent of the total dollar usage but only 10 to 30 percent of the items, whereas C items account for 5 to 15 percent of the total dollar value and about 50 percent of the items. There is no specific rule on where to make the division between A, B, and C items; the percentages used here simply serve as a guideline. Total dollar usage or value is computed by multiplying item usage (volume) times the items dollar value (unit cost). Therefore, an A item could have a low volume but high unit cost, or a high volume and low unit cost.

ABC analysis gives managers useful information to identify the best methods to control each category of inventory. Class A items require close control by operations managers. Class C items need not be as closely controlled and can be managed using automated computer systems. Class B items are somewhere in the middle.

4 Fixed Quantity Systems

In a **fixed quantity system (FQS)**, *the order quantity or lot size is fixed; that is, the same amount, Q, is ordered every time.* FQSs are used extensively in the retail industry. For example, most department stores have cash registers that are tied into a computer system. When the clerk enters the SKU number, the computer recognizes that the item is sold, recalculates the inventory position, and determines whether a purchase order should be initiated to replenish the stock. If computers are not used in such systems, some form of manual system is necessary for monitoring daily usage. This requires substantial clerical effort and commitment by the users to fill out the proper forms when items are used and is often a source of errors, so it is not recommended.

A **stockout** is the inability to satisfy the demand for an item.

A **backorder** occurs when a customer is willing to wait for the item; a **lost sale** occurs when the customer is unwilling to wait and purchases the item elsewhere.

In a **fixed quantity system (FQS)**, the order quantity or lot size is fixed; that is, the same amount, Q, is ordered every time.

Solved Problem

Consider the data for 20 inventoried items of a small company shown in the spreadsheet in Exhibit 12.2. The projected annual dollar usage column is found by multiplying the annual projected usage based on forecasts (in units) by the unit cost. We can sort these data easily in Microsoft Excel where we have listed the cumulative percentage of items, cumulative dollar usage, and cumulative percent of total dollar usage. Analysis of Exhibit 12.3 indicates that about 70 percent of the total dollar usage is accounted for by the first five items, that is, only 25 percent of the items. In addition, the lowest 50 percent of the items account for only about 5 percent of the total dollar usage. Exhibit 12.4 shows a simple histogram of the ABC analysis classification scheme for this set of data.

Exhibit 12.2 *Usage-Cost Data for 20 Inventoried Items (This spreadsheet is available on the Premium Website)*

	A	B	C	D
1	ABC Inventory Analysis			
2				
3		Projected		Projected
4	Item	Annual		Annual
5	Number	Usage	Unit Cost	Dollar Usage
6	1	15,000	$5.00	$75,000
7	2	6,450	$20.00	$129,000
8	3	5,000	$45.00	$225,000
9	4	200	$12.50	$2,500
10	5	20,000	$35.00	$700,000
11	6	84	$250.00	$21,000
12	7	800	$80.00	$64,000
13	8	300	$5.00	$1,500
14	9	10,000	$35.00	$350,000
15	10	2,000	$65.00	$130,000
16	11	5,000	$25.00	$125,000
17	12	3,250	$125.00	$406,250
18	13	9,000	$0.50	$4,500
19	14	2,900	$10.00	$29,000
20	15	800	$15.00	$12,000
21	16	675	$200.00	$135,000
22	17	1,470	$100.00	$147,000
23	18	8,200	$15.00	$123,000
24	19	1,250	$0.16	$200
25	20	2,500	$0.20	$500

Exhibit 12.3 *ABC Analysis Calculations*

	A	B	C	D	E	F	G	H
28			Projected		Projected	Cumulative	Cumulative	Cumulative
29		Number	Usage	Unit Cost	Dollar Usage	Dollar	Percent	Percent
30	Rank	Item	Annual		Annual	Usage	of Total	of Items
31	1	5	20,000	$35.00	$700,000	$700,000	26.12%	5%
32	2	12	3,250	$125.00	$406,250	$1,106,250	41.27%	10%
33	3	9	10,000	$35.00	$350,000	$1,456,250	54.33%	15%
34	4	3	5,000	$45.00	$225,000	$1,681,250	62.72%	20%
35	5	17	1,470	$100.00	$147,000	$1,828,250	68.21%	25%
36	6	16	675	$200.00	$135,000	$1,963,250	73.24%	30%
37	7	10	2,000	$65.00	$130,000	$2,093,250	78.09%	35%
38	8	2	6,450	$20.00	$129,000	$2,222,250	82.91%	40%
39	9	11	5,000	$25.00	$125,000	$2,347,250	87.57%	45%
40	10	18	8,200	$15.00	$123,000	$2,470,250	92.16%	50%
41	11	1	15,000	$5.00	$75,000	$2,545,250	94.96%	55%
42	12	7	800	$80.00	$64,000	$2,609,250	97.34%	60%
43	13	14	2,900	$10.00	$29,000	$2,638,250	98.43%	65%
44	14	6	84	$250.00	$21,000	$2,659,250	99.21%	70%
45	15	15	800	$15.00	$12,000	$2,671,250	99.66%	75%
46	16	13	9,000	$0.50	$4,500	$2,675,750	99.82%	80%
47	17	4	200	$12.50	$2,500	$2,678,250	99.92%	85%
48	18	8	300	$5.00	$1,500	$2,679,750	99.97%	90%
49	19	20	2,500	$0.20	$500	$2,680,250	99.99%	95%
50	20	19	1,250	$0.16	$200	$2,680,450	100.00%	100%

Exhibit 12.4 *ABC Histogram for the Results from Exhibit 12.3*

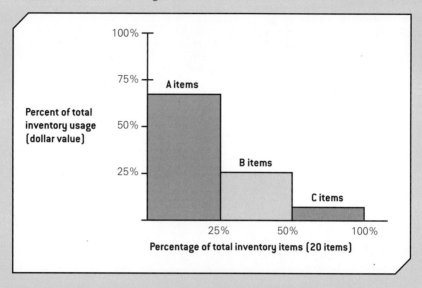

A more appropriate way to manage a FQS is to continuously monitor the inventory level and place orders when the level reaches some "critical" value. The process of triggering an order is based on the inventory position. **Inventory position (IP)** *is defined as the on-hand quantity (OH) plus any orders placed but which have not arrived (called scheduled receipts, SR), minus any backorders (BO), or*

$$IP = OH + SR - BO \qquad [12.1]$$

When the inventory position falls at or below a certain value, r, called the *reorder point*, a new order is placed.

Why not base the reordering decision on the physical inventory level, that is, just the on-hand quantity, instead of a more complex calculation? The answer is simple. When an order is placed but has not been received, the physical stock level will continue to fall below the reorder point before the order arrives. If the ordering process is automated, the computer logic will continue to place many unnecessary orders simply because it will see the stock level being less than r, even though the original order will soon arrive and replenish the stock. By including scheduled receipts, the inventory position will be larger than the reorder point, thus preventing duplicate orders. Once the order arrives and no scheduled receipts are outstanding, then the inven-

tory position is the same as the physical inventory. Backorders are included in the inventory position calculation because these items have already been sold and are reserved for customers as soon as the order arrives.

The choice of the reorder point depends on the lead time and the nature of demand. One approach to choosing the reorder point is to use the *average demand during the lead time* (μ_L). If d is the average demand per unit of time (day, week, and so on), and L is the lead time expressed in the same units of time, then the average demand during the lead time is calculated as follows:

$$r = \mu_L = (d)(L) \qquad [12.2]$$

(From a practical perspective, it is easier to work with daily data rather than annual data, particularly if a firm does not operate seven days per week.)

A summary of fixed quantity systems is given in Exhibit 12.5. Exhibits 12.6 and 12.7 contrast the performance of FQS when demand is relatively stable and highly variable. The dark lines in these exhibits track the actual inventory

Inventory position (IP) is defined as the on-hand quantity (OH) plus any orders placed but which have not arrived (called scheduled receipts, SR), minus any backorders (BO).

Exhibit 12.5 Summary of Fixed Quantity System (FQS)

Managerial Decisions	Order Quantity (Q) and Reorder Point (r)
Ordering decision rule	A new order is triggered whenever the inventory position for the item drops to or past the reorder point. The size of each order is Q units.
Key characteristics	The order quantity Q is always fixed.
	The time between orders (TBO) is constant when the demand rate is stable.
	The time between orders (TBO) can vary when demand is variable.

Exhibit 12.6 Fixed Quantity System (FQS) Under Stable Demand

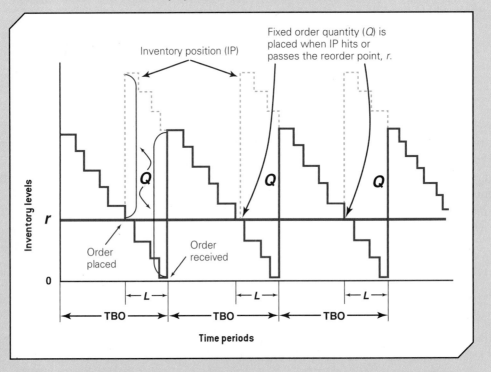

levels. In Exhibit 12.6, we see that the time between orders (TBO) is also constant in the deterministic and static case, and therefore, the ordering cycle repeats itself exactly. Here, the TBO is constant because there is no uncertainty and average demand is assumed to be constant and continuous. Recall from our previous discussion that the reorder point should be based on the inventory position, not the physical inventory level. In Exhibit 12.6 you can see that the inventory position jumps by Q when the order is placed. With the highly variable demand rate, the TBO varies while Q is constant.

Exhibit 12.7 *Fixed Quantity System (FQS) with Highly Variable Demand*

4.1 The EOQ Model

*The **Economic Order Quantity (EOQ)** model is a classic economic model developed in the early 1900s that minimizes the total cost, which is the sum of the inventory-holding cost and the ordering cost.* Several key assumptions underlie the quantitative model we will develop:

- Only a single item (SKU) is considered.
- The entire order quantity (Q) arrives in the inventory at one time.
- Only two types of costs are relevant—order/setup and inventory-holding costs.
- No stockouts are allowed.
- The demand for the item is deterministic and continuous over time.
- Lead time is constant.

Under the assumptions of the model, the cycle inventory pattern is shown in Exhibit 12.8. Suppose that we begin with Q units in inventory. Because units are assumed to be withdrawn at a constant rate, the inventory level falls in a linear fashion until it hits zero. Because no stockouts are allowed, a new order can be planned to arrive when the inventory falls to zero; at this point, the inventory is replenished back up to Q. This cycle keeps repeating. This regular pattern allows us to compute the total cost as a function of the order quantity, Q.

Cycle inventory *(also called **order** or **lot size inventory**) is inventory that results from purchasing or producing in larger lots than are needed for immediate consumption or sale.* From the constant demand assumption, the average cycle inventory can be easily computed as the average of the maximum and minimum inventory levels:

$$\text{Average cycle inventory} = (\text{Maximum inventory} + \text{Minimum inventory})/2$$
$$= Q/2 \qquad [12.3]$$

The **Economic Order Quantity (EOQ)** model is a classic economic model developed in the early 1900s that minimizes the total cost, which is the sum of the inventory-holding cost and the ordering cost.

Cycle inventory (also called **order** or **lot size inventory**) is inventory that results from purchasing or producing in larger lots than are needed for immediate consumption or sale.

Exhibit 12.8 *Cycle Inventory Pattern for the EOQ Model*

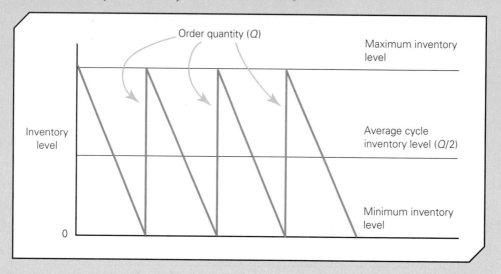

If the average inventory during each cycle is $Q/2$, then the average inventory level over any number of cycles is also $Q/2$.

The inventory-holding cost can be calculated by multiplying the average inventory by the cost of holding one item in inventory for the stated period (see equation 12.4). The period of time selected for the model is up to the user; it can be a day, week, month, or year. However, because the inventory-holding costs for many industries and businesses are expressed as an annual percentage or rate, most inventory models are developed on an annual cost basis. Let

> I = annual inventory-holding
> charge expressed as a percent
> of unit cost

> C = unit cost of the inventory
> item or SKU

The cost of storing one unit in inventory for the year, denoted by C_h, is given by $C_h = (I)(C)$. Thus, the general equation for annual inventory-holding cost is

$$\text{Annual inventory holding cost} = \left(\text{Average inventory}\right)\left(\begin{array}{c}\text{Annual holding}\\\text{cost}\\\text{per unit}\end{array}\right)$$

$$= \tfrac{1}{2}QC_h \qquad [12.4]$$

The second component of the total cost is the ordering cost. Because the inventory-holding cost is expressed on an annual basis, we need to express ordering costs as an annual cost also. Letting D denote the annual demand for the product, we know that by ordering Q items each time we order, we have to place D/Q orders per year. If C_o is the cost of placing one order, the general expression for the annual ordering cost is shown in equation 12.5.

$$\begin{array}{c}\text{Annual}\\\text{ordering}\\\text{cost}\end{array} = \left(\begin{array}{c}\text{Number of}\\\text{orders}\\\text{per year}\end{array}\right)\left(\begin{array}{c}\text{Cost}\\\text{per}\\\text{order}\end{array}\right) = \left(\dfrac{D}{Q}\right)C_o \qquad [12.5]$$

Thus the total annual cost shown in equation 12.6—inventory-holding cost given by equation 12.4 plus order or setup cost given by equation 12.5—can be expressed as

$$TC = \tfrac{1}{2}QC_h + \dfrac{D}{Q}C_o \qquad [12.6]$$

The next step is to find the order quantity, Q, that minimizes the total cost expressed in equation 12.7. By using differential calculus, we can show that the quantity that minimizes the total cost, denoted by Q^*, is given by equation 12.7. Q^* is referred to as the *economic order quantity*, or *EOQ*.

$$Q^* = \sqrt{\dfrac{2DC_o}{C_h}} \qquad [12.7]$$

Solved Problem

The sales of a popular mouthwash at Merkle Pharmacies over the past six months has averaged 2,000 cases per month, which is the current order quantity. Merkle's cost is $12.00 per case. The company estimates its cost of capital to be 12 percent. Insurance, taxes, breakage, handling, and pilferage are estimated to be approximately 6 percent of item cost. Thus the annual inventory-holding costs are estimated to be 18 percent of item cost. Since the cost of one case is $12.00, the cost of holding one case in inventory for one year is $C_h = (IC) = 0.18(\$12.00) = \2.16 per case per year.

The cost of placing an order is estimated to be $38.00 per order regardless of the quantity requested in the order. From this information, we have

$$D = 24{,}000 \text{ cases per year.}$$

$$C_o = \$38 \text{ per order.}$$

$$I = 18 \text{ percent.}$$

$$C = \$12.00 \text{ per case.}$$

$$C_h = IC = \$2.16.$$

Thus, the minimum-cost economic order quantity (EOQ) as given by equation 12.7 is

$$\text{EOQ} = \sqrt{\frac{2(24{,}000)(38)}{2.16}} = 919 \text{ cases rounded to a whole number.}$$

For the data used in this problem, the total-cost model based on equation 12.6 is

$$TC = \tfrac{1}{2}Q(\$2.16) + \frac{24{,}000}{Q}(\$38.00)$$

$$= \$1.08Q + \frac{912{,}000}{Q}.$$

For the EOQ of 919, the total cost is calculated to be $(1.08)(919) + (24{,}000/919)(\$38.00) = \$1{,}984.90$.

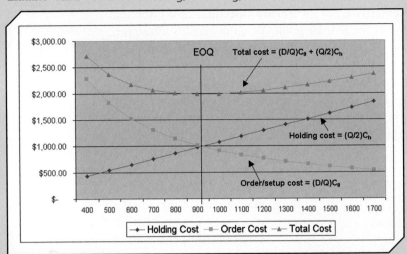

Exhibit 12.9 *Chart of Holding, Ordering, and Total Costs*

We can compare this total cost using EOQ with the current purchasing policy of $Q = 2{,}000$. The total annual cost of the current order policy is

$$TC = 1.08(2{,}000) + 912{,}000/2{,}000$$
$$= \$2{,}616.00$$

Thus, the EOQ analysis has resulted in a $2,616.00 − $1,984.90 = $631.10 savings, or 24.1 percent cost reduction. Notice also that the total ordering costs ($992) are equal to the total inventory holding costs ($992) for the EOQ. In general, this will always be true for the EOQ model. Exhibit 12.9 graphs the total cost when EOQ = 919 cases and you can see the curve is relatively flat around the minimum total cost solution.

To find the reorder point, let us suppose that the lead time to order a case of mouthwash from the manufacturer is three days. Considering weekends and holidays, Merkle operates 250 days per year. So, on a daily basis, the annual demand of 24,000 cases corresponds to a demand of 24,000/250 = 96 cases. Thus we anticipate 288 cases to be sold during the three-day lead time. Therefore, Merkle should order a new shipment from the manufacturer when the inventory level reaches 288 cases using equation 12.2. Also note that the company will place 24,000/919 = 26.12, or approximately 26 orders per year. With 250 working days per year, an order would be placed every 250/26 = 9.6 days. This represents the average time between orders (TBO) of 9.6 days in Exhibit 12.6.

4.2 Safety Stock and Uncertain Demand in a Fixed Order Quantity System

Stockouts occur whenever the lead-time demand exceeds the reorder point. When demand is uncertain, using EOQ based only on the average demand will result in a high probability of a stockout. One way to reduce this risk is to increase the reorder point by adding safety stock. To determine the appropriate reorder point, we first need to know the probability distribution of the lead-time demand, which we often assume to be normally distributed. The appropriate reorder point depends on the risk that management wants to take of incurring a stockout. A **service level** is the desired

A **service level** is the desired probability of not having a stockout during a lead-time period.

probability of not having a stockout during a lead-time period. For example, a 95 percent service level means that the probability of a stockout during the lead time is .05. Choosing a service level is a management policy decision.

When a normal probability distribution provides a good approximation of lead time demand, the general expression for reorder point is

$$r = \mu_L + z\sigma_L \qquad [12.8]$$

where μ_L = average demand during the lead time

σ_L = standard deviation of demand during the lead time

z = the number of standard deviations necessary to achieve the acceptable service level

The term "$z\sigma_L$" represents the amount of safety stock.

Solved Problem

Southern Office Supplies, Inc. distributes a wide variety of office supplies and equipment to customers in the Southeast. One SKU is laser printer paper, which is purchased in reams from a firm in Appleton, Wisconsin. Ordering costs are $45.00 per order. One ream of paper costs $3.80, and Southern uses a 20 percent annual inventory-holding cost rate for its inventory. Thus, the inventory-holding cost is $C_h = IC = 0.20(\$3.80) = \0.76 per ream per year. The average annual demand is 15,000 reams, or about $15,000/52 = 288.5$ per week, and historical data shows that the standard deviation of weekly demand is about 71. The lead time from the manufacturer is two weeks. Using equations 12.9 and 12.10, the average demand during the lead time is $(288.5)(2) = 577$ reams, and the standard deviation of demand during the lead time is approximately $71\sqrt{2} = 100$ reams.

If we apply the EOQ model using the average annual demand, we find that the optimal order quantity would be

$$Q^* = \sqrt{\frac{2DC_o}{C_h}} = \sqrt{\frac{2(15,000)(45)}{0.76}} = 1,333 \text{ reams}$$

Using this order quantity, Southern can anticipate placing approximately 11 orders per year ($D/Q =$

15,000/1,333), slightly more than a month apart. The reorder point without safety stock for this EOQ model would be $2(288.5) = 577$. Using equation 12.6, the total annual cost is $1,012.92.

Suppose Southern's managers desire a service level of 95%, which results in a stockout roughly once every 2 years. Using the normal distribution tables in Appendix A, we find that a 5 percent upper tail area corresponds to a standard normal z-value of 1.645. That is, the reorder point using equation 12.8, r, is 1.645 standard deviations above the mean, or

$$r = \mu_L + z\sigma_L = 577 + 1.645(100) = 742 \text{ reams}$$

This suggests that a policy of ordering 1,333 reams whenever the inventory position reaches the reorder point of 742 will minimize inventory costs and incur a risk of at most a 5 percent probability of stockout during a lead-time period. Note that this policy increases the reorder point by $742 - 577 = 165$ reams, which represents the safety stock.

So what does this additional safety stock cost the company? The cost of the additional safety stock is simply C_h times the amount of safety stock, or ($0.76/ream) (165 reams) = $125.40 per year. Although this policy increases the cost by $125, customers should be much more satisfied because of the smaller chance of experiencing a stockout.

In many cases, we do not know the mean and standard deviation of demand during the lead time, but only for some other length of time, such as a month or year. Suppose that μ_t and σ_t are the mean and standard deviation of demand for some time interval t, and that the lead time L is expressed in the same units (days, weeks, and so on). If the distributions of demand for all time intervals are identical to and independent of each other, we can use some basic statistical results to find μ_L and σ_L based on μ_t and σ_t as follows:

$$\mu_L = \mu_t L \qquad [12.9]$$

$$\sigma_L = \sigma_t \sqrt{L} \qquad [12.10]$$

Hewlett-Packard

The Hewlett-Packard (HP) Company has complex supply chains for its products. The Vancouver division manufactures one of HP's popular printers and ships them to distribution centers (DCs) in the United States, the Far East, and Europe. Because the printer industry is highly competitive, HP dealers like to carry as little inventory as possible, but must supply goods to end-users quickly. Consequently, HP operates under a lot of pressure to provide high levels of availability at the DCs for the dealers. DCs operate as inventory stocking points with large safety stocks to meet a target off-the-shelf fill rate, where replenishment of goods comes from manufacturing. HP developed a quantitative model to compute cost-effective target inventory levels considering safety stock to meet fill rate requirements. The model helped to improve inventory investment by over 20 percent. What would the HP chief financial officer think of this result?[7]

5 Fixed Period Systems

an alternative to a fixed order quantity system is a **fixed period system (FPS)**—*sometimes called a periodic review system—in which the inventory position is checked only at fixed intervals of time,* T, *rather than on*

a continuous basis. At the time of review, an order is placed for sufficient stock to bring the inventory position up to a predetermined maximum inventory level, M, sometimes called the replenishment level, or "order-up-to" level.

There are two principal decisions in an FPS:

1. the time interval between reviews, and
2. the replenishment level.

We can set the length of the review period judgmentally based on the importance of the item or the convenience of review. For example, management might select to review noncritical SKUs every month and more critical SKUs every week. We can also incorporate economics using the EOQ model.

The EOQ model provides the best "economic time interval" for establishing an optimal policy for an FPS system under the model assumptions. This is given by

$$T = Q^*/D \qquad [12.11]$$

where Q^* is the economic order quantity. The optimal replenishment level is computed by

$$M = d(T + L) \qquad [12.12]$$

where d = average demand per time period (days, weeks, months, etc.), L is the lead time in the same time units, and M is the demand during the lead time plus review period. When demand is stochastic, managers can add appropriate safety stock to the optimal replenishment level to ensure a target service level.

The choice of which system—FQS or FPS—to use depends on a variety of factors, such as how many total SKUs the firm must monitor, whether computer or manual systems are used, availability of technology and human resources, the nature of the ABC profile, and the strategic focus of the organization such as customer service or cost minimization. Thus, the ultimate decision is a combination of technical expertise and subjective managerial judgment.

A summary of fixed period systems is given in Exhibit 12.10. Exhibit 12.11 shows the system operation graphically. In Exhibit 12.11, at the time of the first review, a rather large amount of inventory (IP_1) is in stock, so the order quantity (Q_1) is relatively small. Demand during the lead time was small, and when the order arrived, a large amount of inventory was still available. At the third review cycle, the

> A **fixed period system (FPS)**—sometimes called a periodic review system—is one in which the inventory position is checked only at fixed intervals of time, T, rather than on a continuous basis.

stock level is much closer to zero since the demand rate has increased (steeper slope). Thus, the order quantity (Q_3) is much larger and during the lead time, demand was high and some stockouts occurred. Note that when an order is placed at time T, it does not arrive until time $T + L$. Thus, in using a FPS, managers must cover the risk of a stockout over the time period $T + L$, and therefore, must carry more inventory.

To add safety stock to the replenishment level (M) in an FPS, we can use the same statistical principles as with the FQS. We must compute safety stock over the period $T + L$ so the replenishment level is computed as follows:

$$M = \mu_{T+L} + z \times \sigma_{T+L}$$
$$\mu_{T+L} = \mu_t (T + L)$$
$$\sigma_{T+L} = \sigma_t \sqrt{T + L} \qquad [12.13]$$

Exhibit 12.10 *Summary of Fixed Period Inventory Systems*

Managerial Decisions	Review Period (*T*) and Replenishment Level (*M*)
Ordering decision rule	Place a new order every *T* periods, where the order quantity at time *t* is $Q_t = M - IP_t$. IP_t is the inventory position at the time of review, *t*.
Key characteristics	The review period, *T*, is constant and placing an order is time-triggered.
	The order quantity Q_t varies at each review period.
	M is chosen to include the demand during the review period and lead time, plus any safety stock.
	Stockouts can occur when demand is stochastic and can be addressed by adding safety stock to the expected demand during time *T + L*.

Solved Problem

Refer back to the previous Solved Problem on Southern Office Supplies. Using the same information (ordering costs = $45.00 per order, inventory-holding cost = $0.76 per ream per year, and average annual demand = 15,000 reams), we can apply the EOQ model using the average annual demand, and find that the optimal order quantity would be

$$Q^* = \sqrt{\frac{2DC_o}{C_h}} = \sqrt{\frac{2(15,000)(45)}{0.76}} = 1,333 \text{ reams}$$

Data indicate that it usually takes two weeks ($L = 2$ weeks) for Southern to receive a new supply of paper from the manufacturer.

Using equation 12.11 we compute the review period as
$$T = Q^*/D = 1,333/15,000 = .0889 \text{ years}$$

If we assume 260 working days/year, then $T = 260(.0889) = 23.1$ days, which is approximately five weeks. Whether to round T up or down is a manage-

ment decision. Since the average annual demand is 15,000 units, the average weekly demand is 15,000/52 = 288.46. From equation 12.12, the optimal replenishment level is

$$M = (d)(T + L) = 288.46(5 + 2) = 2,019.22 \text{ units}$$

Therefore, we review the inventory position every five weeks and place an order to replenish the inventory up to an M level of 2,019 units.

To add safety stock to the M level we compute the standard deviation of demand over the period $T + L$ using equation 12.13 and the standard deviation of weekly demand of 71 reams as follows.

$$\sigma_{T+L} = 71\sqrt{5+2} = 187.8 \text{ reams}$$

and then the safety stock is

$$z\sigma_{T+L} = 1.645(187.8) = 309 \text{ reams}.$$

The M level with safety stock and a 95% service level is
$M = 2019 + 309 = 2,328$ reams.

Exhibit 12.11 *Operation of a Fixed Period System (FPS)*

6 Single-Period Inventory Model

t he single-period inventory model applies to inventory situations in which one order is placed for a good in anticipation of a future selling season where demand is uncertain. At the end of the period the product has either sold out, or there is a surplus of unsold items to sell for a salvage value. Single-period models are used in situations involving seasonal or perishable items that cannot be carried in inventory and sold in future periods.

One example is the situation faced by Banana Republic at the beginning of the chapter; other examples would be ordering dough for a pizza restaurant, which stays fresh for only three days, and purchasing seasonal holiday items such as Christmas trees. In such a single-period inventory situation, the only inventory decision is how much of the product to order at the start of the period. Because newspaper sales are a typical example of the single-period situation, the single-period inventory problem is sometimes referred to as the *newsvendor problem*.

The newsvendor problem can be solved using a technique called *marginal economic analysis*, which compares the cost or loss of ordering one additional item with the cost or loss of not ordering one additional item. The costs involved are defined as

c_s = the cost per item of overestimating demand (salvage cost); this cost represents the loss of ordering one additional item and finding that it cannot be sold.

c_u = the cost per item of underestimating demand (shortage cost); this cost represents the opportunity loss of not ordering one additional item and finding that it could have been sold.

The optimal order quantity is the value of Q^* that satisfies equation 12.14 is:

$$P(\text{demand} \leq Q^*) = \frac{c_u}{c_u + c_s} \qquad [12.14]$$

This formula can be used for any probability distribution of demand, such as a uniform or a normal distribution.

Solved Problem

Let us consider a buyer for a department store who is ordering fashion swimwear about six months before the summer season. The store plans to hold an August clearance sale to sell any surplus goods by July 31. Each piece costs $40 per pair and sells for $60 per pair. At the sale price of $30 per pair, it is expected that any remaining stock can be sold during the August sale. We will assume that a uniform probability distribution ranging from 350 to 650 items, shown in Exhibit 12.12, describes the demand. The expected demand is 500.

The retailer will incur the cost of overestimating demand whenever it orders too much and has to sell the extra items available after July. Thus, the cost per item of overestimating demand is equal to the purchase cost per item minus the August sale price per item; that is, $C_s = \$40 - \$30 = \$10$. In other words, the retailer will lose $10 for each item that it orders over the quantity demanded. The cost of underestimating demand is the lost profit (opportunity loss) due to the fact that it could have sold but was not available in inventory. Thus the per-item cost of underestimating demand is the difference between the regular selling price per item and the purchase cost per item; that is, $C_u = \$60 - \$40 = \$20$. The optimal order size Q must satisfy this condition:

Exhibit 12.12 *Probability Distribution for Single Period Model*

$$P(\text{demand} \leq Q^*) = \frac{c_u}{c_u + c_s} = \frac{20}{20 + 10} = \frac{20}{30} = \frac{2}{3}$$

Because the demand distribution is uniform, the value of Q^* is two-thirds of the way from 350 to 650. Thus, $Q^* = 550$ swimwear SKUs. Note that whenever $c_u < c_s$, the formula leads to the choice of an order quantity more likely to be less than demand; hence a higher risk of a stockout is present. However, when $c_u > c_s$, as in the example, the optimal order quantity leads to a higher risk of a surplus. If the demand distribution were other than uniform, then the same process applies. The optimal order quantity, Q^*, must still satisfy the requirement that $P(\text{demand} \leq Q^*) = 2/3$.

There's More to Inventory Modeling

The inventory models we discussed are the basic models for managing inventories. Many other models have been developed to assist managers in other situations. For example, there are cases in which it may be desirable—from an economic point of view—to plan for and allow shortages. This situation is most common when the value per unit of the inventory is very high, and hence the inventory-holding cost is high. An example is a new-car dealer's inventory. Most customers do not find the specific car they want in stock, but are willing to back-

order it. Another example is when suppliers offer discounts for purchasing larger quantities of goods. This often occurs because of economies of scale of shipping larger loads, from not having to break apart boxes of items, or simply as an incentive to increase total revenue. You might have noticed such incentives at stores like Amazon, where CDs or DVDs are often advertised in discounted bundles—for example, two CDs by the same artist for a lower price than buying them individually. For both of these situations, quantitative models have been developed for finding optimal inventory order policies.

Problems, Activities, and Discussions

1. Discuss some of the issues that a small pizza restaurant might face in inventory management. Would a pizza restaurant use a fixed order quantity or period system for fresh dough (purchased from a bakery on contract)? What would be the advantages and disadvantages of each in this situation?

2. List some products in your personal or family "inventory." How do you manage them? (For instance, do you constantly run to the store for milk? Do you throw out a lot of milk because of spoilage?) How might the ideas in this chapter change your way of managing these SKUs?

3. Interview a manager at a local business about his or her inventory and materials-management system, and prepare a report summarizing its approaches. Does the system use any formal models? Why or why not? How does the manager determine inventory-related costs?

4. The Welsh Corporation uses 10 key components in one of its manufacturing plants. Perform an ABC analysis from the data in Exhibit 12.13, shown below. Explain your decisions and logic.

Exhibit 12.13 *ABC Data for Problem 4*

SKU	Item Cost $	Annual Demand
WC219	$ 0.15	13,000
WC008	1.20	22,500
WC916	3.25	400
WC887	0.41	6,200
WC397	4.65	12,300
WC654	2.10	350
WC007	0.90	225
WC419	0.45	6,500
WC971	7.50	2,950
WC713	12.00	1,500

5. MamaMia's Pizza purchases its pizza delivery boxes from a printing supplier. MamaMia's delivers on-average 200 pizzas each month. Boxes cost 20 cents each, and each order costs $10 to process. Because of limited storage space, the manager wants to charge inventory holding at 30 percent of the cost. The lead time is one week, and the restaurant is open 360 days per year. Determine the economic order quantity, reorder point, number of orders per year, and total annual cost. If the supplier raises the cost of each box to 25 cents, how would these results change?

6. Refer to the situation in Problem 5. Suppose the manager of MamaMia's wants to order 200 boxes each month. How much more than the optimal cost will be necessary to implement this policy?

7. Crew Soccer Shoes Company is considering a change of their current inventory control system for soccer shoes. The information regarding the shoes is given below.

 Demand = 200 pairs/week
 Lead time = 3 weeks
 Order cost = $65/order
 Holding cost = $4.00/pair/yr
 Cycle service level = 95%
 Standard deviation of weekly demand = 50
 Number of weeks per year = 52

 The company decides to use a fixed order quantity system. What would be the reorder point and the economic order quantity? Explain how the system will operate.

8. Tune Football Helmets Company is considering changing its current inventory control system for football helmets. The information regarding the helmets is given below.

 Demand = 200 units/week
 Lead time = 2 weeks
 Order cost = $60/order
 Holding cost = $1.50/unit/yr
 Cycle service level = 95%
 Standard deviation of weekly demand = 40
 Number of weeks per year = 52

 Compute T and M for a fixed period inventory system model with and without safety stock. Explain how this system would operate.

9. The reorder point is defined as the demand during the lead time for the item. In cases of long lead times, the lead-time demand and thus the reorder point may exceed the economic order quantity, Q^*. In such cases the inventory position will not equal the inventory on hand when an order is placed, and the reorder point may be expressed in terms of either inventory position or inventory on hand. Consider the EOQ model with $D = 5,000$, $C_o = \$32$, $C_b = \$2$, and 250 working days per year. Identify the reorder point in terms of inventory position and in terms of inventory on hand for each of these lead times.

 a. 5 days c. 25 days
 b. 15 days d. 45 days

10. The J&B Card Shop sells calendars featuring a different Colonial picture for each month. The once-a-year order for each year's calendar arrives in September. From past experience the September-to-July demand for the calendars can be approximated by a normal distribution with $\mu = 500$ and standard deviation $= 50$. The calendars cost \$4.50 each, and J&B sells them for \$10 each.

a. Suppose that J&B throws out all unsold calendars at the end of July. Using marginal economic analysis, how many calendars should be ordered?

b. If J&B sells any surplus calendars for \$1 at the end of July and can sell all of them at this price, how many calendars should be ordered?

ASR Electronics Case Study

ASR Electronics is a small eBay virtual store. One of its popular digital cameras sells an average of about 10 units per day, but the demand is quite variable. On some days, it may be as low as zero or may spike up about 20 units. Exhibit 12.14 shows some historical sales figures over a 10-week period. The owner of the business, Anita, is unsure of how to manage her inventory. She has been ordering the equivalent of one week's average demand (70 units) from the manufacturer, which arrives via FedEx every Monday morning. However, she has observed that on many days

© Murat Koc/istockphoto.com

stockouts occur, and she must contact the customers and tell them that their shipments will be delayed from their promised delivery dates. This is causing some negative feedback on her eBay site, and she is becoming quite concerned. The cameras cost her \$150 and her order costs are estimated to be \$25 per order. She uses a 20% carrying cost rate. As the owner of a small business, she needs to control her costs and does not want to maintain too much unnecessary inventory.

Exhibit 12.14 *(These data are available on an Excel spreadsheet on the Premium Website.)*

	Week 1	Week 2	Week 3	Week 4	Week 5	Week 6	Week 7	Week 8	Week 9	Week 10
Monday	10	8	8	0	8	2	11	12	11	5
Tuesday	8	5	5	10	10	6	16	2	13	12
Wednesday	20	8	17	7	11	11	13	17	19	17
Thursday	16	16	14	10	12	3	13	15	11	7
Friday	8	7	3	4	5	15	9	14	13	15
Saturday	14	8	9	13	11	12	9	6	8	10
Sunday	6	17	7	4	7	13	13	17	5	0
Weekly Total	82	69	63	48	64	62	84	83	80	66
Daily Average	11.71	9.86	9.00	6.86	9.14	8.86	12.00	11.86	11.43	9.43

Case Questions for Discussion

1. Using her current ordering policy of 70 units, calculate her expected annual order and inventory carrying costs. Show how a fixed order quantity system operates by calculating the ending inventory each day over the 10-week period using the data provided and equation 12.1, realizing that there are no back orders. (We suggest doing this on a spreadsheet.) Assume that 70 units have arrived and are in inventory at the start of Week 1. What is the average ending inventory? How often does a shortage occur and when it does, what is the average amount?

2. Compute the optimal EOQ (round any fractional values up). How does the expected annual cost using the EOQ compare with the 70-unit order policy? Illustrate the results of using the EOQ by calculating the ending inventory each day over the 10-week period in the same fashion as in question 1. Assume that all orders arrive at the beginning of the day. What is the average ending inventory? How often does a shortage occur and when it does, what is the average amount?

3. By experimenting, with different order quantities (in 10-unit increments), identify an order quantity that reduces the chance of a stockout to less than 5% (that is, less than 4 times over the 10-week period).

4. Compare the total costs of the current ordering policy ($Q = 70$), the optimal EOQ policy, and your best answer to Question 3 over the 10-week period based on the average inventory and the number of orders placed. What would you recommend to Anita? (Note: The instructor may or may not assign questions 3 and 4).

RESOURCE MANAGEMENT

t he corporate office just doesn't get it! They set a budget and staffing level that doesn't fit this location. I can't do the work and ensure accuracy of the patients' prescriptions when the corporate office gives me an annual budget for only two pharmacists and two pharmacy technicians," exclaimed Bill Carr, the manager of a retail pharmacy in a high-growth suburban location. The store was part of a national pharmaceutical chain with over 1,000 locations in the United States. The pharmacy was open 16 hours a day on Monday through Saturday and 10 hours on Sunday. Carr established two shifts for these professionals but they were now exhausted. The most senior pharmacist had already threatened to quit if something wasn't done to correct the problem soon. Carr also had considered reducing the time the store was open, but that would hurt store revenue.

© Jeff Greenberg / Alamy

learning outcomes

After studying this chapter you should be able to:

LO1 Describe the overall frameworks for resource planning in both goods-producing and service-providing organizations.

LO2 Explain options for aggregate planning.

LO3 Describe how to evaluate level production and chase demand strategies for aggregate planning.

LO4 Describe ways to disaggregate aggregate plans using master production scheduling and material requirements planning.

LO5 Explain the concept and application of capacity requirements planning.

What do **you** think?

Think about planning a party or some student-related function. What resources do you need to pull it off, and how might you plan to ensure that you have everything at the right time and in the right quantity?

Resource management *deals with the planning, execution, and control of all the resources that are used to produce goods or provide services in a value chain.* Resources include materials, equipment, facilities, information, technical knowledge and skills, and of course, people. Typical objectives of resource management are to (1) maximize profits and customer satisfaction; (2) mini-

mize costs; or (3) for not-for-profit organizations such as government and churches, maximize benefits to their stakeholders.

The preceding example highlights the difficulty service managers face when corporate budgets constrain their ability to grow and build market share. Here, a high-growth suburb with many new homeowners has created a situation where demand exceeds capacity. The pharmacy is constrained by too few pharmacists and technicians and therefore is confronted with options such as overtime, reduced store hours, and higher chance of errors. Clearly, resources must be matched better to the needs of customers and the level of demand.

Resources include materials, equipment, facilities, information, technical knowledge and skills, and, of course, people.

Resource management deals with the planning, execution, and control of all the resources that are used to produce goods or provide services in a value chain.

1 Resource Planning Framework for Goods and Services

© Garry Gay/Alamy

a generic framework for resource planning is shown in Exhibit 13.1. This framework is broken down into three basic levels. Level 1 represents aggregate planning. **Aggregate planning** *is the development of a long-term output and resource plan in aggregate units of measure.* Aggregate plans define output levels over a planning horizon of one to two years, usually in monthly or quarterly time buckets. They normally focus on product families or total capacity requirements rather than individual products or specific capacity allocations. Aggregate plans also help to define budget allocations and associated resource requirements.

Aggregate planning is driven by demand forecasts. High-level forecasts are often developed for aggregate groups of items. For instance, a consumer-products company like Procter & Gamble might produce laundry soap in a variety of sizes. However, it might forecast the total demand for the soap in dollars over some future time horizon, regardless of product size. Aggregate planning would then translate these forecasts into monthly or quarterly production plans.

In Exhibit 13.1, Level 2 planning is called disaggregation. **Disaggregation** *is the process of translating aggregate plans into short-term operational plans that provide the basis for weekly and daily schedules and detailed resource requirements.* To disaggregate means to break up or separate into more detailed pieces. Disaggregation specifies more-detailed plans for the creation of individual goods and services or the allocation of capacity to specific time periods. For goods-producing firms, disaggregation takes Level 1 aggregate planning decisions and breaks them down into such details as order sizes and schedules for individual subassemblies and resources by week and day.

Aggregate planning is the development of a long-term output and resource plan in aggregate units of measure.

Disaggregation is the process of translating aggregate plans into short-term operational plans that provide the basis for weekly and daily schedules and detailed resource requirements.

Execution refers to moving work from one workstation to another, assigning people to tasks, setting priorities for jobs, scheduling equipment, and controlling processes.

To illustrate aggregate planning and disaggregation, a producer of ice cream might use long-term forecasts to determine the total number of gallons of ice cream to produce each quarter over the next two years. This projection provides the basis for determining how many employees and other resources such as delivery trucks would be needed throughout the year to support this plan. Disaggregation of the plan would involve developing targets for the number of gallons of each flavor to produce (which would sum to the aggregate planned number for each quarter); purchasing requirements for cream, chocolate, and other ingredients; work schedules and overtime plans; and so on.

As another example, an airline might use long-term passenger forecasts to develop monthly aggregate plans based on the number of passenger miles each month. This aggregate plan would also specify the resource requirements in terms of total airline capacity, flight crews, and so on. Disaggregation would then create detailed point-to-point flight schedules, crew work assignments, food purchase plans, aircraft maintenance schedules, and other resource requirements.

Level 3 focuses on executing the detailed plans made at Level 2, creating detailed resource schedules and job sequences. **Execution** *refers to moving work from one workstation to another, assigning people to tasks, setting priorities for jobs, scheduling equipment, and controlling processes.* Level 3 planning and execution in manufacturing is sometimes called *shop floor control* and is addressed further in the next chapter.

Resource management for most service-providing organizations generally does not require as many intermediate levels of planning as it does for manufacturing.

Exhibit 13.1 *Framework for Resource Management Planning for Goods and Services*

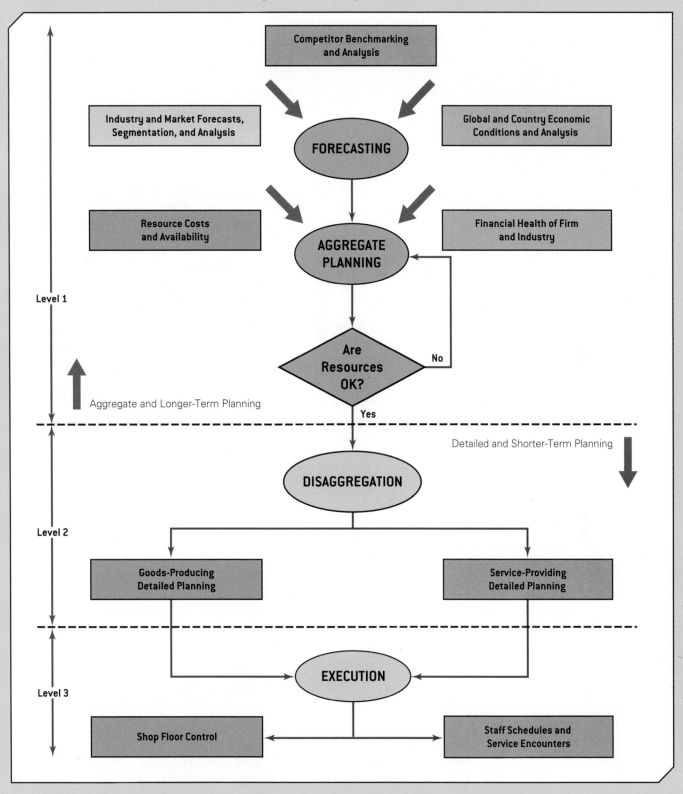

This is illustrated in Exhibit 13.2. Service firms frequently take their aggregate plans and disaggregate them down to the execution level as detailed front-line staff and resource schedules, job sequences, and service encounter execution. There are several reasons for this:

- Most manufactured goods are discrete and are "built up" from many levels of raw materials, component parts, and subassemblies. However, many services are instantaneous or continuous and nondiscrete, such as credit card authorizations or a telephone call or seeing a movie or arriving for service at a bank teller window. Hence, there is no need for multiple levels of planning for some services.

- Services do not have the advantage of physical inventory to buffer demand and supply uncertainty, so they must have sufficient service capacity on duty at the right time in the right place to provide good service to customers, making short-term demand forecasting and resource scheduling absolutely critical.

Some services, however, use the three levels of planning similar to manufacturing firms. For example, many service facilities, such as fast-food restaurants, need to be close to the customer, requiring them to be

scattered within a geographical area. In these cases, the firm creates aggregate plans at the corporate level and then disaggregates them by region or district (geographically). This is similar to Level 2 intermediate planning in manufacturing. Regional and district offices further disaggregate these plans and budgets given the intermediate-level budgets and resource constraints. Level 3 resource planning and execution occurs at the store level, where local forecasts, food and other supply orders, staff work shifts and schedules, and service encounters are created.

2 Aggregate Planning Options

managers have a variety of options in developing aggregate plans in the face of fluctuating demand: workforce changes, inventory smoothing, and adjustments to facilities, equipment,

Exhibit 13.2 *Two Levels of Disaggregation for Many Service Organizations*

Level 1 Aggregate Planning

(see Exhibit 13.1)

Level 3

Detailed Planning and Execution

```
        Resource and
        Aggregate Planning  ←──────────┐
              │                          │
              ↓                       Revise
              Is                         │
          Aggregate      ── No ─────────┘
          Capacity
            OK?
              │
             Yes
              │
              ↓
          Execution
          ┌───┴────┐
          ↓        ↓
  Detailed Resource    Inputs to Budgets,
  Schedule, Sequencing, Financing, and Cash
  and Service Encounter   Flow Analysis
      Execution
```

Exhibit 13.3 *Example Aggregate Planning Variables and Revenue/Cost Implications*

Aggregate Planning Decision Options	Revenue/Cost Implications
Demand Management • Pricing strategies • Promotions and advertising	• Increased revenue and lower unit costs • Economies of scale
Production rate • Overtime • Undertime • Subcontracting	• Higher labor costs and premiums • Idle time/lost opportunity costs • Overhead costs and some loss of control
Workforce • Hiring • Layoffs • Full- and part-time labor mix	• Acquisition and training costs • Separation costs • Labor cost and productivity changes
Inventory • Anticipation (build) inventories • Allow stockouts • Plan for back orders	• Inventory carrying costs • Lost sales (revenue) and customer loyalty costs • Back-order costs and customer waiting costs
Facilities, Equipment, and Transportation • Open/closed facilities and hours • Resource utilization • Mode (truck, rail, ship, air) • Capacity and resource utilization	• Variable and fixed costs • Speed and reliability of service and delivery • Low- to high-utilization impact on unit costs • Inbound and outbound costs per ode • Number of full or partial loads

and transportation. These are summarized in Exhibit 13.3. The choice of strategy depends on corporate policies, practical limitations, and cost factors.

Demand Management Marketing strategies can be used to influence demand and to help create more feasible aggregate plans. For example, pricing and promotions can increase or decrease demand or shift it to other time periods. In services, recall that demand is time-dependent and there is no option to store the service. A hotel manager, for example, may advertise a low weekend rate to the local market in an attempt to increase short-term revenue and contribution to profit and overhead. Thus, demand management strategies are crucial for good aggregate planning and capacity utilization.

Production-Rate Changes One means of increasing the output rate without changing existing resources is through planned overtime. Alternatively, hours can be reduced during slow periods through planned undertime. However, reduced overtime pay or sitting idle can seriously affect employee morale. Subcontracting during periods of peak demand may also alter the output rate. This would probably not be a feasible alternative for some companies, but it is effective in industries that manufacture a large portion of their own parts, such as the machine-tool industry. When business is brisk, components can be subcontracted; when business is slow, the firm may act as a subcontractor to other industries that may be working at their capacity limit. In that way, a stable workforce is maintained.

Workforce Changes Changing the size of the work- force is usually accomplished through hiring and layoffs. Both have disadvantages. Hiring additional labor usually results in higher costs for the personnel department and for training. Layoffs result in severance pay and additional unemployment insurance costs, as well as low employee morale.

In many industries, changing workforce levels is not a feasible alternative. In firms that consist primarily of jobs with low skill requirements, however, it may be cost-effective. The toy industry is a good example. Accurate forecasts for the winter holiday season cannot be made until wholesale buyers have placed orders, usually around midyear. Toy companies maintain a minimal number of employees until production is increased for the holidays. Then they hire a large number of part-time workers in order to operate at maximum capacity.

Inventory Changes In planning for fluctuating demand, inventory is often built up during slack periods and held for peak periods. However, this increases carrying costs and may necessitate more warehouse space. A related strategy is to carry back orders or to tolerate lost sales during peak demand periods. But this may be unacceptable if profit margins are low and competition is high.

Facilities, Equipment, and Transportation Facilities, equipment, and transportation generally represent long-term capital investments. Short-term changes in facilities and equipment are seldom used in traditional aggregate planning methods because of the capital costs involved. However, in some cases, it might be possible to rent additional equipment such as industrial forklifts, small machines, trucks, or warehouse space to accommodate periods of high demand.

3 Strategies for Aggregate Planning

t o illustrate some of the major issues involved with aggregate planning, consider the situation faced by Golden Beverages, a producer of two major products—Old Fashioned and Foamy Delite root beers. The spreadsheet in Exhibit 13.4 shows a monthly aggregate demand forecast for the next year. Notice that demand is in barrels per month—an aggregate unit of measure for both products. Golden Beverages operates as a continuous flow factory and must plan future production for a demand forecast that fluctuates quite a bit over the year, with seasonal peaks in the summer and winter holiday season.

How should Golden Beverages plan its overall production for the next 12 months in the face of such fluctuating demand? Suppose that the company has a normal production capacity of 2,200 barrels per month and a current inventory of 1,000 barrels. If it produces at nor-

mal capacity each month, we have the aggregate plan shown in Exhibit 13.4. To calculate the ending inventory for each month, we use equation 13.1.

$$\text{Ending inventory} = \text{Beginning inventory} + \text{Production} - \text{Demand} \quad [13.1]$$

For example, January is $1,000 + 2,200 - 1,500 = 1,700$ and February is $1,700 + 2,200 - 1,000 = 2,900$. A **level production strategy** *plans for the same production rate in each time period.* The aggregate plan for

Exhibit 13.4 *Level Aggregate Production Plan for Golden Beverages (This spreadsheet is available on the Premium Website.)*

	A	B	C	D	E	F	G
1	Golden Beverages Production Plan						
2	Level Production Strategy - 2200 barrels/month						
3							
4	Production cost ($/bbl)			$ 70.00			
5	Inventory holding cost ($/bbl)			$ 1.40			
6	Lost sales cost ($/bbl)			$ 90.00			
7	Overtime cost ($/bbl)			$ 6.50			
8	Undertime cost ($/bbl)			$ 3.00			
9	Rate change cost ($/bbl)			$ 5.00			
10	Normal production rate			2,200			
11							
12					Cumulative		
13			Cumulative		Product	Ending	Lost
14	Month	Demand	Demand	Production	Availability	Inventory	Sales
15						1,000	
16	January	1,500	1,500	2,200	3,200	1,700	0
17	February	1,000	2,500	2,200	5,400	2,900	0
18	March	1,900	4,400	2,200	7,600	3,200	0
19	April	2,600	7,000	2,200	9,800	2,800	0
20	May	2,800	9,800	2,200	12,000	2,200	0
21	June	3,100	12,900	2,200	14,200	1,300	0
22	July	3,200	16,100	2,200	16,400	300	0
23	August	3,000	19,100	2,200	18,600	0	500
24	September	2,000	21,100	2,200	21,300	200	0
25	October	1,000	22,100	2,200	23,500	1,400	0
26	November	1,800	23,900	2,200	25,700	1,800	0
27	December	2,200	26,100	2,200	27,900	1,800	0
28						3,200	
29		Production	Inventory	Lost Sales	Overtime	Undertime	Rate Change
30	Month	Cost	Cost	Cost	Cost	Cost	Cost
31							
32	January	$ 154,000	$ 2,380	$ -	$ -	$ -	$ -
33	February	$ 154,000	$ 4,060	$ -	$ -	$ -	$ -
34	March	$ 154,000	$ 4,480	$ -	$ -	$ -	$ -
35	April	$ 154,000	$ 3,920	$ -	$ -	$ -	$ -
36	May	$ 154,000	$ 3,080	$ -	$ -	$ -	$ -
37	June	$ 154,000	$ 1,820	$ -	$ -	$ -	$ -
38	July	$ 154,000	$ 420	$ -	$ -	$ -	$ -
39	August	$ 154,000	$ -	$ 45,000	$ -	$ -	$ -
40	September	$ 154,000	$ 280	$ -	$ -	$ -	$ -
41	October	$ 154,000	$ 1,960	$ -	$ -	$ -	$ -
42	November	$ 154,000	$ 2,520	$ -	$ -	$ -	$ -
43	December	$ 154,000	$ 2,520	$ -	$ -	$ -	$ -
44		$1,848,000	$ 27,440	$ 45,000	$ -	$ -	$ -
45							
46	Total cost	$1,920,440					

A **level production strategy** plans for the same production rate in each time period.

© Newhouse News Service/Landov

Golden Beverages shown in Exhibit 13.4 is an example of a level production strategy with a constant production rate of 2,200 barrels per month. A level strategy avoids changes in the production rate, working within normal capacity restrictions. Labor and equipment schedules are stable and repetitive, making it easier to execute the plan. However, ending inventory builds up to a peak of 3,200 barrels in March and lost sales are 500 barrels in August due to inventory shortages.

An alternative to a level production strategy is to match production to demand every month. *A **chase demand strategy** sets the production rate equal to the demand in each time period.* While inventories will be reduced and lost sales will be eliminated, many production-rate changes will dramatically change resource levels (that is, the number of employees, machines, and so on). A chase demand strategy for Golden Beverages is shown in Exhibit 13.5 with a total cost of $1,835,050. As compared with the level production strategy documented in Exhibit 13.4, the cost of the chase demand strategy is $1,920,440 – 1,835,050 = $85,390 less. Notice that no inventory carrying or lost sales costs are incurred, but substantial overtime, undertime, and rate-change costs are required.

Given the large number of aggregate planning decision variables with an infinite number of possible levels and combinations, countless alternative aggregate plans could be developed. Good solutions using spreadsheets can often be found by trial-and-error approaches.

A **chase demand strategy** sets the production rate equal to the demand in each time period.

How Can We Use Aggregate Planning for a Tennis Club?

Services face many of the same issues in planning and managing resources as do manufacturing firms. Consider a 145-acre large oceanfront resort located in Myrtle Beach, South Carolina, that is owned and operated by a major corporation. The tennis club and four courts are located next to the Sport & Health Club. All courts are lighted for night play, and there is no more room to build additional tennis courts. The demand for tennis lessons is highly seasonal, with peak demand in June, July, and August. In the summer months when resort rooms are 98 percent to 100 percent occupied, requests for lesson time far exceed capacity, and owner and hotel guest complaints were increasing dramatically. The manager of the health club might consider a chase resource strategy with a base full-time tennis staff of two people and the use of part-time staff for much of the year. Or, she might consider a level strategy with four full-time staff and no part-time staff.

Managers have many options for developing aggregate plans.

© C Borland/PhotoLink/Photodisc/Getty Images

Exhibit 13.5 *Chase Demand Strategy for Golden Beverages*

	A	B	C	D	E	F	G
1	Golden Beverages Production Plan						
2	Chase Demand Strategy						
3							
4	Production cost ($/bbl)			$ 70.00			
5	Inventory holding cost ($/bbl)			$ 1.40			
6	Lost sales cost ($/bbl)			$ 90.00			
7	Overtime cost ($/bbl)			$ 6.50			
8	Undertime cost ($/bbl)			$ 3.00			
9	Rate change cost ($/bbl)			$ 5.00			
10	Normal production rate			2,200			
11							
12					Cumulative		
13			Cumulative		Product	Ending	Lost
14	Month	Demand	Demand	Production	Availability	Inventory	Sales
15						1,000	
16	January	1,500	1,500	500	1,500	0	0
17	February	1,000	2,500	1,000	2,500	0	0
18	March	1,900	4,400	1,900	4,400	0	0
19	April	2,600	7,000	2,600	7,000	0	0
20	May	2,800	9,800	2,800	9,800	0	0
21	June	3,100	12,900	3,100	12,900	0	0
22	July	3,200	16,100	3,200	16,100	0	0
23	August	3,000	19,100	3,000	19,100	0	0
24	September	2,000	21,100	2,000	21,100	0	0
25	October	1,000	22,100	1,000	22,100	0	0
26	November	1,800	23,900	1,800	23,900	0	0
27	December	2,200	26,100	2,200	26,100	0	0
28		2,175				1,000	
29		Production	Inventory	Lost Sales	Overtime	Undertime	Rate Change
30	Month	Cost	Cost	Cost	Cost	Cost	Cost
31							
32	January	$ 35,000	$ -	$ -	$ -	$ 5,100	$ 8,500
33	February	$ 70,000	$ -	$ -	$ -	$ 3,600	$ 2,500
34	March	$ 133,000	$ -	$ -	$ -	$ 900	$ 4,500
35	April	$ 182,000	$ -	$ -	$ 2,600	$ -	$ 3,500
36	May	$ 196,000	$ -	$ -	$ 3,900	$ -	$ 1,000
37	June	$ 217,000	$ -	$ -	$ 5,850	$ -	$ 1,500
38	July	$ 224,000	$ -	$ -	$ 6,500	$ -	$ 500
39	August	$ 210,000	$ -	$ -	$ 5,200	$ -	$ 1,000
40	September	$ 140,000	$ -	$ -	$ -	$ 600	$ 5,000
41	October	$ 70,000	$ -	$ -	$ -	$ 3,600	$ 5,000
42	November	$ 126,000	$ -	$ -	$ -	$ 1,200	$ 4,000
43	December	$ 154,000	$ -	$ -	$ -	$ -	$ 2,000
44		$ 1,757,000	$ -	$ -	$ 24,050	$ 15,000	$ 39,000
45							
46	Total cost	$ 1,835,050					

4 Disaggregation in Manufacturing

or manufacturing firms, Exhibit 13.6 shows a typical system for disaggregating aggregate plans into executable operations plans. Three important techniques in this process are master production scheduling (MPS), materials requirements planning (MRP), and capacity requirements planning (CRP).

Aggregate Planning for Candy Manufacturing

ggregate plans at a company that was acquired by Nestle are focused on quality, personnel, capital, and customer-service objectives.[1] It exports confectionery and grocery products (e.g., candy bars, boxed chocolates, cookies, and peanut butter) to over 120 countries.

One of its major brand items that has a highly seasonal demand is boxed chocolates. Boxed chocolates are produced in three types, with a total of nine distinct end items: Black Magic, in 2 lb., $1\frac{1}{2}$ lb., 1 lb., and $\frac{1}{2}$ lb. boxes; Rendezvous, in 14oz. boxes; and Dairy Box, in the same four sizes as Black Magic. Forecasting is accomplished by dividing the year into 13 periods of four weeks each. Sales planning provides an item forecast, by period, for the full 13 periods. This estimate is updated every four weeks, reflecting the latest information on available inventories and estimated sales for the next 13 periods.

Aggregate planning is performed by first converting all items to a poundage figure. The planning task is to calculate levels of production that will best meet the quality, personnel, capital, and customer service restrictions. It is a stated company policy and practice to maintain a stable workforce. Short-term capacity can be increased with overtime and/or with part-time employees. The amount of inventory investment has become a major concern, and inventory levels must be kept low to meet restrictions on capital investment.

Exhibit 13.6 *Disaggregation Framework for Manufacturing Plans and Schedules*

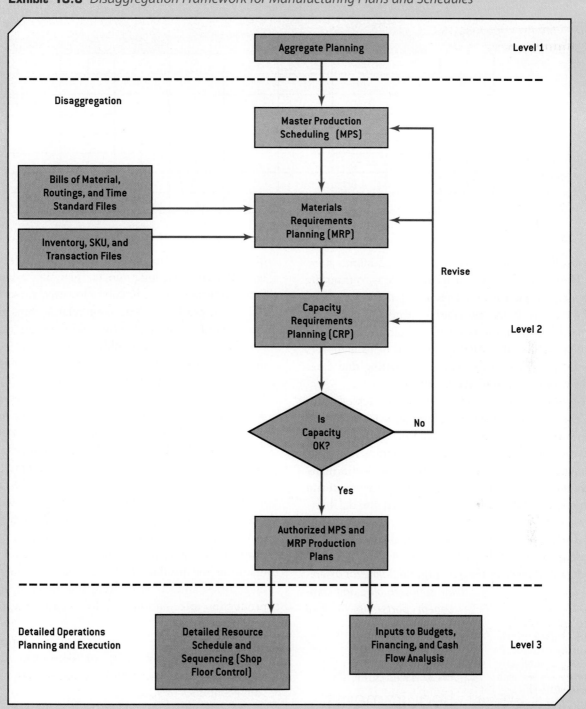

4.1 Master Production Scheduling

A master production schedule (MPS) is a statement of how many finished items are to be produced and when they are to be produced. An example of a portion of an MPS with an eight-week planning horizon is shown in Exhibit 13.7. Typically, the master schedule is developed

Exhibit 13.7 *Eight-Week Master Production Schedule Example*

		Week								
		1	2	3	4	5	6	7	8	
	Model A		200		200		350 ←			← MPS
	Model B	150	100		190			120 ←		← Planned Quantities
	•	•	•	•	•	•	•	•	•	
	•	•	•	•	•	•	•	•	•	
	•	•	•	•	•	•	•	•	•	
Totals	X			75		75	75		60	
Aggregate production plans (units)		500	800	350	600	280	750	420	300	

for weekly time periods over a 6- to 12-month horizon. The purpose of the master schedule is to translate the aggregate plan into a separate plan for individual finished goods. It also provides a means for evaluating alternative schedules in terms of capacity requirements, provides input to the MRP system, and helps managers generate priorities for scheduling by setting due dates for the production of individual items.

For make-to-order industries, order backlogs provide the needed customer-demand information; thus the known customer orders (called *firm orders*) determine the MPS. In some industries where a few basic subassemblies and components are assembled in many different combinations to produce a large variety of end products, the MPS is usually developed for the basic subassemblies and not for the ultimate finished goods. Therefore, a different plan and schedule are needed to assemble the final finished good. *A **final assembly schedule (FAS)** defines the quantity and timing for assembling subassemblies and component parts into a final finished good.*

4.2 Materials Requirements Planning

To produce a finished product, many individual parts or subassemblies must be manufactured or purchased and then assembled together. Fixed order quantity and fixed-period inventory systems (see Chapter 12) were used long ago for planning materials in manufacturing environments. However, these systems did not capture the dependent relationships between the demand for finished goods and their raw materials, components, and subassemblies. This insight led to the development of materials requirements planning.

Materials requirements planning (MRP) *is a forward-looking, demand-based approach for planning the production of manufactured goods and ordering materials and components to minimize unnecessary inventories and reduce costs.* MRP projects the requirements for the individual parts or subassemblies based on the demand for the finished goods as specified by the MPS. The primary output of an MRP system is a time-phased report that gives (1) the purchasing department a schedule for obtaining raw materials and purchased parts, (2) the production managers a detailed schedule for manufacturing the product and controlling manufacturing inventories, and (3) accounting and financial functions production information that drives cash flow, budgets, and financial needs.

MRP depends on understanding three basic concepts—(1) the concept of dependent demand, (2) the concept of time-phasing, and (3) lot sizing to gain economies of scale.

MRP depends on understanding three basic concepts—(1) the concept of dependent demand, (2) the concept of time-phasing, and (3) lot sizing to gain economies of scale.

Dependent demand *is demand that is directly related to the demand of other SKUs and can be calculated without needing to be forecasted.* The concept of dependent demand is best understood by examining the bill of materials. A *bill of materials (BOM)* defines the hierarchical relationships between all items that comprise a finished good, such as subassemblies, purchased parts, and manufactured in-house parts. Some firms call the BOM the product structure. A BOM may also define standard times and alternative routings for each item.

For labor-intensive services, the analogy to the BOM is a bill of labor (BOL). *A **bill of labor (BOL)** is a hierarchical record analogous to a BOM that defines labor inputs necessary to create a good or service.* For example, a BOL for surgery includes the doctors and supporting surgery technicians and nurses. A broader concept is a *bill of resources (BOR)* where the labor, information (like X-rays, blood tests, and so on), equipment, instruments, and parts are all defined in a BOM format to support each specific type of surgery. Exhibit 13.8 shows the structure of a typical BOM.

End items *are finished goods scheduled in the MPS or FAS that must be forecasted.* These are the items at Level 0 of the BOM. For example, item A in Exhibit 13.8 is an end item. *A **parent item** is manufactured from one or more components.* Items A, B, D, F, and H are parents in Exhibit 13.8. End items are composed of components and subassemblies. **Components** *are any item (raw materials, manufactured parts, purchased parts) other than an end item that goes into a higher-level parent item(s).* Items B, C, D, E, F, G, H, and I are all components in the BOM in Exhibit 13.8. *A **subassembly** always has at least one immediate parent and also has at least one immediate component.* Subassemblies (sometimes called *intermediate items*) reside in the middle of the BOM; items B, D, F, and H in Exhibit 13.8 are examples. BOMs for simple assemblies might be flat, having only two or three levels, while more complex BOMs may have up to 15 levels.

To understand the nature of dependent demand, assume that we wish to produce 100 units of end item A in Exhibit 13.8. Exhibit 13.9 shows the calculations for each of the items in the BOM, taking into account on-hand inventory. For each unit of A, we need one unit of items B and F. We have 33 units on hand for subassembly B, so we need to make only 100 − 33, or 67, units of B. Similarly, we have 20 units of F available and therefore require an additional 100 − 20 = 80 units. Next, at Level 2 of the BOM, for each unit of B, we need one unit of components C and D; and for each F, we need one unit of components G and H. Because we need to produce only an additional 67 units of B, and we have 12 units of component C on-hand, we need to produce an additional 67 − 12 = 55 units of C.

You should check the remaining calculations in Exhibit 13.9. Note that item D is a common subassembly that is used in both subassemblies B and H. Thus, we must include the requirements of item B (67 units) and item H (50 units) in computing the number of Ds to produce: 67 + 50 − 47 = 70 units.

Dependent demand also occurs in service businesses, but few managers recognize it. Many service organizations such as restaurants and retail stores offer repeatable and highly structured services and

Where's the Surgery Kit?

A 374-bed hospital with nine operating rooms in Houston, Texas, uses bills of materials and master production scheduling to plan surgeries and the surgical kits needed for a seven-day planning horizon. Bills of labor (BOL) are used to schedule surgeons, nurses, and orderlies. The bill of material (BOM) file contains the materials, instruments, and supplies needed for various surgical procedures. End items are specific surgery procedures with a lot size of one. The concept and methods of dependent demand are alive and well in this surgery suite![2]

© Photos.com

Exhibit 13.8 *Example of a Bill of Materials and Dependent Demand*

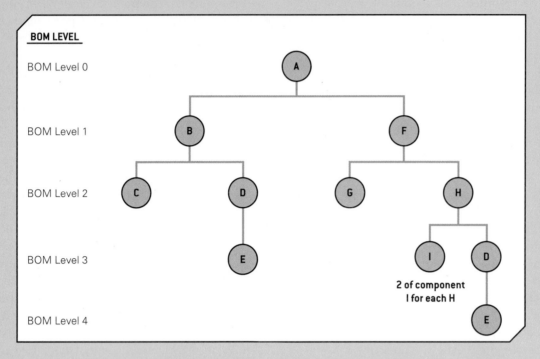

BOM LEVEL

BOM Level 0

BOM Level 1

BOM Level 2

BOM Level 3

2 of component
I for each H

BOM Level 4

The service required to assemble an order can be defined in terms of the bill of materials (BOM) and lead times.

4.3 Time Phasing and Lot Sizing in MRP

Although the dependent demand calculations as described in the previous section provide the number of components or subassemblies needed in the BOM, they do not specify when orders should be placed or how much should be ordered. Because of the hierarchy of the BOM, there is no reason to order something until it is required to produce a parent item. Thus, all dependent demand requirements do not need to be ordered at the same time, but rather are *time-phased* as necessary. In addition, orders might be consolidated to take advantage of ordering economies of scale—this is called *lot sizing*. **MRP explosion** *is the process of using the logic of dependent demand to calculate*

Exhibit 13.9 *Dependent Demand Calculations*

Item	On-Hand Inventory	Dependent Demand Calculations
A	0	100 − 0 = 100
B	33	100 − 33 = 67
C	12	67 − 12 = 55
D	47	67 + 50 − 47 = 70
E	10	70 − 10 = 60
F	20	100 − 20 = 80
G	15	80 − 15 = 65
H	30	80 − 30 = 50
I	7	50 × 2 − 7 = 93

MRP explosion is the process of using the logic of dependent demand to calculate the quantity and timing of orders for all subassemblies and components that go into and support the production of the end item(s).

have high goods content of 50 percent or more. Therefore, the logic of dependent demand can be used to plan the goods-content portion of the customer benefit package. For example, meals in a restaurant can be thought of as end items.

the quantity and timing of orders for all subassemblies and components that go into and support the production of the end item(s). In this section we will illustrate the process of time phasing.

Time buckets *are the time period size used in the MRP explosion process and usually are one week in length.* Although small buckets such as one day are good for scheduling production over a short time horizon, they may be too precise for longer-range planning. Thus, larger buckets such as months are often used as the planning horizon gets longer. We assume that all time buckets are one week in length.

An MRP record consists of the following:

- **Gross requirements (GR)** *are the total demand for an item derived from all of its parents.* This is the quantity of the component needed to support production at the next-higher level of assembly. Gross requirements can also include maintenance, repair, and spare-part components that are added to the dependent demand requirements.

- **Scheduled or planned receipts (S/PR)** *are orders that are due or planned to be delivered.* A scheduled receipt was released to the vendor or shop in a previous time period and now shows up as a scheduled receipt. (In some of our examples we assume, for simplicity, that all scheduled receipts are zero.) A planned order receipt is defined later. If the order is for an outside vendor, it is a *purchase order*. If the order is produced in-house, it is a *shop or manufactured order*.

- **Planned order receipt (PORec)** *specifies the quantity and time an order is to be received.* When the order arrives it is recorded, checked into inventory, and available for use. It is assumed to be available for use at the beginning of the period.

- **Planned order release (PORel)** *specifies the planned quantity and time an order is to be released to the factory or a supplier.* It is a planned order receipt offset by the item's lead time. Planned order releases generate the gross requirements for all components in the MRP logic.

- **Projected on-hand inventory (POH)** *is the expected amount of inventory on-hand at the beginning of the time period considering on-hand inventory from the previous period plus scheduled receipts or planned order receipts minus the gross requirements.* The formula for computing the projected on-hand inventory is defined by equation 13.2 as follows:

$$\text{Projected on-hand in period } t \ (\text{POH}_t) = \text{On-hand inventory in period } t-1 \ (\text{OH}_{t-1})$$
$$+ \ \text{Scheduled or planned receipts in period } t \ (\text{S/PR}_t) - \text{Gross requirements in period } t \ (\text{GR}_t)$$

or

$$\text{POH}_t = \text{OH}_{t-1} + \text{S/PR}_t - \text{GR}_t \quad [13.2]$$

Lot sizing *is the process of determining the appropriate amount and timing of ordering to reduce costs.* It can be uneconomical to set up a new production run or place a purchase order for the demand in each time bucket. Instead, it is usually better to aggregate orders and achieve economies of scale. Many different lot-sizing rules have been proposed. Some are simple heuristic rules, whereas others seek to find the best economic trade-off between the setup costs associated with production and the holding costs of carrying inventory. We discuss three common lot-sizing methods for MRP—lot-for-lot (LFL), fixed order quantity (FOQ), and periodic order quantity (POQ).

To illustrate these, we will consider the production of a simple product (A) whose bill of materials and inventory records are given in Exhibits 13.10 and 13.11. Note that item B is a common component for both items A and C; therefore, we cannot compute the gross requirements for item B until the planned order releases for items A and C have been determined.

Suppose that the MPS calls for 150 units of product A to be completed in week 4; 300 units in week 5; 50 units in week 6; and 200 units in week 7. We assume that the lead time is one week. The MPS in Exhibit 13.12 shows the demand for product A. The planned order releases are offset by one week to account for the lead time.

First consider item C. The MRP explosion is given in Exhibit 13.13. Notice from the BOM in Exhibit 13.10 that two units of item C are needed to produce one unit of end-item A. Therefore, the gross requirements

Time buckets are the time period size used in the MRP explosion process and usually are one week in length.

Gross requirements (GR) are the total demand for an item derived from all of its parents.

Scheduled or planned receipts (S/PR) are orders that are due or planned to be delivered.

Planned order receipt (PORec) specifies the quantity and time an order is to be received.

Planned order release (PORel) specifies the planned quantity and time an order is to be released to the factory or a supplier.

Projected on-hand inventory (POH) is the expected amount of inventory on hand at the beginning of the time period considering on-hand inventory from the previous period plus scheduled receipts or planned order receipts minus the gross requirements.

Lot sizing is the process of determining the appropriate amount and timing of ordering to reduce costs.

Exhibit 13.10 Bill of Materials

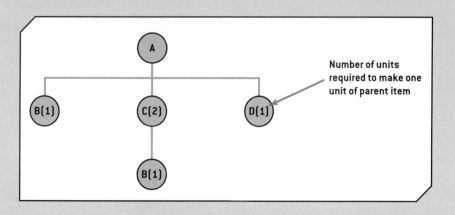

Exhibit 13.11 Item Inventory File

	Item	Item	Item
Data category	B	C	D
Lead time (weeks)	1	2	1
Beginning (on-hand) inventory	100	10	40
Scheduled receipts	none	200 (week 2)	50 (week 3)

Exhibit 13.12 Example MPS

MPS	Lead time = 1 week for assembly						
Week	1	2	3	4	5	6	7
Product A—end-item	0	0	0	150	300	50	200
Planned order release	0	0	150	300	50	200	0

it clearly shows the true nature of dependent demand. Notice that LFL requires four planned orders and the average inventory during this planning horizon is $10 + 210 + 0 + 0 + 0 + 0 + 0 = 220/7 = 31.4$ units/week. The LFL rule minimizes the amount of inventory that needs be carried; however, it ignores the costs associated with purchase orders or production setups. Thus, this rule is best applied when inventory carrying costs are high and setup/order costs are low.

The projected on-hand quantity assumes the receipt of the planned order or scheduled receipt (S/PR$_t$) and is computed using equation 13.2. LFL always tries to drive inventory levels to zero. We must compute the planned order release for item C before we can do the same for item B.

For example, using equation 13.2 we compute the following:

for item C in Exhibit 13.13 are directly derived from the planned order releases in the MPS in Exhibit 13.12 (that is, $150 \times 2 = 300$ units in period 3; $300 \times 2 = 600$ units in period 4; and so on).

Lot-for-Lot Rule *An ordering schedule that covers the gross requirements for each week is called lot-for-lot (LFL).* In other words, we simply place orders each week to ensure that enough inventory is available to prevent shortages. If LFL is used for all dependent items,

An ordering schedule that covers the gross requirements for each week is called lot-for-lot (LFL).

$$POH_1 = OH_0 + S/PR_1 - GR_1 = 10 + 0 - 0 = 10$$
$$POH_2 = OH_1 + S/PR_2 - GR_2 = 10 + 200 - 0 = 210$$
$$POH_3 = OH_2 + S/PR_3 - GR_3 = 210 + 90 - 300 = 0$$
$$POH_4 = OH_3 + S/PR_4 - GR_4 = 0 + 600 - 600 = 0$$
$$POH_5 = OH_4 + S/PR_5 - GR_5 = 0 + 100 - 100 = 0$$
$$POH_6 = OH_5 + S/PR_6 - GR_6 = 0 + 400 - 400 = 0$$
$$POH_7 = OH_6 + S/PR_7 - GR_7 = 0 + 0 - 0 = 0$$

The planned order releases in Exhibit 13.13 are planned but have not yet been released.

Exhibit 13.13 *MRP Record for Item C Using the Lot-for-Lot (LFL) Rule*

Item C (two units of C are needed for one unit of A) Description		Lot size: LFL Lead time: 2 weeks						
Week		1	2	3	4	5	6	7
Gross requirements		0	0	300	600	100	400	0
Scheduled receipts			200					
Projected OH inventory	10	10	210	0	0	0	0	0
Planned order receipts		0	0	90	600	100	400	0
Planned order releases		90	600	100	400			

*The **action bucket** is the current time period.* When a planned order release reaches the action bucket, analysts evaluate the situation and release the order to the appropriate provider—supplier or in-house work center. In Exhibit 13.13, for example, only the planned order of 90 units of item C is in the action bucket or current time period of week 1. Therefore, the planned order needs to be released in week 1 and will show up the next week in the scheduled receipts row. Clearly, the total number of MRP calculations is enormous in multiproduct situations with many components, making a computer essential. Action notices are usually computer-generated and provide a variety of information to help inventory planners make decisions about order releases delaying scheduled receipts, and expediting when necessary.

Fixed Order Quantity Rule The **fixed order quantity (FOQ) rule** uses a fixed order size for every order or production run. This is similar to the fixed order quantity approach for independent demand items. The FOQ can be a standard-size container or pallet load or determined economically using the economic order quantity formula in Chapter 12. In the rare case where the FOQ does not cover the gross requirements, the order size is increased to equal the larger quantity, and FOQ defaults to LFL.

The rationale for the FOQ approach is that large lot sizes result in fewer orders and setups and therefore reduce the costs associated with ordering and setup. This allows the firm to take advantage of price breaks by suppliers and production economies of scale, and avoid less-than-truckload shipments (which are usually more expensive than full truckloads). However, this creates larger average inventory levels that must be held at a cost, and it can distort the true dependent demand gross requirements for lower-level components. Thus,

the FOQ model is best applied when inventory carrying costs are low and setup/order costs are high.

We will illustrate this rule for item B in Exhibit 13.10. Exhibit 13.14 shows the MRP explosion. Note that component part commonality increases the dependent demand requirements as shown in the gross requirements row. For example, the 700-unit gross requirement in period 4 is due to the planned order release in the MPS for 300 units of item A in week 4 (see Exhibit 13.12) plus the planned order release for parent item C of 400 units in week 4 (see Exhibit 13.13).

Suppose that the FOQ is chosen using the EOQ as $\sqrt{2 \times 10{,}000 \text{ units} \times 864/\$1} = \sqrt{640{,}000} = 800$ units. Using equation 13.2, we compute the following projected on-hand inventories for each period:

$$POH_1 = OH_0 + S/PR_1 - GR_1 = 100 + 0 - 90 = 10$$

$$POH_2 = OH_1 + S/PR_2 - GR_2 = 10 + 800 - 600 = 210$$

$$POH_3 = OH_2 + S/PR_3 - GR_3 = 210 + 800 - 250 = 760$$

$$POH_4 = OH_3 + S/PR_4 - GR_4 = 760 + 0 - 700 = 60$$

$$POH_5 = OH_4 + S/PR_5 - GR_5 = 60 + 0 - 50 = 10$$

$$POH_6 = OH_5 + S/PR_6 - GR_6 = 10 + 800 - 200 = 610$$

$$POH_7 = OH_6 + S/PR_7 - GR_7 = 610 + 0 - 0 = 610$$

Notice that FOQ results in three planned orders and an average inventory is 10 + 210 + 760 + 60 + 10 + 610 + 610 = 2,270/7 = 324.3 units/week. To understand the difference with LFL, we encourage you to compare these results to the LFL approach.

The **action bucket** is the current time period.

The **fixed order quantity (FOQ) rule** uses a fixed order size for every order or production run.

Exhibit 13.14 *Item B Fixed Order Quantity (FOQ) Lot Sizing and MRP Record*

Item B Description		1	2	3	4	5	6	7
Lot size: 800 units **Lead time: 1 week**								
Week		1	2	3	4	5	6	7
Gross requirements		90	600	250	700	50	200	0
Scheduled receipts								
Projected OH inventory	100	10	210	760	60	10	610	610
Planned order receipts		0	800	800	0	0	800	0
Planned order releases		800	800			800		

Some MRP users only use the simple LFL rule; others apply other lot sizing approaches to take advantage of economies of scale and reduce costs.

Periodic Order Quantity Rule The **periodic order quantity (POQ)** *orders a quantity equal to the gross requirement quantity in one or more predetermined time periods minus the projected on-hand quantity of the previous time period.* For example a POQ of two weeks orders exactly enough to cover demand during a two-week period, and therefore may result in a different quantity every order cycle. The POQ might be selected judgmentally—for example, "order every 10 days"—or be determined using an economic time interval, which is the EOQ divided by annual demand (D). For example, if $EOQ/D = 0.1$ of a year, and assuming 250 working days per year, then POQ = 25 days, or about every five weeks. A POQ for a one-week time period is equivalent to LFL. Using this rule, the projected on-hand inventory will equal zero at the end of the POQ time interval.

The **periodic order quantity (POQ)** orders a quantity equal to the gross requirement quantity in one or more predetermined time periods minus the projected on-hand quantity of the previous time period.

We illustrate this rule for item D using a POQ = 2 weeks. The result is shown in Exhibit 13.15. Using equation 13.2, we compute the following:

$$POH_1 = OH_0 + S/PR_1 - GR_1 = 40 + 0 - 0 = 40$$
$$POH_2 = OH_1 + S/PR_2 - GR_2 = 40 + 0 - 0 = 40$$
$$POH_3 = OH_2 + S/PR_3 - GR_3 = 40 + 50 + 360 - 150 = 300$$

$$POH_4 = OH_3 + S/PR_4 - GR_4 = 300 + 0 - 300 = 0$$
$$POH_5 = OH_4 + S/PR_5 - GR_5 = 0 + 250 - 50 = 200$$
$$POH_6 = OH_5 + S/PR_6 - GR_6 = 200 + 0 - 200 = 0$$
$$POH_7 = OH_6 + S/PR_7 - GR_7 = 0 + 0 - 0 = 0$$

The first time that POH becomes negative "without" a planned order receipt is in week 3 (40 + 50 − 150 = −60). Therefore, if we order 60 units to cover week 3 requirements plus 300 units to cover week 4 requirements, we have an order quantity of 360 units. The next time the POH is negative "without" a planned order receipt is week 5 (0 + 0 − 50 = −50). This requires us to order 50 units to cover week 5 requirements plus 200 units to cover week 6 requirements. For this example, POQ results in two planned orders of 360 and 250 units. The average inventory is 40 + 40 + 300 + 0 + 200 + 0 + 0 = 580/7 = 82.9 units/week.

The POQ approach results in moderate average inventory levels compared to FOQ because it matches order quantities to time buckets. Furthermore, it is easy to implement because inventory levels can be reviewed according to a fixed schedule. However, POQ creates high average inventory levels if the POQ becomes too long, and it can distort true dependent demand gross requirements for lower-level components. An economic-based POQ model is best applied when inventory carrying costs and setup/order costs are moderate.

Exhibit 13.15 *Item D Fixed Period Quantity (POQ) Lot Sizing and MRP Record*

Item D Description							Lot size: POQ = 2 weeks Lead time: 1 week		
Week		1	2	3	4	5	6	7	
Gross requirements				150	300	50	200		
Scheduled receipts				50					
Projected OH inventory	40	40	40	300	0	200	0	0	
Planned order receipts		0	0	360	0	250	0	0	
Planned order releases			360		250				

As you see, lot-sizing rules affect not only the planned order releases for the particular item under consideration but also the gross requirements of all lower-level component items. Some MRP users only use the simple LFL rule; others apply other lot sizing approaches to take advantage of economies of scale and reduce costs. Exhibit 13.16 summarizes the MRP explosion for the BOM in Exhibit 13.10.

5 Capacity Requirements Planning

Capacity requirements planning (CRP) *is the process of determining the amount of labor and machine resources required to accomplish the tasks of production on a more detailed level, taking into account all component parts and end items in the materials plan.* For example, in anticipation of a big demand for pizzas on Super Bowl Sunday, one would have to ensure that sufficient capacity for dough making, pizza preparation, and delivery is available to handle the forecasted demand.

Capacity requirements are computed by multiplying the number of units scheduled for production at a work center by the unit resource requirements and then adding in the setup time. These requirements are then summarized by time period and work center. To

© Munshi Ahmed/Bloomberg News/Landov

illustrate CRP calculations, suppose the planned order releases for a component are as follows:

Time period	1	2	3	4
Planned order release	30	20	40	40

Assume the component requires 1.10 hours of labor per unit in Work Center D and 1.5 hours of setup time. We can use equation 10.2 from Chapter 10 to compute the total hours required (called *work center load*) on Work Center D:

$$\text{Capacity required } (C_i) = \text{Setup time } (S_i) + [\text{Processing time } (P_i) \times \text{Order size } (Q_i)]$$

The capacity requirement in period 1 is 1.5 hours + (1.10 hours/unit)(30 units) = 34.5 hours. Similarly, in period 2 we have 1.5 hours + (1.10 hours/unit)(20 units) = 23.5 hours, and in periods 3 and 4 we have 1.5 hours + (1.10 hours/unit)(40 units) = 45.5 hours. The total load on Work Center D is 149 hours during these 4 weeks, or 37.25 hours per week if averaged.

Such information is usually provided in a **work center load report**, as illustrated in Exhibit 13.17. If sufficient capacity is not available, decisions must be made about overtime, transfer of personnel between departments, subcontracting, and so on. The master production schedule may also have to be revised to meet available capacity by shifting

> **Capacity requirements planning (CRP)** is the process of determining the amount of labor and machine resources required to accomplish the tasks of production on a more detailed level, taking into account all component parts and end items in the materials plan.

Exhibit 13.16 *Summary of MRP Explosion for Bill of Materials in Exhibit 13.10*

MPS **Lead time = 1 week for assembly**

Week	1	2	3	4	5	6	7
Product A—end-item	0	0	0	150	300	50	200
Planned order releases	0	0	150	300	50	200	0

Item C (two units of C are needed for one unit of A)
Description **Lot size: LFL**
 Lead time: 2 weeks

Week		1	2	3	4	5	6	7
Gross requirements		0	0	300	600	100	400	0
Scheduled receipts			200					
Projected OH inventory	10	10	210	0	0	0	0	0
Planned order receipts		0	0	90	600	100	400	0
Planned order releases		90	600	100	400			

Item B
Description **Lot size: 800 units**
 Lead time: 1 week

Week		1	2	3	4	5	6	7
Gross requirements		90	600	250	700	50	200	0
Scheduled receipts								
Projected OH inventory	100	10	210	760	60	10	610	610
Planned order receipts		0	800	800	0	0	800	0
Planned order releases		800	800			800		

Item D
Description **Lot size: POQ = 2 weeks**
 Lead time: 1 week

Week		1	2	3	4	5	6	7
Gross requirements				150	300	50	200	
Scheduled receipts				50				
Projected OH inventory	40	40	40	300	0	200	0	0
Planned order receipts		0	0	360	0	250	0	0
Planned order releases			360		250			

certain end-items to different time periods or changing the order quantities. For example, the workload in Exhibit 13.17 in periods 3 and 4 could be scheduled to period 2 to fill the idle time and avoid overtime in periods 3 and 4. However, additional inventory carrying costs would be incurred. So, as you see, leveling out work center load involves many cost trade-offs. This closed-loop, iterative process provides a realistic deployment of the master schedule to the shop floor.

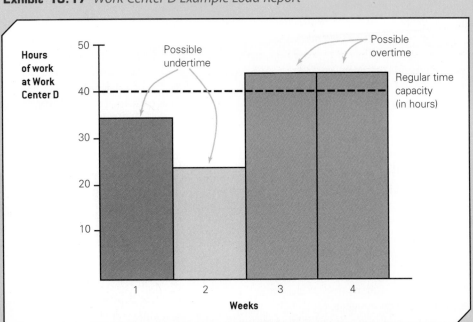

Exhibit 13.17 *Work Center D Example Load Report*

Problems, Activities, and Discussions

1. Interview a production manager at a nearby goods-producing company to determine how the company plans its production for fluctuating demand. What approaches does it use?

2. The forecasted demand for fudge for the next four months is 140, 160, 90, and 70 pounds.

 a. What is the recommended production rate if a level strategy is adopted with no back orders or stockouts? What is the ending inventory for month 4 under this plan?

 b. What is the level production rate with no ending inventory in month 4?

3. The Silver Star Bicycle Company will be manufacturing men's and women's models of its Easy-Pedal 10-speed bicycle during the next two months, and the company would like a production schedule indicating how many bicycles of each model should be produced in each month. Current demand forecasts call for 150 men's and 125 women's models to be shipped during the first month and 200 men's and 150 women's models to be shipped during the second month. Additional data are shown in Exhibit 13.18.

 Last month Silver Star used a total of 4,000 hours of labor. Its labor relations policy will not allow the combined total hours of labor

Exhibit 13.18 *Silver Star Bicycle Data*

Model	Production Costs	Labor Required for Manufacturing (hours)	Labor Required for Assembly (hours)	Current Inventory
Men's	$40	10	3	20
Women's	$30	8	2	30

(manufacturing plus assembly) to increase or decrease by more than 500 hours from month to month. In addition, the company charges monthly inventory at the rate of 2 percent of the production cost based on the inventory levels at the end of the month. Silver Star would like to have at least 25 units of each model in inventory at the end of the two months.

a. Establish a production schedule that minimizes production and inventory costs and satisfies the labor-smoothing, demand, and inventory requirements. What inventories will be maintained, and what are the monthly labor requirements?

b. If the company changed the constraints so that monthly labor increases and decreases could not exceed 250 hours, what would happen to the production schedule? How much would the cost increase? What would you recommend?

4. Draw a simple bill of materials (BOM) for an automobile given the following requirements: (a) clearly label the end-item and each component; (b) BOM must contain no more than 10 items; (c) BOM must contain at least three levels (you may count the end-item Level 0).

5. Given the bill of materials for the printer cartridge (A) shown below, a gross requirement to build 170 units of A, on-hand inventory levels for each item as shown in the table below, and assuming zero lead-times for all items A, B, C, D, and E, compute the net requirements for each item.

6. Each bank teller workstation is forecasted to process 400 transactions (the end-item) on Friday. The bank is open from 9:00 a.m. to 7:00 p.m. on Friday with 90 minutes for lunch and breaks. Three teller windows are open on Friday. A work-study analysis reveals that the breakdown of the transaction mix is 40 percent deposits, 45 percent withdrawals, and 15 percent transfers between accounts. A different form is used for each type of transaction, so there is one deposit slip per deposit, one withdrawal slip per withdrawal, and two transfer slips per transfer.

a. How many transfer slips are needed on Friday?

b. How many withdrawal slips are needed on Friday?

c. Deposit slips are delivered every second day. If the on-hand balance of deposit slips is 50 at this bank, how many deposit slips should be ordered?

d. What is the end-item and component part in this bank example?

e. What are the implications of having too many or too few deposit, withdrawal, and transfer slips? Explain.

7. The BOM for product A is shown next and data from the inventory records are shown in the table. In the master production schedule for product A, the MPS quantity row (showing completion dates) calls for 250 units in week 8. The lead time for production of A is two weeks. Develop the materials requirements plan for the next eight weeks for Items B, C, and D.

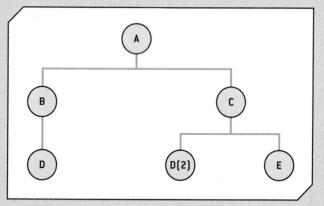

Item	On-Hand Inventory
A	50
B	50
C	90
D	70
E	15

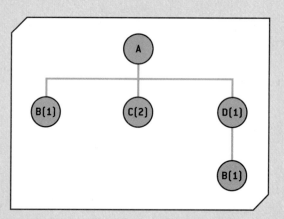

Data Category	B	C	D
Lot-sizing rule	P = 2	FOQ = 1,000	LFL
Lead time	2 weeks	1 week	2 weeks
Scheduled receipts	100 (week 1)	0	0
Beginning (on-hand) inventory	0	100	0

8. David Christopher is an orthopedic surgeon who specializes in three types of surgery—hip, knee, and ankle replacements. The surgery mix is 40 percent hip replacement, 50 percent knee replacement, and 10 percent ankle replacement. Partial bills of materials for each type of surgery are shown in the following information.

Hip Replacement	Knee Replacement	Ankle Replacement
Surgical kits #203 & #428	Surgical kit #203	Surgical kit #108
Hip part package #A	Knee part package #V	Ankle part package #P
Patient's blood type—6 pints	Patient's blood type—4 pints	Patient's blood type—3 pints

a. Given that Dr. Christopher is scheduled to do five hip replacements, three knee replacements, and one ankle replacement next week, how many surgical kits and part packages of each type should the hospital have available next week?

b. How many total pints of blood are needed next week?

c. Design a "mistake-proof" system to ensure each patient gets the correct blood type.

d. What are the implications of a shortage (stockout) of a surgical kit or part package discovered several hours before the operation? What if a part package has a missing part that is not discovered until surgery begins?

9. Consider the master production schedule, bills of materials, and inventory data shown below. Complete the MPS and MRP explosion and identify what actions, if any, you would take given this requirements plan.

Master Production Schedule

	Weeks							
	1	2	3	4	5	6	7	8
Customer req. "A"		5		8			10	
Customer req. "B"						5		10

Lead time for Product "A" is 1 week.
Lead time for Product "B" is 2 weeks.

Bills of Materials

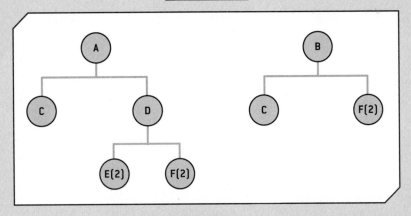

Item File

Item				
	C	D	E	F
Lot sizing rule	LFL	LFL	FOQ (25)	POQ (P = 2)
Lead time (weeks)	3	1	3	1
Beginning (on-hand) inventory	5	8	19	3
Scheduled receipts	8 in week 1	None	25 in week 3	20 in week 1

10. The MPS for product A calls for 100 units to be completed in week 4 and 200 units in week 7 (the lead time is 1 week). Spare part demand for Item B is 10 units per week. The bill of materials for product A is shown on the right, and the inventory records are shown below.

	Item B	Item C
Data category		
Lot sizing rule	FOQ = 500	LFL
Lead time (weeks)	2	3
Beginning (on-hand) inventory	100	10
Scheduled receipts	none	200 (week 2)

a. Develop a material requirement plan for the next 7 weeks for items B and C.

b. Will any action notices be generated? If so, explain what they are and why they must be generated.

11. Garden Manufacturing is a small, family-owned garden tool manufacturer located in Florence, South Carolina. The bills of materials for models A and B of a popular garden tool are shown in Exhibit 13.19 and other additional component information is shown in Exhibit 13.20. There is considerable component part commonality between these two models, as shown by the BOM.

Bill of Materials for Problem 10

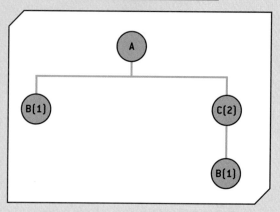

The MPS calls for 100 units of Tool A to be completed in week 5 and 200 units of Tool A to be completed in week 7. End-item A has a 2-week lead time. The MPS calls for 300 units of Tool B to be completed in week 7. End-item B has a 1-week lead time. Do an MRP explosion for all items required to make these two garden tools. What actions, if any, should be taken immediately and what other potential problems do you see?

Exhibit 13.19 *BOM for Two Garden Manufacturing End-Item Tools*

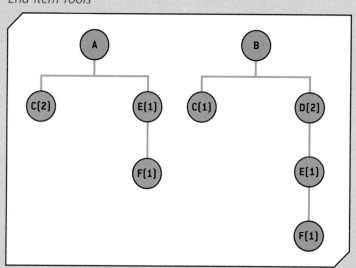

Exhibit 13.20 *Component part information*

Data Category	Item			
	C	D	E	F
Lot-sizing rule	FOQ = 400	LFL	POQ = 4	LFL
Lead time	1 week	2 weeks	2 weeks	1 week
Scheduled receipts	450 (week 1)	50 (week 1)	None	None
Beginning inventory	100	70	50	900

In-Line Industries Case Study

In-Line Industries (ILI) produces recreational in-line skates. Demand is seasonal, peaking in the summer months, with a smaller peak demand during December. For one of its more popular models that is being introduced with some cosmetic upgrades, ILI has forecasted the following demand in pairs of skates for the next year:

Month	Demand (pairs)
January	250
February	500
March	850
April	1,500
May	2,600
June	3,000
July	1,800
August	1,000
September	600
October	400
November	700
December	2,000

© David P. Hall/Masterfile

The manufacturing cost is $80 for each pair of skates, including materials and direct labor. Inventory-holding cost is charged at 20 percent of the manufacturing cost per month. Because this is an "on-demand" good, customers will most likely buy another model if it is not available, thus the lost sales cost is the marginal profit, which is the manufacturer markup of 100 percent, or $80. The normal production rate is 1,000 pairs per month. However, changing the production rate requires administrative costs and is computed to be $1 per unit. Overtime can be scheduled at a cost computed to be $10 per pair. Because ILI produces a variety of other products, labor can be shifted to other work, so undertime cost is not relevant.

Case Questions for Discussion

1. Evaluate the costs of level and chase demand strategies.

2. Comment on potential operational and managerial impacts of these different strategies in a brief report not to exceed one page.

OPERATIONS SCHEDULING AND SEQUENCING

Jean Rowecamp, clinical coordinator of nursing services, was faced with a deluge of complaints by her nursing staff about their work schedules and complaints by floor supervisors about inadequate staffing. The nurses complained they were having too many shift changes each month. Supervisors said they had too many nurses during the days and not enough at night and on the weekends. It seemed that nothing she did would satisfy everyone. The nurses were unionized, so she couldn't schedule them for more than seven consecutive working days and the nurses required at least 16 hours between shift changes. Nurses were constantly making "special requests" for personal time off, despite the negotiated procedures for bidding for shifts and vacation times. Jean lamented that she became an administrator and longed for the days before she had these responsibilities.

© Aldo Murillo/istockphoto.com

learning outcomes

After studying this chapter you should be able to:

LO1 Explain the concepts of scheduling and sequencing.

LO2 Describe staff scheduling and appointment system decisions.

LO3 Explain sequencing performance criteria and rules.

LO4 Describe how to solve single- and two-resource sequencing problems.

LO5 Explain the need for monitoring schedules using Gantt charts.

What do **you** think?

As a student, how do you schedule your homework, school projects, and study activities? What criteria do you use?

Creating schedules is not easy. The nursing example above highlights the complexity of scheduling. For example, union workforce rules and special requests can complicate the scheduling process. Nevertheless, good schedules have to be developed to provide high levels of patient care and to minimize costs. Scheduling is prevalent in nearly every organization and even in our personal lives.

Scheduling is prevalent in nearly every organization and even in our personal lives.

1 Understanding Scheduling and Sequencing

Scheduling *refers to the assignment of start and completion times to particular jobs, people, or equipment.* For example, fast-food restaurants, hospitals, and call centers need to schedule employees for work-shifts; doctors, dentists, and stockbrokers need to schedule patients and customers; airlines must schedule crews and flight attendants; sports organizations must schedule teams and officials; court systems must schedule hearings

Scheduling refers to the assignment of start and completion times to particular jobs, people, or equipment.

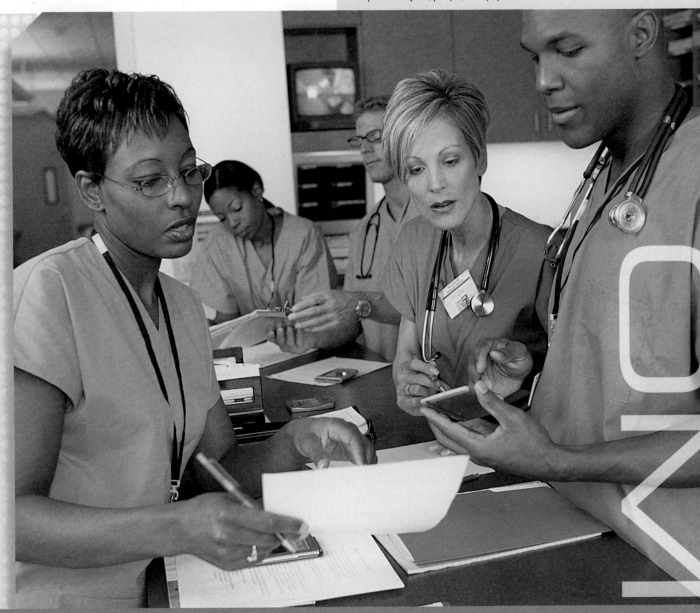

© Comstock Images/Jupiter Images

and trials; factory managers need to schedule jobs on machines and preventive maintenance work; and salespersons need to schedule customer deliveries and visits to potential customers. Many schedules are repeatable over the long term, such as those for retail store staff and assembly line employees. Others might change on a monthly, weekly, or even daily basis, as might be the case with call center employees, nurses, or salespeople.

A concept related to scheduling is sequencing. **Sequencing** *refers to determining the order in which jobs or tasks are processed.* For example, triage nurses must decide on the order in which emergency patients are treated; housekeepers in hotels must sequence the order of rooms to clean; operations managers who run an automobile assembly line must determine the sequence by which different models are produced; and airport managers must sequence outgoing flights on runways. Note that in all these situations, processing takes place using a common resource with limited capacity. Thus, the sequence will ultimately determine how well the resource is used to achieve some objective, such as meeting demand or customer due dates. Generally, a sequence specifies a schedule, and we will see this in various examples later in this chapter.

Scheduling and sequencing are some of the more common activities that operations managers perform every day in every business. They are fundamental to all three levels of aggregation and disaggregation planning as we described in the previous chapter. Good schedules and sequences lead to efficient execution of manufacturing and service plans.

Scheduling and sequencing in back-office or low-contact service processes are similar to that for goods-producing processes. The same scheduling and sequencing concepts and methods used in manufacturing are beneficial in low-contact service processes.

It is not uncommon for a manufacturing facility to have hundreds of workstations or machine centers and to process thousands of different parts. Managers of such facilities also need daily or even hourly updates on the status of production to meet the information needs of supply chain managers, sales and marketing personnel, and customers. Similarly, service managers often manage dozens of part-time workers with varying work availability times (think of a fast-food restaurant manager near a college campus), or ever-changing workloads and demands (think of a hospital nurse administrator). The complexity of these situations dictates that effective scheduling systems be computerized,

Telling Umpires Where to Go

One of the authors of this book developed annual schedules for umpires in the American Baseball League for many years before this activity was merged with the National League. Some of the critical factors in developing these schedules were to ensure that umpire crews were not assigned to consecutive series with the same team if possible; that the number of times a crew was assigned to a team was balanced over the course of the season; that travel sequences be rational and realistic; and that a variety of constraints be met. For instance, it makes more sense to schedule a crew to several consecutive series out on the East Coast or West Coast and move them to nearby cities rather than shuttle them back and forth across the country.

Various constraints limited the scheduling possibilities. For example, one could not schedule a crew for a day game in another city after working a night game on the previous day. In addition, crews need time to rest and travel between game assignments. All these factors needed to be considered in the context of the game schedule, which was created well in advance.

© Shaun Best/Reuters/Landov

Scheduling applies to all aspects of the value chain, from planning and releasing orders in a factory, determining work shifts for employees, and making deliveries to customers.

not only for generating schedules but also for retrieving information so that a salesperson can check the status of a customer's order or project a delivery date. Thus, implementing scheduling systems requires good information technology support.

2 Scheduling Applications and Approaches

Scheduling applies to all aspects of the value chain, from planning and releasing orders in a factory, determining work shifts for employees, and making deliveries to customers. Many problems, such as staff scheduling, are similar across different organizations. Quite often, however (as with the baseball umpiring situation or scheduling classrooms and teachers at a university), unique situational factors require a unique solution approach. In this section we present two common applications of scheduling that are prevalent in operations management.

2.1 Staff Scheduling

Staff scheduling problems are prevalent in service organizations because of high variability in customer demand. Examples include scheduling call center representatives, hotel housekeepers, tollbooth operators, nurses, airline reservation clerks, police officers, fast-food restaurant employees, and many others.

Staff scheduling attempts to match available personnel with the needs of the organization by:

1. accurately forecasting demand and translating it into the quantity and timing of work to be done;
2. determining the staffing required to perform the work by time period;
3. determining the personnel available and the full- and part-time mix; and
4. matching capacity to demand requirements, and developing a work schedule that maximizes service and minimizes costs.

Keeping the Goods Moving

UPS is the world's largest package delivery company and a global leader in supply chain services. UPS has expanded its global capabilities and added guaranteed heavy airfreight services around the world, enabling customers to reach the global marketplace faster. UPS also introduced new time-definite products such as overnight, two-day, and deferred heavy airfreight. Each of these time-dependent services requires different resource schedules and priority sequences for operations activities, such as loading and unloading goods, airplane flight schedules, customer delivery sequences, package and freight handling systems and procedures, and so on.

© John Sommers II/Reuters/Landov

The first step requires converting demand to a capacity measure; that is, the number of staff required. For instance, we might determine that for every $400 dollars of sales forecast, we need one additional full-time employee. The second step determines the quantity and timing of the work to be done in detail, usually by hour of the day, and sometimes in 5- to 10-minute time intervals. Determining the staffing required must take into account worker productivity factors, personal allowances, sickness, vacations, no-shows, and so on.

Step 4 focuses on the matching of capacity to demand requirements; this is the essence of scheduling. Different approaches are required for different situations because of the nature of constraints. If service demands are relatively level over time, as in the case of hotel housekeepers, it is usually easy to schedule personnel on standard weekly work shifts. If the workload varies greatly within a shift, as is the case for telephone customer service representatives, the problem becomes one of scheduling shifts to meet the varying demand. Let us examine a relatively simple problem of

scheduling personnel with consecutive days off in the face of fluctuating requirements.[1]

T.R. Accounting Service is developing a workforce schedule for three weeks from now and has forecasted demand and translated it into the following minimum personnel requirements for the week:

Day	Mon.	Tue.	Wed.	Thur.	Fri.	Sat.	Sun.
Minimum personnel	8	6	6	6	9	5	3

The staff requirements are for full-time accountants who do accounting work such as end-of-month financial statements, tax record organization, and federal, state, and local tax payments. T.R., the owner of the accounting service, wants to schedule the employees so that each employee has two *consecutive* days off and all demand requirements are met.

The staffing procedure is as follows. First, we locate the *set of at least two consecutive days with the smallest requirements*. That is, we find the day with the smallest staff requirements, the next-smallest, and so on, until there are at least two consecutive days. Sunday and Saturday, for example, have requirements of 3 and 5, respectively, while all others are greater than 5. We then circle the requirements for those two consecutive days. Thus we have the following, for employee 1:

Day	Mon.	Tue.	Wed.	Thur.	Fri.	Sat.	Sun.
Requirements	8	6	6	6	9	(5)	(3)

We assign accountant 1 to work on all days that are not circled, that is, Monday through Friday. Then we subtract 1 from the requirement for each day that accountant will work. This gives us the following requirements that remain:

Day	Mon.	Tue.	Wed.	Thur.	Fri.	Sat.	Sun.
Requirements	7	5	5	5	8	5	3

The procedure is repeated with this new set of requirements for accountant 2.

Day	Mon.	Tue.	Wed.	Thur.	Fri.	Sat.	Sun.
Requirements	7	(5)	(5)	(5)	8	(5)	(3)

When there are several alternatives, as in this case, we do one of two things. First, we try to choose a pair of days with the lowest total requirement. If there are still ties, we are to choose the first available pair that makes the most sense to the scheduler. Hence, we again use Saturday and Sunday as days off for accountant 2, since this pair has the smallest total requirement of 8. We subtract 1 from each working day's requirement, yielding the following:

Day	Mon.	Tue.	Wed.	Thur.	Fri.	Sat.	Sun.
Requirements	6	4	4	4	7	5	3

Using Spreadsheet Models to Schedule Medical Residents

© Kingyo/Dreamstime LLC

The chief radiology resident from the University of Vermont's College of Medicine and a group of business students who were enrolled in a semester-long Master of Science course developed a spreadsheet model for creating a one-year schedule for a group of 15 medical residents in the radiology department. Demand for radiology services could occur at any time of the day; thus, they must ensure that adequate personnel are always available. The majority of demand occurs during the weekday working hours; approximately 20 to 25 certified radiologists and the residents serve this demand. Certified radiologists do not work on weeknights; however, a radiology resident is on call and is responsible for all radiology services at the hospital. The resident works the overnight shift alone and must be physically at the hospital, but is off during the next day shift. The radiology chief resident has the task of assigning each resident to these on-call and ER shifts. This scheduling task—to assign one resident to each on-call and ER assignment every day of the year—is incredibly complex because of many requirements and restrictions, such as having one and only one resident assigned to the ER schedule per four-week rotation block.

The student team used Microsoft Excel to create a spreadsheet that would allow them to measure the key metrics of the residents' assignments, such as the number of days worked in each category (e.g., Thursdays, Fridays, etc.). Then, they added an optimization model to find a feasible solution. The model was simple to use and increased the quality of the resulting resident assignments, and decreased the time required to obtain the assignments.[2]

Circling the smallest requirements until we obtain at least two consecutive days again yields the following for employee 3.

Day	Mon.	Tue.	Wed.	Thur.	Fri.	Sat.	Sun.
Requirements	6	(4)	(4)	(4)	7	5	(3)

Notice that Sunday is not adjacent to Tuesday, Wednesday, or Thursday, so we cannot use Sunday in the schedule. Remember we are looking for consecutive

Exhibit 14.1 *Scheduling Procedure for T.R. Accounting Service*

Employee Number	Mon.	Tue.	Wed.	Thur.	Fri.	Sat.	Sun.
4	5	4	4	3	6	(4)	(2)
5	4	3	(3)	(2)	5	4	2
6	3	2	3	2	4	(3)	(1)
7	(2)	(1)	2	1	3	3	1
8	2	1	(1)	(0)	2	2	0
9	(1)	(0)	1	0	1	1	0
10	1	(0)	(0)	0	0	0	0

Exhibit 14.2 *Final Accountant Schedule*

Employee Number	Mon.	Tue.	Wed.	Thur.	Fri.	Sat.	Sun.
1	X	X	X	X	X		
2	X	X	X	X	X		
3	X			X	X	X	X
4	X	X	X	X	X		
5	X	X			X	X	X
6	X	X	X	X	X		
7			X	X	X	X	X
8	X	X			X	X	X
9			X	X	X	X	X
10	X			X	X	X	X
Total	8	6	6	8	10	6	6

pairs of days. Let's choose the Tuesday-Wednesday. The remaining requirements are:

Day	Mon.	Tue.	Wed.	Thur.	Fri.	Sat.	Sun.
Requirements	5	4	4	3	6	4	2

Continuing with this procedure, we obtain the sequence of requirements shown in Exhibit 14.1 (with circled numbers representing the lowest-requirement pair selected). The final accountant schedule is shown in Exhibit 14.2. Even though some requirements are exceeded, such as Thursday with a demand for six accountants yet we schedule eight, the solution mini-

mizes the number of employees required. A more difficult problem that we do not address is that of determining a schedule of rotating shifts so that employees do not always have the same two days off. Over a predetermined longer cycle such as a quarter, all employees rotate through all possible days off. This makes for a fair and more equitable staff schedule, but it is complicated and beyond the scope of this book.

Many software packages are available to help with staff scheduling. However, scheduling is so integrated with the practices and culture of the organization that these standardized software packages normally need to be

Software to Schedule Anywhere

One provider of small business software offers an online employee scheduling system called Schedule-Anywhere (ScheduleAnywhere.com). This service allows managers to schedule employees from any computer with Internet access, whether at work, at home, or on the road. "With over 70,000 users, we get a lot of feedback on what people really need in an employee scheduling system," said Jon Forknell, vice president and general manager of Atlas Business Solutions. "Many of our customers told us they needed an online solution that was affordable and easy to use." Small firms can use the online scheduling service for as little as $20 per month, while large organizations such as AT&T, Amazon.com, Bank of America, and the American Red Cross sign long-term contracts. ScheduleAnywhere gives users the power to

- schedule employees from any computer with Internet access
- create schedules by position, department, location, etc.
- view schedule information in a 1-day, 7-day, 14-day, or 28-day format
- enter staffing requirements and view shift coverage
- see who's scheduled and who's available
- automatically rotate or copy employee schedules
- preschedule time-off requests
- avoid scheduling conflicts
- give employees read/write or read-only access to schedules[3]

Courtesy of Atlas Business Solutions, Inc.

modified to work well in specific operating environments. Accurate input data and the user's understanding of how the software techniques develop the schedules are other challenges when adopting off-the-shelf scheduling software.

2.2 Appointment Systems

Appointments can be viewed as a reservation of service time and capacity. Using appointments provides a means to maximize the use of time-dependent service capacity and reduce the risk of no-shows. Appointment systems are used in many businesses, such as consulting, tax preparation, music instruction, and medical, dental, and veterinarian practices. Indirectly, appointments reduce the cost of providing the service because the service provider is idle less each workday. An appointment system must try and accommodate customers and forecast their behavior, such as the no-show rate or a difficult customer who demands more processing time.

Four decisions to make regarding designing an appointment system are the following:

1. *Determine the appointment time interval* such as 1 hour or 15 minutes. Some professional services such as dentists and physicians use smaller appointment intervals and then take multiples of it, depending on the type of procedure thought to be required by the patient.

2. Based on an analysis of each day's customer mix, *determine the length of each workday and the time off-duty.* Once the on- and off-duty days for the year (annual capacity) are determined and assuming a certain customer mix and overbooking rate (see step 3), the service provider can forecast expected total revenues for the year.

3. *Decide how to handle overbooking* for each day of the week. Often, customers do not show up as scheduled. If the no-show percentage is low, say 2 percent, then there may be no need to overbook. However, once the no-show percentage reaches 10 percent or more, overbooking is usually necessary to maximize

Appointments can be viewed as a reservation of service time and capacity.

revenue and make effective use of perishable and expensive time.

4. *Develop customer appointment rules* that maximize customer satisfaction. For example, some service providers leave one appointment interval open at the end of each workday. Others schedule a 60-minute lunch interval but can squeeze in a customer during lunch if necessary. Telephone and electronic appointment reminders are another way to help maximize service-provider utilization.

3 Sequencing

Sequencing is necessary when several activities (manufacturing goods, servicing customers, delivering packages, and so on) use a common resource. The resource might be a machine, a customer service representative, or a delivery truck. Sequencing can be planned, in which case it creates a schedule. For example, if a student plans to begin homework at 7:00 p.m. and estimates that it will take 60 minutes to complete an OM assignment, 45 minutes to read a psychology chapter, and 40 minutes to do statistics homework, then sequencing the work from most favorite to least favorite—OM, psychology, and statistics—creates the schedule:

Assignment	Start Time	End Time
OM	7:00	8:00
Psychology	8:00	8:45
Statistics	8:45	9:25

3.1 Sequencing Performance Criteria

In selecting a specific scheduling or sequencing rule, a manager must first consider the criteria on which to evaluate schedules. These criteria are often classified into three categories:

1. process-focused performance criteria,
2. customer-focused due date criteria, and
3. cost-based criteria.

The applicability of the various criteria depends on the availability of data. Later we will show how these performance measures are applied to various sequencing rules.

Process-focused performance criteria pertain only to information about the start and end times of jobs and focus on shop performance such as equipment utilization and WIP inventory. Two common measures are flow time and makespan. **Flow time** *is the amount of time a job spent in the shop or factory.* Low flow times reduce WIP inventory. Flow time is computed using equation 14.1.

$$F_i = \Sigma p_{ij} + \Sigma w_{ij} = C_i - R_i \quad [14.1]$$

where

F_i = flow time of job i

Σp_{ij} = sum of all processing times of job i at workstation or area j (run + setup times)

Σw_{ij} = sum of all waiting times of job i at workstation or area j

C_i = completion time of job i

R_i = ready time for job i where all materials, specifications, and so on are available

Makespan *is the time needed to process a given set of jobs.* A short makespan aims to achieve high equipment utilization and resources by getting all jobs out of the shop quickly. Makespan is computed using equation 14.2.

$$M = C - S \quad [14.2]$$

where

M = makespan of a group of jobs

C = completion time of *last* job in the group

S = start time of *first* job in the group

Due-date criteria pertain to customers' required due dates or internally determined shipping dates. Common performance measures are lateness and tardiness, or the number of jobs tardy or late. **Lateness** *is the difference between the completion time and the due date (either positive or negative).* **Tardiness** *is the amount of time by which the completion time exceeds the due date.* (Tardiness is defined as zero if the job is completed before the due date, and therefore no credit is given for completing a job early.) In contrast to process-focused performance criteria, these measures focus externally on customer satisfaction and service. They are calculated using equations 14.3 and 14.4.

$$L_i = C_i - D_i \quad [14.3]$$
$$T_i = \text{Max} (0, L_i) \quad [14.4]$$

> **Flow time** is the amount of time a job spent in the shop or factory.
>
> **Makespan** is the time needed to process a given set of jobs.
>
> **Lateness** is the difference between the completion time and the due date (either positive or negative).
>
> **Tardiness** is the amount of time by which the completion time exceeds the due date.

where

L_i = lateness of job i
D_i = due date of job i
T_i = tardiness of job i

A third type of performance criteria is cost-based. Typical cost includes inventory, changeover or setup, processing or run, and material handling costs. This cost-based category might seem to be the most obvious criteria, but it is often difficult to identify the relevant cost categories, obtain accurate estimates of their values, and allocate costs to manufactured parts or services correctly. In most cases, costs are considered implicitly in process performance and due-date criteria.

3.2 Sequencing Rules

Two of the most popular sequencing rules for prioritizing jobs are

- shortest processing time (SPT), and
- earliest due date (EDD).

In using one of these rules, a manager would compute the measure for all competing jobs and select them in the sequence according to the criterion. For example, suppose that the student we discussed earlier sequenced the homework according to SPT. The sequence would be statistics, psychology, and OM. These rules are often applied when a fixed set of jobs needs to be sequenced at one point in time.

In other situations, new jobs arrive in an intermittent fashion, resulting in a constantly changing mix of jobs needing to be sequenced. In this case, we assign priorities to whatever jobs are available at a specific time and then update the priorities when new jobs arrive. Some examples of these priority rules are

- first-come-first-served (FCFS),
- fewest number of operations remaining (FNO),
- least work remaining (LWR)—sum of all processing times for operations not yet performed, and
- least amount of work at the next process queue (LWNQ)—amount of work awaiting the next process in a job's sequence.

The SPT and EDD rules generally work well in the short term, but in most situations new orders and jobs arrive intermittently and the schedule must accommo-

date them. If SPT were used in a dynamic environment, a job with a large processing time might never get processed. In this case, some time-based exception rule (such as "if a job waits more than 40 hours, schedule it next") must be used to avoid this problem.

Different sequencing rules lead to very different results and performance. The SPT rule tends to minimize average flow time and work-in-process inventory and maximize resource utilization. The EDD rule minimizes the maximum of jobs past due but doesn't perform well on average flow time, WIP inventory, or resource utilization. The FCFS rule is used in many service delivery systems and does not consider any job or customer criterion. FCFS focuses only on the time of arrival for the customer or job. The FNO rule does not consider the length of time for each operation; for example, a job may have many small operations and be scheduled last. Generally, this is not a very good rule. The LWNQ rule tries to keep downstream workstations and associated resources busy.

4 Applications of Sequencing Rules

Sequencing in a job shop, in which several different goods or services are processed, each of which may have a unique routing among process stages, is generally very complex, but some special cases lend themselves to simple solutions. These special cases provide understanding and insight into more complicated scheduling problems. One that we illustrate is scheduling on a single workstation or processor.

4.1 Single-Resource Sequencing Problem

The simplest sequencing problem is that of processing a set of jobs on a single processor. This situation occurs in many firms. For example, in a serial manufacturing process, a bottleneck workstation controls the output of the entire process. Thus, it is critical to schedule the bottleneck equipment efficiently. In other cases, such as in a

Different sequencing rules lead to very different results and performance.

chemical plant, the entire plant may be viewed as a single processor. Single processors for service situations include processing patients through an X-ray or CAT-scanning machine, trucks through a loading/unloading dock, or financial transactions through a control workstation. For the single-processor sequencing problem, a very simple rule—shortest processing time—finds a minimal average flow time sequence. An example of its use follows.

Consider a workstation that has one maintenance mechanic to repair failed machines. We can think of the mechanic as the processor (scarce resource) and the machines awaiting repair as the jobs. Let us assume that six machines are down, with estimated repair times given here, and that no new jobs arrive.

Job (fix machine #)	1	2	3	4	5	6
Processing time (hours)	10	3	7	2	9	6

No matter which sequence is chosen, the makespan is the same, since the time to process all the jobs is the sum of the processing times, or in this example, 37 hours. Therefore, we use average flow time as the criterion to minimize the average time a job spends in the workstation. The idea here is to get the most jobs done as soon as possible. Applying the SPT rule, we use the job sequence 4-2-6-3-5-1. We assume that all jobs are ready for processing at time zero (that is, $R_i = 0$ for all jobs i). Then the flow times (F_i) for the jobs are computed as follows:

Job Sequence	Flow Time
4	2 hours
2	2 + 3 = 5 hours
6	5 + 6 = 11 hours
3	11 + 7 = 18 hours
5	18 + 9 = 27 hours
1	27 + 10 = 37 hours

The average flow time for these six jobs is (2 + 5 + 11 + 18 + 27 + 37)/6 = 100/6 = 16.67 hours.

This means that the average time a machine will be out of service is 16.7 hours. The SPT sequencing rule maximizes workstation utilization and minimizes average job flow time and work-in-process inventory. For example, if you switch jobs 4 and 6 so the job sequence is 6-2-4-3-5-1, note that the average flow time increases to 18 hours. We encourage you to work through the calculations to show this. As long as no additional jobs enter the mix, all will eventually be processed. Of course, the job with the longest processing time will wait the longest (and this customer might not be very happy), but on average, SPT will reduce the average flow time.

When processing times are relatively equal, then most operating systems default to the first-come-first-served (FCFS) sequencing rule. There are, of course, exceptions to this rule. For example, a job for a firm's most important customer might be pushed to the front of the sequence, or the maître d' at a restaurant might seat a celebrity or VIP before other patrons.

In many situations, jobs have due dates that have been promised to customers. Although SPT provides the smallest average flow time and smallest average lateness of all scheduling rules that might be chosen, in a dynamic environment, jobs with long processing times are continually pushed back and may remain in the shop a long time. Thus it is advantageous to consider sequencing rules that take into account the due dates of jobs.

A popular and effective rule for scheduling on a single processor (resource) is the earliest-due-date rule (EDD), which dictates sequencing jobs in order of earliest due date first. This rule minimizes the maximum job tardiness and job lateness. It does not minimize the average flow time or average lateness, as SPT does, however. An example of how the earliest due-date rule is used follows.

Suppose an insurance underwriting work area (that is, the single processor) has five commercial insurance jobs to quote that have these processing times and due dates.

Job	Processing Time (p_{ij})	Due Date (D_i)
1	4	15
2	7	16
3	2	8
4	6	21
5	3	9

If the jobs are sequenced by-the-numbers in the order 1-2-3-4-5, then the flow time, tardiness, and lateness for each job are calculated using equations 14.1, 14.3, and 14.4 on the next page.

Job	Flow Time (F_i)	Due Date	Lateness ($L_i = C_i - D_i$)	Tardiness [Max ($0, L_i$)]
1	4	15	−11	0
2	4 + 7 = 11	16	−5	0
3	11 + 2 = 13	8	5	5
4	13 + 6 = 19	21	−2	0
5	19 + 3 = 22	9	13	13
Average	69/5 =13.8		0	3.6

Using equation 14.2, the makespan is $M_t = C_t - S_t$ = 22 − 0 = 22. If we use the SPT rule to schedule the jobs, we obtain the sequence 3-5-1-4-2. The flow time, tardiness, and lateness are then given as follows:

Job	Flow Time (F_i)	Due Date	Lateness ($L_i = C_i - D_i$)	Tardiness [Max ($0, L_i$)]
3	2	8	−6	0
5	2 + 3 = 5	9	−4	0
1	5 + 4 = 9	15	−6	0
4	9 + 6 = 15	21	−6	0
2	15 + 7 = 22	16	6	6
Average	10.6		−3.2	1.2

Note that the makespan is 22 and that the maximum tardiness and the maximum lateness are both 6. Using the earliest-due-date rule (EDD), we obtain the sequence 3-5-1-2-4. The flow time, tardiness, and lateness for this sequence are given in the following table:

Job	Flow Time (F_i)	Due Date	Lateness ($L_i = C_i - D_i$)	Tardiness [Max ($0, L_i$)]
3	2	8	−6	0
5	2 + 3 = 5	9	−4	0
1	5 + 4 = 9	15	−6	0
2	9 + 7 = 16	16	0	0
4	16 + 6 = 22	21	1	1
Average	10.8		−3.0	0.2

The results of applying three different sequencing rules to the five jobs are shown in Exhibit 14.3. Note that the SPT rule minimizes the average flow time and number of jobs in the system. The EDD rule minimizes the maximum lateness and tardiness. As previously noted, the SPT rule is internally focused whereas the EDD rule is focused on external customers. Using a by-the-numbers sequencing rule, as in 1-2-3-4-5, results in very poor relative performance. This result helps illustrate that random or commonsense sequencing rules seldom give better results than the SPT or EDD rules for sequencing jobs over a single processor.

4.2 Two-Resource Sequencing Problem

In this section, we consider a flow shop with only two resources or workstations. We assume that each job must be processed first on Resource #1 and then on

Exhibit 14.3 *Comparison of Three Ways to Sequence the Five Jobs*

Performance Criteria	Sequence 1-2-3-4-5	Sequence 3-5-1-4-2 (SPT)	Sequence 3-5-1-2-4 (EDD)
Average Flow Time	13.8	10.6	10.8
Average Lateness	0	−3.2	−3.0
Maximum Lateness	13	6	1
Average Tardiness	3.6	1.2	0.2
Maximum Tardiness	13	6	1

Solved Problem

Five tax analysis jobs are waiting to be processed by Martha at T.R. Accounting Service. Use the shortest-processing-time (SPT) and earliest-due-date (EDD) sequencing rules to sequence the jobs. Compute the flow time, tardiness, and lateness for each job, and the average flow time, average tardiness, and average lateness for all jobs. Which rule do you recommend? Why?

Job	Processing Time (days)	Due Date
1	7	11
2	3	10
3	5	8
4	2	5
5	6	17

Solution:

The SPT sequence is 4-2-3-5-1.

Job	Flow Time (F_i)	Due Date (D_i)	Lateness ($L_i = C_i - D_i$)	Tardiness [Max (0, L_i)]
4	2	5	−3	0
2	2 + 3 = 5	10	−5	0
3	5 + 5 = 10	8	2	2
5	10 + 6 = 16	17	−1	0
1	16 + 7 = 23	11	12	12
Average	11.2		+1.0	2.8

The EDD sequence is 4-3-2-1-5.

Job	Flow Time (F_i)	Due Date (D_i)	Lateness ($L_i = C_i - D_i$)	Tardiness [Max (0, L_i)]
4	2	5	−3	0
3	2 + 5 = 7	8	−1	0
2	7 + 3 = 10	10	0	0
1	10 + 7 = 17	11	6	6
5	17 + 6 = 23	17	6	6
Average	11.8		−1.6	2.4

Given the nature of the data, this is not an easy decision. The SPT rule minimizes average flow time and average lateness but job 1 is extremely late by 12 days. The EDD rule minimizes the maximum job tardiness and lateness. Jobs 1 and 5 are tardy by 6 days. If job 5 is a big client with significant revenue potential then the EDD rule is probably best.

Resource #2. Processing times for each job on each resource are known. In contrast to sequencing jobs on a single resource, the makespan can vary for each different sequence. Therefore, for the two-resource sequencing problem, it makes sense to try to find a sequence with the smallest makespan.

S.M. Johnson developed the following algorithm in 1954 for finding a minimum makespan schedule.[4] The following algorithm (procedure) defines Johnson's sequencing rule for the two-resource problem structure.

1. List the jobs and their processing times on Resources #1 and #2.

2. Find the job with the shortest processing time (on either resource).

3. If this time corresponds to Resource #1, sequence the job first; if it corresponds to Resource #2, sequence the job last.

4. Repeat steps 2 and 3, using the next-shortest processing time and working inward from both ends of the sequence until all jobs have been scheduled.

Consider the two-resource sequencing problem posed by Hirsch Products. It manufactures certain custom parts that first require a shearing operation (Resource #1) and then a punch-press operation (Resource #2). Hirsch currently has orders for five jobs, which have processing times (days) estimated as follows:

Job	Shear	Punch
1	4 days	5 days
2	4	1
3	10	4
4	6	10
5	2	3

The jobs can be sequenced in any order but they must be sheared first. Therefore, we have a flow shop situation where each job must first be sequenced on the shear operation and then on the punch operation.

Suppose the jobs are sequenced by-the-numbers in the order 1-2-3-4-5. This schedule can be represented by a simple Gantt chart showing the schedule of each job on each machine along a horizontal time axis (see Exhibit 14.4). This shows, for instance, that job 1 is scheduled on the shear for the first four days, job 2 for the next four days, and so on. We construct a Gantt chart for a given sequence by scheduling the first job as early as possible on the first machine (shear). Then, as soon as the job is completed, it can be scheduled on the punch press, provided that no other job is currently in progress. First, note that all jobs follow each other on the shearing machine. Because of variations in processing times, however, the punch press, the second operation, is often idle while awaiting the next job. The makespan is 37 days, and the flow times in days for the jobs follow:

Job	1	2	3	4	5
Flow Time (days)	9	10	22	34	37

Applying Johnson's Rule, we find that the shortest processing time is for job 2 on the punch press.

Job	Shear	Punch
1	4 days	5 days
2	4	1
3	10	4
4	6	10
5	2	3

Since the minimum time on either machine is on the second machine, job 2, with a one-day processing time, it is scheduled last.

—— —— —— —— <u>2</u>

Next, we find the second-shortest processing time. It is two days, for job 5 on machine 1. Therefore, job 5 is scheduled first.

<u>5</u> —— —— —— <u>2</u>

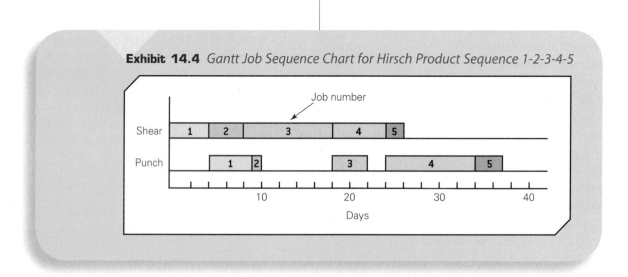

Exhibit 14.4 *Gantt Job Sequence Chart for Hirsch Product Sequence 1-2-3-4-5*

In the next step, we have a tie of four days between job 1 on the shear and job 3 on the punch press. When a tie occurs, either job can be chosen. If we pick job 1, we have the following sequence:

| 5 | 1 | | | 2 |

Continuing with Johnson's Rule, the last two steps yield the complete sequence.

| 5 | 1 | | 3 | 2 |
| 5 | 1 | 4 | 3 | 2 |

The Gantt chart for this sequence is shown in Exhibit 14.5. The makespan is reduced from 37 to 27 days, and the average flow time is also improved from 22.4 to 18.2 days. As noted, the total idle time on the punch press is now only four days, resulting in a punch-press resource utilization of 23/27 or 85.2 percent and we gain 10 days to schedule other jobs. If the sequencing problem structure fits the assumptions of Johnson's Rule, it is a powerful algorithm. Again, common sense scheduling is seldom as good as Johnson's Rule.

Murphy's Law states that if something can go wrong it will, and this is especially true with schedules.

Mobil Oil Corporation

Mobil Oil Corporation runs a nationwide system for dispatching and processing customer orders for gasoline and distillates. It is an integrated operating system that controls the flow of billions in annual sales from initial order entry to final delivery, confirmation, and billing. Although the entire dispatching process is overseen by a handful of people in a small office, it operates more efficiently than the old manual system in all respects: It provides better customer service; greatly improved credit, inventory, and operating cost control; and significantly reduced distribution costs. Central to this new system is computer-assisted dispatch (called CAD at Mobil), designed to assist schedulers in real time as they determine the means by which ordered product will be safely and efficiently delivered to customers.

Scheduling decisions include (1) assigning orders to terminals; (2) assigning orders to delivery trucks; (3) adjusting order quantities to fit truck compartments; (4) loading trucks to their maximum legal weight; and (5) routing trucks and sequencing deliveries. Annual net cost savings is in the millions of dollars.[5]

© Tim Boyle/Getty Images

Exhibit 14.5 *Gantt Job Sequence Chart for Hirsch Product Sequence 5-1-4-3-2*

Solved Problem

A manufacturing process involving machined components consists of two operations done on two different machines. The status of the queue at the beginning of a particular week is as follows:

Job Number	Number of Components	Scheduled Time on Machine 1 (min. per piece)	Scheduled Time on Machine 2 (min. per piece)
101	200	2.5	2.5
176	150	1.5	0.5
184	250	1.0	2.0
185	125	2.5	1.0
201	100	1.2	2.4
213	100	1.2	2.2

The processing on machine 2 must follow processing on machine 1. Schedule these jobs to minimize the makespan. Illustrate the schedule you arrive at with a bar chart.

Solution:

Because this is a two-machine flow shop problem, Johnson's Rule is applicable. Total time in minutes on each machine is the product of the number of components and the unit times, as shown here.

Job	Machine 1	Machine 2	Job	Machine 1	Machine 2
101	500	500	185	312.5	125
176	225	75	201	120	240
184	250	500	213	120	220

The sequence specified by Johnson's Rule is 201-213-184-101-185-176. The schedules are shown in the following two different versions of Gantt charts.

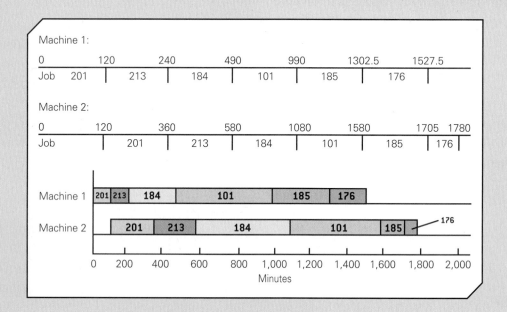

5 Schedule Monitoring and Control

urphy's Law states that if something can go wrong it will, and this is especially true with schedules. Thus, it is important that progress be monitored on a continuing basis. For example, in manufacturing, the master scheduler must know the status of orders that are ahead of schedule or behind schedule due to shortages of material, workstations that are backlogged, changes in inventory, labor turnover, and sales commitments. Schedules must be changed when these things occur. Therefore, reschedules are a normal part of scheduling.

Short-term capacity fluctuations also necessitate changes in schedules. Factors affecting short-term capacity include absenteeism, labor performance, equipment failures, tooling problems, labor turnover, and material shortages. They are inevitable and unavoidable. Some alternatives available to operations managers for

coping with capacity shortages are overtime, short-term subcontracting, alternate process routing, and reallocations of the work force, as described in the previous chapter.

Gantt (bar) charts are useful tools for monitoring schedules, and an example is shown in Exhibit 14.6. The red shaded areas indicate completed work. This chart shows, for example, that job 4 has not yet started on machine 2, job 1 is currently behind schedule on machine 3, and jobs 2 and 5 are ahead of schedule. Perhaps needed material has not yet been delivered for job 4, or perhaps machine 3 has had a breakdown. In any event, it is up to production-control personnel to revise the schedule or to expedite jobs that are behind schedule. Many other types of graphical aids are useful and commercially available.

Exhibit 14.6 *Gantt Chart Example for Monitoring Schedule Progress*

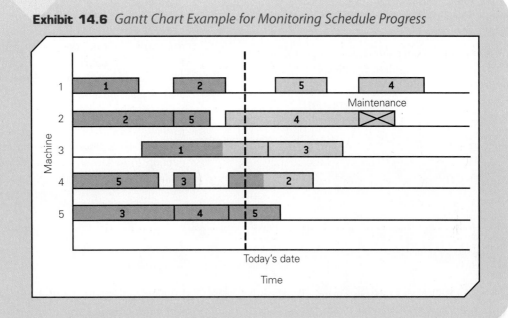

Problems, Activities, and Discussions

1. Interview an operations manager at a nearby manufacturing or service company to find out about scheduling problems the company faces and how they are addressed.

2. Discuss how you decide to schedule your school assignments. Do your informal scheduling rules correspond to any of those in this chapter?

3. Evaluate a good or bad experience you might have had with an appointment from both the customer (you) and organization's perspective. What factors do you think led to this experience?

4. A hospital emergency room needs the following numbers of nurses:

Day	M	T	W	T	F	S	S
Min. number	5	3	2	4	8	7	4

Each nurse should have two consecutive days off. How many full-time nurses are required and what is a good nurse schedule?

5. A supermarket has the following minimum personnel requirements during the week. Each employee is required to have two consecutive days off. How many regular employees are required and what is a good schedule?

Day	Mon.	Tue.	Wed.	Thur.	Fri.	Sat.	Sun.
Min. personnel	4	4	5	6	6	5	4

6. An insurance claims work area has five claims waiting for processing as follows:

Job	Processing Time	Due Date
A	15	26
B	25	32
C	20	35
D	10	30
E	12	20

Compute the average flow time, tardiness, and lateness for the following sequences: SPT sequence, EDD sequence, and the sequence B-A-E-C-D.

What sequencing rule do you recommend and why?

7. Mike Reynolds has four assignments due in class tomorrow, and his class times are as follows:

Class	Time
Marketing 304	9 a.m.
P/OM 385	11 a.m.
Finance 216	12:30 p.m.
Psychology 200	3:30 p.m.

Each class lasts one hour, and Mike has no other classes. It is now midnight, and Mike estimates that the finance, P/OM, marketing, and psychology assignments will take him five, four, three, and six hours, respectively. How should he schedule the work? Can he complete all of it?

8. Monday morning Baxter Industries has the following jobs waiting for processing in two departments, milling and drilling, in that order:

Job	Time Required (hours)	
	Mill	Drill
216	8	4
327	6	10
462	10	5
519	5	6
258	3	8
617	6	2

Develop a minimum makespan schedule using Johnson's Rule. Graph the results on a bar chart.

9. Dan's Auto Detailing business performs two major activities: exterior cleanup and interior detailing. Based on the size of car and condition, time estimates for six cars on Monday morning are as shown in the accompanying table:

	Car Number					
	1	2	3	4	5	6
Exterior	30	35	90	65	45	80
Interior	10	40	20	45	25	55

Sequence the cars so that all exterior detailing is done first and total completion time is minimized. Draw a Gantt chart of your solution. Evaluate the idle time, if any, for these two resources—exterior and interior cleaning capability.

10. Explain why appointments are necessary for many professional services. (Hint: How do services differ from goods as described in Chapter 1?) List and explain some key issues and decisions that must be addressed in designing appointment systems.

Balloons Aloha Case Study

Susie Davis owns Balloons Aloha and must fill balloons with helium and assemble them into certain configurations today for six major parties. Her six customer jobs all need to use the same helium tank (that is, the single processor), and she was wondering what might be the best way to sequence these jobs. Client (job) number 5 is Balloons Aloha's top customer. Her assistant store manager, Lee Sailboat, wants to process them in sequential order (i.e., 1, 2, 3, 4, 5, and 6). Since the balloons lose air quickly, the company waits until the day of the parties to fill them and then the workload is hectic. Business is booming and growing about 15 percent per year in their new store location. The job processing time estimates are as follows:

Job	1	2	3	4	5	6
Processing time (min.)	240	130	210	90	170	165
Due dates (6 a.m. to midnight in minutes from opening)	240	360	480	240	720	780

Case Questions for Discussion

1. Compute the average flow time, lateness, and tardiness for this group of jobs using Mr. Sailboat's sequential order of 1 (first), 2, 3, 4, 5, and 6 (last).

2. In what order would the jobs be processed using the SPT rule? Compute the average flow time, lateness, and tardiness for this group of jobs.

3. Compare the answers in Questions 1 and 2.

4. What are your short-term recommendations for this set of six jobs? Justify. Explain.

5. What are your long-term recommendations with respect to sequencing jobs at Balloons Aloha? Justify. Explain.

© Michael Newman/PhotoEdit

SPEAK UP!

OM2 was built on a simple principle: to create a new teaching and learning solution that reflects the way today's faculty and students teach and learn. Through conversations, focus groups, surveys, and interviews, we collected data that drove the creation of the version of OM2 that you are using today.

But it doesn't stop there – in order to make OM2 an even better learning experience, we'd like you to SPEAK UP and tell us how OM2 works for you.

What do you like about it? What would you change? Do you have additional ideas that would help us build a better product for next year's Operations Management students?

Go to 4ltrpress.cengage.com/om to *Speak Up!*

QUALITY MANAGEMENT

"Wow!" exclaimed Lauren when she saw the ski runs at Deer Valley Resort in Park City, Utah. Deer Valley has been called "The Ritz-Carlton" of ski resorts, and Lauren's dad was expecting exceptional services and a superior ski vacation experience after all he had read in ski magazines. He wasn't disappointed. When he drove up to the slopes, a curbside ski valet took their equipment from his car, parking lot attendants directed him to the closest available parking, and a shuttle transported them from the lot to Snow Park Lodge. From the shuttle, he and his daughter walked to the slopes on heated pavers that prevent freezing and assist in snow removal. Staff provided complimentary mountain tours to familiarize them with the slopes. At the end of the day, they were able to store their skis without charge at the lodge and easily retrieve them the next morning. The resort limits the number of skiers on the mountain to reduce lines and congestion. Everyone is committed to ensuring that each guest has a wonderful experience. Even the food is consistently rated number one by ski-enthusiast magazines.

© blickwinkel/Alamy

What do **you** think?

What satisfying service experiences similar to the Deer Valley episode have you personally encountered?

learning outcomes

After studying this chapter you should be able to:

LO1 Explain the concepts and definitions of quality.

LO2 Describe the quality philosophies and principles of Deming, Juran, and Crosby.

LO3 Explain the GAP model and its importance.

LO4 Describe the concepts and philosophy of ISO 9000:2000.

LO5 Describe the philosophy and methods of Six Sigma.

LO6 Explain the categories of cost of quality measurement.

LO7 Describe how to apply the seven QC Tools.

LO8 Explain the concepts of kaizen and poka-yoke.

High quality of goods and services is simply expected by consumers and business customers and is essential to survival and competitive success.

High quality of goods and services provides an organization with a competitive edge; reduces costs due to returns, rework, scrap, and service upsets; increases productivity, profits, and other measures of success; and most importantly, generates satisfied customers, who reward the organization with continued patronage and favorable word-of-mouth advertising. The Deer Valley example illustrates this well.

Today, the high quality of goods and services is simply expected by consumers and business customers and is essential to survival and competitive success. Quality must be addressed throughout the value chain, beginning with suppliers and extending through operations and postsale services. *Quality management refers to systematic policies, methods, and procedures used to ensure that goods and services are produced with appropriate levels of quality to meet the needs of customers.* From

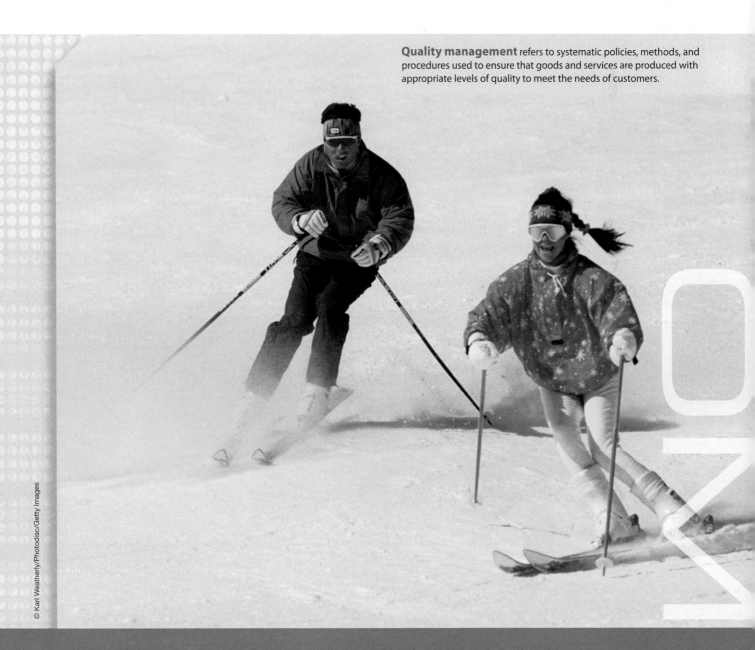

Quality management refers to systematic policies, methods, and procedures used to ensure that goods and services are produced with appropriate levels of quality to meet the needs of customers.

the perspective of operations, quality management deals with key issues relating to how goods and services are designed, created, and delivered to meet customer expectations. The Malcolm Baldrige National Quality Award Criteria described in Chapter 3 provide a comprehensive framework for building quality into organizational processes and practices.

1 Understanding Quality

Why is there so much emphasis on quality today? It helps to review a bit of history. During the Industrial Revolution, the use of interchangeable parts and the separation of work into small tasks necessitated careful control of quality, leading to the dependence on inspection to identify and remove defects and reducing the role of the workers themselves in responsibility for quality. After World War II, two U.S. consultants, Dr. Joseph Juran and Dr. W. Edwards Deming, introduced statistical quality control techniques to the Japanese to aid them in their rebuilding efforts. While presenting to a group of Japanese industrialists (collectively representing about 80 percent of the nation's capital) in 1950, Deming drew the diagram shown in Exhibit 15.1. This diagram depicts not only the basic elements of a value chain, but also the roles of consumers and suppliers, the interdependency of organizational processes, the usefulness of consumer research, and the importance of continuous improvement of all elements of the production system.

Improvements in Japanese quality were slow and steady; some 20 years passed before the quality of Japanese products exceeded that of Western manufacturers.

By the 1970s, primarily due to the higher quality levels of their products, Japanese companies had made significant penetration into Western markets. Most major U.S. companies answered the wake-up call by instituting extensive quality improvement campaigns, focused not only on conformance but also on improving design quality.

In recent years, a new interest in quality has emerged in corporate boardrooms under the concept of *Six Sigma*, a customer-focused and results-oriented approach to business improvement. Six Sigma integrates many quality tools and techniques that have been tested and validated over the years with a bottom-line orientation that has high appeal to senior managers.

What does quality mean? A study that asked managers of 86 firms in the eastern United States to define quality produced several dozen different responses, including

1. perfection,
2. consistency,
3. eliminating waste,
4. speed of delivery,
5. compliance with policies and procedures,
6. providing a good, usable product,
7. doing it right the first time,
8. delighting or pleasing customers, and
9. total customer service and satisfaction. [1]

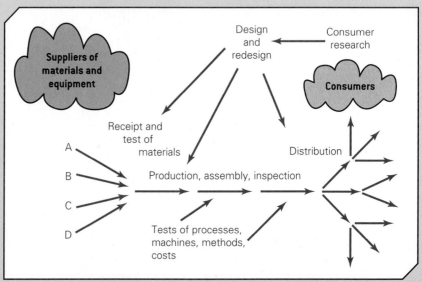

Exhibit 15.1 *Deming's View of a Production System*

Source: Reprinted from *Out of the Crisis*, p. 5, by W. Edwards Deming, by permission of MIT and the W. Edwards Deming Institute. Published by MIT Center for Advanced Educational Services, Cambridge, MA 02139. © 1986 by The W. Edwards Deming Institute.

© Toru Hanai/Reuters/Landov

Many of these perspectives relate to a good's or service's **fitness for use**—*the ability of a good or service to meet customer needs.* From an operations perspective, however, the most useful definition is how well the output of a manufacturing or service process conforms to the design specifications. **Quality of conformance** *is the extent to which a process is able to deliver output that conforms to the design specifications.* **Specifications** *are targets and tolerances determined by designers of goods and services.* Targets are the ideal values for which production is to strive; tolerances are the permissible variation.

Service quality *is consistently meeting or exceeding customer expectations (external focus) and service delivery system performance criteria (internal focus) during all service encounters.* Excellent service quality is achieved by the consistent delivery to the customer of a clearly defined customer benefit package, and associated process and service encounters, defined by many internal and external standards of performance. Performance standards are analogous to manufacturing specifications. For example, "on-time arrival" for an airplane might be specified as within 15 minutes of the scheduled arrival time. The target is the scheduled time, and the tolerance is specified to be 15 minutes.

An established instrument for measuring the external customer perceptions of service quality is SERVQUAL.[2] The initial instrument identified 10 dimensions of service quality performance: (1) reliability, (2) responsiveness, (3) competence, (4) access,

(5) courtesy, (6) communication, (7) credibility, (8) security, (9) understanding/knowing the customer, and (10) tangibles. These were reduced to five dimensions based on further research: tangibles, reliability, responsiveness, assurance, and empathy. Assurance consolidated competence, courtesy, credibility, and security attributes, and is defined as the "knowledge and courtesy of service providers and their ability to convey trust and confidence." Empathy is defined as "caring, individual attention the firm provides its customers" and incorporates the attributes of access, communication, and understanding the customer. SERVQUAL is designed to apply to all service industries; however, dimensions specific to a certain industry or business or process may provide more accurate measures.

Quality is more than simply ensuring that goods and services consistently conform to specifications. Achieving high-quality goods and services depends on the commitment and involvement of everyone in the entire value chain. The principles of total quality are simple:

1. a focus on customers and stakeholders,
2. a process focus supported by continuous improvement and learning, and
3. participation and teamwork by everyone in the organization.

There is considerable evidence that investment in quality—not only in goods, services, and processes but in the quality of management itself—yields numerous benefits. A sample of specific operational and financial results that Baldrige recipients have achieved include:

- Among associates at Clarke American, overall satisfaction has improved from 72 percent to 84 percent over a five-year period. Rising associate satisfaction correlated with an 84 percent increase in revenue earned per associate.
- Pal's Sudden Service, a privately owned quick-service restaurant chain in eastern Tennessee, had customer quality scores averaging 95.8 percent compared with 84.1 percent for its

Fitness for use is the ability of a good or service to meet customer needs.

Quality of conformance is the extent to which a process is able to deliver output that conforms to the design specifications.

Specifications are targets and tolerances determined by designers of goods and services.

Service quality is consistently meeting or exceeding customer expectations (external focus) and service delivery system performance criteria (internal focus) during all service encounters.

best competition, and improved order delivery speed by over 30 percent.

- SSM Health Care's share of the St. Louis market has increased substantially while three of its five competitors have lost market share. It has achieved an AA credit rating from Standard and Poor's for four consecutive years, a rating attained by fewer than 1 percent of U.S. hospitals.

2 Influential Leaders in Modern Quality Management

any individuals have made substantial contributions to quality management thought and applications. However, three people—W. Edwards Deming, Joseph M. Juran, and Philip B. Crosby—are regarded as "management gurus" in the quality revolution.

2.1 W. Edwards Deming

Unlike other management gurus and consultants, Deming (pictured at the right) never defined or described quality precisely. In his last book, he stated, "A product or a service possesses quality if it helps somebody and enjoys a good and sustainable market."[3] The Deming philosophy focuses on bringing about improvements in product and service quality by reducing variability in goods and services design and associated processes. Deming professed that higher quality leads to higher productivity and lower costs, which in turn leads to improved market share and long-term competitive strength. In his early work in the United States, Deming preached his 14 Points. Although management practices today are vastly different than when Deming first began to preach his philosophy, the 14 Points still convey important insights for operations managers as well as every other manager in an organization.

Point 1: *Create a Vision and Demonstrate Commitment*

© Catherine Karnow/Corbis

Point 2: *Learn the Philosophy*

Point 3: *Understand Inspection*

Point 4: *Stop Making Decisions Purely on the Basis of Cost*

Point 5: *Improve Constantly and Forever*

Point 6: *Institute Training*

Point 7: *Institute Leadership*

Point 8: *Drive Out Fear*

Point 9: *Optimize the Efforts of Teams*

Point 10: *Eliminate Exhortations*

Point 11: *Eliminate Numerical Quotas*

Point 12: *Remove Barriers to Pride in Work*

Point 13: *Encourage Education and Self-Improvement*

Point 14: *Take Action*

The 14 Points have become the basis for many organizations' quality approaches (see the feature on Hillerich & Bradsby Co. on the next page).

Deming also advocated a process to guide and motivate improvement activities, which has become known as the *Deming cycle*. The Deming cycle is composed of four stages: *plan, do, study,* and *act* (PDSA). PDSA guides teams to develop an improvement plan, try it out, examine the results, and institute changes that lead to improved results, and then repeat the process all over again.

2.2 Joseph Juran

Like Deming, Juran taught quality principles to the Japanese in the 1950s and was a principal force in their quality reorganization. Juran proposed a simple definition of quality: "fitness for use." Unlike Deming, however, Juran did not propose a major cultural change in the organization, but rather sought to improve quality by working within the system familiar to managers. He argued that employees at different levels of an organization speak in their own "languages." Juran stated that top management speaks in the language of dollars; workers speak in the language of things; and middle management must be able to speak

Hillerich & Bradsby

Hillerich & Bradsby Co. (H&B) has been making the Louisville Slugger brand of baseball bat for more than 115 years. In the mid-1980s, the company faced significant challenges from market changes and competition. CEO Jack Hillerich attended a four-day Deming seminar, which provided the basis for the company's current quality efforts. Returning from the seminar, Hillerich decided to see what changes that Deming advocated were possible in an old company with an old union and a history of labor-management problems. Hillerich persuaded union officials to attend another Deming seminar with five senior managers. Following the seminar, a core group of union and management people developed a strategy to change the company. They talked about building trust and changing the system "to make it something you want to work in."

Employees were interested, but skeptical. To demonstrate their commitment, managers examined Deming's 14 Points and picked several they believed they could make progress on through actions that would demonstrate a serious intention to change. One of the first changes was the elimination of work quotas that were tied to hourly salaries and a schedule of warnings and penalties for failures to meet quotas. Instead, a team-based approach was initiated. While a few workers exploited the change, overall productivity actually improved as rework decreased because workers were taking pride in their work to produce things the right way the first time. H&B also eliminated performance appraisals and commission-based pay in sales. The company has also focused its efforts on training and education, resulting in an openness to change and a capacity for teamwork. Today, the Deming philosophy is still the core of H&B's guiding principles.[4]

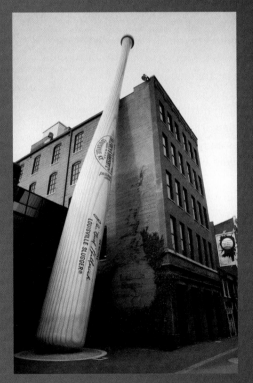

both languages and translate between dollars and things. To get top management's attention, quality issues must be cast in the language they understand—dollars. Hence, Juran advocated the use of quality cost measurement, discussed later in this chapter, to focus attention on quality problems. At the operational level, Juran focused on increasing conformance to specifications through elimination of defects, supported extensively by statistical tools for analysis. Thus, his philosophy fit well into existing management systems.

Juran's prescriptions focus on three major quality processes, called the Quality Trilogy: (1) quality planning—the process of preparing to meet quality goals; (2) quality control—the process of meeting quality goals during operations; and (3) quality improvement—the process of breaking through to unprecedented levels of performance. At the time he proposed this structure, few companies were engaging in any significant planning or improvement activities. Thus, Juran was promoting a major cultural shift in management thinking.

2.3 Philip B. Crosby

Philip B. Crosby authored several popular books. His first book, *Quality Is Free*, sold about one million copies and was greatly responsible for bringing quality to the attention of top corporate managers in the United States. The essence of Crosby's quality philosophy is embodied in what he calls the Absolutes of Quality Management and the Basic Elements of Improvement. Crosby's Absolutes of Quality Management include the following points:

- *Quality means conformance to requirements, not elegance.* Requirements must be clearly stated so that they cannot be misunderstood.

- *There is no such thing as a quality problem.* Problems are functional in nature. Thus, a firm may experience accounting problems, manufacturing problems, design problems, front-desk problems, and so on.
- *There is no such thing as the economics of quality; doing the job right the first time is always cheaper.* Quality is free. What costs money are all actions that involve not doing jobs right the first time.
- *The only performance measurement is the cost of quality, which is the expense of nonconformance.* Quality cost data are useful to call problems to management's attention, to select opportunities for corrective action, and to track quality improvement over time.
- *The only performance standard is "Zero Defects (ZD)."* This simply represents the philosophy of preventing defects in goods and services rather than finding them after the fact and fixing them.

3 The GAP Model

many people view quality by comparing features and characteristics of goods and services to a set of expectations, which may be promulgated by marketing efforts aimed at developing quality as an image variable in their minds. A framework for evaluating quality of both goods and services and identifying where to focus design and improvement efforts is the GAP model.

The GAP model recognizes that there are several ways to mismanage the creation and delivery of high levels of quality. These "gaps" are shown in the model in Exhibit 15.2 and explained in the following list.

- **Gap 1** *is the discrepancy between customer expectations and management perceptions of those expectations.* Managers may think they understand why customers buy a good or service, but if their perception is wrong, then all subsequent design and delivery activities may be misdirected.
- **Gap 2** *is the discrepancy between management perceptions of what features constitute a target level of quality and the task of translating these perceptions into executable specifications.* This represents a mismatch between requirements and design activities that we discussed in Chapter 6.
- **Gap 3** *is the discrepancy between quality specifications documented in operating and training manuals and plans and their implementation.* Gap 3 recognizes that the manufacturing and service delivery systems must execute quality specifications well.
- **Gap 4** *is the discrepancy between actual manufacturing and service delivery system performance and external communications to the customers.* The customer should not be promised a certain type and level of quality unless the delivery system can achieve or exceed that level.
- **Gap 5** *is the difference between the customer's expectations and perceptions.* The fifth gap depends on the other four. This is where the customer judges quality and makes future purchase decisions.

Managers can use this model to analyze goods and services and the processes that make and deliver them to identify and close the largest gaps and improve performance. Failure to understand and minimize these gaps can seriously degrade the quality of a service and present the risk of losing customer loyalty.[5]

4 ISO 9000:2000

to standardize quality requirements for European countries within the Common Market and those wishing to do business with those countries, a specialized agency for standardization, the International Organization for Standardization (ISO), founded in 1946 and composed of representatives from the national standards bodies of 91 nations, adopted a series of written quality standards in 1987. They were revised in 1994, and again (significantly) in 2000. The most recent version is called the ISO 9000:2000 family of standards. The standards have been adopted in the United States by the American National Standards Institute (ANSI) with the endorsement and cooperation of the American Society for Quality (ASQ) and are recognized by about 100 countries.

ISO 9000 defines *quality system standards*, based on the premise that certain generic characteristics of management practices can be standardized and that a well-designed, well-implemented, and carefully managed quality system provides confidence that the outputs will meet customer expectations and requirements.

The standards prescribe documentation for all processes affecting quality and suggest that compliance through auditing leads to continuous improvement. The standards are intended to apply to all types of businesses, including electronics and chemicals, and to services such as health care, banking, and transportation.

Exhibit 15.2 *GAP Model of Quality*

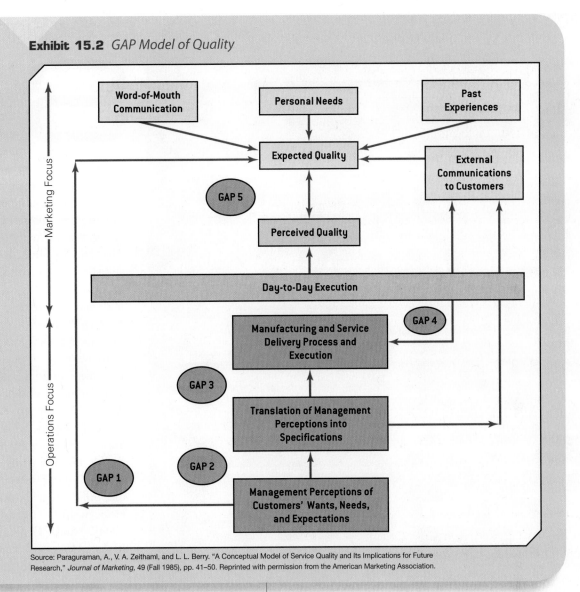

Source: Paraguraman, A., V. A. Zeithaml, and L. L. Berry. "A Conceptual Model of Service Quality and Its Implications for Future Research," *Journal of Marketing*, 49 (Fall 1985), pp. 41–50. Reprinted with permission from the American Marketing Association.

In some foreign markets, companies will not buy from suppliers who are not certified to the standards. The ISO 9000:2000 standards are supported by the following eight principles:

Principle 1—*Customer-Focused Organization*

Principle 2—*Leadership*

Principle 3—*Involvement of People*

Principle 4—*Process Approach*

Principle 5—*System Approach to Management*

Principle 6—*Continual Improvement*

Principle 7—*Factual Approach to Decision Making*

Principle 8—*Mutually Beneficial Supplier Relationships*

ISO 9000 provides a set of good basic practices for initiating a basic quality management system and is an excellent starting point for companies with no formal quality assurance program. For companies in the early stages of developing a quality program, the standards enforce the discipline of control that is necessary before they can seriously pursue continuous improvement. The requirements of periodic audits reinforce the stated quality system until it becomes ingrained in the company.

Sears, Roebuck and Company

Sears, Roebuck and Co., a wholly-owned subsidiary of Sears Holdings Corp., is one of the largest retailers in North America. Sears offers a range of home merchandise, apparel, and automotive products and services through more than 2,400 Sears-branded and affiliated stores in the United States and Canada, including about 926 full-line and 1,100 specialty stores in the United States alone. Sears is the largest national provider of product repair services, with more than 14 million repairs performed annually. The company wanted a consistent process for improving customer satisfaction and enhancing service capabilities. Recognizing that ISO 9000 provides a framework for large organizations to implement a consistent, cohesive program across geographic lines and throughout a multifaceted business, Sears sought ISO 9000 registration to enhance its organizational process compliance.

ISO 9000 became a fundamental tool that provides Sears a base for continued improvements. For example, although the company had calibrated some of its repair tools prior to implementing ISO 9000, the standard requires 100-percent tool calibration for safety and service purposes. This has improved the quality of repairs and service calls. ISO 9000 has also been instrumental in helping to standardize the manner in which technicians record field observations. This is important for solving certain types of problems, such as an appliance or part malfunction and customer abuse of the equipment. To ensure consistency, technicians use a special tool kit for recording the event, including a disposable camera and standardized forms. Sears' efficiency in completing repairs has improved; in one carry-in repair facility, the average daily completion rate for repairing lawn mowers almost doubled."[6]

5 Six Sigma

Six Sigma *is a business improvement approach that seeks to find and eliminate* causes of defects and errors in manufacturing and service processes by focusing on outputs that are critical to customers and results in a clear financial return for the organization. The term Six Sigma is based on a statistical measure that equates to at most 3.4 errors or defects per million opportunities. An ultimate "stretch" goal of all organizations that adopt a Six Sigma philosophy is to have all critical processes, regardless of functional area, at a six-sigma level of capability—a level of near-zero defects. Six Sigma has garnered a significant amount of credibility over the last decade because of its acceptance at such major firms as Motorola, Allied Signal (now part of Honeywell), Texas Instruments, and General Electric. It is facilitated through use of basic and advanced quality improvement and control tools by individuals and teams whose members are trained to provide fact-based decision-making information.

Six Sigma is a business improvement approach that seeks to find and eliminate causes of defects and errors in manufacturing and service processes by focusing on outputs that are critical to customers and results in a clear financial return for the organization.

ISO 9000 Pays Off

Many organizations have realized significant benefits from ISO 9000. At DuPont, for example, ISO 9000 has been credited with increasing on-time delivery from 70 to 90 percent, decreasing cycle time from 15 days to 1.5 days, increasing first-pass yields from 72 to 92 percent, and reducing the number of test procedures by one-third. The first home builder to achieve registration, Michigan-based Delcor Homes, reduced its rate of correctable defects from 27.4 to 1.7 percent in two years and improved its building experience approval rating from the mid-60s to the mid-90s on a 100-point scale.[7]

"There is only one ultimate goal: zero defects—in everything we do."
—Robert Galvin, former Motorola CEO, 1987.

© Jeff Chiu/AP Photo

In Six Sigma terminology, *a defect is any mistake or error that is passed on to the customer* (many people also use the term nonconformance). *A unit of work is the output of a process or an individual process step.* We can measure output quality by defects per unit (DPU), a popular quality measure that we introduced in Chapter 3:

$$\text{Defects per unit} = \frac{\text{Number of defects discovered}}{\text{Number of units produced}} \quad [15.1]$$

The Six Sigma concept characterizes quality performance by *defects per million opportunities (dpmo)*, computed as DPU × 1,000,000/opportunities for error (or, as is often used in services, *errors per million opportunities—epmo*). A "six sigma" quality level corresponds to a dpmo or epmo equal to 3.4 (this is derived from some advanced statistical calculations), which represents almost perfect quality.

For example, suppose that an airline wishes to measure the effectiveness of its baggage handling system. A DPU measure might be lost bags per customer. However, customers may have different numbers of bags; thus, the number of opportunities for error is the total number of checked bags. The use of dpmo and epmo allows us to define quality broadly. In the airline case, we might expand the concept to mean every opportunity for a failure to meet customer expectations from initial ticketing until bags are retrieved.

We noted that a "six sigma" process has a dpmo of 3.4. The sigma level can easily be calculated on an Excel spreadsheet using the cell formula:

=NORMSINV(1 − Number of Defects/Number of Opportunities) + 1.5

or equivalently,

=NORMSINV(1 − dpmo/1,000,000) + 1.5 [15.2]

The value of 1.5 in this formula stems from the mathematical calculation of six sigma. The developers of this concept allowed a process to shift by as much as 1.5 standard deviations from the mean, recognizing that it is not possible to control a process perfectly. Using the formula in equation 15.2, we can show that a three-sigma process has a dpmo of 66,807, a four-sigma process has dpmo = 6,210, and a five-sigma process has dpmo = 233. You can see that moving from a 3- to a 4-sigma level requires about a 10-fold improvement, and moving from a 5- to a 6-sigma level is almost a 70-fold improvement. It isn't easy to reach six sigma quality levels!

Six Sigma has been applied in product development, new business acquisition, customer service,

Solved Problem

Suppose that the average number of bags checked by airline passengers is 1.6, and the airline recorded three lost bags for 8,000 passengers in one month. What is the epmo, and at what sigma level is this process operating?

Solution:

The average number of bags checked is calculated as 8,000 passengers × 1.6 bags/passenger = 12,800. Therefore, using equation 15.1, the number of defects per unit (DPU, in this case lost bags per bags checked) = 3/12,800 = 0.000234375. By multiplying the DPU by 1,000,000, we find the epmo = 234.375. Using the Excel formula, the sigma level is calculated as =NORMSINV(1 − 234.375/1000000) + 1.5 = 4.99828 or about a 5-sigma level.

A **defect** is any mistake or error that is passed on to the customer.

A **unit of work** is the output of a process or an individual process step.

accounting, and many other business functions. For example, suppose that a bank tracks the number of errors reported in customers' checking account statements. If it finds 12 errors in 1,000 statements, this is equivalent to an error rate of 12,000 per million, (somewhere between 3.5 and 4 sigma levels).

5.1 Implementing Six Sigma

Six Sigma has developed from simply a way of measuring quality to an overall strategy to accelerate improvements and achieve unprecedented performance levels. An organization does this by finding and eliminating causes of errors or defects in processes by focusing on characteristics that are critical to customers.[8] The core philosophy of Six Sigma is based on some key concepts:[9]

1. emphasizing dpmo as a standard metric that can be applied to all parts of an organization: manufacturing, engineering, administrative, software, and so on;

2. providing extensive training followed by project team deployment to improve profitability, reduce non-value-added activities, and achieve cycle time reduction;

3. focusing on corporate sponsors responsible for supporting team activities to help overcome resistance to change, obtain resources, and focus the teams on overall strategic objectives;

4. creating highly qualified process improvement experts ("green belts," "black belts," and "master black belts") who can apply improvement tools and lead teams;

5. ensuring that appropriate metrics are identified early in the process and that they focus on business results; and

6. setting stretch objectives for improvement.

The recognized benchmark for Six Sigma implementation is General Electric. GE's Six Sigma problem-solving approach (DMAIC) employs five phases:

1. *Define (D)*
 - Identify customers and their priorities.
 - Identify a project suitable for Six Sigma efforts based on business objectives as well as customer needs and feedback.
 - Identify CTQs (*critical to quality characteristics*) that the customer considers to have the most impact on quality.

2. *Measure (M)*
 - Determine how to measure the process and how is it performing.
 - Identify the key internal processes that influence CTQs and measure the defects currently generated relative to those processes.

3. *Analyze (A)*
 - Determine the most likely causes of defects.
 - Understand why defects are generated by identifying the key variables that are most likely to create process variation.

4. *Improve (I)*
 - Identify means to remove the causes of the defects.
 - Confirm the key variables and quantify their effects on the CTQs.
 - Identify the maximum acceptable ranges of the key variables and a system for measuring deviations of the variables.
 - Modify the process to stay within the acceptable range.

5. *Control (C)*
 - Determine how to maintain the improvements.
 - Put tools in place to ensure that the key variables remain within the maximum acceptable ranges under the modified process.

Using a structured process like the DMAIC approach helps project teams ensure that Six Sigma is implemented effectively.

All Six Sigma projects have three key characteristics: a problem to be solved, a process in which the problem exists, and one or more measures that quantify the gap to be closed and can be used to monitor progress. These characteristics are present in all business processes; thus, Six Sigma can easily be applied to a wide variety of transactional, administrative, and service areas in both large and small firms.

The concepts and methods used in Six Sigma efforts have been around for a long time and may be categorized into seven general groups:

- *elementary statistical tools* (basic statistics, statistical thinking, hypothesis testing, correlation, simple regression);

In less than two years, Allied Signal reported cost savings exceeding $800 million from its Six Sigma initiative.

Taking Six Sigma Out of the Factory

At DuPont, a Six Sigma project was applied to improve cycle time for an employee's application for long-term disability benefits.[10] Some examples of financial applications of Six Sigma include:[11]

- Reduce the average and variation of days outstanding of accounts receivable.
- Close the books faster.
- Improve the accuracy and speed of the audit process.
- Reduce variation in cash flow.
- Improve the accuracy of journal entry (most businesses have a 3–4 percent error rate).
- Improve accuracy and cycle time of standard financial reports.

- *advanced statistical tools* (design of experiments, analysis of variance, multiple regression);
- *product design and reliability* (quality function deployment, reliability analysis, failure mode and effects analysis);
- *measurement* (cost of quality, process capability, measurement systems analysis);
- *process control* (control plans, statistical process control, reducing variation);
- *process improvement* (process improvement planning, process mapping, mistake-proofing);
- *implementation and teamwork* (organizational effectiveness, team assessment, facilitation tools, team development).

You may have covered some of these tools, such as statistics and teamwork, in other courses, and some, such as quality function deployment and statistical process control, are discussed in other chapters of this book.

In applying Six Sigma to services, there are four key measures of the performance: *accuracy*, as measured by correct financial figures, completeness of information, or freedom from data errors; *cycle time*, which is a measure of how long it takes to do something, such as pay an invoice; *cost*, that is, the internal cost of process activities (in many cases, cost is largely determined by the accuracy and/or cycle time of the process; the longer it takes, and the more mistakes that have to be fixed, the higher the cost); and *customer satisfaction*, which is typically the primary measure of success.

6 Cost of Quality Measurement

 he **cost of quality** *refers specifically to the costs associated with avoiding poor quality or those incurred as a result of poor quality.* Cost of quality analysis can help operations managers communicate with senior-level managers, identify and justify major opportunities for process improvements, and evaluate the importance of quality and improvement in operations.

Quality costs can be organized into four major categories: prevention costs, appraisal costs, internal failure costs, and external failure costs.

Prevention costs *are those expended to keep nonconforming goods and services from being made and reaching the customer.* They include:

- *quality planning costs*—such as salaries of individuals associated with quality planning and problem-solving teams, the development of new procedures, new equipment design, and reliability studies;
- *process-control costs*—which include costs spent on analyzing processes and implementing process control plans;
- *information-systems costs*—which are expended to develop data requirements and measurements; and
- *training and general management costs*—which include internal and external training programs, clerical staff expenses, and miscellaneous supplies.

Appraisal costs *are those expended on ascertaining quality levels through measurement and analysis of data to detect and correct problems.* They include:

- *test and inspection costs*—those associated with incoming materials, work-in-process, and finished goods, including equipment costs and salaries;
- *instrument maintenance costs*—those associated with the calibration and repair of measuring instruments; and
- *process-measurement and process-control costs*—which involve the time spent by workers to gather and analyze quality measurements.

The **cost of quality** refers specifically to the costs associated with avoiding poor quality or those incurred as a result of poor quality.

Prevention costs are those expended to keep nonconforming goods and services from being made and reaching the customer.

Appraisal costs are those expended on ascertaining quality levels through measurement and analysis of data to detect and correct problems.

The Unfortunate Costs of Poor Quality

A major news story in 2009 was the case of Peanut Corporation of America. At least 677 people were sickened and nine died after eating salmonella-contaminated products made from peanut butter paste from the Peanut Corporation of America. It was found that at least 12 times, when one of the company's products tested positive for salmonella, the company shopped around for new tests until a laboratory certified that the product was clean. They shipped the products and continued to use the same equipment and processes. Inspectors found roaches, mold, and a leaking roof in one of the company's factories. The salmonella outbreak led to more than 2,000 product recalls, one of the largest in U.S. history. On March 12, 2009, the company issued the following statement: "As you may know, certain recent events have made it necessary for Peanut Corporation of America to seek protection under the U.S. Bankruptcy Code. Effective immediately, all corporate operations will cease." Food safety lawyers are optimistic that victims and their families can still be compensated.[12]

Internal failure costs *are costs incurred as a result of unsatisfactory quality that is found before the delivery of a good or service to the customer.* Examples include:

- *scrap and rework costs*—including material, labor, and overhead;
- *costs of corrective action*—arising from time spent determining the causes of failure and correcting problems;
- *downgrading costs*—such as revenue lost by selling a good or service at a lower price because it does not meet specifications; and
- *process failures*—such as unplanned equipment downtime or service upsets or unplanned equipment repair.

External failure costs *are incurred after poor-quality goods or services reach the customer.* They include:

- *costs due to customer complaints and returns*—including rework on returned items, cancelled orders, discount coupons, and freight premiums;

Internal failure costs are costs incurred as a result of unsatisfactory quality that is found before the delivery of a good or service to the customer.

External failure costs are incurred after poor-quality goods or services reach the customer.

- *goods and services recall costs and warranty and service guarantee claims*—including the cost of repair or replacement as well as associated administrative costs; and
- *product-liability costs*—resulting from legal actions and settlements.

By collecting and analyzing these costs, managers can identify the most important opportunities for improvement.

7 The "Seven QC Tools"

Seven simple tools—flowcharts, checksheets, histograms, Pareto diagrams, cause-and-effect diagrams, scatter diagrams, and control charts—termed the *Seven QC* (quality control) *Tools* by the Japanese, support quality improvement problem-solving efforts.[13] The Seven QC Tools are designed to be simple and visual so that workers at all levels can use them easily and provide a means of communication that is particularly well suited in group problem-solving efforts.

Flowcharts To understand a process, one must first determine how it works and what it is supposed to do. Flowcharting, or process mapping, identifies the sequence of activities or the flow of materials and information in a process. Once a flowchart is constructed, it can be used to identify quality problems as well as areas for productivity improvement. Questions such as "What work activities can be combined, simplified, or eliminated?" "Are process capacities well planned?" and "How is quality measured at points of customer contact?"

Run and Control Charts A **run chart** is a line graph in which data are plotted over time. The vertical axis represents a measurement; the horizontal axis is the time scale. Run charts show the performance and the variation of a process or some quality or productivity indicator over time. They can be used to track such things as production volume, costs, and customer satisfaction indexes. Run charts summarize data in a graphical fashion that is easy to understand and interpret, identify process changes and trends over time, and show the effects of corrective actions.

A **control chart** is simply a run chart to which two horizontal lines, called *control limits*, are added: the *upper control limit (UCL)* and *lower control limit (LCL)*, as illustrated in Exhibit 15.3. Control limits are chosen statistically so that there is a high probability

(generally greater than .99) that points will fall between these limits if the process is in control. Control limits make it easier to interpret patterns in a run chart and draw conclusions about the state of control. The next chapter addresses this topic in much more detail.

Checksheets Checksheets are special types of data collection forms in which the results may be interpreted on the form directly without additional processing. For example, in the checksheet in Exhibit 15.4, one can easily identify the most frequent causes of defects.

Exhibit 15.3 *The Structure of a Control Chart*

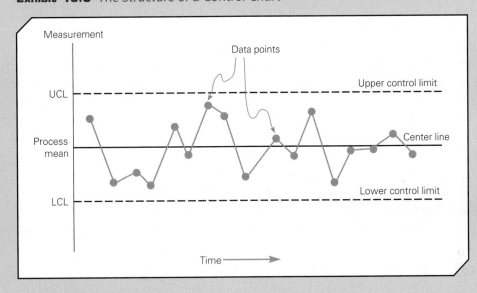

Exhibit 15.4 *Defective Item Checksheet*

Check Sheet

Product: _____

Date: _____

Manufacturing stage: final insp.

Factory: _____

Section: _____

Type of defect: scar, incomplete, misshapen

Inspector's name: _____

Lot no. _____

Order no. _____

Total no. inspected: 2530

Remarks: all items inspected

Type	Check	Subtotal
Surface scars	⌗⌗ ⌗⌗ ⌗⌗ ⌗⌗ ⌗⌗ ⌗⌗ //	32
Cracks	⌗⌗ ⌗⌗ ⌗⌗ ⌗⌗ ///	23
Incomplete	⌗⌗ ⌗⌗ ⌗⌗ ⌗⌗ ⌗⌗ ⌗⌗ ⌗⌗ ⌗⌗ ⌗⌗ ///	48
Misshapen	////	4
Others	⌗⌗ ///	8
	Grand total	115
Total rejects	⌗⌗ ⌗⌗ ⌗⌗ ⌗⌗ ⌗⌗ ⌗⌗ ⌗⌗ ⌗⌗ ⌗⌗ ⌗⌗ ⌗⌗ ⌗⌗ ⌗⌗ ⌗⌗ ⌗⌗ ⌗⌗ ⌗⌗ /	86

Source: Ishikawa, Kaoru. "Defective Item Checksheet," *Guide to Quality Control*. Asian Productivity Organization, 1982, p. 33. Reprinted with permission.

Histograms A histogram is a basic statistical tool that graphically shows the frequency or number of observations of a particular value or within a specified group. Histograms provide clues about the characteristics of the parent population from which a sample is taken. Patterns that would be difficult to see in an ordinary table of numbers become apparent. You are probably quite familiar with histograms from your statistics classes.

Pareto Diagrams The *Pareto principle* was observed by Joseph Juran in 1950. Juran found that most effects resulted from only a few causes. He named this technique after Vilfredo Pareto (1848–1923), an Italian economist who determined that 85 percent of the wealth in Milan was owned by only 15 percent of the people. Pareto analysis separates the vital few from the trivial many and provides direction for selecting projects for improvement.

An example of a Pareto diagram developed from the check sheet in Exhibit 15.4 is shown in Exhibit 15.5. The diagram shows that about 70% of defects result from the top two categories, Incomplete and Surface Scars.

Cause and Effect Diagrams The cause-and-effect diagram is a simple, graphical method for presenting a chain of causes and effects and for sorting out causes and organizing relationships between variables. Because of its structure, it is often called a *fishbone diagram*. An example of a cause-and-effect diagram is shown in Exhibit 15.6. At the end of the horizontal line, a problem is listed. Each branch pointing into the main stem represents a possible cause. Branches pointing to the causes are contributors to those causes. The diagram identifies the most likely causes of a problem so that further data collection and analysis can be carried out.

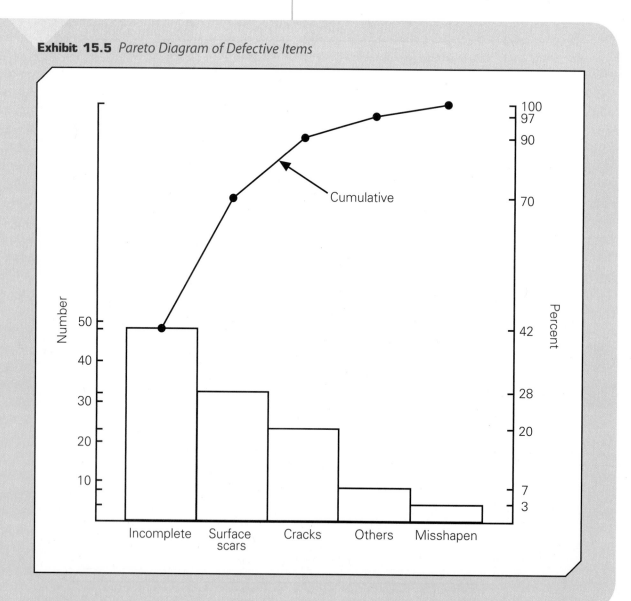

Exhibit 15.5 *Pareto Diagram of Defective Items*

The 7 QC Tools in Action

A large automotive parts distribution center in Europe received orders for replacement parts. The distribution center was having trouble shipping orders on time, and with many customers threatening to switch to other part distributors, the manager needed to reduce order processing time. To better understand the situation, a team created a flowchart of the order fulfillment process showing how an order was received, filled, checked, packed, and finally shipped to the customer. They tracked orders through the distribution center, noting the time each entered and left the various activity areas and recorded them on a check sheet. Next, they analyzed the data using a Pareto diagram and identified picking time as the largest contributor to order processing delays. To provide a more detailed analysis of the picking operation, 50 individual times recorded for picking orders were plotted on a histogram, which showed three distinct clusters of picking times.

During a brainstorming session, a part picker suggested the three humps of the histogram reflected the number of trips made to the parts storage area of the distribution center to complete an order. He explained that many orders were filled with just one trip, but two were sometimes required and, on occasion, even three. By watching the part picking activity for two days, the team members verified that the part picker's theory was indeed correct. With this additional insight, the team brainstormed reasons multiple trips were needed to complete an order and then organized these ideas on a cause-and-effect diagram. After discussion, the team eventually decided the push carts used by the part pickers to carry the parts were too small. The solution was to use bigger carts, which allowed an increase of 20.4 orders per worker each shift, meaning that the four part pickers could fulfill an additional $4 \times 20.4 = 81$ orders during their shift. This significantly improved the order fulfillment time.[14]

Exhibit 15.6 *Cause-and-Effect Diagram for Hospital Emergency Admission*

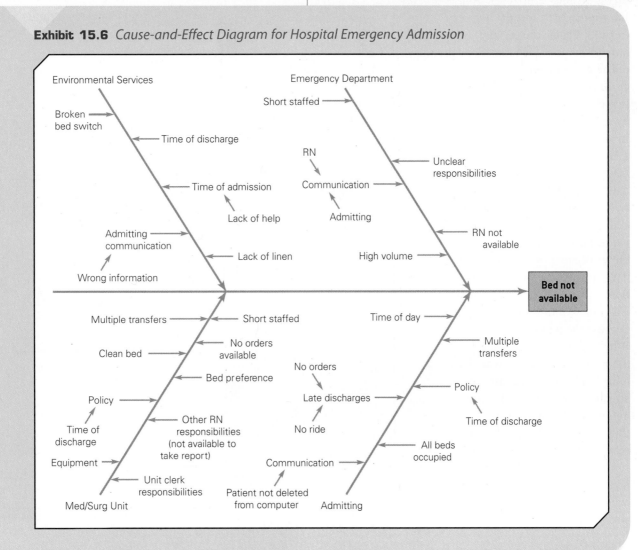

Scatter Diagrams Scatter diagrams are the graphical component of regression analysis. Although they do not provide rigorous statistical analysis, they often point to important relationships between variables, such as the percentage of an ingredient in an alloy and the hardness of the alloy. Scatter diagrams are often used to verify possible causes and effects obtained from cause-and-effect diagrams.

7.1 Root Cause Analysis

The **root cause** is a term used to designate the source of a problem. Using the medical analogy, eliminating symptoms of problems provides only temporary relief; eliminating the root cause provides long-term relief. A useful approach to identify the root cause is called the *5-Why Technique*. This approach forces one to redefine a problem statement as a chain of causes and effects to identify the source of the symptoms by asking why, ideally five times. In a classic example at Toyota, a machine failed because a fuse blew. Replacing the fuse would have been the obvious solution; however, this action would have addressed only the symptom of the real problem. Why did the fuse blow? Because the bearing did not have adequate lubrication. Why? Because the lubrication pump was not working properly. Why? Because the pump axle was worn. Why? Because sludge seeped into the pump axle, which was determined to be the root cause. Toyota attached a strainer to the lubricating pump to eliminate the sludge, thus correcting the problem of the machine failure.

Root cause analysis often uses the Seven QC Tools. For example, Pareto diagrams can also progressively help focus in

on root causes. Exhibit 15.7 shows one example. At each step, the Pareto diagram stratifies the data to more detailed levels (or it may require additional data collection), eventually isolating the most significant issue.

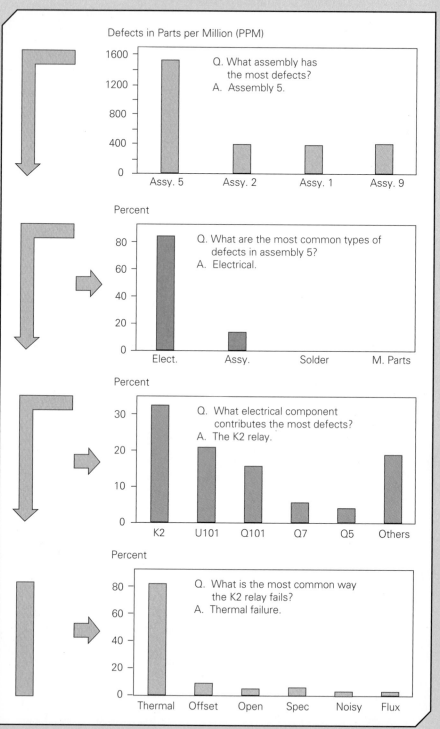

Exhibit 15.7 *Use of Pareto Diagrams for Root Cause Analysis*

Source: *Small Business Guidebook to Quality Management*, Office of the Secretary of Defense, Quality Management Office, Washington, DC (1988).

8 Other Quality Improvement Strategies

any other approaches to quality improvement have been developed and refined over the years. Two powerful approaches are Kaizen and Poka-Yoke.

8.1 Kaizen

The concept of continuous improvement advocated by Deming was embraced by Japanese organizations, leading to an approach known as *kaizen*. **Kaizen** *focuses on small, gradual, and frequent improvements over the long term with minimum financial investment and with participation by everyone in the organization.* In the kaizen philosophy, improvement in all areas of business—cost, meeting delivery schedules, employee safety and skill development, supplier relations, new product development, or productivity—serve to enhance the quality of the firm. Thus, any activity directed toward improvement falls under the kaizen umbrella.

A **kaizen blitz** *is an intense and rapid improvement process in which a team or a department throws all its resources into an improvement project over a short time period, as opposed to traditional kaizen applications, which are performed on a part-time basis.* Blitz teams are generally comprised of employees from all areas involved in the process who understand it and can implement changes on the spot. Improvement is immediate, exciting, and satisfying for all those involved in the process.[15]

8.2 Poka-Yoke (Mistake-Proofing)

Human beings tend to make mistakes inadvertently. Typical process-related mistakes include omitted processing steps, processing errors, setup or changeover errors, missing information or parts, not handling service upsets properly, wrong information or parts, and adjustment errors.

Poka-yoke *(POH-kah YOH-kay) is an approach for mistake-proofing processes using automatic devices or methods to avoid simple human error.* The poka-yoke concept was developed and refined in the early 1960s by the late Shigeo Shingo, a Japanese manufacturing engineer who developed the Toyota production system.[16]

Many applications of poka-yoke are deceptively simple, yet creative, and usually, they are inexpensive to implement. One of Shingo's first poka-yoke devices involved a process at the Yamada Electric plant in which workers assemble a switch having two push buttons supported by two springs.[17] Occasionally, the worker would forget to insert a spring under each button, which led to a costly and embarrassing repair at the customer's facility. In the old method, the worker would take two springs out of a large parts box and then assemble the switch. To prevent this mistake, the worker was instructed first to place two springs in a small dish in front of the parts box, and then assemble the switch. If a spring remained in the dish, the operator knew immediately that an error had occurred. The solution was simple, cheap, and provided immediate feedback to the employee.

Many other examples can be cited:

- Fast-food restaurants used automated french-frying machines that can only be operated one way and the french fries are prepackaged and the equipment automated to reduce the chance of human error.
- A device on a drill counts the number of holes drilled in a workpiece; a buzzer sounds if the workpiece is removed before the correct number of holes has been drilled.
- Computer programs display a warning message if a file that has not been saved is to be closed.

> Many applications of poka-yoke are deceptively simple, yet creative, and usually, they are inexpensive to implement.

Kaizen focuses on small, gradual, and frequent improvements over the long term with minimum financial investment and with participation by everyone in the organization.

A **kaizen blitz** is an intense and rapid improvement process in which a team or a department throws all its resources into an improvement project over a short time period, as opposed to traditional kaizen applications, which are performed on a part-time basis.

Poka-yoke (POH-kah YOH-kay) is an approach for mistake-proofing processes using automatic devices or methods to avoid simple human error.

1. What types of defects or errors might the following organizations measure and improve as part of a quality or Six Sigma initiative?

 a. a department store such as Wal-Mart or Macy's

 b. Walt Disney World or a regional amusement park such as Six Flags

 c. your college or university

2. Explain how service quality is measured. How does it differ from manufacturing, and how can such measurements be used for controlling quality in services?

3. A bank has set a standard that mortgage applications be processed within a certain number of days of filing. If, out of a sample of 1,500 applications, 95 fail to meet this requirement, what is the epmo metric and what sigma level does it correspond to?

4. Over the last year, 1,400 injections were administered at a clinic. Quality is measured by the proper amount of dosage as well as the correct drug. In five instances, the incorrect amount was given, and in three cases, the wrong drug was given. What is the epmo metric and what sigma level does it correspond to?

5. Provide some specific examples of quality costs in a fast-food operation and in the operation of your college or university.

6. The following list gives the number of defects found in 30 samples of 100 electronic assemblies taken on a daily basis over one month. Plot these data on a run chart, computing the average value (center line). How do you interpret the chart?

1	6	5	5	4	3	2	2	4	6
2	1	3	1	4	5	4	1	6	15
12	6	3	4	3	3	2	5	7	4

7. Develop cause-and-effect diagrams for any one of the following problems:

 a. poor exam grade

 b. no job offers

 c. too many speeding tickets

 d. late for work or school

8. Provide some examples of poka-yoke in your daily life.

9. Analysis of customer complaints at an e-commerce retailer revealed the following:

 Billing errors 537

 Shipping errors 2,460

 Electronic charge errors 650

 Shipping delays 5,372

 Packing errors 752

 Construct a Pareto diagram and discuss the conclusions you may draw from it.

10. Which of the Seven QC Tools would be most useful in addressing each of the following situations? Explain your reasoning.

 a. A copy machine suffers frequent paper jams and users are often confused as to how to fix the problem.

 b. The publication team for an engineering department wants to improve the accuracy of its user documentation but is unsure of why documents are not error-free.

 c. A bank needs to determine how many teller positions, drive-through stations, and ATM machines it needs for a new branch bank in a certain busy location. Its information includes the average numbers and types of customers served by other similar facilities, as well as demographic information to suggest the level of customer traffic in the new facility.

 d. A contracting agency wants to investigate why they had so many changes in their contracts. They believe that the number of changes may be related to the dollar value of the original contract or the days between the request for proposal and the contract award.

 e. A travel agency is interested in gaining a better understanding of how call volume varies by time of year in order to adjust staffing schedules.

"I think the waiter wrote in an extra $25 tip on my Sunshine Café bill after I received and signed my credit card receipt," Mr. Mark Otter said to the restaurant manager, Brad Gladiolus. "Mr. Otter, mail me a copy of the restaurant receipt and I'll investigate," responded Mr. Gladiolus. "I don't have the receipt—I lost it—but I have my monthly credit card statement," replied Mr. Otter. Mr. Gladiolus hesitated, then said, "Mr. Otter, I don't see any way to investigate your claim, so there's nothing I can do."

Mr. Gladiolus sat down at his desk and sketched out possible causes of this service upset as follows:

- The customer is responsible for adding the bill and tipping properly, writing legibly, retaining the second receipt, and drinking alcohol responsibly.

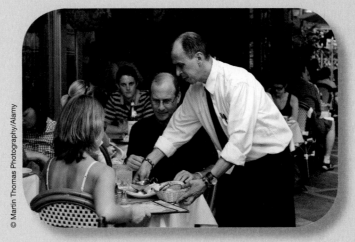

© Martin Thomas Photography/Alamy

- The employee is responsible for typing the bill in the register/computer correctly, going back to the customer if the tip is unreadable and verifying the correct amounts, and being honest.
- The restaurant manager is responsible for investigating the store's receipt history and finding this transaction, auditing the source of the error if possible such as a mistyped decimal or extra zero, and contacting the credit card company and customer to resolve the issue.
- The credit card company, a third party provider in this value chain, is responsible for providing records of the electronic transaction, helping resolve the issue, and issuing a debit or credit to the customer and/or restaurant if needed.

Company Background

Abby Martin's parents came to Florida from Chicago in the 1960s. Her parents bought land in the Cape Coral area. Later they opened a hotel on Fort Myers Beach and Abby was part of the housekeeping staff, her first job. By 17, she was running the hotel on her own. Today, she owns and operates six restaurants

and a by-the-sea hotel. The restaurants are located in shopping centers next to high-traffic facilities such as movie theaters, groups of retail stores, and other clusters of restaurants. Abby uses four different restaurant concepts (i.e., facility décor, size and layout; prices, menus; music and bands; wine list, lounge areas, etc.) for these six restaurants, depending on the location and local market demographics.

Abby has other investments but loves the challenge of managing restaurants. "I have a great passion for finding a need and meeting it," she said. "The secret to our restaurant success is customizing the business to local needs and being very consistent. Offer good food and service at the most reasonable price you can afford. And know that even if you offer all those things you can still fail. The hospitality business is the hardest business, period. You can never sit back and coast."

In her spare time, she is a prominent community figure involved in activities such as helping build the Ronald McDonald House, fund-raising for the hospital cancer foundation, and serving as chairperson of the local board for the Salvation Army. She likes the Salvation Army because they run a lean operation with only six cents spent on management for every one dollar in donations.

Day-to-Day Service Management

Sunshine restaurants are normally open 7 days a week from 11 am to 10 pm. Lunch prices are in the $10 to $20 range and include entrees like a wood-grilled hamburger, seafood salad croissant, and sesame-crusted yellow fin tuna. Dinner prices range from $20 to $30 per person and include dishes like shrimp and scallop scampi, red snapper picatta, and wood-grilled filet mignon. Each restaurant keeps about 20 to 30 popular wines in stock such as a Cakebread Chardonnay. Wine, liquor, and some food items are ordered in bulk to take advantage of volume-price discounts and shipped

directly from the suppliers to individual restaurants. All other items are ordered by the restaurant chef and general manager for each unique restaurant.

Abby, like most entrepreneurs, has her own approach to quality control. She notes that, "I visit my restaurants every few days and as I walk in I immediately begin to watch customer faces and behaviors. I try to see if they are happy, talking, smiling, and enjoying the food and surroundings. I look at their posture and facial expressions. I often talk with customers and ask if everything was to their liking. I ask my employees—waiters, bartenders, kitchen help, managers, and chef—if they have encountered any problems or service breakdowns. I look for untidy floors, tables, and restrooms. I try to learn from negative customer comments or complaints. My employees know that I will try to help them solve any problem—they trust me. I take the pulse of the restaurant in a short visit. I meet weekly with the restaurant chefs. I manage quality by observation and close contact with all of the people in the restaurant. At night I go over the financials and sales data."

A typical Sunshine restaurant has a core staff of about twelve employees consisting of a manager, an assistant manager, chef, assistant chef, four waiters, two bartenders, and two helpers in the kitchen. During peak season each restaurant hires about six to eight additional employees. Peak demand is when the "snow birds" arrived in southwest Florida from November to April. During peak demand the populations of Lee and Collier counties double to almost two million people.

Abby's entrepreneurial approach to managing the business results in about one negative customer complaint per 100 customer comments. The complaints are nearly equal in focusing on food or service quality. Contribution to profit and overhead per restaurant is 35 percent. The typical customer averages one visit every two months, and the customer defection rate is in the five to ten percent range, but is difficult to estimate given the seasonal nature of the business.

Long-term Strategic Issues

Abby Martin has established a reputation in southwest Florida for superior service and food quality in her restaurants. She was considering expanding her restaurants to the Tampa and Orlando areas to leverage her expertise and grow the business for the family. She wondered whether she could maintain the proper financial and quality controls with more restaurants and whether to franchise or not. Due to the 2007-09 credit crunch and high foreclosure rates, there were plenty of commercial properties in good locations for restaurants, and prices were at all-time lows. Abby thought it was now or never in terms of expanding up and down the west coast of Florida. She envisioned as many as twenty Sunshine restaurants in the next five years.

Decisions

Abby wondered when she would ever get the time to analyze these issues. It was not easy keeping up with her businesses. She knew that superior day-to-day food and service quality determines repeat business so she had to successfully resolve this customer complaint about the waiter adding a $25 tip while trying to plan for the future. She happened to be at her hotel so she sat down in a beach chair and watched the brilliant colors of a sunset over the Gulf of Mexico. She began to write down a number of questions she had to answer soon.

Case Questions for Discussion

1. Draw a cause-and-effect diagram for the possible causes of the $25 tip service upset. Select one possible root cause from your diagram and explain how you would investigate and fix it.

2. What is the average value of a loyal customer (VLC) at Abby's restaurants (see Chapter 3)? What is the best way to increase revenue given your VLC analysis?

3. Critique the current quality control system. What changes and improvements do you recommend if Sunshine expands to twenty restaurants?

4. What are your short- and long-term recommendations? Explain your rationale for these recommendations.

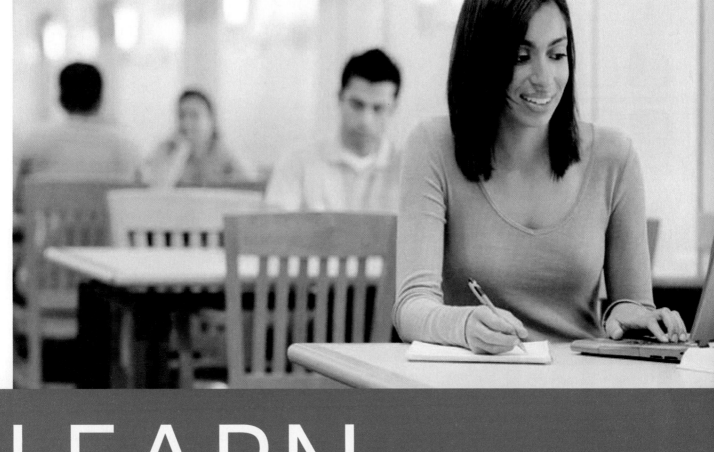

LEARN YOUR WAY!

SHE DID

We know that no two students are alike. You come from different walks of life and with many different preferences. You need to study just about anytime and anywhere. **OM2** was developed to help you learn Operations Management in a way that works for you.

Not only is the format fresh and contemporary, it's also concise and focused. And, **OM2** is loaded with a variety of study tools, like in-text review cards, printable flash cards, and more.

Go to 4ltrpress.cengage.com/om to find plenty of resources to help you study—no matter what learning style you like best!

QUALITY CONTROL AND SPC

marriott has become infamous for its obsessively detailed standard operating procedures (SOPs), which result in hotels that travelers either love for their consistent good quality or hate for their bland uniformity. "This is a company that has more controls, more systems, and more procedural manuals than anyone—except the government," says one industry veteran. "And they actually comply with them." Housekeepers work with a 114-point checklist. One SOP: Server knocks three times. After knocking, the associate should immediately identify herself or himself in a clear voice, saying, "Room Service!" The guest's name is never mentioned outside the door. *Although people love to make fun of such procedures, they are a serious part of Marriott's business, and SOPs are designed to protect the brand. Recently, Marriott has removed some of the rigid guidelines for owners of hotels it manages, empowering them to make some of their own decisions on details.[1]*

© BananaStock/Jupiter Images

What do **you** think?

What opportunities for improved quality control or use of SOPs can you think of at your college or university (e.g., bookstore, cafeteria)?

learning outcomes

After studying this chapter you should be able to:

LO1 Describe quality control system and key issues in manufacturing and service.

LO2 Explain types of variation and the role of statistical process control.

LO3 Describe how to construct and interpret simple control charts for both continuous and discrete data.

LO4 Describe practical issues in implementing SPC.

LO5 Explain process capability and calculate process capability indexes.

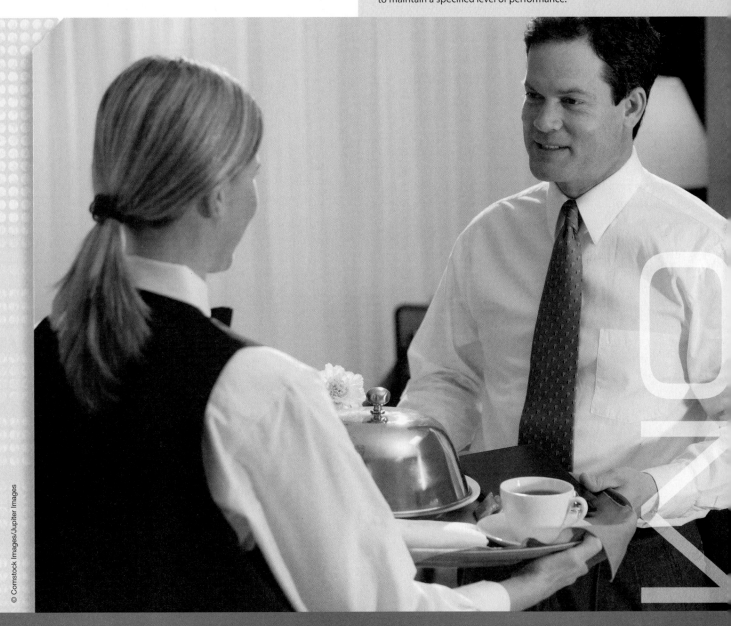

Quality control is vital in ensuring consistent service experiences and creating customer satisfaction, as the Marriott example illustrates. Simple control mechanisms such as checklists and standard operating procedures provide cost-effective means of doing this. Contacting customers after a poor service experience only uncovers the damage that has already occurred, requires extraordinary measures for service recovery, and often results in lost customers.

The task of **quality control** *is to ensure that a good or service conforms to specifications and meets customer requirements by monitoring and measuring processes and making any necessary adjustments to maintain a specified level of performance.* The consequences of a lack of effective quality control systems and procedures can be seri- ous and potentially cause large financial losses or affect a company's reputation. Health care is one industry that has been highly criticized for its lack of effective quality control systems. For instance, a hospital in Philadelphia promised to evaluate and redesign its laboratory procedures after state investigators confirmed that faulty lab tests led to dozens of patients receiving overdoses of a blood-thinning medication, resulting in the deaths of two patients.[2] Many health care organizations are using contemporary manufacturing quality control methods and other quality improvement approaches such as Six Sigma in an effort to minimize such errors.

> The task of **quality control** is to ensure that a good or service conforms to specifications and meets customer requirements by monitoring and measuring processes and making any necessary adjustments to maintain a specified level of performance.

Leveling the Playing Field in Golf

Golf balls must meet five standards to conform to the Rules of Golf: minimum size, maximum weight, spherical symmetry, maximum initial velocity, and overall distance.[3] Methods for measuring such quality characteristics may be automated or performed manually. For instance, golf balls are measured for size by trying to drop them through a metal ring—a conforming ball sticks to the ring while a nonconforming ball falls through; digital scales measure weight to one-thousandth of a gram; and initial velocity is measured in a special machine by finding the time it takes a ball struck at 98 mph to break a ballistic screen at the end of a tube exactly 6.28 feet away.

1 Quality Control Systems

ny control system has three components:

1. a performance standard or goal,
2. a means of measuring actual performance, and
3. comparison of actual performance with the standard to form the basis for corrective action.

Similar control measures are taken in services (we introduced service quality metrics in the previous chapter). Fast-food restaurants, for example, have carefully designed their processes for a high degree of accuracy and fast response time, using hands-free intercom systems, microphones that reduce ambient kitchen noise, and screens that display a customer's order. Timers at Wendy's count every segment of the order completion process to help managers control performance and identify problem areas.

Good control systems make economic sense. The importance of control is often explained by the *1:10:100 Rule*: If a defect or service error is identified and corrected at the design stage, it might cost $1 to fix. If it is first detected during the production process, it might cost $10 to fix. However, if the defect is not discovered until it reaches the customer, it might cost $100 to correct.

The dollar values and the exact ratios differ among firms and industries. However, the fact is that the cost of repair or service recovery grows dramatically the further that defects and errors

Quality at the source means the people responsible for the work control the quality of their processes by identifying and correcting any defects or errors when they first are recognized or occur.

move along the value chain. This rule clearly supports the need for control and a focus on prevention by building quality "at the source." **Quality at the source** *means the people responsible for the work control the quality of their processes by identifying and correcting any defects or errors when they first are recognized or occur.* This requires that employees have good data collection, observation, and analysis skills, as well as the proper tools, training, and support of management.

1.1 Quality Control Practices in Manufacturing

In manufacturing, control is generally applied at three key points in the supply chain: at the receiving stage from suppliers, during various production processes, and at the finished goods stage.

Supplier Certification and Management If incoming materials are of poor quality, then the final manufactured good will certainly be no better. Suppliers should be expected to provide documentation and statistical evidence that they are meeting required specifications. If supplier documentation is done properly, incoming inspection can be completely eliminated. Many companies have formal supplier certification programs to ensure the integrity of incoming materials.

In-Process Control In-process quality control systems are needed to ensure that defective outputs do not leave the process and, more importantly, to prevent them in the first place. An organization must consider trade-offs between the explicit costs of detection, repair, or replacement and the implicit costs of allowing a nonconformity to continue through the production process. In-process control is typically performed by the people who run the processes on the front lines; this is an example of quality at the source.

> The 1:10:100 Rule: If a defect or service error is identified and corrected at the design stage, it might cost $1 to fix. If it is first detected during the production process, it might cost $10 to fix. However, if the defect is not discovered until it reaches the customer, it might cost $100 to correct.

The Ritz-Carlton Hotel Company

The approach used by The Ritz-Carlton Hotel Company to control quality is proactive because of its intensive personalized service environment.[4] The Ritz-Carlton recognizes that many customer requirements are sensory and thus, difficult to measure. However, by selecting, training, and certifying employees, the company is able to assess their work through appropriate sensory measurements—taste, sight, smell, sound, and touch—and take appropriate actions.

The company uses three types of control processes to deliver quality:

- Self control of the individual employee based on their spontaneous and learned behavior.
- Basic control mechanism, which is carried out by every member of the workforce. The first person who detects a problem is empowered to break away from routine duties, investigate and correct the problem immediately, document the incident, and then return to his or her routine.
- Critical success factor control for critical processes. Process teams use customer and organizational requirement measurements to determine quality, speed, and cost performance. These measurements are compared against benchmarks and customer satisfaction data to determine corrective action and resource allocation.

In addition, The Ritz-Carlton conducts both self and outside audits. Self audits are carried out internally at all levels, from one individual or function to an entire hotel. Process walk-throughs occur daily in hotels while senior leaders assess field operations during formal reviews at various intervals.

© Belousov Vitaly/Itar-Tass/Landov

Finished Goods Control Finished goods control is often focused on verifying that the product meets customer requirements. For many consumer products, this consists of functional testing. For instance, a manufacturer of televisions might do a simple test on every unit to make sure it operates properly. Modern technology now allows for such tests to be conducted rapidly and cost-effectively. For example, imaging scanners along food packaging lines easily check for foreign particles.

1.2 Quality Control Practices in Services

Many of the same practices described in the previous section can be applied to quality control for back-office service operations such as check or medical insurance claim processing. Front-office services that involve substantial customer contact must be controlled differently. The day-to-day execution of thousands of service encounters is a challenge for any service-providing organization.

One way to control quality in services is to prevent sources of errors and mistakes in the first place by using the poka-yoke approaches. Another way is to hire and train service providers in service management skills as part of a prevention-based approach to quality control.

Customer satisfaction measurement can provide the basis for effective control systems in services. Customer satisfaction instruments

often focus on service attributes such as attitude, lead time, on-time delivery, exception handling, accountability, and technical support; image attributes such as reliability and price; and overall satisfaction measures. At FedEx, customers are asked to rate everything from billing to the performance of couriers, package condition, tracking and tracing capabilities, complaint handling, and helpfulness of employees.

2 Statistical Process Control and Variation

Statistical process control (SPC) *is a methodology for monitoring quality of manufacturing and service delivery processes to help identify and eliminate unwanted causes of variation.* Variation occurs for many reasons, such as inconsistencies in material inputs; changes in environmental conditions (temperature, humidity); machine maintenance cycles; customer participation and self-service; tool wear; and human fatigue. Some variation is obvious, such as inconsistencies in meal delivery times or food quantity at a restaurant; other variation—such as minute differences in physical dimensions of machined parts—is barely perceptible, but can be determined through some type of measurement process.

Common cause variation *is the result of complex interactions of variations in materials, tools, machines, information, workers, and the environment.* Such variation is a natural part of the technology and process design and cannot be controlled; that is, we cannot influence each individual output of the process. It appears at random, and individual sources or causes cannot be identified or explained. However, their combined effect is usually stable and can be described statistically.

Hilton Hotels

Hilton Hotels uses a simple satisfaction survey. The survey asks direct and detailed questions about the guest bathroom, including such potential dissatisfiers as shower water pressure and temperature and bathtub/sink drainage, as well as the likelihood of future recommendation. It also includes space for open-ended comments.

Completely fill in your response	● Correct		GUESTScope

Please rate your satisfaction with the comfort level of your accommodations.

Level of Satisfaction

	Low		Avg.			High		N/A
	1	2	3	4	5	6	7	
Accommodations look and smell clean and fresh:	☐	☐	☐	☐	☐	☐	☐	☐
Clean and comfortable linens:	☐	☐	☐	☐	☐	☐	☐	☐
Comfort level of pillow:	☐	☐	☐	☐	☐	☐	☐	☐
Comfort level of mattress:	☐	☐	☐	☐	☐	☐	☐	☐
Easily regulated room temperature:	☐	☐	☐	☐	☐	☐	☐	☐
Housekeeping during stay:	☐	☐	☐	☐	☐	☐	☐	☐
Overall satisfaction with this Hilton:	☐	☐	☐	☐	☐	☐	☐	
Likelihood you would recommend Hilton:	☐	☐	☐	☐	☐	☐	☐	
Likelihood, **if returning to the area**, you would return to this Hilton:	☐	☐	☐	☐	☐	☐	☐	
Value of accommodations for price paid:	☐	☐	☐	☐	☐	☐	☐	

Primary purpose of visit? ☐ Individual business ☐ Convention/Meeting ☐ Pleasure
How many times have you been a guest at this Hilton? ☐ 1 ☐ 2 ☐ 3 ☐ 4 ☐ 5+
Did you have a hotel product or service problem during your stay? ☐ Yes ☐ No
If yes—did you report it to the staff? ☐ Yes ☐ No
If yes—was it resolved to your satisfaction? ☐ Yes ☐ No
If yes—what was the nature of the problem? _____

Please share any thoughts on any other aspects of your visit, including the names of any staff members who made your stay more enjoyable: _____

Name: _____ Daytime Phone: _____
Date of Stay: _____ Room: _____
PLEASE DO NOT WRITE BELOW THIS LINE FD2

Variation occurs for many reasons, such as inconsistencies in material inputs, changes in environmental conditions, machine maintenance cycles, customer participation and self-service, tool wear, and human fatigue.

Quality Control for Medical Prescriptions

Poor doctor handwriting is the number one root cause of medication errors. Often the wrong drug is prescribed, or the wrong dosage is used, or drug interactions cause adverse reactions. Mr. J. Lyle Bootman, the dean of the College of Pharmacy at the University of Arizona, noted that "The economic consequences of medication errors are as costly as the entire cost of diabetes, and close to cancer and heart disease. It is a silent disease in America." The Institute of Medicine estimates that a U.S. hospital patient is subject to at least one medication error daily. They estimate that more than 7,000 people die from medication errors every year. The solution is to streamline related processes, build quality control checks into every stage of each process, and use electronic prescription systems to eliminate hand-written prescriptions.[5]

© Creatas/Jupiter Images

Common causes of variation generally account for about 80 to 95 percent of the observed variation in a process. They can be reduced only if better technology, process design, or training is provided. This clearly is the responsibility of management. **Special (or assignable) cause variation** *arises from external sources that are not inherent in the process, appear sporadically, and disrupt the random pattern of common causes.* Special cause variation occurs sporadically and can be prevented or at least explained and understood. For example, a tool might break during a process step, a worker might be distracted by a colleague, or a busload of tourists stops at a restaurant (resulting in unusual wait times). Special cause variation tends to be easily detectable using statistical methods because it disrupts the normal pattern of measurements. When special causes are identified, short-term corrective action generally should be taken by those who own the process and are responsible for doing the work, such as machine operators, order-fulfillment workers, and so on.

Keeping special cause variation from occurring is the essence of quality control. *If no special causes affect the output of a process, we say that the process* is **in control**; *when special causes are present, the process is said to be* **out of control**. A process that is in control does not need any changes or adjustments; an out-of-control process needs correction. However, employees often make two basic mistakes when attempting to control a process:

1. adjusting a process that is already in control, or
2. failing to correct a process that is out of control.

While it is clear that a truly out-of-control process must be corrected, many workers mistakenly believe that whenever process output is off-target, some adjustment must be made. Actually, overadjusting a process that is in control will *increase* the variation in the output. Thus, employees must know when to leave a process alone to keep variation at a minimum.

Statistical process control (SPC) is a methodology for monitoring quality of manufacturing and service delivery processes to help identify and eliminate unwanted causes of variation.

Common cause variation is the result of complex interactions of variations in materials, tools, machines, information, workers, and the environment.

Special (or assignable) cause variation arises from external sources that are not inherent in the process, appear sporadically, and disrupt the random pattern of common causes.

If no special causes affect the output of a process, we say that the process is **in control**; when special causes are present, the process is said to be **out of control**.

3 Constructing Control Charts

Control charts are relatively simple to use. The following is a summary of the steps required to develop and use control charts. Steps 1 through 4 focus on setting up an initial chart; in step 5, the charts are used for ongoing monitoring; and finally, in step 6, the data are used for process capability analysis.

1. Preparation
 a. Choose the metric to be monitored.
 b. Determine the basis, size, and frequency of sampling.
 c. Set up the control chart.
2. Data collection
 a. Record the data.
 b. Calculate relevant statistics: averages, ranges, proportions, and so on.
 c. Plot the statistics on the chart.
3. Determination of trial control limits
 a. Draw the center line (process average) on the chart.
 b. Compute the upper and lower control limits.
4. Analysis and interpretation
 a. Investigate the chart for lack of control.
 b. Eliminate out-of-control points.
 c. Recompute control limits if necessary.
5. Use as a problem-solving tool
 a. Continue data collection and plotting.
 b. Identify out-of-control situations and take corrective action.
6. Determination of process capability using the control chart data

Many different types of control charts exist. All are similar in structure, but the specific formulas used to compute control limits for them differ. Moreover, different types of charts are used for different types of metrics.

*A **continuous metric** is one that is calculated from data that are measured*

A **continuous metric** is one that is calculated from data that are measured as the degree of conformance to a specification on some continuous scale of measurement. Examples are length, weight, and time. Customer waiting time and order lead time, are other examples. Continuous data usually require \bar{x}- ("x-bar") and R-charts.

A **discrete metric** *is one that is calculated from data that are counted.* A dimension on a machined part is either within tolerance or out of tolerance, an order is either complete or incomplete, or a service experience is either good or bad. We can count the number of parts within tolerance, the number of complete orders, or the number of good service experiences. The number of acceptable outcomes is an example of a discrete metric. Discrete data usually require p- or c-charts.

3.1 Constructing \bar{x}- and R-Charts

The first step in developing \bar{x}- and R-charts is to gather data. Usually, about 25 to 30 samples are collected. Samples between size 3 and 10 are generally used, with 5 being the most common. The number of samples is indicated by k, and n denotes the sample size. For each sample i, the mean (denoted \bar{x}_i) and the range (R_i) are computed. These values are then plotted on their respective control charts. Next, the *overall mean* and *average range* calculations are made. These values specify the center lines for the \bar{x}- and R-charts, respectively. The overall mean (denoted $\bar{\bar{x}}$) is the average of the sample means \bar{x}_i:

$$\bar{\bar{x}} = \frac{\sum_{i=1}^{k} \bar{x}_i}{k} \qquad [16.1]$$

The average range (\bar{R}) is similarly computed, using the formula

$$\bar{R} = \frac{\sum_{i=1}^{k} R_i}{k} \qquad [16.2]$$

The average range and average mean are used to compute upper and lower control limits (UCL and LCL) for the R- and \bar{x}-charts. Control limits are easily calculated using the following formulas:

$$\text{UCL}_R = D_4\bar{R} \qquad \text{UCL}_{\bar{x}} = \bar{\bar{x}} + A_2\bar{R}$$

$$\text{LCL}_R = D_3\bar{R} \qquad \text{LCL}_{\bar{x}} = \bar{\bar{x}} - A_2\bar{R} \qquad [16.3]$$

where the constants D_3, D_4, and A_2 depend on the sample size (see Appendix B).

The control limits represent the range between which all points are expected to fall if the process is in statistical control. If any points fall outside the

*A **continuous metric** is one that is calculated from data that are measured as the degree of conformance to a specification on some continuous scale of measurement.*

*A **discrete metric** is one that is calculated from data that are counted.*

control limits or if any unusual patterns are observed, then some special cause has probably affected the process. The process should be studied to determine the cause. If special causes are present, then they are *not* representative of the true state of statistical control, and the calculations of the center line and control limits will be biased. The corresponding data points should be eliminated, and new values for $\bar{\bar{x}}$, \bar{R}, and the control limits should be computed.

In determining whether a process is in statistical control, the R-chart is always analyzed first. Because the control limits in the \bar{x}-chart depend on the average range, special causes in the R-chart may produce unusual patterns in the \bar{x}-chart, even when the centering of the process is in control. For example, a downward trend in the R-chart can cause the data in the \bar{x}-chart to appear out of control when it really is not. Once statistical control is established for the R-chart, attention may turn to the \bar{x}-chart.

Exhibit 16.1 is a spreadsheet template (X-bar&R. xlsx) that allows you to enter data, and computes sample averages and ranges, control limits, and draws the control charts. (This template is available on the Premium Website.) The R- and \bar{x}-charts for the sample data used in the solved problem are shown in Exhibits 16.2 and 16.3, respectively.

Solved Problem

The Goodman Tire and Rubber Company periodically tests its tires for tread wear under simulated road conditions. To study and control its manufacturing processes, the company uses \bar{x}- and R-charts. Twenty samples, each containing three radial tires, were chosen from different shifts over several days of operation. Since $n = 3$, the control limit factors for the R-chart are $D_3 = 0$ and $D_4 = 2.57$. Using equations 16.1 and 16.2, $\bar{\bar{x}}$ is 31.88 and the average range is 10.8. The control limits are computed as follows:

$$UCL = D_4\bar{R} = 2.57(10.8) = 27.8$$

$$LCL = D_3\bar{R} = 0$$

For the \bar{x}-chart, $A_2 = 1.02$; thus the control limits are

$$UCL = 31.88 + 1.02(10.8) = 42.9$$

$$LCL = 31.88 - 1.02(10.8) = 20.8$$

(See Exhibits 16.1 through 16.3.)

3.2 Interpreting Patterns in Control Charts

The location of points and the patterns of points in a control chart enable one to determine, with only a small chance of error, whether or not a process is in statistical control.

A process is in control when the control chart has the following characteristics:

1. No points are outside control limits.
2. The number of points above and below the center line is about the same.
3. The points seem to fall randomly above and below the center line.
4. Most points, but not all, are near the center line, and only a few are close to the control limits.

You can see that these characteristics are evident in the R-chart in Exhibit 16.2. Therefore we would conclude that the R-chart is in control.

When a process is out of control, we typically see some unusual characteristics. An obvious indication that a process may be out of control is a point that falls outside the control limits. If such a point is found, you should first check for the possibility that the control limits were miscalculated or that the point was plotted incorrectly. If neither is the case, this can indicate that the process average has changed.

Another indication of an out-of-control situation is a sudden shift in the average. For example, in Exhibit 16.3, we see that the last eight points are all above the center line, suggesting that the process mean has increased. This might suggest that something is causing excessive tread wear in recent samples, perhaps a different batch of raw material or improper mixing of the chemical composition of the tires. Some typical rules that are used to identify a shift include:

- 8 points in a row above or below the center line;
- 10 of 11 consecutive points above or below the center line;
- 12 of 14 consecutive points above or below the center line;
- 2 of 3 consecutive points in the outer one-third region between the center line and one of the control limits; and
- 4 of 5 consecutive points in the outer two-thirds region between the center line and one of the control limits.

Exhibit 16.1 *Excel Template for x̄- and R-Charts (This Excel template is available on the Premium Website)*

Exhibit 16.2 *R-Chart for Goodman Tire Example*

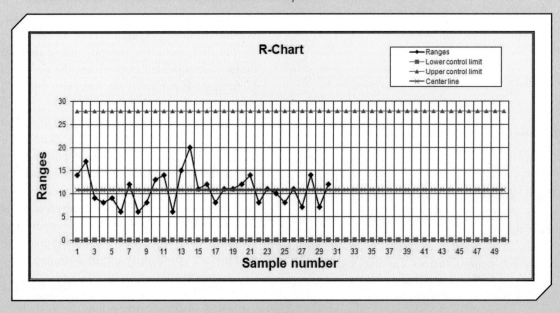

A third thing to look for in a control chart is an increasing or decreasing trend. As tools wear down, for example, the diameter of a machined part will gradually become larger. Changes in temperature or humidity, general equipment deterioration, dirt buildup on fixtures, or operator fatigue may cause such a trend. About six or seven consecutive points that increase or decrease in value usually signify a gradual change. A wave or cycle pattern is also unusual and should be suspect. It might be a result of seasonal effects of material deliveries, temperature swings, maintenance cycles, or periodic rotation of operators. Whenever an unusual pattern in a control chart is identified, the process should be stopped until the problem has been identified and corrected.

Exhibit 16.3 \bar{x}- *Chart for Goodman Tire Example*

3.3 Constructing *p*-Charts

Many quality characteristics assume only two values, such as good or bad, pass or fail, and so on. The proportion of nonconforming items can be monitored using a control chart called a *p-chart*, where *p* is the proportion of nonconforming items found in a sample. Often, it is also called a *fraction nonconforming* or *fraction defective* chart.

As with continuous data, a *p*-chart is constructed by first gathering 25 to 30 samples of the attribute being measured. The size of each sample should be large enough to have several nonconforming items. If the probability of finding a nonconforming item is small, a sample size of 100 or more items is usually necessary. Samples are chosen over time periods so that any special causes that are identified can be investigated.

Let us suppose that *k* samples, each of size *n*, are selected. If *y* represents the number nonconforming in a particular sample, the proportion nonconforming is *y/n*.

Let p_i be the fraction nonconforming in the *i*th sample; the average fraction nonconforming for the group of *k* samples, then, is

$$\bar{p} = \frac{p_1 + p_2 \cdots + p_k}{k} \qquad [16.4]$$

(Note that this formula applies only when all sample sizes are the same!) This statistic reflects the average performance of the process. One would expect a high percentage of samples to have a fraction nonconforming within 3 standard deviations of \bar{p}. An estimate of the standard deviation is given by

$$s_{\bar{p}} = \sqrt{\frac{\bar{p}(1 - \bar{p})}{n}} \qquad [16.5]$$

Therefore, upper and lower control limits are given by

$$\text{UCL}_p = \bar{p} + 3s_{\bar{p}}$$
$$\text{LCL}_p = \bar{p} - 3s_{\bar{p}} \qquad [16.6]$$

If LCL_p is less than zero, a value of zero is used.

Analysis of a *p*-chart is similar to that of an \bar{x}- or *R*-chart. Points outside the control limits signify an out-of-control situation. Patterns and trends should also be sought to identify special causes. However, a point on a *p*-chart below the lower control limit or the development of a trend below the center line indicates that the process might have improved, based on an ideal target of zero defectives. Caution is advised before such conclusions are drawn, because errors may have been made in computation.

Exhibit 16.4 is a spreadsheet template (p-chart. xlsx) that allows you to enter data, and computes the

Exhibit 16.4 *Data and Calculations for p-Chart Example (This Excel template is available on the Premium Website.)*

	A	B	C	D	E	F	G	H
1	Fraction Nonconforming (p) Chart							
2	This spreadsheet is designed for up to 50 samples. Enter data ONLY in yellow-shaded cells.							
3	Click on the sheet tab to display the control chart (some rescaling may be needed).							
4								
5	Sample size		100					
6	Number of samples		25					
7	Average (p-bar)		0.022					
8								
9				Fraction	Standard			
10	Sample	Value		Nonconforming	Deviation	LCLp	CL	UCLp
11	1	3		0.0300	0.014668	0	0.022	0.066
12	2	1		0.0100	0.014668	0	0.022	0.066
13	3	0		0.0000	0.014668	0	0.022	0.066
14	4	0		0.0000	0.014668	0	0.022	0.066
15	5	2		0.0200	0.014668	0	0.022	0.066
16	6	5		0.0500	0.014668	0	0.022	0.066
17	7	3		0.0300	0.014668	0	0.022	0.066
18	8	6		0.0600	0.014668	0	0.022	0.066
19	9	1		0.0100	0.014668	0	0.022	0.066
20	10	4		0.0400	0.014668	0	0.022	0.066
21	11	0		0.0000	0.014668	0	0.022	0.066
22	12	2		0.0200	0.014668	0	0.022	0.066
23	13	1		0.0100	0.014668	0	0.022	0.066
24	14	3		0.0300	0.014668	0	0.022	0.066
25	15	4		0.0400	0.014668	0	0.022	0.066
26	16	1		0.0100	0.014668	0	0.022	0.066
27	17	1		0.0100	0.014668	0	0.022	0.066
28	18	2		0.0200	0.014668	0	0.022	0.066
29	19	5		0.0500	0.014668	0	0.022	0.066
30	20	2		0.0200	0.014668	0	0.022	0.066
31	21	3		0.0300	0.014668	0	0.022	0.066
32	22	4		0.0400	0.014668	0	0.022	0.066
33	23	1		0.0100	0.014668	0	0.022	0.066
34	24	0		0.0000	0.014668	0	0.022	0.066
35	25	1		0.0100	0.014668	0	0.022	0.066

To construct a *c*-chart, we must first estimate the average number of non-conformances per unit, \bar{c}. This is done by taking at least 25 samples of equal size, counting the number of nonconformances per sample, and finding the average. Then, control limits are given by

$$\text{UCL}_c = \bar{c} + 3\sqrt{\bar{c}}$$
$$\text{LCL}_c = \bar{c} - 3\sqrt{\bar{c}} \qquad [16.7]$$

© Jens Meyer/AP Photo

proportion defective, control limits, and draws the control charts. (This template is available on the Premium Website.) The *p*-chart for the sample data used in the solved problem on this page is shown in Exhibit 16.5.

3.4 Constructing *c*-Charts

A *p*-chart monitors the proportion of nonconforming items, but a nonconforming item may have more than one nonconformance. For instance, a customer's order may have several errors, such as wrong item, wrong quantity, wrong price, and so on. To monitor the number of nonconformances per unit, we use a *c*-chart. These charts are used extensively in service applications because most managers of service processes are interested in the number of errors or problems that occur per customer (or patient, student, order), and not just the proportion of customers that experienced problems. The *c*-chart is used to control the *total number* of nonconformances per unit when the size of the sampling unit or number of opportunities for errors is constant.

Solved Problem

The operators of automated sorting machines in a post office must read the ZIP code on letters and divert the letters to the proper carrier routes. Over a month's time, 25 samples of 100 letters were chosen, and the number of errors was recorded. The average proportion defective, \bar{p} is computed as 0.22.

The standard deviation is computed as

$$s_{\bar{p}} = \sqrt{\frac{0.022(1 + 0.022)}{100}} = .01467$$

Thus UCL = .022 + 3(.01467) = .066, and LCL = .022 − 3(.01467) = −.022. Since the LCL is negative and the actual proportion nonconforming cannot be less than zero, the LCL is set equal to zero.

(See Exhibits 16.4 and 16.5.)

Exhibit 16.5 *p-Chart for ZIP Code Reader Example*

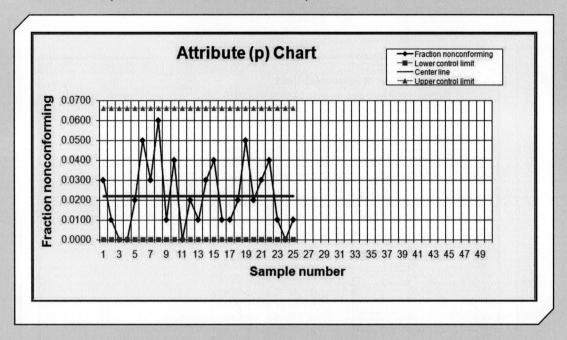

4 Practical Issues in SPC Implementation

Solved Problem

The total number of machine failures over a 25-day period is 45. Therefore, the average number of failures per day is

$$\bar{c} = \frac{45}{25} = 1.8$$

Hence, control limits for a *c*-chart are given by

$$UCL_c = 1.8 + 3\sqrt{1.8} = 5.82$$
$$LCL_c = 1.8 - 3\sqrt{1.8} = -2.22, \text{ or zero}$$

(See Exhibits 16.6 and 16.7.)

Exhibit 16.6 is a spreadsheet template (c-chart. xlsx) that allows you to enter data, and computes the average number of defects per unit, control limits, and draws the control charts. (This template is available on the Premium Website.) The *c*-chart for the sample data used in the solved problem above is shown in Exhibit 16.7, and appear to be in control.

designing control charts involves two key issues:

1. sample size, and
2. sampling frequency.

A small sample size is desirable to keep the cost associated with sampling low. On the other hand, large sample sizes provide greater degrees of statistical accuracy in estimating the true state of control. Large samples also allow smaller changes in process characteristics to be detected with higher probability. In practice, samples of about 5 have been found to work well in detecting process shifts of 2 standard deviations or larger. To detect smaller shifts in the process mean, larger sample sizes of 15 to 25 must be used.

For attributes data, too small a sample size can make a *p*-chart meaningless. Even though many guidelines such as "use at least 100 observations" have been suggested, the proper sample size should be determined statistically, particularly when the true portion of nonconformances is small. If *p* is small, *n* should be large

Exhibit 16.6 *Machine Failure Data for c-Chart (This Excel template is available on the Premium Website.)*

	A	B	C	D	E	F	G	H	I
1	Average Number of Defects (c) Chart								
2	This spreadsheet is designed for up to 50 samples. Enter data ONLY in yellow-shaded cells.								
3	Click on the sheet tab to display the control chart (some rescaling may be needed).								
4									
5	Average (c-bar)		1.8						
6	Standard deviation		1.341640786						
7									
8		Number							
9	Sample	of Defects	LCLc	CL	UCLc				
10	1	2	0	1.8	5.82492				
11	2	3	0	1.8	5.82492				
12	3	0	0	1.8	5.82492				
13	4	1	0	1.8	5.82492				
14	5	3	0	1.8	5.82492				
15	6	5	0	1.8	5.82492				
16	7	3	0	1.8	5.82492				
17	8	1	0	1.8	5.82492				
18	9	2	0	1.8	5.82492				
19	10	2	0	1.8	5.82492				
20	11	0	0	1.8	5.82492				
21	12	1	0	1.8	5.82492				
22	13	0	0	1.8	5.82492				
23	14	2	0	1.8	5.82492				
24	15	4	0	1.8	5.82492				
25	16	1	0	1.8	5.82492				
26	17	2	0	1.8	5.82492				
27	18	0	0	1.8	5.82492				
28	19	3	0	1.8	5.82492				
29	20	2	0	1.8	5.82492				
30	21	1	0	1.8	5.82492				
31	22	4	0	1.8	5.82492				
32	23	0	0	1.8	5.82492				
33	24	0	0	1.8	5.82492				
34	25	3	0	1.8	5.82492				

enough to have a high probability of detecting at least one nonconformance. For example, statistical calculations can show that if $p = .01$, then the sample size must be at least 300 to have at least a 95 percent chance of finding at least one nonconformance.

Managers must also consider the sampling frequency. Taking large samples on a frequent basis is desirable but clearly not economical. No hard-and-fast rules exist for the frequency of sampling. Samples should be close enough to provide an opportunity to detect changes in process characteristics as soon as possible and reduce the chances of producing a large amount of nonconforming output. However, they should not be so

close that the cost of sampling outweighs the benefits that can be realized. This decision depends on the individual application and volume of output.

4.1 Controlling Six Sigma Processes

SPC is a useful methodology for processes that operate at a low sigma level, for example 3-sigma or less. However, when the rate of defects is extremely low, standard control charts are not effective. For example, when using a p-chart for a process with a high sigma

Exhibit 16.7 *c-Chart for Machine Failures*

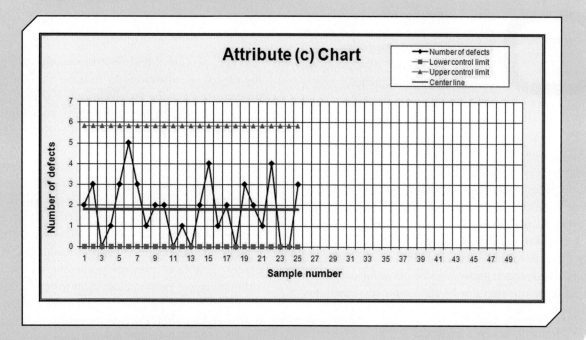

IBM

At one IBM branch, preemployment physical examinations took too long and taxed the medical staff assigned to conduct them. Such examinations are vital for assuring that employees can perform certain jobs without excess stress and that they pose no health threat to other employees. Therefore, the challenge IBM faced was to maintain the quality of the exam while reducing the time needed to perform it by identifying and eliminating waiting periods between the various parts of it.

Preliminary control charts revealed that the average time required for the examination was 74 minutes, but the range varied greatly. New equipment and additional training of the medical staff were suggested as means of shortening the average time. Initial charts indicated that the process was out of control, but continued monitoring and process improvements lowered the average time to 40 minutes, and both the average and range were brought into statistical control with the help of \bar{x} and R-charts.[6]

level, few defects will be discovered even with large sample sizes. For instance, if $p = .001$, a sample size of 500 will have an expected number of only $500(.001) = 0.5$ defects. Hence, most samples will have only zero or one defect, and the chart will provide little useful information for control. Using much larger sample sizes would only delay the timeliness of information and increase the chances that the process may have changed during the sampling interval. Small sample sizes will typically result in a conclusion that any observed defect indicates an out-of-control condition, thus implying that a controlled process will have zero defects, which may be impractical. In addition, conventional SPC charts will have higher frequencies of false alarms and make it difficult to evaluate process improvements. These issues are important for Six Sigma practitioners to understand, in order not to blindly apply tools that may not be appropriate.

5 Process Capability

process capability *refers to the natural variation in a process that results from common causes.* Knowing process capability allows one to predict, quantitatively, how well a process will meet specifications and to specify equipment requirements and the level of control necessary. Process capability has no meaning if the process is not in statistical control because special causes will bias the mean or the standard deviation. Therefore, we should use control charts to first eliminate any special causes before computing the process capability.

A **process capability study** *is a carefully planned study designed to yield specific information about the performance of a process under specified operating conditions.* Typical questions that are asked in a process capability study are:

- Where is the process centered?
- How much variability exists in the process?
- Is the performance relative to specifications acceptable?
- What proportion of output will be expected to meet specifications?

One of the properties of a normal distribution is that 99.73 percent of the observations will fall within 3 standard deviations from the mean. Thus, a process that is in control can be expected to produce a very large percentage of output between $\mu - 3\sigma$ and $\mu + 3\sigma$, where μ is the process average. Therefore, the natural variation of the process can be estimated by $\mu \pm 3\sigma$ and characterizes the capability of the process. One way of computing the standard deviation in this formula is to take a sample of data, compute the sample standard deviation, s, and use it as an estimate of σ. A second approach, often used in conjunction with an \bar{x}- and R-chart, is to estimate s by dividing the

average range by a constant, d_2, which can be found in Appendix B. That is,

$$\sigma = \frac{\bar{R}}{d_2} \qquad [16.8]$$

The process capability is usually compared to the design specifications to indicate the ability of the process to meet the specifications. Exhibit 16.8 illustrates four possible situations that can arise when the observed variability of a process is compared to design specifications. In part a, the range of process variation is larger than the design specification; thus it will be impossible for the process to meet specifications a large percentage of the time. Managers can either scrap or rework nonconforming parts (100 percent inspection is necessary), invest in a better process with less variation, or change the design specifications. In part b, the process is able to produce according to specification, although it will require close monitoring to ensure that it remains in that position. In part c, the observed variation is tighter than the specifications; this is the ideal situation from a quality control viewpoint, since little inspection or control is necessary. Finally, in part d, the observed variation is the same as the design specification, but the process is off-center; thus some nonconforming product can be expected.

5.1 Process Capability Index

The relationship between the natural variation and specifications is often quantified by a measure known as the **process capability index**. The process capability index, C_p, is defined as the ratio of the specification width to the natural variation of the process. C_p relates the natural variation of the process with the design specifications in a single, quantitative measure. In numerical terms, the formula is

$$C_p = \frac{UTL - LTL}{6\sigma} \qquad [16.9]$$

where

UTL = upper specification limit

LTL = lower specification limit

σ = standard deviation of the process (or an estimate based on the sample standard deviation, s)

Note that when $C_p = 1$, the natural variation is the same as the design specification width, UTL–LTL

Exhibit 16.8 *Process Capability versus Design Specifications*

[as in Exhibit 16.8(b)]. Values less than 1 mean that a significant percentage of output will not conform to the specifications. Values of C_p exceeding 1 indicate good capability; in fact, many firms require C_p values of 1.66 or greater from their suppliers, which equates to a tolerance range of about 10 standard deviations. Because 6 standard deviations generally cover the normal variation of output, a range of 10 standard deviations provides adequate comfort so that even if the process shifts a moderate amount and is undetected, nearly all of the output will still be conforming.

The value of C_p does not depend on the mean of the process; thus, a process may be off-center such as in Exhibit 16.8(d) and still show an acceptable value of C_p. To account for the process centering, one-sided capability indexes are often used:

$$C_{pu} = \frac{UTL - \mu}{3\sigma} \text{ (upper one-sided index)} \quad [16.10]$$

$$C_{pl} = \frac{\mu - LTL}{3\sigma} \text{ (lower one-sided index)} \quad [16.11]$$

$$C_{pk} = \min (C_{pl}, C_{pu}) \quad [16.12]$$

For example, a high value of C_{pu} indicates that the process is very capable of meeting the upper specification. C_{pk} is the "worst case" and provides an indication of whether both the lower and upper specifications can be met regardless of where the process is centered. This is the value that most managers pay attention to.

Process capability is important both to product designers and to process owners. If product specifications are too tight, the product will be difficult to manufacture. Employees who run the processes will be under pressure and will have to spend a lot of time adjusting the process and inspecting output.

Solved Problem

A controlled process shows an overall mean of 2.50 and an average range of 0.42. Samples of size 4 were used to construct the control charts. What is the process capability? If specifications are 2.60 ± 0.25, how well can this process meet them?

Solution:

From Appendix B, $d_2 = 2.059$ and $s = \bar{R}/d_2 = 0.42/2.059 = 0.20$. Thus, the process capability is $2.50 \pm 3(0.20)$, or 1.90 to 3.10. Because the specification range is 2.35 to 2.85 with a target of 2.60, we may conclude that the observed natural variation exceeds the specifications by a large amount. In addition, the process is off-center as shown in Exhibit 16.9.

Exhibit 16.9 *Comparisons of Observed Variation and Design Specifications for Solved Problem*

Problems, Activities, and Discussions

1. Provide some examples in business or daily life in which a controlled process is erroneously adjusted and an out-of-control process is ignored.

2. Develop a "personal quality checklist" on which you tally nonconformances in your personal life (such as being late for work or school, not completing homework on time, not getting enough exercise, and so on). What type of chart would you use to monitor your performance?

3. Thirty samples of size 4 of the customer waiting time at a call center for a health insurance company resulted in an overall mean of 8.4 minutes and average range of 0.7 minutes. Compute control limits for \bar{x}- and R-charts.

4. Five samples of table legs produced in an automated cutting process were taken each hour for 20 hours. The length of a table leg in centimeters was measured, and yielded the averages and ranges shown in Exhibit 16.10. Use these data

Exhibit 16.10 *Data for Problem 4 (This spreadsheet is available on the Premium Website.)*

Sample	\bar{x}	R	Sample	\bar{x}	R
1	95.72	1.0	11	95.80	.6
2	95.24	.9	12	95.22	.2
3	95.18	.8	13	95.56	1.3
4	95.44	.4	14	95.22	.5
5	95.46	.5	15	95.04	.8
6	95.32	1.1	16	95.72	1.1
7	95.40	.9	17	94.82	.6
8	95.44	.3	18	95.46	.5
9	95.08	.2	19	95.60	.4
10	95.50	.6	20	95.74	.6

to construct \bar{x}- and R-charts. Assume that the sample size is 5.

5. Thirty samples of size 3, available in the Excel file Problem 16-5 on the Premium Website, were taken

from a machining process over a 15-hour period. Construct control charts using the Excel template available on the Premium Website. Verify the Excel calculations of the control limits by hand using the formulas in the chapter. Does the process appear to be in statistical control? Why or why not?

6. Twenty-five samples of 150 online orders that were picked manually were each inspected prior to shipping, and a total of 48 orders were found to be incomplete or wrong. Compute control limits for a p-chart.

7. One hundred insurance claim forms are inspected daily for 25 working days, and the number of forms with errors are recorded as in Exhibit 16.11. Construct a p-chart using the Excel template. Verify the Excel calculations of the control limits by hand using the formulas in the chapter. If any points are outside the control limits, assume that assignable (special) causes have been determined. Then construct a revised chart.

8. Consider the following data showing the number of errors per thousand lines of code for a software development project. Construct a c-chart and interpret the results.

Sample	1	2	3	4	5	6	7	8	9	10
Number of defects	8	15	9	12	10	6	15	8	5	8

Sample	11	12	13	14	15	16	17	18	19	20
Number of defects	6	8	3	2	5	7	4	5	3	5

Sample	21	22	23	24	25
Number of defects	7	6	8	7	5

9. Suppose that a specification calls for LTL = 2.0 and UTL = 6.0. A sample of 100 parts found μ = 4.5 and σ = 0.5. Compute C_p, C_{pl}, C_{pu}, and C_{pk}. Should the manager consider any action based on these results?

10. An emergency room at a hospital wanted to understand and better control the waiting time of patients. To do this, they constructed \bar{x} and R-charts by sampling the waiting times of the first five patients admitted to the ER at the beginning of each shift (7 a.m., 3 p.m., and 11 p.m.). What do you think of this approach? Will it provide the information the hospital administrators seek? How might the sampling process be improved, and what would you recommend?

Exhibit 16.11 *Data for Problem 7*

Day	Number Nonconforming	Day	Number Nonconforming
1	2	14	2
2	1	15	1
3	2	16	3
4	3	17	4
5	0	18	0
6	2	19	0
7	0	20	1
8	2	21	0
9	7	22	2
10	1	23	8
11	3	24	2
12	0	25	1
13	0		

Dean Door Corporation Case Study

The Dean Door Corporation (DDC) manufactures steel and aluminum exterior doors for commercial and residential applications. DDC landed a major contract as a supplier to Walker Homes, a builder of residential communities in several major cities throughout the southwestern United States. Because of the large volume of demand, DDC expanded its manufacturing operations to three shifts and hired additional workers.

Not long after DDC began shipping windows to Walker Homes, it received some complaints about excessive gaps between the door and frame. This was somewhat alarming to DDC, because its reputation as a high-quality manufacturer was the principal reason that it was selected as a supplier to Walker Homes. DDC placed a great deal of confidence in its manufacturing capability because of its well-trained and dedicated employees, and it never felt the need to consider formal process control approaches. In view of the recent complaints, however, Jim Dean, the company president, suspected that the expansion to a three-shift operation, the pressures to produce higher volumes, and the push to meet just-in-time delivery requests were causing a breakdown in quality.

On the recommendation of the plant manager, Dean hired a quality consultant to train the shift supervisors and selected line workers in statistical

© Royalty-Free/Corbis/Jupiter Images

process control methods. As a trial project, the plant manager wants to evaluate the capability of a critical cutting operation that he suspects might be the source of the gap problem. The target specification for this cutting operation is 30.000 inches with a tolerance of 0.125 inch. Thus, the upper and lower specifications are LSL = 29.875 inches and USL = 30.125 inches. The consultant suggested inspecting five consecutive door panels in the middle of each shift over a 10-day period and recording the dimension of the cut. Exhibit 16.12 shows 10 days' data collected for each shift, by operator.

Case Questions for Discussion

1. Interpret the data in Exhibit 16.12, establish a state of statistical control, and evaluate the capability of the process to meet specifications.

2. What do the initial control charts tell you? Do any out-of-control conditions exist?

3. If the process is not in control, what might be the likely causes, based on the information that is available?

4. What is the process capability? What do the process capability indexes tell the company?

5. Is DDC facing a serious problem that it needs to address? How might the company eliminate the problems found by Walker Homes?

Exhibit 16.12 *DDC Production Data (available on the Premium Website)*

Shift	Operator	Sample	Observation 1	2	3	4	5
1	Terry	1	30.046	29.978	30.026	29.986	29.961
2	Jordan	2	29.972	29.966	29.964	29.942	30.025
3	Dana	3	30.046	30.004	30.028	29.986	30.027
1	Terry	4	29.997	29.997	29.980	30.000	30.034
2	Jordan	5	30.018	29.922	29.992	30.008	30.053
3	Dana	6	29.973	29.990	29.985	29.991	30.004
1	Terry	7	29.989	29.952	29.941	30.012	29.984
2	Jordan	8	29.969	30.000	29.968	29.976	29.973
3	Cameron	9	29.852	29.978	29.964	29.896	29.876
1	Terry	10	30.042	29.976	30.021	29.996	30.042
2	Jordan	11	30.028	29.999	30.022	29.942	29.998
3	Dana	12	29.955	29.984	29.977	30.008	30.033
1	Terry	13	30.040	29.965	30.001	29.975	29.970
2	Jordan	14	30.007	30.024	29.987	29.951	29.994
3	Dana	15	29.979	30.007	30.000	30.042	30.000
1	Terry	16	30.073	29.998	30.027	29.986	30.011
2	Jordan	17	29.995	29.966	29.996	30.039	29.976
3	Dana	18	29.994	29.982	29.998	30.040	30.017
1	Terry	19	29.977	30.013	30.042	30.001	29.962
2	Jordan	20	30.021	30.048	30.037	29.985	30.005
3	Cameron	21	29.879	29.882	29.990	29.971	29.953
1	Terry	22	30.043	30.021	29.963	29.993	30.006
2	Jordan	23	30.065	30.012	30.021	30.024	30.037
3	Cameron	24	29.899	29.875	29.980	29.878	29.877
1	Terry	25	30.029	30.011	30.017	30.000	30.000
2	Jordan	26	30.046	30.006	30.039	29.991	29.970
3	Dana	27	29.993	29.991	29.984	30.022	30.010
1	Terry	28	30.057	30.032	29.979	30.027	30.033
2	Jordan	29	30.004	30.049	29.980	30.000	29.986
3	Dana	30	29.995	30.000	29.922	29.984	29.968

LEAN OPERATING SYSTEMS

W e're getting a lot of complaints from the nursing staff about the condition of the storeroom. They are repeatedly telling us that it is hard to locate supplies quickly—it's too messy." Rachel Thompson, the materials manager at Memorial Hospital, heard this comment from a staff member as they began their meeting. Another staff member, Alan, responded, "That's not our fault. The inventory and ordering processes take too long so we need to overstock." Rachel interrupted, "Let's not get defensive. The overall goal is to make the storeroom easy to use. Our mission is to provide exceptional health care, and having the right items in stock for the doctors and nurses is what we're paid to do! The storeroom should be designed so that someone who has never seen it before can find an item within 30 seconds. Any ideas?"[1]

© Nick Saraco/PhotoLibrary

learning outcomes

After studying this chapter you should be able to:

LO1 Explain the four principles of lean operating systems.

LO2 Describe the basic lean tools and approaches.

LO3 Explain the concept of lean six sigma and how it is applied to improving operations performance.

LO4 Explain how lean principles are used in manufacturing and service organizations.

LO5 Describe the concepts and philosophy of just-in-time operating systems.

What do **you** think?

Can you cite any personal experiences in your work or around your school where you have observed similar inefficiencies (how about your dorm or bedroom?)

In the opening scenario, many things might be done to alleviate the problems in the hospital storeroom. For example, they might make it more visual—maybe color-code the shelves and use simple signs. Another suggestion might be to develop some sort of labeling system on each item that will help to quickly locate any item, or post a stock locator list of all of the supply items in alphabetical order on the doorway that shows the rack and shelf on which an item is located. Inventory can also be reduced by limiting the stock of items that don't turn over quickly and eliminating any obsolete ones. Finally, they might consider restocking the storeroom at the end of each shift, rather than only once each week. Having just enough supplies on hand in the storeroom to last for the shift makes it much less cluttered and will free up some valuable space. The goal is to organize, sort, and standardize the operations of the storeroom; in short, to make it *lean*.

Lean enterprise *refers to approaches that focus on the elimination of waste in all forms, and smooth, efficient flow of materials and information throughout the value chain to obtain faster customer response, higher quality, and lower costs. Manufacturing and service operations that apply the principles of lean enterprise are often called* **lean operating systems**. Lean concepts were initially developed and implemented by the Toyota Motor Corporation, and lean operating systems are often benchmarked with "the Toyota production system."

Lean enterprise refers to approaches that focus on the elimination of waste in all forms, and smooth, efficient flow of materials and information throughout the value chain to obtain faster customer response, higher quality, and lower costs.

Manufacturing and service operations that apply the principles of lean enterprise are often called **lean operating systems**.

© photos.com

> Any activity, material, or operation that does not add value in an organization is considered waste.

Go Lean With *Heijunka*

Just off the shop floor at ESCO Corp.'s Plant No. 3 in the Portland area is a tower of homemade cardboard cubbyholes, called a *heijunka* box. According to sixsigma.com, *heijunka* is "A Japanese term that refers to production smoothing in which the total volume of parts and assemblies are kept as constant as possible." The *heijunka* box system is a system of boxes much like a mailroom set of boxes attached to a wall. Each column of boxes represents a specific period of time, such as a shift or a day, and each row corresponds to a product. Colored cards representing individual jobs (*kanban* cards) are placed on the *heijunka* box to provide a visual representation of upcoming production, making it easy to see what type of jobs are queued for production and the time for which they are scheduled. In effect, this set of boxes on the wall represents a visual production schedule by customer order. At ESCO, the *heijunka* box symbolizes a revolution—how ESCO and dozens of other local companies are helping each other get lean. "We all know it's an incredibly competitive and changing world out there," says ESCO's Dale Gehring, the former manager for the company's Plant No. 3. "The continuous improvement, and achieving operational excellence through lean methods, is our best shot at being successful." Faced with a shrinking local labor pool and growing overseas competition, Portland-area manufacturers have been searching for ways to adapt. Chief among them, Gehring and others say, is embracing the lean production philosophy.[2]

1 Principles of Lean Operating Systems

Lean operating systems have four basic principles:

1. elimination of waste
2. increased speed and response
3. improved quality
4. reduced cost

As simple as these may seem, organizations require disciplined thinking and application of good operations management tools and approaches to achieve them.

Eliminate Waste Lean, by the very nature of the term, implies doing only what is necessary to get the job done. Any activity, material, or operation that does not add value in an organization is considered waste. Exhibit 17.1 shows a variety of specific examples. The Toyota Motor Company classified waste into seven major categories:

1. *Overproduction*: for example, making a batch of 100 when there are orders for only 50 in order to avoid an expensive setup, or making a batch of 52 instead of 50 in case there are rejects. Overproduction ties up production facilities, and the resulting excess inventory simply sits idle.

2. *Waiting time*: for instance, allowing queues to build up between operations, resulting in longer lead times and higher work-in-progress.

3. *Transportation*: the time and effort spent in moving products around the factory as a result of poor layout.

4. *Processing*: the traditional notion of waste, as exemplified by scrap that often results from poor product or process design.

5. *Inventory*: waste associated with the expense of idle stock and extra storage and handling requirements needed to maintain it.

6. *Motion*: as a result of inefficient workplace design and location of tools and materials.

7. *Production defects*: the result of not performing work correctly the first time.

Increase Speed and Response Lean operating systems focus on quick and efficient response in designing and getting goods and services to market, producing to customer demand and delivery requirements, responding to competitors' actions, collecting payments, and addressing customer inquiries or problems. Perhaps the most effective way of increasing speed and response is to synchronize the entire value chain. By this we mean that not only are all elements of the value chain focused on a common goal but that the transfer of all physical materials and information are coordinated to achieve a high level of efficiency.

Exhibit 17.1 Common Examples of Waste in Organizations

Excess capacity	Produce too early	Too much space
Inaccurate information	Long distance traveled	Unnecessary movement of materials, people, and information
Excess inventory	Retraining and relearning time and expense	Equipment breakdowns
Long changeover and setup times	Scrap	Knowledge bottlenecks
Spoilage	Rework and repair	Non-value-added process steps
Clutter	Long unproductive meetings	Misrouting jobs
Planned product obsolescence	Poor communication	
Excessive material handling	Waiting time	
Overproduction	Accidents	

Improve Quality Lean operating systems cannot function if raw materials are bad, processing operations are not consistent, or machines break down. Poor quality disrupts work schedules and reduces yields, requiring extra inventory, processing time, and space for scrap and parts waiting for rework. All these are forms of waste and increase costs to the customer. Eliminating the sources of defects and errors in all processes in the value chain greatly improves speed and agility and supports the notion of continuous flow.

© George Doyle/Stockbyte/Getty Images

Reduce Cost Certainly, reducing cost is an important objective of lean enterprise. Anything that is done to reduce waste and improve quality often reduces cost at the same time. More efficient equipment, better preventive maintenance, and smaller inventories reduce costs in manufacturing firms. Simplifying processes, such as using customer labor via self-service in a fast-food restaurant, depositing a check using an automatic teller machine, and completing medical forms on-line before medical service are ways for service businesses to become leaner and reduce costs.

> Simplifying processes, such as using customer labor via self-service in a fast-food restaurant, depositing a check using an automatic teller machine, and completing medical forms online before medical service are ways for service businesses to become leaner and reduce costs.

2 Lean Tools and Approaches

meeting the objectives of lean enterprise requires disciplined approaches for designing and improving processes. Organizations use several tools and approaches to create a lean organization. We describe some of these here.

2.1 The 5Ss

Workers cannot be efficient if their workplaces are messy and disorganized. Efficient manufacturing plants are clean and well organized. Firms use the "5S"

principles to create this work environment. *The 5Ss are derived from Japanese terms: seiri (sort), seiton (set in order), seiso (shine), seiketsu (standardize), and shitsuke (sustain).*

- *Sort* refers to ensuring that each item in a workplace is in its proper place or identified as unnecessary and removed.
- *Set in order* means to arrange materials and equipment so that they are easy to find and use.
- *Shine* refers to a clean work area. Not only is this important for safety, but as a work area is cleaned, maintenance problems such as oil leaks can be identified before they cause problems.
- *Standardize* means to formalize procedures and practices to create consistency and ensure that all steps are performed correctly.
- Finally, *sustain* means to keep the process going through training, communication, and organizational structures.

2.2 Visual Controls

Visual controls *are indicators for operating activities that are placed in plain sight of all employees so that everyone can quickly and easily understand the status and performance of the work system.* Visual signaling systems are known as *andon*, drawing from the Japanese term where the concept first originated. For example, if a machine fails or a part is defective or manufactured incorrectly, a light might turn on or a buzzer might sound, indicating that immediate action should be taken. Many firms have cords that operators can pull that tell supervisors and other workers that a problem has occurred. Some firms, such as Honda (on the manufacturing floor) and JPMorgan Chase (at its call centers), use electronic "scoreboards" to keep track of daily performance. These scoreboards are located where everyone can see them and report key metrics such as volume, quality levels, speed of service, and so on.

2.3 Single Minute Exchange of Dies (SMED)

Long setup times waste manufacturing resources. Short setup times, on the other hand, enable a manufacturer to have frequent changeovers and move toward single-piece flow, thus achieving high flexibility and product variety. Reducing setup time also frees up capacity for other productive uses. **Single Minute Exchange of Dies (SMED)** *refers to quick setup or changeover of tooling and fixtures in processes so that multiple products in smaller batches can be run on the same equipment.* SMED was pioneered by Toyota and other Japanese manufacturers and has been adopted by companies around the world.

2.4 Small Batch and Single-Piece Flow

One of the practices that inhibits increasing speed and response in manufacturing or service processing of discrete parts such as a manufactured part, invoices, medical claims, or home loan mortgage approvals is **batching**—*the process of producing large quantities of items as a group before being transferred to the next operation.* Batching is often necessary when producing a broad goods or service mix with diverse requirements on common equipment. When making different goods, manufacturers often need to change dies, tools, and fixtures on equipment, resulting in expensive and time-consuming setups and teardowns. For services, preprinted forms or software may have to be changed or modified. By running large batches, setups and teardowns are reduced, providing economies of scale. However, this often builds up inventory that might not match market demand, particularly in highly dynamic markets.

A better strategy would be to use small batches or single-piece flow. **Single-piece flow** *is the concept of ideally using batch sizes of one.* However, to do this economically requires the ability to change between products quickly and inexpensively.

The **5Ss** are derived from Japanese terms: *seiri* (sort), *seiton* (set in order), *seiso* (shine), *seiketsu* (standardize), and *shitsuke* (sustain).

Visual controls are indicators for operating activities that are placed in plain sight of all employees so that everyone can quickly and easily understand the status and performance of the work system.

Single Minute Exchange of Dies (SMED) refers to quick setup or changeover of tooling and fixtures in processes so that multiple products in smaller batches can be run on the same equipment.

Batching is the process of producing large quantities of items as a group before being transferred to the next operation.

Single-piece flow is the concept of ideally using batch sizes of one.

Many companies have made remarkable improvements in reducing product setup times, making small-batch or single-piece flow a reality in job shop environments. Yammar Diesel reduced a machining line tool setting from 9.3 hours to 9 minutes; a U.S. chain saw manufacturer reduced setup time on a punch press from more than 2 hours to 3 minutes, and a midwestern manufacturer was able to cut equipment setup time on a 60-ton press from 45 minutes to 1 minute.

2.5 Quality and Continuous Improvement

Quality at the source requires doing it right the first time, and therefore eliminates the opportunities for waste. Employees inspect, analyze, and control their own work to guarantee that the good or service passed on to the next process stage conforms to specifications. Continuous improvement initiatives are vital in lean environments, as is teamwork among all managers and employees. Six Sigma, in particular, has emerged to be a useful and complementary approach to lean production and has led to a new concept know as *Lean Six Sigma*. A firm might apply lean tools to streamline an order entry process and discover that significant rework is occurring because of incorrect addresses, customer numbers, or shipping charges that results in high variation of processing time. Six Sigma tools might then be used to drill down to the root cause of the problems and identify a solution.

> Quality at the source requires doing it right the first time, and therefore eliminates the opportunities for waste. Employees inspect, analyze, and control their own work to guarantee that the good or service passed on to the next process stage conforms to specifications.

2.6 Total Productive Maintenance

Total productive maintenance (TPM) *is focused on ensuring that operating systems will perform their intended function reliably.* The goal of TPM is to prevent equipment failures and downtime; ideally, to have "zero accidents, zero defects, and zero failures" in the entire life cycle of the operating system.[3] TPM seeks to:

- maximize overall equipment effectiveness and eliminate unplanned downtime;
- create worker "ownership" of the equipment by involving them in maintenance activities; and
- foster continuous efforts to improve equipment operation through employee involvement activities.

Because of its importance in lean thinking, TPM has recently been called "lean maintenance." Lean maintenance is more than preventing failures of equipment and processes; it now includes maintenance and backup systems for software and electronic network systems such as the Internet or wireless networks.

2.7 Manufactured Good Recovery

In an effort to reduce costs and contribute to environmental, social, and economic sustainability, many companies are actively recovering and recycling parts (sometimes called *green manufacturing*). This can occur at various points of the supply chain, as shown in Exhibit 17.2. Once a manufactured good is discarded, one option is to resell the good or its various component parts. Other options include:

- *Repairing* a manufactured good by replacing broken parts so it operates as required.
- *Refurbishing* the good by updating its looks and/or components; for example, cleaning, painting, or perhaps replacing parts that are near failure.
- *Remanufacturing* the good by returning it to close to its original specifications. This is usually done by disassembling it, cleaning or replacing many of the parts, and testing it to ensure it meets certain performance and quality standards.
- *Cannibalizing* parts for use as replacement parts in other goods.

> **Total productive maintenance (TPM)** is focused on ensuring that operating systems will perform their intended function reliably.

Exhibit 17.2 *Integrated Manufactured Good Recovery Value Chain*

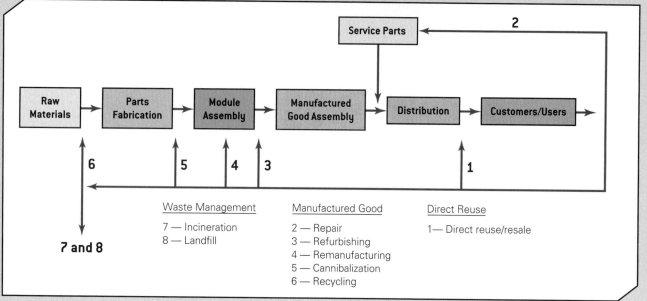

Source: Thierry, M., Salomon, M., Nunen, J., and Wassenhove, L., "Strategic Issues in Product Recovery Management," *California Management Review* 37, no. 2, Winter 1995, p. 118.

Lean and Green

One issue of the *Quadrangle*, a University of Kentucky alumni College of Engineering magazine, noted that "This issue was printed with vegetable ink on 12,125 pounds of paper made with 100% post-consumer recycled fiber. The resulting environmental savings are:

- 41,954 lbs. of wood—a total of 145 trees that supply enough oxygen for 73 people annually;
- 53,050 gallons of water—enough water to take 3,084 eight-minute showers;
- 101 million BTUs of energy—enough energy to power an average American household for 406 days;
- 12,781 lbs. of emissions—carbon sequestered by 153 tree seedlings grown for 10 years;
- 6,812 lbs. of solid waste—a total of 235 thirty-two gallon garbage cans of waste."

This publication is produced twice each year. Think of the total environmental savings if this was done for all the catalogues, magazines, newsletters, and so on that you get in the mail![4]

- *Recycling* goods by disassembling them and selling the parts or scrap materials to other suppliers. If the residual value of the manufactured good has been extracted or it is not economical to do so, the part ends up being incinerated or dumped in a landfill.

3 Lean Six Sigma

Six Sigma is a useful and complementary approach to lean production. For example, a cycle time reduction project might involve aspects of both. Lean tools might be applied to streamline an order entry process. This application leads to the discovery that significant rework occurs because of incorrect addresses, customer numbers, or shipping charges and results in high variation of processing time. Six Sigma tools might then be used to drill down to the root cause of the problems and identify a solution. Because of these similarities, many practitioners have begun to focus on *Lean Six Sigma*, drawing upon the best practices of both approaches. Both are driven by customer requirements, focus on real dollar savings, have the ability to make significant financial impacts on

the organization, and can easily be used in non-manufacturing environments. Both use basic root cause, process, and data analysis techniques.

However, some differences clearly exist between lean production and Six Sigma. First, they attack different types of problems. Lean production addresses visible problems in processes, for example, inventory, material flow, and safety. Six Sigma is more concerned with less visible problems, for example, variation in performance. In essence, lean is focused on efficiency by reducing waste and improving process flow while Six Sigma is focused on effectiveness by reducing errors and defects. Another difference is that lean tools are more intuitive and easier to apply by anybody in the workplace, while many Six Sigma tools require advanced training and expertise of specialists, particularly in statistical analyses, commonly called Black Belts and Master Black Belts. For example, most workers can easily understand the concept of the 5S's but may have more difficulty with statistical methods. Thus, organizations might be well advised to start with basic lean principles and evolve toward more sophisticated Six Sigma approaches. However, it is important to integrate both approaches with a common goal—improving business results. Often Lean Six Sigma is an important part of implementing a strategy built upon sustainability.

© The Timken Company/PRNewsFoto/AP Photo

4 Lean Manufacturing and Service Tours

ean manufacturing plants look significantly different from traditional plants. They are clean and organized, devoid of long and complex production lines and high levels of work-in-process, have efficient layouts and work area designs, use multiskilled workers that perform both direct and indirect work such as maintenance, and have no incoming or final inspection stations. Next, we "tour" a manufacturing firm to examine how it focuses on the four major lean objectives.

4.1 Timken Company

The Timken Company (*www.timken.com*) is a leading global manufacturer of highly engineered bearings and alloy steels and related products and services for three major markets—industrial, automotive, and steel. Timken employs about 18,000 employees in over 50 factories and more than 100 sales, design, and distribution centers located throughout the world. Timken places increasing emphasis on pre- and postproduction services, such as integrated engineering solutions to customer requirements.

Like most manufacturers, Timken faced intense, survival-threatening, global competition, and like many others, it placed itself on the leading edge of the U.S. industrial revival. In 1989, the company launched "Vision 2000," a program of lean production initiatives that developed throughout the 1990s. A key element was increased productivity through lean manufacturing operating principles and technologies, some of which we highlight next.

Eliminate Waste Timken's automotive business uses a "Boot Camp" in which a certain factory identifies several improvement opportunities and Timken employees and managers from other sites then try to solve these specific problems at the host factory. The problems often focus on removing non-value-added steps from processes, reducing process and equipment variation, and eliminating waste. The boot camp approach allows "fresh eyes" to evaluate improvement opportunities and present solutions to host plant management.

Increase Speed and Response Timken has focused on improving its product development process—a non-manufacturing, information-intensive process—with the objective to radically reduce the total cycle time for new product development with fewer errors and to be more responsive to customer requests, competitor capabilities, and marketplace changes. Timken's objective of an integrated supply chain also focuses on agility to better meet customer wants and needs.

Timken exploited computer-aided design and computer-aided manufacturing (CAD/CAM) to better meet customer needs and improve design for

manufacturability. It developed flexible manufacturing systems to facilitate rapid, cost-effective changeover from one product to another, combining the advantages of batch and mass production. Lean manufacturing's most distinguishing characteristic at Timken, however, was the authority and responsibility it gave to people on the shop floor. Initiatives aimed at empowering shop floor employees included more open communication, enhanced training, widespread adoption of a team approach to problem-solving and decision-making, and changes in measures of performance and rewards.

Improve Quality Total quality and continuous improvement have long been areas of focus for Timken. Through programs like Breakthrough and Accelerated Continuous Improvement, thousands of improvement ideas have been implemented, saving millions of dollars. Quality standards are determined for all manufacturing processes, and worldwide quality audits make sure that these standards are being met. Each plant is certified to ISO 9000 or other quality certifications. Timken has applied Six Sigma tools to minimize process variation. One initiative was to improve machine operator efficiency and reduce variability. Workstation processes were standardized and machine operator walking and movement time was eliminated or reduced. The result was improved quality and reduced scrap.

Reduce Cost Timken redefined its mission statement in 1993 to be "the best performing manufacturing company in the world as seen through the eyes of our customers and shareholders." Timken factories, suppliers, and customers share information using the Internet. Purchasing, order fulfillment, manufacturing strategy implementation, Lean Six Sigma, and logistics have been brought together to create an "integrated supply chain model." The purpose of this focus is to reduce asset intensity, improve customer service and systems support, respond faster to customer needs, and better manage inventory levels.

In the late 1990s, Timken decided to integrate its lean manu-

© Barry Sweet/Landov

facturing practices and Six Sigma initiatives into one unified program, Lean Six Sigma. The objective of Timken's Lean Six Sigma program is "to identify and deliver value to our customers and shareholders by improving the flow of product and information through waste elimination and variation reduction." All manufacturing processes are flowcharted and the DMAIC problem-solving framework is used to generate process improvements. The automotive business achieved a net documented savings of $7 million from Lean Six Sigma projects in one year alone.

Service organizations can benefit significantly from applying lean principles. Lean principles are not always transferable to "front office" services that involve high customer contact and service encounters. In these situations, the service provider and firm do not have complete control over creating the service. Different customers, service encounter situations, and customer and employee behaviors cause the creation and delivery of the service to be much more variable and uncertain than producing a manufactured good in the confines of a factory. However, "back office" service processes, such as hospital laboratory testing, check processing, and college application processing, are nearly identical to many manufacturing processes. Time, accuracy, and cost are all important to their performance, and therefore they can clearly benefit from the application of lean principles.

The following discussion shows how lean concepts have been used at Southwest Airlines.[5]

4.2 Southwest Airlines

Since its inception, Southwest Airlines has shown lean performance when compared to other major airlines. They have consistently been profitable while other major airlines have not. What is even more significant is that Southwest has historically operated small planes and short-distance flights and therefore cannot capitalize on economies of scale available to larger airlines.

The vast majority of total airline cost focuses

Bringing Lean to Healthcare

Names such as the "Zip Scripts," "Paper Pushers," and "Stock Squad" are more likely to evoke images of company softball teams than money- and life-saving hospital initiatives. However, at Grand Rapids, Michigan-based Metro Health Hospital, a member hospital of VHA Inc., that's exactly what these groups achieve by applying lean principles to enhance the ability to deliver medications safely to patients. They discovered that the pharmacy had a 14-stage process with some unnecessary steps, resulting in a total lead time of 166 minutes. Technicians were spending 77.4 percent of their time locating products. Lean teams worked to dissect the value-added from non-value-added process steps. For example, when pharmacists needed to fill orders, the information arrived electronically, and the appropriate labels were printed out on a single printer. However, multiple orders went to the printer simultaneously, and the labels were printed according to when they arrived, not according to patient. At the printer, which was inconveniently located, a technician separated labels by patient, peeling them off the strip and placing them on bags for the appropriate patients. Then technicians filled the bags with medication according to which labels were on the bags. This created confusion and led to medication errors resulting from labels printing simultaneously and technicians occasionally placing labels on the wrong bag. After redesigning the system, the pharmacy realized a 33-percent reduction in time to get medications to patients, and reduced the number of process steps from 14 to nine simply by removing non-value-added steps. Patients have experienced a 40 percent reduction in pharmacy-related medication errors, and the severity of those errors has decreased.[6]

on operations management activities: traffic servicing (13 percent), aircraft servicing (7 percent), flight operations (47 percent), reservations and sales (10 percent), and passenger in-flight service (7 percent). Note that the first three are low contact (back office) operations, whereas passenger in-flight service and reservations and sales are high contact service management functions. Therefore, taking a lean approach to all operations is vital to airline performance. Southwest is clearly a lean airline—it does more with less than any other airline competitor. Let us examine some of the reasons.

Eliminate Waste In the airline industry, idle time is the largest form of waste. Southwest locates its planes at noncongested airports to help it minimize airplane turnaround time. Fewer ancillary services reduce the opportunity for waste and inefficiencies. Southwest also enjoys a much lower employee turnover rate than its competitors, resulting in lower training costs.

All the resources at Southwest work to keep the airplanes in the air earning revenue—the primary focus of its strategy. The more time spent on the ground, the less revenue. It relies on motivated employees, a culture focused on the customer, and teamwork to accomplish this strategy. Southwest employees are cross-trained and organized into teams to accomplish all key operational activities. For example, all employees cooperate to ensure timely takeoffs and landings; it is not unusual to see pilots helping load baggage if this will get the plane off on time. This maintains smooth system schedules and reduces the need for reschedules and reticketing, both of which are a form of rework. As one example, in as little as 15 minutes, Southwest can change the flight crew; deplane and board 137 passengers; unload 97 bags, 1,000 pounds of mail, and 25 pieces of freight; load another 123 bags and 600 pounds of mail; and pump 4,500 pounds of jet fuel into the aircraft.[7]

Increase Speed and Response Southwest uses a much simpler structure and operating system than its competitors. It uses only one type of aircraft—the Boeing 737—making it easier to schedule crews, perform maintenance, and standardize such activities as boarding, baggage storage and retrieval, and cabin operations. It books direct flights from point A to B and does not rely on the hub-and-spoke system used by competitors. This makes it easier for many customers to get to their destinations, instead of, for instance, flying from Orlando to Cincinnati or Detroit and then connecting back to Nashville. A simple operating structure reduces the time it takes to make decisions and allows employees to focus on the key drivers of airline performance such as turnaround time. For example, if Southwest can turn its planes around on average in at most $1/2$ hour while competitors take 1 hour, then, assuming a 90-minute flight, approximately one to two more flights per day per plane can be made. This can be a significant economic and strategic advantage.

Southwest was the first airline to introduce ticketless travel. Customers simply get a confirmation number and show up on time. A significant proportion of customers book their flights directly on

Southwest.com. No in-flight full-service meals are provided either, simplifying cabin operations and eliminating the need to stock meals, which increases the time to clean up from the previous flight and prepare for the next flight. Instead, Southwest was the first airline to offer continental breakfast in the gate area, and flight attendants serve drinks and peanuts using specially designed trays. If a customer misses a flight, he or she can use the ticket for a future flight with no penalty; this reduces paperwork and processing, contributing to a leaner operation.

Improve Quality Simplified processes reduce variability in flight schedules, a major source of customer complaints, and therefore improve customers' perceptions of quality and satisfaction. Southwest encourages carry-on baggage; hence, there is less opportunity for losing, misrouting, or damaging baggage. People-oriented employees are carefully chosen and empowered to both serve and entertain passengers.

Reduce Cost Short setup and turnaround time translates into higher asset utilization and reduces the need for costly inventories of aircraft. Southwest does not have assigned seating; customers wait on a first-come, first-served basis and board in zones. This lowers costs, and only a few employees are needed to coordinate passenger boarding. In addition, rather than carry the high overhead costs of airplane maintenance and repair, Southwest outsources these tasks to third parties.

© Kimimasa Mayama/Bloomberg News/Landov

 # 5 Just-in-Time Systems

Just-in-Time (JIT) was introduced at Toyota during the 1950s and 1960s to address the challenge of coordinating successive production activities. An automobile, for instance, consists of thousands of parts. It is extremely difficult to coordinate the transfer of materials and components between production operations. Traditional factories use a **push system**, *which produces finished goods inventory in advance of customer demand using a forecast of sales.* Parts and subassemblies are "pushed" through the operating system based on a predefined schedule that is independent of actual customer demand. In a push system, a model that

A **push system** produces finished goods inventory in advance of customer demand using a forecast of sales.

A **pull system** is one in which employees at a given operation go to the source of required parts, such as machining or subassembly, and withdraw the units as they need them.

might not be selling well is still produced at the same predetermined production rate and held in finished goods inventory for future sale, whereas enough units of a model in high demand might not get produced.

Another problem was that traditional automobile production systems relied on massive and expensive stamping press lines to produce car panels. The dies in the presses weighed many tons and specialists needed up to a full day to switch them for a new part. To compensate for long setup times, large batch sizes were produced so that machines could be kept busy while others were being set up. This resulted in high work-in-process inventories and high levels of indirect labor and overhead.

Toyota created a system based on a simple idea: Produce the needed quantity of required parts each day. This concept characterizes a **pull system**, *in which employees at a given operation go to the source of required parts, such as machining or subassembly, and withdraw the units as they need them.* Then just enough new parts are manufactured or procured to replace those withdrawn. As the process from which parts were withdrawn replenishes the items it transferred out, it draws on the output of its preceding process, and so on. Finished goods are made to coincide with the actual rate of demand, resulting in minimal inventories and maximum responsiveness.

JIT systems are based on the concept of pull rather than push. In a JIT system, a key gateway workstation (such as final assembly) withdraws parts to meet demand and therefore provides real-time information to preceding workstations about how much to produce and when to produce to match the sales rate. By pulling parts from each preceding workstation, the entire manufacturing process is synchronized to the final assembly schedule. JIT operating systems prohibit all process workstations from pushing inventory forward only to wait idle if it is not needed.

A JIT system can produce a steady rate of output to meet the sales rate in small, consistent batch sizes to level loads and stabilize the operating system. This dramatically reduces the inventory required between stages of the production process, thus greatly reducing costs and physical capacity requirements.

5.1 Operation of a JIT System

A simple generic JIT system with two process cycles—one for the customer and a second for the supply process—is shown in Exhibit 17.3. Conceptually, the customer can be an internal or external customer, and the customer-supply configuration in Exhibit 17.3 can be chained together to model a more complex sequence of production or assembly operations. In this process, the customer cycle withdraws what is needed at the time it is needed according to sales. The supply cycle creates the good to replenish only what has been withdrawn by the customer. The storage area is the interface and control point between the customer and supply cycles.

Slips, called Kanban cards (*Kanban* is a Japanese word that means "visual record" or "card"), are circulated within the system to initiate withdrawal and production items through the production process. A **Kanban** *is a flag or a piece of paper that contains all relevant information for an order: part number, description, process area used, time of delivery, quantity available, quantity delivered, production quantity, and so on.* Because of this, a JIT system is sometimes called a Kanban system.

The Kanban system begins when the customer buys or uses the good and an empty container is created. The withdraw Kanban (step 1) authorizes

A **Kanban** is a flag or a piece of paper that contains all relevant information for an order: part number, description, process area used, time of delivery, quantity available, quantity delivered, production quantity, and so on.

Exhibit 17.3 *A Two-Card Kanban JIT Operating System*

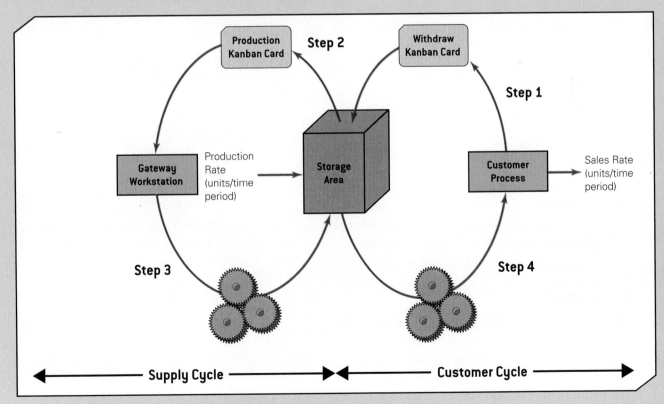

the material handler to transfer empty containers to the storage area. Withdraw Kanbans trigger the movement of parts. The material handler detaches the withdraw-ordering Kanban that was attached to the empty container and places the Kanban card in the storage area or on the Kanban receiving post, leaving the empty container(s) (step 1). A material handler for the supply cycle places a production Kanban on the empty container and this authorizes the gateway workstation to produce parts (step 2). Production Kanbans trigger the production of parts. The container holds a small lot size of parts. Without the authorization of the production Kanban, the gateway workstation and all other workstations may be idle. The gateway workstation must be scheduled to meet the sales rate and it pulls parts from all other workstations. The other workstations in the process do not need to be scheduled because they get their production orders from the production Kanban that pulls parts through the supply process. The supply process returns a full container of parts to the storage area with the production Kanban attached (step 3). The Kanban process is complete when the material handler for the customer process picks up a full container of parts and takes the production Kanban card off the container. Normally, the material handler drops off a withdrawal Kanban and empty container when picking up a full container of parts.

JIT practice is to set the lot size or container size equal to about 5 percent to 20 percent of a day's demand or between 20 to 90 minutes worth of demand. The number of containers in the system determines the average inventory levels. The following equation is used to calculate the number of Kanban cards (K) required:

$$K = \frac{\text{Average daily demand during lead time plus a safety stock}}{\text{Number of units per container}}$$

$$= \frac{d(p + w)(1 + \alpha)}{C} \qquad [17.1]$$

where K = the number of Kanban cards in the operating system.

d = the average daily production rate as determined from the master production schedule.

w = the waiting time of Kanban cards in decimal fractions of a day (that is, the waiting time of a part).

p = the processing time per part, in decimal fractions of a day.

C = the capacity of a standard container in the proper units of measure (parts, items, etc.).

α = a policy variable determined by the efficiency of the process and its workstations and the uncertainty of the workplace, and therefore, a form of safety stock usually ranging from 0 to 1. However, technically, there is no upper limit on the value of α.

Solved Problem

Bracket Manufacturing uses a Kanban system for a component part. The daily demand is 800 brackets. Each container has a combined waiting and processing time of 0.34 days. The container size is 50 brackets and the safety factor (α) is 9 percent.

a. How many Kanban card sets should be authorized?

b. What is the maximum inventory of brackets in the system of brackets?

c. What are the answers to (a) and (b) if waiting and processing time is reduced by 25 percent?

d. If we assume one-half the containers are empty and one-half full at any given time, what is the average inventory in the system for the original problem?

Solution:

a. Using equation 17.1:

$$K = \frac{d(p + w)(1 + \alpha)}{C}$$

$$= \frac{(800 \text{ units})(0.34)(1 + 0.09)}{50} = 5.93$$

$$\cong 6 \text{ (rounded up to 6)}$$

Thus, six containers and six Kanban card sets are necessary to fulfill daily demand.

b. The maximum authorized inventory is $K \times C$ = 6 × 50 = 300 brackets.

c.
$$K = \frac{d(p + w)(1 + \alpha)}{C}$$

$$= \frac{(800 \text{ units})(0.255)(1 + 0.09)}{50} = 4.45$$

$$\cong 5 \text{ (rounded up to 5)}$$

Thus, five containers and five Kanban card sets are necessary to fulfill daily demand. The maximum authorized inventory is now $K \times C = 5 \times 50$ = 250 brackets.

d. The average inventory under this assumption is 300/2 = 150 brackets. Many variables in the JIT system determine whether this assumption is valid or not. For example, for a given combination of daily demand, processing and waiting times, and other process inefficiencies and uncertainties, it is possible for more or fewer containers to be empty (full).

> At the Nashua Corporation, a JIT-oriented study of administrative operations reduced order-cycle time from 3 days to 1 hour, office space requirements by 40 percent, and errors by 95 percent and increased productivity by 20 percent.

The number of Kanban cards is directly proportional to the amount of work-in-process inventory. Managers and employees strive to reduce the number of cards in the system through reduced lead time (p or w), lower α values, or through other improvements. The maximum authorized inventory in the operating system is $K \times C$.

5.2 JIT in Service Organizations

Although JIT has had its biggest impact in manufacturing, many service organizations are increasingly applying it. At the Nashua Corporation, for example, a JIT-oriented study of administrative operations reduced order-cycle time from 3 days to 1 hour, office space requirements by 40 percent, and errors by 95 percent and increased productivity by 20 percent.[8] One overnight package-delivery service saw its inventory investment climb from $16 million to $34 million with conventional inventory management techniques.[9] Implementing JIT reduced its inventory investment, but the company's major objective was to increase profits by providing a 99.9 percent level of service to its customers. Before JIT implementation, its service level—computed by dividing the number of items filled weekly by the number of items requested—was 79 percent. After JIT, the level was 99 percent, and the firm looked forward to meeting its goal. Baxter International is another service company that has experienced the benefits of a JIT system.

Some of the characteristics of a well-designed JIT system are summarized in Exhibit 17.4.

Exhibit 17.4 *Example JIT Characteristics and Best Practices*

- Setup/changeover time minimized
- Excellent preventive maintenance
- Mistake-proof job and process design
- Stable, level, repetitive master production schedule
- Phantom bill of materials with zero lead time
- Fast processing times
- Clean and uncluttered workspaces
- Very little inventory to hide problems and inefficiencies
- Use production cells with no wasted motion
- May freeze the master production schedule
- Use reusable containers
- Outstanding communication and information sharing
- Keep it simple and use visual controls
- High quality approaching zero defects
- Small repetitive order/lot sizes
- Minimize the number of parts/items
- Minimize the number of bill of materials levels
- Facility layout that supports continuous or single-piece flow
- Minimize distance traveled and handling
- Clearly defined performance metrics
- Minimize the number of production, inventory, and accounting transactions
- Good calibration of all gauges and testing equipment
- Employees trained in quality management concepts and tools
- Excellent employee recognition and reward systems
- Employee cross-training and multiple skills
- Empowered and disciplined employees

Problems, Activities, and Discussions

1. Provide some examples of different types of waste in an organization with which you are familiar, such as an automobile repair shop or a fast-food restaurant.

2. Compare the lean service system of Southwest Airlines to a full service airline such as United Airlines or British Airways on the following: (a) airplane boarding process, (b) cabin service, (c) ticket transfer to other Southwest flights, (d) frequent flyer program, (e) baggage handling, (f) seat assignment system, and (g) service encounters.

3. Would you buy a certified remanufactured automobile transmission for 60 percent of the price of a newly manufactured transmission? Why or why not?

4. Interview a manager at a local company that uses JIT. Report on how it is implemented and the benefits the company has realized.

5. Bracket Manufacturing uses a Kanban system for a component. Daily demand is 600 units. Each container has a combined waiting and processing time of 1.2 days. If the container size is 50 and the alpha value (α) is 15 percent, how many kanban card sets should be authorized? What is the maximum authorized inventory?

6. Lou's Bakery has established that JIT should be used for chocolate chips due to the high probability of the kitchen heat melting the chips. The average demand is 180 cups of chocolate chips per week. The average setup and processing time is $1/2$ day. Each container holds exactly two cups. The current safety stock factor is 5 percent. The baker operates six days per week.

 a. How many Kanbans are required for the bakery?

 b. What is the maximum authorized inventory?

 c. If the average setup and processing time is reduced to $3/8$ of a day due to better training and retention of experienced employees, what are the answers to (a) and (b)?

7. An automobile transmission manufacturer is considering using a JIT approach to replenishing its stock of transmissions. Daily demand for transmission #230 is 25 transmissions per day and they are built in groups of six transmissions. Total assembly and waiting time is three days. The supervisor wants to use an alpha value (α) of 3, or 300 percent.

 a. How many Kanbans are required?

 b. What is the maximum authorized inventory?

 c. What are the pros and cons of using such a high alpha (α) value?

8. Do you think applying operations management concepts and methods such as Six Sigma and lean principles can reduce U.S. health care costs? Explain. Provide examples that show how OM can help the U.S. health care industry.

9. What types of "setups" do you perform in your work or school activities? How might you reduce the setup times?

10. Search the Internet for some manufacturing or service tours similar to the ones in this chapter. Classify their practices according to lean principles in a manner similar to the examples.

Community Medical Associates Case Study

Community Medical Associates (CMA) is a large health care system with two hospitals, 25 satellite health centers, and 56 outpatient clinics. CMA had 1.5 million outpatient visits and 60,000 inpatient admissions the previous year. Just a few years ago, CMA's health care delivery system was having significant problems with quality of care. Long patient waiting times, uncoordinated clinical and patient information, and medical errors plagued the system. Doctors, nurses, lab technicians, managers, and medical students in training were very aggravated with the labyrinth of forms, databases, and communication links. Accounting and billing were in a situation of constant confusion and correcting medical bills and insurance payments. The complexity of the CMA information and communication system overwhelmed its people.

Prior to redesigning its systems, physicians were faced with a complex array of appointments and schedules in order to see patients in the hospital, centers, and clinics. For example, an elderly patient with shoulder pain would get an X-ray at the clinic but have to set up an appointment for a CAT scan in the hospital. Furthermore, the patient's blood was sent to an off-site lab while physician notes were transcribed from

tape recorders. Radiology would read and interpret the X-rays and body scans in a consultant report. Past and present medication records were kept in the hospital and off-site pharmacies. Physicians would write paper prescriptions for each patient. Billing and patient insurance information was maintained in a separate database. The patient's medical chart was part paper-based and part electronic. The paper medical file could be stored at the hospital, center, or clinic. Nurses handwrote their notes on each patient, but their notes were seldom input into the patient's medical records or chart.

© ERproductions Ltd./Blend Images/Jupiter Images

"We must access one database for lab results, then log off and access another system for radiology, then log off and access the CMA pharmacy system to gain an integrated view of the patient's health. If I can't find the patient's records within five minutes or so, I have to abandon my search and tell the patient to wait or make another appointment," said one doctor. The doctor continued, "You have to abandon the patient because you have to move on to patients you truly can diagnose and help. If you don't abandon the patient, you might make clinical decisions about the patient's health without having a complete set of information. Not having all the medical information fast has a direct impact on quality of care and patient satisfaction."

Today, CMA uses an integrated operating system that consolidates over 50 CMA databases into one. Health care providers in the CMA system now have access to these records through 7,000 computer terminals. Using many levels of security and some restricted databases, all patient information is accessible in less than two minutes. For example, sensitive categories of patient records, such as psychiatric and AIDS problems, were kept in super-restricted databases. It cost CMA $4.46 to retrieve and transport a single patient's paper-based medical chart to the proper location, whereas the more complete and quickly updated electronic medical record costs $0.82 to electronically retrieve and trans-

port once. A patient's medical records are retrieved on average 1.4 times for outpatient services and 6.8 times for inpatient admissions. In addition, CMA has spent more money on database security, although it has not been able to place a dollar value on this. Electronic security audit trails show who logs on, when, how long he or she views a specific file, and what information he or she has viewed.

The same doctor who made the previous comments two years ago now said, "The speed of the system is what I like. I can now make informed clinical decisions for my patients. Where it used to take several days and sometimes weeks to transcribe my patient medical notes, it now takes no more than 48 hours to see them pop up on the CMA system. Often my notes are up on the system the same day. I'd say we use about one-half the paper we used with the old system. I also find myself editing and correcting transcription errors in the database—so it is more accurate now."

The next phase in the development of CMA's integrated system is to connect it to suppliers, outside labs and pharmacies, other hospitals, and to doctors' home computers.

Case Questions for Discussion

1. Explain how CMA used the four principles of lean operating systems to improve performance.

2. Using the information from the case, sketch the original paper-based value chain and compare it to a sketch of the modern electronic value chain that uses a common database. Explain how the performance of both systems might compare.

3. What is the total annual record retrieval cost savings with the old (paper-based) versus new (electronic) systems?

4. Using lean principles, can you simultaneously improve speed and quality while reducing waste and costs? What are the tradeoffs? Explain your reasoning.

PROJECT MANAGEMENT

t he Olympic Games were established over 2,500 years ago. Athens, Greece, was chosen in 1997 to host the 2004 Games, but organizers badly underestimated the cost and overestimated the city's ability to meet construction and preparation schedules. Organizers were plagued with construction delays and budget overruns, forcing them to complete seven years' worth of work in just four years. Delays in the main stadium's glass-and-steel room pushed back delivery of the entire complex to the end of July, immediately preceding the August 13, 2004, opening ceremonies. The International Olympic Committee had even considered asking the Athens organizers to cancel the Games.[1] Problems also occurred with other venues. Construction delays had consequences for Greece's own athletes, forcing them out of their own training centers. Even the famed Parthenon, which was to have been restored for the Games, was still shrouded with scaffolding when tourists began arriving. Despite all this, the venues were ready—although some at the last minute—and the Games were successfully completed.

What do **you** think?

Think of a project in which you have been involved, perhaps at work or in some student activity. What factors made your project either difficult or easy to accomplish?

learning outcomes

After studying this chapter you should be able to:

LO1 Explain the key issues associated with project management.

LO2 Describe how to apply the Critical Path Method (CPM).

LO3 Explain how to make time/cost tradeoff decisions in projects.

LO4 Describe how to calculate probabilities for project completion time using PERT.

© BananaStock/Jupiterimages

In many firms, projects are the major value creation process, and the major activities in the value chain revolve around projects. Some examples are market research studies, construction, movie production, software development, book publishing, and wedding planning.

*A **project** is a temporary and often customized initiative that consists of many smaller tasks and activities that must be coordinated and completed to finish the entire initiative on time and within budget.* Suppose that a small business is considering expanding its facility. Some of the major tasks in planning for expansion are hiring architects, designing a new facility, hiring contractors, building the facility, purchasing and installing equipment, and hir-ing and training employees. Each of these major tasks consists of numerous subtasks that must be performed in a particular sequence, on time, and on budget. Taken together, these activities constitute a project.

In many firms, projects are the major value creation process, and the major activities in the value chain revolve

A **project** is a temporary and often customized initiative that consists of many smaller tasks and activities that must be coordinated and completed to finish the entire initiative on time and within budget.

around projects. Some examples are market research studies, construction, movie production, software development, book publishing, and wedding planning. In other firms, projects are used on an infrequent basis to implement new strategies and initiatives or for supporting value chain design and improvement activities. Some examples are preparation of annual reports, installing an automated materials handling system, or training employees to learn a new computer support system. Even U.S. courts use projects to help resolve construction claim litigations. Exhibit 18.1 lists a variety of examples of projects in many different functional areas of business.

In all project situations, projects require systematic management. **Project management** *involves all activities associated with planning, scheduling, and controlling projects.* The 2004 Olympic Games provides a good example of the importance of project management.

Project management involves all activities associated with planning, scheduling, and controlling projects.

Good project management ensures that an organization's resources are used efficiently and effectively. This is particularly important, as projects generally cut across organizational boundaries and require the coordination of many different departments and functions and sometimes companies. In addition, most projects are unique, requiring some customization and response to new challenges.

1 The Scope of Project Management

ost projects go through similar stages from start to completion. These stages characterize the project life cycle and form the basis for effective project management.

Exhibit 18.1 *Example Projects in Different Functional Areas That Impact the Value Chain*

Functional Areas	Example Projects
Marketing	Point-of-sale system installation
	New product introduction
	Market research studies
Accounting and Finance	Auditing a firm's accounting and financial systems
	Planning a firm's initial public offering (IPO)
	Auditing a firm's procedures and stock trading rules for compliance with the Securities & Exchange Commission
Information Systems	Software development
	Software upgrades throughout a firm
	Hardware installation
Human Resource Management	Launching and coordinating training programs
	Annual performance and compensation review
	Implementing new benefits plans
Engineering	Designing new manufactured parts
	Implementing a new computer-aided design system
	Installing factory automation
Logistics	Installing an automated warehouse system
	Implementing an order-tracking system
	Building a transportation hub
Operations	Planning preventive maintenance for an oil refinery
	Implementing ERP software and systems
	Installing a revenue management system

1. *Define:* Projects are implemented to satisfy some need; thus the first step in managing a project is to clearly define the goal of the project, its responsibilities and deliverables, and when it must be accomplished. A common way to capture this information is with a specific and measurable *statement of work*. For example, the goal of an accounting audit might be to "audit the firm's accounting and financial statements and submit a report by December 1 that determines statement accuracy in accordance with generally accepted accounting principles in the United States of America. The audit fee shall not exceed $200,000."

2. *Plan:* In this stage, the steps needed to execute a project are defined, it is determined who will perform these steps, and the start and completion dates are developed. Planning entails breaking down a project into smaller activities and developing a project schedule by estimating the time required for each activity and scheduling them so they meet the project due date.

3. *Organize:* Organizing involves such activities as forming a team, allocating resources, calculating costs, assessing risk, preparing project documentation, and ensuring good communications. It also requires identifying a project manager who provides the leadership to accomplish the project goal.

4. *Control:* This stage assesses how well a project meets its goals and objectives and makes adjustments as necessary. Controlling involves collecting and assessing status reports, managing changes to baselines, and responding to circumstances that can negatively impact the project participants.

5. *Close:* Closing a project involves compiling statistics, releasing and/or reassigning people, and preparing a "lessons learned" list.

1.1 Roles of the Project Manager and Team Members

Project managers have significant responsibilities. It is their job to build an effective team, motivate them, provide advice and support, align the project with the firm's strategy, and direct and supervise the conduct of the project from beginning to end. In addition to managing the project, they must manage the relationships among the project team, the parent organization, and the client. The project manager must also have sufficient technical expertise to resolve disputes among functional specialists.

Good project managers recognize that people issues are as important as technical issues. Several principles can help project managers be successful.[3]

- Manage people individually and as a project team.
- Reinforce the commitment and excitement of the project team.
- Keep everyone informed.
- Build agreements and consensus among the team.
- Empower the project team.

In a typical functional organization, a project cuts across organizational boundaries.

Custom Research Inc.

Founded in 1974 and based in Minneapolis, privately-owned Custom Research Inc. (CRI) conducts survey marketing research for a wide range of firms. The bulk of its projects assist clients with new product development in consumer, medical, and service businesses. Meeting customer-specified requirements depends on efficient execution of well-documented, measurable processes that make up their marketing research projects. CRI's steering committee distilled requirements for each research project to four essentials: accurate, on time, on budget, and meeting or exceeding client expectations. Before the first survey data are collected, criteria defining these requirements are determined in consultation with clients during interviews with executives and project team leaders. At CRI, while each project is custom-designed, the process for handling it flows through essentially the same steps across all projects. CRI developed and heavily uses a project implementation manual for interviewing. Internal "project quality recap" reports completed for every study track errors in any step of the project flow. CRI measures the accuracy of results and the quality of personal and telephone interviewing. At the end of each project, clients are surveyed to solicit an overall satisfaction rating based on the customers' expectations. Each month the results of the client feedback are summarized and distributed to all employees. Internally, end-of-project evaluations also are conducted for CRI support teams and key suppliers.[2]

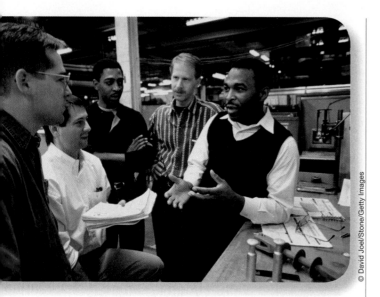

© David Joel/Stone/Getty Images

1.2 Organizational Structure

How a project fits into a firm's organizational structure impacts its effectiveness. Some organizations use a pure project organizational structure whereby team members are assigned exclusively to projects and report only to the project manager. This approach makes it easier to manage projects, because project teams can be designed for efficiency by including the right mix of skills. However, it can result in inefficiencies because of duplication of resources across the organization, for example, having a different information technology support person on each project.

A pure functional organizational structure charters projects exclusively within functional departments, such as manufacturing or research and development.

Although this approach allows team members to work on different projects simultaneously and provides a "home" for the project, it ignores an important reality: In a typical functional organization, a project cuts across organizational boundaries. Assigning projects exclusively to functional areas makes communication across the organization difficult and can limit the effectiveness of projects that require a systems perspective.

A practical solution to this dilemma is a matrix organizational structure, which "loans" resources to projects while still maintaining control over them. Project managers coordinate the work across the functions. This minimizes duplication of resources and facilitates communication across the organization but requires that resources be negotiated. Functional managers may be reluctant to provide the resources, and employees assigned to projects might relegate a project to a lower priority than their daily functional job, making it difficult for the project manager to control the project.

1.3 Factors for Successful Projects

Projects are not always successful. Information technology projects have a notorious rate of failure. One study in the United States found that over 30 percent of software projects are canceled before completion and more than half cost almost double their original estimates. Exhibit 18.2 summarizes the principal factors that help or hinder project management.

Ensuring project success depends on having well-defined goals and objectives, clear reporting relationships and channels of communication, good procedures for estimating time and other resource requirements, cooperation and commitment among all project team members, realistic expectations, effective conflict resolution, and top management sponsorship.

Exhibit 18.2 *Contributors and Impediments to Project Success*

Contributors to Project Success	Impediments to Project Success
Well-defined and agreed-upon objectives	Ill-defined project objectives
Top management support	Lack of executive champion
Strong project manager leadership	Inability to develop and motivate people
Well-defined project definition	Poorly-defined project definition
Accurate time and cost estimates	Lack of data accuracy and integrity
Teamwork and cooperation	Poor interpersonal relations and teamwork
Effective use of project management tools	Ineffective use of project management tools
Clear channels of communication	Poor communication among stakeholders
Adequate resources and reasonable deadlines	Unreasonable time pressures and lack of resources
Constructive response to conflict	Inability to resolve conflicts

Hershey's Halloween Nightmare

Some years ago, Hershey Foods Corp. decided to install an enterprise resource planning system plus companion packages from two other vendors simultaneously during one of the busiest shipping seasons. What was envisioned originally as a 4-year project was squeezed down into just 30 months with disastrous consequences. When the system went live, retailers began ordering large amounts of candy for back-to-school and Halloween sales. Two months later, the company was still having trouble pushing orders through the new system, resulting in shipment delays and deliveries of incomplete orders. The new system required enormous changes in the way Hershey's workers did their jobs, which might not have been adequately addressed in the project management design. One analyst noted that most companies install ERP systems in a more staged manner, especially when applications from multiple vendors are involved.[4]

© Philip Lewis/Alamy

2 Techniques for Planning, Scheduling, and Controlling Projects

all project management decisions involve three factors: *time*, *resources*, and *cost*. Various techniques have long been used to help plan, schedule, and control projects. The key steps involved are:

1. *Project Definition:* Identifying the activities that must be completed and the sequence required to perform them.

2. *Resource Planning:* For each activity, determining the resource needs: personnel, time, money, equipment, materials, and so on.

3. *Project Scheduling:* Specifying a time schedule for the completion of each activity.

4. *Project Control:* Establishing the proper controls for determining progress and developing alternative plans in anticipation of problems in meeting the planned schedule.

Several software packages, such as Microsoft Project™, are available to help project managers plan and manage projects. Although we will not discuss such software in detail, we will introduce the underlying techniques that are used in modern project management software.

To illustrate how these steps are applied in project management, we will use a simple example. Wildcat Software Consulting, Inc. helps companies implement software integration projects. Raj Yazici has been named the project manager in charge of coordinating the design and installation of the new software system. In the following sections, we address the various tasks involved in project definition, resource planning, project scheduling, and project control that he will face in his role as project manager.

2.1 Project Definition

The first step is to define the project objectives and deliverables. Mr. Yazici and his project team decided on the following statements:

- **Project Objective:** To develop an integrative software package within a predetermined budget and promised project completion date that meets all system requirements while providing adequate interfaces with legacy systems.

- **Deliverables:** (1) new software package, (2) successful implementation of the package, (3) pretraining of sales force and PC system operators.

Next, Mr. Yazici needed to identify the specific activities required to complete the project and the sequence in which they must be performed.

Activities *are discrete tasks that consume resources and time.* **Immediate predecessors** *are those activities that must be completed immediately before an activity may start.* Precedence relationships ensure that activities are performed in the proper sequence when they are scheduled.

The initial list of activities and precedence relationships associated with the software integration project is summarized in Exhibit 18.3. For instance, activities A and B can be started anytime, since they do not depend on the completion of prior activities. However, activity C cannot be started until both activities A and B have been completed. Mr. Yazici and his team reviewed and discussed the list several times to be sure that no activities were omitted from the project definition.

Defining the list of activities in a project is often facilitated by creating a work breakdown structure, which breaks a project down into manageable pieces, or items, to help ensure that all of the work elements needed to complete the project are identified. *The* **work breakdown structure** *is a hierarchical tree of end items that will be accomplished by the project team during the project.*[5] A work breakdown structure allows project teams to drill down to the appropriate level of detail in defining activities. For example, activity A might be broken down into the individual tasks of defining the objectives, developing the budget, determining the due date, and identifying staff. Deciding on the appropriate work breakdown structure depends on how responsibility and accountability for accomplishing the tasks are viewed, and the level at which the project team wants to control the project budget and collect cost data.

The activities and their sequence are usually represented graphically using a project network. *A* **project network** *consists of a set of circles or boxes called* **nodes**, *which represent activities, and a set of arrows called* **arcs**, *which define the precedence relationships between activities.* This is called an activity-on-node (AON) network representation. The project network for the software integration project is shown in Exhibit 18.4. You should be able to match the information in Exhibit 18.3 with the network.

Exhibit 18.3 *Project Activities and Precedence Relationships*

Activity	Activity Description	Immediate Predecessors
A	Define software project objectives, budget, due date, and possible staff	none
B	Inventory new and old software interfaces and features	none
C	Assemble teams and allocate work	A, B
D	Design and develop code from old to new databases	C
E	Design and develop code for PC network	C
F	Test and debug PC network code	E
G	Design and develop code for off-site sales force	C
H	New complete system test and debug	D, G, F
I	Train PC system and database operators	D, F
J	Train off-site sales force	H
K	Two-week beta test of new system with legacy backup system	I, J

2.2 Resource Planning

Resource planning includes developing time estimates for performing each activity, other resources that may be required, such as people and equipment, and a realistic budget. Activity times can be estimated from historical data of similar work tasks, or by the judgment and experience of managers and employees who perform the tasks. Cost control is a vital part of project management. This requires good budgeting, which in turn first requires estimating the costs of completing the activities. Exhibit 18.5 shows the estimated times and costs for the activities in the software integration project. We'll make use of these costs later in the chapter.

2.3 Project Scheduling with the Critical Path Method

The **Critical Path Method (CPM)** is an approach to scheduling and controlling project activities. *The*

Exhibit 18.4 *Project Network for the Software Integration Project*

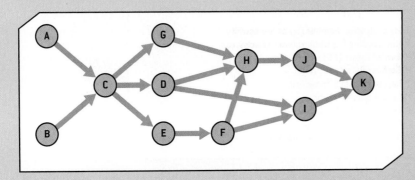

Exhibit 18.5 *Wildcat Software Consulting, Inc. Project Work Activities and Costs*

Activity Letter	Activity Description	Immediate Predecessors	Normal Time (in weeks)	Normal Cost Estimate ($)
A	Define software project objectives, budget, due date, and possible staff	none	3	1,200
B	Inventory new and old software interfaces and features	none	5	2,500
C	Assemble teams and allocate work	A, B	2	500
D	Design and develop code from old to new databases	C	6	300
E	Design and develop code for PC network	C	5	6,000
F	Test and debug PC network code	E	3	9,000
G	Design and develop code for off-site sales force	C	4	4,400
H	New complete system test and debug	D, G, F	3	3,000
I	Train PC system and database operators	D, F	4	4,000
J	Train off-site sales force	H	2	3,200
K	Two-week beta test of new system with legacy backup system	I, J	2	1,800

critical path *is the sequence of activities that takes the longest time and defines the total project completion time.* Understanding the critical path is vital to managing a project because any delays of activities on the critical path will delay the entire project. CPM assumes:

- The project network defines a correct sequence of work in terms of technology and workflow.
- Activities are assumed to be independent of one another with clearly defined start and finish dates.
- The activity time estimates are accurate and stable.
- Once an activity is started it continues uninterrupted until it is completed.

To understand CPM, we need to define several terms. We will replace the simple circled nodes in the project network with boxes that provide other useful information, as shown in Exhibit 18.6.

Exhibit 18.7 shows the software integration project network after all this information has been computed. Use this figure to help follow the discussion of how these values are found in the project scheduling process.

Earliest start and earliest finish times are computed by moving through

> The **critical path** is the sequence of activities that takes the longest time and defines the total project completion time.

Exhibit 18.6 *Activity-on-Node Format and Definitions*

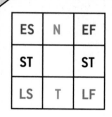

ES	N	EF
ST		ST
LS	T	LF

- Identification number (N) of the activity.
- Normal time (T) to complete the activity.
- Earliest start (ES) time
- Earliest finish (EF) time
- Latest start (LS) time
- Latest finish (LF) time
- Slack time (ST)—the length of time an activity can be delayed without affecting the competition date for the entire project, computed as ST = LS − ES = LF − EF

Exhibit 18.7 *Wildcat Software Consulting Activity-on-Node Project Network*

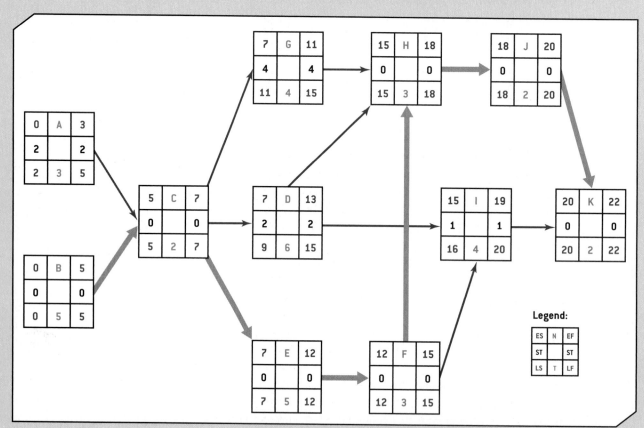

the project network in a forward direction from start to finish, sometimes called the *forward pass* through the network. We begin at the start of the project by assigning all nodes without any immediate predecessors an earliest starting time of 0. Two rules are used to guide the calculations of ES and EF during this step:

Rule 1: EF = ES + T. That is, the earliest time that an activity can be completed is equal to the earliest time it can begin plus the time to perform the activity.

Rule 2: The ES time for an activity equals the largest EF time of all immediate predecessors. Therefore, whenever an activity is preceded by two or more activities,

we must first compute the EF times of the preceding activities using Rule 1. Of course, if an activity has only one immediate predecessor, the ES time is simply equal to the EF time of the immediate predecessor.

To illustrate this process, note that in Exhibit 18.7, the EF time for activity A is $0 + 3 = 3$ and the EF time for activity B is $0 + 5 = 5$. Because both A and B are immediate predecessors to activity C, we use Rule 2 to find the EF time for activity C as the largest of 3 and 5, or 5. Then the EF time for activity C is computed using Rule 1 as EF $= ES + T = 5 + 2 = 7$. Activity G has only one immediate predecessor, so the EF time of activity C becomes the ES time of G. We suggest that you work through all calculations for the ES and EF times in the remainder of the network. The EF time of the last activity specifies the earliest time that the entire project can be completed. For our example, this is 22 weeks. If a project has more than one terminal activity, the earliest project completion time is the largest EF time among these activities.

Latest start and latest finish times are computed by making a *backward pass* through the network, beginning with the ending project activity or activities. First set the LF time for all terminal activities to be the project completion time. In our example, we begin with activity K, setting LF $= 22$, and use the following rules:

Rule 3: LS $=$ LF $-$ T. That is, the latest start time for an activity is equal to its LF time minus the activity time.

Rule 4: The LF time for an activity is the smallest LS time of all immediate successors. Therefore, the LS times of all successors must be computed before moving to a preceding node. If an activity has only one immediate successor, the LF time is simply equal to the LS time of that immediate successor.

To illustrate this backward pass procedure, we first compute LS $=$ LF $-$ T for activity K as $22 - 2 = 20$. Because activity K is the only successor to activities J and I, the LF times for both J and I are set equal to 20 and their LS times are computed using Rule 3. However, consider activity F. Activity F has two successors, H and I. The ES time for H is 15 while the ES time for I is 16. Using Rule 4, we set the EF time for activity F to be the smallest of the ES times for activities H and I, or 15. We encourage you to work through the remaining calculations of this backward pass procedure to better understand how to apply these rules.

After all ES, EF, LS, and LF times of all project activities are computed, we can compute slack time (ST) for each activity. Slack time is computed as ST $=$ LS $-$ ES $=$ LF $-$ EF (note that either one can be used). For example, the slack time for activity A is $5 - 3 = 2 - 0 = 2$, and the slack time for activity B is $5 - 5 = 0 - 0 = 0$. Note that although the earliest start time for activity A is 3, the activity need not begin until time LS $= 5$ and will not delay the completion of the entire project. However, activity B must start exactly on schedule at time 0 or else the project will be delayed.

After all slack times are computed, we may find the critical path. The critical path (CP) is the longest path(s) through the project network; activities on the critical path have zero slack time (ST $= 0$) and if delayed will cause the total project to be delayed. The critical path for the software development project is B–C–E–F–H–J–K, and is denoted by the heavy arrows in Exhibit 18.7. If any activity along the critical path is delayed, the total project duration will be longer than 22 weeks.

There are many ways to display the information in Exhibit 18.7; a summary is given in the table in Exhibit 18.8. Using the cost information in Exhibit 18.5, the total cost to complete the project in 22 weeks is $35,900. The cost of all activities along the critical path is $26,000, or 72.4 percent of total project cost. If you work on an activity on the critical path, it must be completed on time; otherwise, you and your team assigned to this work activity might receive some unwanted attention. If you were a "slacker," however, where would you want to work? Probably on activity G because it has four weeks of slack time!

2.4 Project Control

*A **schedule** specifies when activities are to be performed.* A schedule enables a manager to assign resources effectively and to monitor progress and take corrective action when necessary. Because of the uncertainty of task times, unavoidable delays, or other problems, projects rarely, if ever, progress on schedule. Managers must therefore

> A **schedule** specifies when activities are to be performed.

If you work on an activity on the critical path, it must be completed on time; otherwise, you and your team assigned to this work activity might receive some unwanted attention.

Exhibit 18.8 *CPM Tabular Analysis for Wildcat Software Consulting Using Normal Time*

Activity Name	On Critical Path	Activity Time	Earliest Start	Earliest Finish	Latest Start	Latest Finish	Slack (LS − ES)
A	No	3	0	3	2	5	2
B*	Yes	5	0	5	0	5	0
C*	Yes	2	5	7	5	7	0
D	No	6	7	13	9	15	2
E*	Yes	5	7	12	7	12	0
F*	Yes	3	12	15	12	15	0
G	No	4	7	11	11	15	4
H*	Yes	3	15	18	15	18	0
I	No	4	15	19	16	20	1
J*	Yes	2	18	20	18	20	0
K*	Yes	2	20	22	20	22	0

Project Completion Time = 22 weeks
Total Cost of Project = $35,900 (Cost on CP = $26,000)
Number of Critical Paths = 1

monitor performance of the project and take corrective action when needed.

A very useful tool for depicting a schedule graphically is a Gantt chart, named after Henry L. Gantt, a pioneer of scientific management. Gantt charts enable the project manager to know exactly what activities should be performed at a given time and, more importantly, to monitor daily progress of the project so that corrective action can be taken when necessary.

To construct a Gantt chart, we list the activities on a vertical axis and use a horizontal axis to represent time. The following symbols are commonly used in a Gantt chart:

Symbol	Description
⌐	Scheduled starting time for activity
⌐	Scheduled completion time for activity
▬	Completed work for an activity
◁▷	Scheduled delay or maintenance
∨	Current date for progress review

Using the information in Exhibits 18.5 and 18.7 or 18.8, we will assume that each activity will be scheduled at its early start time, as shown in Exhibit 18.9. The resulting schedule will be an "early-start" or "left-shifted" schedule. For instance, activities A and B can begin at time 0 and have durations of three and five weeks, respectively. Activity C cannot begin until A is completed; thus this activity is scheduled to begin at time 5. After activity C is completed at time 7, activi-

ties G, D, and E can then be scheduled. Activity D, for example, can start as early as week 7. Likewise, activity G can start as early as week 7. If you compare the Gantt chart in Exhibit 18.9 with the project network in Exhibit 18.7 you will see that they portray the same information, just in a different format.

Using this early start schedule, the project is scheduled to be completed in 22 weeks. What happens if an activity on the critical path is delayed? Suppose, for example, that activity E takes six weeks instead of five weeks. Because E is a predecessor of F and the starting time of F is the same as the completion time of E, F is forced to begin one week later. This forces a delay in activity H that is also on the critical path, and in turn delays activities J and K. In addition, activity I is also delayed one week. Now it would take 23 weeks to complete the project, as shown by the Gantt chart in Exhibit 18.10.

The early-start schedule we developed in Exhibit 18.10 gives no consideration to resources. It simply assumes that sufficient resources are available for all activities scheduled at the same time. Usually, however, resources such as labor and equipment that must be shared among the activities are limited. Determining how to allocate limited resources is often a very challenging task.

Exhibit 18.9 *Early Start Schedule for Wildcat Software Project*

3 Time/Cost Trade-Offs

One of the benefits of the Critical Path Method is the ability to consider shortening activity times by adding additional resources to selected activities and thereby reducing the overall project completion time. This is often referred to as "crashing." **Crashing a project** *refers to reducing the total time to complete the project to meet a revised due date.* However, doing so does not come without a cost. Therefore, it is necessary to evaluate the trade-offs between faster completion times and additional costs.

The first step is to determine the amount of time that each activity may be reduced and its associated cost, as shown in Exhibit 18.11. **Crash time** *is the shortest possible time the activity can realistically be completed. The* **crash cost** *is the total additional cost associated with completing an activity in its crash time rather than in its normal time.* We

assume that the normal times and costs are based on normal working conditions and work practices and therefore are accurate estimates. Some activities cannot be crashed because of the nature of the task. In Exhibit 18.11, this is evident when the normal and crash times as well as the normal and crash costs are equal. For example, activities F, H, J, and K cannot be crashed. If you examine the content of these activities, you see that activities H and K related to testing and debugging the new system software, and activities I and J are related to training people to use this new software. In the judgment of the project managers, these work activities could not be expedited by adding any additional resources.

The crash cost is the total additional cost

Crashing a project refers to reducing the total time to complete the project to meet a revised due date.

Crash time is the shortest possible time the activity can realistically be completed.

The **crash cost** is the total additional cost associated with completing an activity in its crash time rather than in its normal time.

Exhibit 18.10 *Example Gantt Chart of Wildcat Software with Activity E Delayed*

Exhibit 18.11 *Wildcat Software Project Data Including Crash Times and Costs*

Activity Letter	Activity Description	Immediate Predecessors	Normal Time (in weeks)	Crash Time (in weeks)	Normal Cost Estimate ($)	Crash Cost Estimate ($)
A	Define software project objectives, budget, due date, and possible staff	none	3	1	1,200	2,000
B	Inventory new and old software interfaces and features	none	5	3	2,500	3,500
C	Assemble teams and allocate work	A, B	2	1	500	750
D	Design and develop code from old to new databases	C	6	3	300	450
E	Design and develop code for PC network	C	5	3	6,000	8,400
F	Test and debug PC network code	E	3	3	9,000	9,000
G	Design and develop code for off-site sales force	C	4	3	4,400	5,500
H	New complete system test and debug	D, G, F	3	3	3,000	3,000
I	Train PC system and database operators	D, F	4	2	4,000	6,000
J	Train off-site sales force	H	2	2	3,200	3,200
K	Two-week beta test of new system with legacy backup system	I, J	2	2	1,800	1,800

associated with completing an activity in its crash time rather than in its normal time.

For example, in the software development project, activity A can be completed in one week at a cost of $2,000 instead of the normal time of three weeks at a cost of $1,200. A key assumption with crashing is that the time can be reduced to any proportion of the crash time at a proportional increase in cost; that is, the relationship between time and cost is linear, as shown in Exhibit 18.12 for activity A. The slope of this line is the crash cost per unit of time and is computed by equation 18.1.

$$\text{Crash cost per unit of time} = \frac{\text{Crash cost} - \text{Normal cost}}{\text{Normal time} - \text{Crash time}}$$
[18.1]

Crashing an activity *refers to reducing its normal time possibly up to its limit—the crash time.* For example, we can crash activity A from its normal time of 3 weeks down to 1 week or anywhere in between. Because the crash cost per unit of time for activity A is ($2,000 − $1,200)/(3 − 1) = $400 per week, crashing the activity from three weeks to two weeks will result in an additional cost of $400. Likewise, crashing from three to one and a half weeks will result in an additional cost of 1.5($400) = $600. Managers can crash a project and ignore the cost implications or they can search for the minimum cost crash schedule to meet the revised due date.

Suppose the client asks Wildcat Software Consulting, Inc., first how much it would cost to complete the project in 20 weeks instead of the current 22 weeks, and second, how much it would cost to finish the project in the fastest possible time.

To address the first question, we need to determine the crash cost per unit of time for each activity using equation 18.1. These are: A—$400 per week, B—$500 per week, C—$250 per week, D—$50 per week, E—$1,200 per week, G—$1,100 per week, and I—$1,000 per week. Activities F, H, J, and K cannot be crashed. Note that the only way the project completion time can be reduced is by crashing activities on the critical path. When we do this, however, another path in the network might become critical, so this must be carefully watched.

In this example, several options exist for completing the project in 20 weeks:

Crashing Option #1

Crash B by one week = $500
Crash C by one week = $250
Additional cost = $750

Crashing Option #2

Crash B by two weeks = $1,000
Additional cost = $1,000

Crashing Option #3

Crash C by one week = $500
Crash E by one week = $1,200
Additional cost = $1,700

The least-expensive option is the first. The critical path remains the same, namely, B–C–E–F–H–J–K. Exhibit 18.13 summarizes the results for this option. Notice that although activity D costs only $50 per week to crash, it is not on the critical path—crashing it would not affect the completion time.

The second question seeks to find the crash schedule that minimizes the project completion time. Again, we will address this using a trial-and-error approach. From the previous crashing solution of 20 weeks, we can

Exhibit 18.12 *Normal versus Crash Activity Analysis*

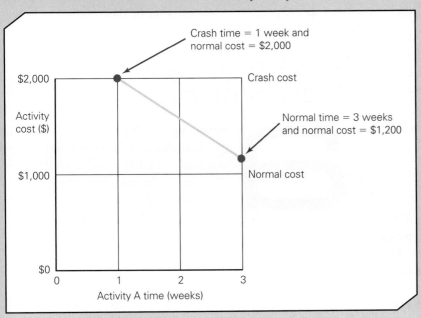

Crashing an activity refers to reducing its normal time possibly up to its limit—the crash time.

Exhibit 18.13 *CPM Tabular Analysis for Wildcat Software Consulting for Target 20-Week Completion Time*

Activity Name	On Critical Path	Activity Time	Earliest Start	Earliest Finish	Latest Start	Latest Finish	Slack (LS − ES)
A	No	3	0	3	1	4	1
B	Yes	4	0	4	0	4	0
C	Yes	1	4	5	4	5	0
D	No	6	5	11	7	13	2
E	Yes	5	5	10	5	10	0
F	Yes	3	10	13	10	13	0
G	No	4	5	9	9	13	4
H	Yes	3	13	16	13	16	0
I	No	4	13	17	14	18	1
J	Yes	2	16	18	16	18	0
K	Yes	2	18	20	18	20	0

Project completion time = 20 weeks
Total project cost 5 $36,650 (cost on CP = $26,750)
Number of Critical Paths = 1

identify two crashing options to shorten the project to 19 weeks:

Crashing Option #4

Crash B by a second week = $500
 Additional cost = $500

Crashing Option #5

Crash E by one week = $1,200
 Additional cost = $1,200

The cheapest way to achieve a project completion date of 19 weeks is Option #4 by crashing B by two weeks and C by one week. The critical path for a 19-week project completion date is still B–C–E–F–H–J–K. The total project cost is now $37,150 ($35,900 + $1,000 + $250). Activities B and C have reached their crash time limits; therefore, to try to find an 18-week completion date we must examine other activities. Only one option is available because activities B, C, F, H, J, and K cannot be crashed further:

Crashing Option #6

Crash E by one week = $1,200
 Additional cost = $1,200

At this point, there are two critical paths: A–C–E–F–H–J–K and B–C–E–F–H–J–K. All other paths through the network are less than 18 weeks. The total project cost is now $38,350 ($35,900 + $1,000 + $250 + $1,200).

The only way to achieve a 17-week project completion time is to crash activity E a second week. The

total project cost for a 17-week completion time is now $39,550 ($35,900 + $1,000 + $250 + $1,200 + $1,200), and four critical paths now exist:

CP Path 1: B–C–E–F–H–J–K
CP Path 2: A–C–E–F–H–J–K
CP Path 3: A–C–D–H–J–K
CP Path 4: B–C–D–H–J–K

All other paths are not critical. Exhibit 18.14 summarizes the results for this 17-week minimum crash cost schedule. We cannot crash any other activities to reduce the project completion time further.

4 Uncertainty in Project Management

nother approach to project management that was developed independently of CPM is called **PERT** (**Project Evaluation and Review Technique**). PERT was introduced in the late 1950s specifically for planning, scheduling, and controlling the Polaris missile project. Since many activities associated with that project had never been attempted previously, it was difficult to predict the time needed to complete the various tasks. PERT was developed as a means of handling the uncertainties in activity completion times. In contrast, CPM assumes that activity times are constant.

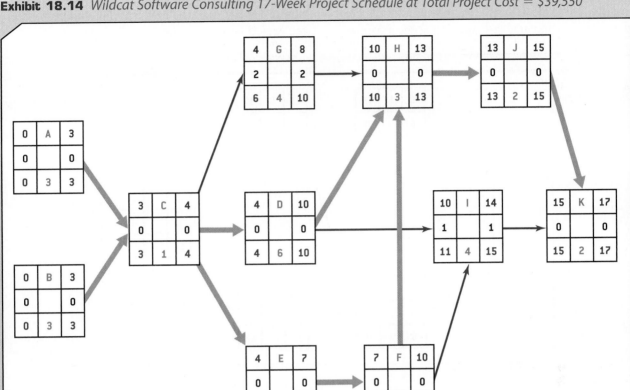

PERT was developed as a means of handling the uncertainties in activity completion times. In contrast, CPM assumes that activity times are constant.

Any variation in critical path activities can cause variation in the project completion date. Also, if a noncritical activity is delayed long enough to expend all of its slack time, that activity will become part of a new critical path, and further delays there will extend the project completion date. The PERT procedure uses the variance in the critical path activities to understand the risk associated with completing the project on time.

When activity times are uncertain, they are often treated as random variables with associated probability distributions. Usually three time estimates are obtained for each activity:

1. **Optimistic time** (*a*)—the activity time if everything progresses in an ideal manner;

2. **Most probable time** (*m*)—the most likely activity time under normal conditions; and

3. **Pessimistic time** (*b*)—the activity time if significant breakdowns and/or delays occur.

Exhibit 18.15 shows an assumed probability distribution for activity B. Note that this is a positively skewed distribution, allowing for a small chance of a large activity time. Different values of *a*, *m*, and *b* provide different shapes for the probability distribution of activity times. Technically, this characterizes a *beta probability distribution*. The beta distribution is usually assumed to describe the inherent variability in these three time estimates. This approach is quite practical because managers can usually identify the best case, worst case, and most likely case for activity times, and it provides much flexibility in characterizing the distribution of times, as opposed to forcing times to a symmetric normal probability distribution. However, with today's software, any type of distribution can be used.

Solved Problem

The critical path calculations for a project network are shown in the accompanying figure. Using the information in Table 1, find the best crashing option to reduce the project completion time to 17 weeks.

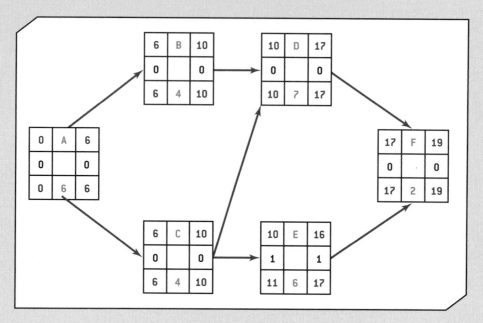

Table 1

Activity	Normal Duration	Normal Cost	Crash Duration	Total Crash Cost	Crash Cost Per Week
A	6	$ 500	4	$1,300	$400
B	4	300	2	1,000	350
C	4	900	3	1,200	300
D	7	1,600	5	2,000	200
E	6	200	4	300	50
F	2	400	1	900	500

One-Week Crash Options:

We might first look at activities common to both critical paths (A-B-D-F and A-C-D-F), namely A and D, and consider crashing each of them individually. Other options are to crash activities B and C together, activity F, and activities A and D together. The lowest-cost option is to crash activity D by one week, costing $200. Now all three paths through the network are critical paths with a total duration of 18 weeks.

Crashing Option #1

Crash A by one week = $400

Crashing Option #2

Crash D by one week = $200

Crashing Option #3

Crash B by one week = $350
Crash C by one week = $300
Total cost = $650

Crashing Option #4

Crash F by one week = $500

Crash Option #5

Crash A by one week = $400
Crash D by one week = $200
Total cost = $600

Second-Week Crash Options:

All other crash options cost more than Option #2. Therefore, we should recommend that we crash D by a second week and E by one week, for a total cost of $250. All three network paths take 17 weeks to complete.

The total normal costs are $3,900 plus crashing D by two weeks (+$400) and E by one week (+$50), so the total cost of a 17-week project-completion schedule is $4,350.

Crashing Option #1

Crash A by one week = $400

Crashing Option #2

Crash D by one week = $200
Crash E by one week = $ 50
Total cost = $250

Crashing Option #3

Crash B by one week = $350
Crash C by one week = $300
Total cost = $650

Crashing Option #4

Crash F by one week = $500

Exhibit 18.15 *Activity Time Distribution for Activity B of Wildcat Software Project*

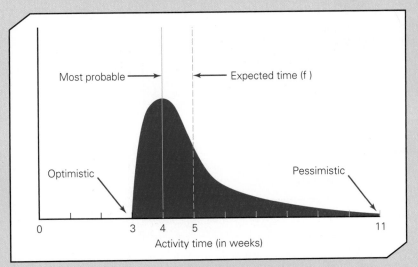

For the Wildcat Software integration project, we will assume that the project manager has developed estimates for these times for each activity, as shown in Exhibit 18.16. The expected time is computed using the following formula:

$$\text{Expected time} = (a + 4m + b)/6 \quad [18.2]$$

Note that the expected times correspond to the normal times we used in the CPM example. We can also show that the variance of activity times is given by the following:

$$\text{Variance} = (b - a)^2/36 \quad [18.3]$$

Both the expected times and variances are shown in Exhibit 18.16.

The critical path is found using the expected times in the same fashion as in the Critical Path Method. PERT allows us to investigate the effects of uncertainty of activity times on the project completion time. In the software integration project, we found the critical path to be B–C–E–F–H–J–K with an expected completion time of 22 weeks. This is simply the sum of the expected times for the activities on the critical path. The variance (σ^2) in project duration is given by the sum of the variances of the critical-path activities:

$$\sigma^2 = 1.78 + 0.11 + 0.44 + 0.11 + 0.11 + 0.11 + 0.11 = 2.77$$

This formula is based on the assumption that all the activity times are independent. With this assumption, we can also assume that the distribution of the project completion time is normally distributed. The use of the normal probability distribution as an approximation is based on the central limit theorem of statistics, which states that the sum of independent activity times follows a normal distribution as the number of activities becomes large. Therefore, we can say that the project completion time for the Wildcat example is normal with a mean of 22 weeks and a standard deviation of $\sqrt{2.77} = 1.66$.

Using this information, we can compute the probability of meeting a specified completion date. For example, suppose

Exhibit 18.16 *Activity Time Estimates for the Wildcat Software Integration Project*

Activity	Optimistic Time (a)	Most Probable Time (m)	Pessimistic Time (b)	Expected Time	Variance
A	2	3	4	3	0.11
B	3	4	11	5	1.78
C	1	2	3	2	0.11
D	4	5	12	6	1.78
E	3	5	7	5	0.44
F	2	3	4	3	0.11
G	2	3	10	4	1.78
H	2	3	4	3	0.11
I	2	3	10	4	1.78
J	1	2	3	2	0.11
K	1	2	3	2	0.11

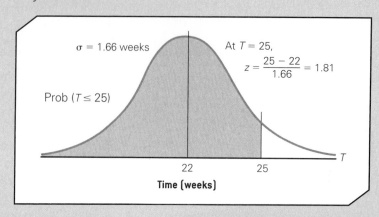

Exhibit 18.17 *Probability of Completing the Wildcat Software Project within 25 Weeks*

$\sigma = 1.66$ weeks

Prob $(T \leq 25)$

At $T = 25$,
$$z = \frac{25 - 22}{1.66} = 1.81$$

22 25

Time (weeks)

that the project manager has allotted 25 weeks for the project. Although completion in 22 weeks is expected, the manager wants to know the probability that the 25-week deadline will be met. This probability is shown graphically as the shaded area in Exhibit 18.17. The z-value for the normal distribution at $T = 25$ is given by

$$z = (25 - 22)/1.66 = 1.81$$

Using $z = 1.81$ and the tables for the standard normal distribution (see Appendix A), we see that the probability of the project meeting the 25-week deadline is .4649 + .5000 = .9649. Thus, while variability in the activity time may cause the project to exceed the 22-week expected duration, there is an excellent chance that the project will be completed before the 25-week deadline.

Solved Problem

Consider the following simple PERT network used to remodel the kitchen at Rusty Buckets restaurant:

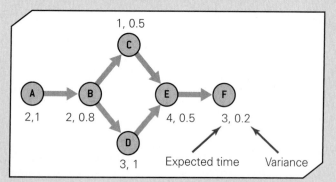

1, 0.5

C

A → B E → F

2,1 2, 0.8 4, 0.5 3, 0.2

D

3, 1 Expected time Variance

a. What is the expected completion time and variance for the project?

b. What is the probability that the project will meet a 12-day deadline?

Solution:

a. There are two paths—A–B–C–E–F = 12 days and A–B–D–E–F = 14 days—through the network. The critical path is A–B–D–E–F = 14 days. The variance of the project time is the sum of the activity variances on the critical path, or 1 + 0.8 + 1 + 0.5 + 0.2 = 3.5 days.

b. $z = (12 - 14)/\sqrt{3.5} = -2/1.871 = -1.0689$. From Appendix A, the probability from 0 to $z = -1.07$ is .3577. Therefore, P(completion time = 12) = .5000 − .3577 = .1423. Also, note that given the high variances along the critical path, there is only a 50 percent chance of completing the project within 14 days (that is, $z = (14 - 14)/1.871 = 0$ and P(completion time = 14) = .5000 − 0 = .5000.

Xerox Global Services

Xerox Global Services is a consulting, integration, and outsourcing arm of Xerox Corporation with a vision "To provide the most comprehensive, most effective connections between people, knowledge, and documents that the world has ever seen." Central to Xerox Global Services' delivery of services is project management. The project manager manages a team that includes technical resource specialists, consultants, and project coordinators. The principal role of the project manager at Xerox Global Services is that of a customer advocate—to ensure that expectations are fully met. This requires careful understanding and documentation of customer expectations such as timeliness, meeting budget, system response, and security. As a manager in the project office notes, "Most projects fail because user requirements are not understood." These requirements are translated into a detailed work breakdown structure with specific tasks assigned to project team members. This also helps to prepare a budget and monitor progress. Finally, after each project is completed, the team conducts a review of "lessons learned"—What went right? and What went wrong?— to continuously improve the company's ability to meet its customer expectations.

Courtesy of Xerox Corporation

Problems, Activities, and Discussions

1. Develop a small example consisting of five activities and illustrate the ideas, rules, and mechanics of forward and backward passes through the project network to compute the critical path.

2. Find an application of project management in your own life (for example, in your home, fraternity, or business organization). List the activities and events that comprise the project, and draw the precedence network. What problems did you encounter in doing this?

3. The local chapter of the Project Management Institute is planning a dinner meeting with a nationally known speaker, and you are responsible

for organizing it. How could the methodology discussed in this chapter help you?

4. Construct a project network for the following activities. Do not attempt to perform any further analysis.

Activity	Immediate Predecessor
A	—
B	—
C	A
D	A, B
E	C, D
F	C, D
G	E
H	F

5. Rozales Manufacturing Co. is planning to install a new flexible manufacturing system. The activities that must be performed, their immediate predecessors, and estimated activity times are shown below. Draw the project network and find the critical path computing early and late start days, early and late finish days, and activity slack.

Activity	Description	Immediate Predecessors	Estimated Activity Time (days)
A	Analyze current performance	—	3
B	Identify goals	A	2
C	Conduct study of existing operation	A	6
D	Define new system capabilities	B	7
E	Study existing technologies	B	2
F	Determine specifications	D	7
G	Conduct equipment analyses	C, F	10
H	Identify implementation activities	C	3
I	Determine organizational impacts	H	4
J	Prepare report	E, G, I	2
K	Establish audit procedure	H	3

6. A computer-system installation project consists of eight activities. The immediate predecessors and activity times in weeks are shown in the table to the right.

 a. Draw the network for this project.

 b. What are the critical path activities?

 c. What is the project completion time?

 d. Construct an early-start-date Gantt chart.

 e. As a project manager, where would you focus your attention, given your analysis?

Table for Problem 6

Activity	Immediate Predecessor	Activity Time
A	—	3
B	—	6
C	A	2
D	B, C	5
E	D	4
F	E	3
G	B, C	9
H	F, G	3

7. Environment Recycling, Inc. must clean up a large automobile tire dump under a state environmental cleanup contract. The tasks, durations (in weeks), costs, and predecessor relationships are shown as follows:

Activity	Predecessor(s)	Normal Time	Crash Time	Normal Cost	Crash Cost
A	—	5	4	$ 400	$ 750
B	A	12	10	1,000	2,200
C	A	7	6	800	1,100
D	—	6	5	600	1,000
E	B, D, C	8	6	1,200	2,200
F	D	3	2	800	1,000
G	D	3	2	500	650
H	E	4	3	400	600
I	F, G, H	6	5	900	1,300

a. Draw the project network.

b. Identify the critical path(s).

c. What is the total project completion time and total cost?

d. What is the total project completion time and lowest cost solution if the state wants to complete the project 3 weeks early?

8. Two international banks are integrating two financial processing software systems as a result of their merger. Preliminary analysis and interviews with all parties involved resulted in the following project information. The "systems integration team" for this project plans to define and manage this project on two levels. The following activities represent an aggregate view, and within each activity is a more detailed view with subtasks and project networks defined. All times are in weeks.

Activity	Predecessor	Normal Time	Crash Time	Normal Cost	Crash Cost
A	—	3	1	$1,000	$ 8,000
B	A	1	1	4,000	4,000
C	A	2	2	2,000	2,000
D	B, C	7	5	3,000	6,000
E	C	5	4	2,500	3,800
F	C	3	2	1,500	3,000
G	E	7	4	4,500	8,100
H	E, F	5	4	3,000	3,600
I	D, G, H	8	5	8,000	18,000

a. Draw the project network.

b. Identify the critical path.

c. What is the total project completion time and total cost?

d. What is the total project completion time and lowest-cost solution if the bank wants to complete the project 2 weeks early?

9. A competitor of Kozar International, Inc. has begun marketing a new instant-developing film project. Kozar has had a similar product under study in its R&D department but has not yet been able to begin production. Because of the competitor's action, top managers have asked for a speedup of R&D activities so that Kozar can produce and market instant film at the earliest possible date. The predecessor information and activity time estimates in months are shown in the next column.

Table for Problem 9

Activity	Immediate Predecessors	Optimistic Time	Most Probable Time	Pessimistic Time
A	—	1	1.5	5
B	A	3	4	5
C	A	1	2	3
D	B, C	3.5	5	6.5
E	B	4	5	12
F	C, D, E	6.5	7.5	11.5
G	E	5	9	13

a. Draw the project network.

b. Develop an activity schedule for this project using early and late start and finish times, compute activity slack time, and define the critical activities.

c. What is the probability the project will be completed in time for Kozar to begin marketing the new product within 26 months?

10. Suppose the estimates of activity times (weeks) for Kozar's project are as follows:

Activity	Optimistic Time	Most Probable Time	Pessimistic Time
A	4	5	6
B	2.5	3	3.5
C	6	7	8
D	5	5.5	9
E	5	7	9
F	2	3	4
G	8	10	12
H	6	7	14

Suppose that the critical path is A-D-F-H. What is the probability that the project will be completed within

a. 20 weeks?

b. 22 weeks?

c. 24 weeks?

University Medical Center Case Study

University Medical Center needs to move from its existing facility to a new and larger facility five miles away from its current location. Due to construction delays, however, much of the new equipment ordered for installation in the new hospital was delivered to the old hospital and put into use. As the new facility is being completed, all this equipment must be moved from the old facility to the new one. This requires a large number of planning considerations. National Guard vehicles and private ambulances are to be contracted to move patients, local merchants would be affected by the move, police assistance would be required, and so on. The following table shows the activities, their predecessors, and estimated times that have been identified.

© liquidlibrary/Jupiter Images

Activity		Immediate Predecessors	Estimated Time (Days)
A	Meet with department heads	None	3
B	Appoint move advisory committee	None	2
C	Plan public relations activities	None	5
D	Meet with police department	None	1
E	Meet with city traffic engineers	A	2
F	Develop preliminary move plan	A	6
G	Develop final move plan	E, F, N	2
H	Establish move admissions policies	B	2
I	Plan dedication	C	3
J	Develop police assistance plan	D	2
K	Consult with contractor	G	1
L	Decide move day	K	4
M	Prepare final move tags	G	3
N	Develop patient forms	H	4
O	Publish plans	L	2
P	Modify plans	O	5
Q	Tag equipment	M	2
R	Implement premove admission policies	N	2
S	Dedication	I	1
T	Prepare for patient move	P, Q	1
U	Patient move	R, S, T	1
V	Secure old facility	U, J	3

Case Questions for Discussion

1. Develop a network for this project.

2. It is important to realize that the activities shown need to be broken down into more detail for actual implementation. For example, for the activity "patient move," managers have to determine which patients to move first (for example, intensive care), the equipment that would have to be in place to support each class of patient, and so on. Discuss what types of subactivities might have to be accomplished in an expanded network for two example activities. You need not draw this expanded network, however.

3. Use the information to find the critical path and the project completion time. Summarize your findings in a report to the hospital administrator.

Appendix A

Areas for the Cumulative Standard Normal Distribution

Entries in the table give the area under the standard normal distribution less than z. For example, for z = -1.25, the area below z is 0.10565. The first half of the table applies to negative values of z.

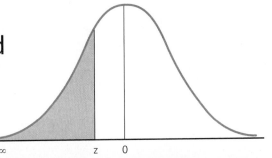

z	0	0.01	0.02	0.03	0.04	0.05	0.06	0.07	0.08	0.09
-3.9	0.00005	0.00005	0.00004	0.00004	0.00004	0.00004	0.00004	0.00004	0.00003	0.00003
-3.8	0.00007	0.00007	0.00007	0.00006	0.00006	0.00006	0.00006	0.00005	0.00005	0.00005
-3.7	0.00011	0.00010	0.00010	0.00010	0.00009	0.00009	0.00008	0.00008	0.00008	0.00008
-3.6	0.00016	0.00015	0.00015	0.00014	0.00014	0.00013	0.00013	0.00012	0.00012	0.00011
-3.5	0.00023	0.00022	0.00022	0.00021	0.00020	0.00019	0.00019	0.00018	0.00017	0.00017
-3.4	0.00034	0.00032	0.00031	0.00030	0.00029	0.00028	0.00027	0.00026	0.00025	0.00024
-3.3	0.00048	0.00047	0.00045	0.00043	0.00042	0.00040	0.00039	0.00038	0.00036	0.00035
-3.2	0.00069	0.00066	0.00064	0.00062	0.00060	0.00058	0.00056	0.00054	0.00052	0.00050
-3.1	0.00097	0.00094	0.00090	0.00087	0.00084	0.00082	0.00079	0.00076	0.00074	0.00071
-3	0.00135	0.00131	0.00126	0.00122	0.00118	0.00114	0.00111	0.00107	0.00104	0.00100
-2.9	0.00187	0.00181	0.00175	0.00169	0.00164	0.00159	0.00154	0.00149	0.00144	0.00139
-2.8	0.00256	0.00248	0.00240	0.00233	0.00226	0.00219	0.00212	0.00205	0.00199	0.00193
-2.7	0.00347	0.00336	0.00326	0.00317	0.00307	0.00298	0.00289	0.00280	0.00272	0.00264
-2.6	0.00466	0.00453	0.00440	0.00427	0.00415	0.00402	0.00391	0.00379	0.00368	0.00357
-2.5	0.00621	0.00604	0.00587	0.00570	0.00554	0.00539	0.00523	0.00508	0.00494	0.00480
-2.4	0.00820	0.00798	0.00776	0.00755	0.00734	0.00714	0.00695	0.00676	0.00657	0.00639
-2.3	0.01072	0.01044	0.01017	0.00990	0.00964	0.00939	0.00914	0.00889	0.00866	0.00842
-2.2	0.01390	0.01355	0.01321	0.01287	0.01255	0.01222	0.01191	0.01160	0.01130	0.01101
-2.1	0.01786	0.01743	0.01700	0.01659	0.01618	0.01578	0.01539	0.01500	0.01463	0.01426
-2	0.02275	0.02222	0.02169	0.02118	0.02068	0.02018	0.01970	0.01923	0.01876	0.01831
-1.9	0.02872	0.02807	0.02743	0.02680	0.02619	0.02559	0.02500	0.02442	0.02385	0.02330
-1.8	0.03593	0.03515	0.03438	0.03362	0.03288	0.03216	0.03144	0.03074	0.03005	0.02938
-1.7	0.04457	0.04363	0.04272	0.04182	0.04093	0.04006	0.03920	0.03836	0.03754	0.03673
-1.6	0.05480	0.05370	0.05262	0.05155	0.05050	0.04947	0.04846	0.04746	0.04648	0.04551
-1.5	0.06681	0.06552	0.06426	0.06301	0.06178	0.06057	0.05938	0.05821	0.05705	0.05592
-1.4	0.08076	0.07927	0.07780	0.07636	0.07493	0.07353	0.07215	0.07078	0.06944	0.06811
-1.3	0.09680	0.09510	0.09342	0.09176	0.09012	0.08851	0.08691	0.08534	0.08379	0.08226
-1.2	0.11507	0.11314	0.11123	0.10935	0.10749	0.10565	0.10383	0.10204	0.10027	0.09853
-1.1	0.13567	0.13350	0.13136	0.12924	0.12714	0.12507	0.12302	0.12100	0.11900	0.11702
-1	0.15866	0.15625	0.15386	0.15151	0.14917	0.14686	0.14457	0.14231	0.14007	0.13786
-0.9	0.18406	0.18141	0.17879	0.17619	0.17361	0.17106	0.16853	0.16602	0.16354	0.16109
-0.8	0.21186	0.20897	0.20611	0.20327	0.20045	0.19766	0.19489	0.19215	0.18943	0.18673
-0.7	0.24196	0.23885	0.23576	0.23270	0.22965	0.22663	0.22363	0.22065	0.21770	0.21476
-0.6	0.27425	0.27093	0.26763	0.26435	0.26109	0.25785	0.25463	0.25143	0.24825	0.24510
-0.5	0.30854	0.30503	0.30153	0.29806	0.29460	0.29116	0.28774	0.28434	0.28096	0.27760
-0.4	0.34458	0.34090	0.33724	0.33360	0.32997	0.32636	0.32276	0.31918	0.31561	0.31207
-0.3	0.38209	0.37828	0.37448	0.37070	0.36693	0.36317	0.35942	0.35569	0.35197	0.34827
-0.2	0.42074	0.41683	0.41294	0.40905	0.40517	0.40129	0.39743	0.39358	0.38974	0.38591
-0.1	0.46017	0.45620	0.45224	0.44828	0.44433	0.44038	0.43644	0.43251	0.42858	0.42465
0	0.50000	0.49601	0.49202	0.48803	0.48405	0.48006	0.47608	0.47210	0.46812	0.46414

Entries in the table give the area under the standard normal distribution less than z. The second half of the table applies to positive values of z. For example, for z = 2.33, the area below z is 0.99010.

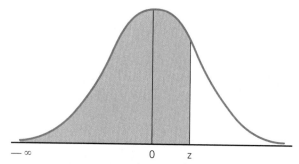

z	0	0.01	0.02	0.03	0.04	0.05	0.06	0.07	0.08	0.09
0	0.50000	0.50399	0.50798	0.51197	0.51595	0.51994	0.52392	0.52790	0.53188	0.53586
0.1	0.53983	0.54380	0.54776	0.55172	0.55567	0.55962	0.56356	0.56749	0.57142	0.57535
0.2	0.57926	0.58317	0.58706	0.59095	0.59483	0.59871	0.60257	0.60642	0.61026	0.61409
0.3	0.61791	0.62172	0.62552	0.62930	0.63307	0.63683	0.64058	0.64431	0.64803	0.65173
0.4	0.65542	0.65910	0.66276	0.66640	0.67003	0.67364	0.67724	0.68082	0.68439	0.68793
0.5	0.69146	0.69497	0.69847	0.70194	0.70540	0.70884	0.71226	0.71566	0.71904	0.72240
0.6	0.72575	0.72907	0.73237	0.73565	0.73891	0.74215	0.74537	0.74857	0.75175	0.75490
0.7	0.75804	0.76115	0.76424	0.76730	0.77035	0.77337	0.77637	0.77935	0.78230	0.78524
0.8	0.78814	0.79103	0.79389	0.79673	0.79955	0.80234	0.80511	0.80785	0.81057	0.81327
0.9	0.81594	0.81859	0.82121	0.82381	0.82639	0.82894	0.83147	0.83398	0.83646	0.83891
1	0.84134	0.84375	0.84614	0.84849	0.85083	0.85314	0.85543	0.85769	0.85993	0.86214
1.1	0.86433	0.86650	0.86864	0.87076	0.87286	0.87493	0.87698	0.87900	0.88100	0.88298
1.2	0.88493	0.88686	0.88877	0.89065	0.89251	0.89435	0.89617	0.89796	0.89973	0.90147
1.3	0.90320	0.90490	0.90658	0.90824	0.90988	0.91149	0.91309	0.91466	0.91621	0.91774
1.4	0.91924	0.92073	0.92220	0.92364	0.92507	0.92647	0.92785	0.92922	0.93056	0.93189
1.5	0.93319	0.93448	0.93574	0.93699	0.93822	0.93943	0.94062	0.94179	0.94295	0.94408
1.6	0.94520	0.94630	0.94738	0.94845	0.94950	0.95053	0.95154	0.95254	0.95352	0.95449
1.7	0.95543	0.95637	0.95728	0.95818	0.95907	0.95994	0.96080	0.96164	0.96246	0.96327
1.8	0.96407	0.96485	0.96562	0.96638	0.96712	0.96784	0.96856	0.96926	0.96995	0.97062
1.9	0.97128	0.97193	0.97257	0.97320	0.97381	0.97441	0.97500	0.97558	0.97615	0.97670
2	0.97725	0.97778	0.97831	0.97882	0.97932	0.97982	0.98030	0.98077	0.98124	0.98169
2.1	0.98214	0.98257	0.98300	0.98341	0.98382	0.98422	0.98461	0.98500	0.98537	0.98574
2.2	0.98610	0.98645	0.98679	0.98713	0.98745	0.98778	0.98809	0.98840	0.98870	0.98899
2.3	0.98928	0.98956	0.98983	0.99010	0.99036	0.99061	0.99086	0.99111	0.99134	0.99158
2.4	0.99180	0.99202	0.99224	0.99245	0.99266	0.99286	0.99305	0.99324	0.99343	0.99361
2.5	0.99379	0.99396	0.99413	0.99430	0.99446	0.99461	0.99477	0.99492	0.99506	0.99520
2.6	0.99534	0.99547	0.99560	0.99573	0.99585	0.99598	0.99609	0.99621	0.99632	0.99643
2.7	0.99653	0.99664	0.99674	0.99683	0.99693	0.99702	0.99711	0.99720	0.99728	0.99736
2.8	0.99744	0.99752	0.99760	0.99767	0.99774	0.99781	0.99788	0.99795	0.99801	0.99807
2.9	0.99813	0.99819	0.99825	0.99831	0.99836	0.99841	0.99846	0.99851	0.99856	0.99861
3	0.99865	0.99869	0.99874	0.99878	0.99882	0.99886	0.99889	0.99893	0.99896	0.99900
3.1	0.99903	0.99906	0.99910	0.99913	0.99916	0.99918	0.99921	0.99924	0.99926	0.99929
3.2	0.99931	0.99934	0.99936	0.99938	0.99940	0.99942	0.99944	0.99946	0.99948	0.99950
3.3	0.99952	0.99953	0.99955	0.99957	0.99958	0.99960	0.99961	0.99962	0.99964	0.99965
3.4	0.99966	0.99968	0.99969	0.99970	0.99971	0.99972	0.99973	0.99974	0.99975	0.99976
3.5	0.99977	0.99978	0.99978	0.99979	0.99980	0.99981	0.99981	0.99982	0.99983	0.99983
3.6	0.99984	0.99985	0.99985	0.99986	0.99986	0.99987	0.99987	0.99988	0.99988	0.99989
3.7	0.99989	0.99990	0.99990	0.99990	0.99991	0.99991	0.99992	0.99992	0.99992	0.99992
3.8	0.99993	0.99993	0.99993	0.99994	0.99994	0.99994	0.99994	0.99995	0.99995	0.99995
3.9	0.99995	0.99995	0.99996	0.99996	0.99996	0.99996	0.99996	0.99996	0.99997	0.99997

Appendix B

Factors for Control Charts

n	x-charts				s-charts				R-charts					
	A	A_2	A_3	c_4	B_3	B_4	B_5	B_6	d_2	d_3	D_1	D_2	D_3	D_4
2	2.121	1.880	2.659	0.7979	0	3.267	0	2.606	1.128	0.853	0	3.686	0	3.267
3	1.732	1.023	1.954	0.8862	0	2.568	0	2.276	1.693	0.888	0	4.358	0	2.574
4	1.500	0.729	1.628	0.9213	0	2.266	0	2.088	2.059	0.880	0	4.698	0	2.282
5	1.342	0.577	1.427	0.9400	0	2.089	0	1.964	2.326	0.864	0	4.918	0	2.114
6	1.225	0.483	1.287	0.9515	0.030	1.970	0.029	1.874	2.534	0.848	0	5.078	0	2.004
7	1.134	0.419	1.182	0.9594	0.118	1.882	0.113	1.806	2.704	0.833	0.204	5.204	0.076	1.924
8	1.061	0.373	1.099	0.9650	0.185	1.815	0.179	1.751	2.847	0.820	0.388	5.306	0.136	1.864
9	1.000	0.337	1.032	0.9690	0.239	1.761	0.232	1.707	2.970	0.808	0.547	5.393	0.184	1.816
10	0.949	0.308	0.975	0.9727	0.284	1.716	0.276	1.669	3.078	0.797	0.687	5.469	0.223	1.777
11	0.905	0.285	0.927	0.9754	0.321	1.679	0.313	1.637	3.173	0.787	0.811	5.535	0.256	1.744
12	0.866	0.266	0.886	0.9776	0.354	1.646	0.346	1.610	3.258	0.778	0.922	5.594	0.283	1.717
13	0.832	0.249	0.850	0.9794	0.382	1.618	0.374	1.585	3.336	0.770	1.025	5.647	0.307	1.693
14	0.802	0.235	0.817	0.9810	0.406	1.594	0.399	1.563	3.407	0.763	1.118	5.696	0.328	1.672
15	0.775	0.223	0.789	0.9823	0.428	1.572	0.421	1.544	3.472	0.756	1.203	5.741	0.347	1.653
16	0.750	0.212	0.763	0.9835	0.448	1.552	0.440	1.526	3.532	0.750	1.282	5.782	0.363	1.637
17	0.728	0.203	0.739	0.9845	0.466	1.534	0.458	1.511	3.588	0.744	1.356	5.820	0.378	1.622
18	0.707	0.194	0.718	0.9854	0.482	1.518	0.475	1.496	3.640	0.739	1.424	5.856	0.391	1.608
19	0.688	0.187	0.698	0.9862	0.497	1.503	0.490	1.483	3.689	0.734	1.487	5.891	0.403	1.597
20	0.671	0.180	0.680	0.9869	0.510	1.490	0.504	1.470	3.735	0.729	1.549	5.921	0.415	1.585
21	0.655	0.173	0.663	0.9876	0.523	1.477	0.516	1.459	3.778	0.724	1.605	5.951	0.425	1.575
22	0.640	0.167	0.647	0.9882	0.534	1.466	0.528	1.448	3.819	0.720	1.659	5.979	0.434	1.566
23	0.626	0.162	0.633	0.9887	0.545	1.455	0.539	1.438	3.858	0.716	1.710	6.006	0.443	1.557
24	0.612	0.157	0.619	0.9892	0.555	1.445	0.549	1.429	3.895	0.712	1.759	6.031	0.451	1.548
25	0.600	0.153	0.606	0.9896	0.565	1.435	0.559	1.420	3.931	0.708	1.806	6.056	0.459	1.541

Source: Adapted from Table 27 of ASTM STP 15D ASTM Manual on Presentation of Data and Control Chart Analysis. © 1976 American Society for Testing and Materials, Philadelphia, PA.

Appendix C

Random Digits

Row										
1	63271	59986	71744	51102	64895	72728	87305	46260	81351	74102
2	64909	23335	73532	81757	21965	65453	23760	66868	67868	56503
3	76396	63407	14768	68665	63302	72754	62437	64619	27648	05504
4	89313	37253	00742	13710	69577	30698	54103	29052	82553	16881
5	48804	42723	07009	10147	48459	76311	77025	43345	66641	02539
6	78305	78150	86853	79058	50031	85448	38960	63251	21470	76644
7	60960	89864	82258	19432	15131	39909	32768	42182	89962	80139
8	18325	72128	03830	27902	07961	28358	49966	61630	54400	25216
9	48518	91563	40764	34192	79970	83471	16365	21223	86587	33442
10	81628	36100	39254	56835	37636	02421	98063	43962	28698	85165
11	56996	66664	29222	10459	71904	78070	62169	20475	42256	07934
12	14801	87412	32615	15290	30120	31865	97614	70509	44171	67206
13	13515	72370	29664	58918	96665	72001	10876	12133	69366	53122
14	31811	01367	34615	47476	48372	47065	42298	14670	23842	67511
15	85501	22581	46211	74733	82948	53980	14905	06808	44448	26285
16	45145	48148	98342	19389	05991	05741	38675	84803	47245	46244
17	42923	06140	84104	25756	33761	12122	59210	39412	48327	89606
18	55791	06180	85084	93868	18804	20985	53991	98457	44282	35188
19	34177	55939	62570	31834	22395	84396	42960	93073	10989	38134
20	42751	51425	41471	16448	05700	06745	93800	10113	78598	17518
21	75679	69889	49966	88109	19138	43983	36837	74278	32107	26215
22	07012	71369	05388	33673	81374	25132	83751	10559	16565	54461
23	41797	13982	14715	54171	85056	21248	80983	92462	08870	23547
24	42741	56932	55818	39790	08742	60991	33612	80408	94023	81026
25	74763	93765	14810	13042	05167	00035	44131	79938	91757	24321
26	33026	36895	46066	09820	73383	44718	27830	66960	40855	18465
27	80670	08848	25084	09735	82975	14712	21282	70310	61714	15275
28	54249	17912	35709	74157	84685	15494	17791	82553	15074	46060
29	76252	12353	82111	29597	27189	16592	17333	09792	98693	10587
30	92813	89047	21866	23882	37345	25823	59942	77750	94198	81737
31	13450	28129	78826	34886	08080	98012	82670	31089	88271	89921
32	73918	75366	04676	04973	59311	43384	43641	87084	64475	46868
33	21604	24978	62263	81498	34041	89035	74592	44386	34638	02829
34	12580	24572	43453	01447	22171	54106	46354	25529	49410	64609
35	06791	38556	93195	59284	39210	95865	76737	92130	87237	26860
36	57315	71086	01471	78161	08100	78305	19330	52629	27742	64925
37	19391	60110	82258	13773	83517	91922	14493	90092	61110	22804
38	24879	11362	04464	37579	21294	94067	21636	21986	96220	49244
39	64443	33916	76511	96896	01013	68986	35418	13819	91897	54944
40	91522	07959	31675	18205	33956	53845	80047	88198	74219	89035

Endnotes

Chapter 1

1. "The way of the mouse," *The News-Press*, Fort Myers, Florida, May 14, 2008, p. B1; The Disney Institute, *Be Our Guest*, New York: Disney Editions, 2001.
2. Dave Demerjian, "Hustle & Flow," *Fast Company*, March 2008, pp. 60-62.
3. Collier, D.A., (1994) *The Service/Quality Solution: Using Service Management to Gain Competitive Advantage*, Jointly published by ASQC Quality Press, Milwaukee, Wisconsin, and Irwin Professional Publishing, Burr Ridge, Illinois, pp.16, 63–64, 167.
4. These differences between goods and services were first defined by Sasser, W.E., Olsen, R.P., and Wyckoff, D.D., *Management of Service Operations*, Boston: Allyn and Bacon, 1978, pp. 8–21, and later improved and expanded by Fitzsimmons, and Sullivan, R.S. *Service Operations Management*, New York: McGraw-Hill, 1982, and Collier, D.A. "Managing A Service Firm: A Different Management Game" *National Productivity Review*, Winter 1983–84, pp. 36–45.
5. Collier, D.A. "New Orleans Hilton & Hilton Towers," *Service Management: Operating Decisions*, Englewood Cliffs, New Jersey: Prentice-Hall, Inc., 1987, p. 120.
6. Jan Carlzon, CEO of Scandinavian Airlines Systems, first defined a moment of trust or truth. See Peters, T.J., and Austin, N., *A Passion for Excellence: The Leadership Difference*, New York: Warner Books, 1985, pp. 58 and 78.
7. Collier, D.A., (1994) *The Service/Quality Solution: Using Service Management to Gain Competitive Advantage*, Jointly published by ASQC Quality Press, Milwaukee, Wisconsin, and Irwin Professional Publishing, Burr Ridge, Illinois, Chapter 4, pp. 63–96.
8. "Mi Kyong Newsom, David A. Collier, and Eric O. Olsen. "Using 'biztainment' to gain competitive advantage," *Business Horizons* (2009) pp. 52, 167–176
9. *AT&T's Total Quality Approach*, AT&T Corporate Quality Office (1992), p. 6.
10. A more comprehensive perspective of the threats to manufacturing can be found in Kaj Grichnik and Conrad Winkler, "Manufacturing's 'Make or Break' Moment," *Strategy + Business*, Winter 2007, pp. 8-10; and Joseph A. De Feo and Matt Barney, "The Future of Manufacturing," *Quality Digest*, Feb 2008 pp. 34-37.
11. Facts in this case adapted from Jeffrey M. O'Brien, "Zappos knows how to kick it," *Fortune*, January 15, 2009, www.fortune.com, and "Zappos," *Fast Company*, March 2009, pp. 75-76.

Chapter 2

1. "It's All About the Shoes," *Fast Company*, New York, N.Y. September 2004, p. 85, http://pf.fastcompany.com/magagazine/86/stollenwerk .html.
2. www.allenedmonds.com. Read about the company history.
3. O'Sullivan, K., and Durfee, D., "Offshoring by the Numbers," *CFO Magazine*, June 2004, p. 53.
4. Selden, Larry, and Colvin, Geoffrey, "What Customers Want," *Fortune*, July 3, 2003, pp. 122–128.
5. S. Davis, *Future Perfect*, Addison-Wesley, New York, 1987, p. 108.
6. Ford Motor Company, Owner Loyalty and Customer Satisfaction Survey Results, 1994, p. 4.
7. Wegryn, Glenn W., and Siprelle, Andrew J., "Combined Use of Optimization and Simulation Technologies to Design an Optimal Logistics Network," http://www.simulationdynamics.com/PDFs/Papers/CLM%20 P&G%20Opt&Sim.pdf.
8. "Bumpy Ride," *Business Week SmallBiz*, February/March, 2009, p. 15.
9. "Is Your Job Next," *Business Week*, February 3, 2003, pp. 50–60.
10. Kahn, G., "Tiger's New Threads," *The Wall Street Journal*, March 26, 2004, p. B1.
11. Ferdows, K., "Making the Most of Foreign Factories," *Harvard Business Review*, March–April, 1997, pp. 73–88.
12. "The Way, Way Back Office," *Business Week*, February 3, 2003, p. 60.
13. Price, R., "Rocky Clocks Out," *The Columbus Dispatch*, Columbus, Ohio, April 28, 2002, pp. A1, A8–A9 and April 29, pp. A1, A4–A5.
14. "Toyota Goes with Standard Approach to Globalization," *The International Herald Tribune*, February 25, 2008
15. Graham, J.L. and Lam, N.M., "The Chinese Negotiation," *Harvard Business Review*, October, 2003, pp. 19–28. We highly recommend reading this article.

Chapter 3

1. Kaplan, Robert S., and Norton, David P., *The Balanced Scorecard*, Boston, MA: Harvard Business School Press, 1996, p. 1.
2. Private communication from Stephen D. Webb, manager of quality control, ground operations, American Airlines.
3. Lashinsky, Adam, "Meg and the Machine," *Fortune*, September 1, 2003, pp. 68–78.
4. Parasuraman, A., Zeithaml, V. A., and Berry, L. L., "SERVQUAL: A Multiple-Item Scale for Measuring Consumer Perceptions of Service Quality," *Journal of Retailing 64*, no. 1 (Spring 1988), pp. 12–40.
5. "Are You Built for Speed?" *Fast Company*, June 2003, p. 85.
6. "Farewell, paper airline tickets," *The News-Press*, Fort Myers, Florida, September 12, 2007, p. B2.
7. Collier, David A., *The Service/Quality Solution* (Milwaukee, WI: ASQC Quality Press, and Burr Ridge, IL: Irwin, Richard D., 1994, pp. 235–260. Also, see for

example, Collier, D.A., "A Service Quality Process Map for Credit Card Processing," *Decision Sciences*, 22(2), 1991, pp. 406–20 or Wilson, D.D. and Collier, D.A., "The Role of Automation and Labor in Determining Customer Satisfaction in a Telephone Repair Service," *Decision Sciences*, 28(3), 1997, pp. 1–21.

8. "Baldrige Award Winners Beat the S&P 500 for Eight Years," *National Institute of Standards and Technology,* www.nist.gov/public_affairs/releases/go2-11.htm.

9. 2007 Malcolm Baldrige Application Summary

10. Heskett, J. L., Jones, T. O., et al. (1994). "Putting the service–profit chain to work." *Harvard Business Review* 72(2): pp. 164–174.

11. Steven H. Hoisington and Tse-Hsi Huang, "Customer Satisfaction and Market Share: An Empirical Case Study of IBM's AS/400 Division," in Earl Naumann and Steven H. Hoisington (eds.) *Customer-Centered Six Sigma* (Milwaukee, WI: ASQ Quality Press, 2001).

Chapter 4

1. Davie Rynecki, "One town, two rivals," *Fortune*, July 26, 2004, pp. 110–119.

2. Selden, Larry, and Colvin, Geoffrey, "Will this Customer Sink Your Stock?" *Fortune*, September 30, 2002, pp. 127–132.

3. Daniel H. Pink, "Out of the Box," *Fast Company*, October 2003, pp. 104-106; Patricia Sellers, "Gap's New Guy Upstairs," *Fortune*, April 14, 2003, pp. 110–116; and "How to Listen to Consumers," *Fortune*, January 11, 1993, p. 77.

4. Zeithaml, V.A., "How Consumer Evaluation Processes Differ Between Goods and Services," in Donnelly, J.H., and George, W. R., eds., *Marketing in Services*, published by the American Marketing Association, Chicago, 1981, pp. 186–199.

5. "Starbucks testing $1 coffee and free refills in Seattle," *The News-Press*, Fort Myers, Florida, January 24, 2008, p. D2.

6. "Southwest Sets Standards on Costs," *The Wall Street Journal*, October 9, 2002, p. A2.

7. *The PIMS Letter on Business Strategy*, The Strategic Planning Institute, Number 4, Cambridge, Mass., 1986.

8. *Business Week*, December 17, 2001, p. 84.

9. "Attack of the Killer Crossovers," *Business Week*, January 28, 2002, pp. 98–100.

10. Lafamore, G. Berton, "The Burden of Choice," *APICS – The Performance Advantage,* January 2001, pp. 40–43.

11. Quinn, James Brian, *Strategies for Change: Logical Incrementalism* (Homewood IL: Richard D. Irwin, 1980).

12. Hill, T., *Manufacturing Strategy: Text and Cases*, Irwin Publishers, Burr Ridge, Illinois, 2nd Edition, 1994.

13. www.mcdonalds.com/corporate/info/vision/index. html. This example is the book author's interpretation of McDonald's public information with the objective of illustrating Professor Terry Hill's generic strategy development framework. It may or may not be perfectly accurate and it is only partially complete due to space limitations.

Chapter 5

1. Adapted from Evan West, "These Robots Play Fetch," *Fast Company* Issue 117, July 2007, p. 49

2. *Award, The Newsletter of Baldrigeplus*, May 7, 2000, www.baldrigeplus.com.

3. Mike Dusharme, "RFID Tunes into Supply Chain Management," *Quality Digest*, October 18, 2007, www. qualitydigest.com.

4. "Honda All Set to Grow," *The Columbus Dispatch*, Columbus, Ohio, September 18, 2002, pp. B1–B2.

5. Adapted from Stephanie N. Mehta, "Under Armour reboots," *Fortune*, February 2, 2009, pp. 29-33.

6. Paul Lukas, "Whither the Checkout Girl?" *Fast Company*, November 2006, p. 50.

7. McManus, Neil, "Robots at Your Service," *Wired*, January 2003, pp. 58–59.

8. Adapted from "Libraries Tuning in to Radio Frequency IDs," The Oklahoman (Oklahoma City, OK), February 6, 2008.

9. "Behind Surging Productivity: The Service Sector Delivers," *The Wall Street Journal*, November 7, 2003. Also, see http://online.wsj.com.

10. "U.S. Producitivity Boom Continues," *The Columbus Dispatch*, Columbus, Ohio, October 24, 2002, p. B1.

11. "Behind Surging Productivity: The Service Sector Delivers," *The Wall Street Journal*, November 7, 2003. Also, see http:/online.wsj.com.

12. "Why WebVan Went Bust," *The Wall Street Journal*, July 16, 2001, p. A22.

13. 2001 Annual Report, *Intel Corporation*, 2200 Mission College Boulevard, Santa Clara, CA (www.intel.com), pp. 3–7.

14. 2001 Annual Report, *Applied Materials*, 3050 Bowers Avenue, Santa Clara, California, p. 19.

Chapter 6

1. Charles Fishman, "To The Moon! (In a Minivan)," *Fast Company* Dec. 2007/Jan. 2008.

2. "A Virtual Focus Group," *Business Week SmallBiz*, August/September, 2008, pp. 42-43.

3. *Business Week: Quality 1991* (special issue), October 25, 1991, p. 73.

4. "Venza Revealed," *Automotive Design and Production*, December 2008, pp. 30-32.

5. Early discussions of this topic can be found in Nussbaum, Bruce and Templeton, John, "Built to Last—Until It's Time to Take It Apart," *Business Week*, September 17, 1990, pp. 102–106. A more recent reference is Lenox, Michael, King, Andrew, and Ehrenfeld, John, "An Assessment of Design-for-Environment Practices in Leading US Electronics Firms," *Interfaces* 30, no. 3, May–June 2000, pp. 83–94.

6. Kevin Kelly, "Going Green: The Challenges & Solutions," *Automotive Design & Production*, January 2008, www. autofieldguide.com.

7. Bitner, M.J., 1992. "Servicescapes: The impact of physical surroundings on customers and employees." *Journal of Marketing*, 56 (2), pp. 57–71; Bitner, M.J., 1993. "Managing the evidence of service." In Scheuing,

E.E. and Christopher, W.F. (Ed.), *The Service Quality Handbook*, American Management Association (AMACOM), New York, NY, pp. 358–370.

8. Bitner, M.J., 1992. "Servicescapes: The impact of physical surroundings on customers and employees." *Journal of Marketing*, 56 (2), pp. 57–71; Bitner, M.J., 1993. "Managing the evidence of service." In Scheuing, E.E. and Christopher, W.F. (Ed.), *The Service Quality Handbook*, American Management Association (AMACOM), New York, NY, pp. 358–370.

9. Bitner, M.J., 1992. "Servicescapes: The impact of physical surroundings on customers and employees." *Journal of Marketing*, 56 (2), pp. 57–71; Bitner, M.J., 1993. "Managing the evidence of service." In Scheuing, E.E. and Christopher, W.F. (Ed.), *The Service Quality Handbook*, American Management Association (AMACOM), New York, NY, pp. 358–370.

10. "Flight of Fancy" *Fast Company*, Nov. 2008, p. 29.

11. Wright, Sarah Anne, "Putting Fast-Food To The Test," *The Cincinnati Enquirer,* July 9, 2000, pp. F1, 2.

12. Layden, Laura, "21st Century Clean," www.naplesnews.com, Naples, Florida, October 21. 2007.

13. Chase, R.B. "Where Does the Customer Fit in a Service Operation?" *Harvard Business Review*, November–December 1978, pp. 137–142.

14. Chase, R.B. 1983, op.cit., pp. 1037–1050. "The Customer Contact Model for Organizational Design," *Management Science*, 1983, 29 (9), pp. 1037–1050.

15. The Disney Institute, *Be Our Guest*, Disney Enterprises, Inc., 2001, p. 86.

16. Collier, D.A., and Baker, T.K., "The Economic Payout Model for Service Guarantees," *Decision Science*, 36, no. 2, 2005, pp. 197-220. Also, see Collier, D.A. "Process Moments of Trust: Analysis and Strategy," *The Service Industry Journal*, Vol. 9, No. 2, April 1989, pp. 205–222.

17. www.lenscrafter.com/al_mission.html, December 2, 2002.

Chapter 7

1. Harrington, H. James, "Looking for a Little Service," *Quality Digest*, May 2000; www.qualitydigest.com.

2. This discussion is adapted from Charles A. Horne, "Product Strategy and the Competitive Advantage," P&IM Review with *APICS News*, 7, no. 12, December 1987, pp. 38–41.

3. Keates, Nancy, "Custom Bikes for the Masses," *The Wall Street Journal OnLine*, September 28, 2007, http://online.wsj.com. 2 Gold, Bela, "CAM Sets New Rules for Production," *Harvard Business Review*, November–December 1982, p. 169.

4. Hayes, R. H., and Wheelwright, S. C., "Linking Manufacturing Process and Product Life Cycles," *Harvard Business Review* 57, no. 1, 1979a, pp. 133–140; Hayes, R. H., and Wheelwright, S. C., "The Dynamics of Process-Product Life Cycles," *Harvard Business Review* 57, No. 2, 1979b, pp. 127–136; and Hayes, R. H., and Wheelwright, S. C., *Restoring Our Competitive Edge*, New York: John Wiley & Son, 1984.

5. Noori, H., *Managing the Dynamics of New Technology: Issues in Manufacturing Management*, Englewood Cliffs, NJ: Prentice-Hall, 1989.

6. Collier, D. A., and Meyer, S. M., "A Service Positioning Matrix," *International Journal of Production and Operations Management* 18, no. 12, 1998, pp. 1123–1244.

7. Collier, D. A., and Meyer, S., "An Empirical Comparison of Service Matrices," *International Journal of Operations and Production Management* 20, no. 5–6, 2000, pp. 705–729.

8. Patricia Houghton, "Improving Pharmacy Service," *Quality Digest*, October 18, 2007

9. "Faster Way to Return Rental Cars," *The Wall Street Journal*, June 12, 2003, p. D4.

10. Hammer, Michael, and Champy, James, *Reengineering the Corporation*, New York: HarperBusiness, 1993, pp. 177–178.

11. Little, J. D. C., "A Proof for the Queuing Formula: $L = \lambda W$," *Operations Research*, no. X, 1961, pp. 383–387.

Chapter 8

1. Shunk, Dan L., "Group Technology Provides Organized Approach to Realizing Benefits of CIMS." *Industrial Engineering*, April 1985. Adapted with permission from Institute of Industrial Engineers, 25 Technology Park/Atlanta, Norcross, GA 30092.

2. "GM plans to lay off 1,600 workers," *The News-Press*, Fort Myers, Florida, October 17, 2008, p. D2.

3. Bell, P.C. and Van Brenk, J., "Vytec Corporation: Warehouse Layout Planning," *The European Case Clearing House*, England, Case # 9B03E013. (http://www.ecch.cranfield.ac.uk).

4. Profiles of Winners, Malcolm Baldrige National Quality Award, and Sunny Fresh Foods Baldrige Application Summary, 1999.

5. Johnson, P., Heimann, V., and O'Neill, K., "The wonderland of virtual teams," *Journal of Workplace Learning*, 13(1), 2001, pp. 24–29.

Chapter 9

1. This scenario is based on Johnson, M. E., "Mattel, Inc: Vendor Operations in Asia," *The European Case Clearing House*, England, Case #601-038-1 (http://www.ecch.cranfield.ac.uk).

2. The Supply-Chain Council was formed in 1996–1997 as a grassroots initiative by firms including AMR Research, Bayer, Compaq Computer, Pittiglio Rabin Todd & McGrath (PRTM), Procter & Gamble, Lockheed Martin, Nortel, Rockwell Semiconductor, and Texas Instruments. See http://www.supply-chain.org/ for information on the Supply Chain council and development of the SCOR model.

3. "Boeing again delays Dreamliner's debut," *USA Today*, January 1, 2008, p. 3B; and "Turbulence in Supply Chain Could Lead to Another Boeing Delay," *Seattle Post-Intelligencer*, March 12, 2008

4. *Dell Fiscal 2003 Report*, www.dell.com. Also see "Dell Knows His Niche and He'll Stick with It," *USA Today*, April 5, 2004, p. 3B.

5. Cherie Blanchard, Clare L. Comm, and Dennis F.X. Mathaisel, "Adding Value ot Service Providers: Benchmarking Wal-Mart," *Benchmarking: An International Journal,* 15, 2, 2008, pp. 166-177.

6. "Wal-Mart's Supply Chain Management Practices," *The European Case Clearing House,* Case #603-003-1, 2003, ECCH@cranfield.ac.uk.

7. Callioni, Gianpaolo, and Billington, Corey, "Effective Collaboration," *OR/MS Today* 28, no. 5, October 2001, pp. 34–39.

8. Facts in this example were drawn from Gallagher, Patricia, "Value Pricing for Profits," *Cincinnati Enquirer,* 21 December 1992, pp. D–1, D–6; "Procter & Gamble Hits Back," *Business Week,* 19 July 1993, pp. 20–22, and Saporry, Bill, "Behind the Tumult at P&G," *Fortune* 7, March 1994, pp. 75–82.

9. Boyer, Mike, "The Parts Are the Whole," *Cincinnati Enquirer,* October 13, 2001, pp. C1, C2.

10. Salter, Chuck, "Surprise Package," *Fast Company,* February 2004, pp. 62–66.

11. Kishpaugh, Larry, "Process Management and Business Results," presentation at the *1996 Regional Malcolm Baldrige Award Conference,* Boston, MA.

12. Texas Instruments Defense Systems & Electronics Group, *Malcolm Baldrige Application Summary (1992).*

13. Adapted from "Wal-Mart Takes Next Step in RFID Tagging," *Dallas Morning News,* January 31, 2008

14. *Supply Chain Digest,* "The 11 Greatest Supply Chain Disasters," 2006. www.scdigest.com.

15. Adapted from "Navigating Today's Supply Chain Challenges," Panel Discussion at the Supply Chain World Conference, Thursday, March 01, 2007, Hyatt Regency, Dallas TX; March 28, 2006 (Material Handling Industry of America, http://www.mhia.org/news/industry/7070/navigating-today-s-supply-chain-challenges accessed 2/11/09) and "Nike Rebounds: How (and Why) Nike Recovered from Its Supply Chain Disaster," *CIO Magazine,* June 15, 2004, http://www.cio.com/article/print/32334.

Chapter 10

1. "Capacity Upgrade Cited as Possible Source of BlackBerry Crash," *The Toronto Star,* February 13, 2008.

2. "Forfeiture cases put on courts' fast track," *The News-Press,* Fort Myers, Florida, September 25, 2008, pp. A1 and A3.

3. http://www.strategosinc.com/focused_factory_example.htm.

4. http://www.briggsandstratton.com.

5. Liberman, W., "Implementing Yield Management," *ORSA/TIMS National Meeting Presentation,* San Francisco, November 1992.

6. Geraghty, M., and Johnson, M., "Revenue Management Saves National Car Rental," *Interfaces* 12, no. 7, 1997, pp. 107–127.

7. Goldratt, Eliyahu M. and Cox, Jeff, *The Goal,* Second Revised Edition, Croton-on-Hudson, N.Y.: North River Press, 1992 and Goldratt, Eliyahu M., *The Theory of Constraints,* Croton-on-Hudson, N.Y.: North River Press, 1990.

8. Jeremy Pastore, Sekar Sundararajan, and Emory W. Zimmers, "Innovative Application," APICS—The Performance Advantage, 14, 3, March 2004, pp. 32–35.

9. http://www.goldratt.com/kreisler.htm.

Chapter 11

1. "Holding Patterns," *CIO Magazine,* www.cio.com/archive May 15, 1999.

2. "Colgate Supports Its Worldwide Brands with mySAP Supply Chain Management," http://www.sap.com/solutions/business-suite/scm/customersuccess/index.aspx, December 6, 2004.

3. Gilliland, M., "Is Forecasting a Waste of Time?" *Supply Chain Management Review,* www.manufacturing.net/scm, July/August 2002.

Chapter 12

1. Louise Lee, "Yes, We Have a New Banana," *Business Week,* May 31, 2004, pp. 70–72.

2. "Chips soon may replace bar codes," *The Sun News,* Myrtle Beach, S.C., July 9, 2003, pp. 1D and 3D.

3. Gary Finke, "Determining Target Inventories of Wood Chips Using Risk Analysis," *Interfaces,* 14, 5, September-October 1984, pp. 53–58.

4. A more complete technical classification and survey of inventory problems is given in E. A. Silver, "Operations Research in Inventory Management," *Operations Research* 29 (1981), pp. 628–645.

5. "RFID for Animals, Food and Farming—the Largest Market of All," IDTechEx, October 19, 2007, http://www.idtechex.com.

6. Grocery Manufacturers of America, "Full-Shelf Satisfaction—Reducing 'Out-of-Stocks in the Grocery Channel, 2002 report. www.gmabrtands.com/publications.

7. Hau L. Lee, Corey Billington, and Brent Carter, "Hewlett-Packard Gains Control of Inventory and Service Through Design for Localization," *Interfaces,* 23, 4, July–August, 1993, pp. 1–11.

Chapter 13

1. Adapted from Visagie, Martin S., "Production Control on a Flow Production Plant" *APICS 1975 Conference Proceedings,* pp. 161–166.

2. Steinberg, E., Khumawala, B., and Scamell, R., "Requirements Planning Systems in the Healthcare Environment," *Journal of Operations Management* 2, no. 4, 1982, pp. 251–259.

Chapter 14

1. This approach is suggested in Tibrewala, R., Phillippe, D., and Browne, J., "Optimal Scheduling of Two Consecutive Idle Periods," *Management Science* 19, no. 1, September 1972, pp. 71–75.

2. Anton Ovchinnikov and Joseph Milner, "Spreadsheet Model Helps to Assign Medical Residents at the University of Vermont's College of Medicine," *Interfaces,* Vol. 38, No. 4, July–August 2008, pp. 311–323.

3. http://www.abs-usa.com/news/scheduleanywhere.epl, September 10, 2004.
4. Johnson, S. M., "Optimal Two- and Three-Stage Production Schedules with Setup Times Included," *Naval Research Logistics Quarterly* 1, no. 1, March 1954, pp. 61–68.
5. Brown, Gerald G., Ellis, Carol J., Graves, Glenn W., and Ronen, David, "Real-Time, Wide-Area Dispatch of Mobil Tank Trucks," *Interfaces* 17, no. 1, 1987, pp. 107–120.

Chapter 15

1. Tamimi, Nabil, and Sebastianelli, Rose, "How Firms Define and Measure Quality," *Production and Inventory Management Journal* 37, no. 3, Third Quarter, 1996, pp. 34–39.
2. Parasuraman, A., Zeithaml, V., and Berry, L., "A conceptual model of service quality and its implications for future research," *Journal of Marketing*, 49 (4), 1985, pp. 41–50. Parasuraman, A., Zeithaml, V., and Berry, L., "SERVQUAL: A multiple-item scale for measuring consumer perceptions of service quality," *Journal of Retailing*, 64(1), 1988, pp. 29–40. Parasuraman, A., Zeithaml, V. A. and Berry, L.L., "Refinement and reassessment of the SERVQUAL instrument," *Journal of Retailing*, Vol. 67, No. 4, 1991, pp. 420–450.
3. Deming, W. Edwards, *The New Economics for Industry, Government, Education*, Cambridge, MA: MIT Center for Advanced Engineering Study, 1993.
4. Adapted from Jacques, March Laree, "Big League Quality," *Quality Progress*, August 2001, pp. 27–34.
5. Parasuraman, A., Zeithaml, V. A., and Berry, L. L., "A Conceptual Model of Service Quality and Its Implications for Future Research," *Journal of Marketing* 49, Fall 1985, pp. 41–50.
6. Adapted from Pam Parry, "Sears Delivers a Better QMS," *Quality Digest*, January 10, 2007.
7. "Home Builder Constructs Quality with ISO 9000," *Quality Digest*, February 2000, p. 13.
8. Snee, Ronald D., "Why Should Statisticians Pay Attention to Six Sigma?" *Quality Progress*, September 1999, pp. 100–103.
9. Marash, Stanley A., "Six Sigma: Business Results Through Innovation," *ASQ's 54th Annual Quality Congress Proceedings*, pp. 627–630.
10. Palser, Lisa, "Cycle Time Improvement for a Human Resources Process," *ASQ's 54th Annual Quality Congress Proceedings*, 2000 (CD-ROM).
11. Hoerl, Roger, "An Inside Look at Six Sigma at GE," *Six Sigma Forum Magazine*, Vol. 1, no. 3, (May 2002), pp. 35–44.
12. "The peanut peril," *Chicago Tribune*, March 7, 2009 (chicagotribune.com); "Peanut firm files for bankruptcy," *The News-Press*, Fort Myers, Florida, February 14, 2009, p. A14.
13. *Reports of Statistical Application Research, Japanese Union of Scientists and Engineers*, 33, no. 2, June 1986.
13. Imai, Masaaki, *KAIZEN—The Key to Japan's Competitive Success*, New York: McGraw-Hill, 1986.

14. Davis R. Bothe, "Improve Service and Administration," *Quality Progress*, September 2003, pp. 53–57
15. Imai, Masaaki, *KAIZEN—The Key to Japan's Competitive Success*, New York: McGraw-Hill, 1986.
16. Robinson, Harry, "Using Poka Yoke Techniques for Early Defect Detection," Paper presented at the Sixth International Conference on Software Testing and Analysis and Review (STAR '97).

Chapter 16

1. Brown, Eryn, "Heartbreak Hotel?" *Fortune*, November 26, 2001, pp. 161–165.
2. "Hospital to Revise Lab Procedures After Faulty Tests Kill 2," *The Columbus Dispatch*, Columbus, Ohio, August 16, 2001, p. A2.
3. "Testing for Conformity: An Inside Job," *Golf Journal*, May 1998, pp. 20–25.
4. Adapted from the Ritz-Carlton Hotel Company 1992 and 1999 Application Summaries for the Malcolm Baldrige National Quality Award.
5. "Medication mistakes formula for disaster," *The News-Press*, Fort Myers, Florida, September 25, 2007, p. E1.
6. McCabe, W. J., "Improving Quality and Cutting Costs in a Service Organization," *Quality Progress*, June 1985, pp. 85–89.

Chapter 17

1. This scenario was inspired by an example described in Anthony Manos, Mark Sattler and George Alukal, "Make Healthcare Lean," *Quality Progress* July 2006.
2. "To Compete Better, Manufacturing Plants Go Lean," *The Sunday Oregonian* (Portland, OR), April 22, 2008.
3. Nakajima, Seiichi, "Explanation of New TPM Definition," *Plant Engineer* 16, no. 1, pp. 33–40.
4. "Quadrangle," *The Magazine of the University of Kentucky College of Enginneering*, Summer/Fall, 2008, 16(1), p. 42 and Neenah Paper's Eco Calculator (www.neenahpaper.com).
5. Ellis, R., and Hankins, K., "The Timken Journey for Excellence," Presentation for the Center of Excellence in Manufacturing Management, Fisher College of Business, Ohio State University, Columbus, Ohio, August 22, 2003. Also see Timken's 2003 Annual Report and "From Missouri to Mars—A Century of Leadership in Manufacturing," http://www.timken.com.
6. "Lean and Pharmacies," *Quality Digest*, October 2006, www.qualitydigest.com.
7. Freiberg, Kevin, and Freiberg, Jackie, *Nuts!*, Austin, TX: Bard Press, 1996, p. 59.
8. Dickinson, Paul E., Dodge, Earl C., and Marshall, Charles S., "Administrative Functions in a Just-in-Time Setting," *Target*, Fall 1988, pp. 12–17.
9. Inman, R., and Mehra, S., "JIT Implementation within a Service Industry: A Case Study," *International Journal of Service Industry Management* 1, no. 3, 1990, pp. 53–61.

Chapter 18

1. http://sportsillustrated.cnn.com/2004/olympics/2004/06/28/bc.oly.athensnotebook.ap/index.html.
2. Baldrige Award Recipient Profile, Custom Research Inc., National Institute of Standards and Technology, 1996, http://baldrige.nist.gov/Custom_Research_96.htm.
3. Randolph, W. Alan, and Posner, Barry Z., "What Every Manager Needs to Know about Project Management," *Sloan Management Review*, Summer 1988, pp. 65–73.
4. Stedman, Craig, "Failed ERP Gamble Haunts Hershey," *Computerworld*, November 1, 1999. www.computerworld.com/news/1999.
5. Jack Gido and James P. Clements, *Successful Project Management*, Second Edition, Mason, OH: Thomson South-Western 2003, p. 103.

Supplementary Chapter A

1. Genovese, S. M., "Work Measurement and Process Improvement Study of Roller Coaster Preventive Maintenance," March 23, 2003, http://www.theroadscholars.com.
2. City of Phoenix, Arizona, Job Description, Operations Analyst, http://www.ci.phoenix.az.us/JOBSPECS/05260.html.
3. Adler, Paul S., "Time-and-Motion Regained," *Harvard Business Review*, Jan.–Feb. 1993, pp. 97–108.
4. Copyright © 2004, David A. Collier. All rights reserved.

Supplementary Chapter B

1. Brady, D., "Why Service Stinks," *Business Week* October 23, 2000, pp. 118–128. This episode is partially based on this article.
2. Adapted from Quinn, et al., "Allocating Telecommunications Resources at L.L. Bean, Inc." *Interfaces*, Vol. 21, No. 1, January/February, 1991, pp. 75–91.
3. Machalaba, D., "Taking the Slow Train: Amtrak Delays Rise Sharply," *The Wall Street Journal*, August 10, 2004, pp. D1–D2.
4. Schatz, A., "Airport Security-Checkpoint Wait Times Go Online," *The Wall Street Journal*, August 10, 2004, p. D2.
5. Graessel, Bob, and Zeidler, Pete, "Using Quality Function Deployment to Improve Customer Service," *Quality Progress* November 1998, pp. 59–63.

Supplementary Chapter C

1. Makuch, William M., Dodge, Jeffrey L., Ecker, Joseph E., Granfors, Donna C., and Hahn, Gerald J., "Managing Consumer Credit Delinquency in the U.S. Economy: A Multi-Billion Dollar Management Science Application," *Interfaces* 22, no. 1, January–February 1992, pp. 90–109.
2. Field, Richard C. "National Forest Planning is Promoting US Forest Service Acceptance of Operations Research," *Interfaces* 14, no. 5, September–October 1984, pp. 67–76.

Supplementary Chapter D

1. "Simulation Dynamics Puts Power into SCM," Reprinted from the June 2001 *IIE Solutions*, http://www.simulationdynamics.com.
2. Chappell, D., and Vernon, T., "GE Capital: Driving the Engine of Success," *Simulation Success*, July 1999, http://www.processmodel.com/html/finance.html.
3. Adapted from Edie, Leslie C., "Traffic Delays at Toll Booths," *Journal of the Operations Research Society of America* 2, no. 2, 1954, pp. 107–138; Landauer, Edwin G., and Becker, Linda C., "Reducing Waiting Time at Security Checkpoints," *Interfaces* 19, no. 5, September–October 1989, pp. 57–65; and Cebry, Michael E., deSilva, Anura H., and DeLisio, Fred J., "Management Science in Automating Postal Operations: Facility and Equipment Planning in the United States Postal Service," *Interfaces* 22, no. 1, January–February, 1992, pp. 110–130.
4. "A Picture is Worth A Thousand Words—Takes on New Meaning for Kodak," *Simulation Success*, July 1999, http://www.processmodel.com/Kodak.pdf.
5. Adapted from Willis, David O., Smith, Jerald R., and Golden, Peggy, "A Computerized Business Simulation for Dental Practice Management," *Journal of Dental Education* 61, no. 10, October 1997, pp. 821–828.

Supplementary Chapter E

1. Balson, William E., Welsh, Justin L., and Wilson, Donald S., "Using Decision Analysis and Risk Analysis to Manage Utility Environmental Risk," *Interfaces* 22, no. 6, November–December 1992, pp. 126–139.
2. Carter, Virgil, and Machol, Robert E., "Optimal Strategies on Fourth Down," *Management Science* 24, no. 16, December 1978, pp. 1758–1762.
3. Baird, Bruce F., *Managerial Decisions Under Uncertainty*, New York: John Wiley & Sons, 1989, p. 6; and Keeney, Ralph L., "Decision Analysis: An Overview," *Operations Research* 30, no. 5, September–October 1982, pp. 803–838.
4. Nichols, Nancy A., "Scientific Management at Merck: An Interview with CFO Judy Lewent," *Harvard Business Review* January–February 1994, pp. 89–99.
5. Brain, M., "How Chess Computers Work," http://www.ibs.howstuffworks.com/ibs//chess1.htm, October 20, 2004.
6. Adapted from: Feinstein, Charles D., "Deciding Whether to Test Student Athletes for Drug Use," *Interfaces* 20, no. 3, May–June 1990, pp. 80–87.

Index

A

ABC inventory analysis, 221, 222–223
Absolutes of Quality Management, 283–284
Actionable measures, 50
Action buckets, 251
Activities
in process design, 122
in project management, 342
Activity-on-node (AON) network, 342, 343, 344
Aggregate planning
examples of, 243, 244
options in, 240–242
in resource management framework, 238–240
strategies for, 242–244
Airline ticketing, electronic, 46
Alamo Rent-a-Car, 127
Alaska Airlines, 4
ALDEP (Automated Layout-DEsign Program), 146
Allen-Edmonds Shoe Corp., 20
Allocation, 185
American National Standards Institute (ANSI), 284
American Society for Quality (ASQ), 284
Andon, 324
Andrews Products, 82
Appointment systems, 266–267
Appraisal costs, 289
Arcs, 342
ASR Electronics case study, 234
Assemble-to-order goods and services, 116
Assembly line balancing, 141–143
Assembly lines, 141–145
Assignable cause variation, 305
Automobile suppliers, 28
Average range, 306

B

Backorders, 221
Backward integration, 29
Backward pass procedure, 345
Balance delay, 143
Balanced scorecard, 52–53
Baldrige National Quality Award, 14, 50–52
Balloons Aloha case study, 276
Banana Republic, 214
BankUSA case studies, 58–59, 151–153, 212–213
Bar coding system, 92–93
Batching, 324, 325
Becton Dickinson (BD), 120
Beta probability distribution, 351, 353
Bias, in forecasting, 211
Bill of labor (BOL), 247
Bill of materials (BOM), 247–248, 250, 254
Bill of resources (BOR), 247
Biztainment, 11
Boeing, 157
Bottlenecks, 130
Bottleneck (BN) work activity, 186–187
Bourbon Bank case study, 112–113
Bracket International (BI) case study, 92–93
Briggs & Stratton, 182
Buhrke Industries, Inc., 25–27
Build-out, in technology, 89, 90
Bullwhip effect, 163–165
Business strategy, 70

C

CAD/CAE, 83
Callaway, 60
Call centers, offshoring of, 32, 33
CAM, 83
Capacity, defined, 175, 176
Capacity cushion, 178
Capacity lag strategy, 182–183

Capacity lead strategy, 182
Capacity management, 174–187
capacity, defined, 175, 176
complementary goods and services in, 181
economies and diseconomies of scale, 176–177
legal bottlenecks, 176
long-term strategies, 181–183
measurement of capacity, 178–181
revenue management systems, 185
safety capacity, 178
shifting and stimulating demand in, 184
short-term strategies, 183–185
Theory of Constraints in, 185–187
Capacity requirements planning, 253–255
Capacity straddle strategy, 182
Cash Movement (CM), 151–153
Cause and effect diagrams, 292, 293
c-charts, 310–311, 312
Cellular layout, 137–138, 139
Center-of-gravity method, 167–168
Chase demand strategy, 243–244
Checksheets, 291
Chevron Texaco, 32
China, holistic thinking in, 36–37
Chiquita Brands, 4
Christopher, David, case study, 190–191
Colgate-Palmolive, 194
Common cause variation, 304–305
Community Medical Associates (CMA) case study, 334–335
Competitive advantage, 61–62
Competitive priorities, 65–69, 74
Complementary goods and services, 181
Component parts, 216
Components, 247
Computer-assisted dispatch (CAD), 273
Computer-integrated manufacturing systems (CIMS), 81–83

Errors per million opportunities (epmo), 287
ESCO Corp., 322
E-service, 83
Esquel Apparel, Inc., 29
Excel
 Add Trendline, 206
 c-chart spreadsheets, 311, 312
 Data Analysis, 208
 p-chart spreadsheets, 309–310
 in scheduling, 264
 \bar{x}-chart and R-chart spreadsheets, 307, 308
Exciters/delighters, 63
Execution, 238–239
Exel, 31
Experience attributes, 64
Exponential-smoothing model, 202–205
External failure costs, 290

F

Facility and work design, 134–153
 assembly line balancing, 141–143
 cellular layout, 137–138, 139
 facility layout, 105, 135, 136–140
 fixed-position layout, 138–139
 human side of work, 148–150
 line balancing approaches, 143–145
 process layout, 137, 139, 145–146
 product layout, 135–136, 139, 140–145
 in service organizations, 139–140
 workplace design, 146–148
Facility layout, 105, 135, 136–140 Facility location, 105, 165–168
Failure-mode-and-effects analysis (FMEA), 104
Federal Express, 43, 45, 85
Fewest number of operations remaining (FNO), 268
Fidelity Investments, 62
Final assembly schedule (FAS), 246
Financial measures, 42
Finished goods inventory, 216, 217
First-come-first-served (FCFS), 268, 269
Fishbone diagrams, 292, 293
Fitness for use, 281
5Ss, 323–324
5-Why Technique, 294
Fixed order quantity (FOQ) rule, 251–252
Fixed period systems, 229–231
Fixed-position layouts, 138–139
Fixed quantity systems (FQS), 221–229

Flexibility, 46, 68
Flexible manufacturing systems (FMS), 83
Flow-blocking delays, 140
Flowcharts (process maps), 123–125, 290, 293
Flow shop processes, 117, 118
Flow time, 130, 267, 269
Focused factories, 177
Focus Packaging, Inc., 177
Forecast error, 199–200
Forecasting, 192–211
 causal, 207–209
 data patterns in time series, 196–198
 defined, 193
 errors and accuracy in, 198–200
 judgmental, 209–210, 211
 method choice, 210–211
 need for, in value chain, 194–195
 planning horizon, 195–196
 regression in, 205–209
 single exponential smoothing, 202–205
 single moving average, 200–202
 statistical models, 200–205, 211
Forward buying, 164
Forward integration, 29
Forward pass procedure, 344–345
14 Points, 282, 283
Fraction defective, 309
Fraction nonconforming, 309

G

Gantt charts, 346, 348
Gap, 63
GAP model of quality, 284, 285
General Electric (GE), 66, 79, 288
Genghis computer system, 18
GE Plastics, 85
Gifford Hospital Pharmacy case study, 133
Global digital revolution, 90
Globalization
 challenges of, 16
 local culture and, 36–37
 location decision and, 166–167
 management decisions and, 34–36
 multinational enterprises and, 33–34
 at Toyota, 36
The Goal (Goldratt), 185
Goal post model, 98
Goods
 biztainment and, 11
 in customer benefit packages, 8–10
 defined, 6
 durable vs. nondurable, 6
 evaluating, 64–65

operations managers and, 6–8
 quality of, 44
 robust, 98
 services compared with, 6–8
Goods and service design flexibility, 46
Goods-producing jobs, 29
Goods quality, 44
Governments, e-commerce in, 86
GPS technology, 169
Green industries, 16
Green manufacturing, 104–105, 325–326
Green practices, 104–105
Greenspan, Alan, 87
Gross requirements (GR), 249
Group technology, 137

H

Hannibal Regional Hospital, 130
Hard technology, 80
Heijunka, 322
Hershey Foods Corp., 341
Hewlett-Packard (HP) Company, 229
High-contact systems, 108
High scalability, 88
Hill, Terry, 71–75
Hillerich & Bradsby, 283
Hilton Hotels, 304
Histograms, 292, 293
Holistic thinking, 37
Honda of America, 45, 82, 134–135
House of Quality, 102
Hsieh, Tony, 18
Hyundai Motor Company, 67

I

IBM, 56, 105, 313
IDEO, 63
Immediate predecessors, 342
In control (process), 305, 307
Independent demand, 219
Infinitely scalable, 88
"Information-free zones," 147–148
Infrastructure, 72, 74
In-Line Industries (ILI) case study, 259
Innovation
 competitive advantage and, 68–69
 defined, 46, 68
 measures of, 47
In-process quality control, 302
Integrated operating systems (IOS), 80
Intel, 105
Interlinking, 48

global digital revolution, 90
group, 137
hard *vs.* soft, 80
influence on OM, 16
manufacturing, 80–81
robots, 78, 81–82
scalability of, 88
service, 83–84
software. *See* Software
supply chain design and, 169
supply chain failures and, 170
in value chains, 84–87
Theory of Constraints (TOC), 185–187
Throughput, 130, 186
Time buckets, 195–196, 249
Time issues
 competitive advantage and, 68
 speed and variance measures, 45
 time-based competition, 14
Time phasing, 248–253
Time series, 196–197
Timken Company, 327–328
Tolerance, 98
Total productive maintenance (TPM), 325
Toyota Motor Company, 36, 104, 165
Tracking signals, 211
Trendline option, 206
Trends, 196–197, 308
TuneMan case study, 38
Two-resource sequencing, 270–274

U

Umpire schedules, 262
Under Armour, 83
United Performance Metals, 5
Unit of work, 287
University Medical Center case study, 358
Upper control limit (UCL), 290–291
UPS, 263
Utilization, 128–131

V

Value, concept of, 22–23
Value analysis, 103
Value chain integration, 30–31
Value chain model, 23–24, 53–55, 158–160
Value chains, 20–38
 backward and forward integration in, 29

at Buhrke Industries, Inc., 25–27
characteristics of global, 33–34
decisions in global, 34–36
defined, 21, 122
at Dell, Inc., 158–160
e-commerce view of, 84–85
examples of, 24, 25–27, 158–160
forecasting and, 194
global business environment and, 33–38
increasing value in, 22
integration of supply chains with, 30–31
local culture and, 36–37
model of, 23–24, 53–55, 158–160
offshoring and, 20, 31–33
operational structure of, 28
as organizational performance model, 53–55
outsourcing in, 29–30
preproduction and postproduction services in, 24–25
at Rocky Brands, Inc., 34, 35
supply chains vs., 27–28
technology in, 84–87
value concept in, 22–23
vertical integration decisions in, 28–29
Value engineering, 103
Value of a loyal customer (VLC), 48–49
Value propositions, 23
Value stream, 125–126
Value stream maps (VSM), 125–126, 127
Variants, 8, 10
Vendor-managed inventory (VMI), 170
Vertical integration, 28–29
Virtual teams, 149, 150
Visteon, 31
Visual controls, 324
"Visual factory," 187
Voice of the customer, 102
Volume flexibility, 46
Vytec Corporation, 146

W

Wait time, 45
Wal-Mart, 161, 169
Waste elimination, 322–323, 327, 329.
 See also Lean operating systems
WebVan, 88
Weyerhauser, 218
Work breakdown structure, 342
Work center load report, 253–255

Workforce. *See also* Jobs
 in aggregate planning, 241
 in capacity adjustments, 184
 diversity of, 74–75
Work-in-progress (WIP) inventory, 216–217
Workplace design, 146–148
Workstations, 140, 146–148

X

\bar{x}-charts, 306–307, 308, 309
Xerox Global Services, 355

Z

Zappos case study, 18
Zero Defects (ZD), 284
"Zhengti guannian," 37

review card

Learning Outcomes

Here you'll find a summary of the key points for each Learning Outcome.

Learning Outcomes

LO¹ Explain the concept of operations management.

Effective operations management is essential to providing high-quality goods and services that customers demand, motivating and developing the skills of the people who actually do the work, maintaining efficient operations to ensure an adequate return on investment, and protecting the environment.

LO² Describe what operations managers do.

Everyone who manages a process or some business activity should process a set of basic OM skills. OM is an integrative and interdisciplinary body of knowledge. OM skills are needed in all functional areas ~~and~~ ... ~~are, education, lodging, consulting,~~ and manufacturing ~~...~~ ...ations managers do include

- Translating mark... ...nd manage goods, services, and processes.
- Helping organiza...
- Ensuring that res... ...d information) and operations are coordinated.
- Exploiting techn...
- Building quality i...
- Determining reso...
- Creating a high p...
- Continually learn... ...global and environmental changes.

How to use this Card:

1. Look over the card to preview the new concepts you'll be introduced to in the chapter.

2. Read the chapter to fully understand the material.

3. Go to class (and pay attention).

4. Review the card one more time to make sure you've registered the key concepts.

5. Don't forget—this card is only one of many OM learning tools available to help you succeed in your operations management course.

LO³ Explain t... ...d services.

- Goods are tangib...
- Customers partic... ...ies, and transactions.
- The demand for s... ...n the demand for goods.
- Services cannot b...
- Service management skills are paramount to a successful service encounter.
- Service facilities typically need to be in close proximity to the customer.
- Patents do not protect services.

LO⁴ Describe a customer benefit package.

A CBP consists of a primary good or service, coupled with peripheral goods and/or services (see Exhibit 1.2).

Each good or service in the CBP requires a process to create and deliver it, and that is why OM skills are so important.

LO⁵ Explain three general types of processes

Exhibits

Key exhibits from the chapter as well as new exhibits are included on the Review Card to make it easier for you to study.

Key Terms 📖 ✝

These icons indicate additional learning tools on the Premium Website—in this case, flash cards and games.

LO¹

Operations managementscienc... ...service... ...fully to...

LO³

A **goo**... ...see, touch, or possibly consume.

A **durable good** ...lasts at le...

A **nond**... ...generally...

A **servi**... ...activity t... ...physical p...

A **service encounter** is an interaction between the customer and the service provider.

A **moment of truth** is any episode, transaction, or experience in which a customer comes into contact with any aspect of the delivery system, however remote, and thereby has an opportunity to form an impression.

Service management integrates marketing, human resource, and operations functions to plan, create, and deliver goods and services, and their associated service encounters.

LO⁴

A **customer benefit package (CBP)** is a clearly defined set of tangible (goods-content) and intangible (service-content) features that the customer recognizes, pays for, uses, or experiences.

Key Terms

The key terms and definitions are organized by Learning Outcome.

Exhibit 1.2 *A CBP Example for Purchasing a Vehicle*

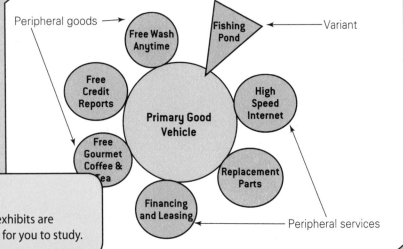

Peripheral goods → Free Wash Anytime — Fishing Pond ← Variant — Free Credit Reports — Primary Good Vehicle — High Speed Internet — Free Gourmet Coffee & Tea — Replacement Parts — Financing and Leasing — Peripheral services

Key Terms

A **primary good or service** is the "core" offering that attracts customers and responds to their basic needs.

Peripheral goods or services are those that are not essential to the primary good or service, but enhance it.

A **variant** is a CBP feature that departs from the standard CBP and is normally location- or firm-specific.

LO⁵

A **process** is a sequence of activities that is intended to create a certain result.

LO⁷

Sustainability refers to an organization's ability to strategically address current business needs and successfully develop a long-term strategy that embraces opportunities and manages risk for all products, systems, supply chains, and processes to preserve resources for future generations.

This icon indicates one or more videos available on the Premium Website to help you understand the chapter's concepts.

Boxed Features

These examples will help you connect what you are learning in class to the real world.

...ng materials and supplies, managing inventory, ...ogy acquisition, and research and development; and ...cluding accounting and information systems, ...arketing.

...evelopment of OM.

OM has evolved historically along several key themes: a focus on efficiency, quality, customization and design, time-based competition, and service (see Exhibit 1.5).

LO⁷ Describe current challenges facing OM.

Current challenges in OM include technology, globalization, changing customer expectations, and a changing workforce.

- Technology was one of the most important influences on the growth and development of OM during the second half of the 20th century. Advances in design and fabrication of goods as well as in information technology have provided the ability to develop products and enhance services that one could only dream of a few decades ago. They also enable managers to more effectively manage and control extremely complex operations.

- Globalization has changed the way companies do business and must manage their ...dvances in communications and transportation, we have passed from the ...l factories with large labor forces and tight community ties to an era of the ...place." No longer are "American" or "Japanese" products manufactured exclusively in America or Japan.

- Consumers' expectations have risen dramatically. They demand an increasing variety of products with new and improved features that meet their changing needs—products that are defect-free, have high performance, are reliable and durable, and are easy to repair; with rapid and excellent service. Companies must now compete on all these dimensions.

- Today's workers demand increasing levels of empowerment and more meaningful work. Service plays a much greater role within organizations. Finally, we live in a global business environment without boundaries.

- Today, manufacturing is truly a global management challenge in which OM plays a vital role. Companies that are persistent innovators of their global operations and supply chains create a huge competitive advantage. For such industries as recycling, genetic engineering, nano technology, green manufacturing, space technology, new ways of energy generation, and robotic medical equipment, new and exciting opportunities emerge for manufacturers. To compete, manufacturers must stay ahead of consumers' needs by increasing product innovation, speeding up time-to-market, and operating highly effective global supply chains.

- A final challenge that nearly every organization faces is sustainability. The three dimensions of sustainability are environmental, social, and economic.

Buying More than a Car

Goods and services are usually bundled together as a deliberate marketing and operations strategy. Mercedes automobiles, for example, bundle a premium good, the automobile, with many premium services. Such services include customized leasing, insurance, and warranty programs that focus on the "financial productivity" of owning a Mercedes vehicle. Other customized services bundled with the vehicle include personalized invitations to drive its new cars on a test track, a 24/7 telephone hot line, and invitations to private owner parties. Such bundling is described by the customer benefit package framework.

Source: Collier, D.A., (1994) *The Service/Quality Solution: Using Service Management to Gain Competitive Advantage*, Jointly published by ASQC Quality Press, Milwaukee, Wisconsin and Irwin Professional Publishing, Burr Ridge, Illinois, Chapter 4, pp. 63-96.

Exhibit 1.5 *Five Eras of Operations Management*

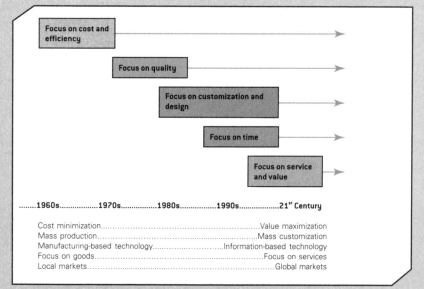

Visit **4ltrpress.cengage.com/om** for additional study tools!

Learning Outcomes

LO¹ Explain the concept of operations management.

Effective operations management is essential to providing high-quality goods and services that customers demand, motivating and developing the skills of the people who actually do the work, maintaining efficient operations to ensure an adequate return on investment, and protecting the environment.

LO² Describe what operations managers do.

Everyone who manages a process or some business activity should process a set of basic OM skills. OM is an integrative and interdisciplinary body of knowledge. OM skills are needed in all functional areas and industries as diverse as health care, education, lodging, consulting, and manufacturing. Some of the key activities that operations managers do include

- Translating market knowledge of customers to design and manage goods, services, and processes.
- Helping organizations do more with less.
- Ensuring that resources (labor, equipment, materials and information) and operations are coordinated.
- Exploiting technology to improve productivity.
- Building quality into goods, services, and processes.
- Determining resource capacity and schedules.
- Creating a high performance workplace.
- Continually learning and adapting the organization to global and environmental changes.

LO³ Explain the differences between goods and services.

- Goods are tangible while services are intangible.
- Customers participate in many service processes, activities, and transactions.
- The demand for services is more difficult to predict than the demand for goods.
- Services cannot be stored as physical inventory.
- Service management skills are paramount to a successful service encounter.
- Service facilities typically need to be in close proximity to the customer.
- Patents do not protect services.

LO⁴ Describe a customer benefit package.

A CBP consists of a primary good or service, coupled with peripheral goods and/or services (see Exhibit 1.2).

Each good or service in the CBP requires a process to create and deliver it, and that is why OM skills are so important.

LO⁵ Explain three general types of processes.

1. **Value creation processes**, focused on primary goods or services, such as assembling dishwashers or providing a home mortgage;

Key Terms

LO¹

Operations management (OM) is the science and art of ensuring that goods and services are created and delivered successfully to customers.

LO³

A **good** is a physical product that you can see, touch, or possibly consume.

A **durable good** is a product that typically lasts at least three years.

A **nondurable good** is perishable and generally lasts for less than three years.

A **service** is any primary or complementary activity that does not directly produce a physical product.

A **service encounter** is an interaction between the customer and the service provider.

A **moment of truth** is any episode, transaction, or experience in which a customer comes into contact with any aspect of the delivery system, however remote, and thereby has an opportunity to form an impression.

Service management integrates marketing, human resource, and operations functions to plan, create, and deliver goods and services, and their associated service encounters.

LO⁴

A **customer benefit package (CBP)** is a clearly defined set of tangible (goods-content) and intangible (service-content) features that the customer recognizes, pays for, uses, or experiences.

Exhibit 1.2 *A CBP Example for Purchasing a Vehicle*

Key Terms

A **primary good or service** is the "core" offering that attracts customers and responds to their basic needs.

Peripheral goods or services are those that are not essential to the primary good or service, but enhance it.

A **variant** is a CBP feature that departs from the standard CBP and is normally location- or firm-specific.

LO⁵

A **process** is a sequence of activities that is intended to create a certain result.

LO⁷

Sustainability refers to an organization's ability to strategically address current business needs and successfully develop a long-term strategy that embraces opportunities and manages risk for all products, systems, supply chains, and processes to preserve resources for future generations.

Buying More than a Car

Goods and services are usually bundled together as a deliberate marketing and operations strategy. Mercedes-Benz automobiles, for example, bundle a premium good, the automobile, with many premium services. Such services include customized leasing, insurance, and warranty programs that focus on the "financial productivity" of owning a Mercedes vehicle. Other customized services bundled with the vehicle include personalized invitations to drive new cars on a test track, a 24/7 telephone hot line, and invitations to private owner parties. Such bundling is described by the customer benefit package framework.

Source: Collier, D.A., (1994) *The Service/Quality Solution: Using Service Management to Gain Competitive Advantage*, Jointly published by ASQC Quality Press, Milwaukee, Wisconsin and Irwin Professional Publishing, Burr Ridge, Illinois, Chapter 4, pp. 63-96.

Exhibit 1.5 *Five Eras of Operations Management*

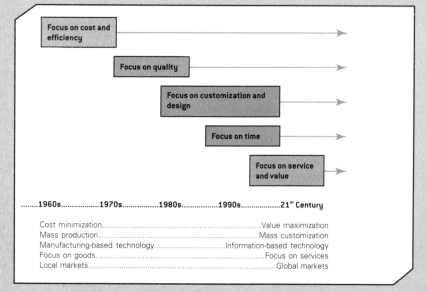

2. **Support processes**, such as purchasing materials and supplies, managing inventory, installation, customer support, technology acquisition, and research and development; and

3. **General management processes**, including accounting and information systems, human resource management, and marketing.

LO⁶ Summarize the historical development of OM.

OM has evolved historically along several key themes: a focus on efficiency, quality, customization and design, time-based competition, and service (see Exhibit 1.5).

LO⁷ Describe current challenges facing OM.

Current challenges in OM include technology, globalization, changing customer expectations, and a changing workforce.

- Technology was one of the most important influences on the growth and development of OM during the second half of the 20th century. Advances in design and fabrication of goods as well as in information technology have provided the ability to develop products and enhance services that one could only dream of a few decades ago. They also enable managers to more effectively manage and control extremely complex operations.

- Globalization has changed the way companies do business and must manage their operations. With advances in communications and transportation, we have passed from the era of huge regional factories with large labor forces and tight community ties to an era of the "borderless marketplace." No longer are "American" or "Japanese" products manufactured exclusively in America or Japan.

- Consumers' expectations have risen dramatically. They demand an increasing variety of products with new and improved features that meet their changing needs—products that are defect-free, have high performance, are reliable and durable, and are easy to repair; with rapid and excellent service. Companies must now compete on all these dimensions.

- Today's workers demand increasing levels of empowerment and more meaningful work. Service plays a much greater role within organizations. Finally, we live in a global business environment without boundaries.

- Today, manufacturing is truly a global management challenge in which OM plays a vital role. Companies that are persistent innovators of their global operations and supply chains create a huge competitive advantage. For such industries as recycling, genetic engineering, nano technology, green manufacturing, space technology, new ways of energy generation, and robotic medical equipment, new and exciting opportunities emerge for manufacturers. To compete, manufacturers must stay ahead of consumers' needs by increasing product innovation, speeding up time-to-market, and operating highly effective global supply chains.

- A final challenge that nearly every organization faces is sustainability. The three dimensions of sustainability are environmental, social, and economic.

Learning Outcomes

LO¹ Explain the concept of value and how it can be increased.

The decision to purchase a good or service or a customer benefit package is based on an assessment by the customer of the perceived benefits in relation to its price. One of the simplest functional forms of value is:

Value = Perceived benefits/Price (cost) to the customer

To increase value, an organization must (a) increase perceived benefits while holding price or cost constant, (b) increase perceived benefits while reducing price or cost, or (c) decrease price or cost while holding perceived benefits constant.

LO² Describe a value chain and the two major perspectives that characterize it.

The value chain begins with suppliers. Inputs are transformed into value-added goods and services through processes or networks of work activities. The value chain outputs—goods and services—are delivered or provided to customers and targeted market segments.

The first perspective of a value chain is input/output model of operations in which suppliers provide inputs to a goods-producing or service-providing process or network of processes (see Exhibit 2.1).

The second perspective is the pre- and postproduction service view that focuses on gaining the customer and keeping the customer (see Exhibit 2.3).

LO³ Describe a supply chain and how it differs from a value chain.

A value chain is broader in scope than a supply chain, and encompasses all pre- and postproduction services to create and deliver the entire customer benefit package. A value chain views an organization from the customer's perspective while a supply chain is more internally focused on the creation of physical goods.

LO⁴ Discuss key value chain decisions.

- Operational structure—Wal-Mart centralizes purchasing while each business at G. E. is a profit center.

Key Terms

LO¹

A **value chain** is a network of facilities and processes that describes the flow of goods, services, information, and financial transactions from suppliers through the facilities and processes that create goods and services and deliver them to customer.

Value is the perception of the benefits associated with a good, service, or bundle of goods and services (i.e., the customer benefit package) in relation to what buyers are willing to pay for them.

A competitively dominant customer experience is often called a **value proposition**.

LO³

A **supply chain** is the portion of the value chain that focuses primarily on the physical movement of goods and materials, and supporting flows of information and financial transactions through the supply, production, and distribution processes.

LO⁴

The **operational structure** of a value chain is the configuration of resources such as suppliers, factories, warehouses, distributors, technical support centers, engineering design and sales offices, and communication links.

Vertical integration refers to the process of acquiring and consolidating elements of a value chain to achieve more control.

Exhibit 2.1 *The Value Chain*

Exhibit 2.3 *Pre- and Postservice View of the Value Chain*

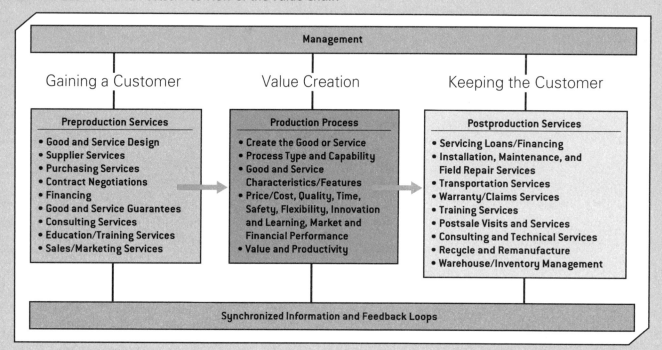

Key Terms

Outsourcing is the process of having suppliers provide goods and services that were previously provided internally.

Backward integration refers to acquiring capabilities at the front-end of the supply chain (for instance, suppliers).

Forward integration refers to acquiring capabilities toward the back-end of the supply chain (for instance, distribution or even customers).

Value chain integration is the process of managing information, physical goods, and services to ensure their availability at the right place, at the right time, at the right cost, at the right quantity, and with the highest attention to quality.

LO⁵

Offshoring is the building, acquiring, or moving of process capabilities from a domestic location to another country location while maintaining ownership and control.

LO⁶

A **multinational enterprise** is an organization that sources, markets, and produces its goods and services in several countries to minimize costs, and to maximize profit, customer satisfaction, and social welfare.

- Vertical integration—Today's automotive supply chain is less vertically-integrated than Henry Ford's early factories.

- Outsourcing—Some large banks and airlines have outsourced their telephone call centers.

- Value chain integration—Orbitz helps integrate the travel industry while Wal-Mart manages their value chain themselves.

LO⁵ Explain offshoring and the key issues associated with it.

Offshoring decisions involve determining what primary, support and/or management processes should move to other countries. The decision to offshore or outsource involves a variety of economic and noneconomic issues.

LO⁶ Identify important issues associated with value chains in a global business environment.

- Global supply chains face higher levels of risk and uncertainty, requiring more inventory and day-to-day monitoring to prevent product shortages.

- Transportation is more complex in global value chains as they often involve more than one mode and foreign company.

- The transportation infrastructure may vary considerably in foreign countries.

- Global purchasing can be a difficult process to manage when sources of supply, regional economies, and even governments change.

- International purchasing can lead to disputes and legal challenges relating to such things as price fixing and quality defects.

- Privatizing companies and property affect trade and regulatory issues.

- Cultural differences must be understood in designing, implementing, and managing operations and logistics.

- Managers must consider questions such as: Why go global? How do markets and competition differ? What functions are necessary? Who will do the work? and many more.

Learning Outcomes

Key Terms

LO¹ Describe the types of measures used for decision making.

Performance measures can be classified into several key categories:

- Financial
- Customer and Market
- Safety
- Quality
- Time
- Flexibility
- Innovation and Learning

Exhibit 3.1 *The Scope of Business and Operations Performance Measurement*

Performance Measurement Category	Typical Organizational-Level Performance Measures	Typical Operational-Level Performance Measures
Financial	Revenue and profit Return on assets Earnings per share	Labor and material costs Cost of quality Budget variance
Customer and market	Customer satisfaction Customer retention Market share	Customer claims and complaints Type of warranty failure/upset Sales forecast accuracy
Safety	Number of accidents/injuries Lost workdays	Safety audit score Workplace safety violations
Quality	Goods quality Service quality Environmental quality	Defects/unit Call center courtesy Toxic waste discharge rate
Time	Speed Reliability	Flow (processing or cycle) time Percent of time meeting promise (due) date
Flexibility	Design flexibility Volume flexibility	Number of engineering changes Assembly line changeover time
Innovation and learning	New product development rates Employee satisfaction Employee turnover	Number of patent applications Number of improvement suggestions implemented Percent of workers trained on statistical process control

LO² Explain how to calculate and use productivity measures.

Productivity = Quantity of Output/Quantity of Input [3.1]

As output increases for a constant level of input, or as the amount of input decreases for a constant level of output, productivity increases. Thus, a productivity measure describes how well the resources of an organization are being used to produce output. Productivity measures are often used to track trends over time.

LO³ Explain how internal and external measures are related.

Cause and effect linkages between key measures of performance often explain the impact of (internal) operational performance on external results, such as profitability, market share, or customer satisfaction. For example, how do goods- and service-quality improvements impact revenue growth? How do improvements in complaint handling affect customer retention? How do increases or decreases in processing time affect customer satisfaction? How do changes in customer satisfaction affect costs and revenues?

The Value of a Loyal Customer (VLC) also provides an understanding of how customer satisfaction and loyalty affect the bottom line. Understanding the effects of operational decisions on revenue and customer retention can help organizations more appropriately use their resources. VLC is computed using the following formula:

LO¹

Measurement is the act of quantifying the performance criteria (metrics) of organizational units, goods and services, processes, people, and other business activities.

An effective **customer-satisfaction measurement system** provides a company with customer ratings of specific goods and service features and indicates the relationship between those ratings and the customer's likely future buying behavior.

Quality measures the degree to which the output of a process meets customer requirements.

Goods quality relates to the physical performance and characteristics of a good.

Service quality is consistently meeting or exceeding customer expectations (external focus) and service delivery system performance (internal focus) for all service encounters.

Errors in service creation and delivery are sometimes called **service upsets** or **service failures**.

Environmental quality focuses on designing and controlling work processes to improve the environment.

Processing time is the time it takes to perform some task.

Queue time is a fancy word for **wait time**—the time spent waiting.

Flexibility is the ability to adapt quickly and effectively to changing requirements.

Goods and service design flexibility is the ability to develop a wide range of customized goods or services to meet different or changing customer needs.

Volume flexibility is the ability to respond quickly to changes in the volume and type of demand.

Innovation refers to the ability to create new and unique goods and services that delight customers and create competitive advantage.

Learning refers to creating, acquiring, and transferring knowledge, and modifying the behavior of employees in response to internal and external change.

Key Terms

LO²

Productivity is the ratio of output of a process to the input.

LO³

The quantitative modeling of cause-and-effect relationships between external and internal performance criteria is called **interlinking**.

The **value of a loyal customer (VLC)** quantifies the total revenue or profit each target market customer generates over some time frame.

LO⁴

Actionable measures provide the basis for decisions at the level at which they are applied.

$$VLC = (P)(CM)(RF)(BLC) \qquad [3.2]$$

where P = the revenue per unit

CM = contribution margin to profit and overhead expressed as a fraction (i.e., 0.45, 0.5, and so on).

RF = repurchase frequency = number of purchases per year

BLC = buyer's life cycle, computed as 1/defection rate, expressed as a fraction (1/0.2 = 5 years, 1/0.1 = 10 years, and so on).

By multiplying the VLC times the absolute number of customers gained or lost, the total market value can be found.

LO⁴ Explain how to design a good performance measurement system.

Good performance measures are actionable. They should be meaningful to the user, timely, and reflect how the organization generates value to customers. Performance measures should support, not conflict with, customer requirements. IBM Rochester, for example, asks the following questions:

- Does the measurement support our mission?
- Will the measurement be used to manage change?
- Is it important to our customers?
- Is it effective in measuring performance?
- Is it effective in forecasting results?
- Is it easy to understand/simple?
- Is the data easy/cost-efficient to collect?
- Does the measurement have validity, integrity, and timeliness?
- Does the measure have an owner?

Exhibit 3.3 *Malcolm Baldrige National Quality Award Model of Organizational Performance*

Source: 2006 Malcolm Baldrige National Quality Award Criteria, U.S. Dept. of Commerce

LO⁵ Describe four models of organizational performance.

Four models of organizational performance—the Malcolm Baldrige National Quality Award framework, the Balanced Scorecard, the Value Chain model, and the Service-Profit Chain—provide popular frameworks for thinking about designing, monitoring, and evaluating performance. The first two models provide more of a "big picture" of organizational performance, while the last two provide more detailed frameworks for operations managers.

Electronic Airline Ticketing—Fast and Less Cost

Paper tickets cost airlines $10 to $17, on average, compared with $1 or less for electronic tickets. As a result, some airlines charge hefty fees for paper tickets and are encouraging customers to use electronic tickets instead. A fully electronic ticketing system will save the U.S. airline industry $3 billion a year. Electronic ticketing also lets airlines record revenue more quickly on their balance sheets and track revenue patterns. Airlines used to have to bundle and ship paper tickets to a processing facility that took weeks to process, but it now takes seconds. Also, boarding passes can be printed at home at the customer's expense and speed up the check-in process at airports.

Source: "Farewell, Paper Airline Tickets," *The News-Press*, Fort Myers, Florida, September 12, 2007, p. B2.

Learning Outcomes

LO¹ Explain how organizations seek to gain competitive advantage.

Creating a competitive advantage requires a fundamental understanding of two things. First, management must understand customer wants and needs—and how the value chain can best meet these needs through the design and delivery of customer benefit packages that are attractive to customers. Second, management must build and leverage operational capabilities to support desired competitive priorities.

LO² Explain approaches for understanding customer requirements.

To correctly identify what customers expect requires being "close to the customer." There are many ways to do this, such as having employees visit and talk to customers, having managers talk to customers, and doing formal marketing research. The Kano model helps to differentiate between basic customer needs, expressed needs, and the "wow" features that can often be order winners.

LO³ Describe how customers evaluate goods and services.

Research suggests that customers use three types of attributes in evaluating the quality of goods and services: search, experience, and credence. This classification has several important implications for operations. For example, the most important search and experience attributes should be evaluated during design, measured during manufacturing, and drive key operational controls to ensure that they are built into the good with high quality. Credence attributes stem from the nature of services, the design of the service system, and the training and expertise of the service-providers.

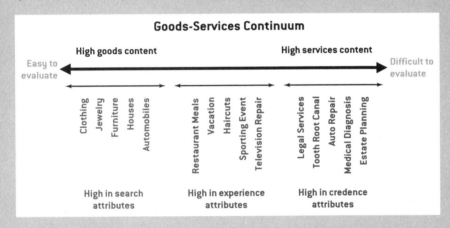

LO⁴ Explain the five key competitive priorities.

Five key competitive priorities are:

1. Cost—Many firms gain competitive advantage by establishing themselves as the low-cost leader in an industry.
2. Quality—Quality is positively and significantly related to a higher return on investment for almost all kinds of market situations.
3. Time—Customers demand quick response, short waiting times, and consistency in performance.
4. Flexibility—Success in globally competitive markets requires a capacity for both design and demand flexibility.
5. Innovation—Many firms focus on research and development for innovation as a core component of their strategy.

Key Terms

LO¹

Competitive advantage denotes a firm's ability to achieve market and financial superiority over its competitors.

LO²

Dissatisfiers: requirements that are expected in a good or service.

Satisfiers: requirements that customers say they want.

Exciters/delighters: new or innovative good or service features that customers do not expect.

Basic customer expectations—dissatisfiers and satisfiers—are generally considered the minimum performance level required to stay in business and are often called **order qualifiers**.

Order winners are goods and service features and performance characteristics that differentiate one customer benefit package from another, and win the customer's business.

LO³

Search attributes are those that a customer can determine prior to purchasing the goods and/or services.

Experience attributes are those that can be discerned only after purchase or during consumption or use.

Credence attributes are any aspects of a good or service that the customer must believe in, but cannot personally evaluate even after purchase and consumption.

LO⁴

Competitive priorities represent the strategic emphasis that a firm places on certain performance measures and operational capabilities within a value chain.

Mass customization is being able to make whatever goods and services the customer wants, at any volume, at any time for anybody, and for a global organization, from any place in the world.

Innovation is the discovery and practical application or commercialization of a device, method, or idea that differs from existing norms.

Key Terms

Strategy is a pattern or plan that integrates an organization's major goals, policies, and action sequences into a cohesive whole.

Core competencies are the strengths that are unique to an organization.

An **operations strategy** defines how an organization will execute its chosen business strategies.

LO⁵ Explain the role of OM and operations strategy in strategic planning.

Developing an operations strategy involves translating competitive priorities into operational capabilities by making a variety of choices and trade-offs for design and operating decisions. That is, operating decisions must be aligned with achieving the desired competitive priorities. For example, if corporate objectives are to be the low-cost and mass-market producer of a good, then adopting an assembly-line type of process is how operations can help achieve this corporate objective. How operations are designed and implemented can have a dramatic effect on business performance and achievement of the strategy. Therefore, operations require close coordination with functional strategies in other areas of the firm, such as marketing and finance. An operations strategy should exploit an organization's core competencies, such as a particularly skilled or creative workforce, customer relationship management, clever bundling of goods and services, strong supply chain networks, extraordinary service, marketing expertise, or the ability to rapidly develop new products or change production-output rates.

Exhibit 4.3 *Hill's Strategy Development Framework*

Corporate Objectives	Marketing Strategy	How Do Goods and Services Qualify and Win Orders in the Marketplace? (Competitive Priorities)	Operations Strategy	
			Operations Design Choices	Infrastructure
• Growth • Survival • Profit • Return on investment • Other market and financial measures • Social welfare	• Goods and services markets and segments • Range • Mix • Volumes • Standardization versus customization • Level of innovation • Leader versus follower alternatives	• Safety • Price (cost) • Range • Flexibility • Demand • Goods and service design • Quality • Service • Goods • Environment • Brand image • Delivery • Speed • Variability • Technical support • Pre- and postservice support	• Type of processes and alternative designs • Supply chain integration and outsourcing • Technology • Capacity and facilities (size, timing, location) • Inventory • Trade-off analysis	• Work force • Operating plans and control system(s) • Quality control • Organizational structure • Compensation system • Learning and innovation systems • Support services

Source: T. Hill, *Manufacturing Strategy: Text and Cases*, 3rd ed., Burr Ridge, IL: McGraw-Hill, 2000, p. 32 and T. Hill, *Operations Management: Strategic Context and Managerial Analysis*, 2nd ed. Prigrame MacMillan, 2005, p. 50. Reprinted with permission from the McGraw-Hill Companies.

Operations design choices are the decisions management must make as to what type of process structure is best suited to produce goods or create services.

Infrastructure focuses on the nonprocess features and capabilities of the organization and includes the workforce, operating plans and control systems, quality control, organizational structure, compensation systems, learning and innovation systems, and support services.

LO⁶ Describe Hill's framework for operations strategy.

Hill's framework defines the essential elements of an effective operations strategy in the last two columns—operations design choices and building the right infrastructure. A key feature of this framework is the link between operations and corporate and marketing strategies. This linkage is described by the four major decision loops that link together the elements of the framework (See Exhibit 4.4).

Exhibit 4.4 *Four Key Decision Loops in Terry Hill's Generic Strategy Framework*

Visit **4ltrpress.cengage.com/om** for additional study tools!

Learning Outcomes

LO¹ Describe different types of technology and their role in manufacturing and service operations.

Some examples of hard technology are computers, computer chips and microprocessors, optical switches and communication lines, satellites, sensors, robots, automated machines, and RFID tags. Some examples of soft technology are database systems, artificial intelligence programs, and voice-recognition software. Computer integrated manufacturing systems (CIMS) play an important role in modern manufacturing.

All organizations face common issues regarding technology:

- The right technology must be selected for the goods that are produced.
- Process resources such as machines and employees must be set up and configured in a logical fashion to support production efficiency.
- Labor must be trained to operate the equipment.
- Process performance must be continually improved.
- Work must be scheduled to meet shipping commitments/customer promise dates.
- Quality must be ensured.

LO² Explain how manufacturing and service technology is strengthening the value chain.

With all the new technology that has evolved, a new perspective and capability for the value chain has emerged—the *e-commerce view of the value chain*. This includes business-to-business (B2B), business-to-customer (B2C), customer-to-customer (C2C) value chains, and government to customer (G2C); some examples are GE Plastics, Federal Express, and eBay, respectively.

Exhibit 5.1 *E-Commerce View of the Value Chain*

Key Terms

LO¹

Hard technology refers to equipment and devices that perform a variety of tasks in the creation and delivery of goods and services.

Soft technology refers to the application of the Internet, computer software, and information systems to provide data, information, and analysis and to facilitate the accomplishment of creating and delivering goods and services.

Computer-integrated manufacturing systems (CIMS) represent the union of hardware, software, database management, and communications to automate and control production activities from planning and design to manufacturing and distribution.

Numerical control (NC) machine tools enable the machinist's skills to be duplicated by a programmable device (originally punched paper tape) that controls the movements of a tool used to make complex shapes.

A **robot** is a programmable machine designed to handle materials or tools in the performance of a variety of tasks.

When **computer numerical control (CNC)** machines are used, the operations are driven by a computer.

Computer-aided design/computer-aided engineering **(CAD/CAE)** enables engineers to design, analyze, test, simulate, and "manufacture" products before they physically exist, thus ensuring that a product can be manufactured to specifications when it is released to the shop floor.

Computer-aided manufacturing **(CAM)** involves computer control of the manufacturing process, such as determining tool movements and cutting speeds.

Flexible manufacturing systems (FMS) consist of two or more computer-controlled machines or robots linked by automated handling devices such as transfer machines, conveyors, and transport systems. Computers direct the overall sequence of operations and route the work to the appropriate machine, select and load the proper tools, and control the operations performed by the machine.

E-service refers to using the Internet and technology to provide services that create and deliver time, place, information, entertainment, and exchange value to customers and/or support the sale of goods.

Key Terms

LO²

An **intermediary** is any entity—real or virtual—that coordinates and shares information between buyers and sellers.

Return facilitators specialize in handling all aspects of customers returning a manufactured good or delivered service and requesting their money back, repairing the manufactured good and returning it to the customer, and/or invoking the service guarantee.

Enterprise resource planning (ERP) systems integrate all aspects of a business—accounting, customer relationship management, supply chain management, manufacturing, sales, human resources—into a unified information system and provide more timely analysis and reporting of sales, customer, inventory, manufacturing, human resource, and accounting data.

Customer relationship management (CRM) is a business strategy designed to learn more about customers' wants, needs, and behaviors in order to build customer relationships and loyalty and ultimately enhance revenues and profits.

LO³

Scalability is a measure of the contribution margin (revenue minus variable costs) required to deliver a good or service as the business grows and volumes increase.

High scalability is the capability to serve additional customers at zero or extremely low incremental costs.

Low scalability implies that serving additional customers requires high incremental variable costs.

LO³ Explain the benefits and challenges of using technology.

The goal of the operations manager is to provide the best synthesis of technology, people, and processes; this interaction is often called the *sociotechnical system*.

Scalability is also a key issue in chains succeed or fail. OM decisions affect the ability to handle changes in demand and variable costs, and therefore, the scalability of a firm's processes and value chain. Monster.com and the failed WebVan are examples of high and low scalability.

LO⁴ Describe the processes of technology development and adoption.

Technology development and adoption generally has three stages—birth, turbulence, and build-out. During the birth stage, design and demand flexibility are critical for gaining a competitive advantage. During the turbulence stage, the objective is to consolidate resources and marketplace advantages and work on building technical and operational capability. The final stage—build-out—is where operational capability becomes the key to a winning competitive strategy. This capability can be realized with a well-synchronized value chain having coordinated physical and information flows.

Exhibit 5.2 *Example Benefits and Challenges of Adopting Technology*

Benefits	Challenges
Creates new industries and job opportunities	Higher employee skill levels required, such as information technology and service management skills
Restructures old and less productive industries	Integration of old (legacy) and new technology and systems
Integrates supply and value chain players	Job shift and displacement
Increases marketplace competitiveness and maintains the survival of the firm	Less opportunity for employee creativity and empowerment
Provides the capability to focus on smaller target market segments (customize)	Protecting the employee's and customer's privacy and security
Improves/increases productivity, quality and customer satisfaction, speed, safety, and flexibility/customization—does more with less	Fewer human service providers resulting in customer ownership not being assigned, nonhuman service encounters, and inability of the customer to change decisions and return goods easily
Lowers cost	Information overload
Raises world's standard of living	Global outsourcing and impact on domestic job opportunities

The WebVan Failure

One dot.com company, WebVan, focused on customers' ordering their groceries on-line and then picking up the orders in a warehouse and delivering them to the customers' homes. The idea was to support the order-pick-pack-deliver process of acquiring groceries through an e-service at the front end of the value chain and with delivery vans at the back end of the value chain. This service made several assumptions about customer wants and needs; for example, that customers have perfect knowledge of what they want when they surf the on-line catalogs; that customers would be home when the delivery arrived; that what the e-catalogue shows is what the customer will get; that the customer doesn't make mistakes when selecting the items; and that time-starved customers are willing to pay a high premium for home delivery. Unfortunately, this was a very high cost process. The $30 to $40 delivery charge for complex and heterogeneous customer orders and the many opportunities for error doomed WebVan. The founders of WebVan did not clearly define their strategy and target market and properly evaluate the operational and logistical issues associated with their value chain design. WebVan designed their system with low scalability and limited growth potential.

Learning Outcomes

LO¹ Describe the steps involved in designing goods and services.

Exhibit 6.1 *An Integrated Framework for Goods and Service Design*

LO² Explain the concept of robust design and the Taguchi loss function.

The Taguchi loss function is a reaction to the *goal post model of* conforming to specifications. Taguchi's approach assumes that the smaller the variation about the nominal specification, the better is the quality. In turn, products are more consistent, and total costs are less. Taguchi measured quality as the variation from the target value of a design specification and then translated that variation into an economic "loss function" that expresses the cost of variation in monetary terms. The loss function is represented by

$$L(x) = k(x - T)^2 \qquad [6.1]$$

LO³ Explain how to calculate system reliability.

If the individual reliabilities are denoted by p_1, p_2, \ldots, p_n and the system reliability is denoted by R_s, then for a series system,

$$R_s = (p_1)(p_2)(p_3) \ldots (p_n) \quad [6.2]$$

The system reliability of an n-component parallel system is computed as

$$R_p = 1 - (1 - p_1)(1 - p_2)(1 - p_3) \ldots (1 - p_n) \quad [6.3]$$

To compute the reliability of systems that include combinations of series and parallel components, *first* compute the reliability of the parallel components and treat the result as a single series component; *then* use the series reliability formula to compute the reliability of the resulting series system.

Key Terms

LO²

Goods that are insensitive to external sources of variation are called **robust**.

LO³

Reliability is the probability that a manufactured good, piece of equipment, or system performs its intended function for a stated period of time under specified operating conditions.

LO⁴

Quality function deployment (QFD) is both a philosophy and a set of planning and communication tools that focus on customer requirements in coordinating the design, manufacturing, and marketing of goods or services.

Customer requirements, as expressed in the customer's own terms, are called the **voice of the customer**.

LO⁵

Prototype testing is the process by which a model (real or simulated) is constructed to test the good's physical properties or use under actual operating conditions, as well as consumer reactions to the prototypes.

Quality engineering refers to a process of designing quality into a manufactured good based on a prediction of potential quality problems prior to production.

Value engineering refers to cost avoidance or cost prevention before the good or service is created.

Value analysis refers to cost reduction of the manufactured good or service process.

Failure-mode-and-effects analysis (FMEA) is a technique in which each component of a product is listed along with the way it may fail, the cause of failure, the effect or consequence of failure, and how it can be corrected by improving the design.

Product and process simplification is the process of trying to simplify designs to reduce complexity and costs and thus improve productivity, quality, flexibility, and customer satisfaction.

A focus on improving the environment by better good or service design is often called **green manufacturing** or **green practices**.

Key Terms

Design for Environment (DfE) is the explicit consideration of environmental concerns during the design of goods, services, and processes and includes such practices as designing for recycling and disassembly.

LO⁶

Service delivery system design includes facility location and layout, the servicescape, service process and job design, technology and information support systems, and organizational structure.

The **servicescape** is all the physical evidence a customer might use to form an impression. The servicescape also provides the behavioral setting where service encounters take place.

Some servicescapes, termed **lean servicescape environments**, are very simple. More complicated structures and service systems are termed **elaborate servicescape environments**.

Service process design is the activity of developing an efficient sequence of activities to satisfy both internal and external customer requirements

LO⁷

Service encounter design focuses on the interaction, directly or indirectly, between the service-provider(s) and the customer.

Customer contact refers to the physical or virtual presence of the customer in the service delivery system during a service experience.

Systems in which the percentage is high are called **high-contact systems**; those in which it is low are called **low-contact systems**.

Customer-contact requirements are measurable performance levels or expectations that define the quality of customer contact with representatives of an organization.

Empowerment simply means giving people authority to make decisions based on what they feel is right, to have control over their work, to take risks and learn from mistakes, to promote change.

A **service upset** is any problem a customer has—real or perceived—with the service delivery system and includes terms such as service failure, error, defect, mistake, or crisis.

Service recovery is the process of correcting a service upset and satisfying the customer.

A **service guarantee** is a promise to reward and compensate a customer if a service upset occurs during the service experience.

LO⁴ Explain the concept and application of quality function deployment.

QFD focuses on turning the voice of the customer into specific technical requirements that characterize a design and provide the "blueprint" for manufacturing or service delivery.

The process is initiated with a matrix, which because of its structure is often called the House of Quality (see Exhibit 6.8 and the Building a Better Pizza box).

Building a House of Quality begins by identifying the voice of the customer and technical features of the design. The roof of the House of Quality shows the interrelationships between any pair of technical features, and these relationships help in answering questions such as "How does a change in one product characteristic affect others?" Next, a relationship matrix between the customer requirements and the technical features is developed. The next step is to add market evaluation and key selling points. Next, technical features of competitive products are evaluated and targets are developed. The final step is to select technical features that have a strong relationship to customer needs, have poor competitive performance, or are strong selling points. Those characteristics will need to be "deployed," or translated into the language of each function in the design and process, so that proper actions and controls are taken to ensure that the voice of the customer is maintained. Characteristics that are not identified as critical do not need such rigorous attention.

LO⁵ Describe methods for designing goods.

For a manufactured good, the detailed design process begins by determining marketing and technical specifications. This step typically involves engineers who translate a concept into blueprints and select materials or purchased components. Key methods include quality engineering, FMEA, product and process simplification, and design for environmental quality.

LO⁶ Explain the five elements of service delivery system design.

Service delivery system design includes facility location and layout, the servicescape, service process and job design, technology and information support systems, and organizational structure. A servicescape has three principal dimensions:

1. *Ambient conditions*, which are manifest by sight, sound, smell, touch, and temperature.
2. *Spatial layout and functionality*—how furniture, equipment, and office spaces are arranged.
3. *Signs, symbols, and artifacts*—the more explicit signals that communicate an image about a firm.

Service process designers must concentrate on developing procedures to ensure that things are done right the first time, that interactions are simple and quick, and that human error is avoided.

LO⁷ Describe the four elements of service encounter design.

The principal elements of service encounter design are customer contact behavior and skills; service-provider selection, development, and empowerment; recognition and reward; and service recovery and guarantees.

Service guarantees are offered prior to the customer buying or experiencing the service and help to minimize the risk to the customer. Service recovery normally occurs after a service upset and may require free meals, discount coupons, or a simple apology.

LO⁸ Explain how goods and service design concepts are integrated at LensCrafters.

Managers at LensCrafters must understand both the goods and service sides of the business to be successful. Complex customer benefit packages require complex operating systems. To design and manage the LensCrafters' processes, an understanding of OM is a critical skill.

Learning Outcomes

LO¹ Describe the four types of processes used to produce goods and services.

Four principal types of processes are used to produce goods and services (See Exhibit 7.1):

1. projects,
2. job shop processes,
3. flow shop processes, and
4. continuous flow processes.

LO² Explain the logic and use of the product-process matrix.

The most appropriate match between type of product and type of process occurs along the diagonal in the product-process matrix (see Exhibit 7.2). As one moves down the diagonal, the emphasis on both product and process structure shifts from low volume and high flexibility, to higher volumes and more standardization.

LO³ Explain the logic and use of the service-positioning matrix.

The SPM focuses on the service encounter level and helps management design a service system that best meets the technical and behavioral needs of customers (see Exhibit 7.3). The position along the horizontal axis is described by the sequence of service encounters. The SPM is similar to the product-process matrix in that it suggests that the nature of the customer's desired service encounter activity sequence should lead to the most appropriate service system design and that superior performance results from generally staying along the diagonal of the matrix. Like the product-process matrix, organizations that venture too far off the diagonal create a mismatch between service system characteristics and desired activity sequence characteristics. As we move down the diagonal of the SPM, the service encounter activity sequence becomes less unique and more repeatable with fewer pathways. Like the product-process matrix, the midrange portion of the matrix contains a broad range of intermediate design choices.

LO⁴ Describe how to apply process and value stream mapping for process design.

Designing a goods-producing or service-providing process requires six major activities:

1. Define the purpose and objectives of the process.
2. Create a detailed process or value stream map that describes how the process is currently performed.
3. Evaluate alternative process designs.
4. Identify and define appropriate performance measures for the process.
5. Select the appropriate equipment and technology.
6. Develop an implementation plan to introduce the new or revised process design.

A process map documents how work either is, or should be, accomplished and how the transformation process creates value. We usually first develop a "baseline" map of how the current process operates in order to understand it and identify improvements for redesign. In service applications, flowcharts generally highlight the points of contact with the customer and are often called *service blueprints* or *service maps*. Such flowcharts often show the separation between the back office and the front office with a "line of customer visibility." A value stream map (VSM) shows the process flows in a manner similar to an ordinary process map; however, the difference lies in that value stream maps highlight value-added versus non-value-added activities and include costs associated with work activities for both value- and non-value-added activities (see Exhibits 7.4 to 7.7).

Key Terms

LO¹

Custom, or **make-to-order**, **goods and services** are generally produced and delivered as one-of-a-kind or in small quantities, and are designed to meet specific customers' specifications.

Option, or **assemble-to-order**, **goods and services** are configurations of standard parts, subassemblies, or services that can be selected by customers from a limited set.

Standard, or **make-to-stock**, **goods and services** are made according to a fixed design, and the customer has no options from which to choose.

Projects are large-scale, customized initiatives that consist of many smaller tasks and activities that must be coordinated and completed to finish on time and within budget.

Job shop processes are organized around particular types of general-purpose equipment that are flexible and capable of customizing work for individual customers.

Flow shop processes are organized around a fixed sequence of activities and process steps, such as an assembly line to produce a limited variety of similar goods or services.

Continuous flow processes create highly standardized goods or services, usually around the clock in very high volumes.

LO²

The **product-process matrix** is a model that describes the alignment of process choice with the characteristics of the manufactured good.

LO³

A **pathway** is a unique route through a service system.

Customer-routed services are those that offer customers broad freedom to select the pathways that are best suited for their immediate needs and wants from many possible pathways through the service delivery system.

Provider-routed services constrain customers to follow a very small number of possible and predefined pathways through the service system.

Key Terms

The **service encounter activity sequence** consists of all the process steps and associated service encounters necessary to complete a service transaction and fulfill a customer's wants and needs.

A **product life cycle** is a characterization of product growth, maturity, and decline over time.

LO⁴

A **task** is a specific unit of work required to create an output.

An **activity** is a group of tasks needed to create and deliver an intermediate or final output.

A **process** consists of a group of activities, and a **value chain** is a network of processes.

A **process map (flowchart)** describes the sequence of all process activities and tasks necessary to create and deliver a desired output or outcome.

A **process boundary** is the beginning or end of a process.

The **value stream** refers to all value-added activities involved in designing, producing, and delivering goods and services to customers.

LO⁵

Reengineering has been defined as "the fundamental rethinking and radical redesign of business processes to achieve dramatic improvements in critical, contemporary measures of performance, such as cost, quality, service, and speed."

LO⁶

Utilization is the fraction of time a workstation or individual is busy over the long run.

The average number of entities completed per unit time—the output rate—from a process is called **throughput**.

A **bottleneck** is the work activity that effectively limits throughput of the entire process.

Flow time, or **cycle time**, is the average time it takes to complete one cycle of a process.

LO⁵ Explain how to improve process designs and analyze process maps.

Management strategies to improve process designs usually focus on one or more of the following:

- *increasing revenue* by improving process efficiency in creating goods and services and delivery of the customer benefit package;
- *increasing agility* by improving flexibility and response to changes in demand and customer expectations;
- *increasing product and/or service quality* by reducing defects, mistakes, failures, or service upsets;
- *decreasing costs* through better technology or elimination of non-value-added activities;
- *decreasing process flow time* by reducing waiting time or speeding up movement through the process and value chain.

Key improvement questions include:

- Are the steps in the process arranged in logical sequence?
- Do all steps add value? Can some steps be eliminated and should others be added in order to improve quality or operational performance? Can some be combined? Should some be reordered?
- Are capacities of each step in balance; that is, do bottlenecks exist for which customers will incur excessive waiting time?
- What skills, equipment, and tools are required at each step of the process? Should some steps be automated?
- At which points in the system might errors occur that would result in customer dissatisfaction, and how might these errors be corrected?
- At which point or points should performance be measured?
- Where interaction with the customer occurs, what procedures and guidelines should employees follow that will present a positive image?

LO⁶ Describe how to compute resource utilization and apply Little's Law.

Two ways of computing resource utilization are defined by equations 7.1 and 7.2:

$$\text{Utilization } (U) = \text{Resources Used/Resources Available} \qquad [7.1]$$

$$\text{Utilization } (U) = \text{Demand Rate/[Service Rate} \times \text{Number of Servers]} \qquad [7.2]$$

Little's Law is a simple formula defined by equation 7.3 that explains the relationship among flow time (T), throughput (R), and work-in-process (*WIP*):

$$\text{Work-in-process} = \text{Throughput} \times \text{Flow time}$$

or

$$WIP = R \times T \qquad [7.3]$$

If we know any two of the three variables, we can compute the third using Little's Law.

For example, if a voting facility processes an average of 50 people per hour and it takes an average of 10 minutes (1/6 hour) for each person to vote, then we would expect $WIP = R \times T = 50 \times (1/6) = 8.33$ voters inside the facility. If a loan department of a bank takes an average of 6 days (0.2 months) to process an application and about 100 applications are in process at any one time, then the throughput of the department is $R = WIP/T = 100/0.2 = 500$ applications per month. If a restaurant uses 200 pounds of dough per week and maintains an inventory of 70 pounds, then the average flow time is $T = WIP/R = 70/200 = 0.35$ weeks.

Learning Outcomes

LO¹ Describe four layout patterns and when they should be used.

Four major layout patterns are commonly used in designing building and processes: product layout, process layout, cellular layout, and fixed position layout. Product layouts support a smooth and logical flow where all goods or services move in a continuous path from one process stage to the next using the same sequence of work tasks and activities. Job shops are an example of firms that use process layouts to provide flexibility in the products that can be made and the utilization of equipment and labor. Cellular layouts facilitate the processing of families of parts with similar processing requirements. The production of large items such as heavy machine tools, airplanes, buildings, locomotives, and ships is usually accomplished in a fixed-position layout. This fixed-position layout is synonymous with the "project" classification of processes.

Exhibit 8.1 *Product Layout for Wine Manufacturer*

Service organizations use product, process, cellular, and fixed-position layouts to organize different types of work. Those that need the ability to provide a wide variety of services to customers with differing requirements usually use a process layout. Service organizations that provide highly standardized services tend to use product layouts.

Exhibit 8.4 *Comparison of Basic Layout Patterns*

Characteristic	Product Layout	Process Layout	Cellular Layout	Fixed-Position Layout
Demand volume	High	Low	Moderate	Very low
Equipment utilization	High	Low	High	Moderate
Automation potential	High	Moderate	High	Moderate
Setup/changover requirements	High	Moderate	Low	High
Flexibility	Low	High	Moderate	Moderate
Type of equipment	Highly specialized	General purpose	Moderate specialization	Moderate specialization

LO² Explain how to design product layouts using assembly line balancing.

Assembly line balancing seeks to achieve the throughput necessary to meet sales commitments and minimize the cost of operations. Typically, one either minimizes the number of workstations for a given production rate or maximizes the production rate for a given number of workstations.

Key Terms

LO¹

Facility layout refers to the specific arrangement of physical facilities.

A **product layout** is an arrangement based on the sequence of operations that is performed during the manufacturing of a good or delivery of a service.

A **process layout** consists of a functional grouping of equipment or activities that do similar work.

In a **cellular layout**, the design is not according to the functional characteristics of equipment, but rather by self-contained groups of equipment (called cells) needed for producing a particular set of goods or services.

A **fixed-position layout** consolidates the resources necessary to manufacture a good or deliver a service, such as people, materials, and equipment, in one physical location.

LO²

Flow-blocking delay occurs when a work center completes a unit but cannot release it because the in-process storage at the next stage is full.

Lack-of-work delay occurs whenever one stage completes work and no units from the previous stage are awaiting processing.

An **assembly line** is a product layout dedicated to combining the components of a good or service that has been created previously.

Assembly line balancing is a technique to group tasks among workstations so that each workstation has—in the ideal case—the same amount of work.

Key Terms

Cycle time is the interval between successive outputs coming off the assembly line.

LO⁴

Ergonomics is concerned with improving productivity and safety by designing workplaces, equipment, instruments, computers, workstations, and so on that take into account the physical capabilities of people.

LO⁵

A **job** is the set of tasks an individual performs.

Job design involves determining the specific job tasks and responsibilities, the work environment, and the methods by which the tasks will be carried out to meet the goals of operations.

Job enlargement is the horizontal expansion of the job to give the worker more variety—although not necessarily more responsibility.

Job enrichment is vertical expansion of job duties to give the worker more responsibility.

To begin, we need to know three types of information:

1. the set of tasks to be performed and the time required to perform each task;
2. the precedence relations among the tasks—that is, the sequence in which tasks must be performed; and
3. the desired output rate or forecast of demand for the assembly line.

The cycle time (CT) must satisfy maximum operation time $\leq CT \leq$ sum of operation times.

Cycle time (CT) is related to the output required to be produced in some period of time (R) by the following equation

$$CT = A/R$$

where A = available time to produce the output and R = demand forecast. For a given cycle time:

Minimum number of workstations required = Sum of task times/Cycle time = $\Sigma t/CT$

Additional formulas for assembly line performance:

Total Time Available = (Number work stations)(Cycle Time) = $(N)(CT)$

Total Idle Time = $(N)(CT) - \Sigma t$

Assembly Line Efficiency = $\Sigma t/(N \times CT)$

Balance Delay = $1 -$ Assembly-line Efficiency

One line balancing decision rule example is to assign the task with the *longest task time first* to a workstation if the cycle time would not be exceeded. The longest task time first decision rule assigns tasks with long task times first, because shorter task times are easier to fit in the line balance later in the procedure. In the real world, assembly line balancing is quite complicated, because of the size of practical problems as well as constraints that mechanization or tooling place on work tasks.

LO³ Explain the concepts of process layout.

In designing process layouts, we are concerned with the arrangement of departments or workcenters relative to each other. Costs associated with moving materials or the inconvenience that customers might experience in moving between physical locations are usually the principal design criteria for process layouts. In general, workcenters with a large number of moves between them should be located close to one another.

LO⁴ Describe issues related to workplace design.

Key questions that must be addressed at the workstation level include:

1. Who will use the workplace? Will the workstation be shared? How much space is required?
2. How will the work be performed? What tasks are required? How much time does each task take? How much time is required to setup for the workday or for a particular job? How might the tasks be grouped into work activities most effectively?
3. What technology is needed?
4. What must the employee be able to see?
5. What must the employee be able to hear?
6. What environmental and safety issues need to be addressed? What protective clothing or gear should the employee wear?

The objective of ergonomics is to reduce fatigue, the cost of training, human errors, the cost of doing the job, and energy requirements while increasing accuracy, speed, reliability, and flexibility. Although ergonomics has traditionally focused on manufacturing workers and service providers, it is also important in designing the servicescape to improve customer interaction in high-contact environments.

LO⁵ Describe the human issues related to workplace design.

Two broad objectives must be satisfied in job design. One is to meet the firm's competitive priorities—cost, efficiency, flexibility, quality, and so on; the other is to make the job safe, satisfying, and motivating for the worker. Resolving conflicts between the need for technical and economic efficiency and the need for employee satisfaction is the challenge that faces operations managers in designing jobs. The relationships between the technology of operations and the social/psychological aspects of work has been understood since the 1950s and is known as the *sociotechnical approach* to job design and provides useful ideas for operations managers. Sociotechnical approaches to work design provide opportunities for continual learning and personal growth for all employees.

Some of the more common approaches to job enrichment are:

- natural work teams, which perform entire jobs, rather than specialized, assembly-line work;
- virtual teams, in which members communicate by computer, take turns as leaders, and join and leave the team as necessary; and
- self-managed teams (SMTs), which are empowered work teams that also assume many traditional management responsibilities.

Virtual teams, in particular, have taken on increased importance in today's business world.

Learning Outcomes

LO¹ Explain the concept of supply chain management.

The basic purpose of a supply chain is to coordinate the flow of materials, services, and information among the elements of the supply chain to maximize customer value. The key functions generally include sales and order processing, transportation and distribution, operations, inventory and materials management, finance, and customer service. A goods-producing supply chain generally consists of suppliers, manufacturers, distributors, retailers, and customers. Raw materials and components are ordered from suppliers and must be transported to manufacturing facilities for production and assembly into finished goods. Finished goods are shipped to distributors who operate distribution centers.

Exhibit 9.1 *Typical Goods-Producing Supply Chain Structure*

Key Terms

LO¹

Distribution centers (DCs) are warehouses that act as intermediaries between factories and customers, shipping directly to customers or to retail stores where products are made available to customers.

Inventory refers to raw materials, work-in-process, or finished goods that are maintained to support production or satisfy customer demand.

Supply chain management (SCM) is the management of all activities that facilitate the fulfillment of a customer order for a manufactured good to achieve satisfied customers at reasonable cost.

Supply chain operations reference (SCOR) model is based on five basic functions involved in managing a supply chain: plan, source, make, deliver, and return. It provides a framework for understanding the scope of SCM.

LO²

A **contract manufacturer** is a firm that specializes in certain types of goods-producing activities, such as customized design, manufacturing, assembly, and packaging, and works under contract for end users.

Efficient supply chains are designed for efficiency and low cost by minimizing inventory and maximizing efficiencies in process flow.

Responsive supply chains focus on flexibility and responsive service and are able to react quickly to changing market demand and requirements.

Exhibit 9.2 *A Value Chain Model of Dell, Inc.*

Key Terms

A **push system** produces goods in advance of customer demand using a forecast of sales and moves them through the supply chain to points of sale where they are stored as finished goods inventory.

A **pull system** produces only what is needed at upstream stages in the supply chain in response to customer demand signals from downstream stages.

The point in the supply chain that separates the push system from the pull system is called the **push-pull boundary**.

Postponement is the process of delaying product customization until the product is closer to the customer at the end of the supply chain.

Multisite management is the process of managing geographically dispersed service-providing facilities.

Order amplification is a phenomenon that occurs when each member of a supply chain "orders up" to buffer its own inventory.

LO³

The **center-of-gravity method** determines the X and Y coordinates (location) for a single facility.

LO⁴

Vendor-managed inventory (VMI) is where the vendor (a consumer goods manufacturer, for example) monitors and manages inventory for the customer (a grocery store, for example).

The **Supply Chain Operations Reference (SCOR) model** is based on five basic functions: plan, source, make, deliver, and return.

A pre- and postproduction view of Dell's value chain helps complete the picture of supply chain management concepts and issues (see Exhibit 9.2).

LO² Describe the key issues in designing supply chains.

Supply chains should support an organization's strategy, mission, and competitive priorities. Many supply chains use contract manufacturing. Outsourcing to contract manufacturers can offer significant competitive advantages, such as access to advanced manufacturing technologies, faster product time-to-market, customization of goods in regional markets, and lower total costs resulting from economies of scale.

Supply chains can be designed from two strategic perspectives—providing high efficiency and low cost or providing agile response. A focus on efficiency works best for goods and services with highly predictable demand, stable product lines with long life cycles that do not change frequently, and low contribution margins. A focus on flexibility and response is best when demand is unpredictable, product life cycles are short and change often because of product innovations, fast response is the main competitive priority, customers require customization, and contribution margins are high.

Two ways to configure and run a supply chain are as a push or pull system. Push systems work best when sales patterns are consistent and when there are a small number of distribution centers and products. Pull systems are more effective when there are many production facilities, many points of distribution, and a large number of products.

Supply chain managers use numerous metrics to evaluate performance and identify improvements to the design and operation of their supply chains. These include delivery reliability, responsiveness, customer-related measures, supply chain efficiency, and financial measures.

The performance of a supply chain, in terms of both costs and service, often suffers from a phenomenon known as the **bullwhip effect**, which has been observed across most industries and increases cost and reduces service to the customer. Many firms are taking steps to counteract this phenomenon by using smaller order sizes, stabilizing price fluctuations, and sharing information on sales, capacity, and inventory data among the members of the supply chain.

LO³ Explain important factors and decisions in locating facilities.

Location decisions in supply and value chains are based on both economic and noneconomic factors.

Facility location is typically conducted hierarchically and involves the following four basic decisions where appropriate: global location decision, regional location decision, community location decision, and local site location decision.

The center-of-gravity method takes into account the locations of the facility and markets, demand, and transportation costs in arriving at the best location for a single facility.

LO⁴ Describe the role of transportation, supplier evaluation, technology, and inventory in supply chain management.

The selection of transportation services is a complex decision, since varied services are available—rail, motor carrier, air, water, and pipeline. Many companies are moving toward third-party logistics providers.

Many companies segment suppliers into categories based on their importance to the business and manage them accordingly.

SCM has benefited greatly from information technology, particularly bar coding and radio frequency identification (RFID) tags, to have accurate receipt information identifying goods that have been received, reduce the time spent in staging (between receipt and storage) at distribution centers, update inventory records, route customer orders for picking, generate bills of lading, and provide various managerial reports.

Careful management of inventory is critical to supply chain time-based performance in order to respond effectively to customers. VMI essentially outsources the inventory management function in supply chains to suppliers. VMI allows the vendor to view inventory needs from the customer's perspective and use this information to optimize its own production operations, better control inventory and capacity, and reduce total supply chain costs.

Learning Outcomes

LO¹ Explain the concept of capacity.

Capacity can be viewed in one of two ways:

1. as the maximum rate of output per unit of time, or
2. as units of resource availability.

Operations managers must decide on the appropriate levels of capacity to meet current (short-term) and future (long-term) demand.

As a single facility adds more and more goods and/or services to its portfolio, the facility can become too large and "unfocused." At some point, diseconomies of scale arise and unit cost increases because dissimilar product lines, processes, people skills, and technology exist in the same facility. The

Exhibit 10.1 *Examples of Short- and Long-Term Capacity Decisions*

Short-Term Capacity Decisions	Long-Term Capacity Decisions
• Amount of overtime scheduled for the next week • Number of ER nurses on call during a downtown festival weekend • Number of call center workers to staff during the holiday season	• Construction of a new manufacturing plant • Expanding the size and number of beds in a hospital • Number of branch banks to establish in a new market territory

focused factory argues to "divide and conquer" by adopting smaller, more focused facilities dedicated to a (1) few key products, (2) a specific technology, (3) a certain process design and capability, (4) a specific competitive priority objective such as next day delivery, and (5) particular market segments or customers and associate volumes.

LO² Describe how to compute and use capacity measures.

Average safety capacity is defined by

Average safety capacity (%) = 100% − Average resource utilization (%)

In a job shop, setup time can be a substantial part of total system capacity, and therefore, must be included in evaluating capacity. A general expression for evaluating the capacity required to meet a given production volume for one work order, i, is

Capacity required (C_i) = Setup time (S_i) + [Processing time (P_i) × Order size (Q_i)] [10.1]

where C_i = capacity requirements in units of time (for instance, minutes, hours, days).

S_i = setup or changeover time for work order i as a fixed amount that does not vary with volume.

P_i = Processing time for each unit of work order i (e.g., hours/part, minutes/transaction, and so on).

Q_i = The size of order i in numbers of units.

If we sum the capacity requirements over all work orders, we can compute the total capacity required:

$$C = \Sigma C_i = \Sigma [S_i + (P_i \times Q_i)] \qquad [10.3]$$

LO³ Describe long-term capacity expansion strategies.

In developing a long-range capacity plan, a firm must make a basic economic trade-off between the cost of capacity and the opportunity cost of not having adequate capacity. Capacity costs include both the initial investment in facilities and equipment, and the annual cost of operating and maintaining them. The cost of not having sufficient capacity is the opportunity loss incurred from lost sales and reduced market share.

Key Terms

LO¹

Capacity is the capability of a manufacturing or service resource such as a facility, process, workstation, or piece of equipment to accomplish its purpose over a specified time period.

Economies of scale are achieved when the average unit cost of a good or service decreases as the capacity and/or volume of throughput increases.

Diseconomies of scale occur when the average unit cost of the good or service begins to increase as the capacity and/or volume of throughput increase.

A **focused factory** is a way to achieve economies of scale without extensive investments in facilities and capacity by focusing on a narrow range of goods or services, target market segments, and/or dedicated processes to maximize efficiency and effectiveness.

LO²

Safety capacity (often called the **capacity cushion**), is defined as an amount of capacity reserved for unanticipated events such as demand surges, materials shortages, and equipment breakdowns.

LO³

Complementary goods and services are goods and services that can be produced or delivered using the same resources available to the firm, but whose seasonal demand patterns are out of phase with each other.

LO⁴

A **reservation** is a promise to provide a good or service at some future time and place.

A **revenue management system (RMS)** consists of dynamic methods to forecast demand, allocate perishable assets across market segments, decide when to overbook and by how much, and determine what price to charge different customer (price) classes.

LO⁵

The **Theory of Constraints (TOC)** is a set of principles that focus on increasing total process throughput by maximizing the utilization of all bottleneck work activities and workstations.

Key Terms

Throughput is the amount of money generated per time period through actual sales.

A **constraint** is anything in an organization that limits it from moving toward or achieving its goal.

A **physical constraint** is associated with the capacity of a resource such as a machine, employee, or workstation.

A **bottleneck (BN) work activity** is one that effectively limits the capacity of the entire process.

A **nonbottleneck (NBN) work activity** is one in which idle capacity exists.

A **nonphysical constraint** is environmental or organizational, such as low product demand or an inefficient management policy or procedure.

Four basic strategies for expanding capacity over some fixed time horizon are: one large capacity increase, small capacity increases that match average demand, small capacity increases that lead demand, and small capacity increases that lag demand (see Exhibit 10.6).

LO⁴ Describe short-term capacity adjustment strategies.

When demand fluctuates above and below average capacity levels, then firms can adjust capacity to match the changes in demand by changing internal resources and capabilities, or manage capacity by shifting and stimulating demand. Short-term adjustments to capacity can be done in a variety of ways, such as adding or sharing equipment, selling unused capacity, changing labor capacity and schedules, changing labor skill mix, and shifting work to slack periods. Some general approaches to influence customers to shift demand are varying the price of goods or services, providing customers with information, advertising and promotion, adding peripheral goods and/or services, and providing reservations. Revenue management systems help organizations maximize revenue by adjusting prices to influence demand.

LO⁵ Explain the principles and logic of the Theory of Constraints.

TOC focuses on identifying bottlenecks (BN) and nonbottlenecks (NBN), managing BN and NBN work activities carefully, linking them to the market to ensure an appropriate product mix, and scheduling the NBN resources to enhance throughput.

Exhibit 10.6 *Capacity Expansion Options*

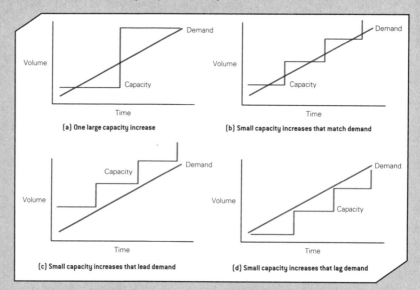

Exhibit 10.7 *Basic Principles of the Theory of Constraints*

Nonbottleneck Management Principles	Bottleneck Management Principles
Move jobs through nonbottleneck workstations as fast as possible until the job reaches the bottleneck workstation.	Only the bottleneck workstations are critical to achieving process and factory objectives and should be scheduled first.
At nonbottleneck workstations, idle time is acceptable if there is no work to do, and therefore, resource utilizations may be low.	An hour lost at a bottleneck resource is an hour lost for the entire process or factory output.
Use smaller order (also called lot or transfer batches) sizes at nonbottleneck workstations to keep work flowing to the bottleneck resources and eventually to the marketplace to generate sales.	Work-in-process buffer inventory should be placed in front of bottlenecks to maximize resource utilization at the bottleneck.
An hour lost at a nonbottleneck resource has no effect on total process or factory output and incurs no real cost.	Use large order sizes at bottleneck workstations to minimize setup time and maximize resource utilization.
	Bottleneck workstations should work at all times to maximize throughput and resource utilization so as to generate cash from sales and achieve the company's goal.

Visit **4ltrpress.cengage.com/om** for additional study tools!

Learning Outcomes

LO¹ Describe the importance of forecasting to the value chain.

Accurate forecasts are needed throughout the value chain, and are used by all functional areas of an organization, such as accounting, finance, marketing, operations, and distribution. Poor forecasting can result in poor inventory and staffing decisions, resulting in part shortages, inadequate customer service, and many customer complaints. In the telecommunications industry, competition is fierce, and goods and services have very short life cycles. Forecasting is typically included in comprehensive value chain and demand-planning software systems. These systems integrate marketing, inventory, sales, operations planning, and financial data.

Exhibit 11.1 *The Need for Forecasts in a Value Chain*

LO² Explain basic concepts of forecasting and time series.

Long-range forecasts cover a planning horizon of 1 to 10 years and are necessary to plan for the expansion of facilities and to determine future needs for land, labor, and equipment. Intermediate-range forecasts over a 3- to 12-month period are needed to plan work-force levels, allocate budgets among divisions, schedule jobs and resources, and establish purchasing plans. Short-range forecasts focus on the planning horizon of up to 3 months and are used by operations managers to plan production schedules and assign workers to jobs, to determine short-term capacity requirements, and to aid shipping departments in planning transportation needs and establishing delivery schedules.

Different time series may exhibit one or more of characteristics: *trend, seasonal, cyclical, random variation, and irregular (one-time) variation.*

All forecasts are subject to error, and understanding the nature and size of errors is important to making good decisions. Generally, three types of forecast error metrics are used:

1. Mean square error, or MSE,

$$MSE = \frac{\Sigma(A_t - F_t)^2}{T} \qquad [11.1]$$

2. Mean absolute deviation (MAD)

$$MAD = \frac{\Sigma|(A_t - F_t)|}{T} \qquad [11.2]$$

3. Mean absolute percentage error (MAPE)

$$MAPE = \frac{\Sigma|(A_t - F_t)/A_t| \times 100}{T} \qquad [11.3]$$

Key Terms

LO¹

Forecasting is the process of projecting the values of one or more variables into the future.

LO²

The **planning horizon** is the length of time on which a forecast is based.

The **time bucket** is the unit of measure for the time period used in a forecast.

A **time series** is a set of observations measured at successive points in time or over successive periods of time.

A **trend** is the underlying pattern of growth or decline in a time series.

Seasonal patterns are characterized by repeatable periods of ups and downs over short periods of time.

Cyclical patterns are regular patterns in a data series that take place over long periods of time.

Random variation (sometimes called **noise**) is the unexplained deviation of a time series from a predictable pattern, such as a trend, seasonal, or cyclical pattern.

Irregular variation is a one-time variation that is explainable.

Forecast error is the difference between the observed value of the time series and the forecast, or $A_t - F_t$.

LO³

Statistical forecasting is based on the assumption that the future will be an extrapolation of the past.

A **moving average (MA)** forecast is an average of the most recent "k" observations in a time series.

Single exponential smoothing (SES) is a forecasting technique that uses a weighted average of past time-series values to forecast the value of the time series in the next period.

Key Terms

LO⁴

Regression analysis is a method for building a statistical model that defines a relationship between a single dependent variable and one or more independent variables, all of which are numerical.

A linear regression model with more than one independent variable is called a **multiple linear regression model**.

LO⁵

Judgmental forecasting relies upon opinions and expertise of people in developing forecasts.

The **Delphi method** consists of forecasting by expert opinion by gathering judgments and opinions of key personnel based on their experience and knowledge of the situation.

LO⁶

Bias is the tendency of forecasts to consistently be larger or smaller than the actual values of the time series.

LO³ Explain how to apply single moving average and exponential smoothing models.

The single moving average concept is based on the idea of averaging random fluctuations in a time series to identify the underlying direction in which the time series is changing.

$$F_{t+1} = \Sigma(\text{most recent "}k\text{" observations})/k$$
$$= (A_t + A_{t-1} + A_{t-2} + \ldots + A_{t-k+1})/k \quad [11.4]$$

MA methods work best for short planning horizons when there are no major trends, seasonal, or business cycle patterns, that is, when demand is relatively stable and consistent. As the value of k increases, the forecast reacts slowly to recent changes in the time series because older data are included in the computation. As the value of k decreases, the forecast reacts more quickly. If a significant trend exists in the time-series data, moving-average-based forecasts will lag actual demand, resulting in a bias in the forecast.

Single exponential smoothing (SES) forecasts are based on averages using and weighting the most recent actual demand more than older demand data. SES methods do not try to include trend or seasonal effects. The basic exponential-smoothing model is

$$F_{t+1} = \alpha A_t + (1 - \alpha)F_t$$
$$= F_t + \alpha(A_t - F_t) \quad [11.5]$$

Typical values for α are in the range of 0.1 to 0.5. Larger values of α place more emphasis on recent data. If the time series is very volatile and contains substantial random variability, a small value of the smoothing constant is preferred. The reason for this choice is that since much of the forecast error is due to random variability, we do not want to overreact and adjust the forecasts too quickly. For a fairly stable time series with relatively little random variability, larger values of the smoothing constant have the advantage of quickly adjusting the forecasts when forecasting errors occur and therefore allowing the forecast to react faster to changing conditions.

LO⁴ Describe how to apply regression as a forecasting approach.

Simple regression models forecast the value of a time series (the dependent variable) as a function of a single independent variable, time.

$$Y_t = a + bt \quad [11.7]$$

In more advanced forecasting applications, other independent variables such as economic indexes or demographic factors that may influence the time series can be incorporated into a regression model. An example is

$$\text{Sales} = \beta_0 + (\beta_1)(\text{Week}) + (\beta_2)(\text{Price})$$

Multiple regression models often provide a more realistic and accurate forecast than simply extrapolating the historical time series.

LO⁵ Explain the role of judgment in forecasting.

When no historical data are available, only judgmental forecasting is possible. The demand for goods and services is affected by a variety of factors, such as global markets and cultures, interest rates, disposable income, inflation, and technology. Competitors' actions and government regulations also have an impact. Thus, some element of judgmental forecasting is always necessary.

The major reasons given for using judgmental methods rather than quantitative methods are (1) greater accuracy, (2) ability to incorporate unusual or one-time events, and (3) the difficulty of obtaining the data necessary for quantitative techniques. Also, judgmental methods seem to create a feeling of "ownership" and add a common sense dimension.

LO⁶ Describe how statistical and judgmental forecasting techniques are applied in practice.

In practice, managers use a variety of judgmental and quantitative forecasting techniques. Statistical methods alone cannot account for such factors as sales promotions, competitive strategies, unusual economic or environmental disturbances, new product introductions, large one-time orders, labor union strikes, and so on. Many managers begin with a statistical forecast and adjust it to account for such factors. Others may develop independent judgmental and statistical forecasts and then combine them, either objectively by averaging or in a subjective manner.

The choice of a forecasting method depends on other criteria such as the time span for which the forecast is being made, the needed frequency of forecast updating, data requirements, the level of accuracy desired, and the quantitative skills needed.

Forecasters should also monitor a forecast to determine when it might be advantageous to change or update the model. The tracking method used most often is to compute the cumulative forecast error divided by the value of MAD at that point in time; that is,

$$\text{Tracking signal} = \Sigma(A_t - F_t)/\text{MAD} \quad [11.8]$$

Typically, tracking signals between plus or minus 4 indicate that the forecast is performing adequately. Values outside this range indicate that you should reevaluate the model used.

Learning Outcomes

LO¹ Explain the importance of inventory, types of inventories, and key decisions and costs.

Inventories may be physical goods used in operations, and include raw materials, parts, subassemblies, supplies, tools, equipment or maintenance, and repair items. In some service organizations, such as airlines and hotels, inventories are not physical goods that customers take with them, but provide capacity available for serving customers.

Inventory managers deal with two fundamental decisions:

1. When to order items from a supplier or when to initiate production runs if the firm makes its own items; and

2. How much to order or produce each time a supplier or production order is placed.

Inventory management is all about making tradeoffs among the costs associated with these decisions.

Inventory costs can be classified into four major categories: ordering or setup costs, inventory holding costs, shortage costs, and unit cost of the SKUs.

LO² Describe the major characteristics that impact inventory decisions.

One of the first steps in analyzing an inventory problem should be to describe the essential characteristics of the environment and inventory system:

1. *Number of items.* To manage and control these inventories, each item is often assigned a unique identifier, called a stock-keeping unit, or SKU.

2. *Nature of demand.* Demand can be classified as independent or dependent, deterministic or stochastic, and dynamic or static.

3. *Number and size of time periods.* The type of approach used to analyze "single-period" inventory problems is different from the approach needed for the "multiple-period" inventory situation.

4. *Lead time.* Lead time is affected by transportation carriers, buyer order frequency and size, and supplier production schedules and may be deterministic or stochastic (in which case it may be described by some probability distribution).

5. *Stockouts.* Backorders result in additional costs for transportation, expediting, or perhaps buying from another supplier at a higher price. A lost sale has an associated opportunity cost, which may include loss of goodwill and potential future revenue.

LO³ Describe how to conduct an ABC inventory analysis.

ABC analysis consists of categorizing inventory items or SKUs into three groups according to their total annual dollar usage.

1. "A" items account for a large dollar value but a relatively small percentage of total items.

2. "C" items account for a small dollar value but a large percentage of total items.

3. "B" items are between A and C.

Class A items require close control by operations managers. Class C items need not be as closely controlled and can be managed using automated computer systems. Class B items are somewhere in the middle.

LO⁴ Explain how a fixed order quantity inventory system operates, and how to use the EOQ and safety stock models.

A way to manage a FQS is to continuously monitor the inventory level and place orders when the level reaches some "critical" value. The process of triggering an order is based

Key Terms

LO¹

Inventory is any asset held for future use or sale.

Inventory management involves planning, coordinating, and controlling the acquisition, storage, handling, movement, distribution, and possible sale of raw materials, component parts and subassemblies, supplies and tools, replacement parts and other assets that are needed to meet customer wants and needs.

Raw materials, component parts, subassemblies, and supplies are inputs to manufacturing and service-delivery processes.

Work-in-process (WIP) inventory consists of partially finished products in various stages of completion that are waiting further processing.

Finished goods inventory is completed products ready for distribution or sale to customers.

Safety stock inventory is an additional amount that is kept over and above the average amount required to meet demand.

Ordering costs or **setup costs** are incurred as a result of the work involved in placing orders with suppliers or configuring tools, equipment, and machines within a factory to produce an item.

Inventory-holding or **inventory-carrying costs** are the expenses associated with carrying inventory.

Shortage or **stockout costs** are costs associated with an SKU being unavailable when needed to meet demand.

Unit cost is the price paid for purchased goods or the internal cost of producing them.

LO²

A **stock-keeping unit (SKU)** is a single item or asset stored at a particular location.

Independent demand is demand for a SKU that is unrelated to the demand for other SKUs and needs to be forecasted.

SKUs are said to have **dependent demand** if their demand is directly related to the demand of other SKUs and can be calculated without needing to be forecasted.

Demand is **deterministic** when uncertainty is not included in its characterization.

Key Terms

Stochastic demand incorporates uncertainty by using probability distributions to characterize the nature of demand.

Stable demand is usually called **static demand**, and demand that varies over time is referred to as **dynamic demand**.

The **lead time** is the time between placement of an order and its receipt.

A **stockout** is the inability to satisfy the demand for an item.

A **backorder** occurs when a customer is willing to wait for the item; a **lost sale** occurs when the customer is unwilling to wait and purchases the item elsewhere.

LO⁴

In a **fixed quantity system (FQS)**, the order quantity or lot size is fixed; that is, the same amount, Q, is ordered every time.

Inventory position (IP) is defined as the on-hand quantity (OH) plus any orders placed but which have not arrived (called scheduled receipts, SR), minus any backorders (BO).

A **service level** is the desired probability of not having a stockout during a lead-time period.

The **Economic Order Quantity (EOQ)** model is a classic economic model developed in the early 1900s that minimizes the total cost, which is the sum of the inventory-holding cost and the ordering cost.

Cycle inventory (also called **order** or **lot size inventory**) is inventory that results from purchasing or producing in larger lots than are needed for immediate consumption or sale.

LO⁵

A **fixed period system (FPS)**—sometimes called a periodic review system—in which the inventory position is checked only at fixed intervals of time, T, rather than on a continuous basis.

on the inventory position. When the inventory position falls at or below a certain value, r, called the *reorder point*, a new order is placed (see Exhibits 12.5 and 12.6).

The choice of the reorder point depends on the lead time and the nature of demand. One approach to choosing the reorder point is to use the *average demand during the lead time* (μL). If d is the average demand per unit of time (day, week, and so on), and L is the lead time expressed in the same units of time, then the average demand during the lead time is calculated as $r = \mu L = (d)(L)$.

The EOQ model is based on the following assumptions:

- Only a single item (SKU) is considered.
- The entire order quantity (Q) arrives in the inventory at one time.
- Only two types costs are relevant—order/setup and inventory holding costs.
- No stockouts are allowed.
- The demand for the item is deterministic and continuous over time.
- Lead time is constant.

Thus the total annual cost is $TC = \frac{1}{2}QC_h + \frac{D}{Q}C_o$

The order quantity that minimizes the total cost, denoted by Q^*, is $Q^* = \sqrt{\frac{2DC_o}{C_h}}$

When demand is uncertain, the appropriate reorder point depends on the risk that management wants to take of incurring a stockout. For normally-distributed demand, the reorder point is $r = \mu_L + z\sigma_L$ where μ_L = average demand during the lead time, σ_L = standard deviation of demand during the lead time, and z = the number of standard deviations necessary to achieve the acceptable service level.

LO⁵ Explain how a fixed period inventory system operates.

For a fixed period inventory system, at the time of review, an order is placed for sufficient stock to bring the inventory position up to a predetermined maximum inventory level, M, sometimes called the *replenishment level*, or *"order-up-to" level*. We can set the length of the review period judgmentally based on the importance of the item or the convenience of review. The EOQ model provides the best "economic time interval" for establishing an optimal policy for a FPS system under the model assumptions. This is given by $T = Q^*/D$. The optimal replenishment level is computed by $M = d(T + L)$ where d = average demand per time period, L is the lead time, and M is the demand during the lead time plus review period (see Exhibits 12.10 and 12.11). Safety stock can also be added to M, if desired.

LO⁶ Describe how to apply the single period inventory model.

The single-period inventory model applies to inventory situations in which one order is placed for a good in anticipation of a future selling season where demand is uncertain. At the end of the period the product has either sold out, or there is a surplus of unsold items to sell for a salvage value.

The news vendor problem can be solved using a technique called *marginal economic analysis*, which compares the cost or loss of ordering one additional item with the cost or loss of not ordering one additional item. The costs involved are defined as:

- c_s = the cost per item of overestimating demand (salvage cost); this cost represents the loss of ordering one additional item and finding that it cannot be sold.

- c_u = the cost per item of underestimating demand (shortage cost); this cost represents the opportunity loss of not ordering one additional item and finding that it could have been sold.

The optimal order quantity is the value of Q^* that satisfies

$P(\text{demand} \leq Q^*) = \frac{c_u}{c_u + c_s}$

Learning Outcomes

LO¹ Describe the overall resource planning frameworks in both goods-producing and service-providing organizations.

Level 1 represents aggregate planning. Aggregate plans define output levels over a planning horizon of one to two years, usually in monthly or quarterly time buckets. They normally focus on product families or total capacity requirements rather than individual products or specific capacity allocations. Aggregate plans also help to define budget allocations and associated resource requirements.

Level 2 planning is called disaggregation. To disaggregate means to break up or separate into more detailed pieces. Disaggregation specifies more detailed plans for the creation of individual goods and services or the allocation of capacity to specific time periods. For goods producing firms, disaggregation takes Level 1 aggregate planning decisions and breaks them down into such details as order sizes and schedules for individual subassemblies and resources by week and day.

Level 3 focuses on executing the detailed plans made at Level 2, creating detailed resource schedules and job sequences. Level 3 planning and execution in manufacturing is sometimes called *shop floor control*.

Resource management for most service-providing organizations generally does not require as many intermediate levels of planning as it does for manufacturing.

LO² Explain options for aggregate planning.

Managers have a variety of options in developing aggregate plans in the face of fluctuating demand:

- **Demand Management** Marketing strategies can be used to influence demand and to help create more feasible aggregate plans.

- **Production Rate Changes** One means of increasing the output rate without changing existing resources is through planned overtime. Alternatively, hours can be reduced during slow periods through planned undertime.

- **Work Force Changes** Changing the size of the work force is usually accomplished through hiring and layoffs.

- **Inventory Changes** In planning for fluctuating demand, inventory is often built up during slack periods and held for peak periods. A related strategy is to carry back orders or to tolerate lost sales during peak demand periods.

- **Facilities, Equipment, and Transportation** Short-term changes in facilities and equipment are seldom used in traditional aggregate planning methods because of the capital costs involved.

LO³ Describe how to evaluate level production and chase demand strategies for aggregate planning.

A level strategy avoids changes in the production rate, working within normal capacity restrictions. Labor and equipment schedules are stable and repetitive, making it easier to execute the plan. An alternative to a level production strategy is to match production to demand every month (chase demand strategy). While inventories will be reduced and lost sales will be eliminated, many production rate changes will dramatically change resource levels (that is, the number of employees, machines, and so on). Both strategies can easily be evaluated using a spreadsheet.

LO⁴ Describe ways to disaggregate aggregate plans using master production scheduling and material requirements planning.

The purpose of the master schedule is to translate the aggregate plan into a separate plan for individual finished goods. It also provides a means for evaluating alternative schedules

Key Terms

LO¹

Resource management deals with the planning, execution, and control of all the resources that are used to produce goods or provide services in a value chain.

Aggregate planning is the development of a long-term output and resource plan in aggregate units of measure.

Disaggregation is the process of translating aggregate plans into short-term operational plans that provide the basis for weekly and daily schedules and detailed resource requirements.

Execution refers to moving work from one workstation to another, assigning people to tasks, setting priorities for jobs, scheduling equipment, and controlling processes.

LO³

A **level production strategy** plans for the same production rate in each time period.

A **chase demand strategy** sets the production rate equal to the demand in each time period.

LO⁴

A **master production schedule (MPS)** is a statement of how many finished items are to be produced and when they are to be produced.

A **final assembly schedule (FAS)** defines the quantity and timing for assembling subassemblies and component parts into a final finished good.

Materials requirements planning (MRP) is a forward-looking, demand-based approach for planning the production of manufactured goods and ordering materials and components to minimize unnecessary inventories and reduce costs.

Dependent demand is demand that is directly related to the demand of other SKUs and can be calculated without needing to be forecasted.

A **bill of labor (BOL)** is a hierarchical record analogous to a BOM that defines labor inputs necessary to create a good or service.

End items are finished goods scheduled in the MPS or FAS that must be forecast.

A **parent item** is manufactured from one or more components.

Components are any item (raw materials, manufactured parts, purchased parts) other than an end item that go into a higher-level parent item(s).

Key Terms

A **subassembly** always has at least one immediate parent and also has at least one immediate component.

MRP explosion is the process of using the logic of dependent demand to calculate the quantity and timing of orders for all subassemblies and components that go into and support the production of the end item(s).

Time buckets are the time period size used in the MRP explosion process and usually are one week in length.

Gross requirements (GR) are the total demand for an item derived from all of its parents.

Scheduled or planned receipts (S/PR) are orders that are due or planned to be delivered.

Planned order receipt (PORec) specifies the quantity and time an order is to be received.

Planned order release (PORel) specifies the planned quantity and time an order is to be released to the factory or a supplier.

Projected on-hand inventory (POH) is the expected amount of inventory on-hand at the beginning of the time period considering on-hand inventory from the previous period plus scheduled receipts or planned order receipts minus the gross requirements.

Lot sizing is the process of determining the appropriate amount and timing of ordering to reduce costs.

An ordering schedule that covers the gross requirements for each week is called **lot-for-lot (LFL)**.

The **action bucket** is the current time period.

The **fixed order quantity (FOQ)** rule uses a fixed order size for every order or production run.

The **periodic order quantity (POQ)** orders a quantity equal to the gross requirement quantity in one or more predetermined time periods minus the projected on-hand quantity of the previous time period.

LO⁵

Capacity requirements planning (CRP) is the process of determining the amount of labor and machine resources required to accomplish the tasks of production on a more detailed level, taking into account all component parts and end items in the materials plan.

in terms of capacity requirements, provides input to the MRP system, and helps managers generate priorities for scheduling by setting due dates for the production of individual items.

MRP projects the requirements for the individual parts or subassemblies based on the demand for the finished goods as specified by the MPS. The primary output of an MRP system is a time-phased report that gives (1) the purchasing department a schedule for obtaining raw materials and purchased parts, (2) the production managers a detailed schedule for manufacturing the product and controlling manufacturing inventories, and (3) accounting and financial functions production information that drives cash flow, budgets, and financial needs. MRP depends on understanding three basic concepts—(1) the concept of dependent demand, (2) the concept of time phasing, and (3) lot sizing to gain economies of scale.

The concept of dependent demand is best understood by examining the bill of materials. Because of the hierarchy of the BOM, there is no reason to order something until it is required to produce a parent item. Thus, all dependent demand requirements do not need to be ordered at the same time, but rather are *time phased* as necessary (see LFL MRP time phased record as an example). In addition, orders might be consolidated to take advantage of ordering economies of scale—this is called *lot sizing*.

An MRP record (see Exhibit 13.13) consists of the following:

- Gross requirements (GR)
- Scheduled or planned receipts (S/PR)
- Planned order receipt (PORec)
- Planned order release (PORel)
- Projected on-hand inventory (POH)

There are three common lot sizing methods for MRP—lot-for-lot (LFL), fixed order quantity (FOQ), and periodic order quantity (POQ). Lot sizing rules affect not only the planned order releases for the particular item under consideration, but also the gross requirements of all lower level component items. Some MRP users only use the simple LFL rule; others apply other lot sizing approaches to take advantage of economies of scale and reduce costs.

LO⁵ **Explain the concept and application of capacity requirements planning.**

Capacity requirements are computed by multiplying the number of units scheduled for production at a work center by the unit resource requirements and then adding in the setup time. These requirements are then summarized by time period and workcenter. Such information is usually provided in a **workcenter load report**. If sufficient capacity is not available, decisions must be made about overtime, transfer of personnel between departments, subcontracting, and so on. The master production schedule may also have to be revised to meet available capacity by shifting certain end items to different time periods or changing the order quantities.

Exhibit 13.13 *MRP Record for Item C Using the Lot-for-Lot (LFL) Rule*

Item C (two units of C are needed for one unit of A) Description weeks								Lot size: LFL Lead time: 2	
Week		1	2	3	4	5	6	7	
Gross requirements		0	0	300	600	100	400	0	
Scheduled receipts			200						
Projected OH inventory	10	10	210	0	0	0	0	0	
Planned order receipts		0	0	90	600	100	400	0	
Planned order releases		90	600	100	400				

Visit **4ltrpress.cengage.com/om** for additional study tools!

Learning Outcomes

Key Terms

LO¹ Explain the concepts of scheduling and sequencing.

Scheduling and sequencing are some of the more common activities that operations managers perform every day in every business. They are fundamental to all three levels of aggregation and disaggregation planning as we described in the previous chapter. Good schedules and sequences lead to efficient execution of manufacturing and service plans. Some examples of scheduling: fast-food restaurants, hospitals, and call centers need to schedule employees for work shifts; doctors, dentists, and stockbrokers need to schedule patients and customers; airlines must schedule crews and flight attendants; sports organizations must schedule teams and officials; court systems must schedule hearings and trials; factory managers need to schedule jobs on machines and preventive maintenance work; and salespersons need to schedule customer deliveries and visits to potential customers. Some examples of sequencing: triage nurses must decide on the order in which emergency patients are treated; housekeepers in hotels must sequence the order of rooms to clean; operations managers who run an automobile assembly line must determine the sequence by which different models are produced; and airport managers must sequence outgoing flights on runways.

LO² Describe staff scheduling and appointment system decisions.

Staff scheduling problems are also prevalent in service organizations because of high variability in customer demand. Examples include scheduling call center representatives, hotel housekeepers, tollbooth operators, nurses, airline reservation clerks, police officers, fast-food restaurant employees, and many others.

Staff scheduling attempts to match available personnel with the needs of the organization by:

1. accurately forecasting demand and translating it into the quantity and timing of work to be done;

2. determining the staffing required to perform the work by time period;

3. determining the personnel available and the full- and part-time mix; and

4. matching capacity to demand requirements, and developing a work schedule that maximizes service and minimizes costs.

The first step requires converting demand to a capacity measure, that is, the number of staff required. The second step determines the quantity and timing of the work to be done in detail, usually by hour of the day, and sometimes in 5- to 10-minute time intervals. Determining the staffing required must take into account worker productivity factors, personal allowances, sickness, vacations, no-shows, and so on. Step 4 focuses on the matching of capacity to demand requirements; this is the essence of scheduling.

A simple problem of scheduling personnel with consecutive days off in the face of fluctuating requirements can be solved as follows. First, locate the *set of at least two consecutive days with the smallest requirements*. Circle the requirements for those two consecutive days. Assign staff to work on all days not circled and update the remaining requirements. When there are several alternatives, do one of two things. First, try

to choose a pair of days with the lowest total requirement. If there are still ties, choose the first available pair that makes the most sense to the scheduler. Continue circling the smallest requirements until you obtain at least two consecutive days and repeat the procedure until all requirements are scheduled.

Appointments can be viewed as a reservation of service time and capacity. Using appointments provides a means to maximize the use of time-dependent service capacity and reduce the risk of no-shows. Appointment systems are used in many businesses, such as consulting, tax preparation, music instruction, and medical, dental, and veterinarian practices. Indirectly, appointments reduce the cost of providing the service because the service provider is idle less each workday. An appointment system must try to accommodate customers and forecast their behavior, such as the no-show rate or a difficult customer who demands more processing time.

Four decisions to make regarding designing an appointment system are:

1. *Determine the appointment time interval,* such as 1 hour or 15 minutes.

2. Based on an analysis of each day's customer mix, *determine the length of each workday and the time off-duty.*

3. *Decide how to handle overbooking* for each day of the week.

4. *Develop customer appointment rules* that maximize customer satisfaction.

LO³ Explain sequencing performance criteria and rules.

Sequencing criteria are often classified into three categories:

1. process-focused performance criteria,

2. customer-focused due date criteria, and

3. cost-based criteria.

Process-focused performance criteria pertain only to information about the start and end times of jobs and focus on shop

LO¹

Scheduling refers to the assignment of start and completion times to particular jobs, people, or equipment.

Sequencing refers to determining the order in which jobs or tasks are processed.

LO³

Flow time is the amount of time a job spent in the shop or factory.

Makespan is the time needed to process a given set of jobs.

Lateness is the difference between the completion time and the due date (either positive or negative).

Tardiness is the amount of time by which the completion time exceeds the due date.

performance such as equipment utilization and WIP inventory. Two common measures are flow time and makespan.

Due date criteria pertain to customers' required due dates or internally determined shipping dates. Common performance measures are lateness and tardiness, or the number of jobs tardy or late.

Cost-based performance criteria include inventory, changeover or setup, processing or run, and material handling costs. In most cases, costs are considered implicitly in process performance and due date criteria.

Two of the most popular sequencing rules for prioritizing jobs are:

- Shortest processing time (SPT)

- Earliest due date (EDD)

In other situations, new jobs arrive in an intermittent fashion, resulting in a constantly changing mix of jobs needing to be sequenced. In this case, we assign priorities to whatever jobs are available at a specific time and then update the priorities when new jobs arrive. Some examples of these priority rules are:

- First-come-first-served (FCFS)

- Fewest number of operations remaining (FNO)

- Least work remaining (LWR)—sum of all processing times for operations not yet performed

- Least amount of work at the next process queue (LWNQ)—amount of work awaiting the next process in a job's sequence

The SPT rule tends to minimize average flow time and work-in-process inventory and maximize resource utilization. The EDD rule minimizes the maximum of jobs past due but doesn't perform well on average flow time, WIP inventory, or resource utilization. The FCFS rule is used in many service delivery systems and does not consider any job or customer criterion. FCFS focuses only on the time of arrival for the customer or job. The FNO rule does not consider the length of time for each operation; for example, a job may have many small operations and be scheduled last. Generally, this is not a very good rule. The LWNQ rule tries to keep downstream workstations and associated resources busy.

LO⁴ Describe how to solve single- and two-resource sequencing problems.

The simplest sequencing problem is that of processing a set of jobs on a single processor. For the single-processor sequencing problem, a very simple rule—shortest processing time—finds a minimal average flow time sequence. The earliest due date rule (EDD), which dictates sequencing jobs in order of earliest due date first, minimizes the maximum job tardiness and job lateness. It does not minimize the average flow time or average lateness, as SPT does, however.

S.M. Johnson developed an algorithm for finding a minimum makespan schedule for a two-resource sequencing problem.

1. List the jobs and their processing times on Resources #1 and #2.

2. Find the job with the shortest processing time (on either resource).

3. If this time corresponds to Resource #1, sequence the job first; if it corresponds to Resource #2, sequence the job last.

4. Repeat steps 2 and 3, using the next-shortest processing time and working inward from both ends of the sequence until all jobs have been scheduled.

Gantt charts are often used to display the results such as shown in Exhibit 14.4.

LO⁵ Explain the need for monitoring schedules using Gantt charts.

Murphy's law states that if something can go wrong it will, and this is especially true with schedules. Thus, it is important that progress be monitored on a continuing basis. Reschedules are a normal part of scheduling.

Short-term capacity fluctuations also necessitate changes in schedules. Factors affecting short-term capacity include absenteeism, labor performance, equipment failures, tooling problems, labor turnover, and material shortages. They are inevitable and unavoidable. Gantt (bar) charts are useful tools for monitoring schedules (see Exhibit 14.6).

Exhibit 14.4 *Gantt Job Sequence Chart for Hirsch Product Sequence 1-2-3-4-5*

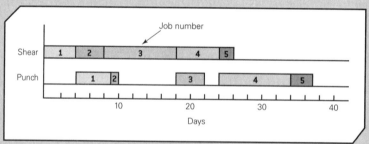

Exhibit 14.6 *Gantt Chart Example for Monitoring Schedule Progress*

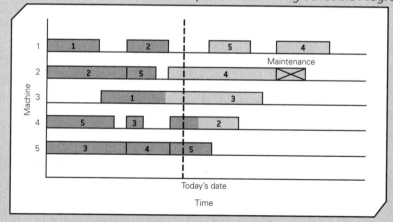

Learning Outcomes

LO¹ Explain the concepts and definitions of quality.

Many perspectives on quality relate to a good or service's fitness for use. From an operations perspective, however, the most useful definition is how well the output of a manufacturing or service process conforms to the design specifications. Excellent service quality is achieved by the consistent delivery to the customer of a clearly defined customer benefit package and associated process and service encounters, defined by many internal and external standards of performance.

An established instrument for measuring the external customer perceptions of service quality is SERVQUAL, which identified five key dimensions: tangibles, reliability, responsiveness, assurance, and empathy.

The principles of total quality are simple:

- a focus on customers and stakeholders,
- a process focus supported by continuous improvement and learning, and
- participation and teamwork by everyone in the organization.

LO² Describe the quality philosophies and principles of Deming, Juran, and Crosby.

The Deming philosophy focuses on bringing about improvements in product and service quality by reducing variability in goods and services design and associated processes. Deming professed that higher quality leads to higher productivity and lower costs, which in turn leads to improved market share and long-term competitive strength. In his early work in the United States, Deming preached his 14 Points:

Point 1: *Create a Vision and Demonstrate Commitment*

Point 2: *Learn the Philosophy*

Point 3: *Understand Inspection*

Point 4: *Stop Making Decisions Purely on the Basis of Cost*

Point 5: *Improve Constantly and Forever*

Point 6: *Institute Training*

Point 7: *Institute Leadership*

Point 8: *Drive Out Fear*

Point 9: *Optimize the Efforts of Teams*

Point 10: *Eliminate Exhortations*

Point 11: *Eliminate Numerical Quotas*

Point 12: *Remove Barriers to Pride in Work*

Point 13: *Encourage Education and Self-Improvement*

Point 14: *Take Action*

Juran proposed a simple definition of quality: "fitness for use." Unlike Deming, however, Juran did not propose a major cultural change in the organization, but rather sought to improve quality by working within the system familiar to managers. Juran stated that top management speaks in the language of dollars; workers speak in the language of things; and middle management must be able to speak both languages and translate between dollars and things. Thus, to get top management's attention, quality issues must be cast in the language they understand—dollars.

Crosby's Absolutes of Quality Management include the following points:

- *Quality means conformance to requirements, not elegance.*
- *There is no such thing as a quality problem.*

Key Terms

LO¹

Quality management refers to systematic policies, methods, and procedures used to ensure that goods and services are produced with appropriate levels of quality to meet the needs of customers.

Fitness for use is the ability of a good or service to meet customer needs.

Quality of conformance is the extent to which a process is able to deliver output that conforms to the design specifications.

Specifications are targets and tolerances determined by designers of goods and services.

Service quality is consistently meeting or exceeding customer expectations (external focus) and service delivery system performance criteria (internal focus) during all service encounters.

LO⁵

Six Sigma is a business improvement approach that seeks to find and eliminate causes of defects and errors in manufacturing and service processes by focusing on outputs that are critical to customers and results in a clear financial return for the organization.

A **defect** is any mistake or error that is passed on to the customer.

A **unit of work** is the output of a process or an individual process step.

LO⁶

The **cost of quality** refers specifically to the costs associated with avoiding poor quality or those incurred as a result of poor quality.

Prevention costs are those expended to keep nonconforming goods and services from being made and reaching the customer.

Appraisal costs are those expended on ascertaining quality levels through measurement and analysis of data to detect and correct problems.

Internal failure costs are costs incurred as a result of unsatisfactory quality that is found before the delivery of a good or service to the customer.

External failure costs are incurred after poor-quality goods or services reach the customer.

LO⁷

The **root cause** is a term used to designate the source of a problem.

Key Terms

LO⁸

Kaizen focuses on small, gradual, and frequent improvements over the long term with minimum financial investment and with participation by everyone in the organization.

A **kaizen blitz** is an intense and rapid improvement process in which a team or a department throws all its resources into an improvement project over a short time period, as opposed to traditional kaizen applications, which are performed on a part-time basics.

Poka-yoke (POH-kah YOH-kay) is an approach for mistake-proofing processes using automatic devices or methods to avoid simple human error.

- *There is no such thing as the economics of quality; doing the job right the first time is always cheaper.*
- *The only performance measurement is the cost of quality, which is the expense of nonconformance.*
- *The only performance standard is "Zero Defects (ZD)."*

LO³ Explain the GAP model and its importance.

The GAP model (see Exhibit 15.2) recognizes that there are several ways to misspecify and mismanage the creation and delivery of high levels of quality.

- **Gap 1** *is the discrepancy between customer expectations and management perceptions of those expectations.*
- **Gap 2** *is the discrepancy between management perceptions of what features constitute a target level of quality and the task of translating these perceptions into executable specifications.*
- **Gap 3** *is the discrepancy between quality specifications documented in operating and training manuals and plans and their implementation.*
- **Gap 4** *is the discrepancy between actual manufacturing and service delivery system performance and external communications to the customers.*
- **Gap 5** *is the difference between the customer's expectations and perceptions.*

LO⁴ Describe the concepts and philosophy of ISO 9000:2000.

ISO 9000 defines *quality system standards*. The ISO 9000:2000 standards are supported by the following eight principles:

Principle 1—Customer-Focused Organization

Principle 2—Leadership

Principle 3—Involvement of People

Principle 4—Process Approach

Principle 5—System Approach to Management

Principle 6—Continual Improvement

Principle 7—Factual Approach to Decision Making

Principle 8—Mutually Beneficial Supplier Relationships

LO⁵ Describe the philosophy and methods of Six Sigma.

The term *Six Sigma* is based on a statistical measure that equates to at most 3.4 errors or defects per million opportunities.

The core philosophy of Six Sigma is based on some key concepts:

- emphasizing dpmo as a standard metric that can be applied to all parts of an organization
- providing extensive training followed by project team deployment to improve profitability, reduce non-value-added activities, and achieve cycle time reduction
- focusing on corporate sponsors responsible for supporting team activities
- creating highly qualified process improvement experts ("green belts," "black belts," and "master black belts") who can apply improvement tools and lead teams
- ensuring that appropriate metrics are identified early in the process and that they focus on business results
- setting stretch objectives for improvement

The Six Sigma problem solving approach is Define, Measure, Analyze, Improve, and Control.

LO⁶ Explain the categories of cost of quality measurement.

Quality costs can be organized into four major categories: prevention costs, appraisal costs, internal failure costs, and external failure costs. By collecting and analyzing these costs, managers can identify the most important opportunities for improvement.

LO⁷ Describe how to apply the Seven QC Tools.

Seven simple tools—flowcharts, checksheets, histograms, Pareto diagrams, cause-and-effect diagrams, scatter diagrams, and control charts—termed the *Seven QC* (quality control) *Tools* by the Japanese, support quality improvement problem-solving efforts. The Seven QC Tools are designed to be simple and visual so that workers at all levels can use them easily and provide a means of communication that is particularly well suited in group problem-solving efforts. Root cause analysis often uses the Seven QC Tools. The root cause is a term used to designate the source of a problem.

LO⁸ Explain the concepts of kaizen and poka-yoke.

The concept of continuous improvement is known as *kaizen*. In the kaizen philosophy, improvement in all areas of business—cost, meeting delivery schedules, employee safety and skill development, supplier relations, new product development, or productivity—serve to enhance the quality of the firm.

Human beings tend to make mistakes inadvertently. Typical process-related mistakes include omitted processing steps, processing errors, setup or changeover errors, missing information or parts, not handling service upsets properly, wrong information or parts, and adjustment errors. Poka-yoke is designed to prevent such errors from occurring.

Learning Outcomes

LO¹ Describe quality control system and key issues in manufacturing and service.

Any control system has three components:

1. a performance standard or goal,
2. a means of measuring actual performance, and
3. comparison of actual performance with the standard to form the basis for corrective action.

The importance of control is often explained by the *1:10:100 Rule*:

If a defect or service error is identified and corrected at the design stage, it might cost $1 to fix. If it is first detected during the production process, it might cost $10 to fix. However, if the defect is not discovered until it reaches the customer, it might cost $100 to correct.

In manufacturing, control is generally applied at three key points in the supply chain: at the receiving stage from suppliers, during various production processes, and at the finished goods stage.

One way to control quality in services is to prevent sources of errors and mistakes in the first place by using the poka-yoke approaches. Another way is to hire and train service providers in service management skills as part of a prevention-based approach to quality control.

LO² Explain types of variation and the role of statistical process control.

Variation occurs for many reasons, such as inconsistencies in material inputs; changes in environmental conditions (temperature, humidity); machine maintenance cycles; customer participation and self-service; tool wear; and human fatigue. Common cause variation is the responsibility of management while front-line employees focus more on special cause variation.

LO³ Describe how to construct and interpret simple control charts for both continuous and discrete data.

The five steps required to develop and construct control charts are (1) preparation such as choose the metric to be monitored and determine sample size and the frequency, (2) collect the data and calculate basic statistics, (3) determine trial upper and lower control limits and center line, (4) investigate and interpret the control chart, eliminate out-of-control points, and recompute the control limits, and (5) use problem-solving tools and take corrective action(s).

Key formulas for an \bar{x} and R-chart are:

$$\bar{\bar{x}} = \frac{\sum_{i=1}^{k} \bar{x}_i}{k} \qquad [16.1]$$

$$\bar{R} = \frac{\sum_{i=1}^{k} R_i}{k} \qquad [16.2]$$

$$UCL_R = D_4\bar{R} \qquad UCL_{\bar{x}} = \bar{\bar{x}} + A_2\bar{R}$$

$$LCL_R = D_3\bar{R} \qquad LCL_{\bar{x}} = \bar{\bar{x}} - A_2\bar{R} \qquad [16.3]$$

where \bar{x}_i is the average of the *i*th sample.

Key Terms

LO¹

The task of **quality control** is to ensure that a good or service conforms to specifications and meets customer requirements by monitoring and measuring processes and making any necessary adjustments to maintain a specified level of performance.

Quality at the source means the people responsible for the work control the quality of their processes by identifying and correcting any defects or errors when they first are recognized or occur.

LO²

Statistical process control (SPC) is a methodology for monitoring quality of manufacturing and service delivery processes to help identify and eliminate unwanted causes of variation.

Common cause variation is the result of complex interactions of variations in materials, tools, machines, information, workers, and the environment.

Special (or assignable) cause variation arises from external sources that are not inherent in the process, appear sporadically, and disrupt the random pattern of common causes.

If no special causes affect the output of a process, we say that the process is **in control**; when special causes are present, the process is said to be **out of control**.

LO³

A **continuous metric** is one that is calculated from data that are measured as the degree of conformance to a specification on some continuous scale of measurement.

A **discrete metric** is one that is calculated from data that are counted.

LO⁵

Process capability refers to the natural variation in a process that results from common causes.

A **process capability study** is a carefully planned study designed to yield specific information about the performance of a process under specified operating conditions.

The relationship between the natural variation and specifications is often quantified by a measure known as the **process capability index**.

Key formulas for a *p*-chart are:

$$\bar{p} = \frac{p_1 + p_2 + \cdots + p_k}{k}$$

$$s_{\bar{p}} = \sqrt{\frac{\bar{p}(1 - \bar{p})}{n}}$$

$$UCL_p = \bar{p} + 3s_{\bar{p}}$$

$$LCL_p = \bar{p} - 3s_{\bar{p}}$$

where p_i is the fraction nonconforming in the *i*th sample.

Key formulas for a *c*-chart are:

$$UCL_c = \bar{c} + 3\sqrt{\bar{c}}$$

$$LCL_c = \bar{c} - 3\sqrt{\bar{c}}$$

where \bar{c} is the average number of nonconformances per unit.

A process is in control when the control chart has the following characteristics:

1. No points are outside control limits.

2. The number of points above and below the center line is about the same.

3. The points seem to fall randomly above and below the center line.

4. Most points, but not all, are near the center line, and only a few are close to the control limits.

LO⁴ Describe practical issues in implementing SPC.

Designing control charts involves two key issues:

1. sample size, and

2. sampling frequency.

A small sample size is desirable to keep the cost associated with sampling low. On the other hand, large sample sizes provide greater degrees of statistical accuracy in estimating the true state of control. Large samples also allow smaller changes in process characteristics to be detected with higher probability. In practice, samples of about 5 have been found to work well in detecting process shifts of 2 standard deviations or larger. To detect smaller shifts in the process mean, larger sample sizes of 15 to 25 must be used.

Taking large samples on a frequent basis is desirable but clearly not economical. No hard-and-fast rules exist for the frequency of sampling. Samples should be close enough to provide an opportunity to detect changes in process characteristics as soon as possible and reduce the chances of producing a large amount of nonconforming output. However, they should not be so close that the cost of sampling outweighs the benefits that can be realized.

SPC is a useful methodology for processes that operate at a low sigma level, for example 3-sigma or less. However, when the rate of defects is extremely low, standard control charts are not effective.

Example Problem

A controlled process shows an overall mean of 2.50 and an average range of 0.42. Samples of size 4 were used to construct the control charts. What is the process capability? If specifications are 2.60 ± 0.25, how well can this process meet them?

From Appendix B, $d_2 = 2.059$ and $s = \bar{R}/d_2 = 0.42/2.059 = 0.20$. Thus, the process capability is 2.50 ± 3(0.020), or 1.90 to 3.10. Because the specification range is 2.35 to 2.85 with a target of 2.60, we may conclude that the observed natural variation exceeds the specifications by a large amount. In addition, the process is off-center (see exhibit below).

Comparison of Observed Variation and Design Specifications

LO⁵ Explain process capability and calculate process capability indexes.

Knowing process capability allows one to predict, quantitatively, how well a process will meet specifications and to specify equipment requirements and the level of control necessary. Process capability has no meaning if the process is not in statistical control because special causes will bias the mean or the standard deviation. Therefore, we should use control charts to first eliminate any special causes before computing the process capability.

Typical questions that are asked in a process capability study are

• Where is the process centered?

• How much variability exists in the process?

• Is the performance relative to specifications acceptable?

• What proportion of output will be expected to meet specifications?

The process capability index, C_p, is defined as the ratio of the specification width to the natural tolerance of the process.

$$C_p = \frac{UTL - LTL}{6\sigma} \qquad [16.9]$$

Values of C_p exceeding 1 indicate good capability. To account for the process centering, one-sided capability indexes are often used:

$$C_{pu} = \frac{UTL - \mu}{3\sigma} \text{ (upper one-sided index)} \quad [16.10]$$

$$C_{pl} = \frac{\mu - LTL}{3\sigma} \text{ (lower one-sided index)} \quad [16.11]$$

$$C_{pk} = \min (C_{pl}, C_{pu}) \qquad [16.12]$$

Learning Outcomes

LO¹ Explain the four principles of lean operating systems.

Lean operating systems have four basic principles:

1. elimination of waste
2. increased speed and response
3. improved quality
4. reduced cost

The Toyota Motor Company classified waste into seven major categories:

1. *Overproduction*: for example, making a batch of 100 when there are orders for only 50 in order to avoid an expensive setup, or making a batch of 52 instead of 50 in case there were rejects. Overproduction ties up production facilities, and the resulting excess inventory simply sits idle.

2. *Waiting time*: for instance, allowing queues to build up between operations, resulting in longer lead times and higher work-in-progress.

3. *Transportation*: the time and effort spent in moving products around the factory as a result of poor layout.

4. *Processing*: the traditional notion of waste, as exemplified by scrap that often results from poor product or process design.

5. *Inventory*: waste associated with the expense of idle stock and extra storage and handling requirements needed to maintain it.

6. *Motion*: as a result of inefficient workplace design and location of tools and materials.

7. *Production defects*: the result of not performing work correctly the first time.

Lean operating systems focus on quick and efficient response in designing and getting goods and services to market, producing to customer demand and delivery requirements, responding to competitor's actions, collecting payments, and addressing customer inquiries or problems.

LO² Describe the basic lean tools and approaches.

The 5Ss are derived from Japanese terms: seiri (sort), seiton (set in order), seiso (shine), seiketsu (standardize), and shitsuke (sustain).

- *Sort* refers to ensuring that each item in a workplace is in its proper place or identified as unnecessary and removed.

- *Set in order* means to arrange materials and equipment so that they are easy to find and use.

- *Shine* refers to a clean work area. Not only is this important for safety, but as a work area is cleaned, maintenance problems such as oil leaks can be identified before they cause problems.

- *Standardize* means to formalize procedures and practices to create consistency and ensure that all steps are performed correctly.

- Finally, *sustain* means to keep the process going through training, communication, and organizational structures.

Visual signaling systems are known as *andon,* drawing from the Japanese term where the concept first originated. For example, if a machine fails or a part is defective or manufactured incorrectly, a light might turn on or a buzzer might sound, indicating that immediate action should be taken. Many firms have cords that operators can pull that tell supervisors and other workers that a problem has occurred.

Batching is often necessary when producing a broad goods or service mix with diverse requirements on common equipment. By running large batches, setups and teardowns are reduced, providing economies of scale. However, this often builds up inventory that might not match market demand, particularly in highly dynamic markets. A better strategy would be to use small batches or single-piece flow. However, to do this economically requires the ability to change between products quickly and inexpensively.

Key Terms

LO¹

Lean enterprise refers to approaches that focus on the elimination of waste in all forms, and smooth, efficient flow of materials and information throughout the value chain to obtain faster customer response, higher quality, and lower costs.

Manufacturing and service operations that apply the principles of lean enterprise are often called **lean operating systems**.

LO²

The **5Ss** are derived from Japanese terms: seiri (sort), seiton (set in order), seiso (shine), seiketsu (standardize), and shitsuke (sustain).

Visual controls are indicators for operating activities that are placed in plain sight of all employees so that everyone can quickly and easily understand the status and performance of the work system.

Single Minute Exchange of Dies (SMED) refers to quick setup or changeover of tooling and fixtures in processes so that multiple products in smaller batches can be run on the same equipment.

Batching is the process of producing large quantities of items as a group before being transferred to the next operation.

Single-piece flow is the concept of ideally using batch sizes of one.

Total productive maintenance (TPM) is focused on ensuring that operating systems will perform their intended function reliably.

LO⁵

A **push system** produces finished goods inventory in advance of customer demand using a forecast of sales.

A **pull system** is one in which employees at a given operation go to the source of required parts, such as machining or subassembly, and withdraw the units as they need them.

A **Kanban** is a flag or a piece of paper that contains all relevant information for an order: part number, description, process area used, time of delivery, quantity available, quantity delivered, production quantity, and so on.

The goal of TPM is to prevent equipment failures and downtime; ideally, to have "zero accidents, zero defects, and zero failures" in the entire life cycle of the operating system.

Many companies are actively recovering and recycling parts (sometimes called *green manufacturing*).

LO3 Explain the concept of lean six sigma and how it is applied to improving operations performance.

Six Sigma is a useful and complementary approach to lean production. Lean Six Sigma draws upon the best practices of both approaches; however, they attack different types of problems. Lean production addresses visible problems in processes, for example, inventory, material flow, and safety. Six Sigma is more concerned with less visible problems, for example, variation in performance.

LO4 Explain how lean principles are used in manufacturing and service organizations.

Lean manufacturing plants look significantly different from traditional plants. They are clean and organized, devoid of long and complex production lines and high levels of work-in-process, have efficient layouts and work area designs, use multiskilled workers that perform both direct and indirect work such as maintenance, and have no incoming or final inspection stations.

Lean principles are not always transferable to "front-office" services that involve high customer contact and service encounters. Different customers, service encounter situations, and customer and employee behaviors cause the creation and delivery of the service to be much more variable and uncertain than producing a manufactured good in the confines of a factory. However, "back-office" service processes, such as hospital laboratory testing, check processing, and college application processing, are nearly identical to many manufacturing processes.

LO5 Describe the concepts and philosophy of just-in-time operating systems.

Just-in-Time (JIT) was introduced at Toyota during the 1950s and 1960s to address the challenge of coordinating successive production activities. Toyota created a system based on a simple idea: Produce the needed quantity of required parts each day. Then just enough new parts are manufactured or procured to replace those withdrawn. As the process from which parts were withdrawn replenishes the items it transferred out, it draws on the output of its preceding process, and so on. Finished goods are made to coincide with the actual rate of demand, resulting in minimal inventories and maximum responsiveness.

A JIT system can produce a steady rate of output to meet the sales rate in small, consistent batch sizes to level loads and stabilize the operating system. This dramatically reduces the inventory required between stages of the production process, thus greatly reducing costs and physical capacity requirements. In a JIT process, the customer cycle withdraws what is needed at the time it is needed according to sales. The supply cycle creates the good to replenish only what has been withdrawn by the customer. The storage area is the interface and control point between the customer and supply cycles.

Slips, called Kanban cards (*Kanban* is a Japanese word that means "visual record" or "card"), are circulated within the system to initiate withdrawal and production items through the production process. The number of Kanban cards is directly proportional to the amount of work-in-process inventory.

Exhibit 17.3 A Two-Card Kanban JIT Operating System

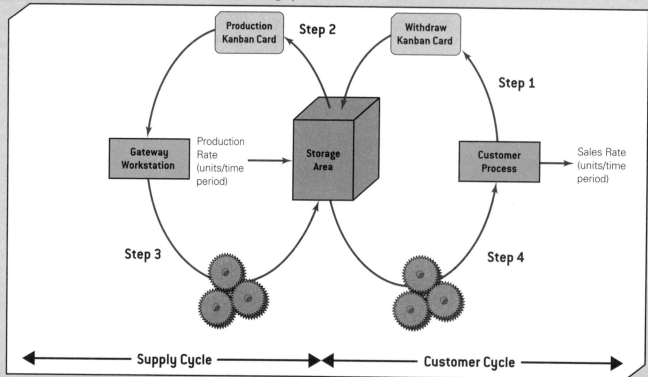

Learning Outcomes

LO¹ Explain the key issues associated with project management.

In many firms, projects are the major value creation process, and the major activities in the value chain revolve around projects. In other firms, projects are used on an infrequent basis to implement new strategies and initiatives or for supporting value chain design and improvement activities.

Most projects go through similar stages from start to completion.

1. *Define:* The first step in managing a project is to clearly define the goal of the project, responsibilities, deliverables, and when it must be accomplished.

2. *Plan:* In this stage, the steps needed to execute a project are defined, it is determined who will perform these steps, and the start and completion dates are developed.

3. *Organize:* Organizing involves such activities as identifying a project manager, forming a team, allocating resources, calculating costs, assessing risk, preparing project documentation, and ensuring good communications.

4. *Control:* This stage assesses how well a project meets its goals and objectives and makes adjustments as necessary.

5. *Close:* Closing a project involves compiling statistics, releasing and/or reassigning people, and preparing "lessons learned."

The job of project managers is to build an effective team, motivate them, provide advice and support, align the project with the firm's strategy, and direct and supervise the conduct of the project from beginning to end. In addition to managing the project, they must manage the relationships among the project team, the parent organization, and the client. The project manager must also have sufficient technical expertise to resolve disputes among functional specialists.

A matrix organizational structure "loans" resources to projects while still maintaining control over them is an effective structure for projects. Project managers coordinate the work across the functions. This minimizes duplication of resources and facilitates communication across the organization but requires that resources be negotiated. Ensuring project success depends on having well-defined goals and objectives, clear reporting

Key Terms

LO¹

A **project** is a temporary and often customized initiative that consists of many smaller tasks and activities that must be coordinated and completed to finish the entire initiative on time and within budget.

Project management involves all activities associated with planning, scheduling, and controlling projects.

LO²

Activities are discrete tasks that consume resources and time.

Immediate predecessors are those activities that must be completed immediately before an activity may start.

The **work breakdown structure** is a hierarchical tree of end items that will be accomplished by the project team during the project.

A **project network** consists of a set of circles or boxes, called **nodes**, which represent activities, and a set of arrows, called **arcs**, which define the precedence relationships between activities.

The **critical path** is the sequence of activities that takes the longest time and defines the total project completion time.

A **schedule** specifies when activities are to be performed.

Exhibit 18.2 *Contributors and Impediments to Project Success*

Contributors to Project Success	Impediments to Project Success
Well-defined and agreed-upon objectives	Ill-defined project objectives
Top management support	Lack of executive champion
Strong project manager leadership	Inability to develop and motivate people
Well-defined project definition	Poorly-defined project definition
Accurate time and cost estimates	Lack of data accuracy and integrity
Teamwork and cooperation	Poor interpersonal relations and teamwork
Effective use of project management tools	Ineffective use of project management tools
Clear channels of communication	Poor communication among stakeholders
Adequate resources and reasonable deadlines	Unreasonable time pressures and lack of resources
Constructive response to conflict	Inability to resolve conflicts

Key Terms

LO³

Crashing a project refers to reducing the total time to complete the project to meet a revised due date.

Crash time is the shortest possible time the activity can realistically be completed.

The **crash cost** is the total additional cost associated with completing an activity in its crash time rather than in its normal time.

Crashing an activity refers to reducing its normal time possibly up to its limit—the crash time.

relationships and channels of communication, good procedures for estimating time and other resource requirements, cooperation and commitment among all project team members, realistic expectations, effective conflict resolution, and top-management sponsorship.

LO² Describe how to apply the Critical Path Method (CPM).

All project management decisions involve three factors: *time*, *resources*, and *cost*. Various techniques have long been used to help plan, schedule, and control projects. The key steps involved are:

1. *Project Definition:* Identifying the activities that must be completed and the sequence required to perform them

2. *Resource Planning:* For each activity, determining the resource needs: personnel, time, money, equipment, materials, and so on

3. *Project Scheduling:* Specifying a time schedule for the completion of each activity

4. *Project Control:* Establishing the proper controls for determining progress and developing alternative plans in anticipation of problems in meeting the planned schedule

The **Critical Path Method (CPM)** is an approach to scheduling and controlling project activities. CPM assumes:

- The project network defines a correct sequence of work in terms of technology and workflow.

- Activities are assumed to be independent of one another with clearly defined start and finish dates.

- The activity time estimates are accurate and stable.

- Once an activity is started it continues uninterrupted until it is completed.

Earliest start and earliest finish times are computed by moving through the project network in a forward direction from start to finish, sometimes called the *forward pass* through the network.

Rule 1: The earliest time that an activity can be completed is equal to the earliest time it can begin plus the time to perform the activity.

Rule 2: The ES time for an activity equals the largest EF time of all immediate predecessors.

Latest start and latest finish times are computed by making a *backward pass* through the network, beginning with the ending project activity or activities.

Rule 3: The latest start time for an activity is equal to its LF time minus the activity time.

Rule 4: The LF time for an activity is the smallest LS time of all immediate successors.

Slack time is computed as $ST = LS - ES$ or $LF - EF$

The critical path (CP) is the longest path(s) through the project network; activities on the critical path have zero slack time ($ST = 0$) and if delayed will cause the total project to be delayed.

Because of the uncertainty of task times, unavoidable delays, or other problems, projects rarely, if ever, progress on schedule. Managers must therefore monitor performance of the project and take corrective action when needed. Gantt charts are often used for this purpose.

LO³ Explain how to make time/cost tradeoff decisions in projects.

The first step is to determine the amount of time that each activity may be reduced and its associated cost. Then determine the crash cost per unit of time for each activity. To find the crash schedule that minimizes the project completion time, use a trial-and-error approach.

LO⁴ Describe how to calculate probabilities for project completion time using PERT.

PERT (Project Evaluation and Review Technique) was developed as a means of handling the uncertainties in activity completion times. The PERT procedure uses the variance in the critical-path activities to understand the risk associated with completing the project on time.

When activity times are uncertain, they are often treated as random variables with associated probability distributions. Usually three time estimates are obtained for each activity: optimistic, most probable, and pessimistic times.

The expected project completion time is the sum of the expected times for the activities on the critical path. The variance in project duration is given by the sum of the variances of the critical-path activities.

Expected time = $(a + 4m + b)/6$ [18.2]

Variance = $(b - a)^2/36$ [18.3]

Using this information, we can compute the probability of meeting a specified completion date.

formulacard OM2

Breakeven quantity for outsourcing

$$Q^* = \frac{FC}{VC_2 - VC_1}$$ [2.1]

Productivity

$$\text{Productivity} = \frac{\text{Quantity of Output}}{\text{Quantity of Input}}$$ [3.1]

Value of a loyal customer

$$VLC = (P)(CM)(RF)(BLC)$$ [3.2]

Taguchi loss function

$$L(x) = k(x-T)^2$$ [6.1]

System reliability of an *n*-component series system

$$R_s = (p_1)(p_2)(p_3)\ldots(p_n)$$ [6.2]

System reliability of an *n*-component parallel system

$$R_p = 1 - (1 - p_1)(1 - p_2)(1 - p_3)\ldots(1 - p_n)$$ [6.3]

Resource utilization

$$\text{Utilization }(U) = \frac{\text{Resources Used}}{\text{Resources Available}}$$ [7.1]

$$\text{Utilization }(U) = \frac{\text{Demand Rate}}{[\text{Service Rate} \times \text{Number of Servers}]}$$ [7.2]

Little's Law

$$WIP = R \times T$$ [7.3]

Feasible range of cycle times

Maximum operation time $\leq CT \leq$ Sum of operation times [8.1]

Cycle time

$$CT = A/R$$ [8.2]

Theoretical minimum number of workstations

Minimum number of workstations required
$$= \text{Sum of task times/Cycle time} = \Sigma t/CT$$ [8.3]
Total time available
$$= (\text{Number of workstations})(\text{Cycle time})$$
$$= (N)(CT)$$ [8.4]
Total idle time $= (N)(CT) - \Sigma t$ [8.5]
Assembly-line efficiency $= \Sigma t/(N \times CT)$ [8.6]
Balance delay $= 1 - $ Assembly-line efficiency [8.7]

Center of gravity

$$C_x = \Sigma X_i W_i/\Sigma W_i$$ [9.1]
$$C_y = \Sigma Y_i W_i/\Sigma W_i$$ [9.2]

Average safety capacity

$$\text{Average safety capacity (\%)} = \frac{100\% - \text{Average}}{\text{resource utilization (\%)}}$$ [10.1]

Capacity required to meet a given production volume for one work order (*i*)

Capacity required (C_i)
$$= \text{Setup time }(S_i) + [\text{Processing time }(P_i) \times \text{Order size }(Q_i)]$$ [10.2]

Total capacity required over all work orders

$$C = \Sigma C_i = \Sigma[S_i + (P_i \times Q_i)]$$ [10.3]

Mean square error (MSE)

$$\text{MSE} = \frac{\Sigma (A_t - F_t)^2}{T}$$ [11.1]

Mean absolute deviation (MAD)

$$\text{MAD} = \frac{\Sigma |(A_t - F_t)|}{T}$$ [11.2]

Mean absolute percentage error

$$\text{MAPE} = \frac{\Sigma |(A_t - F_t)/A_t| \times 100}{T}$$ [11.3]

Moving average (MA) forecast

$$F_{t+1} = \Sigma(\text{most recent "}k\text{" observations})/k$$
$$= (A_t + A_{t-1} + A_{t-2} + \ldots + A_{t-k+1})/k$$ [11.4]

Exponential-smoothing forecasting model

$$F_{t+1} = \alpha A_t + (1 - \alpha)F_t$$
$$= F_t + \alpha(A_t - F_t)$$ [11.5]

Smoothing constant approximate relationship to the value of *k* in the moving average model

$$\alpha = 2/(k + 1)$$ [11.6]

Linear regression forecasting model

$$Y_t = a + bt$$ [11.7]

Tracking signal

Tracking signal $= \Sigma(A_t - F_t)/\text{MAD}$ [11.8]

Inventory position (IP)

$$IP = OH + SR - BO$$ [12.1]

Average demand during the lead time

$$r = \mu_L = (d)(L)$$ [12.2]

Average cycle inventory

Average cycle inventory $= (\text{Maximum inventory} + \text{Minimum inventory})/2 = Q/2$ [12.3]

Annual inventory holding cost

$$\text{Annual inventory holding cost} = \left(\text{Average inventory}\right)\left(\text{Annual holding cost per unit}\right) = \frac{1}{2}QC_h$$ [12.4]

Annual ordering cost

$$\text{Annual ordering cost} = \left(\text{Number of orders per year}\right)\left(\text{Cost per order}\right) = \left(\frac{D}{Q}\right)C_o$$ [12.5]

Total annual cost

$$TC = \frac{1}{2}QC_h + \frac{D}{Q}C_o$$ [12.6]

Economic order quantity

$$Q^* = \sqrt{\frac{2DC_o}{C_h}}$$ [12.7]

Reorder point with safety stock

$$r = \mu_L + z\sigma_L$$ [12.8]

Mean demand during lead time with uncertain demand

$$\mu_L = \mu_t L \qquad [12.9]$$

Standard deviation of demand during lead time with uncertain demand

$$\sigma_L = \sigma_t \sqrt{L} \qquad [12.10]$$

Economic time interval

$$T = Q^*/D \qquad [12.11]$$

Replenishment level without safety stock (FPS)

$$M = d(T + L) \qquad [12.12]$$

Replenishment level with safety stock (FPS)

$$M = \mu_{T+L} + z \times \sigma_{T+L}$$
$$\text{where } \mu_{T+L} = \mu_t(T + L)$$
$$\sigma_{T+L} = \sigma_t \sqrt{T + L} \qquad [12.13]$$

Marginal economic analysis for a single period inventory model

$$P(\text{demand} \leq Q^*) = \frac{c_u}{c_u + c_s} \qquad [12.14]$$

Projected on-hand inventory

Ending Inventory = Beginning Inventory
+ Production − Demand $\qquad [13.1]$

$$\text{Projected on-hand in period } t \, (\text{POH}_t) = \text{On-hand inventory in period } t-1 \, (\text{OH}_{t-1})$$

$$+ \text{Scheduled or planned receipts in period } t \, (\text{S/PR}_t) - \text{Gross requirements in period } t \, (\text{GR}_t)$$

or

$$\text{POH}_t = \text{OH}_{t-1} + \text{S/PR}_t - \text{GR}_t \qquad [13.2]$$

Flow time

$$F_i = \Sigma p_{ij} + \Sigma w_{ij} = C_i - R_i \qquad [14.1]$$

Makespan

$$M = C - S \qquad [14.2]$$

Lateness (L)

$$L_i = C_i - D_i \qquad [14.3]$$

Tardiness (T)

$$T_i = \text{Max}\,(0, L_i) \qquad [14.4]$$

Overall mean

$$\bar{\bar{x}} = \frac{\sum_{i=1}^{k} \bar{x}_i}{k} \qquad [16.1]$$

Average range

$$\bar{R} = \frac{\sum_{i=1}^{k} R_i}{k} \qquad [16.2]$$

Upper and lower control limits

$$\text{UCL}_R = D_4\bar{R} \qquad \text{UCL}_{\bar{x}} = \bar{\bar{x}} + A_2\bar{R}$$
$$\text{LCL}_R = D_3\bar{R} \qquad \text{LCL}_{\bar{x}} = \bar{\bar{x}} - A_2\bar{R} \qquad [16.3]$$

Average fraction nonconforming for p-chart

$$\bar{p} = \frac{p_1 + p_2 \cdots + p_k}{k} \qquad [16.4]$$

Standard deviation of fraction nonconforming for p-chart

$$s_{\bar{p}} = \sqrt{\frac{\bar{p}(1 - \bar{p})}{n}} \qquad [16.5]$$

Upper and lower control limits for p-charts

$$\text{UCL}_P = \bar{p} + 3s_{\bar{p}}$$
$$\text{LCL}_P = \bar{p} - 3s_{\bar{p}} \qquad [16.6]$$

Upper and lower control limits for c-charts

$$\text{UCL}_c = \bar{c} + 3\sqrt{\bar{c}}$$
$$\text{LCL}_c = \bar{c} - 3\sqrt{\bar{c}} \qquad [16.7]$$

Approximation of standard deviation with \bar{x}- and R-charts

$$\sigma = \frac{\bar{R}}{d_2} \qquad [16.8]$$

Process capability index

$$C_p = \frac{UTL - LTL}{6\sigma} \qquad [16.9]$$

One-sided capability index

$$C_{pu} = \frac{UTL - \mu}{3\sigma} \text{ (upper one-sided index)} \qquad [16.10]$$

$$C_{pl} = \frac{\mu - LTL}{3\sigma} \text{ (lower one-sided index)} \qquad [16.11]$$

$$C_{pk} - \text{min}\,(C_{pl}, C_{pu}) \qquad [16.12]$$

Number of Kanban cards required

$$K = \frac{\text{Average daily demand during lead time plus a safety stock}}{\text{Number of units per container}}$$

$$= \frac{d(p+w)(1+\alpha)}{C} \qquad [17.1]$$

Crash cost per unit of time

$$\text{Crash cost per unit of time} = \frac{\text{Crash cost} - \text{Normal cost}}{\text{Normal time} - \text{Crash time}} \qquad [18.1]$$

Expected time

Expected time $= (a + 4m + b)/6 \qquad [18.2]$

Variance of activity times

Variance $= (b - a)^2/36 \qquad [18.3]$